INVITATION TO THE GALLERY
An Introduction to Art

Richard Phipps
Capital University

Richard Wink
Ohio State University

wcb
Wm. C. Brown Publishers
Dubuque, Iowa

Book Team
Karen Speerstra *Editor*
Carol Mills *Assistant Editor*
Sharon R. Nesteby *Editorial Assistant*
Anne Scheid *Designer*
Mavis M. Oeth *Permissions Editor*
Faye M. Schilling *Photo Editor*

wcb group

Wm. C. Brown *Chairman of the Board*
Mark C. Falb *President and Chief Executive Officer*

wcb

Wm. C. Brown Publishers, College Division
G. Franklin Lewis *Executive Vice-President, General Manager*
E. F. Jogerst *Vice-President, Cost Analyst*
Chris C. Guzzardo *Vice-President, Director of Marketing*
George Wm. Bergquist *Editor-in-Chief*
Beverly Kolz *Director of Production*
Bob McLaughlin *National Sales Manager*
Craig S. Marty *Director of Marketing Research*
Colleen A. Yonda *Production Editorial Manager*
Marilyn A. Phelps *Manager of Design*
Faye M. Schilling *Photo Research Manager*

INVITATION TO THE GALLERY
An Introduction to Art

Contents

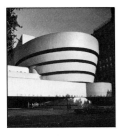

PART II STYLE IN ART 87

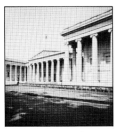

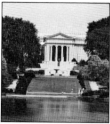

Tour 5
Religious Expression:
East and West 117

*The Cleveland Museum of Art
Cleveland, Ohio*

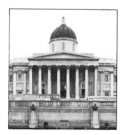

Tour 6
The Renaissance in
Europe 143

*The National Gallery
London, England*

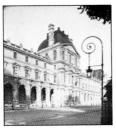

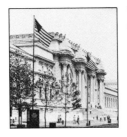

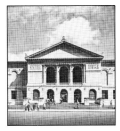

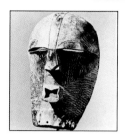

Colorplates

Preface

INVITATION TO THE GALLERY may resemble a guide to art museums, but it offers much more. The basic idea behind our approach is to stimulate the activities that any course in art appreciation hopes to achieve—to encourage people to visit galleries and museums, to purchase art, and above all, to recognize the artistic quality of everything we encounter in life. The book could very well be subtitled "What to Look for in Art."

As in any endeavor, the only way to learn how to appreciate art is to look at it, a lot of it. The text contains over six hundred illustrations from eleven different museums and offers a broad survey of the most acclaimed works of art in the world. Although the museum or the gallery is still the best place to see art in profusion and diversity, the benefit of simulated museum tours provides the closest proximity to the actual experience of seeing art in person.

Perhaps the most unique feature of this book is the arrangement of art fundamentals and style periods into selected museum tours and nontraditional location tours around the world. The discussions of line, value, color, and texture, for example, are illustrated by works of art from the permanent collection at the National Gallery, Washington, D.C., and the discussion of composition is illustrated by works at the Detroit Institute of Arts. It is as though we were taking a tour of a particular museum and concentrating on how each artist combines traditional and individual techniques, the principles and elements of art. During each visit, we begin with basic art concepts, which as we proceed, become more complex. This is similar to the common practice of incorporating museum field trips as part of any art course curriculum. No book on art appreciation should ignore the real-life experience of gallery visits that are basic to active participation in the visual arts. We have also found that each museum or gallery has a unique character that results in great measure from the works that constitute its permanent collection. Much of that flavor is reflected in the works selected for this book.

The material is organized into three parts: Part I (the first three tours) presents the basic tools and skills of viewing art as seen through the eyes of the artist. Part II continues with an extensive analysis of artistic styles arranged chronologically from the beginning of recorded history to the present day. Part III includes a brief discussion of the changing nature of today's art, provides a glimpse of how art has burst out of the confines of museums and galleries, suggests possibilities for the future, and takes a broad look at "primitive" art around the world.

Ten full-color foldouts offer a unique approach for viewing the great works of art, allowing for uninterrupted reading and the opportunity to make comparisons with other art works. Renowned artists, as well as principles, terms, innovations, and great monuments throughout art history are encountered on the simulated museum tours. They should elicit a renewed interest in the understanding of art, provide visual tools to promote personal enrichment, and a foundation for further study in studio art, art education, or art history.

The material covered is designed for beginning students in art appreciation or the humanities and for the general public seeking to learn more about how to look at painting, sculpture, or architecture. It may also serve as a resource for museum docents. The terminology is nontechnical so that an art background is not necessary for full comprehension of the concepts covered.

Selected quotations, diagrams, boldfaced terms, and a pronunciation guide help to clarify concepts as they are encountered in the text. An illustrated glossary of terms completes the text.

Viewing and studio exercises, along with responses, follow each tour to permit the reader to apply the concepts discussed to other works as a viewer, and to some of the same problems with which artists work every day. Listening exercises using musical references are also suggested to clarify the relationship between concurrent styles in art and music. At the end of each Part, the reader finds a list of suggested reading sources.

"The Information Desk" was prepared by contributing author Susan Hood, an art educator and historian at Indiana University, South Bend. It offers additional assistance to the student by addressing the various ways in which a museum functions. "The Information Desk" discusses the role of those who work there, the types of exhibits and the ways they are displayed, the difficulties of preserving various kinds of artworks, and the advantages of museum membership.

Forty biographies are provided for those who wish to learn more about the lives and times of individual, prominent artists representative of those whose works are discussed in the text.

An Instructor's Manual offers suggestions for class presentation and supplementary materials such as films, slides, bibliographical references, additional studio problems, and related art concepts pertinent to art but not contained in the book's tours. To further enhance the instructional package, an accompanying set of fifty slides is available to adopters of *Invitation to the Gallery* from **wcb**. An expanded slide set coordinated to the text is also available from Sandak, Inc. TestPak, a **wcb** computerized testing service, and a set of **wcb** teaching transparencies round out the supplementary instructional materials.

ACKNOWLEDGMENTS

Our deepest gratitude goes to Karen Speerstra, editor at Wm. C. Brown who offered continued confidence in this project, to the entire **wcb** Book Team, and to a host of museum personnel whose cooperation made this book possible. Our thanks and appreciation are due to the following reviewers who offered not only encouragement but constructive criticism at various stages of manuscript preparation: Susan Hood, Indiana University at South Bend; Don Alexander, Louisiana State University in Shreveport; Phyllis Knerl Miller, University of Houston; Edward R. Pope, University of Wisconsin at Madison; Darryl W. Halbrooks, Eastern Kentucky University at Richmond; John E. Dolin, Marshall University at Huntington; Jerry Vargo, Indiana State University in Terre Haute; Norman Gambill, South Dakota State University at Brookings; Vera B. Townsend, University of Missouri at Columbia; Joyce Lyon, University of Minnesota, Minneapolis; Joshua Kind, Northern Illinois University; Harry H. Kirk, Shippensburg State University; Ralph Davis, Albion College; Jeanne Labarbera, California Polytechnic State University; Peter L. Myer, Brigham Young University; Lallah Miles Perry, Delta State University; Kurt Wild, University of Wisconsin at River Falls; Dennis A. Whitcopf, Eastern Kentucky University; Robert L. Mode, Vanderbilt University; Jean G. Brenner, Marion College of Fond du Lac, and Loren T. Baker, Roberts Wesleyan College. We are also grateful to our colleagues closer to home who shared their creative insights and inspiration during months of work; in particular, Howard A. Wilson, Gary Ross, Ann Bremner, and Katy Lin of Capital University and Dianne Almendinger and Bruce Aument of The Ohio State University.

INVITATION TO THE GALLERY
An Introduction to Art

PART I
LOOKING AT ART
THROUGH THE ARTIST'S EYES

A WONDERFUL BOOK by composer Aaron Copland, *What to Listen for in Music,* has been on the market for a number of years. It is a music appreciation book that analyzes music, in a pleasingly elementary way, from a composer's point of view. *Invitation to the Gallery* is an art book with the same approach. Part I of this book analyzes art from the artist's point of view.

We shall learn to look at art in ways that may not have occurred to us before. We progress from the primary ingredients, through the elements of composition, to the basic principles of art. We will, in effect, go through the same procedures and solve some of the same problems as the artist does in the creation of artworks. The purpose of such experiences is not to learn how to become an artist, but rather to establish a vocabulary of visual skills that will help us to refine our ability to view art. The perceptive viewer shares with the artist the ability to find subtle differences in things that seem similar; the viewer becomes a better viewer in the same way that the artist becomes a better artist—through familiarity and experience.

The three tours constituting this phase of the program take place in three of America's most outstanding art museums. The National Gallery of Art serves as a good starting place—square in the middle of our national capital. The Detroit Institute of Art is our next stop, where we shall concentrate on the way artists compose their works by structuring shapes and space. The Guggenheim Museum in New York City will provide us with an array of modern artworks for the purpose of examining basic principles of art, from unity to symbolism.

The viewing and studio exercises at the end of each tour are designed to test our ability to apply newly acquired skills of viewing to other artworks. The exercises have been formulated according to the purpose of these first three tours—to learn how to look at all art, regardless of type or style, and to come to know something of what the artists are communicating to us.

How often have we heard, "*Look* at this painting and tell me what you *see*," implying that seeing is a more astute process than looking. In music, they say, "*Listen* to this composition and tell me what you *hear*." We have *looked* at works of art all our lives, in one way or another, but what we have actually *seen* is perhaps less than we suspect. Our purpose is to be able to *see* more in a work of art, and in order to do this in a meaningful way, we must know the language of artists and something of the means by which they express themselves.

The National Gallery of Art

Washington, D.C.

NATIONAL GALLERY OF ART

Tour 1

Ingredients Used by the Artist

The Gallery

Perhaps the most impressive achievement of the National Gallery of Art is that though it opened less than fifty years ago, it is considered to be one of the great museums of the world. Founded by Andrew W. Mellon in 1941, the National Gallery was conceived and is maintained as a museum for the people and for their enjoyment of art. It is this basic philosophy that determines the museum's display policy. So that individuals may be free to view and examine each piece without distraction or impediment, artworks are spaced at wide intervals approaching the ideal, but usually impracticable, display in which each work of art can be viewed individually.

The collection focuses on painting and sculpture from the thirteenth to the present century. As one might expect, the collection of American art is exceptional, including paintings by such artists as Gilbert Stuart, Winslow Homer, Mary Cassatt, and James McNeill Whistler.

A striking feature of the National Gallery is the new East Building; its geometric lines contrast sharply with the imposing classic style of the Ionic columns of the gallery's main entrance. Although the initial purpose of the East Building was to make room for the gallery's rapidly expanding collection, it is used primarily to display various works of twentieth-century art and, as the directors put it, "of beyond."

The National Gallery is located on the Mall, just blocks away from the Capitol. Close by are the Library of Congress and the Smithsonian Institution museums, the Freer Gallery, the Hirshhorn Museum, the Museum of Natural History, and other galleries. Thus, in the midst of the nation's capital is a cultural center unlike any other in the world.

Tour Overview

To understand art, we must first learn something of its elements, or basic ingredients—line, value, color, and texture. Because these ingredients are basic to all art, they are demonstrated by works that may look very different from one another and that were created in different periods and in different cultures, but the elements are common to all. This means that we can look at a painting from twelfth-century Europe, a mask from nineteenth-century Africa, and a sculpture from twentieth-century North America using the same basic set of viewing skills.

We begin with the simplest ingredient—line—and will proceed to its more subtle uses by viewing artworks in the permanent collection of the National Gallery. We will then examine the use of light in terms of value (the degree of lightness and darkness) and contrast in relation to one of the most appealing elements in art—color. Part of the tour will be spent in considering tactile and visual texture in painting as well as in sculpture and architecture.

Artists use the basic ingredients of art to express individual responses to the world about them or to communicate ideas and impressions from their personal worlds of emotion or imagination. At the end of this and other gallery tours, there will be opportunities for you to test your ability to see in all works of art the ways in which line, value, color, and texture are used to create the artist's vision. You will also have the chance to exercise your own talent in making use of these basic ingredients.

Drawing consists not in the literal interpretation of linear contours or shapes; it is a mark of the artist's ability to resolve the lines of demarcation into separate parts, select certain parts for emphasis, and recombine them into a new ensemble that is a form in itself, not merely a duplication of the shape of an object.

Albert C. Barnes

LINE AND ITS FUNCTIONS

In the visual arts, especially in painting and sculpture, an artwork often begins as a sketch—some strokes of a pencil, pen, brush, or chalk on paper or canvas. These sketches are quick, linear, "shorthand" images that record the essence of a particular moment in time or of some characteristic feature of the subject, which may exist either in reality or in the imagination of the artist.

Artists often depart from realistic representation of their subject in order to emphasize aspects other than the actual form. "A painter," the famous Spanish artist Pablo Picasso said, "paints to unload himself of feelings and visions."[1] For this reason, the expressive capability of line and the spontaneous quality of a sketch or a drawing are so valued by artists that some may dispense with preliminary sketches and attempt to capture the essence of their subject in the creative process—allowing it to become the impetus of the painting or the sculpture.

In upcoming tours, we will encounter many visual art forms that started with some type of preliminary drawing. Sometimes the artist drew directly on the canvas. In other cases, the artist thought through a given composition and proceeded without a preliminary drawing. In a more direct approach the artist simply "drew in color," making few or no preliminary lines before the actual work began. Pierre Bonnard's painting *Stairs in the Artist's Garden* (see fig. 1.58) seems to be the result of this direct method.

Line—actual or implied—is used to outline a shape or to suggest its three-dimensional quality—that is, to model it. Line can also capture expressive qualities, create impressions of depth or of movement, and direct visual perception.

As a first step in realizing how line is used, imagine the paper or canvas of an artwork as one side of a block of space (fig. 1.1). The paper or canvas then becomes a "window" with a view of the world created by the artist's perception, imagination, and skill. At various times in history, some artists have drawn their subjects on the surface of this window, called the **picture plane.** Other artists have directed our gaze beyond the picture plane into illusions of depth or infinite distance.

1. Robert Goldwater and Marco Treves, eds., *Artists on Art: From the 14th to the 20th Century* (New York: Pantheon Books, 1974) p. 421.

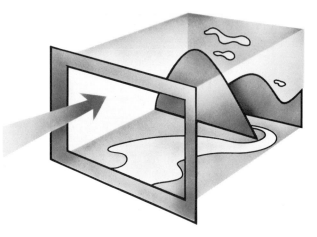

Figure 1.1 Imagine the canvas as a block of space to see the location of subject matter and how artists envision a series of lines and shapes creating the illusion of space.

Painting is drawing with the additional means of color. Painting without drawing is just "coloriness," color excitement. To think of color for color's sake is like thinking of sound for sound's sake. Who ever heard of a musician who was passionately fond of B-flat? Color is like music. The palette is an instrument that can be orchestrated to build form.

John Sloan

Contour Line

Line created to describe the outer edges of objects or shapes is called **contour** line. Contour line, drawn or painted, may vary in width because the artist is illustrating that different parts of a subject possess different degrees of weight, size, importance, or distance from the viewer. Contour lines are usually thinned when forms are meant to retreat into the space of the paper or canvas, and thickened when the forms are meant to appear closer to the viewer.

In Rembrandt van Rijn's drawing *Jan Cornelius Sylvius, the Preacher* (fig. 1.2), notice that the lines depicting the chair and the book edge were drawn with wider, heavier strokes than the lines of the robe. Not only did Rembrandt intend to make the chair and the book edge appear closer to the picture plane, but he also wanted to express their weight in relation to the robe. Still thinner lines sketching the face, hair, and beard suggest their relative weight and farther distance from the picture plane.

We must depend on these few quickly drawn lines for all the information Rembrandt conveys. If all the lines were of approximately the same thickness, the illusions of relative depth and weight would be lost (fig. 1.3).

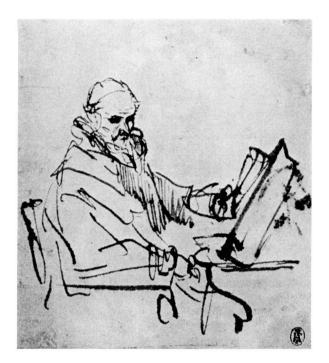

Figure 1.2 *Jan Cornelius Sylvius, The Preacher,* Rembrandt van Rijn;
National Gallery of Art, Washington; Rosenwald Collection 1959.
(Date: ca. 1644–45; Pen and bistre drawing; 134 × 122 mm.).

Figure 1.3 Rembrandt's subject loses its sense of relative weight and depth when all lines are the same size.

Also notice how Rembrandt engages the mind's eye to establish these relationships. Even though lines are fragmented, they suggest enough aspects of the subject matter so that we supply the missing connections—a demonstration of an artist's use of *actual* line and *implied* line.

Before we move on, look again at the preacher's arm. Try to visualize beneath his robe the proportions of his shoulder, his upper arm, and then his elbow and forearm, which rest on the arm of the chair. The shape of the preacher's arm is roughly drawn and would be unnatural if considered by itself. Here, then, is an example of how an artist may distort reality to emphasize a pose or to suit the **design** of his work. Seen in the context of the drawing, the preacher's arm is perfectly acceptable.

In *Study of Saskia Lying in Bed* (fig. 1.4), Rembrandt shows us how an artist can capture a moment's vision and the essence of his subject in quickly drawn lines. Flowing lines sketch the softness of bedding and clothing, and the expressive details of his wife's relaxed face and hand preserve Rembrandt's sudden recognition and enjoyment of her graceful repose.

Rembrandt's sketch of *Saskia* was spontaneous—a succession of quickly drawn lines that captured the essence of a scene. The *Annunciation to Joachim* by Wolfgang Huber (fig. 1.5) was more carefully drawn because

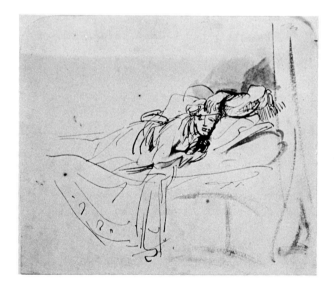

Figure 1.4 *Study of Saskia Lying in Bed,* Rembrandt van Rijn;
National Gallery of Art, Washington; Ailsa Mellon Bruce Fund 1966.
(Date: ca. 1638; Pen and brush in bistre, wash; 145 × 178 mm.).

Huber wanted to describe all the elements of his study. So, it seems that as artists move further away from attempting to capture essences and toward achieving pictorial reality, the results will vary in effect and in degree of spontaneity. As viewers, if we insist on looking only for pictorial detail or realism, we may miss the aesthetic message of the individual artist.

Figure 1.5 *The Annunciation to Joachim,* Wolfgang Huber;
National Gallery of Art, Washington; Rosenwald Collection 1950.
(Date: 1514, Pen and ink drawing, 220 × 147 mm.).

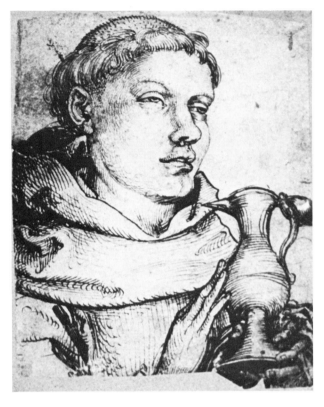

Figure 1.6 *Bust of a Monk Assisting at Communion,* Martin
Schongauer;
National Gallery of Art, Washington; Rosenwald Collection.
(Pen and brown ink, 125 × 103 mm., 5 × 4¹/₁₆ in.).

In 1916, Walter R. Sickert, a painter himself, commented on how Rembrandt's drawings may be compared with the drawings of artists who go beyond the essential in making a statement.

> All draftsmen do two things in succession. First they draw, and then, sometimes, generally one may say, they upholster their drawings. This upholstery corresponds to padding in literature and may be very skillfully and beautifully done, as it may be poorly done.[2]

The beauty of spontaneity in a Rembrandt sketch is in its selected essences and its inspired perception, immediately and skillfully expressed. Rembrandt did not "upholster" his sketch; he stopped after the first stage, and we can thus appreciate its essential statement.

2. Goldwater and Treves, *Artists on Art,* p. 395.

Modeling Line

Up to this point, we have been concerned with contour line, or line that describes the outer edges of shapes. Line plays a further role within the boundaries enclosed by contour lines.

In the drawing by Martin Schongauer, *Bust of a Monk Assisting at Communion* (fig. 1.6), notice how smooth, curved lines **model,** or suggest the three-dimensional form of the polished surface of the ewer. Further, how by repeating lines more and more closely together, or by adding lines similarly spaced across the earlier lines, the artist suggested darker values in the monk's robe. As lines are drawn so that the spaces between them diminish, an area appears to darken and retreat into shadow. The more space between the lines, the more an area appears lighter or closer to the viewer. This technique is called **hatching** or **crosshatching** (fig. 1.7).

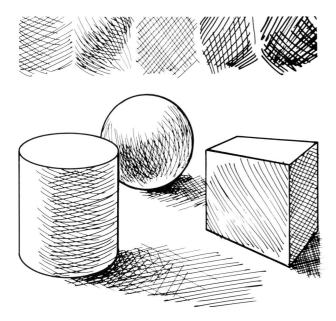

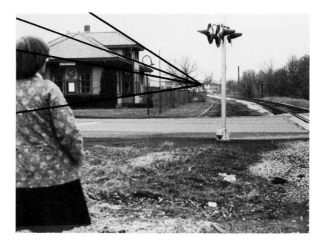

Figure 1.8 Lines of sight and linear perspective.

Figure 1.7 Lines used to depict shadow and three-dimensional shapes by modeling the form with a technique of crosshatching lines.

Perspective

Thick and thin contour lines and modeling lines are used to create the illusion of a third dimension, or depth, beyond the flat surface of a canvas or paper. As early as the fifteenth century, however, artists observed that not only do distant objects appear smaller to the viewer but that the contours of individual objects appear to diminish toward the edges farther away from the viewer. Notice that the roof of the building at the left in figure 1.8 seems to slant downward, as if the far end of the building were not as high as the end facing us. Further, our gaze is drawn beyond the picture plane (in this case, the surface of the photograph), not only by the slant of the roof but by the railroad tracks at the right, to a point on the horizon.

Linear Perspective

Renaissance artists of the fifteenth and sixteenth centuries soon formulated the principle of **linear perspective.** By arranging the contour lines of figures and objects to diminish along "lines of sight," so that the imaginary extensions of these lines converged at one or more "vanishing" points on the horizon, the viewer's sensation of depth, of seeing into the drawing or paintings, was achieved. By depicting human perception of distance—in which lines known to be parallel nonetheless appear to diminish and converge—the artist could create more convincing illusions of depth and space.

One-Point Perspective In *The Annunciation,* by an Umbrian painter called the Master of the Barberini Panels (fig. 1.9), the edges of the roofs, columns, curbs,

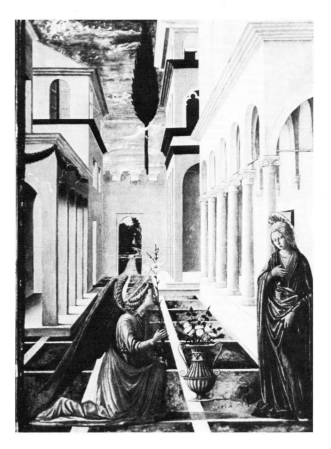

Figure 1.9 *The Annunciation,* Master of the Barberini Panels; National Gallery of Art, Washington; Samuel H. Kress Collection. (Date: ca. 1450; Tempera on wood; 0.88 × 0.63; 34½ × 24¾ in.).

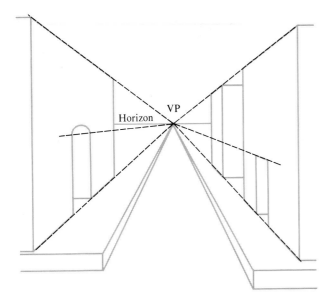

Figure 1.10 One-point perspective.

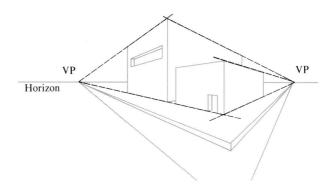

Figure 1.12 Two-point perspective.

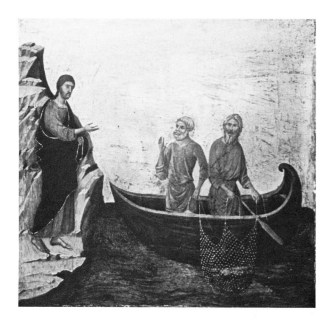

Figure 1.11 *The Calling of the Apostles Peter and Andrew;* Duccio di Buoninsegna;
National Gallery of Art, Washington; Samuel H. Kress Collection.
(Date: 1308–11; Tempera on wood; 0.435 × 0.460; 17⅛ × 18⅛ in.).

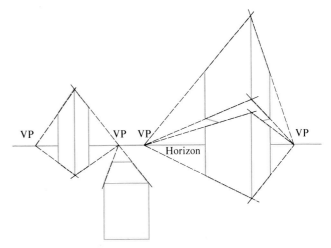

Figure 1.13 Perspective with multiple vanishing points.

The eye level and the viewpoint from the position of the artist depicting a scene determines the angle of linear perspective. As viewers, we see the scene from precisely the same viewpoint as the artist. The Umbrian painter's eyes were directed to the imagined horizon line at about the same level as the Virgin Mary's eyes in his composition. Therefore, all the lines above that eye level seem to converge *downward* to that point and all the lines below that eye level will converge *upward* to that point.

Two-Point Perspective If you stand on a street corner, the edges of a corner building diagonally opposite to your position will seem to converge in lines of sight down the streets on either side of it. This perspective is achieved in painting by drawing lines from each side of the vertical lines representing the edges closest to the viewer and by extending these lines to their two separate vanishing points on the horizon. Artists refer to this technique as **two-point perspective** (fig. 1.12). In fact, it is often necessary for the artist to follow the extension of lines of sight to multiple points on the horizon to achieve a desired illusion (fig. 1.13). Structures and figures seek their own vanishing points and, depending on the number of lines of sight followed by the artist, many vanishing points on the horizon may be used.

and the designs on the street appear to converge at an imaginary point, located just left of center, on the horizon. This painting is based on **one-point perspective** (fig. 1.10), the simplest application of the principle. Compare the work with a painting of an earlier style period, Duccio di Buoninsegna's *The Calling of the Apostles Peter and Andrew* (fig. 1.11). As we can see, creating the illusion of depth with linear perspective was relatively untried in Duccio's time.

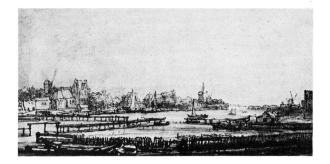

Figure 1.14 *View over the River Amstel from the Rampart,*
Rembrandt van Rijn;
National Gallery of Art, Washington; Rosenwald Collection 1954.
(Date: ca. 1646; Drawing pen and wash of East India ink; 3½ × 7¼ in.).

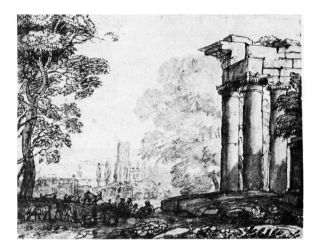

Figure 1.15 *Landscape with a Ruined Portico, Trees, and Pastoral
Figures,* Claude Lorrain;
National Gallery of Art, Washington; Syma Busiel Fund and Pepita Milmore
Fund 1975. (Date: ca. 1650–55; Black chalk, pen and brown ink; brown wash
heightened with white on pink prepared paper; 202 × 266 mm.).

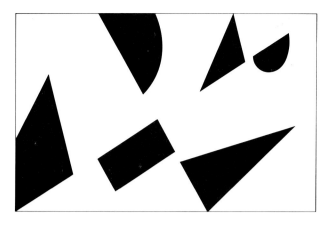

Figure 1.16 Shapes arranged within framed space.

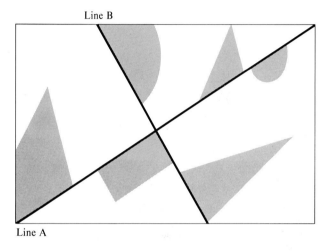

Figure 1.17 Subjective lines *A* and *B* provide a sense of relationship
between shapes where no actual lines exist.

Aerial Perspective

Outdoor scenes such as Rembrandt's *View over the River
Amstel from the Rampart* (fig. 1.14) combine the use
of heavy contour lines in the foreground and linear per-
spective to create a feeling of space. Our gaze is drawn
across the water toward the boats and buildings in the
distance. Building on the principle of our perception of
reality, Rembrandt provided greater detail in the fore-
ground and less detail in the less distinct background.
Based not only on the limits of human vision but on the
effect of atmospheric changes, this technique is known
as **aerial perspective.** Thus, especially in traditional
landscapes, we can expect to find dark, thick, and de-
tailed line in the foreground, while the background im-
ages will be light, thin, and indistinct. The techniques of
foreground detail, modeling, linear perspective, and at-
mospheric perspective are demonstrated by Claude Lor-
rain in his drawing *Landscape with a Ruined Portico,
Trees, and Pastoral Figures* (fig. 1.15).

Implied Line

Artists are sensitive to visual phenomena, whether or not
they understand them in a scientific sense, and enlist
them in creating illusions. For example, our eyes follow
the actual contour lines in painting and sculpture, but in
some works the artist gives us enough information so that
the mind's eye supplies lines where none actually exist.
As viewers, it is important that we become consciously
aware of these subjective or implied lines in order to rec-
ognize how they contribute to an artwork's form and
movement. Study figure 1.16. Are you aware of any in-
visible lines that connect the shapes? If the artist sup-
plied these implied lines, as in figure 1.17, it would be
evident that the drawing is based almost entirely on two
diagonal lines that intersect near the center of the dis-
play and that relate the shapes to one another within the
framed space. The artist, by arranging the straight edges
of the shapes, has tried to make us respond to the design
of the whole without delineating it for us.

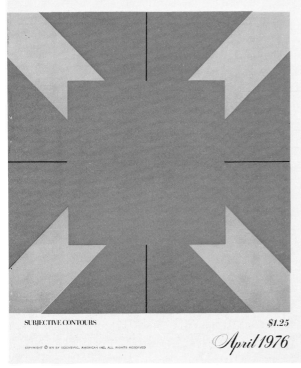

Figure 1.18 Visual perception of an implied square.

Inside the cover image:

SCIENTIFIC
AMERICAN

SUBJECTIVE CONTOURS $1.25

April 1976

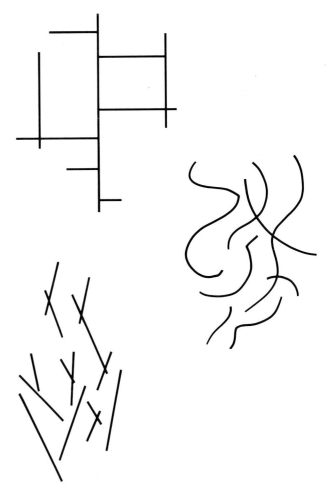

Figure 1.19 Actual lines create feelings of stability, motion, or rhythm as they interact.

Another example of the use of subjective line appeared on the cover of an issue of *Scientific American* (fig. 1.18). A large white square is perceived in the center of the diagram, but no square actually exists—the square is implied by the placement of the chevrons and the measured lines. The fact that our visual perception can be beguiled into seeing what is not actually there, or can be enlisted to sense a subtle message, has provided artists with insight as to how we can be led to respond to works of art.

Lyonel Feininger expected viewers to complete lines subjectively in his work *Zirchow VII* (see colorplate 2). The process of forming subjective lines from foreground to background contributes to the feeling of depth, serves to hold the picture together, and allows various elements in the painting to work together well.

Movement and Rhythm

The subjects of some paintings and drawings appear to be fixed or static, while others seem to be caught in motion. In many cases, this illusion of movement is caused by the way in which the artist uses actual or implied lines to create a sense of tension or stress (fig. 1.19).

As we view paintings and sculptures, imagine an axis penetrating each form (whether it is geometric or irregular) through the center of its mass and in the direction of its inclination. The simple forms in figure 1.20 illustrate this elemental and important concept. If we apply this concept to the painting *Apollo Pursuing Daphne* by Giovanni Battista Tiepolo (fig. 1.21), it will provide us with a better sense of the overall design of the work (fig. 1.22). The implied axis lines are diagonal and opposed in direction, undergirding the sense of tension and movement in the painting.

Basic linear rhythms are also evident in sculpture. David Smith's sculpture *Cubi XXVI* (fig. 1.23) is a perfect example of the effective use of diagonal lines to express tension or captured movement in three-dimensional art. The entire piece appears to be about to fall, even though it is firmly planted on the floor.

On the other hand, the vertical axis of Constantin Brancusi's sculpture *Bird in Space* (fig. 1.24), along with the slightly curved surface, produces a feeling of graceful

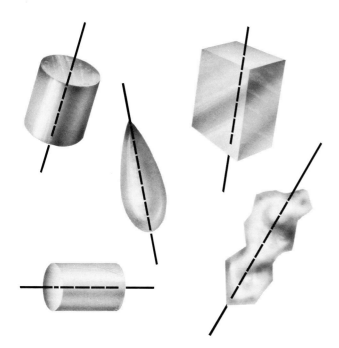

Figure 1.20 The axes of shapes and volumes create tension as they interact.

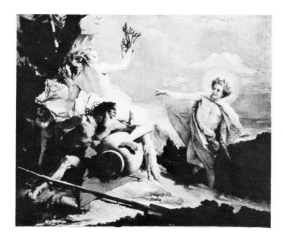

Figure 1.21 *Apollo Pursuing Daphne,* Giovanni Battista Tiepolo;
National Gallery of Art, Washington; Samuel H. Kress Collection.
(Date: ca. 1755–60; Canvas; 0.688 × 0.872; 27 × 34¼ in.).

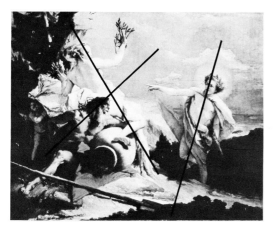

Figure 1.22 Implied-axis lines in *Apollo Pursuing Daphne*

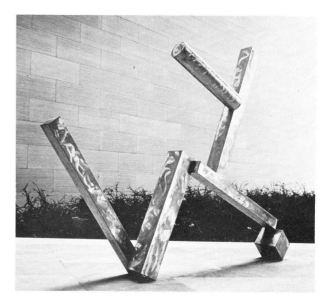

Figure 1.23 *Cubi XXVI,* David Smith;
National Gallery of Art, Washington; Ailsa Mellon Bruce Fund.
(Date: 1965; Steel; 3.034 × 3.834 × 0.656; 119½ × 151 × 25⅞ in.).

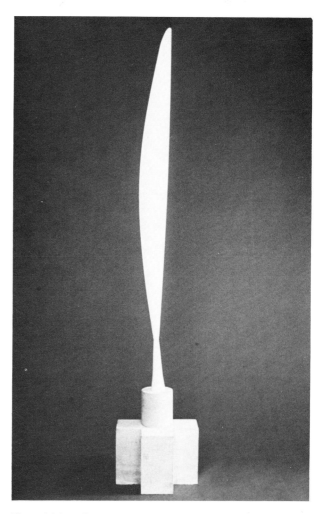

Figure 1.24 *Bird in Space,* Constantin Brancusi;
National Gallery of Art, Washington; Gift of Eugene and Agnes Meyer.
(Date: 1925; Marble, stone and wood; height: 3.446; 136½ in.).

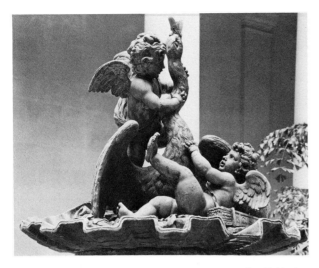

Figure 1.25 *Cherubs Playing with a Swan,* Jean-Baptiste Tubi, the elder;
National Gallery of Art, Washington; Andrew W. Mellon Collection.
(Date: 1670–75; Lead, with traces of gilding; 1.19 × 1.50; 47 × 59 in.).

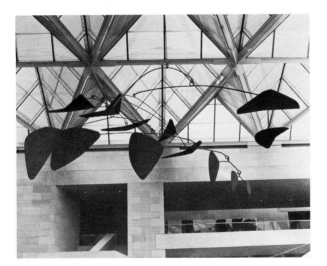

Figure 1.26 One of Alexander Calder's mobiles on display in the central courtyard of the East Building of the National Gallery.
The National Gallery of Art, Washington; Gift on the Collectors Committee 1977. (Date: 1976; Aluminum and steel; 9.103 × 23.155; 29′10½″ × 76′).

control. Notice the linear movement expressed in Jean-Baptiste Tubi's *Cherubs Playing with a Swan* (fig. 1.25). All of the contour lines curve and spiral to the top in a swirling pyramid. The interrelationships of linear rhythms supply artworks with a quality of movement that contributes to their overall expressive content.

Some of Alexander Calder's sculptures actually move and are known as **mobiles.** One of his larger mobiles is on display in the central courtyard of the East Building

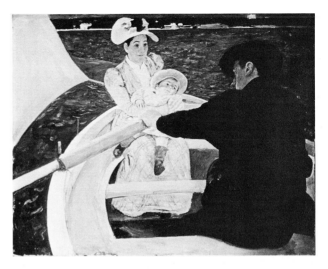

Figure 1.27 *The Boating Party,* Mary Cassatt;
National Gallery of Art, Washington; Chester Dale Collection.
(Date: 1893–94; Canvas; 0.902 × 1.171; 35½ × 46⅛ in.).

of the National Gallery (fig. 1.26). Imagine the interaction of constantly changing patterns as air currents move not only the individually suspended shapes but cause the entire sculpture to turn on its axis.

Path of Vision

As we first encounter a painting, our eyes are drawn to a part of it and then—urged by the nature of the painting's elements, particularly the actual and subjective lines—move across its surface in a guided pattern. One example of this path of vision as directed by the artist may be seen in *The Boating Party* by Mary Cassatt (fig. 1.27). Our gaze may fall first on the center of the painting—the woman's face and the figure of the child. From that light area we are led by the strongly curved contour line around the edge of the boat toward the bottom of the picture, then to the right and along the powerful dark arm of the man, toward his lighter-colored face, and then back to the starting point, completing a circle. If we continue to examine the picture, it is quite likely that our eyes will follow this somewhat circular visual path over and over again. This movement of our eyes about the surface of the canvas is called the "path of vision." Although there is, of course, no superimposed circle on the original work to guide us along this particular path, the artist's positioning of light and dark shapes, their contours of actual and subjective line, lead our eyes along an intended path. Other paths of vision are possible in this painting; for example, from the bottom edge along the gunwale to the woman's face looking at the man. Quite naturally, you look at him and follow his gaze down the oar, up the sail, and back to the woman's face.

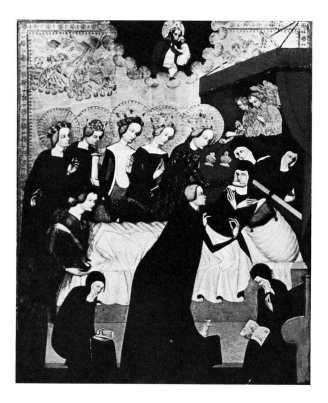

Figure 1.28 *The Death of Saint Clare,* Master of Heiligenkreuz;
National Gallery of Art, Washington; Samuel H. Kress Collection.
(Date: ca. 1410; Wood; 0.664 × 0.545; 26⅛ × 21⅜ in.).

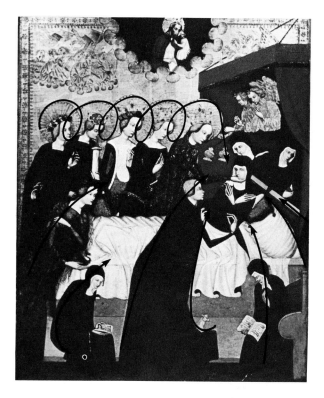

Figure 1.29 *The Death of Saint Clare,* Master of Heiligenkreuz,
showing paths of vision.

The light area in Cassatt's painting is the **focal point** of the painting; so called because the entire composition of the work is designed around this center of interest. In *The Descent from the Cross* (colorplate 1), the broken body of Christ and his anguished mother are bathed in torchlight. If Rembrandt had not used this technique to light the focal point of his painting, the central figures in this drama would have been lost in the night crowd.

An artist called the Master of Heiligenkreuz made the figure of the dying woman the focal point of the painting called *The Death of Saint Clare* (fig. 1.28). In this case, nearly all of the design features of the painting (fig. 1.29) direct our attention to this focal point: the gaze of the five women standing behind the bed; their halos, which seem to create a rolling line leading toward the saint's face; the two women seated at the foot of the bed who are inclined in Saint Clare's direction; the woman standing before the bed leaning toward her; and the strong contour lines of her garment, which create lines that lead once again to the focal center. Wherever our gaze first falls—and there are at least three light areas

that might initially attract our eyes—the linear features urge us to turn our regard to the center of interest of the painting.

Our eyes will not always be drawn about a painting as they were in the Cassatt work. Some artists invite us to become involved in less traditional ways. In *Zirchow VII* by Lyonel Feininger (colorplate 2), the carefully chosen colors of the abstract geometric forms draw our eyes, by arrangement, into and out of an imagined depth as we look from right to left.

In viewing a painting, the viewpoint is fixed; in viewing a sculpture, the possible viewpoints are numerous, depending on a viewer's eye level and relative position to the three-dimensional sculpture. In other words, the contour lines, the subjective lines, and our path of vision, or visual direction, are transformed as we move full circle around the sculpture—one of the major differences between the two art forms. Sculptures can cause markedly

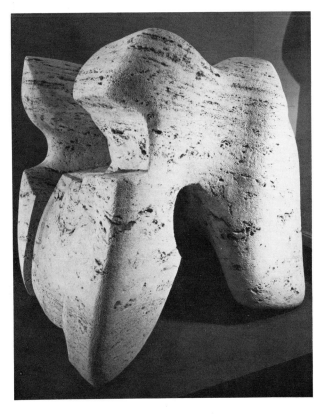

Figure 1.30 *Stone Memorial,* Henry Moore;
National Gallery of Art, Washington; Collection of Mr. and Mrs. Paul
Mellon. (Date: 1961–69; Roman travertine; 1.517 × 1.749; 59¾ × 68⅞ in.).

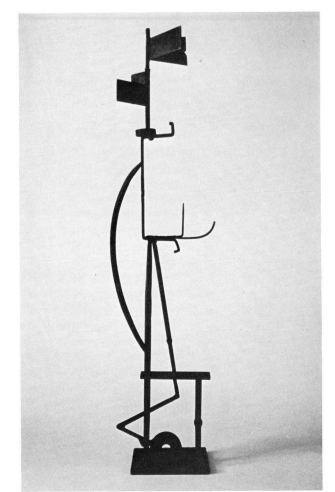

Figure 1.31 *The Sentinel I,* David Smith;
National Gallery of Art, Washington; Gift of the Collectors Committee.
(Dated [19]56; Steel; 2.276 × 0.429 × 0.575; 89⅝ × 16⅞ × 22⅝ in.).

different eye movements. At Henry Moore's *Stone Memorial* (fig. 1.30) our eyes move smoothly in a horizontal direction, while at David Smith's *The Sentinel I* (fig. 1.31) our eyes move from element to element in a vertical, interrupted movement.

The Expressive Qualities of Line

One of the most expressive uses of line is the art of fine handwriting known as **calligraphy.** Calligraphic forms of writing have been common to many cultures in which communication has been based on symbols written with brush or pen and ink. In some ways these symbols have become as important an art form as painting (fig. 1.32). In fact, in some early artworks, writing and painting were blended together. Centuries old, calligraphy has evolved as a painting and graphic art form and its uses serve many types of artisans.

The expressive qualities in line may be thought of as either **lyric** or **angular.** Lyric lines are smooth, graceful, flowing, connected, calm, or even poetic or melodic as in Auguste Rodin's *Dancing Figure* (fig. 1.33). Using only arching, curving lines, Rodin expresses the grace and

beauty of a dancing nude figure. His slight distortion of the human anatomy emphasizes the graceful quality of the connected, flowing lines.

John Marin's painting, on the other hand, is full of angular lines. In his *Woolworth Building, No. 31* (fig. 1.34), diagonal, jagged, and straight lines express the harshness and tension of the big city. Marin's own words prove his intentions. He did not include all the windows in the skyscraper nor did he include other details of the scene. His purpose was to portray the "gist" of the city; that is, the activity and frenetic life of New York. For him, the angular lines and wrenched perspectives expressed them as well as anything.

> I see great forces at work; great movements; the large buildings and the small buildings; the warring of the great and small influences of one mass on another greater or smaller mass. Feelings are aroused which give me the desire to express the reaction of these "pull forces," those influences which play with one another; great masses pulling smaller masses, each subject in some degree to the other's power.

到
美
術

Figure 1.32 Oriental calligraphy.

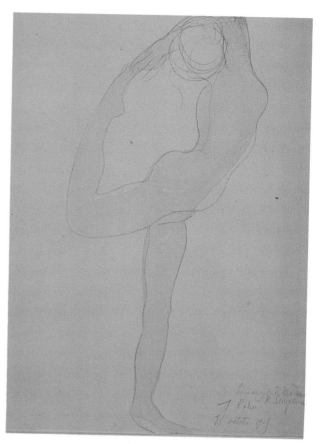

Figure 1.33 *Dancing Figure,* Auguste Rodin;
National Gallery of Art, Washington; Gift of Mrs. John W. Simpson 1942.
(Date: 1905(?); Watercolor and pencil outline; 322 × 242 mm.).

In life all things come under the magnetic influence of other things, the bigger assert themselves strongly, the smaller not so much, but still they assert themselves, and though hidden they strive to be seen and in so doing change their bent and direction.

While these powers are at work pushing, pulling, sideways, downwards, upwards, I can hear the sound of their strife and there is great music being played.

And so I try to express graphically what a great city is doing. Within the frames there must be balance, a controlling of these warring, pushing, pulling forces. This is what I am trying to realize. But we are all human.[3]

3. Sheldon Reich, *John Marin* (Tucson: University of Arizona Press, 1970) pp. 54–55.

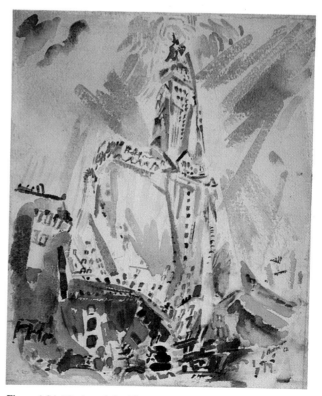

Figure 1.34 *Woolworth Building, No. 31,* John Marin;
National Gallery of Art, Washington; Gift of Eugene and Agnes E. Meyer 1967. (n.d. Watercolor on paper 18¾ × 15⅝ in.).

Figure 1.35 *Nude Woman in a Tub*, Ernst Ludwig Kirchner. © R.N. Ketterer (Ink watercolor and colored crayon, ca. 1923).

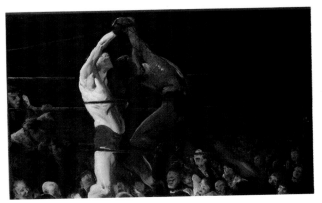

Figure 1.36 *Both Members of This Club*, George Wesley Bellows; National Gallery of Art, Washington; Chester Dale Collection. (Date: 1909; Canvas; 1.150 × 1.605; 45¼ × 63⅛ in.).

Figure 1.37 *Both Members of This Club* (detail), George Wesley Bellows; National Gallery of Art, Washington; Chester Dale Collection. (Date: 1909; Canvas; 1.150 × 1.605; 45¼ × 63⅛ in.).

Marin's comment, "we are all human," is meant to remind us that both artist and viewers are on common ground. Individually unique, we all share the limitations of human perception.

It is tempting to speculate on Ernst Kirchner's intent in using angular lines to distort and exaggerate the features of his *Nude Woman in a Tub* (fig. 1.35). Although we cannot say with certainty that Kirchner intended to present in this painting the dark side of human nature or his inner feelings about women and life in general, we can note that his *style* is consistent with the type of painting known as German Expressionism. As we learn more about this style in Tour 10, we may return to the Kirchner work and speculate about it from a better-informed point of view.

The lines in George Bellows's dynamic painting *Both Members of This Club* (fig. 1.36) describe the spontaneous energy of the activity in the ring. Close examination of one of the boxer's legs proves that an expressive shape and contour line can be achieved with a quick swish of the brush (fig. 1.37).

Line as an ingredient used by the artist is thus a basic criterion in establishing the expressive qualities in all works of art. As we proceed on our gallery tours, remember that all works of art contain line in some form and that each line in these works serves a function. Our task as viewers is to learn to discern that function.

TWO COMPONENTS OF LIGHT: VALUE AND COLOR

Light for the visual artist is like sound to the musician. In music, sound is organized according to its pitch, loudness, duration, and tone quality. In art, light is organized according to value (degree of light and dark) and color.

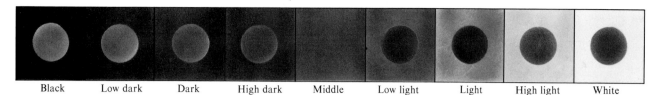

| Black | Low dark | Dark | High dark | Middle | Low light | Light | High light | White |

Figure 1.38 The gray spots seem to change in value from the top of the scale to the bottom because of contrast alone.

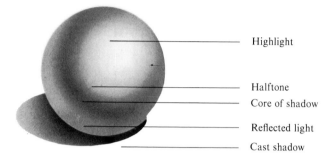

— Highlight

— Halftone
— Core of shadow

— Reflected light
— Cast shadow

Figure 1.39 The effects of light and shade as used by artists to create the illusion of form is known as chiaroscuro.

Our study of subjective line has shown that our eyes are drawn to light areas and that light areas seem to advance toward us while darker areas seem to retreat. Contrasts and differences in value are used to define or model, to identify levels of pictorial space (**foreground, middleground, background**), to unify design, and to express mood. It is the *contrast* in values that affects our perception in surprising ways. For example, look at the squares in the scale of values in figure 1.38. The squares range in hue from pure white to light gray to dark gray to black. Each spot in a square is identical to the other spots in value, but as your eyes travel down the scale from the white square to the black square, the gray spot in each of the squares seems to be lighter than the preceding spot. The spot of gray in each square demonstrates your eyes' sensitivity to contrast.

The Role of Value

Artists use contrasting values to suggest the three-dimensional forms of their subjects in two-dimensional drawings or paintings. The use of light and shadow to render three-dimensional forms in pictorial space is referred to as **chiaroscuro** (kee´-ah-row-skoo´-row). This technique of using changes in value to create form has been used only since the Renaissance (see Tour 6). Notice how light and dark values caused by light from a single source are used to transform the contour line of a circle into a modeled sphere (fig. 1.39).

Many of the great masters were fascinated by the effects of natural and artificial light on their subjects.

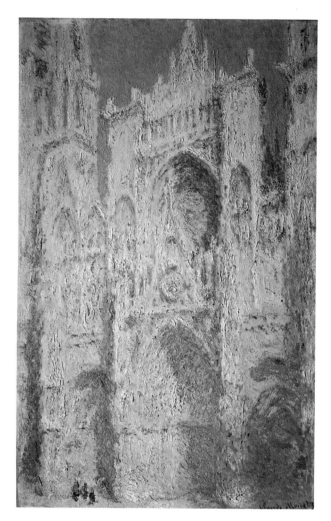

Figure 1.40 *Rouen Cathedral, West Facade, Sunlight,* Claude Monet;
National Gallery of Art, Washington; Chester Dale Collection.
(Dated [18]94; Canvas; 1.002 × 0.660; 39½ × 26 in.).

Rembrandt created certain works that emphasized the effect of light over all other elements (colorplate 1). Claude Monet was also fascinated by the varying effects of natural light as it was reflected by the surface of forms. He painted the Rouen Cathedral (fig. 1.40) over thirty times in order to show how light at different times of the day changed the appearance of the cathedral. (Notice how Monet's concern with the reflection of natural light overrode his concern to depict architectural detail.)

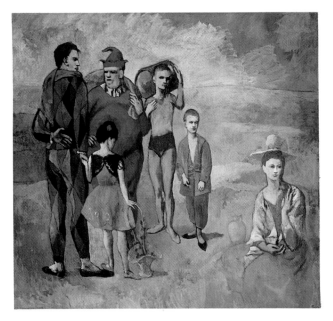

Figure 1.41 *Family of Saltimbanques,* Pablo Picasso; National Gallery of Art, Washington; Chester Dale Collection. (Date: 1905; Canvas; 2.128 × 2.296; 83¾ × 90⅜ in.).

Artists may choose to use the natural formation of light and shade, they may augment natural light with artificial light to highlight an object or to deepen contrasts of light and shadow, or they may model form by using patterns of alternating values. They achieve lighter values by mixing white, or darker values by mixing black, with colored pigment. The use of alternating values may be found throughout the tours in paintings from all style periods. The twentieth-century artist Pablo Picasso contrasted light and dark shapes in the figures and pictorial space of *Family of Saltimbanques* (fig. 1.41). Note the dark figures against the lighter or darker areas. Note also the lighter skirt of the girl against the man's dark pants, which are in turn darker than the surrounding areas.

The painting *Holy Family on the Steps* by Nicolas Poussin (colorplate 3) is a classic example of how value plays a major role in design. High contrast between light and dark values illustrates Poussin's mastery in using form to complete a unified design pattern—a pattern of space division in which the placement of each object depends upon every other object on the canvas—the relationship of parts in perfect harmony. A pyramidal

Background

Middleground

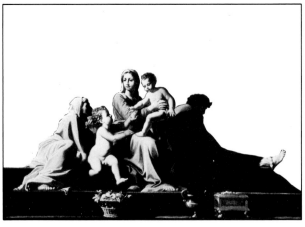

Foreground

Figure 1.42 Background, middleground, and foreground of Poussin's *Holy Family on the Steps.*

superstructure of figures dominates the canvas. The area occupied by the four human figures left of center in the foreground of the painting is dominant because the figures are light in value. This dominance is made all the more dramatic by its high contrast with the dark human figure on the right and the dark structures of the middleground in the upper left portion of the canvas. The middle value of the background contrasts, in turn, with these areas (fig. 1.42).

Compare Nicolas Poussin's painting with Honoré Daumier's *Advice to a Young Artist* (fig. 1.43): the human figures in both works are dramatized by value contrasts. Daumier contrasted the highest level of light, which strikes the page in the portfolio, against the darkest dark of the older man's coat. Poussin portrayed Saint Joseph in cast shadow and the Christ Child in the highest level of light. The contrasting values in both works provide the illusion of depth—from limited or shallow space in the Daumier work to deep space or infinity in the Poussin work.

Value can also be used to express mood. Compare the expressive content on the faces of two figures in Picasso's painting *Family of Saltimbanques* (fig. 1.41). The face of the boy carrying an acrobat's balancing barrel is darkened by cast shadows, while the woman's face appears in high light. One can imagine that the boy is more wistful or depressed than the woman, purely from the artist's use of value. Even more dramatic is the mystery and isolation created by torchlight in Rembrandt's *Descent from the Cross* (see colorplate 1). The use of extreme contrast in value transcends mere pictorial description and invites the viewer into a psychological framework. Compare the overall dark quality of Rembrandt's painting with Picasso's *Two Youths* (fig. 1.44), which is mostly light in value. Remember that such differences contribute the individually expressive impact of paintings.

It is often easier to discern the contrast of values in a painting by examining a black and white photograph of the work. Color, as we noted earlier, is one of the most appealing ingredients of art, but artists are always aware of a color's *value* as well as its *hue* (name of color). The

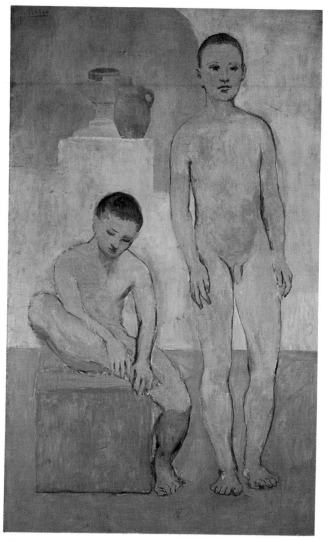

Figure 1.44 *Two Youths*, Pablo Picasso;
National Gallery of Art, Washington; Chester Dale Collection.
(Date: 1905; Canvas; 1.515 × 0.937; 59⅝ × 36⅞ in.).

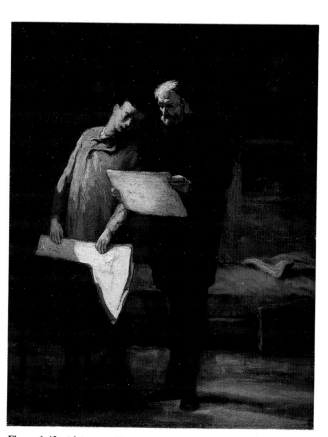

Figure 1.43 *Advice to a Young Artist*, Honoré Daumier;
National Gallery of Art, Washington; Gift of Duncan Phillips.
(Date: probably after 1860; Canvas; 0.41 × 0.33; 16⅛ × 12⅞ in.).

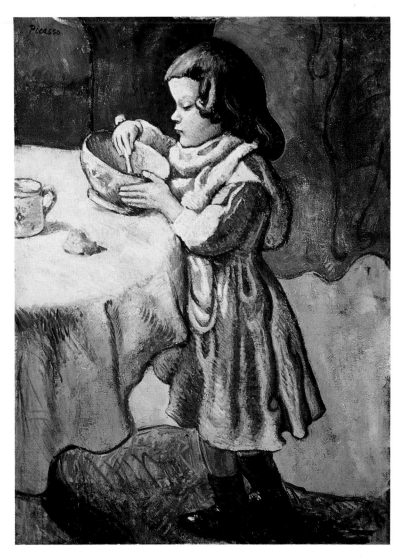

Figure 1.45 *Le Gourmet,* Pablo Picasso;
National Gallery of Art, Washington; Chester Dale Collection.
(Date: 1901; Canvas; 0.928 × 0.683; 36½ × 26⅞ in.).

red of the Virgin Mary's garment is no more important
to Poussin's painting (see colorplate 3) than the *value* of
the red in terms of lightness and darkness. Red, in this
case, was chosen as the dominant color for the work; yet
it is not isolated because reds of lighter value are used
at the lower end of her skirt and on the apples.

Sculptors and architects employ contrasts in value.
Cherubs Playing with a Swan by Tubi (fig. 1.25), which
is in a garden courtyard of the National Gallery, is an
example of sculpture and architecture working together
very effectively. Value contrasts abound in and around
the forms of the sculpture and fountain area. The light
stone of the courtyard surrounding the fountain con-
trasts sharply with the darker masses of projecting and
receding portions of the cherubs. A **foil** for the cherubs
is provided by greenery and fountain stones at the bottom
of the pool, which act as further points of interest due
to their differences in texture and color.

The Nature of Color

Color is one of the most important ingredients used by
artists. You have already seen how value extends its in-
fluence into the use of color. Experience teaches the artist
that each tiny patch of color in a painting possesses *hue,
value,* and *intensity* (saturation of color). Picasso's *Two
Youths* (fig. 1.44) is painted in light values of red and
his *Le Gourmet* (fig. 1.45) in dark values of blue. Fur-
ther examination of *Le Gourmet* reveals the third prop-
erty of color known as **intensity, saturation,** or **chroma**
(the terms mean about the same thing): the blue of the
child's garment is more intense or vivid than the hue we
normally think of as blue. The model in figure 1.46 dem-
onstrates hue, value, and intensity.

Neutral values

B Changes in value. As a range of white to grey to black is added to a color, it changes in *value*

C Changes in intensity. As a color blends with a neutral gray, it changes in *intensity* but not in value.

A Changes in hue. As a color progresses on the color wheel between the primary colors (red, blue, yellow) it changes in *hue.*

Figure 1.46 Model of the three characteristics of color: *A,* hue; *B,* value; and *C,* intensity.

White

High light

Yellow

Yellow-orange

Light

Yellow-green

Orange

Low light

Green

Red-orange

Medium

Blue-green

Red

High dark

Blue

Red-violet

Dark

Blue-violet

Violet

Low dark

Black

Figure 1.47 Value scale.
From Ocvirk, Otto G. et al., *Art Fundamentals: Theory and Practice,* 5th ed. Copyright © 1985 by Otto Ocvirk, Robert Bone, Robert Stinson, and Philip Wigg. All rights reserved. Reprinted by permission.

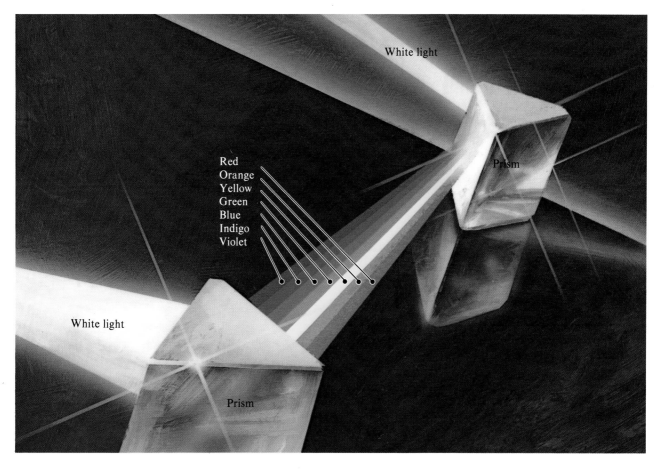

Red
Orange
Yellow
Green
Blue
Indigo
Violet

White light

White light

Prism

Prism

Figure 1.48 The colors of the spectrum in Newton's experiment.

The value scale in figure 1.47 could be extended to include as many circles as desired. Nine changes in value have been selected to illustrate the transition from white to black. Grays are achieved by mixing black with white pigment in increasing proportions. These changes in value are then translated in the adjacent circles into color. So, in effect, we are seeing the same gradations of value in a color as those that occur in the value scale of white to gray to black.

One of the simplest techniques of achieving definite color harmony in a painting is to plan a **monochromatic** work, in which the artist uses one color with accompanying changes in value and avoids the problems posed by the addition of other hues, especially nonharmonious or conflicting hues.

Artists' intuitive perceptions of compatible and noncompatible colors were clarified by Isaac Newton who, in 1666, began a series of scientific experiments designed to discover the nature of color. Newton observed that sunlight refracted through a prism revealed the natural spectrum of all the colors (fig. 1.48). This phenomenon had been observed before, of course, whenever natural conditions, like rain or heavy mist, caused the sunlight to be refracted into a rainbow. Others had even worked with a prism before Newton began his experiments; however, he decided to prove that those familiar colors were indeed components of sunlight. He did so by combining the spectrum into pure white light again by running the spectrum, or dispersed light, through a second prism. This second experiment proved that all colors are contained in sunlight, that all colors combined produce white light, and conversely that the result of the absence of color (or the absence of light) is black. This rule is valid only for light; it does not hold true for pigments, which produce gray when mixed.

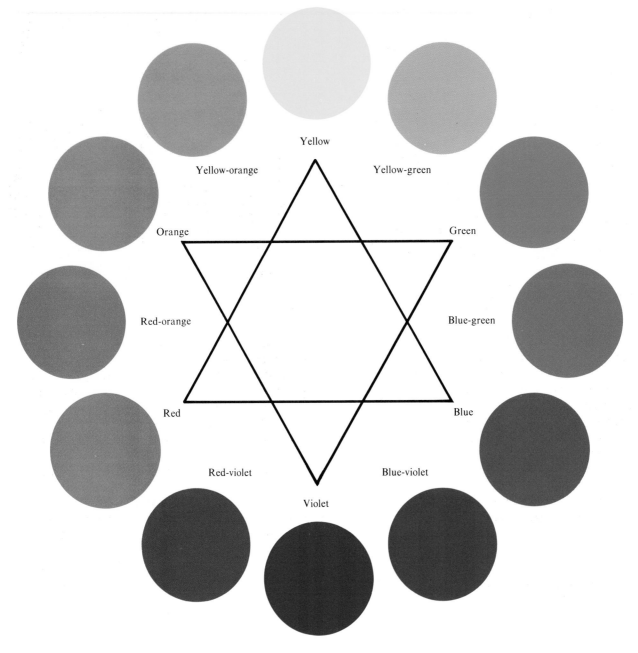

Figure 1.49 The color wheel.
From Ocvirk, Otto G. et al., *Art Fundamentals: Theory and Practice,* 5th ed.
Copyright © 1985 by Otto Ocvirk, Robert Bone, Robert Stinson, and Philip
Wigg. All rights reserved. Reprinted by permission.

The Color Wheel

As Newton's experiments progressed, he observed that some of the hues in the spectrum are the result of the mixing of other colors—red and yellow produce orange, and so on. However, the position of red and indigo at either end of the light spectrum does not produce purple.

By contriving a color wheel to illustrate the color spectrum, Newton was able to combine red and indigo to produce purple and also to reveal special relationships between the hues that had, in years past, not been observed (fig. 1.49).

Those hues that cannot be achieved by mixing any other colors are called **primary:** red, yellow, and blue. The primary hues that are adjacent in the color wheel can be

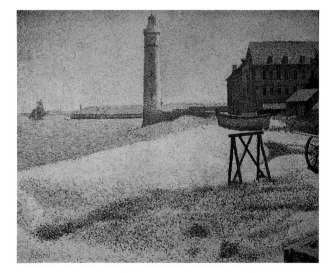

Figure 1.50 *The Lighthouse at Honfleur,* Georges Seurat;
National Gallery of Art, Washington; Collection of Mr. and Mrs. Paul
Mellon. (Date: 1886; Oil on canvas; 0.667 × 0.819 26¼ × 32¼ in.).

Figure 1.51 *Madame Camus,* Edgar Degas;
National Gallery of Art, Washington; Chester Dale Collection.
(Date: 1869–70; Canvas; 0.727 × 0.921; 28⅝ × 36¼ in.).

mixed to achieve other hues that are called **secondary** colors: red and yellow = orange; yellow and blue = green; blue and red = violet. **Tertiary** hues are made from a mixture of a primary color with its adjacent secondary color: blue and green = blue-green; yellow and orange = yellow-orange; and so on.

Artists soon discovered that mixing pigment colors that were placed directly across from each other on the color wheel produced graying effects, or less intense colors. These colors are called **complementary** colors: green, which is directly across from red; orange, which is opposite blue; and violet, which faces yellow.

Color Harmony

Artists need to balance each new color added to their palette in much the same way that composers of music need to balance their harmonies when adding more tones to their chords. Whenever artists use colors found next to each other on the color wheel, the system is called an **analogous** combination. Look again at the color wheel and imagine an artist selecting such groups as orange, yellow-orange, and yellow; or blue, blue-green, and green; or simply violet and blue-violet. In these examples, each color combination has in its makeup a common hue, and it is this common hue that provides color harmony in an artwork.

Whenever artists select colors spaced at an equal distance from each other on the color wheel, the selection involves a **triad** of colors. Obvious triads are red, yellow, and blue, or orange, green, and violet.

We might point out that using formulas in color selection carries with it the danger of producing stilted results. Most artists rely on their intuition rather than on scientific formulas in the selection of their color systems. Formulas are used most often as a point of departure rather than as a hard and fast rule. The carefully selected palette of a painter is composed of individually chosen, balanced mixtures of color that express the artistic statement of a unique individual, not of common formulas.

Some artists have experimented with a painting technique called **pointillism,** the application of small dots of different colors side-by-side on the canvas. Instead of mixing colors on the palette, the artist relies on the viewer's visual perception to blend the dots of color. The visual result is a suggestion of shapes and colors; for example, tiny dots of red and yellow in close proximity may be seen as orange. Examine the painting *The Lighthouse at Honfleur* (fig. 1.50) by Georges Seurat. The farther away you stand from this painting, the more those small dots of paint fuse into realistic shapes and solid color units.

Colors have relative visual warmth or coolness. Edgar Degas's painting *Madame Camus* (fig. 1.51) is painted in **warm** tones (reds), and Picasso's *Le Gourmet* (see fig. 1.45) in **cool** tones (blues).

Figure 1.52 *Family Group,* William Glackens;
National Gallery of Art, Washington; Gift of Mr. and Mrs. Ira Glackens.
(Date: 1910–11; Canvas; 1.828 × 2.133; 72 × 84 in.).

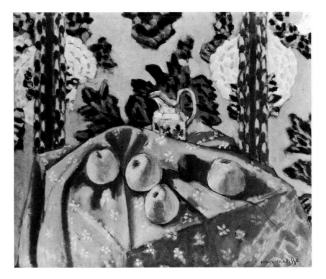

Figure 1.53 *Still Life: Apples on Pink Tablecloth,* Henri Matisse;
National Gallery of Art, Washington; Chester Dale Collection.
(Date: ca. 1922; Canvas; 0.604 × 0.730; 23¾ × 28¾ in.).

William Glackens, in his painting *Family Group* (fig. 1.52), used primary colors in the red of the woman's dress, the yellow of the window blind, and the blue of the child's dress. In the range of the other colors chosen, the predominance of blues and violets, or cool colors, is balanced effectively by the continual appearance of warm hues, such as reds, oranges, and yellows. The artist has, in other words, "warmed the cool" of the dominant blues. Artists can also "cool the warm" by reversing this process—Glackens could just as easily have created a color tonality in warm colors and "cooled" it with spots of cool colors.

An unusual feature of Glackens's painting is the high intensity of many of its hues. The woman in the foreground wears a dress of high-intensity violet, which tends to attract our attention. We soon discover that certain hues in a variety of intensities located strategically throughout the painting control the order in which the eye perceives parts of the painting.

Emotional reactions to color are not only immediate but are often so subtle that we may not be aware of how and why various hues and their associations affect us. Colors can bring about several different reactions at the same time. Blue, for example, can evoke feelings of coolness, sadness, or loneliness. Red is a warm color, but it can also elicit impressions of savagery or violence. Compare the red in Johannes Vermeer's *The Girl with the Red Hat* (colorplate 5) to the red in Francisco de Goya's *The Bullfight* (colorplate 6). The red in the latter is used to contribute to the violence and turbulence of a bullfight, and the red in the former is used to enhance a feeling of warmth, which incidentally also balances the opposing cool color of the girl's blue dress.

Colors are also used to heighten the illusion of depth. Warm colors like red, orange, and yellow appear to advance toward the viewer while cool colors like blue, violet, and green seem to retreat into space. Henri Matisse's *Still Life: Apples on Pink Tablecloth* (fig. 1.53) illustrates depth caused by color alone. The warm colors in the foreground, when set against the retreating blue-green of the background wall, create a three-dimensional effect. Had the colors of the tablecloth and the wall been reversed, the painting would provide quite a different visual experience—perhaps a diminished feeling of depth.

Like notes of a musical scale, colors may be used in an infinite number of ways to create different emotional responses. Artists throughout history, from those who created prehistoric cave paintings to today's computer artists, have used color to achieve similar goals.

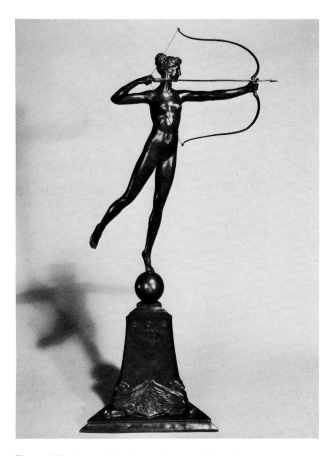

Figure 1.54 *Diana of the Tower,* Augustus Saint-Gaudens; National Gallery of Art, Washington; Pepita Milmore Memorial Fund. (Date: 1899; Bronze; .966 × .485 × .289; 38 × 19⅛ × 11⅜ in.).

TEXTURE: TACTILE AND VISUAL

Two different kinds of texture are found in art: tactile and visual. Tactile texture is real; that is, we can actually feel, by touch, the quality of the surface of an artwork. Augustus Saint-Gaudens's *Diana of the Tower* (fig. 1.54) is of a highly polished bronze that provides not only a smooth tactile surface but also a shiny visual texture. We do not need to touch the work to realize its smoothness. On the other hand, Amedeo Modigliani used limestone, a rough texture that enhances the expressive power of his work *Head of a Woman* (colorplate 4). Within this work, the hair and flesh are of different visual textures, while the tactile texture of the limestone is, of course, maintained throughout.

Figure 1.55 *Snow Flurries,* Andrew N. Wyeth; National Gallery of Art, Washington; Gift of Dr. Margaret I. Handy. (Date: 1953; Tempera on panel; 0.945 × 1.220; 37¼ × 48 in.).

A process that can help you recognize the expressive differences inherent in the surface of natural materials is to make chalk, or charcoal, and paper rubbings of various types of surfaces. The sculptor has the option of choosing a texture or textures from among a variety of natural sculptural media that will best communicate the essence of the subject matter and the aesthetic vision of the artist. In addition to working with stone, wood, or other three-dimensional media to achieve expressive goals, sculptors may select other raw materials that are consistent with their aesthetic intent. Some have even dressed their bronze figures with real cloth costumes and adorned them with jewelry.

Sculpture capitalizes on the effects of light and shadow striking tactile surfaces and textures, which enhance the visual appeal. Painters sometimes use actual texture in their works to achieve more interesting results. A technique like **impasto** (paint applied heavily with a palette knife or brush) provides a rough, visually active surface. Francisco de Goya's *The Bullfight* (colorplate 6) illustrates how the heavy application of paint creates a rough texture and contributes to the overall expressive power of the piece. On the other hand, Andrew Wyeth's painting *Snow Flurries* (fig. 1.55) illustrates that changes in dark and light, lack of hard edges, limited palette, and unfinished brushstrokes served to create the rough visual texture that the artist intended.

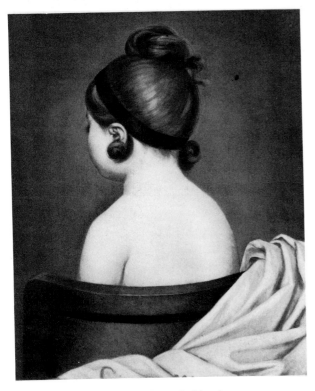

Figure 1.56 *The Model,* Baron François Gérard; National Gallery of Art, Washington; Chester Dale Collection. (Date: ca. 1790; Canvas; 0.612 × 0.502; 24⅛ × 19¾ in.).

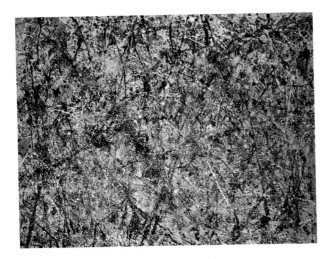

Figure 1.57 *Number 1, 1950 (Lavender Mist),* Jackson Pollock; National Gallery of Art, Washington; Ailsa Mellon Bruce Fund. (Dated [19]50; Oil, enamel and aluminum on canvas; 2.210 × 2.997; 87 × 118 in.).

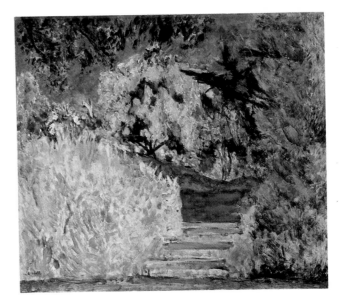

Figure 1.58 *Stairs in the Artist's Garden,* Pierre Bonnard; National Gallery of Art, Washington; Ailsa Mellon Bruce Collection. (Date: 1942–44; Canvas; 0.633 × 0.731; 24⅞ × 28¾ in.).

Smooth texture is exemplified in Baron Francois Gérard's painting *The Model* (fig. 1.56), in which all surfaces and edges are either smooth or soft. The selected texture suits the youthfulness of the model, as in the uninterrupted, smooth surface of her back. Compare this work to a similar subject in Kirchner's *Nude Woman in Tub* (fig. 1.35). Kirchner's use of irregular, angular lines and distortion, along with a disregard for correct human anatomy, all provide a rough visual texture. Jackson Pollock's use of overlapping lines (fig. 1.57) in his *Number 1, 1950 (Lavender Mist)* creates a field of energy composed of random, interlaced lines. Up close, you can see that Pollock's rough texture was achieved by his dripping paint directly from a can, or off the end of a stick, onto the canvas.

Texture is a versatile, creative ingredient of art. Relative weight or mass can be depicted by varying texture—roughly textured objects usually appear heavier than smooth ones. The feeling of space and distance can be enhanced in a painting by applying heavy, rough textures to the foreground and finer textures to the middleground and the background. Sensations of movement or energy can be expressed more vividly by rough textures; smooth textures tend to express serenity.

Perhaps the most powerful function of texture, however, is the way it can express human feelings and stir human response. It is impossible, of course, to link specific emotions to certain types of texture, because texture is only one ingredient of a work. For example, Pierre Bonnard's *Stairs in the Artist's Garden* (fig. 1.58) and

Figure 1.59 *The Much Resounding Sea,* Thomas Moran;
National Gallery of Art, Washington; Gift of the Avalon Foundation.
(Date: 1884; Canvas; 0.636 × 1.576; 25 × 62 in.).

> The art work is not the paint on the canvas or the print
> on the page; it is the moment of creation by the artist and
> the moment of understanding by the viewer.
>
> *Walker Percy*

Thomas Moran's *The Much Resounding Sea* (fig. 1.59)
were both created with rough textures. The emotional
impact of the two works is nevertheless vastly different
because of their subject matter, of course, and because
Bonnard's texture is combined with warm colors and
high-key values, while Moran's texture is combined with
cool colors and low-key values. The moods or emotional
statements of the two pictures are thus different even
though the textures are similar.

Our *awareness* of texture should be an important con-
sideration when we are analyzing a work of art. We
should notice how the artist uses texture along with the
other art ingredients of line, value, and color to express
the total message of the work.

SUMMARY

On this tour we have examined artworks at the National
Gallery in Washington, D.C. to learn how artists use the
basic ingredients of art: line, value, color, and texture.

The most basic element, line—either actual line (vis-
ible) or implied line (subjective and not visible)—is used
by artists to give contour (outline) or to model (suggest
a three-dimensional quality) subject matter. Various
thicknesses of line are used to express various degrees of
weight as well as distance from the picture plane. By
using aerial perspective and by using linear perspective,
that is, by arranging contours along lines of sight di-
minishing toward the horizon, an artist can produce the
illusions of depth and space. Line also expresses and
evokes many sensations of movement or rhythm and is
an important ingredient in directing the path of vision
and in unifying the design of an artwork.

Two other essential ingredients of art are value and
color. Value (the degree of lightness or darkness) is used
by artists to model shapes or to create the illusion of light
and shade (chiaroscuro). The properties of color include
value, hue (the name of the color), and intensity (satu-
ration of color). Artists utilize the color wheel to identify
primary, secondary, and tertiary hues. Those hues di-
rectly across from one another on the color wheel are
called complementary colors. When placed side by side,
the complementary hues are intensified; when blended,
they tend to neutralize each other. Color is used in
painting to provide depth, eye direction, and dominance.
Light and intense hues appear to advance while dark,
less intense hues seem to retreat. Light hues draw our
attention more readily than dark hues because our eyes
respond to light more than to its absence. Color also has
the power to elicit emotional responses.

Texture in art is either tactile (felt by touch) and the
product of the artwork's material and its treatment, or
it is visual (perceived) and created by the utilization of
such artistic techniques as impasto, contrast, quality of
brushstrokes, and the overlapping of line and formal ele-
ments. The effects of texture on viewers can range from
calming to agitating.

Figure 1.60 *The Scream,* Edvard Munch;
National Gallery of Art, Washington; Rosenwald Collection.
(Date: 1912; Lithograph; 140 × 100 in.).

Figure 1.61 *The Prophet,* Emil Nolde;
National Gallery of Art, Washington; Rosenwald Collection.
(Date: 1912; Woodcut; 126 × 88 ⅕ in.).

VIEWING EXERCISES

1. Describe the predominant kind of linear rhythm in Edvard Munch's *The Scream* (fig. 1.60) and Emil Nolde's *The Prophet* (fig. 1.61). Would the effect be the same if the rhythm of each work was transferred to the other?

2. How is line important to the meaning or the emotional content of both works? Imagine how the meaning would change if each artist had used different techniques.

3. Describe how line is used to create texture in these works. Does texture affect how you perceive the predominant figures in each work?

4. How would the meaning of the Munch lithograph be affected if linear perspective was not used?

5. Describe how line was used to clarify the different parts of the subject matter in *The Scream.*

6. Does it bother you that only the essence of the subject is portrayed in *The Prophet*? Why are more lines unnecessary to describe his physical appearance? How would your response be different if *The Prophet* had been painted in a realistic style similar to Vermeer's *The Girl with the Red Hat* (colorplate 5)?

7. How has subjective line been used to suggest the attitude or feeling of the subject in Wilhelm Lehmbruck's *Seated Youth* (fig. 1.62)?

8. Discuss the different ways in which André Derain, *The Old Bridge* (fig. 1.63), and John Sloan, *The City from Greenwich Village* (fig. 1.64), used light in their landscapes.

9. Explain how the monochromatic use of blue in Picasso's *The Tragedy* (colorplate 7) influences the way you feel about the meaning of the painting.

10. Line in art is sometimes equated with **melody** in music. Compare Peter Tchaikovsky's long sweeping melody from the first movement of his Symphony no. 6 with the lines in Rodin's *Dancing Figure* (fig. 1.33).

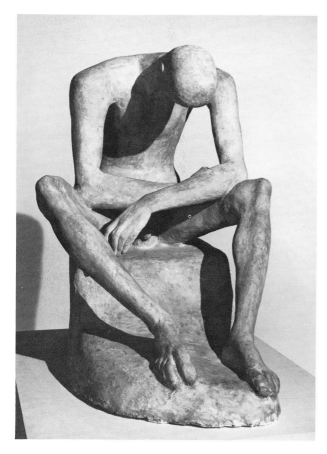

Figure 1.62 *Seated Youth,* Wilhelm Lehmbruck;
National Gallery of Art, Washington; Andrew W. Mellon Fund.
(Date: 1917; Composite tinted plaster; 40⅝ × 30 × 45½; 1.032 × .762 × 1.155 in.).

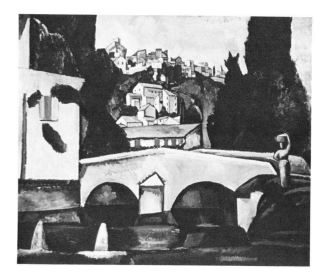

Figure 1.63 *The Old Bridge,* André Derain;
National Gallery of Art, Washington; Chester Dale Collection.
(Date: 1910; Canvas; 0.810 × 1.003; 31⅞ × 39½ in.).

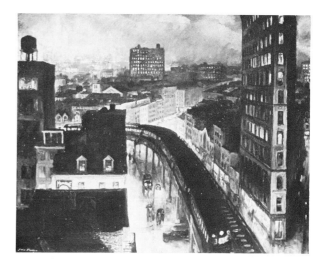

Figure 1.64 *The City from Greenwich Village,* John Sloan;
National Gallery of Art, Washington; Gift of Helen Farr Sloan.
(Date: 1922; Canvas; 0.660 × 0.857; 26 × 33¾ in.).

STUDIO EXERCISES

Suggested media and supplies: sketchbook; pen and ink, pencil or felt-tip pen, black charcoal; any painting medium; pastel colored chalk or colored pencils; brush; rubber cement or glue.

1. Draw in your sketchbook a single object, figure, or face that describes a *mood* or *feeling,* using as few lines as possible to express the subject. Use pen and ink, pencil, or felt-tip pen.
2. Using black charcoal, redraw the object from exercise 1 and place the subject in some type of environment or setting—a landscape, a room, in outer space, etc. Select appropriate textures and light and dark values for your composition.
3. Use any medium to achieve color and rework exercise 2 with a warm or a cool palette.
4. With pencil, make a collection of textural rubbings from your environment, each on a separate sheet of paper. Cut and assemble the textures into shapes, and with glue or rubber cement arrange and attach the pieces on a large sheet of paper to create the same subject matter as *The Old Bridge* (fig. 1.63). Be sure to change the variables of size, shape, and position to ensure that your composition is not a direct copy of the Derain.

RESPONSES TO VIEWING EXERCISES

1. Nolde's lines are jagged and angular, which affects the portrayal of the age, character, and personality of the subject. Munch's curvilinear lines depict fear, danger, mystery, isolation. Lines seem to emanate from the "screamer" and are carried into the surrounding landscape.

2. Nolde's coarse texture, with its harsh contrast between heavy line and white space, creates angularity that enhances the effect of the picture's serious content.

3. Munch's interwoven texture of curvilinear lines creates continuous visual activity. Without the feeling of depth, the relationship of the figure and his environment would be lost; it is this relationship—the frustration with conditions in his environment—that is responsible for the scream.

4. Repetition of diagonal thick and thin lines suggests a flat plane moving to the distance, an illusion reinforced by the smaller figures farther away, which suggests isolation or alienation.

5. Repetition of horizontal lines and white space suggests water, lines closer to the viewer add shoreline and hills, and clouds alternate with white spaces in the sky area. Repetition of vertical lines is used to clarify the foreground and clothing on the figure.

6. Nolde has selected only the crucial shapes forming the structure of the face. The details are readily supplied by the viewer, so additional lines are unnecessary. Abstraction is considered necessary by artists who wish to portray the spirit of the subject rather than its detailed description. The prophet possesses a violent and mysterious quality that could have been lost in a realistic interpretation.

7. Lehmbruck used the curved line of the figure's axis in a position of dejection or rest. Imagine what the effect would have been if the head had been raised.

8. Derain used abstracted shapes of light to form his composition rather than portray objects as they would appear in a natural setting. Sloan's portrayal depends on artificial light sources and on the use of resulting contrasts to elicit mood and space. Gradations of light and deep shadow move back in space to the horizon. In the Derain, the larger-to-smaller-sized shapes of light and dark create space.

9. The cold, blue tone involves the viewer as a witness to a sorrowful event. Bowed heads and folded arms add to the foreboding implications of the work.

10. Both the melodic line and the artistic line display the same graceful sweeping gesture of the dancer. Both may be thought of as "lyric" as opposed to angular.

The Detroit
Institute of Arts

Detroit, Michigan

Tour 2

The Composition
of Shapes in Space

The Gallery

Like many of its sister institutions in the United States, the Detroit Institute's permanent collection has grown enormously in the past few decades. This speaks well of contemporary American culture and of the state of Michigan in particular; the growth reflects an ever-widening financial support for the arts in that state. The Detroit Institute of Arts has been a city institution since 1919 and received active support from the city through the 1920s. In recent years, continuing support for the arts has not solely depended on the benevolent few. Programs of awareness and education have helped to bring arts and the interested public closer together. The endeavors of the Detroit Institute are especially significant because, in spite of the devastating effects of a seesaw economy, the institute continues to flourish.

In addition to an evolving collection of artworks, acquisitions since the 1920s indicate certain strengths of the institute; among these the collection of German expressionist paintings stands out. A considerable number of works by such leading expressionists as Kandinsky, Beckmann, Kirchner, Klee, and Nolde constitute the heart of this particular collection. The compilation of such an important group of works was no accident; the institute's director during the twenty years preceding the end of World War II was an avid proponent of German expressionist painters and sculptors. Detroit was, in fact, the first city in the country to become a major repository of German expressionist art; subsequently other museums became interested in the style. More recent acquisitions, especially those in the areas of African, Oceanic, Native American, and Asian Art, have provided a breadth of styles as well as a firm balance among them.

Building renovation and additions have also furnished more space to display what has become one of America's finest art collections.

Tour Overview

The Detroit tour will focus on a discussion of two major elements in the composition of an art work: *shapes* and the *space* that surrounds them. Works will be selected to illustrate the ways artists use shapes and the ways in which they make space "work"—that is to say, how space interrelates with shapes and becomes as important as shapes to the composition. Artists compose their works using the basic ingredients described in the National Gallery tour. We will now learn how artists use line, value, color, and texture to achieve a sense of unity and balance by creating an interchange between positive shapes (figure) and negative spaces (ground).

Since historical style periods are not germane to the discussion in this tour, we will be comparing paintings of various periods such as Pieter Bruegel's sixteenth-century painting *The Wedding Dance* and Arthur Bowen Davies's colorful twentieth-century painting *Dances*. We will discover that artists throughout history, whether they were consciously aware or working intuitively, were concerned with the basics of composition, the relationships of shapes and space. It will become apparent that these concerns were just as important in three-dimensional art—sculpture and architecture.

We shall begin our tour with the use of various types of subject matter, both realistic and abstract, and how artists place them in a balanced context of surrounding space. If we approach this preliminary stage of viewing art from the standpoint of artists and learn how they manipulate these elements, we can perhaps better appreciate the final results.

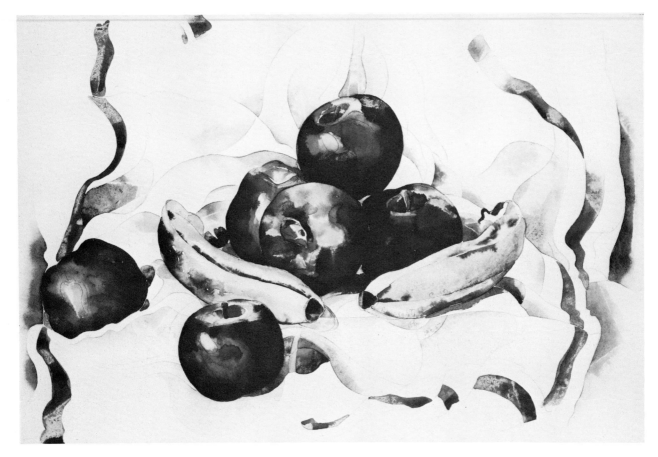

Figure 2.1 Charles Demuth, *Still Life with Apples and Bananas,* 1925. Watercolor and pencil on paper; 11⅞ × 18 in.; 30.16 × 45.72 cm. Courtesy of The Detroit Institute of Arts. Bequest of Robert H. Tannahill.

SELECTING SHAPES

Throughout subsequent tours, you will encounter examples of painting, sculpture, and architecture that will represent the more important style periods in art history. One of the fundamental components of style has been how the artist chooses to form shapes representing simple forms that may or may not resemble realistic objects or figures. In either case, these shapes are often referred to as **subject matter.**

Choosing Subject Matter

Choosing appropriate subject matter is one of the artist's primary concerns, because this aspect of creating art is one of the most fundamental and personal choices that the artist makes. The professor of art often assigns to students "projects" that are really explorations of a historical reservoir of subject matter that has inspired past artists and continues to inspire present artists. The following are examples of such subject matter:

Nature (animate forms or landscapes and seascapes)

Still life (inanimate objects)

The human figure

Dreams and the imagination

Religion, politics, and social issues

The other arts (especially literature and music)

The work of other artists (especially from other style periods and cultures)

Shapes and space (derived from the free application of art media without reference to nature)

Whether the subject matter is a flower, or fruit or dishes on a table, or a nude figure, the artist transforms it as the artwork is created. The artist must give shape to the subject matter and place it in a context of surrounding space. Even an intangible concept or idea must be given form that will communicate it visually. The artist's process of selecting shapes and placing them in context according to personal inspiration or motivation is

Figure 2.2 Demuth's *Still Life: Apples and Bananas* shown out of focus. Courtesy of The Detroit Institute of Arts. Bequest of Robert H. Tannahill.

called **composition.** Part of our task as viewers, then, is to see beyond the obvious depiction of objects into the artist's composition of basic shapes and space.

Arranging Basic Shapes

Many words can be used to describe shapes: precise, amorphous, rigid, flexible, geometric, organic, biomorphic, active, calm, and so on. The diversity of shapes used to express forms in art is as varied as the experiences and skills of individual artists. It doesn't matter whether the subject matter is realistic or not; artists must first visualize even the most realistic forms as if they were basic shapes. Thus, a compositional arrangement of shapes may be completed in any style consistent with the artist's objectives.

When composing their works, artists deal with the interaction of solid shapes and empty space. They refer to this concept as the interaction of **positive space** and **negative space.** In fact, it is often the overall interrelationship or interaction of these two elements that we should respond to in an artwork rather than to individual parts.

Artists are aware of how each stroke of the brush and each chip of stone is affecting all other areas in the work. Paul Cézanne spoke of this ongoing awareness in his declaration, "I advance all of my canvas at one time."

Art instructors are fond of asking their students, "Where's the large shape?" They want students to see the overall shape formed by the grouping of individual shapes of subject matter. Note how Charles Demuth used this overall shape in composing the painting *Still Life with Apples and Bananas* (fig. 2.1).

At first you may not recognize the large shape of Demuth's carefully balanced and predetermined arrangement, but if you look at his painting when it is reduced to basic light and dark patterns (fig. 2.2), the arrangement is more obvious. By showing the work out of focus, the pictorial components that would be likely to distract your attention are obscured. When artists must plan the distribution of light and dark during the process of composition, they usually squint their eyes at their work to create the same kind of out-of-focus view and for the same reason. Squinting also enables the artist to gauge how the work should be painted progressively from large general parts to specific details.

Figure 2.3 Morgan Russell, *Baroque Synchromy No. 11,* 1920. Oil on canvas; 20 × 24 in.; 50.8 × 60.96 cm. Courtesy of The Detroit Institute of Arts. Gift of Theodore Racoosin.

Demuth grouped the fruit to create one, large, colorful shape in the center of the canvas so that you are encouraged to see a large, integrated unit rather than individual shapes. Other artists group animate subject matter such as people and animals into arrangements that also comprise larger forms in their paintings. At this point, it would be helpful to look through the many works of art in this book and find other examples of this technique.

The simplest forms are common geometric figures: squares, triangles, rectangles, and circles. These sometimes appear in an artwork in their familiar forms, as ends in themselves, or can be discerned as the framework of natural and physical objects transformed by the artist.

Morgan Russell's painting *Baroque Synchromy No. 11* (fig. 2.3) is made up of a series of geometric shapes that seem at first to be placed aimlessly in space; contrasts occur in value and in texture and in continual

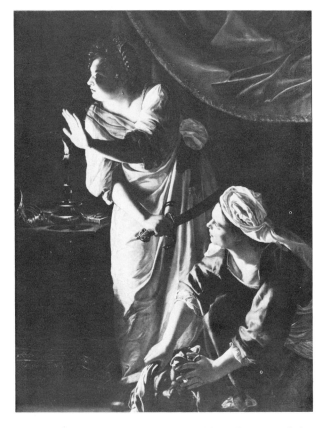

Figure 2.4 Artemisia Gentileschi, *Judith and Maidservant with the Head of Holofernes.* Oil on canvas; 6 ft. ½ in. × 55¾ in.; 184.15 × 141.61 cm. Courtesy of The Detroit Institute of Arts. Gift of Mr. Leslie H. Green.

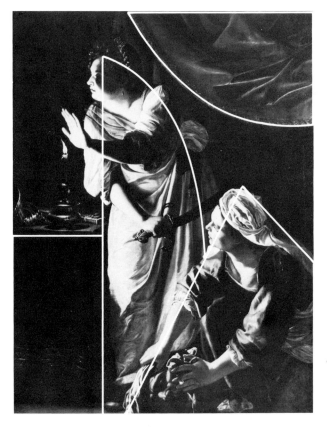

Figure 2.5 Fundamental shapes of Gentileschi's *Judith and Maidservant with the Head of Holofernes.* Courtesy of The Detroit Institute of Arts. Gift of Mr. Leslie H. Green.

overlapping. They appear to float on the surface of the canvas. The floating shapes are actually quite logically structured according to a few, implied, basic directional lines. Russell's decision to use abstract shapes is consistent with his attempt to visualize the work in terms of how effectively the units relate to the outside dimensions of the canvas.

We retraced the planning of Artemisia Gentileschi in *Judith and Maidservant with the Head of Holofernes* (fig. 2.4) and included a sketch of the fundamental shapes underlying her composition (fig. 2.5). These sketches are used only to give you some insight into how artists see beyond subject matter to the manner in which it may be expressed as basic compositional shapes.

The Jan van Eyck painting *Saint Jerome in His Study* (fig. 2.6) provides an example of shapes working together. Suppose we look at the basic superstructure of the painting. If we draw lines around the basic shapes and omit the finer details, we can see how they relate to one another in the total composition (fig. 2.7). It is likely that van Eyck planned these shape relationships before completing the detailed rendering of the figure and the room.

Now notice in figure 2.7 how your gaze is drawn into the space of the painting by following van Eyck's overlapping shapes from the lion in the foreground to the far wall (follow the numbers from foreground to background). Similarly, we can sense the three-dimensional space occupied by the figures in Pieter Bruegel's *The*

Figure 2.6 Jan van Eyck, *Saint Jerome in His Study,* 1435.
Oil and tempera on wood panel; 7⅞ × 5 in.; 20 × 12.7 cm.
Courtesy of The Detroit Institute of Arts. City of Detroit Purchase.

Figure 2.7 Progression of shapes from foreground to background in van Eyck's *Saint Jerome in His Study.* Courtesy of The Detroit Institute of Arts. City of Detroit Purchase.

Figure 2.8 Pieter Bruegel, the Elder, *The Wedding Dance,* ca. 1566.
Oil on panel; 47 × 62 in.; 119.38 × 157.48 cm. Courtesy of The Detroit
Institute of Arts. City of Detroit Purchase.

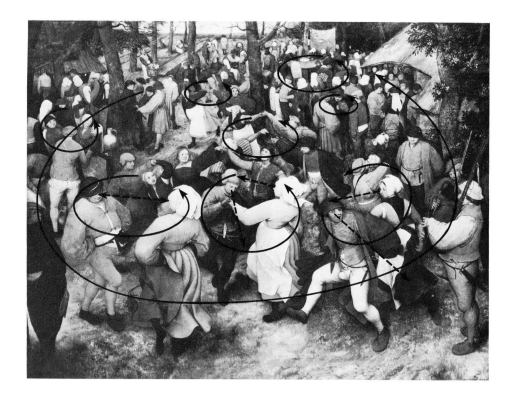

Figure 2.9 The figures in Bruegel's *The Wedding Dance* are grouped
into composite units following circular patterns. Courtesy of The
Detroit Institute of Arts. City of Detroit Purchase.

Figure 2.10 Felix-Edouard Vallotton, *Standing Nude Woman Holding Gown on Her Knee,* 1904.
Oil on canvas; 51¼ × 38¼ in.; 130.18 × 97.16 cm. Courtesy of The Detroit Institute of Arts. Founders Society Purchase, Robert H. Tannahill Foundation Fund.

impressions of wildly dancing figures. The artist formed the female figures by using darker background shapes and by using lighter shapes for the principal foreground figures. Distribution of these changing values entices our path of vision to follow from shape to shape, from areas of dark to light, until we come to realize the well-balanced compositional unit of the painting. Our eyes continually move from one area to another, from side to side, in ways that hold our attention on the canvas long enough for us to understand the artist's message.

From Realistic to Nonrepresentational Shapes

As we commented earlier, it doesn't matter if the subject matter is realistic or not; an artist in planning a composition must first visualize the most realistic form as if it were simply a basic shape in the context of space and then may transform its appearance according to inspiration or motivation. Consider as an example artists who often choose as subject matter the human form. They recognize in the human body a subject with unlimited potential for the expression of feelings, and because of the human experience shared by artist and viewer, can use the human figure as a vehicle for their own powerful statements. From among thousands of paintings, let's examine four examples of the human figure in the Detroit collection that can be categorized as **naturalistic, stylized, abstract,** or **nonrepresentational.**

Felix-Edouard Vallotton's oil painting *Standing Nude Woman Holding Gown on Her Knee* (fig. 2.10) is a natural rendering of the human body. But, as was the case with van Eyck, certain decisions were made by the artist regarding the arrangement of shapes and space. He placed the nude on the left side of the picture in a vertical position in relation to the diagonals of the gown and couch. Where van Eyck drew us back into the space of the painting, Vallotton created a dynamic relationship of opposing linear directions in order to hold our attention on the central figure.

Emil Nolde, in his watercolor *Portrait of the Artist and His Wife* (colorplate 8), chose to stylize features and clothing. Although the faces most likely resemble those of the artist and his wife, we can easily see that Nolde shows only the characteristic, linear essence of their realistic features. However, the linear quality is only part of the story. When Nolde added color, he created a pattern of four large basic shapes that alternate in value and intensity.

Wedding Dance (fig. 2.8). At first glance, the figures seem to be randomly scattered over the canvas, but a closer look shows the figures grouped into well-planned composite units following circular patterns. Notice how the figures decrease in size as they are placed nearer to the horizon. Collectively, all the circles of dancing figures are a part of a larger oval shape that encompasses most of the canvas. Compositionally, the smaller figures closer to the horizon move within the oval to form a total unit (fig. 2.9). Look closely at the heads and faces of both the dancing and the still figures. Following the direction of their eyes makes your eyes move to various other figures in the painting, setting up additional tensions that amplify the festive excitement of the occasion.

Now consider how a twentieth-century painter expressed similar subject matter. *Dances* by Arthur Bowen Davies (colorplate 14) consists of two-dimensional, stylized figures on a flat picture plane. We see an arrangement of various interlocking shapes that collectively form

Figure 2.11 Pablo Ruiz y Picasso, *Bather by the Sea,* 1881–1973. Gouach on paper; 25¼ × 18¼ in.; 64.14 × 46.36 cm. Courtesy of The Detroit Institute of Arts. Bequest of Robert H. Tannahill.

Figure 2.12 Barnett Newman, *Be I,* 1970. Acrylic on canvas; 111½ × 84 in.; 283.2 × 213.4 cm. Courtesy of The Detroit Institute of Arts, Founders Society Purchase. W. Hawkins Ferry Fund and Mr. and Mrs. Walter B. Ford II Fund.

Picasso's *Bather by the Sea* (fig. 2.11) is an abstracted shape based on the human figure. Each portion of anatomy is treated as a shape, rather than as a part of the body—the human figure is barely recognizable. Picasso was not reproducing the natural human form but rather using its basic shapes to construct parts of a total composition. This is only a general idea of a human body; the artist wanted us to see shapes of the body—the *essence* of the whole form.

Barnett Newman's acrylic on canvas *Be I* (fig. 2.12) is an example of a work that goes beyond abstraction. It is completely nonrepresentational; no reference to anything animate can be discerned. Only the title gives us a clue as to what the shapes may represent. While we may have trouble identifying with a painting that bears

no resemblance to anything seen or remembered, it is easy to see, without distractions, the relationship between two identical geometric shapes of intense color separated by a vertical line. Remember in considering artworks that artists do not always copy reality; they *interpret* it.

In *The Wild Poppies* (colorplate 13), Henri Matisse used poppies only as models for a form of expression that symbolized the essence of flowers. Just as van Eyck visualized his painting in terms of essential shapes, Matisse did the same thing with poppies. But Matisse chose not to fill in details or provide a literal description of the flowers; he was more interested in the abstract shapes of poppies and their ability to speak to us in their purest form—line, shape, space, and color. No matter what shapes are used in painting, sculpture, or architecture, the usual intent of the artist is to orchestrate them into arrangements in space that will inform or delight the viewer.

Horizon

Horizon

Figure 2.13 George Grosz, *New York,* 1934.
Watercolor; 23½ × 16¾ in.; 59.69 × 42.55 cm. Courtesy of The Detroit Institute of Arts. Gift of Mrs. Lillian Henkel Haass.

MAKING SPACE WORK—THE PAINTER

All painters reveal the dimensions of space in their works by using basic elements in various ways. While some, like Bruegel (fig. 2.8), plan a painting from foreground to background, others, like Newman (fig. 2.12), reveal a new illusion of space devoid of natural physical images. Cézanne's paintings reveal that he sometimes intentionally flattened the surface of objects while preserving their natural identity. His painting *The Three Skulls* (colorplate 11) is characteristic of how he achieved volume by repeating small facets of color in side-by-side strokes. It is similar to the way we learned,

in Tour 1, how volume was achieved with the use of value and of crosshatching. We also learned that a fixed viewpoint and a single horizon line have been traditional in painting, but painters, experimenting with the possibilities of the multiple viewpoints offered by sculpture and architecture, may offer two or more different viewpoints in the same work. For example, Georg Grosz's *New York* (fig. 2.13) illustrates how multiple horizon levels can be presented without destroying the effectiveness of the painting. Grosz allows us to see, in the limited format of a single canvas, more than one view of the city.

Unified figure-ground

Ground dominating figure

Figure dominating ground

Figure 2.14 The interchange principle: figure-ground, positive-negative, or solid-void.

The Figure-Ground Principle

Artists have been continually driven to find solutions to the problems imposed by pictorial, sculptural, and architectural space. We observed one such solution in the use of linear perspective and its ability to add the illusion of a third dimension to a two-dimensional painting or drawing. Another way to achieve this illusion is to arrange shapes in the space of the canvas to create what we will call the **figure-ground** between the shapes of subject matter and surrounding, unfilled areas. This principle describes the condition of a work in which both filled and unfilled areas of the canvas are equally important.

Figure 2.15 A reducing glass enables the artist to view a work in a smaller size and analyze the composition from a new point of view.

For our purposes we will use the term *figure* to describe solid objects and the term *ground* to refer to the space left over. Other terms are used to describe this important interchange: *positive-negative, figure-field,* and *volume-void.* To achieve interchange between the two, the artist must balance the size and position of shapes to form a composition in which we are not so much aware of either figure or ground but rather of how figure and ground interact as a single unit. Notice in figure 2.14 how the black shapes (figure) and white portions of space (ground) are made to **interchange** and form unified wholes.

Painters are intuitively aware of this interchange among portions of the composition and how objects interact within the space of a canvas. You can judge if the solids and voids in a painting seem to belong together if the design works even when the painting is turned upside down. In fact, during the process of creating, artists often turn a work this way to confirm the fact that these parts agree from a new vantage point, or use a mirror to reverse the painting, or view it through a **reducing glass** (the opposite of a magnifying glass) that diminishes the size of a painting to one or two inches (fig. 2.15). No matter what technique is used, all artists ask, "Have I made any one part, object, or shape in such a way that it calls too much attention to itself because of its value, color, size, or position?" If so, that part will need to be

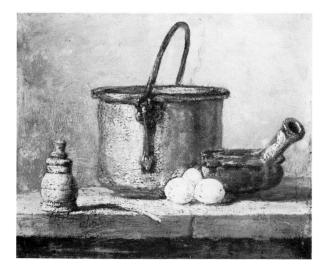

Figure 2.16 Jean Simeon Chardin, *Still Life,* ca. 1732.
Oil on canvas; 6⅝ × 8¼ in.; 16.83 × 20.96 cm. Courtesy of The Detroit
Institute of Arts. Bequest of Robert H. Tannahill.

Figure 2.17 The figure-ground relationship of Chardin's *Still Life.*
Courtesy of The Detroit Institute of Arts. Bequest of Robert H. Tannahill.

Figure 2.18 Ferdinand Hodler, *Portrait of a Woman,* ca. 1910.
Oil on canvas; 21⅝ × 15¼ in.; 54.9 × 38.7 cm. Courtesy of The Detroit
Institute of Arts. City of Detroit Purchase.

adjusted so that it comes together with other parts
forming the work. Sometimes it is apparent that the
ground is meant to dominate the figure, and other times
that the figure is meant to dominate the ground. Jean-
Baptiste Chardin divided his painting *Still Life* (fig. 2.16)
into two major parts. In figure 2.17, we can see how the
proportion of objects in the painting was carefully
planned for a satisfying interchange of figure and ground.
Had all the objects been of such sizes that they filled the
space completely, there would have been little room for
the visual relief provided by the shape of the ground.

Notice next the larger shape of a figure against a
smaller ground in the *A Woman* by Ferdinand Hodler
(fig. 2.18). An example of the opposite effect can be
imagined by visualizing the outside edge of the canvas
larger, without increasing the size of the figure. The
ground would thus dominate the figure and create a dif-
ferent effect. It is obvious that artists are not always con-
cerned with a symmetrical balance between figure and
ground, though space relationships are indeed impor-
tant.

Figure 2.19 Orazio Gentileschi, *Young Woman with a Violin,*
ca. 1612. Oil on canvas; 32¾ × 38½ in.; 83.19 × 97.79 cm. Courtesy of The
Detroit Institute of Arts. Gift of Mrs. Edsel B. Ford.

Figure 2.20 Winslow Homer, *Girl and Laurel,* 1879.
Oil on canvas; 22⅝ × 15¾ in.; 57.47 × 40.01 cm. Courtesy of The Detroit
Institute of Arts. Gift of Dexter M. Ferry, Jr.

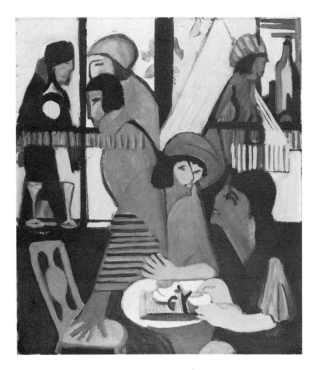

Figure 2.21 Ernst Ludwig Kirchner, *Café,* 1928.
Oil on canvas; 31½ × 27½ in.; 80 × 69.9 cm. Courtesy of The Detroit
Institute of Arts. Gift of Mr. and Mrs. A. D. Wilkinson.

Contrast

Shapes in two-dimensional space are placed in contrast
to one another—light shapes against dark shapes, or dark
against light. Hodler chose a light ground to support the
darker figure of the woman. On the other hand, Orazio
Gentileschi placed the lighter figure of a young woman
against a darker background (fig. 2.19). In both exam-
ples, the stark contrasts in value seem to bring the fig-
ures closer to the viewer and heighten the importance of
pictorial space while dramatizing the subjects.

The same results can be achieved with changes in tex-
ture or color from shape to shape, which help the viewer
discern adjacent areas of the painting or perceive the
dominance of a figure. Winslow Homer's *Girl and Laurel*
(fig. 2.20) illustrates how changes in color and value re-
sult in a high contrast between figure and ground—the
girl and her surroundings. Changing textures among the
sky, flowers, rocks, and clothing add to our appreciation
of each area as a separate but related part of the com-
position.

Integration of Shapes and Space

Painters use dark and light shapes to balance and inte-
grate space. In *Café* (colorplate 12 and fig. 2.21),
Kirchner used color and value to integrate the whole
canvas into one unit. The numbers 1 through 7 in figure

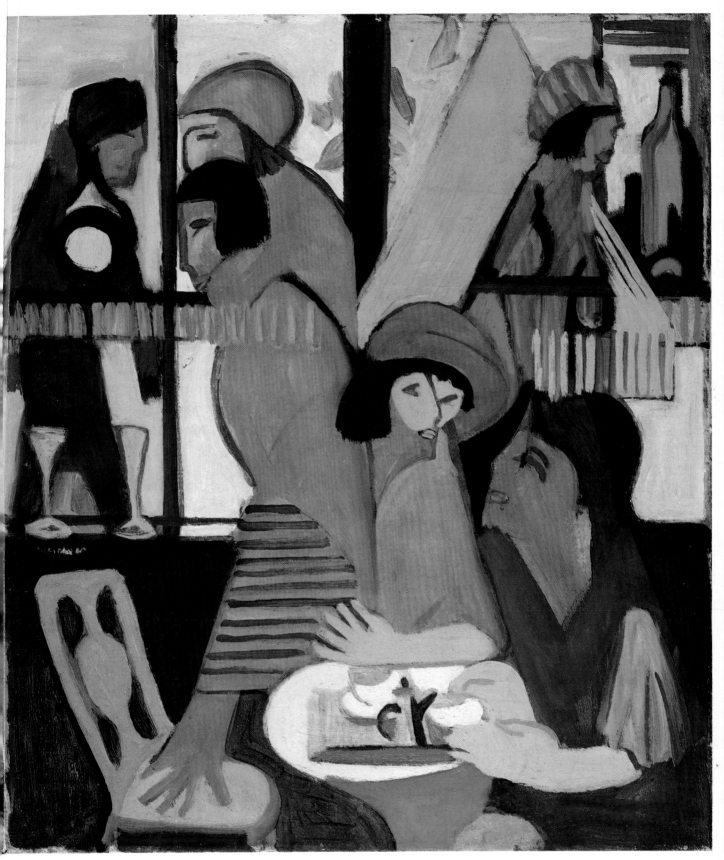

Plate 12 *Café,* Ernst Ludwig Kirchner.
1928. Oil on canvas, 31½ × 27½ in. (80 × 69.9 cm.).
The Detroit Institute of Arts, Gift of Mr. and Mrs. A. D. Wilkinson.

Plate 13 *The Wild Poppies* (center panel), Henri Matisse.
1953. Charcoal and gouache on paper, 31½ × 134⅝ in. (80 × 342 cm.).
The Detroit Institute of Arts, Founders Society Purchase, Robert H. Tannahill Foundation Fund.

Plate 14 *Dances,* Arthur Bowen Davies.
1914. Oil on canvas, 84 × 150 in. (213.4 × 381 cm.).
The Detroit Institute of Arts, Gift of Ralph Harman Booth.

Figure 2.22 The location of dark colors and values in Kirchner's *Café*. Courtesy of The Detroit Institute of Arts. Gift of Mr. and Mrs. A. D. Wilkinson.

Figure 2.23 Rhythmic distribution of light color and value in Kirchner's *Café* is evident even when the painting is viewed upside down. Courtesy of The Detroit Institute of Arts. Gift of Mr. and Mrs. A. D. Wilkinson.

2.22 show the location of Kirchner's darkest darks, which are well distributed over the surface. This was not accidental; the artist established a rhythm by repeating the darks and provided an overall harmony evident even when the painting is intentionally turned upside down (fig. 2.23). This same rhythm can be seen in the distribution of the lightest light areas (*a* through *g*).

Artists use transparency also as a means of integrating figures and grounds. Transparent and translucent colors allow us to see through one shape into another, providing a dimension beyond overlapping. Notice that very little distinction between positive and negative areas is provided by Franz Marc in his vibrant painting *Animals in a Landscape* (fig. 2.24). The use of color that appears to be transparent and a rather flat linear treatment produced a total integration of subject and background. The animal form in the lower center of the picture plane is nearly lost in its surroundings—the opposite effect of high contrast between subject and background. We also see an animal form resting in a position as it would be seen from a high vantage point and two other animals in the foreground as they would be seen from a lower vantage point. As in the Grosz work (fig. 2.13), two horizons allow more than one view of the scene. Marc also used the concept of *interpenetration* with lines that reach the edge of a shape and are continued on its other side (see fig. 2.34).

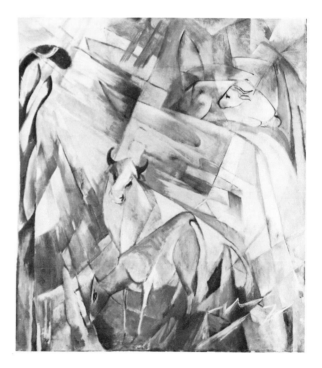

Figure 2.24 Franz Marc, *Animals in a Landscape*, 1914. Oil on canvas; 43⅜ × 39¼ in.; 110.17 × 99.7 cm. Courtesy of The Detroit Institute of Arts. Gift of Robert H. Tannahill.

The Composition of Shapes in Space **49**

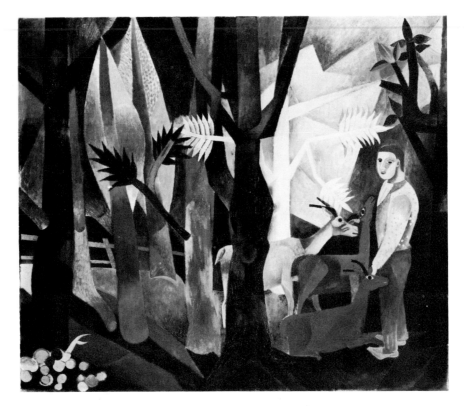

Figure 2.25 Heinrich Campendonk, *In the Forest*
Oil on canvas; 33 × 39 in.; 83.82 × 99.06 cm. Courtesy of The Detroit
Institute of Arts. Gift of Robert H. Tannahill.

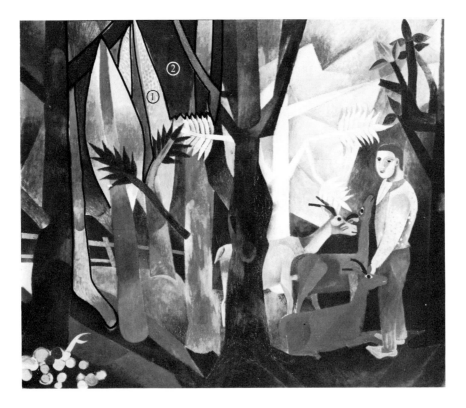

Figure 2.26 Campendonk used overlapping shapes to form an
optical illusion. Courtesy of The Detroit Institute of Arts. Gift of Robert H.
Tannahill.

Figure 2.27 Gerard Terborch, *A Lady at Her Toilet,* ca. 1660. Oil on canvas; 30 × 23½ in.; 76.2 × 59.69 cm. Courtesy of The Detroit Institute of Arts. Founders Society Purchase, Eleanor Clay Ford Fund, General Membership Fund, Endowment Income Fund and Special Activities Fund.

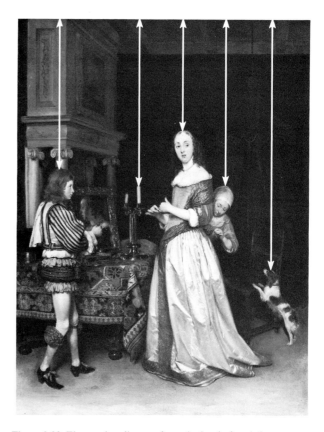

Figure 2.28 The varying distance from the head of each figure to the top of the canvas gives the illusion of three-dimensional space. Courtesy of The Detroit Institute of Arts. Founders Society Purchase, Eleanor Clay Ford Fund, General Membership Fund, Endowment Income Fund and Special Activities Fund.

Heinrich Campendonk's painting *In the Forest* uses overlapping shapes to form an optical illusion (colorplate 9). The color scheme as well as the similarity of size and shapes of subject matter offers a continual panorama of forms that seem to move toward and away from the picture plane. If you examine any one shape and its adjacent shape simultaneously, you will see that you can visually cause one of them to advance; look again and that same shape will appear to recede.

The same relationships are apparent in a black and white photograph of the Campendonk work (fig. 2.25). The outlined shapes illustrate how the tree forms are overlapped to show depth, but the shapes actually seem to move forward as we look alternately at the two parts. Test this yourself by looking at shapes marked 1 and 2 in figure 2.26 and try to decide which one is in front of the other. Campendonk painted the shapes so that they seem to flip-flop between positive and negative.

Creating Pictorial Space

Painters throughout history have been creating the illusion of volume or solidity on the painting surface. In Gerard Terborch's painting *A Lady at Her Toilet* (fig. 2.27), we see the kind of attention given to this rendering of realistic forms in three-dimensional space, which was illustrated in Tour 1 as a box of air whose farthest side might reach infinity. Try to imagine the figures in Terborch's painting—lady, dog, and attendants—as if they were all the same height. The result would be static and flat. As it is, the varying distance from each figure to the top of the canvas (fig. 2.28) presents us with a feeling of the space in the room.

As you will recall from Tour 1, the Schongauer drawing (fig. 1.6) used line to depict volume; Poussin's use of chiaroscuro and color (colorplate 3) gave mass and volume to his figures. You also saw how artists convey the weight of objects through various applications of texture, as in the Bonnard painting (fig. 1.58).

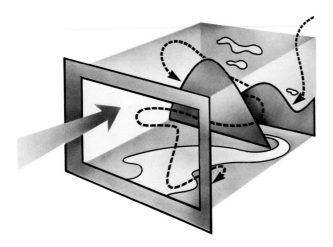

Figure 2.29 The dotted line indicates negative areas in the picture space.

Figure 2.31 A study of figure-ground in Lorrain's *A Seaport at Sunset*. Courtesy of The Detroit Institute of Arts. Gift of Mr. and Mrs. Edgar B. Whitcomb.

Figure 2.30 Claude Lorrain, *A Seaport at Sunset,* 1643. Oil on copper panel; 16 1/16 × 20⅝ in.; 40.8 × 52.39 cm. Courtesy of The Detroit Institute of Arts. Gift of Mr. and Mrs. Edgar B. Whitcomb.

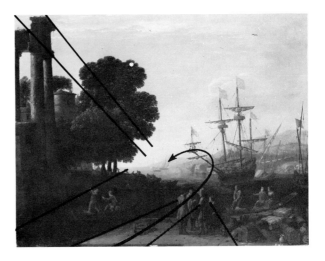

Figure 2.32 Linear depth in Lorrain's *A Seaport at Sunset*. Courtesy of The Detroit Institute of Arts. Gift of Mr. and Mrs. Edgar B. Whitcomb.

Figure 2.29 illustrates the way artists see positive and negative shapes in landscapes. They see objects surrounded by space, similar to a stage set where the audience senses space between objects that seem to retreat into the distance.

A Seaport at Sunset by Claude Lorrain (fig. 2.30) consolidates a number of components in the attempt to capture the effects of space in landscape. The way in which these ingredients interact results in a sensation of three dimensionality.

In Lorrain's landscape, the masterful use of light and value gives us a sense of being drawn into space. Pictorial depth is achieved by softening the value of distant objects, by overlapping, and by using linear perspective. The high contrast between the large, dark, foreground shape and the lighter background shapes provides a sense of drama (fig. 2.31). Lorrain added depth to his painting by placing the columns on the left in linear perspective. He heightened the sense of drama by providing us with a linear "entrance" into the work by means of the edge of the dock (fig. 2.32). This path of vision is picked up

Figure 2.33 Ernst Barlach, *The First Day,* 1920.
Woodcut; 12¾ × 17⅝ in. Courtesy of The Detroit Institute of Arts. Founders Society Purchase, Hal H. Smith Fund.

by the anchored ship and continued by the mountain range, which diminishes in size near the horizon. Here then is a painter of the seventeenth century whose intense interest in making space "work" led him to utilize value, color tonality, figure-ground interchange, aerial and linear perspective, and linear movement—all in one painting.

In contrast, a twentieth-century artist's unique resolution of pictorial space can be seen in *The First Day* by Ernst Barlach (fig. 2.33). The figure of God appears to be three-dimensional due to Barlach's dramatic use of black and white. The simplified figure and cloud forms are combined as one image within the limited dimensions (12¾″ × 17⅝″) of the work. His skill in portraying emotionally charged subjects through simplicity of statement and linear direction is pervasive in all Barlach's work, regardless of medium.

MAKING SPACE WORK—THE SCULPTOR

Sculptors use the elements of composition in much the same way as painters do. The effects of transparency seen in Marc's painting (fig. 2.24) are even more apparent in Naum Gabo's sculpture *Linear Construction No. 4* (not shown, but see similar work in Tour 10, fig. 10.35). Both works achieved different degrees of depth and space-shape relationships that are not static, but changing and active. In addition, movement from shape to shape is achieved in the Marc painting by lines that reinforce the interrelatedness of foreground, middleground, and background. The same type of movement exists in the sculpture in which actual stainless steel strings move through the open spaces of the three-dimensional form.

Figure 2.34 The interpenetration of shapes in painting and sculpture provides a unique relationship of volume and space.

[Volume is] the space that an object occupies in the atmosphere. The essential basis of art is to determine that exact space; this is the alpha and omega, this is the general law.

Auguste Rodin

The strings in the Gabo construction are just far enough apart to allow us to see the effect of interpenetrating planes. These planes cut through other planes and come together as one to form the final sculpture. The word "interpenetration" is often used with regard to shapes that appear to intersect or to go through other shapes. Figure 2.34 illustrates this concept as a sculptor might use it, but it is common to all art forms.

The sculptor's problem differs from the painter's challenge in creating illusions of space in that sculpture involves actual mass or volume that can be felt, measured, and seen from more than one point of view. The open spaces within or around sculpture also interact with the volumes.

Figure 2.35 Ernst Barlach, *The Avenger*, 1914.
Metal, bronze, cast patina; 17½ × 8½ × 23½ in.; 44.45 × 21.59 × 59.69 m.
Courtesy of The Detroit Institute of Arts. Gift of Mrs. George Kamperman in
memory of her husband Dr. George Kamperman.

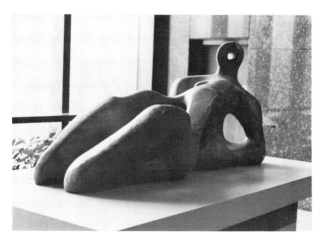

Figure 2.36 Henry Moore, *Reclining Figure*.
1939. Carved elm. 37 × 79 × 30 in.; 94 × 200.7 × 76.2 cm. The Detroit
Institute of Arts. Gift of the Dexter M. Ferry, Jr., Trustee Corporation.

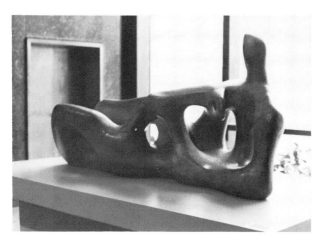

Figure 2.37 Henry Moore, *Reclining Figure*.
1939. Carved elm. 37 × 79 × 30 in.; 94 × 200.7 × 76.2 cm. The Detroit
Institute of Arts. Gift of the Dexter M. Ferry, Jr., Trustee Corporation.

The powerful thrust of the running figure in Barlach's sculpture *The Avenger* (fig. 2.35) is caused by the linear direction of the robe and the balance of the figure on one foot as if caught in stop-frame action. The space in front creates a void that seems to pull the figure forward. Volumes and voids can be perceived as equal components and integral parts of the whole comparable to the two-dimensional figure-ground principle that we saw in painting.

Volumes and Voids

Perhaps the most dramatic use of volumes interacting with voids is seen in the work of the sculptor Henry Moore. Many people familiar with Moore's work have wondered why he often places open spaces where there are none in reality. Look at his *Reclining Figure* (figs. 2.36, 2.37, and colorplate 10). After we determine that this sculpture is indeed of a human figure, the holes in the figure's chest may seem at first to look foolish or even startling. This impression is caused by Moore's representation of familiar subject matter (a person) in a very unfamiliar way—with huge holes in the head and the chest. He could have created totally nonrepresentational forms whose volumes and voids would interact in much the same way as Alexander Calder's *The X and Its Tails* (fig. 2.38) in which the subject is quite unfamiliar. Like Moore, Calder was as concerned with the open areas between shapes as he was with the actual shapes of the metal parts (fig. 2.39).

Calder saw the *shapes of voids* between solid masses of steel. Therefore, in cutting, forming, and welding, he was simultaneously aware of the dimensions of the open spaces as they were being created by the formation of the solid masses. Suppose we could place *The X* on a large mechanized turntable. Imagine standing in one place and watching the sculpture turn slowly before us. From a single viewpoint, you would see continuously changing forms and voids appearing and disappearing. This interaction of volumes and voids is one of the major concerns of artists who create three-dimensional compositions. If we move around Calder's stable work, or **stabile,** we can view the variety of shapes and spaces presented—a continual panorama of negative and positive space. Remember that some of Calder's sculptures actually move and are known as **mobiles** (see fig. 1.26) and provide interaction of constantly changing patterns of the individually suspended shapes and of the entire sculpture as it turns on its axis.

Another awareness of volume and void is provided by the sculptor Louise Nevelson, who is most often associated with an art form known as **assemblage.** Nevelson

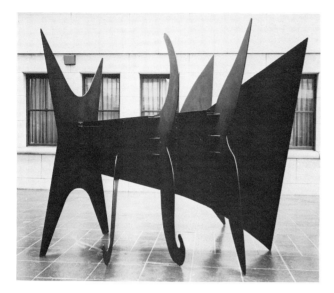

Figure 2.38 Alexander Calder, *The X and Its Tails.*
Metal; steel plate construction; paint, black; 10 × 10 × 12 ft.;
3.048 × 3.048 × 3.6576 m. Courtesy of The Detroit Institute of Arts. Gift of
W. Hawkins Ferry.

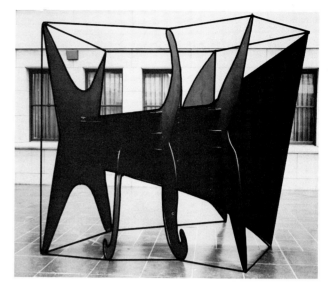

Figure 2.39 The shapes of space between the solid shapes of
Calder's *The X and Its Tails.* Courtesy of The Detroit Institute of Arts.
Gift of W. Hawkins Ferry.

Figure 2.40 Louise Nevelson, *Homage to the World,* 1966.
Wood, paint, black construction; 8 ft. 6 in. × 28 ft. 8 in.; 2.5908 × 8.7376 m.
Courtesy of The Detroit Institute of Arts. Founders Society Purchase, Friends
of Modern Art Fund and other Founders Society Funds.

has achieved fame with her assemblages, which are literally assembled from, and constructed of, forms found in her environment. Her *Homage to the World* (fig. 2.40), which shows the immense size of her work, consists of a rhythmic succession of open and closed shapes. Although no two are exactly the same, Nevelson achieved a unified effect by repeating the assembled shapes in five horizontal bands. Her consistent treatment of the wood forms, which are painted with one color, heightens our awareness of the interaction of open and closed spaces while relating the parts to the whole.

If it seems strange that sculptors view open spaces as important aspects of a work, consider first that the work will be viewed from all sides. Look again at the several views of Moore's *Reclining Figure* and notice how the holes appear to have opened and closed according to the viewpoint. The holes' surfaces, or sides, that continue from exterior to interior are as important as the actual holes themselves. The artist anticipates the varieties of silhouettes that will be presented to viewers as they stroll around the sculpture.

Figure 2.41 David Smith, 1906–65, *Cubi I* 1963.
Metal, steel, stainless steel construction; 10 ft. × 4 in.; 3.1496m. Courtesy of
The Detroit Institute of Arts, Founders Society Purchase, Special Purchase
Fund.

Figure 2.42 The line of implied motion in Smith's *Cubi I*.
Courtesy of The Detroit Institute of Arts, Founders Society Purchase, Special
Purchase Fund.

Sculptors are, therefore, involved in dynamic space activation. The David Smith sculpture *Cubi I* (fig. 2.41) illustrates how stainless steel shapes are made to appear active. Notice how Smith placed the cubes in an undulating curve. Our eyes follow the curve from the larger shape at the bottom to the top. Smith explained, "I want you to travel by perception the path I traveled in creating"[1] (fig. 2.42).

SUMMARY

Artists compose their works by arranging shapes or forms in two- or three-dimensional space. The selection of media and subject matter often follows as the first step in beginning a composition, whether paint on canvas, clay, steel, or any other medium. Then, perceiving objects as elemental shapes, artists begin their task of arranging solids in such a way as to interact with the voids that surround them. In other words, the artist selects parts from nature, assigns them a level of importance, and pictorially arranges them to best express aesthetic goals.

The figure-ground principle is an important consideration in composition, as well as contrast and the integration of shapes and space. For example, the sculptor uses not only three-dimensional shapes but also their interrelationship with the actual space around and through them. The shapes of space created by holes or openings, and space surrounding sculpture, are as important to the work as sculpted or cast parts. Painters are also aware of the relationship between open areas (negative space) and subject matter (positive space).

Interchange to achieve order and unity with subject matter is heightened by the use of value and color, distributed in such a way as to visually balance the compositions. The illusion of transparency and interpenetration are two additional techniques that bring parts into closer harmony with one another.

In the tours that follow, now that you are aware of the basic ingredients and how an artist enlists these in selecting and composing shapes in space, look for these elements and compare how each artist chooses to transform them in a creative and individual manner. Remember too that when painters or sculptors do not choose natural forms as their subject matter, we should try to discern what the artist is calling to our attention. Try to discover the purpose of the artwork—what it is expressing—rather than search for a realistic counterpart.

1. Barbara Rose, ed., *Readings in American Art Since 1900: A Documentary Survey* (New York: Frederick A. Praeger, 1968).

Figure 2.43 Giovanni Battista Piranesi, *Prison with Drawbridge in Center.*
Etching; 21¾ × 16¼ in. Courtesy of The Detroit Institute of Arts. Founders Society Purchase, Hal H. Smith Fund and Elizabeth P. Kirby Fund.

VIEWING EXERCISES

1. Compare August Rodin's use of the female form in *Dancing Figure* (fig. 1.33) with that of Vallotton (fig. 2.10), Nolde (colorplate 8), and Picasso (fig. 2.11).

2. Since certain kinds of shapes are often the hallmark of an artist, we often use them to recognize an artist's style and sometimes even to establish the year that a work was completed. Due to progressive changes in an individual artist's style, however, this technique is not always reliable. Compare Matisse's *The Wild Poppies* (colorplate 13) with his *Still Life: Apples on Pink Tablecloth* (fig. 1.53). Why do you think Matisse's style changed from the use of realistic to abstract shapes?

3. Trace the paths of vision your eyes follow as you look at Giovanni Battista Piranesi's etching (fig. 2.43). Discuss the extent to which you think these were intentional paths created by the artist, or perhaps the unintentional result of a maze of interesting lines.

The Composition of Shapes in Space **57**

Figure 2.44 Charles Sheeler, *Still Life, Zebra Plant Leaves*, ca. 1938.
Silver print 7¾ × 9⅝ in.; 19.69 × 24.45 cm. Courtesy of The Detroit Institute of Arts. Founders Society Purchase, Beatrice W. Rogers Fund and Edward E. Rothman Fund.

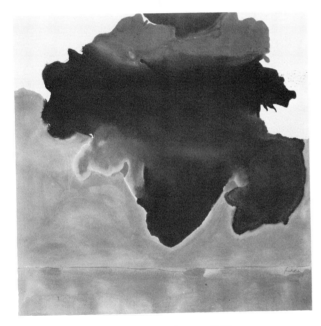

Figure 2.45 Helen Frankenthaler, *The Bay*, 1963.
Acrylic on canvas; 6 ft. 8¾ in. × 6 ft. 9¾ in.; 2.05105 × 2.07645m. Courtesy of The Detroit Institute of Arts. Gift of Dr. and Mrs. Hilbert H. DeLawter.

Figure 2.46 Paul Gauguin, *Self-Portrait*, ca. 1890.
Oil on canvas; 18³⁄₁₆ × 15 in.; 46.2 × 38.1 cm. Courtesy of The Detroit Institute of Arts. Gift of Robert H. Tannahill.

4. Discuss what Charles Sheeler did to achieve the illusion of solid mass and space in his print *Still Life, Zebra Plant Leaves* (fig. 2.44).

5. Speculate on the objectives of two contemporary artists, Helen Frankenthaler (fig. 2.45) and Barnett Newman (fig. 2.12) regarding their choices of shape relationships, the interrelationships of volumes and voids, and the use of space.

6. Paul Gauguin composed his *Self Portrait* (fig. 2.46) by bringing the shapes and forms together and enabling the space to work in terms of the total canvas or picture plane. However, if we were to alter the composition as in figure 2.47, the original relationships would be lost. Discuss how the space relationships changed, but were not necessarily improved.

7. The artist's use of volume and space can be compared with the musical composer's use of sound and silence. Listen to the third movement of Beethoven's Symphony no. 5 and compare the relationship between sound and silence with the alternation between volumes and open space in Matisse's *The Wild Poppies* (colorplate 13).

Figure 2.47 Altered composition of Gauguin's *Self-Portrait*. Courtesy of The Detroit Institute of Arts. Gift of Robert H. Tannahill.

STUDIO EXERCISES

Suggested media and supplies: assorted sheets of colored paper; rubber cement or glue; drawing paper; any painting medium; heavy paper or cardboard; cutting knife; tracing paper; scissors.

1. Using different colors of paper, cut shapes of poppies in various sizes, similar to those in Matisse's painting (colorplate 13). Reassemble and glue the shapes in a composition that creates an illusion of three-dimensional space. Use overlapping shapes and vary the negative spaces between the forms by changing their position in order to activate the movement from the front to the back of the picture plane. Refer to the compositional techniques in the Campendonk (colorplate 9) and the Marc (fig. 2.24).

2. Fundamental shapes contribute to a total composition. With this in mind, use tracing paper and draw the basic underlying lines and shapes of Marc's *Animals in a Landscape* (fig. 2.24). Without regard for what the shapes represent, redraw them on a larger piece of drawing paper. Use color as desired to create an abstract design that echoes the structure of the original painting.

3. Using the Calder sculpture in figure 2.38 as a guide, cut a variety of angular shapes from heavy paper or cardboard. The size of your final work will be determined by the size of the available cardboard. Assemble the cardboard shapes in space so that they fit together and stand by themselves. You may glue, tape, cut, or fold them so that they interconnect or penetrate one another. The objective will be to create a sculptural composition in which the shapes vary from every viewpoint—an asymmetrical balance rather than a symmetrical one. Precolored cardboard will add to the effectiveness of the final work. You may repeat the exercise using only squares and rectangles for the sculpture.

RESPONSES TO VIEWING EXERCISES

1. Rodin selected flowing curvilinears to show the lyric essence of a figure, while Picasso, also concerned with simplicity, distorted his figure anatomically to express feelings rather than to portray a realistic human form. Nolde reduced his portraits to linear essences of character, while Vallotton used a more formal and traditional approach in rendering the figure and in arranging objects in the composition.

2. One of the ways in which Matisse sought new realms of expression was to reduce subjects to essentials and to establish new relationships of shapes and space unrelated to formal qualities of the past.

3. The paths of vision are numerous and probably unintentional. Beginning at the bottom right edge, our eyes move in and out of shapes in a seemingly endless manner. These eye movements are contained within the picture plane by simpler bold shapes located around the outer edges. We could follow any one of several paths of vision set in motion by the system of ramps, posts, and arches.

4. Sheeler used the following strategies:
 a. placed a single light source to highlight the still life
 b. cast a shadow from the leaves to the pitcher
 c. painted a gray background in contrast to the darker still life
 d. placed the highest light on the pitcher (achieving a center of interest)
 e. overlapped the three objects from the foreground to the background
 f. placed the objects different distances from the top edge of the painting

5. Formal, traditional criteria used to judge landscape painting cannot always be applied to an analysis of paintings employing such nonrepresentational amorphous or geometric shapes. Investigating new directions in art are as important to the visual artist as to the writer or the musician. Canvas space becomes an arena for representing the personal and social attitudes of artists and not always for representing the natural and physical environment.

6. The altered version is compositionally sound, but the subject matter is expressed in a new way simply by raising the eye level. Changes occur in
 a. color balance and tonal quality
 b. interchange
 c. dark and light shapes that integrate the canvas
 d. size relationships of shapes

7. The alternation of similar elements in both works creates a definitive rhythm that could be termed "regular and intermittent."

Solomon R. Guggenheim Museum

New York City

Tour 3

The Organizing Principles of Art

The Gallery

The Solomon R. Guggenheim Museum is perhaps one of the most distinctive and renowned structures of its kind. Designed by Frank Lloyd Wright and completed in 1959, the unified design of the Guggenheim is a simple inverted spiral.

As visitors enter the museum, they are encouraged to cross an open display area to an elevator. Above their heads is a core of space and light rising to the top of the spiral. The elevator carries them to the top level and to the beginning of a wide descending ramp that follows the far curve of the spiral, offering them an effortless stroll past the artworks. On their left, hung on the inner walls or displayed in side rooms entered at various levels along the ramp, is the museum's collection of modern and twentieth-century art; on their right is the light and space of the spiral's core. The ramp returns them to its base and the open area before the street-level entrance/exit.

Located on Fifth Avenue facing the east side of Central Park, the Guggenheim is a major showplace for new artists—many of whose works become part of the permanent collection—and is also one of New York City's must-see tourist attractions. The stark white of the exterior that molds the inner spiral like a great seashell is an arresting sight for passersby used to the traditional facades of the buildings that wall Fifth Avenue.

I would like to realize myself. In this sense, I would like to be considered a realist. For me, abstraction is real, probably more real than nature.

Joseph Albers

Tour Overview

"What is it?" is perhaps the question most frequently asked by visitors examining for the first time an abstract painting or sculpture in the Guggenheim collection of modern and twentieth-century art. The reason behind their question is that many viewers are used to identifying subject matter solely by its realistic shape. Not all of the art in this tour is abstract in the extreme, but we should be prepared to approach a number of works with a better question: "What is the artist expressing?"

The term *abstract,* as it is applied to art, has acquired a connotation implying that the artist has distorted reality. To abstract a realistic subject, however, is to express one or more of its qualities, not its physical shape; therefore, an artist may present an abstraction that depicts the essence of the subject matter. The artist's intent may be to call our attention to an aspect of the subject we might have never noticed before. Each work of art has something to say to us: a message from the artist to the world. To achieve this goal, artists take care to synthesize all the basic elements of art at their command into single, powerful statements.

The organizing principles of art actually apply universally to all the arts—the visual arts, music, dance, and drama, and they apply to both the creative process as well as the appreciation of artworks in that our knowledge of them makes our experience more satisfying. In this tour we will study the need for *unity* and *coherence* in art, and what better example of unity could we find than the museum building itself? Along with unity we shall also continue to examine its counterpart—*variety.* Both play important roles in maintaining *balance* in a composition. *Form, style, content,* and *symbolism* are also important principles of art, as are the ways in which these factors are interrelated.

We should keep in mind that although the art we are viewing on this tour is for the most part modern or contemporary, the principles they demonstrate apply as well to the art of all ages and cultures. In fact, it may be easier to recognize these basic principles in artworks in which means of expression are emphasized more than realism. Therefore, while not all of the artworks are extremely abstract, several will require our open-minded approach as we analyze the basic principles involved in their makeup. In Tours 9, 10, and 11, we will learn more about how abstraction developed in twentieth-century art, but for now, we need only remember that all of the organizing principles of art apply to the creation and appreciation of art, no matter what the style, from the beginning of time to the present day.

CONTENT, FORM, AND STYLE

We are already aware of the impact of some of the visual elements: how angular lines create a different response than lyrical ones; how certain colors are warmer or cooler than others; how texture, contrast, and value also create psychological effects. Equally powerful are the artist's choices of content, form, and style.

Subject matter is, as we know, the person, place, thing, or abstract shape selected by the artist. *Content, form,* and *style* are terms in art that have special significance because of their relation to one another. **Content** refers to the overall meaning of the artwork—the artist's intent; that is, its aesthetic message. **Form** is the result of the artist's total visual organization of the work, and **style** refers to the artist's individual manner of executing all the visual elements. Compare two paintings of similar subject matter by different artists: Modigliani's *Nude* (colorplate 16) and Picasso's *Three Bathers* (colorplate 19). Most people immediately notice the great difference between the warm, sensual realism of Modigliani's nude and the chilling, statuary abstraction of Picasso's bathers. Modigliani and Picasso each have a distinct personal style or characteristic approach to the nude figure. When many artists adopt some of the same techniques of execution or some of the same elements of form, a group style emerges.

Content in art, therefore, transcends subject matter; it encompasses meaning. More specifically, content is the meaning of the form of the artwork and the purpose of the artist's marshaling, integration, and direction of all the visual elements in order to express the message of the artwork.

What do Picasso's shapes mean? Suppose we were to look at the extreme fullness and roundness of those human forms as manifestations of Picasso's wish to portray women as fertile and strong. One problem in determining the content of an artwork is the inescapable variability of individual response. What we see in an artwork is influenced by what we bring to that experience. Our personal backgrounds are brought into play in every encounter with an artwork, and since each of us brings a different background of experience to the encounter, we must assume that no matter what generalizations are applied to a given artwork, each of us may well interpret it in a unique way. Therefore, because the process of recognizing what meaning the artist meant to convey in the artwork demands something from its viewers, we look for clues.

UNITY AND COHERENCE

Our first clue, and a basic principle of art, is that in an effort to express feelings about the subject matter in a coherent way, the artist will have tried to bring together every visual element in the artwork for the purpose of communicating its message, which is focused on a central theme, or **motif.** This is the method used to achieve unity in the artwork.

Before Albert Gleizes painted his *Portrait of an Army Doctor* (fig. 3.1), he experimented in seven studies (fig. 3.2) to find an effective way to make a cohesive, unified

Figure 3.1 Albert Gleizes, *Portrait of an Army Doctor,* 1914–15.
Oil on canvas; 47¼ × 37⅜ in.; 119.8 × 95.1 cm.
Solomon R. Guggenheim Museum, New York.
Gift, Solomon R. Guggenheim, 1937.
Photo: Robert E. Mates.

Study No. 1

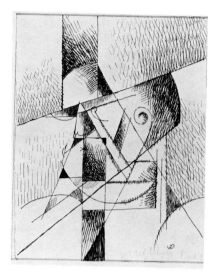

Study No. 2

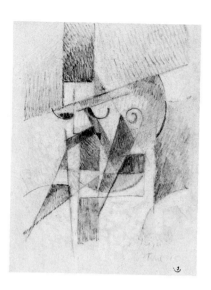

Study No. 3

Study No. 4

Study No. 5

Study No. 6

Study No. 7

Figure 3.2 Seven studies illustrating the progressive steps used by Gleizes to develop a final painting. (See fig. 3.1).

Study No. 1 for *Portrait of an Army Doctor,* 1915.

Ink on paper; 7¾ × 6 in.; 19.7 × 15.2 cm.
Solomon R. Guggenheim Museum, New York.
Photo: Robert E. Mates.

Study No. 3 for *Portrait of an Army Doctor,* 1915.

Pencil on paper; 8⅜ × 6½ in.; 21.3 × 16.5 cm.
Solomon R. Guggenheim Museum, New York.
Photo: Robert E. Mates.

Study No. 5 (?) for *Portrait of an Army Doctor,* 1915.

Ink with crayon on paper mounted on board; 9½ × 7¾ in.; 24.1 × 19.7 cm.
Solomon R. Guggenheim Museum, New York.
Photo: Robert E. Mates.

Study No. 7 for *Portrait of an Army Doctor,* 1915.

Ink with crayon on paper; 9¾ × 7⅞ in.; 24.8 × 20 cm.
Solomon R. Guggenheim Museum, New York.
Photo: Robert E. Mates.

Study No. 2 of *Portrait of an Army Doctor,* 1915.

Ink on paper; 7½ × 6 in.; 19.1 × 15.3 cm.
Solomon R. Guggenheim Museum, New York.
Photo: Robert E. Mates.

Study No. 4 (?) for *Portrait of an Army Doctor,* 1915.

Pencil on paper; 9⅝ × 7¾ in.; 24.5 × 18.8 cm.
Solomon R. Guggenheim Museum, New York.
Photo: Robert E. Mates.

Study No. 6 (?) for *Portrait of an Army Doctor,* 1915.

Ink on paper; 8⅜ × 7⅛ in.; 1.3 × 18.1 cm.
Solomon R. Guggenheim Museum, New York.
Photo: Robert E. Mates.

Figure 3.3 Beethoven's four-note motif from his Symphony no. 5.

Figure 3.4 The repetition of the cross-brace motif in the Eiffel Tower is similar to Beethoven's four-note motif in his Symphony no. 5.
Bildarchir Foto Marburg/Art Resource, NY.

statement. The studies graphically illustrate how an artist's work progresses as he or she carefully organizes all artistic elements to express coherently its meaning.

Gleizes experimented with different alternatives as he attempted to define the space of his canvas—reevaluating space relationships in each study by changing the sizes of shapes, adding values, varying the position of units, altering space between units, and adding new lines.

He chose the final form of his oil painting as the best organization of all the artistic elements, but he could have developed a successful and different oil painting from any one of the studies.

There are a number of avenues to achieving unity in all forms of visual art: the development of a central theme; repetition; scale, proportion, and visual balance; harmony and consistency; and rhythm.

Repetition

It is in repeating shapes, line, value, texture, and color in painting and sculpture that unity is most readily achieved. Kandinsky's *Blue Mountain* (colorplate 17) displays two features that merge as one and help to unify the painting—its texture and its vivid colors. The texture on the surface of the canvas is rough, as though Kandinsky had dabbed oil paint heavily in forming the shapes of trees, hills, sky, and figures. On the other hand, the colors are pure and vivid. Recall our discussion on color intensity. Here is the quintessence of color saturation and its effect on our eyes. Indeed, consistency in the use of any medium—pigment in painting, sound in music, or movement in dance—as well as the harmonious interaction of various kinds of art elements, will produce unified results.

At the end of Tour 2, we became familiar with the famous four-note motif of Beethoven's Fifth Symphony. As a matter of fact, that motif—three short tones and one long one (da-da-da-dum)—is heard throughout all four movements of the symphony (fig. 3.3). Beethoven used repetition of that motif as a means to create unity or coherence in the total score. The structural crossbracing of Gustave Eiffel's tower in Paris is an equally famous repeated motif (fig. 3.4). Repetition is as important an art principle as it is a structurally sound architectural device.

Let's take a look at the Eiffel Tower as seen by the painter Robert Delaunay (fig. 3.5). This particular painting of the Eiffel Tower is said to be his third interpretation, which was painted in 1911. Delaunay was trying to show the tower in terms of how the structure looked from a variety of viewpoints, a characteristic style of many cubist painters of the early 1900s. (More will be said about cubism when we tour the Museum of Modern Art, New York.) Cubists had realized that they could depict various angles and viewpoints simultaneously on one canvas. Delaunay's interpretation might have seemed fragmented or disjointed to us before Tour 2, but now that we are aware of the device of multiple viewpoints we recognize Delaunay's attempt as a fresh, new look at the basic elements composing this unique structure. His single idea is thus achieved—a statement of energy and power, reinforced from any angle, that goes beyond the fixed steel of the actual monument.

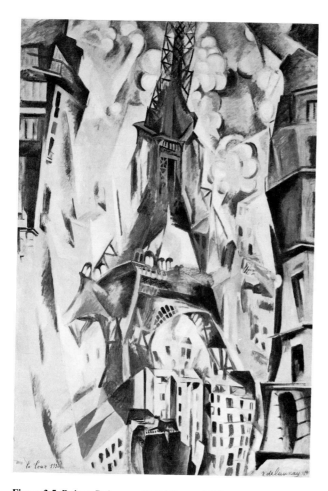

Figure 3.5 Robert Delaunay, *Eiffel Tower,* 1911.
Oil on canvas; 79½ × 54½ in.; 202 × 138.4 cm.
Solomon R. Guggenheim Museum, New York.
Gift, Solomon R. Guggenheim, 1937.
Photo: Robert E. Mates.

Figure 3.6 Composite of Kandinsky's *Composition 8* and Rousseau's *The Football Players.*

Figure 3.7 Louise Nevelson, *Luminous Zag: Night,* 1971.
Painted wood, 105 boxes, total 120 × 193 × 10¾ in.;
304.8 × 490.3 × 27.3 cm.
Solomon R. Guggenheim Museum, New York. Gift, Sidney Singer, 1977.

Figure 3.8 Pablo Picasso, *Le Moulin de la Galette,* Autumn 1900.
Oil on canvas; 34¾ × 45½ in.; 88.2 × 115.5 cm.
Solomon R. Guggenheim Museum, New York.
Gift, Justin K. Thannhauser.
Photo: Robert E. Mates.

Without unity, any work of art would lose its ability to express its message coherently to the viewer. Suppose two paintings of different styles were combined into a single, composite work. Figure 3.6 was created by laying a part of Henri Rousseau's *The Football Players* (see fig. 3.25) over Kandinsky's *Composition 8* (see fig. 3.27). The individual areas of the composite result are not in agreement and fight for our attention. No dominant theme is evident. Even such a fabricated work, however, might become unified if Kandinsky's angular, geometric background were superimposed over the entire canvas.

Repetition of a painting technique or of a basic design ingredient is an important key to achieving unity in an artwork. The sculpture *Luminous Zag: Night* by Nevelson (fig. 3.7) and the painting *Le Moulin de la Galette* (fig. 3.8) by Picasso are excellent examples of unity achieved through repetition. The surface of the Nevelson sculpture is covered with black paint. In addition, repetition of surface texture is achieved with over one hundred tiny boxes of similar configuration. Likewise, Picasso's painting is coherent because of repetition; there is a consistent distribution of light and dark areas that is reminiscent of an interlocking picture puzzle.

Figure 3.9 Fernand Léger, *Starfish,* 1942.
Oil on canvas, 58 × 50 in.
Solomon R. Guggenheim Museum, New York.
Fractional Gift of Evelyn Sharp to the Solomon R. Guggenheim Museum, 1977.
Photo: Robert E. Mates.

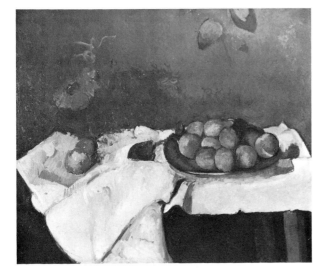

Figure 3.10 Paul Cézanne, *Still Life: Plate of Peaches,* 1879–80.
Oil on canvas, 23½ × 28⅞ in.; 59.7 × 73.3 cm.
Solomon R. Guggenheim Museum, New York.
Gift, Justin K. Thannhauser.
Photo: Robert E. Mates.

Shapes separated

Shapes touching

Shapes overlapping

Figure 3.11 Overlapping shapes add to the coherence and unity of a composition.

> For me a picture is a plane surface covered with representations of objects—beasts, birds, or humans—in a certain order in which anecdotal illustrational logic has no importance. The visual effectiveness of the painted composition comes first.
>
> *Marc Chagall*

Coherence

Coherence is an important principle in achieving unity through a harmonious relationship of shapes, color, and line. Two ways to achieve coherence are by overlapping or touching units (objects) and by consistency of style. Paul Klee's *Rolling Landscape* (colorplate 18) features units that do not overlap or even touch, but unity is achieved with color tonality, consistency of treatment, and thick lines of fairly equal size that seem to float in space. On the other hand, Fernand Léger's *Starfish* (fig. 3.9) consists almost entirely of overlapping units that are biomorphic and geometric. Some of Léger's shapes appear to be translucent so that the viewer can see through the units to view interesting changes of pattern. A more vivid representation of overlapping shapes and the resulting effect on unity is seen in Cézanne's *Still Life: Plate of Peaches* (fig. 3.10). Every object in the composition overlaps with another, and because all units are clustered, we sense that all objects belong together. A simple diagram (fig. 3.11) shows the coherence depicted by overlapping shapes, especially when seen in contrast to the same shapes separated in space or touching one another.

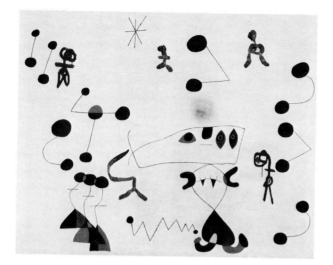

Figure 3.12 Joan Miró, *Woman in the Night,* March 1, 1945.
Oil on canvas; 51⅛ × 63¾ in.; 129.9 × 161.9 cm.
Solomon R. Guggenheim Museum, New York.
Fractional Gift of Evelyn Sharp to the Solomon R. Guggenheim Museum, 1977.
Photo: Robert E. Mates.

Figure 3.13 Repetition in various forms.

Joan Miró's unique style is most illustrative of the use of a repetitive motif in the quest for unity. His *Woman in the Night* (fig. 3.12) repeats similar shapes, especially black dots, over its entire surface. Furthermore, Miró connected many of the shapes with thin black lines as if to make sure they were held together. It is the literal repetition of these shapes that maintains the artistic unity of this work.

But repetition is not always exact, or literal; it may be developmental. Take a simple shape, such as a small circle, repeat it literally and a certain effect is produced. But if we were to repeat that shape in one slightly larger or smaller, an entirely different result would occur (fig. 3.13).

A DELICATE BALANCE: UNITY AND VARIETY

Unity alone can provide the cohesiveness to hold together the components of an artwork and to express an aesthetic idea in a significant and powerful way. Without *variety,* however, the work will most likely lose some of its excitement and impact. Therefore, artists are faced with another challenge: to maintain some kind of balance between unity and variety. The unity strengthened by the repetition of circles in Kandinsky's painting *Several Circles* (fig. 3.14) was obviously intentional. Thus, variety became necessary to temper such a simplistic choice of subject matter, and this was easily achieved by varying the size, color, and value of the circles. The balance is delicate because these two principles of unity and variety are opposing forces. Kandinsky was apparently mindful of this balance when he created his *Painting No. 198* (colorplate 56), which consists mainly of heavy black

Figure 3.14 Vasily Kandinsky, *Several Circles,* January–February 1926.
Oil on canvas; 55¼ × 55⅜ in.; 140.3 × 140.7 cm.
Solomon R. Guggenheim Museum, New York.
Gift, Solomon R. Guggenheim, 1941.
Photo: Robert E. Mates.

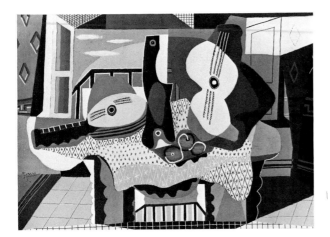

Figure 3.15 Pablo Picasso, *Mandolin and Guitar,* 1924.
Oil with sand on canvas; 55⅜ × 78⅞ in.; 140.6 × 200.4 cm.
Solomon R. Guggenheim Museum, New York.

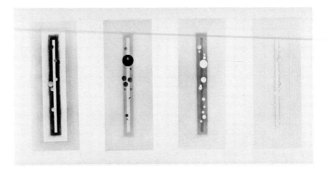

Figure 3.16 Rudolf Bauer, *Tetraptychon II No. 1, No. 2, No. 3, No. 4,* 1936.
Oil on canvas, approx. 52 × 79 in.
Solomon R. Guggenheim Museum, New York.
Photo: Robert E. Mates.

lines—some short and staccatolike, some broad and sweeping—superimposed over small patches of intense color. A sense of wholeness is achieved by the even distribution of interlocking lines, shapes, and intense color.

Variety of another kind was achieved by Frank Lloyd Wright when he counteracted the progressively smaller spirals from top to bottom with the use of angular, straight lines on the exterior of the Guggenheim. Part of the impact of this dynamic structure is due to this contrast between the opposing forces, between unity and variety.

The Effects of Alternation

Sometimes, especially in abstract works, coherence is achieved by interlocking shapes. The painting by Picasso titled *Mandolin and Guitar* (fig. 3.15) resembles a puzzle because its shapes are interlocked at fairly regular intervals and appear to be wrapped around one another. Interaction between unity and variety is marked by the **alternation** of contrasting forces and also by progressing and flowing units.

The technique of alternating units is uniquely exemplified in Rudolf Bauer's four paintings titled *Tetraptychon II, No. 1, No. 2, No. 3, No. 4* (Teht-rap-tyk-en) (fig. 3.16). Bauer used not only a variety of unequal spaces, but also different value changes in each work. In painting No. 1, the circles progress both in size and value from light gray in the smaller circles to dark gray in the larger ones, while the background remains a consistent light gray. In No. 2, the circles remain consistent in value while the rectangle beneath changes from dark to lighter gray. Bauer changed his approach again in No. 3 by alternating values in both the rectangles and

the circles. Finally, values in No. 4 are nearly all the same in both circles and rectangles, reducing the alternation-progression technique to variations in size alone.

We can see the variety of expressions possible to the artist if the units were repeatedly alternated with changes in value, size, and position. Although Bauer was not attempting to make this analogy for us, we can, nevertheless, see the important role that variety plays in the conception of art. This type of search for unity can be seen in the sketchbooks of most artists.

We need to see how this principle works in a realistic painting like Picasso's *Le Moulin de la Galette* (see fig. 3.8). The principle of progressive shapes is illustrated in the diminishing sizes of the figures' heads. Alternation occurs in the contrast of value on the dancers' garments, and literal repetition can be seen in the pattern of glowing lights in the background.

Bauer's nonobjective paintings illustrate a valuable lesson for the art viewer. First, we should be able to accept the units in each of his paintings as substitutes for realistic subject matter (for instance, we might imagine the dots as representing trees or figures). This is often achieved by manipulating the original objects and expressing them in simpler terms. While it may take a while to break away from our dependency on realistic depiction, it is most certainly worth the effort.

CENTRAL THEME

Quite often, the central theme or essence of a work is found in the development of a very simple idea. The Guggenheim Museum itself, for example, has a spiral as its central theme, or motif. In other artworks, the central theme may be less obvious and more complex. At times we may have to refer to the title of a work to give us an initial clue, but don't count on it—often titles are chosen randomly and have nothing to do with the themes.

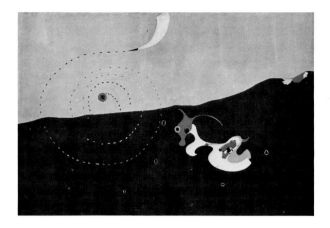

Figure 3.17 Joan Miró, *Landscape, (The Hare),* Autumn 1927.
Oil on canvas; 50 × 76⅝ in.; 129.6 × 194.6 cm.
Solomon R. Guggenheim Museum, New York.

Pure artistic composition has two elements: (1) the
composition of the whole picture, (2) the creation of the
various forms which, by standing in different relationships
to each other, decide the composition of the whole. Many
objects have to be considered in the light of the whole,
and so ordered as to suit the whole. Singly, they will have
little meaning, being of importance only in so far as they
help the general effect.

Piet Mondrian

Look at figure 3.17, Joan Miró's *Landscape* (*The
Hare*) and then at Picasso's *Mandolin and Guitar* (see
fig. 3.15). Even though one shape in *Landscape* may re-
semble an animal, we cannot be certain of what it rep-
resents. Originally, Miró gave viewers no hint as to the
meaning of his painting; later, however, he identified the
shape on the right as a hare and explained that the work
was based on an actual experience in which he saw a
hare running across a field at sunset. Now that the title
identifies the hare in a landscape and we know that the
object above the horizon is the setting sun, we have more
information to use as we attempt to interpret Miró's
composition and his experience at that moment.

The title of Picasso's still life tells us that it includes
a mandolin and a guitar (additional information sup-
plied by the museum tells us that the objects are placed
on a table before a window in a room located in a town
called Juan-les-Pins). The shapes of the mandolin and
the guitar are recognizable and so are the window and
the table. Because the subject matter is a still life, the
colorful objects near the center suggest fruit.

Both Miró and Picasso intended that we should re-
spond to the content, form, or style in each work—to
something beyond its subject matter. Once the subject
matter is identified, we can concentrate on one or more
of the important features in the work, such as the unique
way in which the shapes in the Picasso seem to overlap

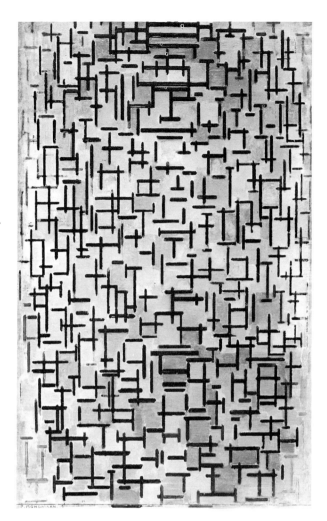

Figure 3.18 Piet Mondrian, *Composition 1916,* 1916.
Oil on canvas, with wood strip at bottom edge; 46⅞ × 29⅜ in.;
119 × 75.1 cm.
Solomon R. Guggenheim Museum, New York.
Photo: Robert E. Mates.

and interlock. (This technique, by the way, is typical of
cubism or the cubist style of painting in which shapes
are reduced to simplistic geometric equivalents—heads
may become circles, bodies are triangles, and buildings
look like cubes or pyramids.) But in all cases, we should
be able to recognize the central theme or motif or some
feature that dominates the artwork.

Creating Emphasis

Sometimes artists studiously avoid creating emphasis or
a dominant theme or motif as if they want us to respond
to the entire work at once. Concern for the total impact
of the painting is more important to them than attention
to a single object or an area of emphasis. Such is the case
with Jackson Pollock's later action paintings, one of
which we saw on the National Gallery tour (see fig. 1.57).
Another example is found in Piet Mondrian's painting
Composition 1916 (fig. 3.18). The overall composition

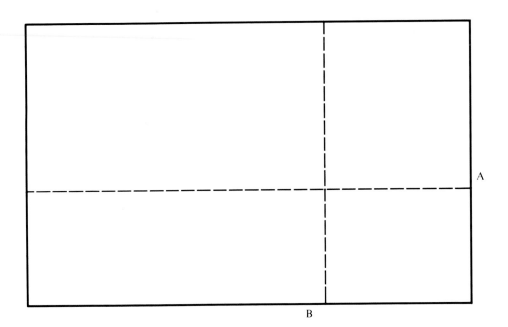

Figure 3.19 The *Golden Rectangle: A* is to *B* as *B* is to *A* plus *B*, or *A*:*B* = *B* : *A*+*B*; and the *Golden Section:* the lesser part is to the larger part as the larger part is to the whole.

places hardly any emphasis on one area, except for a few heavier lines at the top. Consequently, our gaze glides effortlessly over the painting's surface, taking in the orderly array of Mondrian's pluses and minuses.

Most paintings feature an object, figure, or area that is emphasized in some way. In Paul Cézanne's *Still Life: Plate of Peaches* (see fig. 3.10), the plate of peaches is not only identified by the title as the central theme but it is also the area or shape, the focal point of the painting, that first draws our attention and is meant to sustain our interest.

Artists assign emphasis to objects or areas in a painting by contrast and arrangement of shapes. The plate of peaches stands out in contrast to the shapes around it because it is a large oval while the others are more rectangular. Contrast can also be seen between the bright foreground and the dark background, which brings the vivid fruit forward almost as if to offer it to the viewer. Because light areas attract attention, the large white tablecloth might have become the focal point, but Cézanne carefully folded the cloth so that its contour lines point toward and emphasize the plate of peaches.

Artists may also create interest in an object or shape by isolating it from other objects. The two peaches, though less intense in hue and smaller in area than those on the plate, hold their own balance of emphasis due to their isolation on the ground of the tablecloth.

But why did Cézanne place the plate of peaches, which is the *focal point* of his painting, to the right and slightly below the true center or *focal center* of the canvas and make a point of placing two peaches to the left of center?

HARMONIOUS INTERACTION

There are interesting reasons why the center of interest, or *focal point,* is usually not found at the *focal center* of a canvas. Because of the way human eyes are spaced, the range of our lateral vision is greater than the range of our vertical vision, and so we tend to see within a rectangular area, which may have been the inspiration of an ancient Greek mathematical formula for achieving a scale of compositional beauty. Proposed by Euclid, the formula defined the proportions of a **golden rectangle** in which the ratio of its shorter side to its longer side is the same as the ratio of its longer side to the sum of the length of its shorter and its longer side, or roughly a ratio of three to five (like the ratio of a 3″ × 5″ card).

The "divine proportions" of a painting were defined by Lucas Pacioli during the Renaissance as a **golden section**—a ratio for dividing a line or a shape or a canvas in which the lesser part is to the larger part as the larger part is to the whole (fig. 3.19). Apparently, a painting composed according to the golden section is especially satisfying to the viewer.

There are thousands of landscape paintings in which horizons are situated in the lower or upper half rather than straight across the middle. We find large shapes— trees or buildings—placed on the right or left side of a painting, almost always in the same general area of the canvas, whose placement corresponds to the geometric ratio of the outside dimensions of the canvas (see Claude Lorrain's *A Seaport at Sunset,* fig. 2.30). Consequently,

Figure 3.20 Pablo Picasso, *Garden in Vallauris,* June 10, 1953.
Oil on canvas; 7⅜ × 10½ in.; 18.7 × 26.7 cm.
Solomon R. Guggenheim Museum, New York.
Gift, Justin K. Thannhauser.
Photo: Robert E. Mates.

I think the presence of a large painting is quite different from that of a small one. A small one can have as much scale, vigor, space, but I like to paint the large ones. There's an excitement about the larger areas, and I think you confront yourself much more with a big canvas.

Franz Kline

most paintings and sculptures seem to be asymmetrical; that is to say, the horizon is not in the center of the painting, and the center of interest is usually not in the focal center.

Most examples of the golden rectangle and the golden section are found in traditional paintings before 1900. Nontraditional artists, however, especially those artists who derive their subject matter from conceptual ideas rather than from realistic subject matter, often use startling scales and proportions that purposely deviate from these traditional rules (see Newman's work, fig. 2.12).

Scale

To distinguish between the terms *scale* and *proportion,* it is best to think of **scale** as the overall dimension, or *size of a work,* and **proportion** as the *relative size of the individual parts of a work.* Let's assume that most paintings measure somewhere around 24″ × 36″ (about two feet tall and three feet wide). We may thus be quite startled when we encounter paintings or sculpture that are either tiny or enormous in comparison to this typical size. *Garden in Vallauris* by Picasso (fig. 3.20) measures only 7⅜″ × 10½″, barely larger than the reproduction in this book. This is most unexpected because most artists choose large-scale canvases for views of natural scenery. Some of Claude Monet's paintings of ponds of water lilies, for example, are almost twenty feet wide, and a painting by Charles Le Brun in the Louvre is over forty-one feet wide.

Figure 3.22 Edgar Degas, *Dancer Moving Forward, Arms Raised*, 1882–95.
Bronze, 13¾ in.; 35 cm. high
Solomon R. Guggenheim Museum, New York.
Gift, Justin K. Thannhauser.
Photo: Robert E. Mates.

Figure 3.21 Edouard Vuillard, *Place Vintimille. (Left Panel),*
1908–10.
Distemper on cardboard mounted on canvas; two panels: 78¾ × 27⅜ in., 200
× 69.5 cm.; 78¾ × 27½ in., 200 × 69.9 cm.
Solomon R. Guggenheim Museum, New York. Gift, Justin K. Thannhauser.
Photo: Robert E. Mates.

Artists can create interest by changing the traditional outer dimensions of their work. Edouard Vuillard's painting *Place Vintimille* left panel (fig. 3.21), measures 78¾ inches from top to bottom and yet it is only 27⅜ inches from side to side. Other paintings appear in the form of a diamond, a lozenge, a circle, in free forms where the outside dimensions conform to the shapes in the painting, and sometimes a painting is divided into parts, as Vuillard's *Place Vintimille,* and hung with space between the parts.

Sculptural scales can vary even more than those for paintings. Compare Edgar Degas's 13¾ inch bronze sculpture titled *Dancer Moving Forward, Arms Raised* (fig. 3.22) with some of the outdoor sculpture pieces you may have seen.

The fact that I made use of cows, milkmaids, roosters, and provincial Russian architecture as my source forms is because they are part of the environment from which I spring and which undoubtedly left the deepest impression on my visual memory of any experiences I have known. Every painter is born somewhere.

Marc Chagall

Regardless of other features of an artwork, its scale alone carries a special meaning for the viewer's consideration. We must keep in mind, however, that a large-scale work is not necessarily more profound than an unusually small-scale work of art. Artists are quick to agree that they work on large-scale works the same way they work on small-scale works—the proportion or relationship among the parts is equally important in both.

Proportion

A much more complicated consideration than the scale, or the actual size, of a painting or sculpture is the concept of its proportion, or the relative size of its individual shapes and spaces. Earlier in this tour we saw examples illustrating the dominance of certain shapes over others. Cézanne's plate of peaches dominates the painting because of its relative size and intense colors (see fig. 3.10). Much more extreme examples of domination by proportion serve purposes other than merely to draw our attention to focal points. The figure of the violinist in Marc Chagall's *Green Violinist* (colorplate 21) is completely out of proportion to the other objects in this rather large and imposing painting—the violinist nearly fills all the available space of the canvas. Further, the brilliant hues of the man's coat, hat, and face assure the figure's total domination of the work's form. Such domination is significant to the content, or meaning, of the painting: the importance years ago in a small Russian village of the local musician—the prototype of the "fiddler on the roof," as it were. Therefore—as Chagall himself said—the visual effectiveness of his work was more important than "correct" relative size.

Perhaps more disturbing are instances in which the artist portrays parts of the human figure in unreal proportions. For example, the pastel rendering by Picasso titled *Three Bathers* (colorplate 19) is not anatomically correct. Picasso drew the hands and feet of his nudes larger than life; conversely, the heads are smaller than they should be in relation to the bodies. We should consider too the swimming figure in the background, whose enormous size relative to her apparent position out in the sea actually brings her close to the viewer, and she becomes more integrated with the other two figures. The female figures in this painting resemble the solid, massive structures of stone sculpture, or the exaggerated

Figure 3.23 Symmetrical balance.

There is no *must* in art because art is free.

Vasily Kandinsky

heaviness of nudes found in seventeenth-century paintings (see Tour 7), perhaps communicating to us Picasso's portrayal of women as symbols of strength.

Visual Balance

Because artists are aware of the innate human sense of visual balance, they can either choose to satisfy it or stir our interest in their compositions by deliberately avoiding pure symmetry but still satisfying our natural inclination for balance. Two broad categories of composition result: symmetrical balance and asymmetrical balance.

The more obvious of the two categories is **symmetrical balance** because it simply means that one half of a work—right, left, or top, bottom—is a mirrorlike image of the other (fig. 3.23). Symmetrical balance is often found in artworks dating from the Middle Ages through the Renaissance. As we proceed on our tours, we shall encounter in these style periods more examples of pure symmetry in which the focal point is located directly in the center of the painting and an equal number of similar objects or figures are placed on either side.

As we examine the principle of **balance** and its contribution to the unity of an artwork, we must remember that there is no absolute standard. Some manifestation of balance is an integral part of an artwork, and our task is to recognize its nature and to see how it contributes to the artist's total effort. In other words, we should never decide that a work of art is bad or ineffective solely because it may not be visually balanced. We should, on the other hand, be aware of balance and its function in an artistic statement.

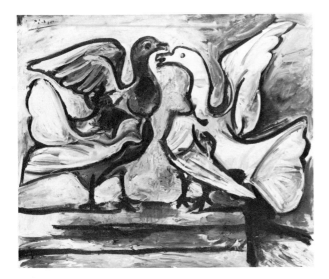

Figure 3.24 Pablo Picasso, *Two Doves with Wings Spread,* March 16–19, 1960.
Oil on linen; 23⁹⁄₁₆ × 28¾ in.; 59.7 × 73 cm.
Solomon R. Guggenheim Museum, New York.
Gift, Justin K. Thannhauser.
Photo: Robert E. Mates.

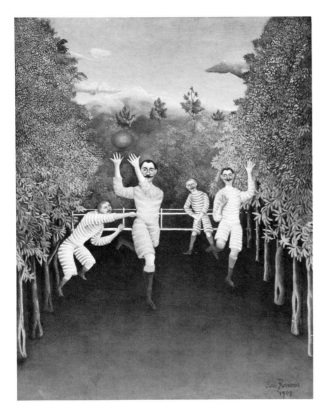

Figure 3.25 Henri Rousseau, *The Football Players,* 1908.
Oil on canvas; 39½ × 31⅝ in.; 100.5 × 80.3 cm.
Solomon R. Guggenheim Museum, New York.
Photo: Robert E. Mates.

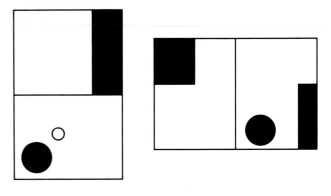

Figure 3.26 Asymmetrical balance.

Picasso's *Two Doves with Wings Spread* (fig. 3.24) represents symmetrical balance, though the doves are not the same value. It is almost as if one dove were peering into a mirror. Symmetrical balance is somewhat the case as well in Henri Rousseau's painting *The Football Players* (fig. 3.25). The trees on both sides of the playing field are placed in neat rows along the ground and leave a symmetrical opening to the sky at the top of the painting. There are two players on the left and two on the right.

It is rare that balance is found in as exact symmetry as we saw in Newman's painting *Be I* (fig. 2.12). Both Picasso and Rousseau were careful to supply a measure of imbalance to add interest to their paintings. For example, Picasso made his doves of different value and turned them at slightly different angles. Rousseau presented his human figures in progressively different sizes and poses.

The less easily resolved by the artist but more visually interesting type of balance is the broad category called **asymmetrical balance** in which the artist utilizes the technique of "equal but opposing forces" (fig. 3.26).

The technique of equal but opposing forces employed in asymmetrical balance is demonstrated in Kandinsky's *Composition 8* (fig. 3.27) which is composed of abstract geometric shapes and lines. The large "A" shape just right of the center is balanced by the large circle in the upper left corner. They are quite different in shape and weight from one another, but they should be viewed as equal in the sense that each serves as the dominant shape in its own half of the painting. We can easily see what would have happened had Kandinsky omitted the large circle on the left. If you cover enough of the left portion of figure 3.27 with your hand—say, the left third of the space—so that the large A shape is directly in the middle of the remaining two-thirds, you will sense that an important part of the energy is drained from the work. The asymmetrical opposition of these two dominant shapes provides vitality and interest that the A shape and other elements in the artwork are unable to supply.

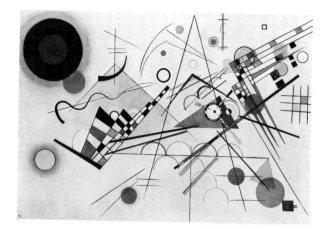

Figure 3.27 Vasily Kandinsky, *Composition 8,* July 1923.
Oil on canvas; 55⅛ × 79⅛ in.; 140 × 201 cm.
Solomon R. Guggenheim Museum, New York.
Gift, Solomon R. Guggenheim, 1937.
Photo: Robert E. Mates.

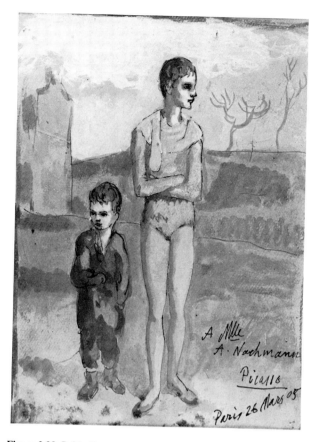

Figure 3.28 Pablo Picasso, *Young Acrobat and Child,* March 26,
1905.
Ink and gouache on gray cardboard; 12⁵⁄₁₆ × 9⅞ in.; 31.3 × 35.1 cm.
Solomon R. Guggenheim Museum, New York.
Gift, Justin K. Thannhauser.
Photo: Robert E. Mates.

Another technique used in asymmetrically balanced
compositions is *eye direction.* When people or animals
are the subject matter, our eyes follow the direction of
their gaze. Picasso, in his *Young Acrobat and Child* (fig.
3.28), placed the larger figure of the acrobat directly in
the center of the canvas and the smaller figure of the
child slightly to the left of center. Cover the figure of the
child with your hand and view the painting. By having
the dominant figure look to the right, Picasso draws our
attention to the right side of the canvas. Remove your
hand and notice the effect on the balance of the com-
position by the direction of the child's gaze, which is for-
ward and to the left. Of course, other factors are also at
work to balance this painting.

It is rare that an artist uses only one device to achieve
asymmetrical balance. For example, the church tower in
Miró's *Prades, the Village* (colorplate 20), which is
clearly the dominant feature of the painting, is placed in
the upper right portion of the canvas. The large tree on
the left helps to balance the tower, but the composition
would be top-heavy had not Miró painted the tilled fields
below in brilliant, eye-catching colors. The tower now is
balanced by the total landscape. This example is slightly
oversimplified, but we can see how the principle is ap-
plied.

Franz Marc produced a number of paintings wherein
a single large form dominates the composition. The
yellow cow of colorplate 15 seems to be in fair proportion
to the other elements in the painting, but again it fills
up nearly all the space of the canvas. In this case, the
calming effects of the yellow seem almost necessary on
such a large shape in order to balance the energy of the
intense reds, blues, and oranges of the surrounding land-
scape.

The energy of Vincent van Gogh's painting *Moun-
tains at Saint-Remy* (fig. 3.29) illustrates the powerful
influence of both color and value as balancing forces. The

Figure 3.29 Vincent van Gogh, *Mountains at Saint-Remy,* July
1889.
Oil on canvas; 28¼ × 35¾ in.; 71.8 × 90.8 cm.
Solomon R. Guggenheim Museum, New York.
Gift, Justin K. Thannhauser.
Photo: Robert E. Mates.

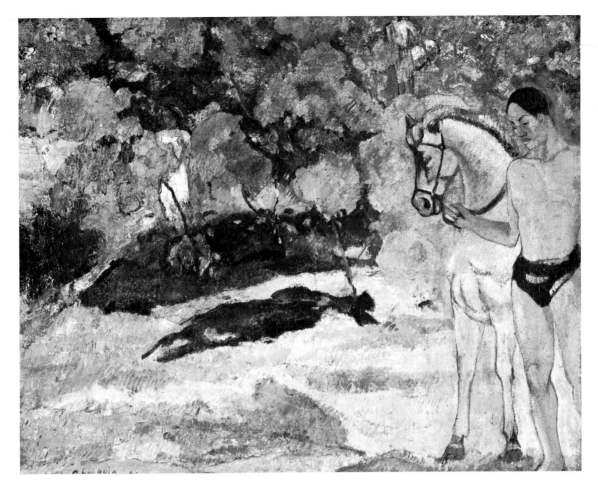

Figure 3.30 Paul Gauguin, *In the Vanilla Grove, Man and Horse,* 1891.
Oil on burlap; 28¾ × 36¼ in.; 73 × 92 cm.
Solomon R. Guggenheim Museum, New York.
Gift, Justin K. Thannhauser.
Photo: Robert E. Mates.

painting would have been bottom heavy if van Gogh had not placed an area of lighter value in the lower right portion of the canvas. Again, by covering with your hand the road at the base of the painting, you can readily see how the dominant hillside becomes too powerful to balance the area of the sky, which is lighter in value and smaller in size.

You will see, however, many instances in which an artist deliberately placed important objects or figures in one area of a work without providing a balance of forces in other areas. Remembering that such deliberate imbalance in no way adversely affects the quality of a painting, look at the arrangement of shapes in Paul Gauguin's *In the Vanilla Grove, Man and Horse* (fig. 3.30). The man and horse dominate the entire composition, but their position on the extreme right edge of the canvas causes an imbalance, even though we can find opposing contour lines, differences in value, and eye direction focusing on the center of the picture plane.

THE USE OF SYMBOLISM

Art is important because it presents a unique form of communication. The most popular form of communication—words—cannot possibly capture and express the emotional content of a passage of music or of a work of visual art. On the other hand, words are capable of communicating in ways that music and visual art are not. The *mode* of communication is different, and each form deals with different aspects of life experience.

Both methods of communication—the literary and the artistic—deal with symbols. The words you are now reading are symbols designed to communicate thoughts quickly and effectively. On one level, an artwork could merely be a picture of something the artist wishes to communicate to others. Symbols point beyond themselves; they give outer things an inner meaning. The

Figure 3.31 Literal repetition of a single motif. Andy Warhol, *Green Coca-Cola Bottles*, 1962.
Oil on canvas; 82¼ × 57 in.;
Collection of Whitney Museum of American Art, New York.

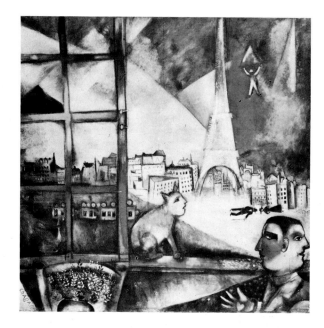

Figure 3.32 Marc Chagall, *Paris Through the Window*, 1913.
Oil on canvas; 53½ × 55¾ in.; 135.8 × 141.4 cm.
Solomon R. Guggenheim Museum, New York.
Gift, Solomon R. Guggenheim, 1937.

"I am against the terms 'fantasy' and 'symbolism' in themselves. All our interior world is reality—and that perhaps more so than our apparent world. To call everything that appears illogical, 'fantasy,' fairy-tale, or chimera—would be practically to admit not understanding nature."

Marc Chagall

words "Coca-Cola bottles" convey to us a mental picture of familiar objects; so does a painting of the same objects. However, such objects are often used by artists to convey deeper, more significant meanings. Andy Warhol's *Green Coca-Cola Bottles* (fig. 3.31), not at the Guggenheim, is obviously designed to communicate something more than the objects themselves.

Artists are aware of the inherent meanings in symbols and use them, along with other features of an artwork, to enhance their message. The number of symbols used in a work can vary from one or two to a complicated collection. Some of these symbols have obvious meanings; others are far more obscure.

Symbolism is often found in the form of sacred images or magical objects. Famous cave paintings of ancient history are said to have been the result of an attempt by primitive people to magically gain control of animals in their environment. Because nearly all of these pictures are of animals, and because primitive tribes of today still use such images, authorities postulate that early primitives drew pictures of those animals they wished to

control with the intent to kill them easily, eat the meat, and clothe themselves with the hides (see fig. 4.7). They apparently thought that by drawing pictures of these animals they could somehow wield magical power over them—something on the order of voodoo dolls. Others believe that many of these cave drawings are merely attempts to tell stories of hunting exploits. Since their language was probably quite limited, it is logical to assume that early cave dwellers resorted to artistic means to relate more vividly their experiences.

Christian **icons** were often painted on wooden panels that were attached with hinges to form a screen. The images usually depicted sacred figures and Christian legends and were, and still often are, used in worship.

Chagall's *Paris Through the Window* (fig. 3.32) appears to be composed entirely of symbolic objects and images. As we begin to speculate about the meanings of symbols, we must caution ourselves not to become more fanciful than the artist intended. Chagall presents the usual symbols of Paris—the Eiffel Tower and the surrounding city buildings—portrayed in a cubist style (see

Figure 3.34 Alexej Jawlensky, *Helene with Colored Turban,* 1910.
Oil on board; 37⅛ × 31⅞ in.; 94.2 × 81 cm.
Solomon R. Guggenheim Museum, New York.
Photo: Robert E. Mates.

Figure 3.33 Fernand Léger, *Woman Holding a Vase,* 1927.
Oil on canvas, 57⅝ × 38⅜ in.; 146.3 × 97.5 cm.
Solomon R. Guggenheim Museum, New York.
Photo: Robert E. Mates.

Tour 10). The linear quality and bold coloration dominate the overall composition. Other objects that vie for our attention include a parachuting man, a Janus- or two-faced man, a cat with a human head, a couple strolling down the street sideways, and an upside-down train! The mood is rather grim and the atmosphere somewhat chaotic. The horse is typical of the way Chagall uses animals to establish a close link between men, women, and nature. The man with two faces may be Chagall himself, looking back to the simple peasant village in his native Russia and looking ahead to the upbeat ways of Western Europe. By juxtaposing reality (the city and the room) with Chagall's own fantasies, he supplied the painting with a heightened sense of imagery. Chagall certainly meant for his objects to convey powerful symbolic meanings to viewers; otherwise, he would have made more of an effort to unify them, to organize them into a more neatly balanced composition of artistically related forms.

THE SENSATION OF MOTION

In varying degrees, artworks seem to elicit the sensation of motion. Some actually move, either via electric power or air currents (as we pointed out in our discussion of Calder's mobiles), but most are designed so that the viewer *senses* motion. Compare three paintings of female figures: Léger's *Woman Holding a Vase* (fig. 3.33), Alexej Jawlensky's *Helene with Colored Turban* (fig. 3.34), and Degas's *Dancers in Green and Yellow* (fig. 3.35). In each of these paintings there is a different amount of motion. Léger's figure is stoic and motionless, in spite of several curved contours, because the harshly vertical stance and hard-edged shapes contribute to sculpturelike immobility. Jawlensky's woman is more inclined, head slightly bowed, and her bodily contours are curvilinear. Degas's dancers are poised as if about to begin their routine. All the figures are leaning one way or another; after all, dancers are expected to move. Thus, both Jawlensky's and Degas's paintings possess more inherent motion than Léger's painting.

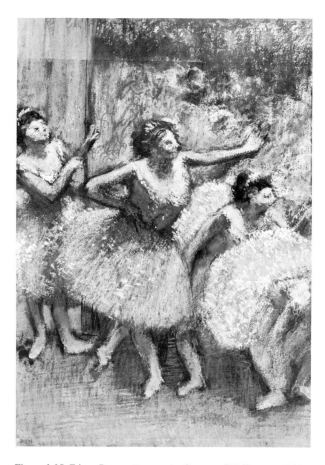

Figure 3.35 Edgar Degas, *Dancers in Green and Yellow,* ca. 1903.
Pastel on several pieces of paper mounted on board; 38⅞ × 28⅛ in.;
98.8 × 71.5 cm.
Solomon R. Guggenheim Museum, New York.
Gift, Justin K. Thannhauser.
Photo: Robert E. Mates.

Figure 3.36 Paul Klee, *In the Current Six Thresholds,* 1929.
Oil and tempera on canvas; 17⅛ × 17⅛ in.; 43.5 × 43.5 cm.
Solomon R. Guggenheim Museum, New York.
Photo: Robert E. Mates.

Figure 3.37 Natalie Goncharova, *Cats,* 1913.
Oil on canvas; 33¼ × 33 in.; 84.4 × 83.8 cm.
Solomon R. Guggenheim Museum, New York.
Photo: Robert E. Mates.

We expect that certain objects will move while others
will remain still. While architectural structures never
move, painters may instill a small degree of motion in
their architectural subjects just to excite our senses. *Eiffel
Tower* (see fig. 3.5) shows a structure and surrounding
buildings that seem to be alive with motion because De-
launay used predominantly diagonal lines rather than the
expected vertical lines of architecture.

Recall how various kinds of line create motion. Two
totally abstract works, *In the Current Six Thresholds*
by Klee (fig. 3.36) and *Cats* by Natalie Goncharova (fig.
3.37), demonstrate extreme opposites in the quality and
the quantity of motion—an essentially horizontal/ver-
tical application vs. a diagonal one. Klee's *Thresholds*
seems to convey the very essence of calm without the
slightest hint of recognizable subject matter, while Gon-
charova's *Cats* pictures frenetic activity. Countless di-
agonal, crisscrossing lines, plus dramatic value contrasts,
create the ceaseless motion we sense in this lively
painting.

TYPES OF RHYTHM

Motion quite often occurs in a regular pattern caused by the repetition of similar elements. Sometimes artists repeat identical or very similar motifs, as we find in Andy Warhol's *Green Coca-Cola Bottles* (see fig. 3.31). But more often we see repetition of similar objects alternating with different objects so that a kind of regular rhythmic beat is projected, similar to the metric beat we feel in music. When this occurs, we say that a work has a definable **rhythm.** An example of simple rhythm was seen in Mondrian's *Composition 1916* (fig. 3.18), which is composed entirely of horizontal and vertical lines of about the same size in a crisscross pattern. No matter which path our eyes take over the canvas, patterns occur that establish a rhythm. Mondrian's rhythm is easy to see because of the abstract nature of the subject matter; we are not distracted by realistic objects.

We can nevertheless see similar rhythms in more conventional paintings that use pictorial subject matter. The alternation of dark and light values in Picasso's *Le Moulin de la Galette* (fig. 3.8) sets up a provocative rhythm that seems to accompany the dancing figures. The repetition is echoed by the lanterns in the painting. As we might expect, rhythm of a more subtle nature can be instilled through the careful use of color. Cézanne's quiet landscape *Montagne Sainte-Victoire* (see fig. 9.20) seems to shimmer as though soft breezes were rustling through the trees. Part of this effect is due to Cézanne's use of fuzzy contours or outlines. But his paintings reflect a pulsating rhythm because of small facets of colors sprinkled throughout or in selected areas of the canvas. Remember Cézanne's *Peaches* (fig. 3.10)? The plate of fruit seems to pulsate in the same subtle way as his landscapes.

Kandinsky too used color to create rhythm in his *Painting No. 198* (colorplate 56). Both the repetition of heavy, crisscrossing lines and the infusion of high-intensity, contrasting hues serve to produce a pounding rhythm, bold and aggressive in character. Even though these representative paintings are vastly different in style, rhythm plays a prominent role in each.

SUMMARY

We have examined works at the Guggenheim Museum illustrating how the principles of art apply to specific masterpieces. Works of art are recognized as "masterpieces" not because of an exclusive or exemplary use of any one design principle, but because of the interrelationship of many factors. Unity and coherence depend in part on the employment of repetition or the skillful use of a dominant idea or feature. Unity is created in an artwork by an effective interrelationship among its individual parts to the extent that it seems to be making a single, "unified" statement.

Unity as a principle of art has, by definition, far-reaching implications. It applies to any of the visual arts and music, dance, theater, and architecture. Remember that the creation of a sense of unity is the result of the artist's endeavor to express feelings in a coherent and consistent manner. To achieve this goal, the artist takes care to synthesize all the elements or ingredients at his or her command into a single, powerful statement.

Unity and coherence depend in part on repetition of components and the domination of a central theme. Together they provide a means of bringing the parts of an artwork together in an orderly and unique fashion.

Domination, or emphasis in painting, is created by contrast and placement of subject matter. Subject matter, in turn, is arranged to be balanced either symmetrically or asymmetrically depending on the artist's purpose or the dictates of tradition. Balance is effected by the proportion of parts to one another and to the whole. The "golden section" refers to the way in which a work is divided into parts to achieve the most satisfying optical division of space. "Good proportion" or "out-of-proportion" are relative terms and subject to personal interpretation. Most of the motion in art is only a sensation caused by a careful balance and repetition of parts. Even the actual motion in sculpture, such as mobiles, depends as much on the balance of parts as it does on air currents forcing shapes to move. The sensation of motion may even be felt in architecture. If you stand in the lower lobby of the Guggenheim and look up at the circular ramps, various feelings of movement may result.

In upcoming tours, *form* will refer to the overall structure of a work while *content* will describe meaning. Messages, social comment, or meaning will be communicated through many different forms of symbolism. Some of these have been used since the dawn of history to cast magic spells or record everyday experiences.

Figure 3.38 Vasily Kandinsky, *Levels,* March 1929.
Oil on board; 22¼ × 16 in.; 56.6 × 40.6 cm.
Solomon R. Guggenheim Museum, New York.
Photo: Robert E. Mates.

Figure 3.39 Lyonel Feininger, *Gelmeroda IV,* 1915.
Oil on canvas, 39½ × 31¾ in; 100 × 79.7 cm.
Solomon R. Guggenheim Museum, New York. Photo: Robert E. Mates

VIEWING EXERCISES

1. Describe the techniques used by Léger to achieve unity and variety in his painting *Woman Holding a Vase* (fig. 3.33).

2. What method did Picasso use to achieve coherence in his *Mandolin and Guitar* (fig. 3.15)?

3. What is the most prominent unifying principle used by Seurat in his painting *The Lighthouse at Honfleur* (fig. 1.50)?

4. Compare two paintings by Kandinsky, *Composition 8* (fig. 3.27) and *Levels* (fig. 3.38), and discuss the types of balance used.

5. The painting *Gelmeroda IV* (fig. 3.39) by Feininger is a cubist interpretation of a small church; the steeple is near the center of the picture. Discuss the rhythm of the composition and analyze the content and symbolism.

6. Listen to the first movement of Beethoven's Symphony no. 5 and compare the repetition of the opening four-note motif with the repeated pattern of crossbeams in the Eiffel Tower.

STUDIO EXERCISES

Suggested media and supplies: charcoal; drawing paper; pastel or colored chalk or colored pencils; scissors; rubber cement or glue.

1. In the tour, we saw artists providing unity through the use of a central theme. An example was Delaunay's *Eiffel Tower* (fig. 3.5). To explore this principle further, redraw the composition of the Picasso landscape (fig. 3.20) in charcoal, creating a different central theme from that used by Picasso. For instance, the central tree may be made smaller, the houses bigger, the foreground foliage lighter, and so on.

2. With Cézanne's *Still Life: Plate of Peaches* (fig. 3.10) as reference, use colored chalk or colored pencils to create a composition with the same subjects, but in the style of Picasso during the period shown in his *Mandolin and Guitar* (fig. 3.15). Remember to use only the visible objects in the Cézanne—the same number of peaches, plate, table, and drape. Color may be used as you prefer.

3. Repeat exercise 2 using Kandinsky's *Composition 8* (fig. 3.27) as the style for recomposing the Cézanne subject matter.

4. Some artists often create a composition using the same motif in regular or irregular patterns. Find objects in a magazine and make a number of photocopies of them. Cut out objects and assemble them in a **montage** on a cardboard background. (A montage is a collection of disparate images that forms a unified whole.) The repeated images could be placed side by side or in an overlapping pattern in any number of ways. Even more options are open if you have access to a color photocopier or one that enlarges or reduces the images. The resulting composition should be a well-balanced grouping of shapes.

RESPONSES TO VIEWING EXERCISES

1. Consistent treatment of geometric shapes is the most obvious technique of Léger in achieving unity in this painting. Unity is also provided by the repetition of machined pieces combined to resemble a **collage.** (A collage may combine images with other real materials and textures.) Variety is supplied by the changes in shape, size, color, and in the alternation of curvilinear and vertical lines.

2. As is the case with so many works whose realistic subject matter has been abstracted or simplified to some degree, the shapes appear as though they had been pasted onto the canvas in cutout pieces rather than painted. The perceived flatness—no shadows or chiaroscuro—seemingly causes the objects to interlock, like a picture puzzle.

3. Even a photographic reproduction of the original painting displays the bold, rough brushwork over the entire surface. This consistent brush technique thus unifies the painting with a very distinct texture.

4. The balance in *Levels* is symmetrical while the balance in *Composition 8* is asymmetrical. (*Levels* is uncharacteristic of Kandinsky's work, which is usually balanced asymmetrically.) Notice the variety of smaller shapes within the broader context of unity supplied by the large geometric tree shapes.

5. The repetition of geometric shapes in Feininger's painting, alternating between dark and light values, creates a continuous movement from bottom to top. Most of the linear treatment is diagonal, which lends more visual activity to the basic rhythm. The steeple itself seems to vault up and out of the picture plane as if to reach toward heaven. The light around it assumes unearthly dimensions resembling crystalline forms. This illusion is made all the more dramatic by being framed with dark vegetation.

6. Both motifs establish strong unity in the total statement of each work. Throughout Beethoven's entire symphony, the four-note motif reappears in one form or another, which is one of the reasons that this particular work is so distinctive. The same may be said of the Eiffel Tower—very few architectural structures display so much repetition of intricate crossbeams.

SUGGESTED READINGS

Albers, Josef. *Interaction of Color.* rev. ed. New Haven, Conn.: Yale University Press, 1975.

Arnheim, Rudolf. *Art and Visual Perception: A Psychology of the Creative Eye.* Berkeley: University of California Press, 1971.

Betti, Claudia, and Sale, Teel. *Drawing: A Contemporary Approach.* New York: Holt, Rinehart & Winston, 1986.

Bevlin, Marjorie E. *Design Through Discovery.* 4th ed. New York: Holt, Rinehart & Winston, 1984.

Chaet, Bernard. *The Art of Drawing.* 3d ed. New York: Holt, Rinehart & Winston, 1983.

Coleman, Ronald L. *Sculpture: A Basic Handbook for Students.* 2d ed. Dubuque, Iowa: Wm. C. Brown Publishers, 1980.

Feldman, Edmund B. *The Artist.* Englewood Cliffs, N.J.: Prentice-Hall, 1982.

Fry, Roger. *Vision and Design.* Edited by J. B. Bullen. New York: Oxford University Press, 1981.

Goldstein, Nathan. *The Art of Responsive Drawing.* 3d ed. Englewood Cliffs, N.J.: Prentice-Hall, 1984.

Goldstein, Nathan. *Painting: Visual and Technical Fundamentals.* Englewood Cliffs, N.J.: Prentice-Hall, 1979.

Goldwater, Robert, and Treves, Marco, ed. *Artists on Art: From the 14th to the 20th Century.* New York: Pantheon Books, 1974.

Hamilton, George H. *Nineteenth and Twentieth Century Art: Painting, Sculpture, Architecture.* New York: Harry Abrams, 1970.

Henri, Robert. *The Art Spirit.* Edited by Margery A. Ryerson. New York: Harper & Row, 1984.

Itten, Johannes. *The Art of Color.* New York: Van Nostrand Reinhold, 1974.

Kuh, Katherine. *The Artist's Voice.* New York: Harper & Row, 1962.

Lauer, David A. *Design Basics.* 2d ed. New York: Holt, Rinehart & Winston, 1985.

Loran, Erle. *Cézanne's Composition: Analysis of His Form with Diagrams and Photographs of His Motifs.* 3d ed. Berkeley: University of California Press, 1963.

Marin, John. *Letters of John Marin.* 1931. Reprint. Edited by Herbert J. Seligmann. Westport, Conn.: Greenwood, 1984.

Mayer, Ralph W. *The Artist's Handbook of Materials and Techniques.* 4th rev. ed. New York: Viking Press, 1981.

Nicolaides, Kimon. *The Natural Way to Draw: A Working Plan for Art Study.* Boston: Houghton Mifflin, 1975.

Nin, Anaïs. *The Novel of the Future.* New York: Macmillan, 1968.

Ocvirk, Otto G., et al. *Art Fundamentals: Theory and Practice.* 5th ed. Dubuque, Iowa: Wm. C. Brown Publishers, 1985.

Percy, Walker. *The Message In the Bottle.* New York: Farrar, Strauss & Giroux, 1975.

Piper, David. *Looking at Art: An Introduction to Enjoying the Great Paintings of the World.* New York: Random House, 1984.

Reich, Sheldon. *John Marin: A Stylistic Analysis.* 2 vols. Tucson: University of Arizona Press, 1970.

Richardson, J., and Coleman, Floyd W. *Basic Design: Systems, Elements, Applications.* Englewood Cliffs, N.J.: Prentice-Hall, 1983.

Ross, John, and Romano, Clare. *The Complete Printmaker.* New York: The Free Press, 1972.

Sherman, Hoyt L. *Drawing by Seeing.* New York: Hinds, Hayden, and Eldredge, 1947.

Sickert, Walter. *A Free House! or, the Artist as Craftsman.* 1947. Reprint. Edited by Osbert Sitwell. New York: AMS Press, 1984.

Simpson, Ian, et al. *Painter's Progress: An Art School Year in Twelve Lessons.* New York: Van Nostrand Reinhold, 1984.

Sloan, John, *The Gist of Art: Principles and Practices Expounded in the Classroom.* New York: Dover Publications, 1977.

Weitz, Morris. *Problems in Aesthetics: An Introductory Book of Readings.* 2d ed. New York: Macmillan, 1970.

Wold, Milo A., and Cykler, Edmund. *An Introduction to Music and Art in the Western World.* 7th ed. Dubuque, Iowa: Wm. C. Brown Publishers, 1983.

Wink, Richard, and Williams, Lois. *Invitation to Listening.* 2d ed. Boston: Houghton Mifflin, 1976.

Zelanski, Paul, and Fischer, Mary Pat. *Design Principles and Problems.* New York: Holt, Rinehart & Winston, 1984.

PART II
STYLE IN ART

I N THE FIRST THREE TOURS, we cut across the boundaries of time in order to
gain an understanding of the universal nature of art and how its principles apply in
widely diverse cultures. We will now share some insights into how art is created and will
use our basic functional viewing and studio skills as we encounter art firsthand. Our
museum visits in Part II will have a different purpose; the masterpieces we encounter will
allow us to trace the development of historic style periods.

As we analyze style, we will notice a consistency in the use of the basic elements
within a given era. Because of the influence of prominent artists and tenor of a time,
artists tend to apply the principles of art in similar and consistent ways. Many
mannerisms result not only from the influence of prominent artists, but also from the
environment that nurtures groups of artists.

While there is never agreement on "periods," artistic style periods seem to begin and
end when significant changes occur. Important artists die and new ones come into
prominence, often because their style is fresh and somehow more satisfying to a new
generation of art consumers. We have divided the history of art into a number of style
periods and will examine these in the following tours through some of the world's most
important museums. The designated time periods are only approximations, however, since
various periods overlap. Without a significant single event such as the famous
impressionist exhibition of 1874, it is sometimes difficult to determine precisely when one
period ends and another begins. Basically, these changes occur as the result of a *shift of
emphasis* in the application of the art elements. One of these shifts of emphasis is
between *form* and *feeling;* that is, one style period seems to emphasize form and structure
and the next period will emphasize the expression of feelings and emotion. Furthermore,
this broad shift of emphasis seems to recur in an alternating pattern throughout the
entire history of Western art.

Art has often been regarded as a mirror reflecting the life, circumstances, and
environment within which art works are created. However, it might be more useful for us
to regard art, especially in a historical context, as a comment on life rather than a mere
reflection. This attitude enables artists to communicate with viewers about life as the
artists interpret it. The great artists, since the dawn of history, have painted and sculpted
more than just images; they have created objects that bear their unique reactions to
circumstances that shaped their own growth and development. And while there have been
collaborative or workshop-produced works, art is, after all, created by human beings just
like ourselves and reminds us everytime we see it of human commonality and diversity. 𝕏

Tour of the Centuries

Figure 4.1

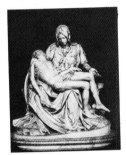

Figure 7.17

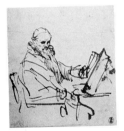

Figure 6.18

Figure 1.2

Years	Style Period	Painters		Sculptors	Architects
B.C. 28000	Stone Age	Cro-Magnon (Lascaux Cave Painting)		(Vogelherd House)	
B.C. 8000	Egyptian			(Narmer Palette)	(Walls of Jericho) (The Great Pyramids) (Megaliths) (Stonehenge)
B.C. 2800	Bronze Age	Banquet Scene		Block Statues Kamares Pitcher Goat and Tree	The Sphinx
B.C. 1000		Greek Vase Painting		Hollow Casting Nike of Samothrace	Parthenon
A.D. 30	Roman	Mosaics and Paintings St. Matthew Illuminated Manuscript		Portland Vase The Good Shepherd	Colosseum Pantheon Old St. Peter's
A.D. 1200 to 1500	Gothic				Notre Dame Cathedral, Paris Milan Cathedral
A.D. 1400 to 1500	Renaissance	Altdorfer Campin Mantegna Bellini Bosch Veronese Crivelli Huber Antonello Van Eyck Cranach Bronzino Tintoretto Van der Weyden	Correggio Masaccio Botticelli Da Vinci Dürer Michelangelo Raphael El Greco Titian Holbein Bruegel Uccello	Michelangelo Bronzino Pollaiuolo Bernini	Bramante
A.D. 1600	Baroque	Pozzo Le Nain Terborch Rubens Van Dyke Rembrandt Lorrain	Hals de Heem Vermeer Poussin Gentileschi Velasquez Caravaggio	Puget	Borromini
A.D. 1700	Rococo/Neoclassicism	Watteau Boucher Fragonard Robert Piranesi	David Ingres Tiepolo Chardin Gérard	Clodion Canova Houdon	

Figure 8.26

Years	Style Period	Painters		Sculptors		Architects
A.D. 1800	Romanticism	Blake Goya Géricault Delacroix Vuillard	Courbet Bingham Gros Hicks Charpentier	Carpeaux		Vignon
A.D. 1850	Realism/Impressionism/ Post Impressionism	Morisot Constable Turner Daumier Monet Cassatt Homer Cole Corot Glackens Moran Bierstadt	Pissaro Renoir Degas Manet Seurat Van Gogh Cézanne Toulouse-Lautrec Gauguin Böcklin	Rodin		
A.D. 1905 to 1940	Expressionism/Fauvism/ Cubism/Futurism/ Suprematism/ Neoplasticism/ Constructivism/ Fantasy/Dada/ Surrealism	Munch Nolde Kirchner Kandinsky Derain Chagall Matisse Marc Feininger Demuth Rousseau Rouault Gris Marin Bonnard Kollwitz Carra Gleizes Hodler Vallotton Davies Bauer	Picasso Braque Léger Boccioni Malevich Mondrian Chirico Klee Delvaux Schwitters Miró Magritte Dali Goncharova Delaunay Modersohn- Becker O'Keeffe Jawlensky Sheeler Siqueiros Sloan Bellows Campendonk	Archipenko Gabo Duchamp Arp Oppenheim Moore Brancusi Lehmbruck Barlach Lipchitz Giacometti Modigliani Rickey De Rivera Ray		Wright Mies Van Der Rohe Le Corbusier
A.D. 1950	Abstract Expressionism (action painters)/ Geometric Abstraction	Pollock Bacon Kline Albers Rothko Reinhardt	de Kooning Davis Stella Tobey Nicholson	Calder		
A.D. 1960	Abstract Expressionism (color field)/ Minimalism/Pop Art/ Technological Art	Motherwell Hofmann Frankenthaler Lichtenstein Warhol Held Ramos	Bourke-White (Photography) Adams (Photography)	Johns Nevelson Judd D. Smith Rauschenberg Oldenburg Segal	Flavin Chryssa Newman Indiana Noguchi	Utson
A.D. 1970 to Present	Super Realism/ Conceptual and Environmental Art/ Op Art/Technological Art	Harmon Heckbert Zeltzer Estes Torlakson Wyeth Riley Russell		Hanson Caro Di Suvero Winsor Chicago	Morris Smithson Oppenheim Christo Holt	Belluschi

Note: The selected artists and early works listed above are representative of their style periods. Their works are discussed and illustrated throughout *Invitation to the Gallery.*

Figure 8.19

Figure 10.1

Figure 2.36

Figure 14.7

Figure 11.33

The British Museum

London, England

Tour 4 Early Beginnings

The Gallery

Before proceeding on a tour of the British Museum, let us consider its vast holdings. The museum's collections are assigned to various departments that are visited by over two million people each year. The resident experts in charge of these departments are world renowned in their specific areas of scholarship. These departments are Coins and Medals; Egyptian Antiquities; Western Asiatic Antiquities; Greek and Roman Antiquities; Medieval Art; Prehistoric and Romano-British Antiquities; Oriental Art; Prints and Drawings; the British Library; and the Museum of Mankind. The department of ethnography is located in a separate facility southwest of the museum grounds at Burlington Gardens, about two blocks from Picadilly Circus. The range of collections in the departments covers thousands of years and numbers in the hundreds of thousands of artifacts. Also included are the holdings of the National Library of Research and Reference, with its seven million volumes and scores of manuscripts. This, in effect, makes its present responsibilities as much those of a library as those of a museum.

The original museum opened in 1759, and the present front colonnade and portico were completed in 1847. The museum's stated purpose is to document human achievement, from Greek statues to Easter Island carvings. The museum not only collects, preserves, and exhibits artifacts, but also documents their authenticity and publishes the results.

The museum's collection of the art of antiquity is so extensive that it has become valuable to a wide spectrum of scholars, including anthropologists, archaeologists, and historians. We will focus on the collection's artistic quality and unique styles.

Tour Overview

As we progress through our tours of artistic style, arranged roughly in chronological order, we shall discover that artists from the earliest times to the present day were striving to express similar concepts and ideas. While we may not study the works as art historians (or even critics) do, we can appreciate them by using the same set of basic precepts as those covered on our first three tours.

During this fourth tour we will see work from only five departments of the British Museum: Prehistoric, Western Asiatic, Egyptian, Greek and Roman, and Romano-British. Since major works representing significant style changes are found in several locations, we have taken the liberty of referring to selections from other museums and sites on the basis of their archaeological, historic, and artistic importance. We will look primarily at the artistic significance of the artifacts and include political, social, or religious insights only as they pertain to the works' aesthetic merit. We will also speculate as to how these artifacts might have been formed and introduce you to studio techniques that could be helpful in appreciating the work from the artist's point of view.

THE WORLD'S FIRST ARTISTS

Our earliest indications of the existence of artists are from the upper Paleolithic period, roughly between 32,000–8,000 B.C. We know little of these people who carved, chipped, and painted early figures of women, men, horses, bulls, mammoths, and bisons. But we assume that these prehistoric artists linked fertility and the clan's physical and spiritual well-being with their creative efforts.

Figure 4.1 *Venus of Willendorf,* ca. 15,000–10,000 B.C. Stone, H. 4⅜ in.; Museum of Natural History, Vienna. © Arch. Phot./ S.P.A.D.E.M., Paris/V.A.G.A., New York, 1985.

Figure 4.2 Prehistoric sculpture in the round preserved to some degree the shape of the original mass.

To me there is no past or future in art. If a work of art cannot live always in the present, it must not be considered at all.

Pablo Picasso

Prehistoric Sculpture

The work of early sculptors can be seen in the many so-called *Venuses* that have been found throughout Europe and Asia from the Pyrenees to Siberia, dating from 15,000 to 10,000 B.C. Figures of this kind illustrate that selective realism has been fundamental to artistic endeavors from earliest times.

In addition, these oldest sculptural forms of which the Venus of Willendorf (fig. 4.1) is the most famous—fleshy female figures carved from bone, ivory, or stone—have been interpreted as **cult objects** symbolizing fertility. It has been conjectured that, due to these figures' similarity in design, a system of rules probably dictated a standard form. Because the persons who made these Venus figures utilized exaggeration, distortion, and

omission, the figures were formed in much the same way that artists today form their work. These three factors are as much a part of the carving of the Venus figures as they are in the contemporary conception of forms in art, literature, music, dance, or drama.

Although widely separated by time and distance, the sculptors of these Venus figures used a common procedure to create the form. The process entailed the formation of a three-dimensional work known as **sculpture in the round** (fig. 4.2), which meant that the form could be viewed from any angle. The artists started the sculpting process from a chunk of material that was either geometric or irregular. Small chips were eliminated from all sides with a flint tool. The objective was apparently to preserve the shape of the original solid

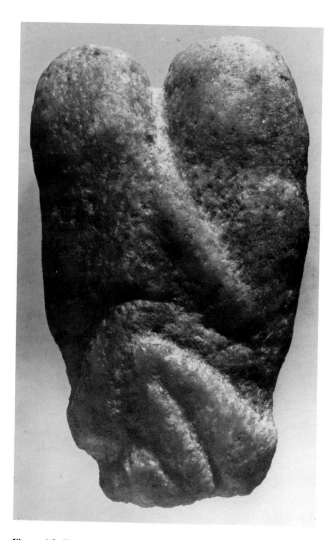

Figure 4.3 *Figurine in Calcite,* Ain Sakhri, Jordan; ca. 10,000 B.C.; H. 4 in. Reproduced by courtesy of the Trustees of the British Museum.

Figure 4.4 Animals in bas-relief, a technique of carving in which negative areas are cut more deeply than positive areas.
Photo Douglas Mazonowicz. Gallery of Prehistoric Art, New York.
Cap Blanc, Les Eyzies, Dordogne Valley, Southern France.

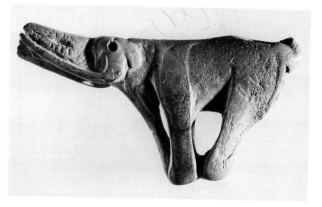

Figure 4.5 *Mammoth,* ca. 10,500 B.C.
Reindeer antler, L. 4¾ in. Reproduced by courtesy of the Trustees of the British Museum.

mass. The female form and sexual characteristics were designed to fit within this mass. For instance, a Venus was often cut from a pebble of limestone; the pebble's shape is therefore apparent if we gauge the outside edge of the figure and calculate where the solid mass began. The shape depicted by the dotted line in figure 4.2 could well have been the contour of the original limestone pebble. One of the earliest examples of a sculpture-in-the-round carving at the British Museum is a figurine carved from a single chunk of calcite that features two figures in an embrace (fig. 4.3).

Along with sculptures in the round, prehistoric artists were involved in carving works in **bas-relief** (bah-relief) in which negative areas are lower than the raised figures. Animals were typically subjects of this technique (fig. 4.4). But no matter what they were working on, pebbles or outcrops of rock, sculptors from earlier eras always

attempted to maintain the integrity of natural material in its original state. It is perhaps because of this close relationship between the natural materials and the formed work, that present artists admire these works of the past and speak of their integrity. Even if this ancient work was created according to formulae and strictures, even if there were natural constraints, we sense that the maker must have been concerned as well with pleasing the eye and the mind; today, we speak of these as aesthetic concerns.

The small sculpture designated as *Mammoth* (fig. 4.5) was carved from a reindeer antler and, like the earlier Venus figures, follows the original shape of the material. It may have been the handle of a spear-thrower.

Primitive artisans adapted natural materials and sculpted or painted figures or designs for use in sacred rites, as in the antler frontlet headdress of figure 4.6, or for special utilitarian purposes rather than to be admired for their beauty alone. But, as we can see from the spear-thrower handle the elaborate carving goes far beyond the demands of simple function. There seems to be no doubt about it; early craftsmen were concerned about aesthetics as well. Thus their works of art have as much aesthetic appeal for us today as they did for our ancestors who hunted mammoths and lived in caves.

Cave Paintings

Cave paintings—colorful animals painted or engraved on limestone walls—may be some of the most significant archaeological art discoveries of all time. The first examples were sighted in the Altamira cave of northern Spain in 1879 but were not recognized as paintings dating from the Paleolithic period for another sixty years. Scientists tell us that these vivid, lively animal portraits were consistently painted over a five-thousand-year period during what is designated as the Old Stone Age.

Although these works, which to our eyes are highly sophisticated, are found in over two hundred caves in France, Spain, and Italy, the Lascaux (lahs-koh′) cave, found in 1940 in southern France, offers some of the finest examples of late Stone Age art. In the "Great Hall" of the cave, which is hundreds of yards underground, the paintings of horses, deer, and bison command an awesome awareness of their vitality.

Why did early artists enter deep recesses of caves armed with torches and pigments? Why did they create these large images (some of them sixteen-feet long) of mammoths, bison, deer, horses, mountain goats, oxen, elephants, lions, fish, and birds? Since these animals must have been sources of food, the paintings were most likely used to act out or later record successful hunts. These paintings seem to illustrate, for the first time, conscious, human concern for controlling the environment. Some of the engravings have holes and others are pitted as if by flying rocks. They appear to have been practice targets. A spiritual fervor—a hunting magic—is portrayed in these paintings. Even in Africa today, painted animal images are used as "doubles"; by symbolically slaying an image, the hunter feels more certain of later killing the actual animal.

In a few of the cave paintings, human figures appear as dancers, dressed as animals, wearing antlers or horses' heads. Some of the masks we will see in Part III represent later, but similar attempts to capture animals' spirits. Other human figures, boxlike with sticks for arms and legs, appear along with geometric configurations that may be symbols yet to be interpreted. Human handprints also appear—perhaps as early autographs.

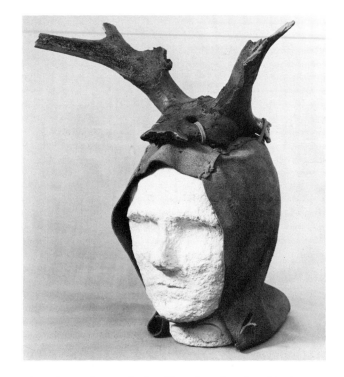

Figure 4.6 *Antler Frontlet Headdress,* from Star Carr, North Yorkshire. ca. 7,500 B.C.
L. 6⅞ in. Reproduced by courtesy of the Trustees of the British Museum.

The powdered pigments used by prehistoric artists came from crushed manganese, red ochre, hematite, or burnt bones. The colors ranged from yellows, browns, reds, to black. Besides using pointed sticks, the artists seemed to have applied solid and shaded colors by swatches of fur or moss, and with their fingers. Some applications of color appear to have been blown through tubes. Both solid and broken lines of various widths outline the figures. These random and often superimposed shapes produce integrated patterns filled with excitement and drama (fig. 4.7).

Whether by intent or by accident, those early artists present us with a look at formal color harmony and a lively display of value changes and space relationships. Look closely at the varieties of thickness and fluency of line; the changes of size, placement, and scale of the animals produce a level of refinement not often reached by the most accomplished painters of today. The economy of line and the distortion of natural proportions create powerful, subtle images. Of course, it would be an oversimplification to assume that cave art was created simply as decoration or as art for art's sake. We cannot dismiss the fact, however, that satisfaction was realized from making art either for personal or for social needs. Early artists were not without the ability we call aesthetic, and their work was grounded in tradition and guided through their apprenticeship. Anthropologists and art historians continue their research in attempts to discover the meaning and function of prehistoric artworks as they relate to the social system within which the artist worked.

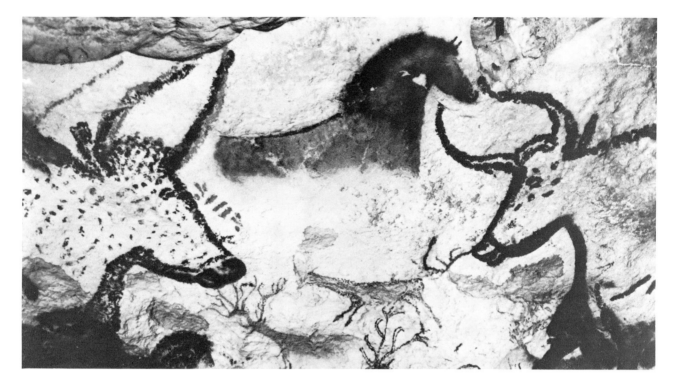

Figure 4.7 Rock paintings of reindeer, bulls, horses, and bison.
Lascaux Cave, Dordogne, France.
Courtesy of the French Government Tourist Office.

Prehistoric Pottery

Around 8,000 B.C. significant changes in climate and geography caused communal changes as well. People who had been hunters and gatherers became planters and harvesters. Pottery making soon became an important function of this life-style in which food could be grown and stored. Vessels were made by hand-molding coils or shapes of clay that were then fired in **kilns** (kils). The British Museum's collection includes examples of late Neolithic and Bronze Age pottery that illustrate a high degree of refinement. The person who created the beaker displayed in figure 4.8 showed concern for the relationship between the beaker's shape and its accompanying decoration. The lines and diagonal motifs on the beaker were either drawn with a tool or pressed into the clay with a sharp object to create texture. The rows of decoration were made in a variety of widths but maintained the unity of the work in the type and size of the impressions from top to bottom. In certain other examples, decorative motifs simply enhanced the surface, without regard to the overall shape of the pot. Sometimes lines were **incised,** creating textures different from the original clay surface. In examining all work of this kind, we should remember to think of the ceramic surface as the *ground* and the applied decoration as the *figure,* so that we are aware of the interchange principle covered in Tour 2.

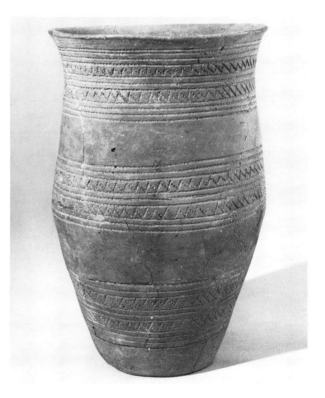

Figure 4.8 *Beaker* from Barnack, Cambridgeshire, ca. 1800 B.C.
H. 9½ in. Reproduced by courtesy of the Trustees of the British Museum.

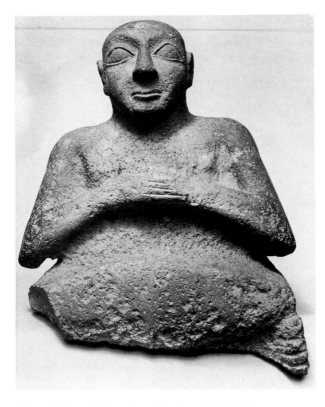

Figure 4.9 *Seated Figure from Ubaid*, ca. 2600–2350 B.C. Basalt, H. 14¾ in. Reproduced by courtesy of the Trustees of the British Museum.

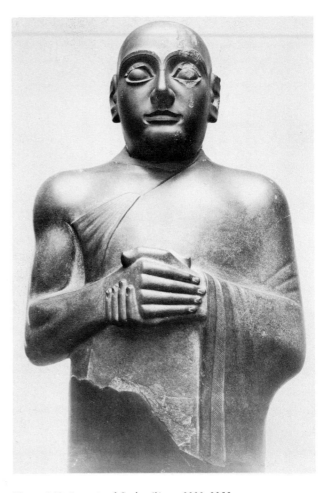

Figure 4.10 *Portrait of Gudea (?)*, ca. 2290–2255 B.C. Diorite, with traces of gilt on the nails. H. 30¼ in. Reproduced by courtesy of the Trustees of the British Museum.

WESTERN ASIATIC ANTIQUITIES

The artifacts in the British Museum collection of Western Asiatic Antiquities are dated roughly from 7,000 B.C. to A.D. 700 and attributed to many regions and ancient civilizations throughout the area we now call the Near East: Lebanon, Syria, Iran, Iraq, Turkey, Israel, and Jordan. Ancient Mesopotamia, or the "Land Between The Rivers," flowered when the people living along the Tigris and Euphrates river basins learned to irrigate and farm the desert. City states dotted the area known today as southern Iraq, but known thousands of years ago as Sumer. The Sumerians had a written language and a religion centered around nature gods. Pyramid-shaped temple towers called **ziggurats** stretched heavenward by ramps and stairs. Much of the art appears to have had mythological and religious import. In addition to relief figures, Sumerian sculptors created free-standing figures, or sculptures in the round. (See Fig. 4.18)

Let's look first at two pieces of free-standing sculpture in the round and attempt to share in the artistic process of the two early artists. Compare and contrast the *Seated Figure from Ubaid* (oo-bah-id), an example of Sumerian art from about 2600–2350 B.C. (fig. 4.9), with the *Portrait of Gudea (?)* (goo-dee′-ah) from the Neo-Sumerian period of about 2290–2255 B.C. (fig. 4.10). The artists chose not to make the shapes of these figures completely representative of human anatomy. This is heightened by sculpting the work in a **closed form** in which all parts touch and maintain the original shape of the stone. The first thing we notice in both figures is the exaggerated size of the eyes and the stylized noses and mouths. It is apparent that the intention was not to make a portrait of an individual but a "type" of figure, sculpted in terms of formulas and conventions. Both figures illustrate the convention of sculpting disproportionately large heads above short necks and large shoulders. Strength is thus portrayed in the attitude of the figures even though both are characterized by inconsistencies in human proportions.

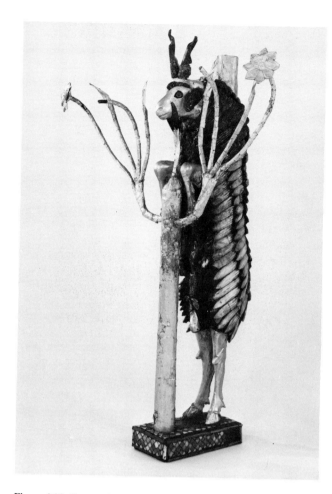

Figure 4.11 *Goat and Tree,* ca. 2500 B.C.
Gold, wood, and lapis lazuli, H. 18 in. Reproduced by courtesy of the Trustees of the British Museum.

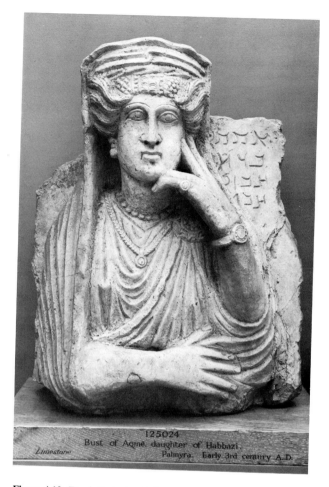

Figure 4.12 *Tomb Portrait,* third century A.D.
Limestone, H. 21 in. Reproduced by courtesy of the Trustees of the British Museum.

In the Gudea figure, careful attention was given to the modeling of surface details. Note the more refined manner in which the sculptor carved the lips—the line of the upper lip was brought around at the corners to encircle the lower lip. Subtle sculpting of detail like this is found over the entire figure; note the stylized folds in the tunic and the way the garment seems to flow over the surface. All surfaces were brought to a high luster during the final polishing stages to create a remarkable illusion of flesh and cloth. Paint traces have been found suggesting that clothing may have been painted onto the sculpture in an attempt to make the figure more lifelike. Look at the figure's left elbow and the careful way in which the hard diorite stone was sculpted around the corners in one continuous line. Note how the hands were precisely interlocked to form a solid, squared shape. Fingernails were also carved to highlight the king's hands. The hands in other figures from this era were often placed in the same praying position.

The Sumerian room of the British Museum also contains a work surprisingly different from the closed form sculpture of the Gudea and Ubaid figures. The *Goat and Tree* (fig. 4.11), sometimes called the *Ram in the Thicket,* is thought to have been an offering stand or a fertility symbol. This twenty-inch figure is made of gold, silver, lapis lazuli, shell, and red limestone and could be thought of as **open form** due to the extension of parts into open space. This clever aggregate of contrasting natural materials was added to and held together by a wooden core known as an **armature.**

In the Syrian Room, we find a stone tomb portrait (fig. 4.12) that reflects the artist's free and bold rendering of the subject. The eyebrows were stated with basic incised lines, and the arms and cloth folds were achieved with a direct sculpting approach that was allowed to remain in a rough state. This simplicity can also be seen in the hair and the surface of the face on the tomb portrait. It is interesting to note this deviation from the stylized modeling and attention to surface refinement that we saw in the Gudea figure.

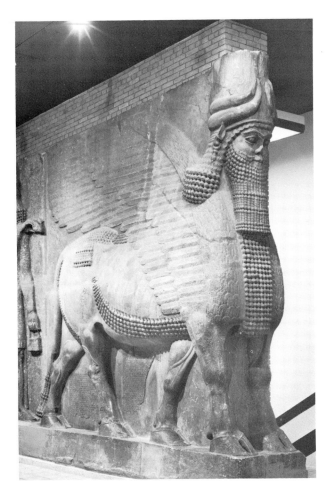

A characteristic sculptural form was introduced by the Assyrian military leader, King Sargon (772–705 B.C.), who had two colossal figures of human-headed winged bulls (fig. 4.13) placed at the entrance to his palace in his new city on the site known as Khorsabad. These sixteen-ton figures are artistically significant in that they incorporate the techniques of both sculpture and bas-relief in each unit. In each winged composite we see parts of a bull, a lion, and a bird. Built to be seen from either side or from the front, the fifth leg disappears from view as the sculpture is seen in profile. In spite of their large scale, much attention was given to detail on these impressive limestone creatures.

The walls inside the palace were covered with relief sculptures similar to the famous *King Assurbanipal's* (ah-sir-bahn'-ee-pahl) *Lion Hunt* (fig. 4.14). In a style typical of many such narrative reliefs of Assyrian art, the artist left the negative areas free of unnecessary detail and showed no recession into depth. The resulting shallow space allows the viewer to concentrate completely on the figures.

Close examination of the originally painted alabaster relief reveals that the artist combined contrasting perspectives and styles in the same work. The defined muscles of the animals create naturalistic forms in opposition to the stylized garments covering the king and the horses. The lion on the right shows an incorrect placement of its right front leg, while the lion on the left is anatomically correct. The artist seems to have chosen to balance these vital forms in this manner. Artists around the world today are making similar compositional judgments.

Figure 4.13 *Human-Headed Winged Bull,* ca. 710 B.C.
Stone, L. 16 ft. Reproduced by courtesy of the Trustees of the British Museum.

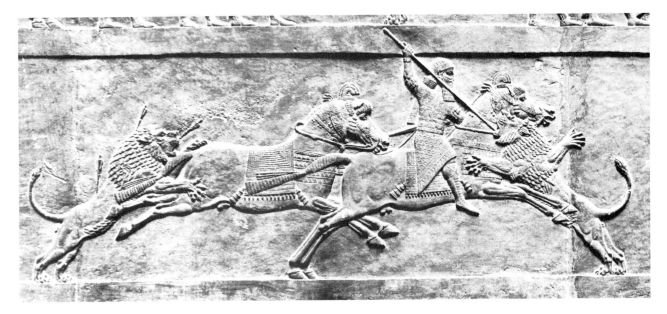

Figure 4.14 *King Assurbanipal's Lion Hunt,* ca. 650 B.C.
Alabaster relief, originally painted, H. 66 in. Reproduced by courtesy of the Trustees of the British Museum.

EGYPTIAN ANTIQUITIES

The collection of Egyptian antiquities at the museum includes seventy thousand artifacts and covers all aspects of one of history's most fascinating cultures. Even though only a small part of this vast collection is on display, visitors can see representative works from 4000 B.C. to 200 B.C. covering the important periods in Ancient Egypt's history. Our objective on this tour is not to pause before examples of art from every recorded Egyptian period but rather to analyze selected works that reflect what has come to be known as the Egyptian style of art. We should not forget why we are here—primarily to become aware of artistic styles through an examination of art as seen through the eyes of the artist.

Egyptian Sculpture

Visitors to the Egyptian Sculpture Gallery are first introduced to the *Rosetta Stone* (fig. 4.15), which in itself merits a visit even though it is not usually classified as a work of art. Dating from 196 B.C., this important monument, discovered in 1799, provided scholars with three inscriptions—Egyptian **hieroglyphics** at the top, Demotic script (people's writing) in the middle, and Greek

Figure 4.15 *Rosetta Stone*, 196 B.C.
Basalt, H. 3 ft. 9 in. Courtesy, Field Museum of Natural History, Chicago.

Working my way from one floor to the next of the British Museum's Egyptian world is like being on a dreamwalk: here a snake encrusted in gems, and everywhere lotuses, carved, painted and jewelled, abloom on tomb, on mummy, on papyri, on paintings, and on gems; eels and crocodiles mummified and buried with the pomp of the nobles they accompanied; the birds caught in the paw of a cat retriever (dogs were not then used as such); gold flowing like water, spilling over the images of nobles; imperturbable gods with heads of falcon, or cobra, or bird, or cat; court records of thieves (like modern ones, but in that period written in hieroglyphics on papyri); jewels of devastating beauty; titanic statues and a massive bronze scarab.

Fleur Cowles

at the bottom—all telling the same story. The importance of the discovery of the Rosetta stone is incalculable; the texts provided a key to unlock at last ancient Egyptian hieroglyphics and scripts and made possible the translation of inscribed objects and records that had survived the centuries.

Because hieroglyphic texts were included on nearly all ancient Egyptian sculpture, the purposes of specific statuary became relatively clear. For example, we know that sculptures were produced for use in religious ceremonies or as parts of the architectural detail of temples. We also know that most works were placed in tombs or in the courts of temples as visible symbols of gods or kings. Tomb sculptures were usually representations of the dead and were often very accurate portraits sculpted from the most permanent of materials including limestone, sandstone, granite, and diorite. They were inscribed with the names of the *Ka* or the spirits of the dead and served as replacements for mummies in the event that they were destroyed.

Characteristics of Egyptian Sculpture

The Egyptian language did not even include words for art or artist. Imagination and creativity were not encouraged; rather technical accuracy to authorized standards was demanded. Works of Egyptian art were many times the results of collaborations between stonemasons, sculptors, painters, goldsmiths, and draftsmen. Egyptian sculptors carved a block of stone from the front, back, top, and sides to create a permanent, closed-form yet lifelike rendering. Figures rarely suggested movement. Throughout the various dynasties, block sculpture in the round followed relatively constant formulas. The compact figure was usually projected from a back slab or back pillar, and followed stylized poses and attitudes.

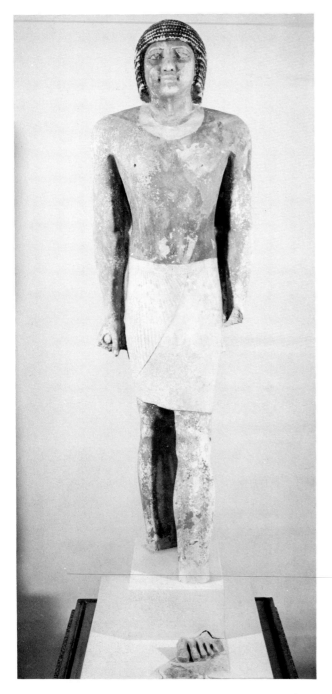

Figure 4.16 *Nenkheftka,* fifth dynasty, 2400 B.C., from Deshashva.
Painted limestone; H. 4½ ft.
Reproduced by courtesy of the Trustees of the British Museum.

Standing figures often advanced the left leg as we see in the statue of figure 4.16. In most royal statues the arms were close to the body and if the figure was seated, the legs were formed as part of the carved unit of the throne. Some figures were carved from blocks of stone so that the forms and planes of the sculptured surface met at right angles, thus avoiding undercutting. (See Tour 7.)

Figure 4.17 The mastaba was a stone tomb that covered the burial chamber.

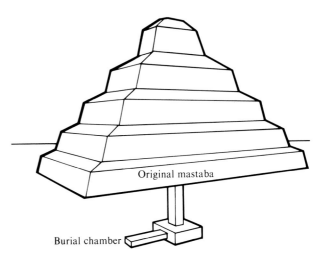

Figure 4.18 The stepped pyramid was built over the mastaba.

This method of sculpture produced few breakable parts and contributed to the endurance of these figures.

Expensive quarried stone was usually reserved for royal figures. Lesser court officials were rendered in wood, clay, or softer stone. These sculptures were covered with a ground layer of **gesso** and painted. Fine woods were left in their original state; lips, eyes, clothing, and headgear were sometimes painted on the stone sculptures.

Egyptian Architecture

Blocklike sculptures represent a striving for compactness comparable to the designs used in Egyptian architecture. One of the first architectural forms to reflect this compactness was the design of a rectangular tomb known as the **mastaba** (mah-stah′-ba) (fig. 4.17). It is conjectured that this basic structure eventually led to the stepped pyramid of King Zoser, where diminishing sizes of mastabas were piled on top of one another, resulting in the familiar pyramidal shape (fig. 4.18). Tombs such as the stepped pyramid were symbols of the divinity of the king and were intended to preserve his mummified remains and his possessions for his use in the afterlife. This monumental form of architecture was possibly the forerunner of the true pyramid construction of the famous Great Pyramids of Giza (ghee′-zah).

Figure 4.19 Post-and-lintel form of construction.

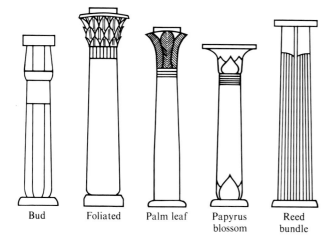

Bud Foliated Palm leaf Papyrus Reed
 blossom bundle

Figure 4.20 Egyptian columns designed after local flora.

The pyramids of the Old Kingdom, some of which have bases covering thirteen acres, are monuments of the largest scale on earth. In building these structures, the Egyptians used the most basic form of construction, **post and lintel** (fig. 4.19). This system created the need for column designs commensurate with the majesty of the tombs and temples of which they were a part. The various column shapes reflect the design of some of the natural plants found in Egypt: stylized papyrus, palms, and lotus plants (fig. 4.20).

Egyptian Relief Sculpture and Paintings

One of the oldest and most significant historic works in the Egyptian style is the relief *Palette of King Narmer* (fig. 4.21), at a museum in Cairo, dating from 3000 B.C. Both sides display decorative picture writing and the center section of the front side offers a mixing area for eye makeup.

The palette also provides important historical documentation of how artisans came to represent the human figure in most areas of Egyptian art. We see an image on the back representing the king in the act of slaying an enemy. Below this are two figures previously fallen under the king's blows. The sculptor also included the

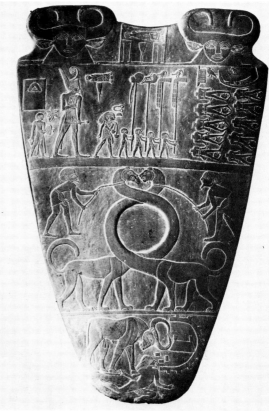

Front

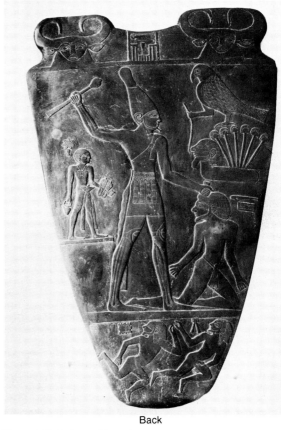

Back

Figure 4.21 *Palette of King Narmer*, ca. 3100 B.C. Slate, H. 25 in. Egyptian Museum Cairo.

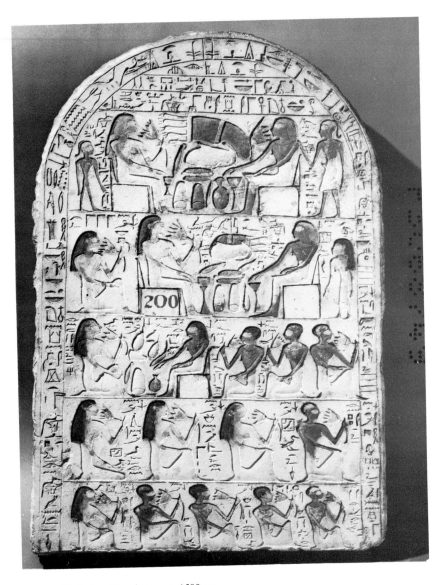

Figure 4.22 *Stela of Inpuhotpe,* ca. 1580 B.C.
Limestone. Reproduced by courtesy of the Trustees of the British Museum.

hawk Horus, god of heaven and earth, and the king's protector. The larger-than-life figure of the king towers above the common people and is symbolic of the divine importance of Egyptian rulers. The figures of kings will change proportionately in later sculptures and paintings, but certain characteristics will remain much the same. For example, the depiction of arms, legs, and head in profile while showing a frontal view of the eyes and the torso established a tradition that would remain relatively constant for thousands of years.

The front and the back of the palette were divided into separate bands, or ground planes, to portray certain events. The shapes of figures were carefully designed to relate to these areas. This depiction of events in scenariolike bands is also typical of the way artisans treated space in Egyptian paintings. Notice the absence of depth and volume.

The **sunken relief** is a form of sculpture wherein the figures are cut to a shallow depth with incised contours and are sculpted within these outlines to appear in horizontal registers, as in the *Stela of Inpuhotpe* (ihn-poo-hot'-pee) (fig. 4.22).

There are many similarities between this style of relief sculpture and Egyptian tomb painting. In the painting *Banquet Scene* (fig. 4.23), notice the similar use of side views of faces, arms, and legs and frontal views of eyes. The characteristic use of separate bands as ground planes also prevails. A heavy black line separates the spectators above from the performers below. The audience is understood to be in back of the foreground stage. The hieroglyphic calligraphy in the *Book of the Dead of Anhai* (ahn'-hah-ee) (fig. 4.24) also follows the tiered visual model. Narratives of this kind, depicting activities of the deceased and the Egyptians' perception of the afterlife, decorated burial chambers.

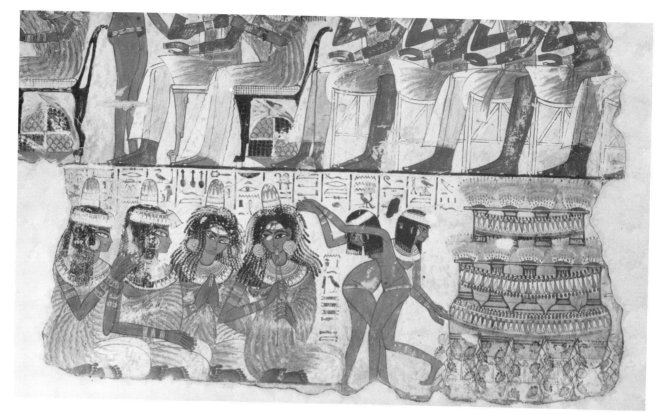

Figure 4.23 *Banquet Scene,* detail of a fragment from a wall
painting, 1580–1314 B.C.
Dimensions of the whole fragment: 27¼ × 11¾ in. Reproduced by courtesy of
the Trustees of the British Museum.

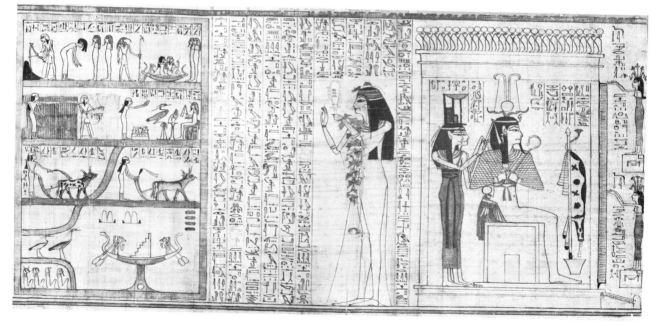

Figure 4.24 *Agricultural Scenes from the Book of the Dead of
Anhai,* 1100 B.C.
Papyrus, H. 16½ in. Reproduced by courtesy of the Trustees of the British
Museum.

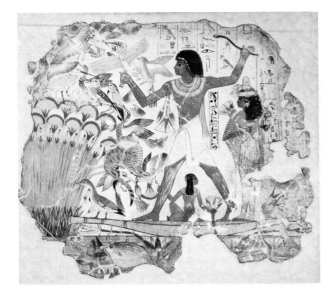

Figure 4.25 *Scene of Fowling, from the Tomb of Neb-amon at Thebes,* ca. 1400 B.C.
Painting on stucco, H. 32¼ in. Reproduced by courtesy of the Trustees of the British Museum.

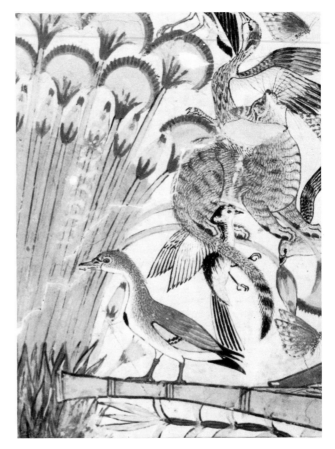

Figure 4.26 *Scene of Fowling* (detail).

In the same room at the museum is the *Scene of Fowling* (fig. 4.25), one of the most beautiful works of the New Kingdom (ca. 1400 B.C.). The painting depicts a hunting scene with King Neb-amon (nehb-ah′-muhn), his wife, and his child. The surface is covered with many forms of vegetation and wildlife indigenous to the marshes of the Nile valley. The entire scene is covered with narrative details of the event depicted, but the imposing figure of the king dominates the compositional design.

Let's pause in this room of the gallery to reflect on the previous three works (figs. 4.23, 4.24, 4.25) and to try to determine why the paintings are such distinctive artistic works, how they reflect the canons of relief sculpture, and why this skill and artistry appeals to our contemporary tastes. First, we can easily see that the painters were highly skilled in reducing objects to their essential contours without losing the uniqueness of each form in the composition. Egyptian painters had a gift for rendering without unnecessary detail. As a result, a balance was achieved between realistic renderings and stylized interpretations of human, natural, and animal forms.

Secondly, geometric shapes, pictographic symbols, and organic forms were combined into sound compositional units. Nothing seems purposeless, unnecessary, or contradictory. A keen and sensitive use of subject matter in overlapping and adjacent shapes results in balance and coherence. These shapes are placed in negative areas in such a way that they do not "fill" space; rather, they provide activity with rhythmic order and a sense of structural unity.

Third, the outlining and exquisite detail in the three paintings reveal a fluency of execution and directness of expression characteristic of Egyptian scribes and draftsmen. A detailed look at various sections of each painting reveals that outlining was achieved with continuous brushstrokes. These strokes were stylized and simplified to a point at which only a few marks were needed to explain the subject adequately. Look closely at the *Scene of Fowling,* and note in particular the bird plumage, cat fur, butterfly wings, and fish scales. A limited palette of red-ochre for darks, shades of blue for most halftones, and white for the lights was used in a restrained color scheme.

One way of summarizing the excellence of the Egyptian style is to examine this particular painting in some detail. If we look closely at various areas of the work we can discover how easy it is to find a "painting within a painting" when the shape relationships are so carefully balanced. Even in this cropped section of the painting, we still feel a completeness and coherence (fig. 4.26). Common among painters is the practice of masking off portions of their work in order to find a more balanced solution. Usually, this is done when the painting seems lost and the only possible remedy is to find a part that can salvage the effort. However, in most work by Egyptian artisans, the composition is so completely resolved that every portion of the space works and is thus able to stand alone as an elegant compositional unit.

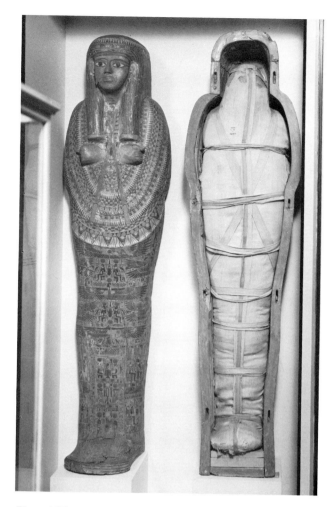

Figure 4.27 *Mummy and Coffin of Priestess,* ca. 1000 B.C.
Reproduced by courtesy of the Trustees of the British Museum.

Egyptian Mummy Cases

Intricate color patterns and careful attention to detail
were also important in the art of mummy coffins. Two
rooms at the British Museum are devoted to mummies
and coffins, which serve to illustrate the funerary cus-
toms used throughout ancient Egyptian history. The
highly ornamented cases, meant to preserve the body for
the next life, were given special attention. In the coffin
of figure 4.27, the painter used funerary scenes on the
inside and on the outside of the coffin and arranged ex-
terior design motifs to fit the human form. Notice the
near-perfect way in which the body was carefully band-
aged. Notice also how on the front of the coffin the highly
ornamental shawl was designed to encircle the head and
breast areas with bands of geometric shapes that direct
our attention to the symbolic portrait of the deceased.
The painted decoration on this case complements the
total form in a manner similar to the sculpted detail on
free-standing or relief figures in stone. In both cases, the
artisan felt the need to integrate surface refinement with
the volume of the entire work. Notice the similarity be-
tween the total shape of the case and the simplicity we
saw in the statue of figure 4.16.

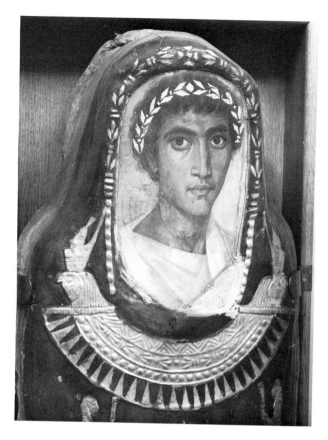

Figure 4.28 *Mummy of Artemidorus with a Portrait of the
Deceased,* ca. A.D. 200.
H. 5½ ft. Reproduced by courtesy of the Trustees of the British Museum.

Mummies of a later period may be seen in the Coptic
Corridor on the upper floor, which contains artifacts from
Graeco-Roman and Early Christian Egypt. Elements of
Egyptian, Classical, and Christian styles were combined
as in the *Mummy of Artemidorus* (ahr-teh'-mih-dor'-
us) (fig. 4.28). The portraits on these cases were unique
in that they were either modeled in plaster as a mask or
painted on a wood panel and inserted in the wrapping
covering the mummy's face. The panel portraits were
painted with brushes dipped into a combination of molten
wax and pigment in a process known as **encaustic.** Hot
wax paintings have been proven to be quite durable in
the desert climate of Egypt. The artist's thick, waxy
brushwork can be seen in the detail of the head of Ar-
temidorus. Although the artist followed a naturalistic
style to depict the subject (as compared with the earlier,
more idealized renditions of heads in sculpture and
painting), the scenes covering the rest of the sarco-
phagus are typically divided by bands.

An interesting comparison can be made between the
mummy portraits of the priestess and of Artemidorus.
A strange blending of influences from East and West is
apparent in both, and the artists, though widely sepa-
rated by media and culture, used directness and sim-
plicity in their handling of paint.

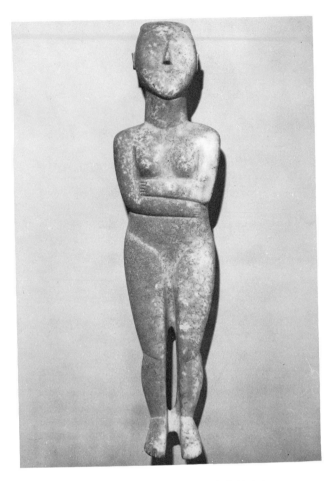

Figure 4.29 *Marble Figurine of Woman with Folded Arms,* ca. 2500–2000 B.C.
H. 30¼ in. Reproduced by courtesy of the Trustees of the British Museum.

GREEK AND ROMAN ANTIQUITIES

The British Museum's holdings in Greek and Roman antiquities range from the Cycladic islands off the Greek mainland (2500 B.C.) to the last years of the Roman Republic (ca. A.D. 500). The Egyptians influenced Greek art, but unlike Egypt's preoccupation with death and the afterlife, Greece glorified life and human capacity for perfection in mind and body.

The Cycladic Room features marble female figurines from the Cyclades, the islands that "cycle" around Apollo and Artemis' birthplace, Delos, off the Greek mainland. These angular, stylized figures, which usually represent pregnant women with arms folded, were carved with a high degree of simplicity and abstraction, possibly to accommodate painted details (fig. 4.29). Red and black color traces have been found indicating that hair, mouths, eyes, and jewelry had been painted on the idols.

The economic, static, and relatively primitive style of the Cyclades is contrasted by work from the Cretan civilization (3000–1000 B.C.) in the Greek Bronze Age

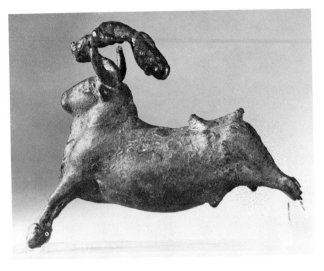

Figure 4.30 *Bronze Acrobat Vaulting on a Bull,* ca. 1600 B.C.
L. 6⅛ in. Reproduced by courtesy of the Trustees of the British Museum.

Room. The *Bronze Acrobat Vaulting on a Bull* (fig. 4.30) is significant for its display of freedom and movement, quite unlike the stiff, immobile work of the Egyptians.

Greek Vase Painting

Greek civilization was slow to develop on the mainland, but this area was eventually settled by immigrants around 3000 B.C. By 1100 B.C. the Mycenaean (mahee'-see-nee'-an) civilization had collapsed and Greece found itself in a period of hardship that lasted for three hundred years. This "dark age" of poverty in Greece curtailed large-scale building and wall painting. As a result, vase painting was substituted and developed into a major art form rivaling architecture and sculpture.

The foundations for pottery making were laid with the work done in the *geometric style,* produced during the eighth century B.C. (fig. 4.31). Works from this period were known for their sharp, hard-edge, geometric patterns, often drawn with mechanical drawing instruments.

The human figure was slowly introduced into pottery decoration, first as a silhouette and later as a modeled and realistic depiction. The *amphora,* or wine jar, in figure 4.32 was executed by Exekias (egg-zek'-ee-es), one of the most famous artists in antiquity. This amphora is an example of a vase-painting technique known as **black figure** because the decoration and figures were first painted in black **slip** over the lighter clay body. Details were incised into the clay surface with sharp, pointed tools. Details were also scratched from the darker shapes of the figures, exposing the lighter clay body beneath. This process is known as **sgraffito.** An alternative to this technique was to add decoration directly to the flat surface of the pottery with colored slip. Since slip does not make pottery nonporous, transparent or colored **glazes,**

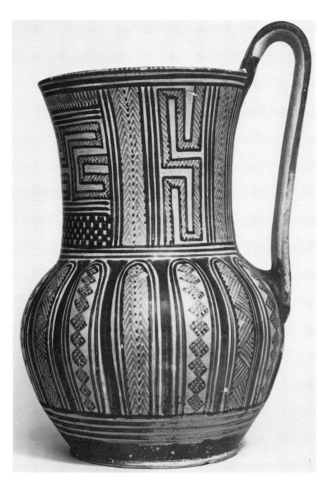

Figure 4.31 *Pitcher with "Geometric" Decoration,* ca. 740 B.C.
H. 8½ in. Reproduced by courtesy of the Trustees of the British Museum.

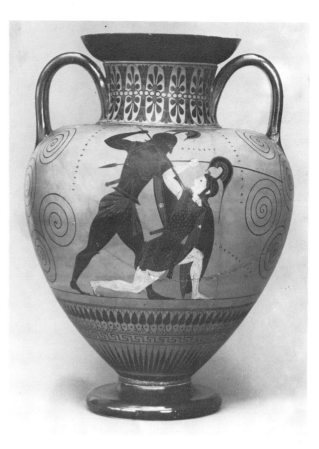

Figure 4.32 *Exekias, Achilles Slays the Amazon Penthesileia,*
black-figured neck-amphora, ca. 540 B.C.
H. 16⅓ in. Reproduced by courtesy of the Trustees of the British Museum.

or silicas, were also used by potters to cover the surface and form a glassy coating over the clay body and slip decoration. However, the Greeks' interest in detailed illustrations of legends, satyrs, athletes, and domestic scenes, in action and movement, often deterred them from using this glossy glaze because of the danger of its causing the drawing to run and so destroy the meticulous detail.

The basic process of vase decorating and glazing remained the same for centuries in Greece, but later generations perfected the technique and toward the end of the sixth century B.C., added an innovation. In order to create more lifelike figures, the red color of the clay body was allowed to remain. The cup designed by Epiktetos (ep-ik-teht′-os), one of the most famous **red figure** painters of the era, reverses the figures with the ground— the figures are the color of the clay body while black glaze was used to fill in the background. (fig. 4.33). This technique enabled the artist to brush on details in a more spontaneous manner than was possible when incising with a pointed tool. The artist also used white to highlight the flesh on figures, which was similar to what had been done in the black figure style.

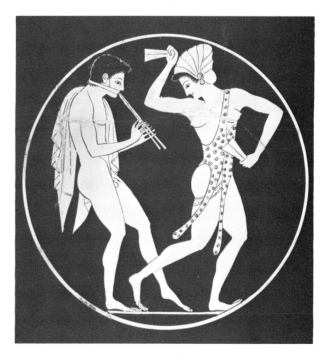

Figure 4.33 Epiktetos, *Cup* (detail), ca. 510 B.C.
Diameter 13 in. Reproduced by courtesy of the Trustees of the British Museum.

Figure 4.34 *Bronze Griffin from a Cauldron,* ca. 650 B.C.
H. 9¼ in. Reproduced by courtesy of the Trustees of the British Museum.

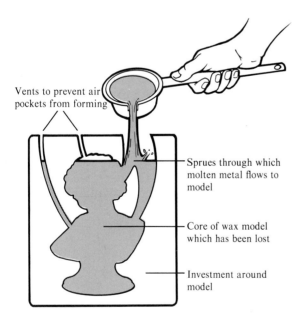

Vents to prevent air
pockets from forming

Sprues through which
molten metal flows to
model

Core of wax model
which has been lost

Investment around
model

Figure 4.35 The lost-wax process.

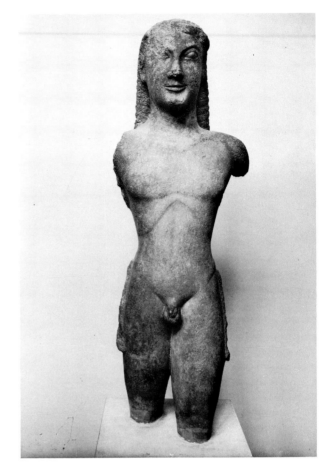

Figure 4.36 *Marble Statue of a Youth (Kouros),* ca. 560 B.C.
H. 30½ in. Reproduced by courtesy of the Trustees of the British Museum.

Greek Sculpture and Architecture

Some of the very earliest Greek sculpture was formed
by the **lost-wax** process. An example of such hollow
casting is the griffin head in figure 4.34. The represen-
tation of the mythical beast shows an Eastern influence
that gained importance in classical art; the piece is one
of the earliest hollow bronze castings from Greece. The
complicated lost-wax process (fig. 4.35) starts with a clay
or plaster image that is covered with a layer of wax. This,
in turn, is surrounded by an outer layer of clay and sand.
Then the wax is melted away, or "lost," so that molten
bronze can be poured into an opening to replace the
hollow area formerly occupied by the wax. The outer shell
is removed, exposing the final artifact. The lost-wax
casting was important in the Greeks' production of many
types of full-figure and portrait sculpture for centuries
to follow.

Greek sculpture strives for the fullness and warmth
of the human body. The marble *kouros* (kew-rohs) or
youth figure, (fig. 4.36) served either as a funerary figure,
or as an offering to gods, or represented a victor in games

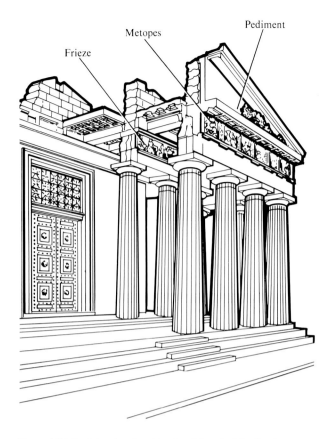

Figure 4.37 Sculptural and architectural detail of the Parthenon: *frieze*, a decorative band along the top of a wall; *metopes*, segmented spaces on a frieze; *pediment*, a gable.

Figure 4.38 *Hestia, Dione, Aphrodite*, East Pediment, Parthenon, 438–432 B.C.
H. 4 ft., L. 10 ft. 4 in. Reproduced by courtesy of the Trustees of the British Museum.

Every bridle flashes and each man gives his horse its rein, as onward the whole troop surges, servants of Athena, mistress of horses.

Sophocles,
Oedipus at Colonus

The Elgin Marbles are some of the finest works of art ever shaped in stone. . . . They are the crown of the British Museum's Greek collection.

Tyrone Guthrie

or Apollo, god of music and poetry. As opposed to Egyptian statuary, the kouroi figures were freestanding and symmetrically positioned to duplicate the natural proportions of anatomy.

Sometimes marble figures were used as columns on porches of temples. The Greek temple is as much sculpture as it is architecture. The classical age in Athens (from about 480 to 323 B.C.) produced great literature and great sculptural structures in the Acropolis. As a temple to Athena, goddess of wisdom, the Parthenon represents the mathematical harmony the Greeks so cleverly perfected. Many of the surviving sculptures from the Parthenon's **pediments, metopes** (meh′-toh-pee), and **frieze** were brought to London by Lord Elgin during the nineteenth century (fig. 4.37). The sculpture on display

is, for the most part, fragmentary but represents a preserved portion of Greece's sculptural masterpieces. Had the British Ambassador to Turkey not brought the statuary to England, it can be argued that everything would have been destroyed under Turkish rule.

In its original state, rising up out of the rock of the Acropolis, high against the Mediterranean sky, the Parthenon must have dazzled the viewer. The backgrounds of the sculptured areas were blue and red to accentuate the brilliantly painted and white marble figures. All the statuary was completed in only twelve years.

Three headless figures from that maze of statuary now recline in the Duveen Gallery on the museum's main floor. The popular title of this section of the pediment is *The Three Fates* (fig. 4.38). They were executed in the round, even though from forty feet below the east pediment, no one could have seen the back of the sculpture. Aphrodite (afro-dite′-ee), goddess of love, leans back against Dione, her mother. Hestia (hess′-tee-ah), goddess of the hearth, wears intricately folded clothing, as do the other two, in flowing, clinging contours.

Figure 4.39 *Lapith Overcoming a Centaur,* 445–440 B.C.
Marble relief, H. 4 ft. 5 in. Reproduced by courtesy of the Trustees of the
British Museum.

Others, no doubt, will better mould the bronze
To the semblance of soft breathing, draw from marble,
The living countenance; and others plead
With greater eloquence, or learn to measure,
Better than we, the pathways of the heaven,
The risings of the stars: remember, Roman,
To rule the people under law, to establish
The way of peace, to battle down the haughty,
To spare the meek. Our fine arts, these forever.

Virgil,
The Aeneid

All ninety-two square slabs (fig. 4.39), or relief met-
opes, found at the museum depict mythological battle
scenes symbolizing Athens' victories in the Persian Wars.
Naturalism and technical skill can be seen in the real-
istic rendering of the horses in the *North Frieze of the
Parthenon,* profound evidence of the high-level achieve-
ment of Greek sculptors (fig. 4.40). The artist over-
lapped the figures riding abreast, making them appear
to recede into space even though they are in very low
relief (only 2¼ inches). Close examination of the area
around the horses' hooves will reveal the importance of
the overlapping technique in the illusion of depth.

Greek art provides us with classical standards of
judgment. In the space of only about one thousand years,
the Greeks provided us with philosophy, literature,
sculpture, music, architecture, vase painting, and deco-
rative arts that all produced a quality of life that has,
perhaps, never been equaled.

Figure 4.40 *A Group of Young Horsemen from the North Frieze of the Parthenon,* (Slabs xxxvii–xxxviii).
H. 3 ft. 7 in. Reproduced by courtesy of the Trustees of the British Museum.

Roman Art

In walking through the Roman rooms, we find ourselves asking, is there an actual "style" of Roman art or have they only modeled their work after Greek bronzes and marble statues?

It's a fair question since many elements of Greek art easily found their way into Roman life. With a few name changes, the Romans even borrowed the Greek gods. However, a style of art from early inhabitants of Italy, called the Etruscans, gave Roman art a unique synthesis of early Oriental and Greek roots. The Etruscans preferred **terra cotta** to marble and their tombs have left us numerous clay and bronze sculptures.

The Romans excelled in administration and law, engineering and warfare. It's been said that where the Greeks theorized, the Romans acted. They energetically governed a host of nations, including Greece, and offered order and organized security to thousands of people. They felt destined to lead the world and their art reflects that severe authority and realism. Roman architecture achieved monumental heights with their Colosseum and Augustan temples. By developing the rounded arch, their architects and engineers built bridges, aqueducts, and sophisticated cities.

Some painting and mosaic work remains, but it was in portraiture that Roman artists excelled. Busts and cameos, coins, and full statues were everywhere; an example is the life-size marble portrait of *Lady Antonia* (fig. 4.41). The Romans were much more likely to use a severe linear style as opposed to the Greeks who treated their subjects more idealistically; the style seemed to symbolize Rome's order and strength.

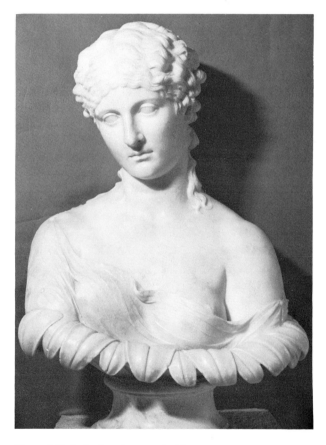

Figure 4.41 *Lady Antonia,* portrait, 36 B.C.
Marble, H. 27 in. Reproduced by courtesy of the Trustees of the British Museum.

Figure 4.42 *Mirror Back,* end of first century B.C.
Incised and patinated bronze with handle of linked, soldered, iron rings,
H. 13¾ in. Reproduced by courtesy of the Trustees of the British Museum.

Figure 4.43 *Mirror Back* (detail).

Figure 4.44 Many textural surfaces may be created with chasing tools and punches.

ROMANO-BRITISH ANTIQUITIES

As people migrated, they naturally took their technology and art with them. Among other things, Roman military invaders brought to Britain walls and roads, mosaicked baths and Roman coins. For four or five hundred years, around the time of Christ's birth, civilizations mixed into what we call Romano-British. Celtic and Saxon metals and designs mixed with Roman crafting to produce such artifacts as *Desborough Mirror* (fig. 4.42). Its elegant spiral, curving lines create positive and negative shapes resulting in a formal composition. In this case, the curved shapes of the handle flow into the design and become an outline for its symmetrical decoration. The negative areas are made up of crosshatched units of three parallel lines repeated throughout, thus providing a contrast with the raised positive areas in the design (fig. 4.43). These groups of lines in the negative areas were massed together to create texture. They were **chased:** hammered into the metal surface in a repeated fashion with a flat, sharp tool (fig. 4.44). The surface was then heightened by the application of chemicals to darken the deep metal impressions and give it a characteristic **patina,** or surface color.

The Iron Age room contains a piece of Celtic art that should not be overlooked due to its unusually high degree of artisanship and mysterious origin. It is called a *torc* (fig. 4.45) and is thought to have been worn as a neck ring in battle in 50 B.C. An alternative theory is that torcs were worn only by women on special social occasions.

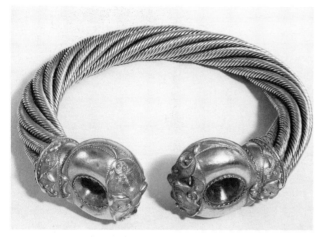

Figure 4.45 *Electrum Torc,* first century B.C.
Gold alloy, diameter 7¾ in. Reproduced by courtesy of the Trustees of the British Museum.

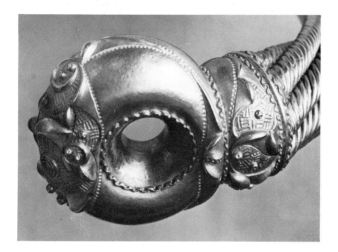

Figure 4.46 *Electrum Torc* (detail).

An interesting feature of this piece is the three-line chased motif (fig. 4.46) in the negative areas of the *terminal*—identical to that used in the Desborough Mirror from 100 B.C. Could this be mere coincidence? It seems odd that two different artists, living in different locales and separated by a span of fifty years, would have used identical decorative techniques. Perhaps the chasing tools were passed on from one time or place to another. But it is more interesting for us to imagine that something more intriguing was happening. Such design motifs could be our first indication that certain conventions, tools, and techniques were being shared by an elite group of artists among early societies, and these conventions asserted a powerful influence on their progeny.

SUMMARY

One of the most interesting aspects of ancient art is the realization that artisans then made similar decisions and choices regarding the use of basic art principles as artisans are making now. We can look at cave paintings fifteen thousand years old and find qualities of art that apply to contemporary paintings, even though ancient art was most often made to be functional and not purely artistic in nature.

Freestanding and relief sculpture followed accepted conventions in Western Asiatic antiquities. Histories and narratives were recorded and told through elaborate carvings. Stylized features of the head in sculpture are similar in examples dating centuries apart.

Egyptian art has an almost universal appeal due to its unique style and rich social heritage. Its secrets unlocked by the discovery of the Rosetta Stone, Egyptian art appeals to anthropologists and archaeologists as well as to art lovers. The ancient Egyptians' concern for the hereafter prompted them to produce art that would last forever. So we find, along with the mummified remains of bodies, encaustic tomb portraits that are as lustrous now as they were two thousand years ago.

Conventions were strong among Egyptian artisans. Idealized human proportions and closed-form sculpture were the most universal. The pyramids symbolize the Egyptians' concern for perpetuity and also serve as a guide for understanding the style of their sculpture—majestic, solid, and eternal.

The British Museum's collection of classical Greek and Roman antiquities dates from about 2500 B.C. Greek art predates Roman art and is generally characterized by an elegance, grace, and refinement unrivaled in previous civilizations. Clearly the most spectacular exhibit of its kind anywhere in the world, the collection of sculpture from the Parthenon is displayed in a proximity similar to its original position on the building's structure. The attention to three-dimensional detail and skill in imitating nature can be seen at close range. Although the Romans adopted the mannerisms and techniques of the Greeks, their art seems somewhat more austere and less idealized. However, the similarity between the two is so strong that it is difficult to identify a Roman style that differs significantly from that of the Greeks.

Motifs and techniques of design in Romano-British antiquities (ca. 300 B.C. to A.D. 500) appear to have been passed down from one generation of artisans to the next.

VIEWING EXERCISES

1. Examine *Banquet Scene* (fig. 4.23) and identify where the artist has used lines and shapes to form patterns of repetition. Even though the painting is filled with repeated shapes, subtle differences exist between one pattern and the next. Locate such patterns and identify how the shapes, lines, and values differ.

2. Repetition is also used extensively in the *Book of the Dead* (fig. 4.24). Locate where and how the artist used repetition and balance to unify this work, which is characteristic of the Egyptian style.

3. Examine the wall painting in the *Scene of Fowling* (fig. 4.25) and identify how the artist has used shapes and lines rhythmically to provide a feeling of movement.

4. Imagine what life would be like today if we didn't have the knowledge that explains certain phenomena to us—why people age and die, the change of seasons, the weather, etc. Perhaps symbols were created to exert some control over things prehistoric people did not understand. Are there things today that we do not understand? Do we have symbolic images or icons to exert some control over them?

STUDIO EXERCISES

Suggested media and supplies: tracing paper; black pencil, crayon, ink, or felt-tip pen.

1. Using tracing paper, trace the complete subject matter in both tiers of *Banquet Scene* (fig. 4.23). Enclose your drawing in a rectangle by placing a straight line around the top, sides, and bottom edges. Test your powers of imagination: What is missing from the painting around the edges? With any drawing medium, complete the painting by filling in the spaces around the figures and other shapes.

2. Trace the outline of the pitcher in Fig. 4.31. Then gradually add your own geometric design until reaching a point where you feel the original style has not been compromised.

Figure 4.47 Greek vase types.

3. Redraw the outline of the ceramic shapes pictured in figure 4.47. Add your own decoration to these Greek vase shapes. Your designs need not follow Greek patterns or pictoral illustrations; however, the vase marked *A* should be designed in a red-figure technique, and the *B* vase should utilize a black-figure design. Shade in the dark with black pencil, crayon, ink, or felt-tip pen. Consider any or all of such elements and principles as repetition, variety, balance, rhythm, unity, and dominance.

RESPONSES TO VIEWING EXERCISES

1. *Banquet Scene* (fig. 4.23) has many shapes that form patterns throughout the painting. Note how the artist repeated the seated figures in the top tier: the legs of each are in the same diagonal position except for subtle changes in shape and size. Notice the changes in dress length and the divisions of folds on the figures. The heads are, of course, in profile, as are the chairs, with some alternation of dark and light. The arms of the figures are similarly repeated in the top tier. Likewise, the striped decoration on the garments and the coiled hair are similar in both the bottom and top tiers.

2. The geometric division of the entire scene from the *Book of the Dead* (fig. 4.24) is asymmetrically balanced. The parts on the page create a unit and are well proportioned with near-mathematical accuracy. The mathematical balance of parts to the whole is as perfectly proportioned as the dimensions of the Parthenon. This work also abounds with repetition, which is especially apparent in the hieroglyphics, and in the decoration on the king's cape and on the architectural structure.

3. The arm movements of the king, the open wings of birds, and in fact the overall pattern of interlocking diagonal shapes creates constant motion. The placement of contrasting vertical hieroglyphics in the background adds to the dynamic counterpoint.

4. Religion, or belief in powers beyond scientific facts, is a universal human phenomenon. From the dawn of prehistory, people have relied on faith whenever factual knowledge was not available. People today, in overwhelming numbers, believe in God and a life hereafter and fashion sacred images to support their faith. Some believe in the probability of life on other planets in our solar system. Scientists have speculated about the infinity of space or the possibility that space is ever-expanding from the original Big Bang.

The Cleveland
Museum of Art

Cleveland, Ohio

Tour 5

Religious Expression: East and West

The Gallery

The Cleveland Museum of Art, located at University Circle, is surrounded by landscaped gardens and overlooks the Wade Park Lagoon. Nearby are the famous Severance Hall, home of the Cleveland Orchestra; the Cleveland Institute of Music; and Case Western Reserve University. Like most art museums, Cleveland boasts the usual services—ample parking, restaurant, and bookstore, but Cleveland is especially proud of its outstanding educational programs.

The Department of Education, established in 1915, one year before the museum opened to the public, has a professional staff of approximately twenty full- and part-time instructors. The department offers gallery talks, guided tours of the museum, classes for young people and adults, and slide-tapes and art films. The museum also organizes educational exhibitions, usually drawn from and designed to interpret areas of the museum's collections.

Cleveland was also among the first art museums in the country to offer music programs as part of its regularly scheduled activities. Weekly organ recitals and a series of free and subscription concerts by local and internationally known musicians are scheduled in the museum's 750-seat Gartner Auditorium, part of the Education Wing built in 1971. The Education Wing also contains two large special exhibition galleries, classrooms, lecture halls, and an audiovisual center.

As is the case with only a few of America's museums, Cleveland has collections in many areas. We have chosen one of its special strengths, Far Eastern art. We can thank former director and chief curator of Oriental art Sherman Lee for his prominent role in developing this splendid collection. Another area of particular distinction, that of European medieval art, will be discussed during our tour.

Tour Overview

The art of the Orient and Western medieval art are joined in this tour because of their commonality. This may not be immediately apparent to many Westerners because most know little about Oriental philosophy and religion. Most Westerners do know that medieval art in Europe was very much an expression of Christian religious beliefs. Religious beliefs also shape much of the character of Oriental art. Because this tour encompasses geographically diverse areas and a wide span of time, we have created a tour time line in order to help you link East and West. We have chosen to include in the time line only the major historical events discussed in this tour. The time line appears on page 118.

Although the museum's Oriental collection includes Indian, Chinese, Korean, Japanese, and Southeast Asian art, we will examine only the art forms that are deeply rooted in the cultures of India, China, and Japan.

Indian culture was greatly influenced from its inception by the conceptions and practices of Hinduism (ca. 2500–1500 B.C.) and Buddhism (sixth century B.C.), and while Indian culture was many faceted, its most distinctive mark was the desire to transcend the personal ego. This feature is demonstrated over and over again in the Cleveland collection by artworks celebrating the practice of strict self-denial and scenes from the life of Buddha and the *bodhisattvas* (bo-dee-sat'-vas), or enlightened beings capable of becoming Buddhas.

The Chinese way of life was strongly influenced by the advent of Taoism (dow'-ism) (sixth century B.C.), which embraced a natural mysticism that considered civilization a "spoiler" of humanity and nature and thus cultivated spontaneity and immediacy of experience, and Confucianism. Confucius (551–479 B.C.) taught respect for ancestors, parental authority, loyalty, discipline, and hard work. The diversity of these two world views was in part responsible for the great variety of styles and subject matter in artworks of China.

◀ *South Entrance to The Cleveland Museum of Art; Architects: Hubbell and Benes, 1916; Photograph: The Cleveland Museum of Art/Robert Falk*

117

Religious Expression: East and West

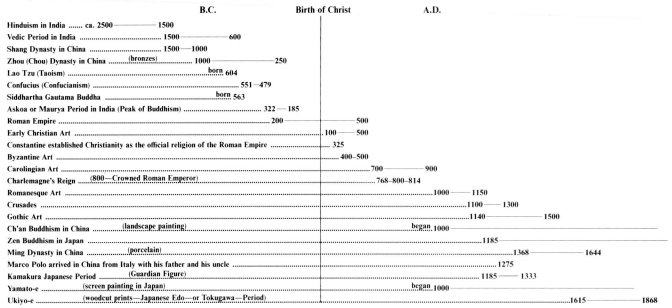

	B.C.	Birth of Christ	A.D.
Hinduism in India ca. 2500————1500			
Vedic Period in India 1500————600			
Shang Dynasty in China 1500—1000			
Zhou (Chou) Dynasty in China(bronzes)............ 1000————250			
Lao Tzu (Taoism)born 604			
Confucius (Confucianism) 551—479			
Siddhartha Gautama Buddhaborn 563			
Askoa or Maurya Period in India (Peak of Buddhism) 322—185			
Roman Empire 200————500			
Early Christian Art100————500			
Constantine established Christianity as the official religion of the Roman Empire325			
Byzantine Art ... 400—500			
Carolingian Art ... 700————900			
Charlemagne's Reign(800—Crowned Roman Emperor)768–800–814			
Romanesque Art .. 1000————1150			
Crusades ... 1100————1300			
Gothic Art .. 1140————1500			
Ch'an Buddhism in China(landscape painting)began 1000			
Zen Buddhism in Japan 1185			
Ming Dynasty in China(porcelain)1368————1644			
Marco Polo arrived in China from Italy with his father and his uncle 1275			
Kamakura Japanese Period(Guardian Figure) 1185————1333			
Yamato-e(screen painting in Japan)began 1000			
Ukiyo-e(woodcut prints—Japanese Edo—or Tokugawa—Period)1615————1868			

Buddhist missionaries arrived in China around A.D. 200 bringing with them ideals of Indian culture. In China, none of the traditions of Taoism, Confucianism, or Buddhism stood alone, but rather merged to help create the very distinctive Chinese way of life. In time, these religious and philosophical Chinese traditions made their way to Japan (particularly during the sixth century A.D.) and influenced art forms originating in the islands of Japan.

Japanese Shintoism, or the Way of the Gods, provided spiritual insights into all of nature and helps explain the Japanese artists' reverence and respect for natural materials. Total harmony between natural and created objects reflects ancient religious attitudes. Meditation and rigorous self-discipline characterized the later form of Buddhism in Japan known as Zen and created the aesthetic basis for some forms of Japanese art.

The Far East is no different from other geographic locations in that the study of its art history could last a lifetime and fill volumes. Therefore, selections from the artifacts at the Cleveland Museum will be used in the hope of developing an intuitive or felt sense of style in the art of the Far East. Such a sense will enable us to say with some assurance, "That work is Chinese, or that seems to be Japanese." The complete development of such a sense comes only after a long association with many artworks that together form an overall impression. After long association with art objects, we find ourselves better able to see diversities within two or more works which at first only seemed to have an "oriental" look. Even an "oriental" look is often misleading and an astute observer will surely find exceptions to widely accepted art principles identified with individual Asian cultures. Many times, however, the medium, the technique, the process, or some pictorial symbol offers a distinctive clue for identifying an art style, culture, or country—for instance, an example from this tour is the woodblock of the Japanese and from the last tour examples would be the hieroglyphics of the Egyptians or the Roman arch.

Medieval European artists also dealt in rich symbolic expressions, and like the Far Eastern artists, portrayed their religious truths in pottery, decorative art pieces, sculpture, and architecture. Early Christian art often shows biblical scenes appearing in frescoes, mosaics, and tapestries. On the second part of our tour, encompassing the medieval period, we will examine the treasures of the Romanesque and Gothic periods representing roughly the ninth through the fourteenth centuries.

THE ART OF INDIA

Thousands of years of diverse philosophies, religions, and innumerable cross-influences have affected the art of India. The Hindu way of life is part of this vast tapestry of culture and is depicted in many outstanding works in the Cleveland collection. Hinduism incorporated earlier native beliefs and art traditions and eventually embraced the *Vedas,* hymns, prayers, and universal concepts written in *Sanskrit,* an ancient language of India. Hindu artists were inspired by stories and legends of the major gods. For the Hindu, a spark of the divine became embodied in the various visible worship objects. The aim of Hinduism is to discover the true nature of the self in light of the only real Existence, or Brahma. All men and women are on a wheel of life, or cycle of reincarnation, until finally they become one with Brahma. The natural sensual beauty of male and female figures in Hindu art depict the joyous fullness of divine existence.

Over the years, many different schools of Hindu art developed, each interpreting old religious traditions in various ways. One rich young Indian prince born about 563 B.C. left his family and palace to study with Hindu *gurus* in order to discover the cause of pain. This search for enlightenment eventually led Prince Siddhartha Gautama to reform Hinduism. He preached a simple message of salvation, which was to meditate, give up worldly attachments, and do good works. Buddha, or "The Enlightened One", as he became known, taught his followers that countless rebirths in the cycle of reincarnation were not necessary. All beings would eventually reach *Nirvana* and be released from the wheel of life. Buddhism reached its peak with Asoka's (d. 232 B.C.) reign as the greatest Buddhist emperor of India. We should remember that Buddhism resulted from a reformation of Hinduism and that Indian art was altered periodically with influences from Asian, Persian, and Greek art.

Painting and sculpture were sometimes created by teams of ten to fifteen artisans, each concerned with a separate specialty. For instance, some were limited to painting margin colors, others painted only faces, and others worked on a single skill such as drawing horses. Unlike Western artisans, Indian artisans who were involved in creating art forms were almost always anonymous, as their rich heritage dictated, but each was certainly a master in bringing an individual, creative effort to the final artwork. Not only were Indian artists enjoined not to call attention to their individual work, but it was also necessary for them to create religious art within rigid specifications, especially in terms of poses and symbolism.

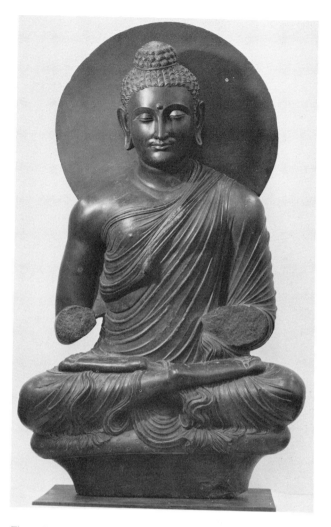

Figure 5.1 *Seated Buddha.* Sculpture, ca. 200 A.D. Indian, Gandharan Region,
Gray schist; 51 × 31 in.
Cleveland Museum of Art, Leonard C. Hanna, Jr., Bequest.

Indian Sculpture

One of the earliest examples of Buddhist sculpture in the Cleveland collection is the *Seated Buddha* from Gandhara (fig. 5.1). Here we see the sculptor using the Greek style in specific details—the twisted hairdo, the togalike monastic garment known as a *sanghäti,* and attention to musculature. The delicate and almost transparent drapery reminds us of the similar treatment of clothing in the Parthenon pediment figures at the British Museum. In fact, the sculptural quality is almost identical to the way the Greeks and the Romans employed a decorative flowing pattern while simultaneously retaining the nature of hanging and folded cloth.

The Buddha is seated in the common lotus position, a posture of meditation. We notice first that the eyes are only slightly open, indicating that the Buddha "sees but not sees." We see the characteristic *urna* (uhr'-nah), or third eye, in the middle of the forehead, which looks within the Buddha. The "bump" or *ushnisha* (oosh-nee'-shah), on top of the head symbolizes wisdom and enlightenment. The long earlobes were caused by the weight of heavy jewelry and indicate that the Buddha had once been a prince of the Sakya clan. The circular, halo-shaped disc, which was later adopted as a Christian symbol, was originally a sixth century B.C. Persian symbol for the god known as *Ahura Mazda* (ah-hoor'-ah mahz'-dah), whose spirit was represented as rays of light. These rays were used to symbolize the Buddha's enlightenment.

Indian sculpture, however, can also be colorful, worldly, and sensual as in the sandstone *Yakshi* (fig. 5.2). Sensuality and generally rounded forms were used consistently throughout this period of Indian art. The *Yakshi* (yahk-shee) of figure 5.2 is typical of the vivacious and voluptuous females often used in the same composition with male figures exemplifying strength and energy. The anatomical distortions were deliberate attempts to symbolize the power and life of the male and female human forms and the fertility of nature.

The impressive Hindu masterpiece *Shiva Nataraja, Lord of the Dance* (shee'-vah nah-tah-rah'-jah) shows *Shiva,* one of the most enigmatic of the Hindu gods, representing creativity and at the same time symbolizing the myth of Death/Life (fig. 5.3). The story begins with the Shiva who has been asleep for millions of years; he awakens, shakes the drum in his right hand, and begins to dance. The dance causes the universe to come into being. He tires after aeons of dancing and destroys the universe with the fire in his left hand. He returns to sleep and the universe perishes until he awakens again. This story represents an important Hindu conception of how change and creativity occur, or Death/Life. The hand pointing to the foot shows that the dance represents life. The fourth hand is a benediction assuring us that all is well and that Death/Life, or change and creativity, are the stuff of our existence.

Countless Shivas were produced during the eleventh century and became so important that reproductions continued to be made well into the twentieth century. One of the reasons for the universal popularity of this image of Shiva is due to the way the spectator becomes caught up in the dynamism, vitality, and energy felt while walking around the work. Its raised position adds to the sensation of ever-changing postures in the arms and legs, with each succeeding silhouette providing a new figure in a manner similar to time-lapse photography.

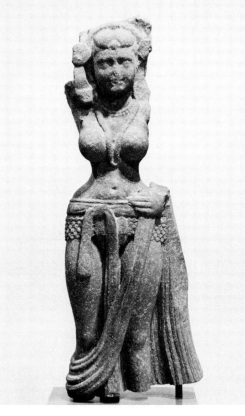

Figure 5.2 *Yakshi.* Sculpture, Indian, Mathura, Kushan Period, second century A.D.
Mottled red sandstone; H. 49 in.
Cleveland Museum of Art, Purchase from the J. H. Wade Fund.

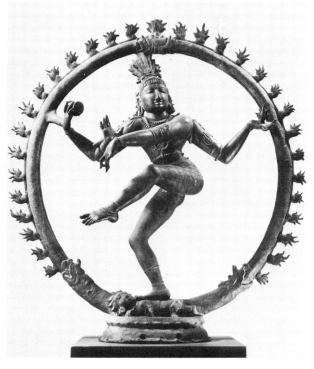

Figure 5.3 *Shiva Nataraja, Lord of the Dance.* Sculpture, South Indian, Chola Period, eleventh century.
Copper; 43⅞ × 40 in.
Cleveland Museum of Art, Purchase from the J. H. Wade Fund.

One of the most memorable pieces in the Indian collection is *A Guardian of Shiva* (fig. 5.4), characterized by highly ornate decoration. The overwhelming amount of carving in the elaborate costume may be somewhat disconcerting; it seems too busy to absorb in a single viewing. However, at the same time we respect artistic efforts that require such an uncanny level of patience and skill, not to mention the time involved in sculpting. The profuse decoration of the figure seems to intensify its supernatural state of being. Indian temples are, likewise, intricately decorated. Complex and profuse carvings dominate interior and exterior walls.

Indian Painting

Because it is more fragile, Indian painting has not been as well preserved as Indian sculpture and architecture. What has remained is divided among such forms as temple murals, palm-leaf paintings, manuscript pages, and even miniature forms of illustration. *Sita in the Garden of Lanka with Ravana and His Demons* (fig. 5.5) is an early eighteenth-century painting on paper in which the narration, artistic quality, and skill merge as one complete statement for the perceptive viewer. An unfamiliar aspect of the subject matter is the multiple-armed figure representing Ravana (rah-vah′-nah), the ten-headed King of Demons, who is showing his power by

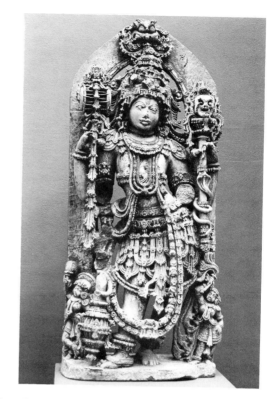

Figure 5.4 *A Guardian of Shiva.* Sculpture, Indian, Hoysala Dynasty, Mysore, thirteenth century.
Stone; 44⅝ × 19⅜ in.
Cleveland Museum of Art, John L. Severance Fund.

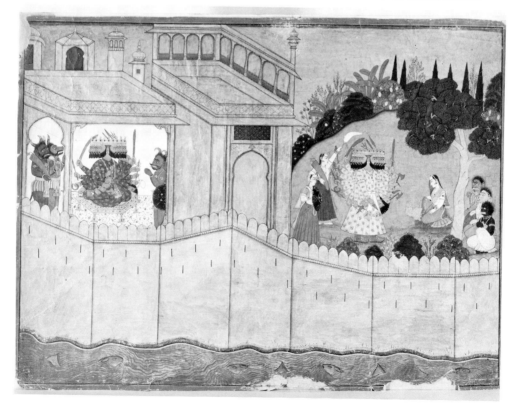

Figure 5.5 *Sita in the Garden of Lanka with Ravana and His Demons.* Painting, Indian, Punjab Hills, Guler School, ca. 1720.
Gold and color on paper; 22¾ × 33¼ in.
Cleveland Museum of Art, Gift of George P. Bickford.

holding a variety of weapons. Using the terms and viewing skills we have learned and consistently applied as viewers of art, we can arrive at a clearer understanding of what we sense or feel in this work. We can begin by noting some of its more obvious characteristics.

1. The Indian love of detail is seen in the treatment of the figures; they seem even more detailed due to the use of large, surrounding, flat surfaces.

2. The buildings were not painted in proportion with the fence or the figures. It is possible that proportion was an unimportant concern when seen against the sequence of events in the garden. The height of the fence changes dramatically in front of the events in the garden, making it an important division of space and not just a fence to be judged on its correct proportions alone.

3. Linear perspective was tilted deliberately to show a view of roofs that would not be seen in terms of correct landscape drawing. The space the buildings occupy, and the decoration and detail on the architecture were more important to the painter than a true representation of natural and physical objects. For instance, the door on the left end of the building was painted as seen from the front, not as it actually exists in a three-quarter view. Also, both roofs are rendered so that, depending on how we view the roof tops, the front end of each will appear to flip-flop.

4. The vertical-horizontal axes of fence, building, water, hill, tree, or foliage leave the viewer with a sense of flat forms in vertical space rather than in deep space.

5. The flattening of shapes is more pronounced because of a lack of shadows. (This is a technique we will see used in Chinese landscape painting.)

6. Flat and subtle color changes were used throughout the painting.

Although the work is not representative of all regional styles from India's long history, it does possess separate features that, when considered together, form a composite of an Indian style different from styles of other cultures.

Figure 5.6 *Li-Ting,* hollow-legged tripod. Chinese, from Hsi-An(?), Late Early Chou Period, ca. 1027–900 B.C.
Bronze; H. 9 in., W. 10⅞ in.
Cleveland Museum of Art, Gift from various donors by exchange and the John L. Severance Fund.

THE ART OF CHINA

Significant contributions to Chinese art were made during the Shang (ca. 1500 to 1000 B.C.), and Chou (Chou) (ca. 1000 to 250 B.C.) dynasties. Extraordinary casting skills and techniques produced many bronze artifacts such as tools, weapons, animal forms, and vessels that exhibit a variety of shapes and decoration. Evidence suggests that Shang and Chou bronzes were not made by the lost-wax method (though some late Chou pieces may have been cast by that method). An example of the **piece-mold** process, whereby different units of the work were modeled in reverse from clay, is the Chou *Li-Ting* (fig. 5.6), a hollow-legged tripod. These units were then joined together to form a one-of-a-kind mold assembly prior to the pouring of bronze. The technical proficiency of the artists can be appreciated more fully by closely examining the precise definition of edges on the relief motifs as well as the incised background areas. This skill and mastery of tools and equipment has not been equalled by artists in any culture dating from these early centuries.

Figure 5.7 *Staff Finial*. Chinese, Chin-T'sun, Period of Warring States, ca. 481–221 B.C.
Bronze; H. 5⁵/₁₆ in.
Cleveland Museum of Art, Purchase from the J. H. Wade Fund.

Bronze vessels inlaid with dazzling turquoise, malachite, gold, or silver were produced as richly ornamented objects. Of particular significance is a late *Staff Finial* in bronze (fig. 5.7), a six-inch mounting that cleverly combines both symmetrical and asymmetrical design in the same piece. Gold and silver inlays highlight the intricate interweaving of the dragon-and-bird motif. The positive and negative interchange seems at first confusing and unclear in terms of the representation of natural forms. Yet we can recognize the highly stylized animals if we concentrate on them as individual figures.

Walled Shang cities and such centralized power created a culture capable of mining and smelting ore, of providing workshops and foundries and master designers to model and mold bronze, "the precious metal." Bronze vessels were used for food and wine sacrifices to the great spirit, Shang Ti, "The First Ancestor." Although the Chou continued the Shang reverence for ancestors, they believed Heaven, or Sky, to be the supreme universal power. China moved from the Stone Age to the Bronze Age, from "an art motivated and prescribed by religious ritual to an art of playful inventiveness and rhythmic grace."[1]

1. John D. La Plante, *Asian Art*. 2d ed. (Dubuque, Iowa: Wm. C. Brown Publishers, 1985), p. 122.

Figure 5.8 Yin-yang symbol.

Chinese Painting

Poetry, calligraphy, and painting were considered to be the highest forms of expression in early China. The art of calligraphy was practiced for years by Chinese students before they became painters because the value of their work depended on distinctive qualities of brushwork. Many artists were followers of Lao Tzu (ca. 604 B.C.) and believed Tao or "The Way" enabled one to put oneself into the harmony moving through all of nature.

Meditation and contemplation of nature enabled the translation of natural forms into a graphic vocabulary of bold or shaded strokes (see colorplate 23). The materials themselves, black ink on white paper or silk—the interaction of dark and light—depicted ancient Taoist concepts of duality. Another precept that helped guide the Chinese in the execution of landscape paintings was the cosmological principles of *yin-yang*, or the synthesis of two opposite forces. The common graphic associated with yin-yang (fig. 5.8) represents the most basic principle used by the Chinese artist in establishing a unified relationship of the subject matter and the surrounding background in landscape painting. This duality was discussed in the Detroit tour and was termed *interchange*, in which positive (figure) and negative (ground) shapes are both important in the context of a painting. This interaction ensures completeness and coherence in the work and is as important to the Western artist as it was and is to the Chinese artist. The dualism of yin-yang, however, was extended to the use of mutual dependencies in Chinese landscape painting. The upper and lower parts were related and responded to one another not only in theme but in the quality of brushstrokes—the parts were complementary rather than separate and distinct portions of the painting. Balances were also achieved between qualitative portions of the painting: dark and thick were used as foils for light and thin; dense texture alternated with sparse texture; large was balanced against small.

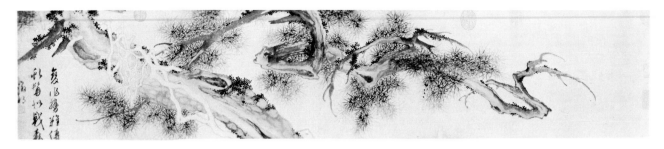

Figure 5.9 *Old Pine Tree,* handscroll. Painting by Wen Cheng-ming, Chinese, Ming Dynasty, 1470–1559.
Ink on paper; 10¾ × 53½ in.
Cleveland Museum of Art, Andrew R. and Martha Holden Jennings Fund.

First we see the mountains in the painting, then we see the painting in the mountains.

Li Li-Weng,
seventeenth century

Landscape painting was a subject capable of expressing many religious philosophies. Chinese artists could express the scholarly discipline and ordered relationships of Confucianism, the romantic natural harmony embodied in Taoism, or the subtle metaphysical spiritual insights of Buddhism. Ch'an reformed Indian Buddhism into a system that looked, sounded, and functioned as Chinese. Written texts and iconography were no longer as important as artistic expressions of spiritual insights. Painters most often worked from memory, but evidence shows that the Chinese also rendered landscape subjects from on-the-spot sketching.

Landscape painters over a period of many dynasties used a subtle range of muted colors. The full spectrum of intense colors commonly associated with Western artists were not available to the early Chinese artists. Black and gray ink monochrome, earth tones, and mineral pigments such as azurite and malachite contributed to the color variations. Symbolic brushwork was used to re-create landscape forms representing clouds, rocks, rivers, mountains, or foliage; other natural forms such as flowers, birds, animals, and figures were painted on a variety of surfaces including paper made from bamboo and cotton.

Trees and mountains have been dominant motifs in landscape painting in many cultures, but they were of particular concern to the Chinese artist. Mountains were usually depicted through a series of repeated "wrinkles" that illustrated the continual rhythm of the mountain ranges' contours somewhat like a topographical map

(colorplate 23). Characteristic mountain landscapes usually feature a central or "chief" mountain, which is taller than the others and often centered in the painting. Perhaps because the mist seems transitory and the vista inaccessible, there is a timeless and profound quality about these works. Such qualities or ideas seem to fit naturally within the realm of the artist. For example, the expressive pine branches in the scroll in figure 5.9 masterfully illustrate the highest form of brush control. The painting represents the nature of a pine rather than an unexpressive portrait of a single tree, a simple copy of branches and needles. Creating "essences" has long been a goal of the Oriental painter.

Three Basic Painting Formats

The history of Chinese painting includes many stylistic changes over the centuries; however, we will need to make some generalizations in our tour to formulate aspects of a Chinese style. One way to accomplish this is to explain the three basic formats with which the professional Chinese painter was involved: the *handscroll,* the *hanging scroll,* and the *album leaf.*

The *handscroll* was a significant form of painting because it combined a beginning, development, and end in a single work varying in length from one foot to forty feet. It was stored in a roll and viewed, as it was unrolled, from the right to the left, allowing it to be appreciated in the same manner as it was painted. The spectator could reroll what had been viewed and in effect experience an ever-changing panorama that added the element of time to viewing landscape painting (fig. 5.10).

Most artists used soft-bristled brushes to create intricate patterns and detail in their landscapes. Notice in figure 5.10 the use of repeated dots to create a buildup of dark areas that flow in an even transition from shape to shape. On the other hand, areas are sometimes left blank by the Chinese painter to point to the importance of the negative areas in the composition. They suggest infinity with the sky free of distracting clouds or other surface treatments designed to fill open space.

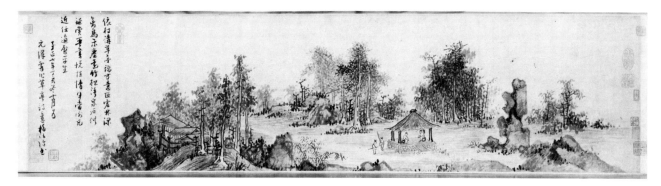

Figure 5.10 *Poetic Feeling in a Thatched Pavilion,* handscroll.
Painting by Wu Chen, Chinese, Yuan Dynasty, 1280–1354.
Ink on paper; 9⅜ × 39⅛ in.
Cleveland Museum of Art, Leonard C. Hanna, Jr., Bequest.

Owners and artists often stamped their paintings with red identifying seals of well-designed calligraphy that were things of beauty in themselves. They also inscribed poetic thoughts on the painting in vertical rows of calligraphy. These may also have been added by a friend or a collector of the work, because there has always been a great deal of pride of ownership and draftsmanship associated with Chinese culture. This writing and stamping on the paintings was a valued aspect of the work in Oriental art and provided a balance of shapes in the composition.

The Chinese painter also created *hanging scrolls,* which were conceived longitudinally and which gave a vertical disposition to the subject matter. When not in use, the hanging scroll was stored in a roll similar to the handscroll and was equally portable (colorplate 23). To view the work, as intended by the artist, it is necessary to start at the bottom and move up. Various eye levels are presented in the upward movement so that we will "read" the work completely. It is another example of the Chinese painter capturing the mood by overlapping clusters of rock and foliage so they seem to move back in space. Centuries of painters to follow were to be inspired by just such a recreation of forms and not by a representational, three-dimensional copy of nature. An even distribution of visible brushstrokes gives a sense of interrelatedness to the foreground, middle ground, and background. The artist's struggle to create art forms that capture their natural counterpart can also be seen by comparing an actual photograph of the setting (fig. 5.11).

The *album leaf* format was often used with other leaves to form a sequential book, combining poetry, painting, and calligraphy. Some album leaves, however, like *River Village-Fisherman's Joy* (colorplate 25) were originally used as fans. The painting usually began by first outlining the subject matter and later filling in the appropriate color and washes. Examine the lines carefully and notice how the thickness of some lines adds a

Figure 5.11 Photograph of mountain range used as subject for the painting in colorplate 23.

dimension of form and volume to the shape. (Recall our discussion of this technique in Tour 1.) Other lines that do not vary in size are used simply as enclosures for subject matter. This type of linear treatment lasted for many centuries and was combined with other techniques to create a tradition for the Chinese painter.

Pausing to examine *River Village* more closely, we see other techniques used to achieve feeling and quality in the formal composition of the fan.

1. Recession into space is implied by using diminishing sizes and alternating areas of light and dark. Predominantly horizontal and flat linear shapes are stacked vertically in space to create depth, and the middleground seems to hang in space due to the lack of linear or aerial perspective. The subject matter creates a sense of unity and logical progression into space without faithfully copying all the natural forms.

2. The mountains, buildings, and trees are "types" rather than actual renditions of reality. The shapes are developed parallel to the vertical picture plane where accurate detail is avoided and no particular locale is described. Only the essential character of the subject is presented; local color and other clues to the location are not given.

3. A path of vision proceeds from the lower right corner to the mountain range in the upper left, and then veers to the right, returning to the original position through the trees.

4. There is a lack of a specific light source.

5. The fan shape offers the illusion that the viewer is looking through a window, because of the space beyond the top, sides, and bottom of the image.

6. Asymmetry is used in the fan, as in most other Chinese paintings.

These characteristics can be found singly or collectively in many Chinese works. Tradition dictated that Chinese artists imitate earlier artists and copy their techniques of composition and style, adding innovations as they expressed their own spiritual discoveries.

Chinese Sculpture and Ceramics

Moving from the painting galleries to the sculpture court, we see a number of works using Buddhist themes. One of the most popular forms on display is referred to as the *Bodhisattva,* or "Buddha-to-be." A number of works at the museum are devoted to a particular bodhisattva, a compassionate spiritual being known as *Kuan-yin* (kwahn-yin′), who appears in many paintings and sculptures. The first thing we see in a wooden statue of Kuan-yin carved during the thirteenth century (fig. 5.12) is the conventional manner in which drapery hangs from the figure and clings to the body form. The posture of the Kuan-yin figure is, for the most part, casual and relaxed.

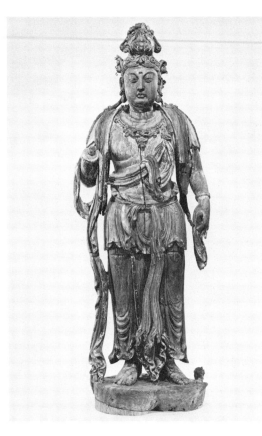

Figure 5.12 *Bodhisattva.* Sculpture, Chinese, Chin Period, thirteenth century, 1115–1234.
Wood—cryptomeria?; 57½ × 22½ in.
Cleveland Museum of Art, Andrew R. and Martha Holden Jennings Fund.

We can appreciate this carved figure all the more if we remember that it started as a solid tree trunk. It was sculpted one chip at a time, finally arriving at the intricate and elaborate result we see here. The subtractive process of sculpture involves eliminating small scoops of wood and gradually refining the surface until the desired result is achieved. This process was also used in sculpting the Venus figures from stone, as we saw in the British Museum tour (see pp. 92–93). The only difference was in the types of tools used in the process.

The famous *Cranes and Serpents* (fig. 5.13) guards the entrance way to the Chinese collection. We can see in the surface decoration the remarkable skill and talent of Chinese artisans. This awesome ceremonial pair, dating from ca. 600–222 B.C., is considered to be one of the most outstanding objects in the Oriental collection. These creatures, which are over two thousand years old,

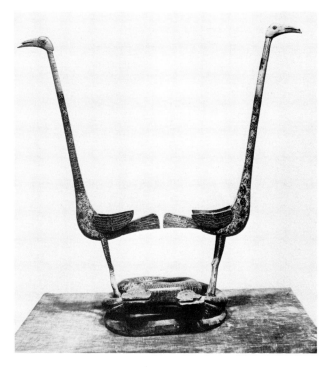

Figure 5.13 *Cranes and Serpents,* drum stand. Sculpture, Chinese, late Chou Period, ca. 600–222 B.C.
Lacquered wood; 4 ft. 4¼ in. × 4 ft. 1 in.
Cleveland Museum of Art, Purchase from the J. H. Wade Fund.

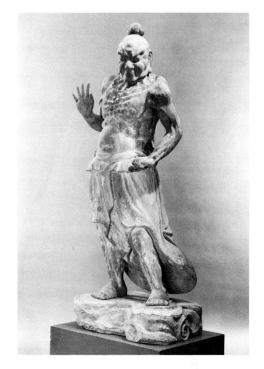

Figure 5.14 *Guardian Figure.* Sculpture, Japanese, Shiga Prefecture, Kamakura Period, 1185–1333.
Wood; H. 66⅛ in.
Cleveland Museum of Art, Leonard C. Hanna, Jr., Bequest.

could easily be mistaken for contemporary pieces. The intricately applied decoration on the birds and serpents is subdued by the subtle simplicity of the larger forms created by the necks, wings, and bodies of the birds. It would seem that the Chinese artist was able to combine simplicity with elaboration in unique ways.

Some Chinese ceramic forms also feature the kind of dominant, stylized characteristics as those found in Chinese sculpture. The porcelain *Wine Cup* (colorplate 22), produced in one of the ceramic centers that flourished during the Ming dynasty, illustrates how design motifs are made to look simple, yet are elaborately conceived as they encircle the entire cup. The artist created shapes that move fluidly to neighboring shapes in an almost continuous fashion across the surface, at the same time complementing the outside contour. Upon close examination, we see that devotion to craftsmanship was a common denominator in Chinese art objects regardless of their size and type. This cup is only 1⅞ inches high, but if we could slowly turn the cup in our hands, the decoration would unfold like a handscroll, with formal design characteristics similar to those of landscape painting.

THE ART OF JAPAN

Japanese art, while contrasting sharply with Chinese art, reveals an equally skillful and sensitive style. Differences can be found in the use of coloration, contrasts, and the decorative quality of design. Similarities exist because the Chinese style migrated to the Japanese islands and was influenced as well by the Buddhist religion.

Japanese Sculpture

Wood carvings from the Kamakura period of thirteenth-century Japan represent an important sculptural innovation. Portions of works like the *Guardian Figure* (fig. 5.14) were formed individually and then assembled, thus allowing freedom in the sculpting process. Some sculpture was carved from solid blocks, but these often warped and cracked due to weather and age. To avoid this problem, artisans employed methods of laminating blocks and slabs together. The *Guardian Figure* is a typical example of the Kamakura image with all of its movement, energy, and expression of ferocity. The natural flow and texture of clothing and figure parts were achieved largely through **undercutting** (see fig. 7.7).

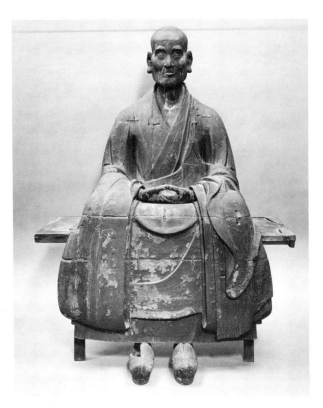

Figure 5.15 *Portrait of Hoto Kokushi (Priest Kakushin).* Sculpture,
Japanese, Kamakura Period, 1185–1333, ca. 1285.
Wood with traces of lacquerlike coating (?); H. 36 in.
Cleveland Museum of Art, Leonard C. Hanna, Jr., Bequest.

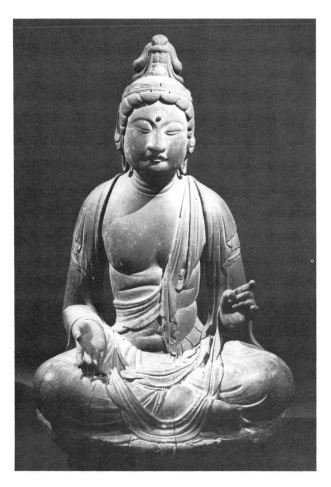

Figure 5.16 *Nikko, the Sun Bodhisattva.* Sculpture, Japanese,
Konin Period, ca. 800.
Carved from one block on *taxus cuspidatus,* a Japanese yew; H. 18⅜ in.
Cleveland Museum of Art, John L. Severance Fund.

One of the masterpieces in the collection is the *Portrait of Hoto Kokushi* (hoh-toh koh-koo'-shee), a Zen priest of the Zen Buddhism sect (the most rigorously disciplined form of Buddhism) that arose in Japan in A.D. 1200. Many Zen priests extended to their artworks the Zen principles of discipline and obedience. The sculpted priest in figure 5.15 conveys a sense of the sixty to eighty years of rigid, daily and hourly, Zen discipline and the kind of serenity achieved through such devotion. The sculptor captured the essence of this discipline in the calm posture and facial expression, which illustrate how clearly the priest is at peace with himself. This compelling figure is another example of the expertise of Japanese sculptors striving to achieve the Buddhist standard of perfection. We have to look ahead to the Baroque and Renaissance sculptors of Europe to find other artists with similar levels of skill.

An outstanding figure, which underscores the potential of the Japanese artist, is the Buddhist sculpture *Nikko, the Sun Bodhisattva* (fig. 5.16), a supreme artistic achievement. As you study it, do you feel a sense of compassionate warmth and dignity? Note the gesture and feeling expressed by the hands and the perfectly rendered fluid nature of the clothing. Similar to the Kamakura figures, *Nikko* was carved from one block of

wood, in this case from the Japanese yew tree. We can gain some idea of the discipline and skill of the sculptor if we analyze the way he sculpted the wood and at the same time avoided cutting in too far, which would have destroyed the figure parts (fig. 5.17). Imagine how the artist eliminated large wood chunks around the hands. Add to this concern the need to work on the entire block a small piece at a time, eliminating chips of wood from all sides. Possibly the artist used a sketch on paper or in clay to help visualize the area to be eliminated.

The Nikko figure reveals marks left by the gouge as it passed over the surface of the base under the figure. The artist chose to leave these marks, possibly to serve as contrast to the smoothness of the flesh and clothing. Painters also provide this kind of contrast of surface treatment in works with rough and smooth textures or dark and light values (see discussion on texture in Tour 1).

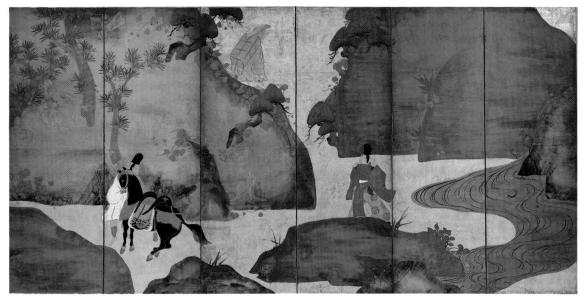

Plate 24 *Utsunoyama: The Pass through the Mountains,* Fukaye Roshu.
Japanese, Edo Period, (1699–1757). Six-fold screen; opaque color on gold ground, 53⅜ × 107 in. (135.6 × 271.8 cm.).
CMA, John L. Severance Fund.

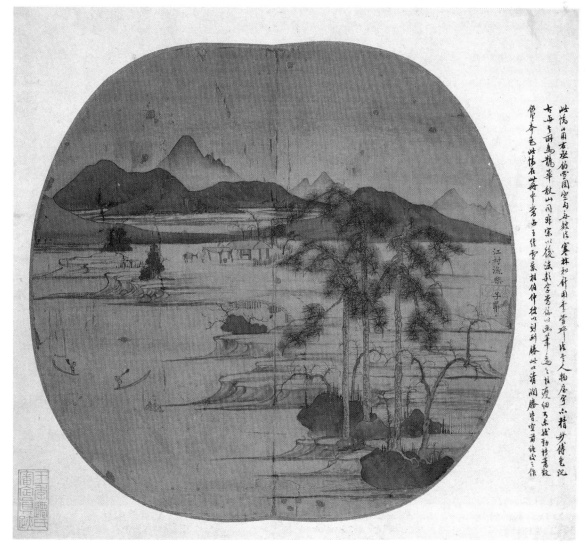

Plate 25 *River Village—Fisherman's Joy,* Chao Meng-fu.
Chinese, Yuan Dynasty, (1254–1322). Album leaf: ink and color on silk, 11¼ × 11¹³/₁₆ in. (28.6 × 30 cm.).
CMA, Leonard C. Hanna, Jr., Bequest.

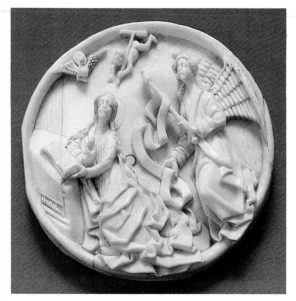

Plate 26 *Medallion with the Annunciation.*
Germany, Upper Rhine, ca. 1470. Ivory, diam.: 2¾ in. (7 cm.).
CMA, Andrew R. and Martha Holden Jennings Fund.

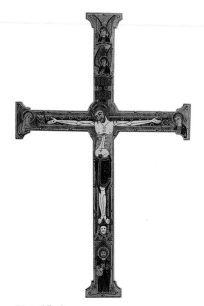

Plate 27 *Cross.*
French, Limoges, Lomousin, ca. 1189, by the Master of the
Grandmont Altar. Champlevé enamel and gilding on copper,
26⅜ × 16½ in. (67 × 41.9 cm.). CMA, Gift from J. H. Wade.

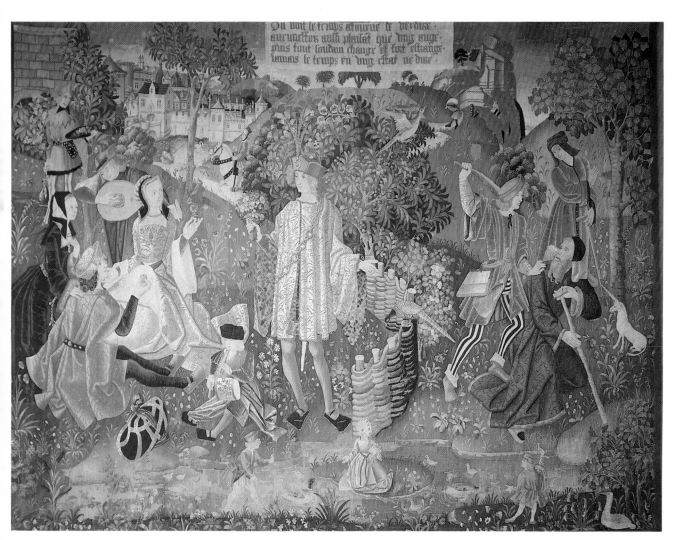

Plate 28 *Time.*
French, Valley of Loire, 1500–1510. Wool and silk, 133½ × 173 in. (339 × 439.4 cm.).
CMA, Leonard C. Hanna, Jr., Bequest.

Eliminating larger areas slowly in order to not go beyond the imagined figure. The work progressing from the general to the specific.

Original block

Areas to be considered first and chipped as larger chunks. Not necessarily figure surfaces.

Subject in the interior of the block. Contours to be determined during the act of sculpting.

Figure 5.17 The Nikko figure shown in the subtractive stages of being carved from a solid block of wood.

Japanese Screen Painting

Japanese landscape painters developed a style that contrasts sharply with the subtle brush and ink work of the Chinese. Japanese painters approached design and color differently than the Chinese artist. Japanese paintings were generally more vigorous and bold than the quiet landscape paintings of the Chinese. The Japanese were also more concerned with humans in a story-telling situation. Their compositions used shape, color, and line in a more decorative fashion; ink and color were applied in a flat manner and often in conjunction with a gold or silver background.

One of the easiest ways to see this is to compare a Japanese hanging scroll (fig. 5.18) and a Chinese hanging scroll (colorplate 23). The Japanese brushwork is obviously more angular than that of the Chinese, and the Japanese hard-edge technique provides for sharper contrasts and a clearer sense of movement from bottom to top, all of which are not as apparent in the Chinese landscape. Perspective was often tilted in Japanese painting to give us a bird's-eye view of buildings without roofs or

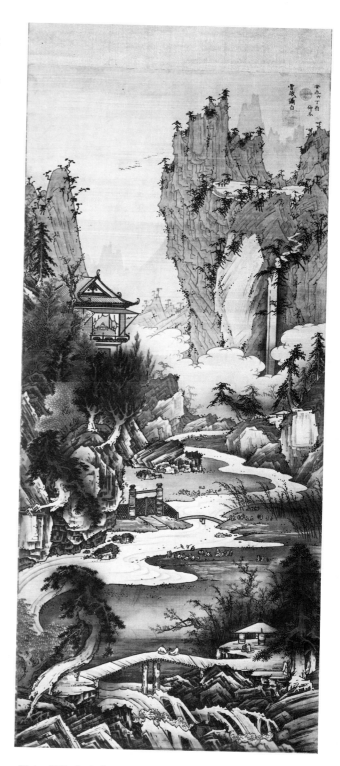

Figure 5.18 *Orchid Pavilion Gathering,* hanging scroll. Painting by Soga Shohaku, Japanese, Edo Period, 1731–1781.
Ink on silk; 48 5/16 × 21 7/8 in.
Cleveland Museum of Art, Purchase from the J. H. Wade Fund.

Figure 5.19 *Yuzu Nembutsu Engi* (*Efficacy of Repeated Invocations to the Amida Buddha*), handscroll. Painting, Japanese, fourteenth century.
Ink, color, and gold on paper; 11¹⁵⁄₁₆ in. × 45 ft. ¾ in overall.
Cleveland Museum of Art, Mr. and Mrs. William H. Marlatt Fund, John L. Severance Fund, and Edward L. Whittemore Fund.

side walls. The handscroll (fig. 5.19) is typical of how the Japanese artist did what Westerners sense as taking liberties with linear perspective.

Screen painting called *Yamato-e* (yah-ma′-toh-eh′) emerged as a Japanese art form around the eleventh century. Painted screens, which were often made in two, four, and six sections, were originally used in a practical manner to brighten dimly lit interiors of temples and homes. They were made to be viewed from right to left in the same manner as scrolls. *The Pass through the Mountains* (colorplate 24) illustrates the placing of shapes, which for the most part are abstract, in dramatic arrangements. In fact, parts of the screen could be viewed as a stage setting. The design of *The Pass* is composed of shapes that interchange and form a pattern of figures and background of equal importance. The lightest area, which is winding up the middle of the painting, is made up of squares of gold leaf, serving as ground support for ink and color. The painting is brought together by strategically placed red floral accents over the entire surface. Imagine for a moment that the shapes of foliage in the middle and background are flats placed on a stage, and that the rocks in the foreground are also flat and standing vertically in front of the actors. This gift of predictably composing the painting surface was a typical Japanese innovation.

Japanese Woodcuts

Woodblock printing was used to create multiple and therefore inexpensive Buddhist religious images and to illustrate books in East Asia as early as the eighth century. The Japanese elevated the technique of producing affordable art prints during the Edo (Tokyo) Period of 1615–1868. The rise of a prosperous merchant leisure class at that time and the resulting changes in life-styles produced the art of *ukiyo-e* (oo-kee′-oh-eh′), "pictures of the floating world." The Buddhist concept of transience—a "floating life"—led to a renewed appreciation of everyday pleasurable occurrences. Music, dancing, games, theater, festivals, love, fashion, hairstyles were all rendered by *ukiyo-e* artists.

The School of *ukiyo-e* started in painting but was soon reflected in hundreds of thousands of woodblock prints, conveniently designed for mass consumption and able to reflect rapidly changing popular styles and tastes.

The West learned of Oriental art through woodcut prints rather than through older, more traditional Oriental art forms. French impressionists were influenced by the shapes of Japanese woodcut compositions (see Tour 9), and thanks to the postimpressionists, fine Japanese print collections can be found throughout Europe and America.

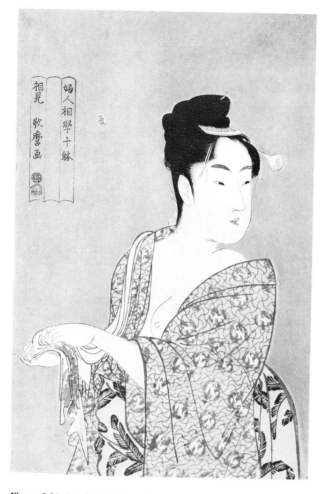

Figure 5.20 *Uwaki, Half-Length Portrait,* from the series *Fujin Sogaku Jittai: Studies in Physiognomy; Ten Kinds of Women.* Print by Kitagawa Utamaro, Japanese, Edo Period, ca. 1794; 1753–1806. Color and mica on paper; 14¼ × 10 in. Cleveland Museum of Art, Bequest of Edward L. Whittemore.

Figure 5.21 *Fuji in Clear Weather.* Print by Katsushika Hokusai, Japanese, ukiyo-e School. Color woodblock; 10¹/₁₆ × 14¾ in. Cleveland Museum of Art, Bequest of Edward L. Whittemore.

Figure 5.22 The basic shape of figure-field in the Katsushika Hokusai print of Mount Fuji.

Three of the works selected for viewing on this tour are attributed to the famous masters of the eighteenth and nineteenth centuries: Utamaro (oo-tah-mah′-roh), Hokusai (hoh-koo-sah′-ee), and Hiroshige (hee-roh-shee′-geh). Prints of beautiful women became very popular with Oriental urban consumers as well as with audiences in the West. One painter in particular, Kitagawa Utamaro (1753–1806), became famous for creating a standard of worldliness and sensuality in his female subjects. Notice in figure 5.20 that Utamaro showed more interest in the quality and expressiveness of line than in the filling of background with distracting subject matter. We can more easily appreciate the true nature of the subject's face, hair, and costume because only the figure is offered as the dominant shape. The subtlety of lines on the face, hair, ornaments are all the more delicate when compared to the thicker lines used on the garment. We can thus see the artist's intent to express differing weight of forms.

Following the death of Utamaro in 1806, Katsushika Hokusai (1760–1849) became popular as an artist with a concern for scenes from everyday life. His experiments with Western motifs and techniques led to a renewal of the Japanese landscape through the print medium. Figure 5.21 is the eighth of thirty-six prints in the famous series entitled *Fuji in Clear Weather.* Color was used in a stronger fashion, lacking the subtle changes ascribed by earlier woodcut artists. This near flat use of color complements the simple use of two abstract shapes as the foundation for the work. These compositional shapes can be reduced to a basic figure-ground division (fig. 5.22). A sense of balance is achieved with the calligraphy block in the upper left corner, contrasting with the heavier mountain shape in the lower right quadrant. The reversal of darker tree forms in the lower left with the repeated light cloud shapes above are complemented by the dark mountain shape, white snow lines, and cloud forms on the right half of the print.

Figure 5.23 *Yokkaichi* (*The Hurricane*) (*Tokaido Gojusan Tsugi*).
Print by Utagawa Hiroshige I, (1797–1858), Japanese.
Color woodblock; 14$^{15/16}$ × 9$^{15/16}$ in.
Cleveland Museum of Art, Gift of Mrs. T. Wingate Todd.

Another popular landscapist working in the tradition of *ukiyo-e* was Utagawa Hiroshige (1797–1858), whose prints were more realistic than those of Hokusai but were still as fresh and innovative in their use of landscape subjects. The composition of *The Hurricane* (fig. 5.23) is similar to Western landscape painting in the placement of horizon, sky, and ground. This approach is also evident in the way he placed the ground plane in perspective leading into the distance from the lower left—a treatment of space not unlike the work of Claude Lorrain. A unique feature of many of Hiroshige's landscapes was his portrayal of seasons and various weather-related subjects. *The Hurricane* is one such work from his celebrated series entitled *Fifty-Three Stations of Tokaido.* He created a feeling of movement toward the left with the wind moving the tall grass, the flowing coat of the person on the foot bridge, and the man chasing his hat. However, the dynamic tension we sense in this composition is the result of an equal pull to the right as portrayed by foot bridge, tree trunk, foreground boat, and the movement implied by the person walking. This strong pulling in both directions creates the final mood and energy felt in the print.

Leaving the lower Oriental galleries, we will proceed to the rotunda to begin our tour of art in medieval Europe.

MEDIEVAL EUROPE

Since the dates and artists of the medieval period overlap with the beginning of the Renaissance period, it will be difficult to make a clear distinction between this tour and the next. As in any gallery visit, the actual movement from period to period is not always chronologically arranged, and many variables affect how we see artworks.

Our discussion of the medieval period begins with art styles that have been labeled **Early Christian** and **Byzantine,** and date from the first century A.D. to about A.D. 700. Early Christian art is so named, at least in part, because it presents narratives based on scriptures, and truth to the narrative overrides the concern for what we think of as pictorial accuracy. However, the style is also a derivative of the Greco-Roman tradition. In the two sculptures *The Good Shepherd* and *Jonah under the Gourd Vine* (figs. 5.24 and 5.25), we see both the narrative aspect of early Christian art as well as the graceful lines of the Greco-Roman influence. The shepherd is not merely a pastoral portrait but a symbol of Christ as the Good Shepherd; Jonah, a scriptural personage, is shown in the classical reclining position.

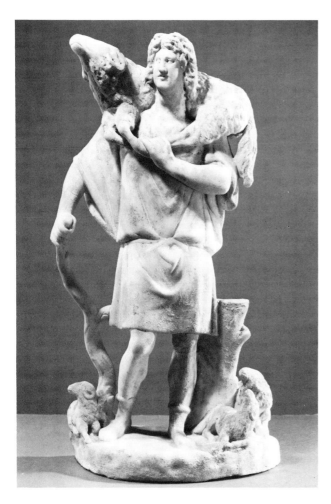

Figure 5.24 *The Good Shepherd.* Sculpture, Eastern Mediterranean, probably Asia Minor, early Christian era, ca. 260–275.
Marble; 19¾ × 10⅛ × 6¼ in.
Cleveland Museum of Art, John L. Severance Fund.

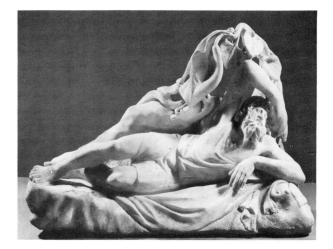

Figure 5.25 *Jonah Under the Gourd Vine.* Sculpture, Eastern Mediterranean, possibly Asia Minor, early Christian era, ca. 260–275.
Marble; 12⅝ × 18¼ × 6⅞ in.
Cleveland Museum of Art, John L. Severance Fund.

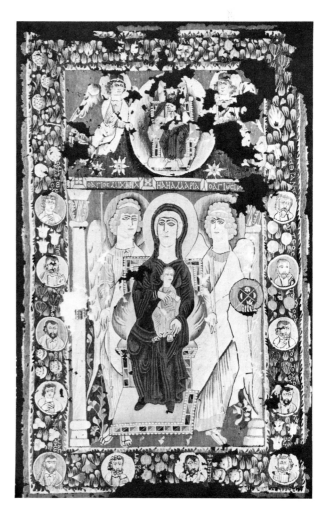

Figure 5.26 *Icon of the Virgin.* Tapestry, Egypt, Byzantine Period, sixth century.
Wool; 70⅜ × 43¼ in.
Cleveland Museum of Art, Leonard C. Hanna, Jr., Bequest.

In about the fifth century, Eastern influences began to appear in architecture in the form of intricate spires, elaborate minarets, and extensive **mosaics.** In painting, this style, which came to be known as Byzantine, was characterized by a highly stylized rendering of human figures, most often in a frontal position. Colors were rich with lavish use of gold, and the subject matter was, of course, still religious. Typically, there is very little feeling of deep space in Byzantine art; objects tend to be decorative, even abstract, on a flat, neutral surface. The tapestry *Icon of the Virgin* (fig. 5.26) exemplifies the Byzantine style.

Medieval art of the eighth to the tenth centuries is called **Carolingian**—after the emperor Charlemagne—and is characterized by a combination of stylized figures and realistic icons. While this style continued in the Early Christian and Byzantine narrative tradition, much of the emphasis shifted to a highly stylized treatment of subject matter resembling art of classical antiquity.

Figure 5.27 *Medallion, Bust of Christ.* German, Frankish, second half of eighth century.
Cloisonné enamel on copper; 1 15/16 diam.
Cleveland Museum of Art, Purchase from J. H. Wade Fund.

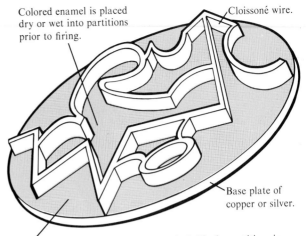

Colored enamel is placed dry or wet into partitions prior to firing.

Cloissoné wire.

Base plate of copper or silver.

Base plate is enameled and permanently holds the partitions in place. They may also be soldered to the base metal before the first firing.

Figure 5.28 Cloisonné enameling process.

Medieval Icons

Medieval Europe was divided by politics, language, and tradition. Visual Christian symbols provided a common understanding and a unifying force. The form of a fish, for instance, was a symbol recognized as meaning "Christ" or "Christian." In addition to Christ's exhortation to his fishermen disciples to become "fishers of men," the Greek word for "fish," *ikhthys,* is an anagram for Jesus Christ. As we learned in our tour of the Guggenheim, art communicates with symbols, and religious symbols or icons can represent vivid religious experiences. Anonymous medieval artists and craftsmen dedicated their lives to designing liturgical furnishings, furniture, jewelry, illuminated manuscripts, sculpture, paintings, and architecture.

Many of the religious images in the Cleveland collection are small and uniquely abstract in design. One of the rarest examples in the collection is the *Medallion—Bust of Christ* (fig. 5.27), in which the figure is surrounded by some traditional symbols of Christ: Alpha and Omega, signifying the beginning and ending of all things. Even though the work is small in size (only 1.9 inches in diameter), it imparts a feeling of monumentality because the artist treated the small surface as if it were large. This is achieved with attention to simplicity, and a degree of abstraction that is as evident here as it is in stained glass windows many times larger. The material is a **cloisonné** (kloy-soh-nay′), or enameled work on copper, achieved by fusing molten glass to the surface of metal. Wall partitions, or fences, of metal are fixed permanently to the background base plate and serve to separate colors prior to the melting process in a kiln heated to around 1800 degrees Fahrenheit (fig. 5.28).

Besides the Alpha and Omega and the Cross, hundreds of other medieval images served as Christian symbols. The dove, for instance, symbolized peace, purity, and the Holy Spirit. Water symbolized baptism and rebirth. The halo represented saintliness and the skull represented Golgotha, the place of Christ's crucifixion, and the vanity of earthly life. Flowers assumed various meanings: the rose for martyrdom, the lily for purity, the iris for Mary's sorrow. Many borrowed images such as grapes, which had symbolized the Roman god of wine, took on sacramental significance for the Christian.

Romanesque Art

By the eleventh century, most of Europe was Christianized. Churches sprang up in every village. It wasn't long before many of the fire-prone wooden roofs of early churches were replaced by vaulted stone structures, demanding thick stone walls to support them. These rounding arches and vaulting techniques, inspired by early Roman influences, had been revived by Charlemagne a century before. The Romanesque style of architecture, named after the Roman influence, used Roman masonry techniques—vaulted stone roofs, and rounded arches. This Romanesque architectural style spread throughout Europe. In spite of regional variations, Romanesque churches all created a fortress-like,

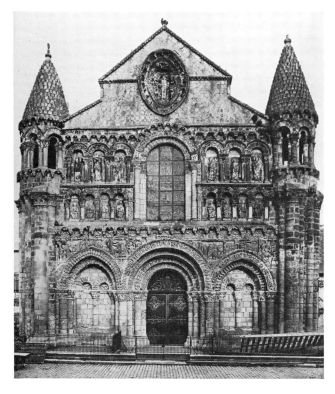

Figure 5.29 The Romanesque style of architecture. Notre Dame la Grande, Poitiers (France). ca 1130–45.

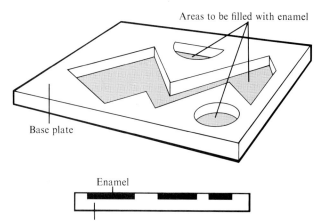

Figure 5.30 Champlevé enameling process.

Areas to be filled with enamel

Base plate

Enamel

Side view of metal base plate with enamel filling the etched areas

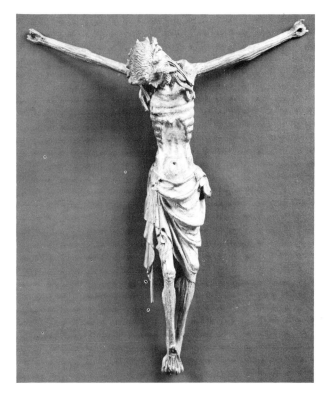

Figure 5.31 *Corpus*. Sculpture, Germany, Middle Rhenish (Cologne), fourteenth century, ca. 1380. Walnut; H. 16⅜ in., Armspan 14½ in. Cleveland Museum of Art, Andrew R. and Martha Holden Jennings Fund.

solid, protective interior. For example, note how the Romanesque church, Notre Dame la Grande (fig. 5.29) appears heavy and firmly planted. Most longitudinal floor plans were based on the Roman **basilica** plan of a central nave and side aisles with upper galleries.

The powerful religious feeling of the time was expressed in the Romanesque *Cross* (colorplate 27) made with an enameling process called **champlevé** (shamp-leh-veh′) (fig. 5.30). In this process, the design is etched or "cut" by acid into the top of the base plate to a level just below the surface. These areas are filled with enamel and fired many times in order to bring the surface flush with the top of the base plate. The cross also contains areas filled by **gilding** a thin layer of gold to some parts of the background.

An interesting comparison can be made between the enameled crucifix and the walnut *Corpus* (fig. 5.31). While both are emotionally charged, one is highly stylistic and the other is quite naturalistic. The enameled figure is divided into many small, flat, decorative units that flow from one to the other forming a symbolic body of Christ. The shapes forming the wooden figure were created with a directness thought by many to be possible only with the swift brush of the painter. The simplicity and unstudied look of the wood crucifix is misleading, since we would assume that the lack of anatomical detail would mean a loss of expression and feeling. However,

the opposite is true; we see the torment, frailty, and suffering first, and only after careful scrutiny are we aware of the sculptor's selection of the most expressive stage to call the work complete. A high level of emotionalism was portrayed with what seems to us to be a minimum of effort. Both Christ figures were conceived with regard to the relationship of individual body parts working together as shapes rather than with strict attention to anatomical accuracy.

Although we tend to think of large cathedrals when we think of medieval art, the galleries are full of works surprisingly different in size and scale, using rich and varied forms of expression. One of these forms is a medallion in ivory (colorplate 26), which is slightly smaller than the circumference of an average coffee cup. However, the size of this work does not diminish its impact on the viewer. When we compare it with the cloisonné *Medallion,* we are conscious first of the similar way the craftsmen have carved the subject matter in order to complement the circular forms. Consider what changes in design would have had to be made if the subject matter had been placed in a rectangle instead of a circle. Notice the shadows cast by the ivory medallion's positive areas—the artist consciously created, in effect, a three-dimensional type of chiaroscuro. The overlapping forms and the feeling of depth from the front level to the background adds a sense of recession into space, which was not a factor in the enameled medallion where the subjects seem suspended in vertical space. If we look ahead to the Louvre Tour we can compare this medieval piece with a sculpture of the baroque period. The Saint Teresa

sculpture (see fig. 7.6) was invested with folded drapery patterns similar to those on the ivory medallion. The drastic difference in size between the altarpiece and the small ivory medallion underscores again the artists' need to design parts in relationship to one another and to the whole.

Artifacts from the Gothic Period

The architecture of the Gothic period mirrored the rise of the great European cities. This period, the twelfth through the fifteenth centuries, gave birth to the spired cathedral—an ambitious, towering structure symbolizing the Christian's lofty striving toward heaven.

The Romanesque and the Gothic periods each exhibit a characteristic style in architecture that was a result of changes in building methods. There is religious significance in the development of Gothic methods of construction, for builders wanted to allow light (for a symbolic reason) into the heights of vaulted interiors. The Gothic cathedral at Milan (fig. 5.32) seems much lighter than

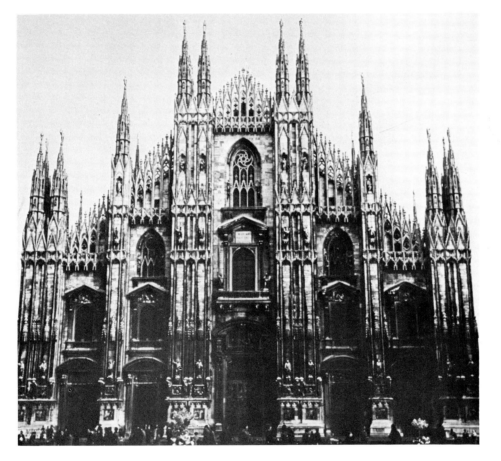

Figure 5.32 The Gothic style of architecture.
Milan Cathedral, 1386.
Courtesy of the Italian Government Travel Office, Chicago, Ill.

the Romanesque church (fig. 5.29) and appears to be reaching upward. As you can see, the Gothic style is obviously more vertical, highly elaborate, and ornamented. The pointed arches carry both architectural and religious significance. Aside from the fact that the lofty arches point toward heaven, they are practical because the weight of the arches is distributed and reduces the need for massive supports. Gothic architects therefore had the freedom to design high-vaulted interiors and walls with windows (fig. 5.33). Dimly lit interiors gave way to walls of stained glass filling the cathedral with a spectrum of rich ethereal colors. Unity and visual power were achieved on a grand scale. Highly decorative pinnacles, breathtaking sweeps, stained glass, and relief sculptures characterized the Gothic structures.

These characteristics were reflected in Gothic painting in Europe where it reached its greatest stature in Siena and Florence, Italy. The altarpiece by Ugolino di Nerio (oo-goh-lee′-noh dee neh′-ree-oh) (active ca. 1305–39) *Madonna and Child with Saints* (fig. 5.34) follows a tradition established for using a large central panel flanked by smaller sections. The sections are constructed as a series of rounded arches topped by covering gables.

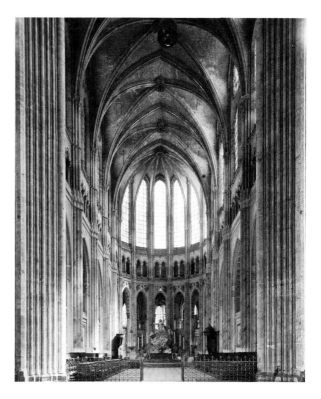

Figure 5.33 The Gothic arch allowed the freedom to design high-vaulted interiors.
Chartres Cathedral, France, 1194–1220. View of interior to the east.
Bildarchir Foto Marburg/Art Resource, NY.

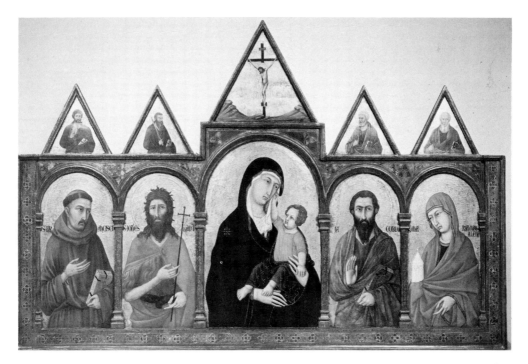

Figure 5.34 *Madonna and Child with St. Francis, St. John the Baptist, St. James the Great and Mary Magdalen.* Painting by Ugolino di Nerio da Siena, Italian, Sienese, fourteenth century. Polyptych panel—poplar; 48¼ × 75¾ (122.5 × 192.5 cm.) Cleveland Museum of Art, Leonard C. Hanna, Jr., Bequest.

Figure 5.35 *St. Lawrence,* by Tilmann Riemenschneider. Sculpture, German, ca. 1460–1531.
Painted and gilded lindenwood; H. 37¼ in.
Cleveland Museum of Art, Leonard C. Hanna, Jr., Bequest.

Figure 5.36 The large S curve and inner linear movements illustrating the dynamic tension in the *St. Lawrence* figure.

The Gothic mode of expression in the lindenwood sculpture of *St. Lawrence* (fig. 5.35) by Tilmann Riemenschneider (ree′-men-shneye′-der) is illustrated by dramatic darks and lights created by deep undercutting and amplified by painted and gilded wood surfaces. The observer may not even be aware that the figure is a carving, because it so skillfully projects the strong sense of presence, melancholy, and air of saintliness associated with the total work. Specifically, the face, pensive and almost alive, the rigid position of the hands, and the twisted clumps of hair frozen in space all contribute to a three-dimensional elegance.

On closer examination of *St. Lawrence,* we can see the emergence of a growing concern of the sculptor—the presence of an imaginary S curve that can be described as the longest line through the work (fig. 5.36). An axis line, in effect, allows the artist to see the movement of the larger parts in relationship to the key direction of the sculpture. Most sculptors do not carve blindly into the media without having some form of visual reference enabling all parts to be sculpted in proportion to

one another. The arrows in the drawing trace the viewer's path from bottom to top, and illustrate the inner movements set up by the various directions of the angular folds and positions of the figure parts. From this, it is easy to imagine other views with different linear movements. We can appreciate, therefore, the visual and manual skills of the sculptor and the extent of virtuosity needed to work in this demanding medium.

The artifacts in the medieval treasury range from parchment illuminations and manuscripts, with their skillful combinations of text and illustrations, to small bronze and enamel ornaments and plaques, and from column capitals to altars and large scale tapestries.

A **tapestry** is a heavy, handwoven pictorial design in which patterns are freely woven by the horizontal (*weft*) threads running crosswise to the vertical (*warp*) threads. The weaving process is done on the reverse side of the tapestry; it is a slow procedure usually requiring a team of artisans. Tapestries were used as murals to cover walls in residences, churches, and palaces. Even though the art has been compared to that of painting, a gap still

exists between the demands of weaving and the freedom allowed in painting. One task in the production of tapestry was the creation of a pattern, or **cartoon.** The weavers took over the second stage by completing the cartoon in thread on the loom; they had to be both technicians and artists in order to capture the subtleties created by the cartoon designer. Peter Rubens created cartoons for tapestries in the seventeenth century, and in the twentieth century, Picasso, Miró, and Matisse worked on similar commissions. Perhaps the most famous medieval tapestry is the *Bayeux Tapestry,* a precise medieval pictorial document in fifty-eight scenes. It currently hangs in the Town Hall of Bayeux, France.

An eleven- by fourteen-foot tapestry, *Time* (colorplate 28) is one of three silk and wool masterpieces dating from the late Gothic period (1500–1510). This detail shows the picturesque quality of life in the lush French countryside, stressing the pleasures of youth and the sorrows of age. Its medieval characteristics include shallow space, unnatural scale, and stylized figures. *Time,* due to its subtle modeling of drapery folds, could pass as a painting. While the intricacy displayed in the tapestry's natural forms is a testimony of medieval artisans' interest in humans' association with nature, it also illustrates their great skill in creating space and linear movements in the weaving process.

SUMMARY

Although it may be fairly easy to distinguish Far Eastern art from Western art, the differences between Indian, Chinese, and Japanese art are much more subtle. Indian sculpture is highly ornate and represents figures in a stylized manner reflecting their religious beliefs. Iconography and symbolism were more important than the true depiction of nature. Indian painting distorts reality in favor of storytelling priorities, while both Chinese and Japanese paintings are usually closer to nature.

Japanese art was often influenced by the Chinese and can generally be distinguished in paintings by more intense hues, bolder contours, and sharper contrasts. As a rule, Chinese painting is more subdued in terms of line, color, and texture. Regarding sculpture, it is much more difficult to draw a definitive line between the two styles. At least in early works, Japanese sculpture retained some of the Chinese conventions.

Medieval art relied heavily on the use of religious symbols and images as subject matter. The intensity of feeling for religious themes is reflected in emotionally charged depictions of the crucifixion and the ordeals of the martyrs. Both Romanesque and Gothic styles were influenced by advances in church architecture.

Figure 5.37 *Swallow and Lotus,* hanging scroll. Painting by Mu Ch'i, Chinese, Sung Dynasty.
Ink on silk; 36⅛ × 18½ in.
Cleveland Museum of Art, Purchase from the J. H. Wade Fund.

VIEWING EXERCISES

1. Let us compare a Chinese landscape (colorplate 23) with a Japanese landscape (fig. 5.18). Identify the similarities and differences between the two.

2. The negative areas in painting were as important to the Chinese as they were to Western artists. Examine the negative areas in figure 5.37 and discuss how open space is an important consideration.

3. The six-panel screen in figure 5.38 is not only an outstanding example of Zen painting, it also gives the viewer an excellent opportunity to view painting sequentially from right to left. Follow the artist's path by uncovering each panel from right to left and identify how the artist carries you from winter to spring.

4. The relief carving in ivory entitled *Journey to Bethlehem* (fig. 5.39) is an important artifact in the Cleveland medieval collection. Discuss the design organization of the subject matter.

5. As you listen to a recording of *The Play of Daniel,* compare its twelfth-century sounds with the style of Ugolino's altarpiece (fig. 5.34).

STUDIO EXERCISES

Suggested media and supplies: sketchbook; any drawing medium; watercolor or ink; oriental bamboo brush.

1. Refer to any contemporary painting and make a sketch with any drawing media in the style of the Chinese artists. Using a brush, rework your sketch with paint or ink by adding subdued color and calligraphy.

2. Repeat the exercise in no. 1 using the precepts of the Japanese artist.

3. Read the following Chinese poem from the T'ang Dynasty and make a pencil or pen-and-ink sketch of the tree described in any style you feel would express it best:

 Here is a tree older than the forest itself;
 The years of its life defy reckoning.
 Its roots have seen the upheavals of hill and valley,
 Its leaves have known the changes of wind and frost.
 The world laughs at its shoddy exterior
 And cares nothing for the fine grain of the wood inside.
 Stripped free of flesh and hide.
 All that remains is the core of truth.[2]

2. Burton Watson, trans., *Cold Mountain; 100 Poems by the T'ang Poet Han-Shan.* © 1962 Columbia University Press. By permission.

RESPONSES TO VIEWING EXERCISES

1. Both paintings provide a path through the landscape as well as a path of vision from bottom to top. The two artists "stacked" the planes of foreground, middleground, and background so that the paintings "read" vertically rather than in terms of deep space. There is also a comparable sense of open space that makes the subject appear to be larger than it is. The Japanese scroll is more decorative, with sharper contours, while the edges of the Chinese scroll seem to dissolve. The linear quality of the Chinese painting is lyric while the Japanese scroll is more angular.

2. The artists placed open, negative areas as a foil for the subject matter. The natural forms would be effective in a different way had the entire surface been filled in completely. The scroll also underscores a subtle balance in the composition. For instance, placing your finger over the swallow dramatizes its importance as an object in this open area. If it were not for the bird, the negative space would be too large in relation to the lotus plants in the corner.

3. Beginning at the lower side of the right-hand edge, your eyes proceed across the panels in two paths. One path can be found along the bottom of the tree shapes that lead into the courtyard in the far left panel, and another path follows the tops of the trees from right to left.

4. The overall composition is symmetrical. Mary, as the focal point, is assured of her importance by placement in the central foreground. Architectural detail—such as the two central, decorated columns; the rosettes; and the gaze of the two side figures—helps to ensure that she remains the dominant character in the scene.

5. Both the *Play of Daniel* and the altar piece rely on the use of repetition. In the music, simple rhythmic motifs are repeated often and may be compared to the repeated panels in the altarpiece. Both use religious themes and shallow space, which in the music is characterized by melody accompanied only by simple percussion instruments.

Figure 5.38 *Winter and Spring Landscape,* six-fold screen. Painting
by Shubun, Abbot of Shokoku-ji, Kyoto. Japanese, Muromachi
Period, ca. 1390–1464.
Ink and slight color on paper; 46¼ in. × 12 ft. 7½ in.
Cleveland Museum of Art, The Norweb Collection.

Figure 5.39 *Journey to Bethlehem.* Italy, Campania, workshop in
Amalfi, ca. 1100–30.
Ivory; 6⁷/₁₆ × 4⅜ in.
Cleveland Museum of Art, Leonard C. Hanna, Jr., Bequest.

The National Gallery

London, England

Tour 6

The Renaissance in Europe

The Gallery

The National Gallery of London is located on the north edge of Trafalgar Square. The influence of classical architecture can be seen in dignified, orderly rows of Corinthian columns, the pediment, and the dome of the building, which was completed in 1838. Although the gallery contains no sculpture, it boasts a magnificent collection of paintings, drawings, and prints, the majority of which dates from about 1400 to 1800.

On a typical day at the National Gallery, visitors are impressed by large numbers of children who enjoy taking quizzes prepared by the gallery staff to help them learn more about the works on display. Information on the collection is also available to the general public in many rooms. In addition, a book shop sells a wide variety of books, prints, and reproductions. Audiovisual shows are also available to help visitors appreciate the holdings.

No cameras are allowed in the gallery, and if visitors intend to sketch any of the works, they are cautioned to use pencils rather than ballpoint pens in case artworks are marked accidentally. Such restrictions are an attempt to preserve the masterpieces for posterity. The philosophy of the gallery seems to be to enhance the appreciation of two-dimensional arts and to nurture a sense of their exceptional value. Such a philosophy makes a tour of the National Gallery an ideal experience for both casual viewers and connoisseurs.

What a piece of work is man! How noble in reason! How infinite in faculty! In form, in moving, how express and admirable! In action how like an Angel! In apprehension, how like a God! The beauty of the world! The paragon of animals!

William Shakespeare,
Hamlet

Tour Overview

The French term *Renaissance,* which means "rebirth" or "revival," was first applied to the renewed interest in the artistic values of ancient Greece and Rome that began in Italy in the fourteenth century. The revival of classical ideals was, however, only a point of departure; that revival did not occur as a sudden burst of aesthetic insight. The medieval period was not without its own artistic achievements, and the process of development leading toward the dramatic changes evidenced in the Renaissance period came about gradually. We usually think of the Renaissance as spanning the years 1400 to 1600.

The most unique aspect of the advent of the Renaissance is that the people seemed to be aware that something significant was occurring. They sensed that they were different from their predecessors. In short, they *knew* they were in a renaissance. This is remarkable—especially considering that even today we are not quite sure what style period we are in, or what label will be applied to it by future historians. Considering all that took place in nearly every human field of endeavor, it is not an exaggeration to say that the Renaissance was truly an era of splendor.

Before 1400, the measure of all things was the religious order. The church had assumed authority for the interpretation of scripture and life and acted as arbiter of moral behavior. After 1400, people realized the importance of a more humanistic attitude toward life. Emphasis began to develop on the power of human intellect rather than on religious fervor, on rationality rather than on faith, and on the worth of a person's life on earth rather than in a hoped-for life after death. Important to the arts was the emergence of a new regard for the individual's interpretation of human existence and senses rather than reliance on traditional authority.

Certain key events contributed to these significant changes. The prosperous trading centers of Europe, especially those in Italy, produced individuals and families of considerable wealth. This wealth gradually became influential enough to nullify the controls of the church over the moral behavior of the citizenry. Secularism was

gaining ground very quickly and soon became evident in the arts: as we will see, one of the most striking new elements was the use of the nude as subject matter. Indeed, the first appearance of nudes in the Renaissance signaled the return of artists' interest in classical antiquity and mythological subject matter.

The new secular approach to the arts also resulted in more representational subject matter and the desire for intellectual control. In religious circles, the new emphasis on the importance of the individual and the human capacity for intellectual achievement eventually resulted in the Reformation, the most dramatic event in church history. The movement could also be viewed as the culmination of a series of events that resulted in a more informed and educated society. The invention of printing and the development of papermaking around 1450 made possible wider distribution of books including the Bible. The more people learned from reading, the more convinced they became of their own place in the natural order of the universe.

In the arts, oil as a vehicle for mixing pigment was developed. **Tempera** was the main medium before 1400, and while its luster and brilliance of hue are unmatched in other media, the Renaissance artist was more interested in the unity of subtle mixtures of hues and in their ability to imitate nature.

In a broader sense, discoveries in all the intellectual pursuits had an impact on the development of the Renaissance style in art. Through mathematics, Renaissance artists discovered the possibilities of a true rendering of nature through linear perspective. This study also revived interest in the aesthetically satisfying proportions of the golden section. With linear perspective came the discovery of **foreshortening,** a technical advance that showed organic subjects with their long axis lines projected toward the viewer. (See p. 160.)

The Renaissance revival of classical ideals in art can probably be traced to university scholars who became interested in classical literature. This revival had its counterpart in the visual arts in the adoption of classical subject matter—in fact, some of the new works were copies of original models, particularly of sculptures. Subject matter from Greek mythology rather than from the Bible became popular with painters. Despite these secular subjects, new compositional techniques, and an increased use of implied motion, the Renaissance artist maintained a rational control—an approach to the senses through the intellect. So while paintings took on a new dynamic appearance and as sculpture moved away from static monumentality, we shall also see in artworks of the Renaissance a tendency to maintain symmetry and balance. Human subjects released from their medieval impersonality were portrayed as individuals, revealing more about themselves. Their portraits tell us something about ourselves, for they appear as real men and women.

MASTERS OF THE EARLY RENAISSANCE

One of the most famous paintings of the fifteenth century launches our tour of the Renaissance style. Jan van Eyck's (yahn van ah-eek) (1395–1441) *The Marriage of Giovanni (?) Arnolfini and Giovanna Cenami (?)* (colorplate 33) exhibits some of the changes that are indicative of this new style. The most obvious feature of this rather small (32¼″ × 23½″) oil painting is the richness of texture in the folds of drapery and garments. Renaissance painters were fascinated by the almost limitless possibilities in depicting folds in cloth. We shall see how this fascination develops through the style period. Another obvious feature of the work is the very austere countenance of the two figures, perhaps a holdover of the preceding medieval period. While the subjects are secular, there are nevertheless numerous religious symbols found in the picture. A single candle burns in the chandelier, symbolizing an all-seeing God. A rosary hanging on the wall beside the mirror and the carved figures in the frame of the mirror are religious symbols as well. Margaret, the patron saint of childbirth, is carved on the back of the chair. The dog traditionally symbolizes fidelity. The shoes of both the man and the woman have been removed, possibly symbolizing reverence. The mysterious quality of all these symbols is only part of the total message that van Eyck invested in this painting. Look again at the mirror. The reflection reveals the man and woman from the rear, but there are two additional figures standing about where we, the spectators, should be standing. Are they and we witnesses to this marriage? There has been much speculation that one of the additional figures in the mirror represents the artist's self-portrait, since the inscription on the wall translates, "Jan van Eyck was here, 1434." Such subtle treatment of symbols, combined with an exceptionally skillful rendering of the subject matter, elevates this work far above the ordinary.

Artists like van Eyck were beginning to paint and sculpt real people as individuals rather than as general types. Giovanni Arnolfini was a silk merchant; his wife, Giovanna Cenami, was an Italian, born in Paris. Arnolfini's cool gaze and confident demeanor appear in his other portraits as well. Depicting the psychological characteristics of actual persons led to a highly refined art of portraiture, which culminated during this period in the portrait paintings by Leonardo da Vinci, Hans Holbein, and El Greco.

The realistic effects of light, especially natural light, were recognized by van Eyck and those artists who followed him, particularly his fellow Flemish painters. Oil paint enabled them to present light in ways Italian

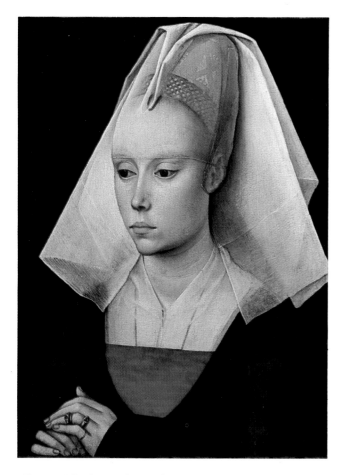

Figure 6.1 Rogier van der Weyden, *Portrait of a Lady.*
Oil on panel; 14¼ × 10½ in.
The National Gallery, London.

Figure 6.2 Masaccio, *The Holy Trinity with the Virgin and St. John,* ca. 1428.
Fresco.
Alinari/Art Resource, NY.

painters working in **fresco,** painting on wet plaster, at the time could not. Note the way he has introduced natural light through the window on the left to cast shadows on the objects in the room. This skillful use of light complements the three-dimensional quality suggested by the linear perspective of the room. Note also the strong chiaroscuro in Arnolfini's facial features.

Another master artist of early fifteenth-century Flanders was Rogier van der Weyden (roh-zhee-ay van der veye-dn) (1399–1464), whose finely executed *Portrait of a Lady* (fig. 6.1) reveals his acute sense of balance. The whole composition seems to consist of pyramids— one formed by the hands, another by the headdress, and another by the entire figure. These shapes are counterbalanced by inverted pyramids in the bodice, the neckline of the garment, and the bottom edges of the headdress. Again, the fascination with the effects of the cloth's shapes and planes nearly overpower the total design of the painting.

Perhaps even more spectacular than the skillful treatment of filmy cloth was Rogier's success in presenting his subject in a three-quarter view as opposed to a profile

or a frontal view. She is projected out into the viewer's space, and thereby invites the viewer in. The face displays a delicate modeling with soft light, and its three-dimensional quality provides the subject with a sensitive reality. It is Rogier's treatment of his subjects as thinking, feeling persons that set the standards for further development of Renaissance portraiture.

The early Italian Renaissance artist Masaccio (mah-sah'-chee-oh) (1401–28) was among the first to formulate and execute the principles of perspective. In his short life, Masaccio nearly revolutionized painting by his use of light, color, and linear perspective. A fresco, *The Holy Trinity with the Virgin and St. John* (fig. 6.2), in the Church of Santa Marca Novella in Florence shows his ability to create deep architectural spaces. He seems to have opened up the flat wall of the church with the precisely painted, **barrel-vaulted** ceiling of his fresco. This technique of combining painting and architecture to create illusions of space continues to the present day. Many buildings in modern Europe have architectural detail painted around windows and doors to make them appear more elaborate.

In Masaccio's *The Virgin and Child* (colorplate 32), the Virgin is seated on a throne that is treated with strong one-point perspective. The symmetrically balanced space in the painted panel is controlled by the placement of four angels surrounding the two central figures, the Virgin and Child. Sharp foreshortening of the lutes in the foreground further defines the reality of space. Although the extremely soft modeling of both Madonna and Child nearly obscure their facial features, the deep folds and rich intensity of the Virgin's robe provide dramatic contrast and thus play a major role in the success of this painting.

With their attention on the depiction of reality through perspective and even chiaroscuro, early Renaissance painters had not yet discovered or concerned themselves with the full effects of light and shade. The Florentine Paolo Uccello's (pah-oh'-loh oo-chel'-oh) (1397–1475) painted panel *Niccolo Mauruzi da Tolentino at the Battle of San Romano* (colorplate 30) shows virtually no regard for natural light—there are no shadows on the ground where one would normally expect them. The anatomy of the animals is painted as if they had been carved from wood, similar to merry-go-round horses unrealistically frozen in midair. Again we see the artist's obvious pleasure in his rendering of the soldiers' rich garments and elaborate metal armour. This opulence and attention to intricate detail supply the picture with considerable unity, though they do not provide the spectator with an accurate account of the battle itself.

A flowering hedge oddly divides the panel's space: the battle appears in the foreground while a rather unrelated, almost pastoral, scene is depicted in the background. However, we must recognize Uccello's almost fanatical interest in the geometric presentation of solids in space. The broken lances scattered uniformly across the ground are placed in perfect one-point perspective, with the lines converging somewhere behind the head of the white horse in the center of the panel. Take note, too, of the relatively skillful foreshortening of the slain person on the ground in the left side of the painting. These elements, along with the diagonal lines in the upper half of the picture, control the space and the perception of depth. These principles, seen here in their early beginnings, set the stage for the depiction of realistic space that would occupy Renaissance artists for the next one hundred fifty years.

Robert Campin (roh-behr cam-pan') (1378–1444) was among the first Flemish Renaissance masters of oil painting. The most remarkable feature of his painting *The Virgin and Child before a Firescreen* (fig. 6.3) is the rich, angular folds of the Virgin's garment. Part of this successful treatment of light and shade is attributed to the use of oil in tempera, which slows the drying process and allows for the full development of layer upon

Figure 6.3 Robert Campin, *The Virgin and Child before a Firescreen,* ca. 1430.
Oak panel; 25 × 19¼ in.
The National Gallery, London.

layer of modeling. Campin's style is also characterized by the placement of a biblical scene in an ordinary household setting. A firescreen serves as the Virgin's halo, the familiar manger scene is replaced by a respectable house, and the clothing and other trappings are of the fifteenth century. This obvious blend of sacred and secular elements is not just a sign of the times; it is possible that Campin wished for viewers to identify on a more personal basis with the Holy Family. In any case, Campin's work indicates that the shift from sacred to secular subject matter in art was by then firmly established. The human subjects were treated much more naturalistically. This painting also reflects Campin's intent to depict visual space. The exaggerated perspective of the floor tiles quickly leads our eyes back to the open window and out over the small town and hills in the distance.

Campin was obviously quite skillful in his ability to manipulate rounded forms (notice the master touch in the rendering of the Virgin's hands), in his use of linear patterns, and also in his understanding of the relationship of objects within the total framework. Not only is the firescreen carefully placed behind the Virgin's head

Figure 6.4 Andrea Mantegna, *The Agony in the Garden,* ca. 1455. Tempera on panel; 62.9 × 80 cm. (24¾ × 31½ in.). The National Gallery, London.

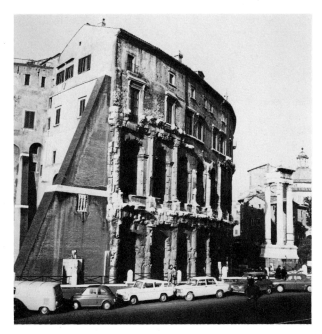

Figure 6.5 Architectural structure revived in Mantegna's painting: Theater of Marcellus. SEF/Art Resource, NY.

Figure 6.6 Giovanni Bellini, *The Agony in the Garden,* 1458–59. Panel; 32 × 50 in. The National Gallery, London.

to appear as a halo, but the gentle sweep of her body axis, its relationship to the position of the child's body and even the attitude of her head all contribute to a balanced and unified linear design. It is interesting to note that the child is not in a position for comfortable nursing, which must have been of less concern to Campin than the arrangement of figures and forms in his composition. Even in these early stages of the Renaissance, artists had come to realize that art was, in many ways, an interpretation of life.

As we observe the Italian Andrea Mantegna's (mahntayn′-ya) (1431–1506) tempera painting *The Agony in the Garden* (fig. 6.4), a number of style elements are apparent. First, Mantegna had learned very well the lessons of linear perspective and foreshortening, both of which can be seen in the greatly receding space and in one of the sleeping figures. The rekindled interest in classical art was becoming a larger consideration in painting. Unable to use nude models, artists looked to classical statuary; therefore, the human forms took on the look of ancient Greek sculpture in their solid, immobile positions.

Further evidence of Mantegna's interest in the art of antiquity can be seen in some of the buildings in the distance. While the architecture is mainly that of the Middle Ages, the round structure in the center resembles the Roman Theater of Marcellus (fig. 6.5) or perhaps even the famous Colosseum in Rome. Mantegna also attended to fine detail and was interested in natural light and cast shadows. However, while a strong light enters the picture from the left, there is also other, undefined light giving the scene an ethereal glow.

Hanging next to Mantegna's work in the National Gallery is a painting by the Venetian Giovanni Bellini (joh-vah′-nee bell-ee′-nee) (1430–1516). Bellini's work involves the same subject matter and even has the same title as the painting by Mantegna: *The Agony in the Garden* (fig. 6.6). Although inspired by Mantegna's original work, Bellini was apparently more interested in opening vast space and concentrating on the beauties of nature. The later work presents the human forms in more realistic poses and so has a lifelike quality. The same skills of foreshortening and perspective are evident, but Bellini's rendering of the garments is somewhat more sophisticated. The folds fit tightly against the bodies, giving

the garments a wet appearance. The treatment of light, however, is closer to that in the earlier model—there is little indication of a specific light source and we find almost no shadow. The use of retreating planes of light and dark in high contrast contribute to the impression of open space in this painting.

Besides being the leader of the Venetian School of painting, Bellini had an uncanny ability to present a supernatural event within a natural setting. Notwithstanding the spiritual figure standing out in space, the scene appears to be quite commonplace. The holy personages seem to be altogether human—even their faintly rendered halos seem to fit well with the naturalistic setting. Remember that the Renaissance period is considered to be a "classical" period, where rationality takes precedence over emotion. In this painting, emotion and the supernatural are under control. This was to become a hallmark of the new style.

THE DEVELOPING CHARACTERISTICS OF THE HIGH RENAISSANCE

The High Renaissance, late 1400s to about 1520, is well known for its pervasive use of perspective. A rather extraordinary painting by Carlo Crivelli (kree-vel'-lee) (1435–93) titled *The Annunciation, with S. Emidius* (colorplate 29) is one of its most elaborate examples. With its spectacular one-point perspective of architectural components and the lavish inclusion of details, it is difficult to predict where the viewer's eye will be first attracted. All lines converge on a point near the brown-cloaked figure in the far left background. As perfect as this linear design appears to be, the laserlike beam of heavenly light ignores those rules; there is no way that such a beam could reach the Virgin from that point in the sky. But never mind; the painting should be enjoyed more for its vivid treatment of color and sumptuous detail. The plethora of objects in the composition is highly decorative, approaching the rich design of tapestry. This work deserves careful study; many of the small details are symbolic of the event depicted. Crivelli's depiction of classically oriented architecture is of special interest from the Roman arch in the background to the building in the foreground tiered from simple to complex design, bottom to top.

This return to classical forms can be seen more clearly by comparing this painting with the Palazzo Riccardi (pah-laht'-zoh ree-kahr'-dee), located in Florence (fig. 6.7). The same tiered floors and heavy cornice were depicted in Crivelli's painting. Other features in the Palazzo that reveal classical influence include the arched

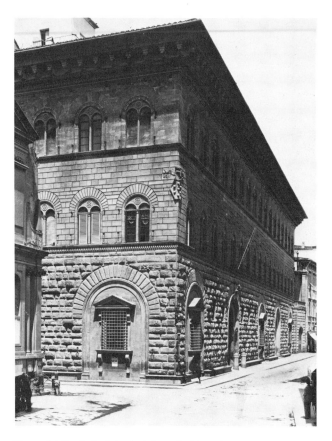

Figure 6.7 Revival of classical forms in fifteenth-century architecture. Michelozzo, architect; Palazzo Riccardi, Florence. Alinari/Art Resource, NY.

windows and doorways and the rustic masonry from the bottom tier to the top. Compare this structure with the Theater of Marcellus (see fig. 6.5) for the classical connection.

Reverence for classical forms in architecture can be seen in a work by Donato Bramante (doh-nah'-toh brah-mahn'-tay) (1444–1514), one of the leading architects of the period. Bramante's oddly isolated Tempietto (tem-pee-eh'-toh), located in Rome (fig. 6.8), appears to be a direct derivative of the early Temple of the Sibyl (Sih'-bl), dating from the first century (fig. 6.9). But Bramante took classical motifs—the circular design, colonnade, and dome—to create a new, unified structure. Created to mark the location of Saint Peter's crucifixion, Tempietto represents the perfect union of classical ideals with Renaissance vision and creativity.

As the use of oil in painting became more and more universally accepted, the development of the art of

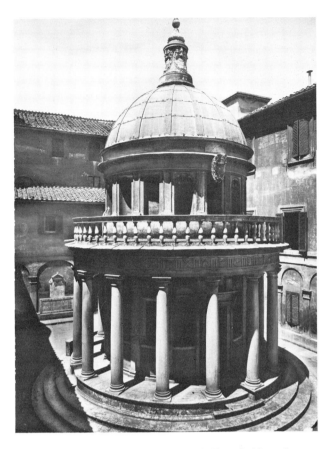

Figure 6.8 Donato Bramante. Tempietto, S. Pietro in Montorio, Rome.
Alinari/Art Resource, NY.

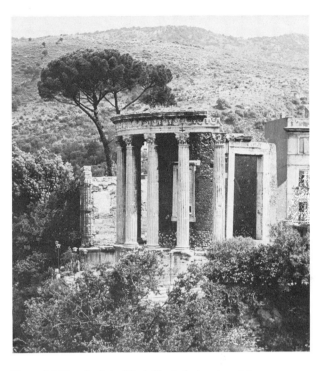

Figure 6.9 Temple of the Sibyl, Tivoli, first century B.C.
Scala/Art Resource, NY.

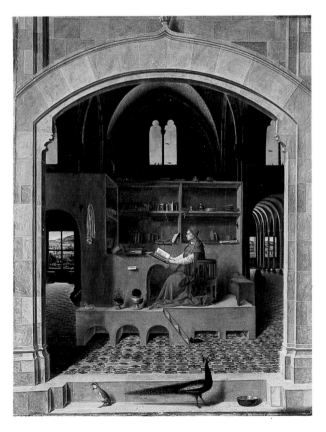

Figure 6.10 Antonello da Messina, *St. Jerome in His Study,* ca. 1474.
Oil on lime panel; 14¼ × 18 in.
The National Gallery, London.

painting itself progressed accordingly. Even in the High Renaissance period, Antonello da Messina (ahn-toh-nel'-loh dah meh-see'-nah) (1430–79) displayed his virtuosity in the treatment of light with a now famous, but surprisingly small, painting entitled *St. Jerome in His Study* (fig. 6.10). We can see light entering the room from various sources—the main arch in the foreground, the windows in the rear at eye level, and the arched windows above. Various sources of light create contrasts both subtle and stark, and serve to enliven an otherwise static composition. Beyond that, Antonello introduced the effects of *reflected* light—a technique well above the average artist's ability at that time. Reflected light defines the edges of the bookcase directly in front of Saint Jerome and, in fact, highlights spots in otherwise shaded areas. The masonry directly below the cat (left side) is glowing from light that comes in the rear window and that is reflected off an unseen wall facing the window.

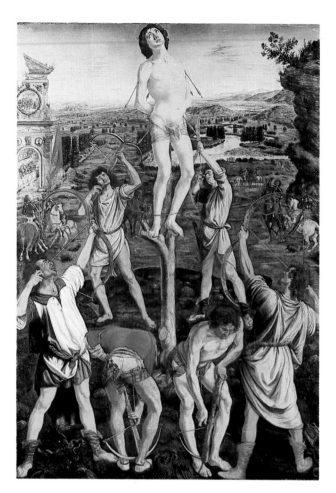

Figure 6.11 Antonio Pollaiuolo, *The Martyrdom of St. Sebastian,* 1475.
Tempera on panel; 9 ft. 6½ in. × 6 ft. 7½ in.
The National Gallery, London.

Renaissance artists of the late 1400s are known for the way they used symmetrical balance. Antonio Pollaiuolo's (poh-lah-ee-oo-oh′-low) (1429–98) monumental painting *The Martyrdom of St. Sebastian* (fig. 6.11) seems to have been constructed just to illustrate the activation of space. Each figure on one side of the center line formed by Saint Sebastian and the post is mirrored by a similar figure on the other side. However, the four archers in the foreground are mirrored in reverse. All figures are variously garbed, revealing Pollaiuolo's skill in depicting drapery. This painting can be divided into two dimensions: the foreground with its studied, solid pyramidal formation of human figures, and the background with its linear and aerial perspective drawing the viewer back toward the distant hills. The background, which can be viewed as a separate entity, is also balanced symmetrically—the rock formation on the right balances the Roman-like ruins on the left. The men and horses on either side of the painting are also in balance with the rest of the composition. This work illustrates the Renaissance ideal of symmetrical composition. The picture's formal balance is relaxed by the masterful treatment of the human figures.

Sandro Botticelli (bot-tee-chel′-lee) (1445–1510) of Florence developed a style of painting based on classical subject matter using graceful, elegant lines. Compared to the work of Uccello or Masaccio, his figures seem almost weightless. *Venus and Mars* (fig. 6.12) places the figure of a cool, restrained Venus in a classical position of repose. Both figures incorporate the free-flowing lines found in Greek sculpture. We can also appreciate Botticelli's great skill in modeling rounded, three-dimensional forms: the helmet and lance, both of

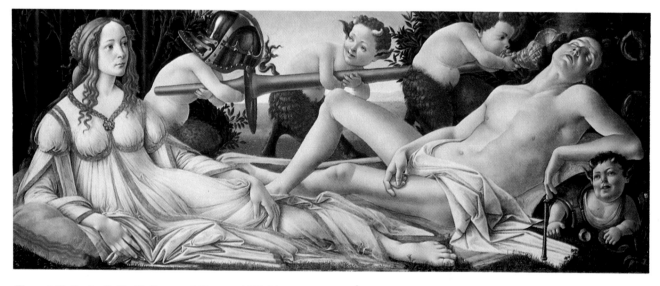

Figure 6.12 Sandro Botticelli, *Venus and Mars,* ca. 1475–80.
Tempera on panel; 27¼ × 68 in.
The National Gallery, London.

which are about to be stolen by young satyrs, are masterfully rounded with the use of highlights and shaded areas. Notice the detail; even individual blades of grass are depicted. On the other hand, the human forms lack surface detail, betraying the fact that Botticelli used classical sculptures as his models. The result is a classical simplicity of line and shape, a restrained emotional content, and a controlled balance between limited space and shapes.

Botticelli was only one of many Renaissance artists inspired by Greek mythology. The story of Venus and Cupid was a perennial favorite. Although the German painter, Lucas Cranach (krah'-nahk) (1472–1553) defers to antiquity for his subject in the painting *Cupid Complaining to Venus* (fig. 6.13), his technique is sixteenth-century German. A friend and follower of Luther, Cranach shied away from religious themes to paint classical figures in outdoor German settings. Most striking about this work are the strong contrasts and the treatment of Venus's nude body, which stretches gracefully across the canvas and dominates the composition.

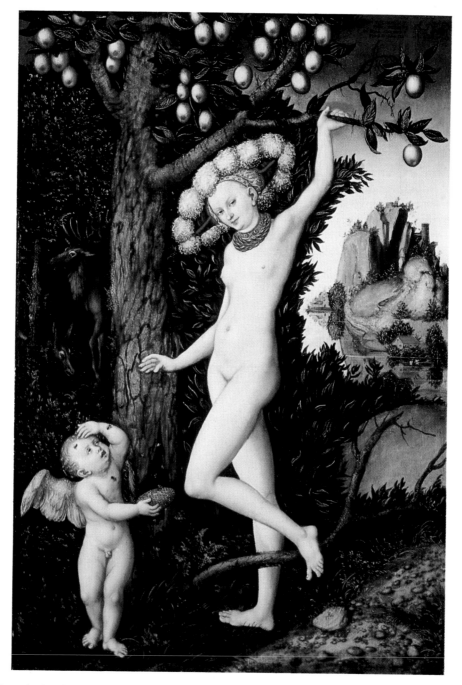

Figure 6.13 Lucas Cranach, *Cupid Complaining to Venus,* ca. 1522. Oil on panel; 32 × 21½ in. The National Gallery, London.

The soft chiaroscuro of both nudes is typical of Cranach. The musculature is all but invisible, and the youthful contours of the female provide a powerful contrast to the rough tree bark and the dense, dark shrubbery.

We find in countless Renaissance paintings a definite division between foreground and background. The foreground usually dominates the design, is often thrust toward the viewer, and is characteristically set in high contrasting value and intense hues. The background is usually set back toward a distant horizon. In this case, Cranach created an unlikely, fantastic rock formation as a backdrop for this somewhat naive theme.

Cranach's treatment of light should be mentioned briefly. Here again, the source is undefined. Light seems to be striking the shapes in the foreground but is casting very little shadow. In the background, the light strikes the rocks from the left, casting dark shadows on the right side of the rocks, but not on the ground. Thus Cranach was using light in the manner of many artists of that time: to illuminate their subjects, rather than to enhance naturalistic appearance.

Almost as a direct contrast to the portrayal of the beautiful and the noble of classic subject matter, the Dutch painter Hieronymus Bosch (heer-on'-ih-mus bohsh) (1450–1516) condemned our sensuousness and stressed our frail human nature. His canvases continue to challenge viewers with their mysterious narratives and disturbing imagery. His oil painting *Christ Mocked* (fig. 6.14), while not as famous or enigmatic as other works of his depicting grotesque views of damned, is nonetheless powerful and influential. The five human figures occupy most of the painting's space. All figures are advanced toward the viewer and placed in a series of diagonal axes. The tension of the resulting formal design is thus coupled with the emotional tension between the grotesque, mocking faces and the placid figure of Christ. You might say that the work is a study of facial expressions but without the careful modeling of forms that we saw in Botticelli. Bosch seems to have been intent on expressing our failings in that circle of faces while still maintaining the hope that we might find some decency within ourselves. With all its intensity and tension, this is actually one of Bosch's more tranquil compositions. Bosch's strong influence on Pieter Bruegel will be seen when we tour the works of the mannerists.

Albrecht Dürer (ahl-brehkt' doo-rer) (1471–1528) was one of the most important painters in the development of German Renaissance art. His mastery in engraving made low-cost prints available to the average person and the resulting popularity made him a rich man. As a woodcut artist he learned to carve every line with careful precision and he carried this technique over into his painting. He drew and painted everything he saw, and he saw beauty in the most common corners of nature.

Figure 6.14 Hieronymus Bosch, *Christ Mocked,* ca. 1480. Oil on panel; 29 × 23¼ in. The National Gallery, London.

He that works in ignorance works more painfully than he who works in understanding; therefore let all learn to understand art aright.

Albrecht Dürer

Looking at Dürer's portrait *The Painter's Father* (fig. 6.15), we cannot help but be fascinated by the psychic closeness between the subject and the viewer. The figure's strength is established in part by his intense stare aimed directly at the viewer. The background is flat and formless and thus advances the figure closer to us, forcing our attention even more directly on the subject.

The pyramidal shape seemed to be a favorite among Renaissance artists. Dürer's figure is pyramidal as well, but his unique skill and penchant for duplicating nature led him always toward intricate detail and exact rendering of his subject. Close examination will reveal tiny cracks and wrinkles in the subject's face and individual hairs on his head. It is interesting to compare Dürer's detail and finite rendering with the work of his German contemporary, Cranach, who cared less for detail than for total effect and contrast.

Figure 6.15 Albrecht Dürer, *The Painter's Father*, 1497.
Oil on panel; 20 × 15¾ in.
The National Gallery, London.

> The mind of the painter should be like a mirror which is filled with as many images as there are things placed before him.
>
> *Leonardo da Vinci*

Figure 6.16 Leonardo da Vinci, *The Virgin and Child, St. Anne and the Infant St. John*, ca. 1500.
Charcoal on paper; 54¾ × 39¾ in.
The National Gallery, London.

Three Major High Renaissance Artists: Leonardo, Michelangelo, and Raphael

No Renaissance artist has achieved the enduring fame of Leonardo da Vinci (veen'-chee) (1452–1519), a fifteenth-century Florentine who prepared treatises on science, as well as on art, and felt they were equally important as means of expression. His achievements in painting, sculpture, architecture, science, and music have established him through the centuries as the epitome of the Renaissance man.

His inquiring mind led him to do anatomical dissections, to create all kinds of inventions including flying machines, and to fill notebooks with scientific drawings. But it is for his painting that Leonardo wanted to be remembered. Perhaps Leonardo's most important advance

in graphic art was the technique of blending his subjects with the space that surrounds them. Outlines are blurred by softening light and shade using **sfumato** (sfoo-mah'-toh), an Italian term for the hazy, smoky effects of real light in our atmosphere. Leonardo used sfumato to blend figures into their environment and to achieve a close harmony between objects and space. The human forms in *The Virgin and Child, St. Anne and the Infant St. John* (fig. 6.16) seem to emerge gradually through softly glowing highlights. The limited palette of Leonardo's approach results in a restrained tonality and lends a sophisticated refinement to the picture. The unity is enhanced even further by grouping the four figures into a large composite shape that dominates the design. This charcoal drawing is actually a cartoon that has become quite fragile with age. It thus became necessary for the National Gallery to glaze the surface of the drawing and place it in a small room dimly lighted so that reflections are minimized and visibility enhanced.

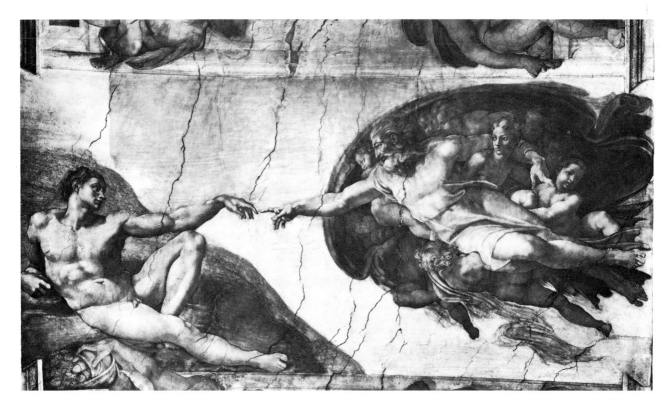

Figure 6.17 Michelangelo, *The Creation of Adam,* detail of the ceiling fresco; Sistine Chapel, the Vatican, Rome, 1508–12. Alinari/Art Resource, NY.

A similar group of figures is seen in Leonardo's *The Virgin of the Rocks* (colorplate 34). Three subordinate figures surround the Virgin, whose form dominates the composition because of her position, large size, and the contrasting blue color of her garment. Leonardo arranged these figures into a roughly three-dimensional pyramid. With the Christ Child advanced slightly toward the viewer, the grouping relates more naturally to its mysterious, rocky surroundings. The limited palette, mostly reddish browns and blues, also contributes to the harmony between figures and space. The people are depicted here in a blend of naturalism and idealized beauty. The Virgin appears to be poised in holy beneficence, but her face, notwithstanding the presence of a thin, faint halo, has the look of a portrait painting. The Child, whose demeanor appears to be that of a mature man, holds his hand in the form of a blessing.

Leonardo's philosophy of art was not merely to reproduce nature on canvas but to restructure it in order to express feelings that transcend nature. That is part of the reason for the slight deviation from reality in the human figures and in the fantastic rocky landscape. The relationship between the craggy rocks and the calm blue sky was more important to Leonardo than each entity. Artists ever since Leonardo have emulated his approach to the harmony of shapes and the way in which they occupy space.

Leonardo's contemporary and rival was Michelangelo Buonarroti (mih-kel-ahn'-jel-oh boo-ohn-ah-roh'-tee) (1475–1564), a Florentine artist. In spite of the fact that Michelangelo insisted he was *not* a painter, he is known internationally for his paintings in the Sistine Chapel at the Vatican in Rome. He nearly single-handedly completed the panoramic task in under four years. Lying on his back, seventy feet above the floor, he illustrated the Biblical story of Creation, the fall and the redemption of humankind by painting into wet plaster over three hundred interracting figures. This Vatican ceiling fresco was commissioned by Pope Julius II, and Michelangelo accomplished it between sculpture commissions.

The Creation of Adam (fig. 6.17) is a detailed, and actually a very small, portion of the ceiling painting in the Sistine Chapel. The entire ceiling is about thirty or forty times as large as this often-reproduced detail. Perhaps we see this particular piece of the total work so often because people recognize its energy and forcefulness. The thrusting power of the figure of God is coupled with strong diagonals and stark contrasts. But through all this intensity we can also see the grace with which Michelangelo imbued his figures—the very embodiment of handsome elegance fused with tension and dramatic expression.

His first successful work, however, was *Pieta* (pee-ay-tah'), which is located at St. Peter's Basilica in Rome.

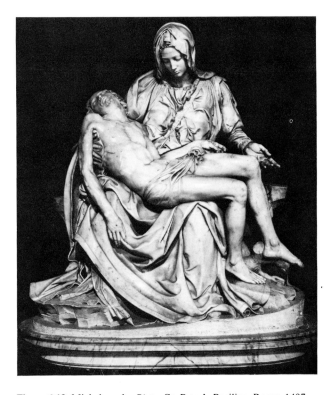

Figure 6.18 Michelangelo, *Pieta,* St. Peter's Basilica, Rome, 1497.
Marble; H. 69 in.
Anderson/Art Reference Bureau.

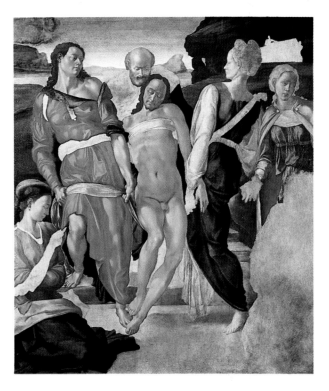

Figure 6.19 Michelangelo, *The Entombment,* 1506.
Oil on panel; 62½ × 58¾ in.
The National Gallery, London.

Carved from marble in 1497, this famous sculpture (fig. 6.18) is characteristic of the Renaissance style because it shows that Michelangelo had the courage to distort the figures rather than to copy them. He made his own rules, and was thus able to express himself more dramatically. The powerful undercutting seen in the folds of the Virgin's garment is our first clue to this deviation. The resulting strong contrasts in light and shade are balanced by the calm, restrained faces of both figures. This balance between opposing forces is one of Michelangelo's most telling stylistic characteristics. His interest in proper balance resulted in a blatant distortion of Mary's body in relationship to the body of Christ. The two figures are evenly distributed between vertical and horizontal positions. However, if we could imagine Mary standing, she would be considerably taller than her slain son. Michelangelo deliberately distorted her size in order to achieve a balanced relationship between the two forms. Furthermore, Mary's face belies her actual age because the artist rendered her with idealized, classical beauty. Indeed, Mary's beauty and somewhat sensual body reveal the influence of secular elements in even the most pious of subjects.

Michelangelo's painting *The Entombment* (fig. 6.19) hangs in the National Gallery. Even in its unfinished state, this work stands as a monument to Michelangelo's strength of expression. The dead Christ is being carried in improvised slings by the three figures surrounding him.

My beard turns up to heaven; my nape falls in,
Fixed on my spine: my breast bone visibly
Grows like a harp: a rich embroidery
Bedews my face from brush-drops thick and thin.
. .
Come then, Giovanni try
to succour my dead pictures and my fame;
Since foul I fare and painting is my shame.

Michelangelo Buonarroti,
Sonnet V to Giovanni da Pistoia
(On the Painting of the Sistine Chapel)

Their body axes are thrust outward in opposing directions, creating a dynamic tension with the serene central figure. The nearly expressionless faces on all participants in this drama balance the latent energy that is felt by the viewer. Classical restraint thus controls the tension and emotional content. It is difficult to say just how the composition would have been affected had Michelangelo completed the figure in the lower right corner and the tomb in the upper right corner. At the very least, he probably was attempting to establish symmetrical balance with the figure in the left foreground. However, the balance is not distributed in the absence of the figure since Michelangelo chose to fill nearly all the painting's space with human subjects.

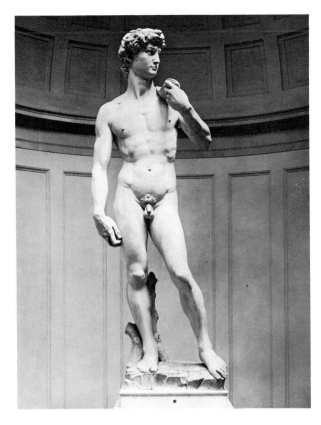

Figure 6.20 Michelangelo, *David*, Florence, 1501–4.
Marble; H. 13 ft. × 10½ in.
Alinari/Art Resource, NY.

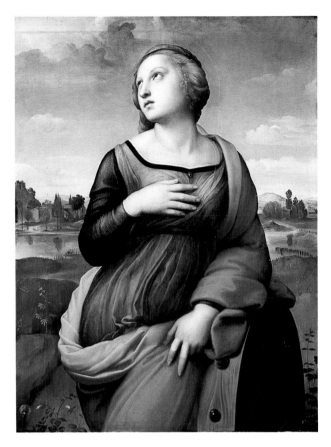

Figure 6.21 Raphael, *St. Catherine of Alexandria*, 1506–7.
Oil on panel; 28 × 20¾ in.
The National Gallery, London.

The best artist has no concept which some single marble does not enclose within its mass, but only the hand which obeys the intelligence can accomplish that. . . .

Michelangelo

On his deathbed, Michelangelo is supposed to have said, "I die just as I am beginning to learn the alphabet of my profession."

No discussion of Michelangelo is complete without mention of another of his greatest masterpieces, *David* (fig. 6.20). The over thirteen-foot tall sculptured figure of David stands relaxed, with the weight shifted to the right leg, thus causing the hips and shoulders to tilt in opposing directions. The resulting pose is called **contrapposto** and is derived from classical antiquity. The classical pose, plus the idealized beauty of the perfect human form, is evidence that Renaissance artists revived the techniques and philosophies of Greece and Rome.

There is little doubt that Leonardo and Michelangelo are the perennial Renaissance favorites of the average gallery observer. But the greatest Renaissance painter, and perhaps even the greatest of all time, is generally considered to be Raffaello Santi (rah-fay-el′-oh sahn′-tih) (1483–1520), called Raphael (rah′-fay-el), who worked in Urbino and Florence and produced countless madonnas, portraits, tapestry cartoons, and architectural designs. His works reveal an eclectic adaption of Leonardo's and Michelangelo's finest qualities. Raphael's phenomenal skill and personal vision brought Renaissance art to its highest level of development. By incorporating Leonardo's style of portraiture (for example, in Leonardo's *Mona Lisa*) and sfumato, and by maintaining some of the graceful lines and dynamism of Michelangelo, Raphael produced paintings exquisitely balanced between vitality and restraint, between freedom and control, and between naturalism and idealism. The ideal beauty of *St. Catherine of Alexandria* (fig. 6.21)

Figure 6.22 Raphael, *Madonna and Child with SS. John the Baptist and Nicholas of Bari (The Ansidei Madonna)*, 1506. Oil on panel; 9 ft. × 4 ft. 11¾ in. The National Gallery, London.

is immediately apparent. The soft chiaroscuro of her face is enhanced by the rich hues of her garments. The hazy sfumato of the background seems to blend the figure into the landscape. Saint Catherine's body resembles the contrapposto of classical sculpture but is imbued with more of a swirling motion. All elements seem to be in perfect harmony and balance; the figure interacts with the landscape—neither fights for our attention. The same is true for the rich hues of her garments; they are not bright enough to overpower the delicate shadings of other areas of the painting. Above all, it is perhaps Raphael's treatment of light that helps to control this perfect balance of elements. The sfumato derived from Leonardo is enkindled with a controlled intensity of both hue and value that results in a soft glow of color and light unlike

anything Renaissance artists had produced. His compositions possessed a luminous clarity that was capable of defining strong contrasts as well as maintaining a unified thematic statement.

Raphael's concern for symmetrical balance and order is best seen in his oil painting *Madonna and Child with SS. John the Baptist and Nicholas of Bari,* (*The Ansidei Madonna*) (fig. 6.22), which is placed in an adjacent corner of the same room of the National Museum that houses Leonardo's *The Virgin of the Rocks* (colorplate 34). The classical architecture in the painting is depicted with precise symmetry and the figures are distributed accordingly. However, the strict symmetry of the architecture is offset by the curvilinear rhythm of the human figures. All four heads are inclined to the right, and each body axis is curved in a soft S pattern. The staff carried by each supporting figure is inclined toward the central figures, helping to control the design. The Roman arch and the accompanying arched framework of the painting also tend to contain and hold together the design. The light, which seems at first to be entering the picture from the upper right side, is not the only source of illumination. Raphael used light to make his figures radiant, as if glowing from some inner source. Again, it was the artist's courage to distort and exaggerate reality that resulted in the extraordinary quality of High Renaissance art.

THE RISE OF MANNERISM

Raphael's death in 1520 is a date that is often taken to mark the end of the High Renaissance. A transitional period between the Renaissance and the baroque periods is known as **mannerism.** The Italian word for *manner* comes from the same root as the word for *hand* and refers to manual techniques. The sixteenth-century biographer Vasari used the term *mannerism* to describe the style of artists working "in the manner of" Raphael and Michelangelo. New style characteristics were beginning to appear in the works of artists all over Europe. In portraiture, painters began to flatter their patrons with heightened, idealized beauty. The artists' skill, learned from the great masters of the High Renaissance, was now applied to impressive and highly elaborate renderings of their subjects, their finery, and their rich possessions; in other words, they presented a "mannered" treatment of subject matter.

Figure 6.23 Hans Holbein, the Younger, *Jean de Dinteville and Georges de Selve (The Ambassadors)*, 1533.
Oil and tempera on panel; 6 ft. 9½ in. × 6 ft. 10½ in.
The National Gallery, London.

Figure 6.24 Hans Holbein, the Younger, *The Ambassadors,* detail of anamorphic skull as viewed from the side.
The National Gallery, London.

Hans Holbein (hohl′-bine), the Younger (1497–1543), who was a prominent German painter associated with this style, later became Henry VIII's court painter. His double portrait of *Jean de Dinteville and Georges de Selve* (*The Ambassadors*) (fig. 6.23) depicts two men so idealized that they appear to be cold and impersonal. The warm humanism that was so carefully developed earlier was lost to a certain degree. Holbein's virtuosity, which he obviously considered more important, is displayed in the intricate, detailed elements on shelves between the two figures—the lute, the book, and the scientific instruments.

Holbein's mannerism is seen particularly in the strange, unrelated shape in the central foreground. It has been generally decided that this shape is actually a skull that can be identified by viewing the painting from the side (fig. 6.24). The contrast between such a strange amorphous apparition and the remaining figures in this finely detailed portrait marks a definite departure from the portraiture of Leonardo and Raphael.

Mannerist artists were clearly moving away from the classical restraint and symmetrical balance of the High Renaissance. Especially in painting, these artists seemed to be more interested in elegant stylishness and an artificial treatment of reality. The look of natural life so

carefully and masterfully developed by Raphael, in a sense, died with him. While mannerists did not abandon classical tendencies altogether, their emphasis was most certainly shifted toward other concerns. One of these concerns was the portrayal of turbulent motion and a sense of drama.

Tiziano Vecelli (teetz-ee-ah′-no veh-chell′-ee), better known as Titian (tish′-yen) (1488–1576), one of the greatest Venetian painters, was nearly seventy when he first visited Rome to see the famous masterpieces first hand. Late in life, he captured robust Greek mythological characters in a glowing, healthy style, usually based on a red ground that gave deep, rich tones to his work. *Bacchus and Ariadne* (bah′-kus and ah-ree-ahd′-nuh) (fig. 6.25), one of his large works based on a mythological tale, is exhibited on a free-standing screen in the middle of a room at the museum, as if to recognize its outstanding quality. Titian chose to invest dramatic action into this picture: Bacchus is shown leaping somewhat unrealistically from his chariot, followed by others who seem to be bursting into the scene from outside the picture frame. This manner of opening space was to influence painters of the baroque period to follow. Titian's painting is built around two sweeping cross-diagonals. The first diagonal begins with Ariadne and follows Bacchus' cloak and the formation of the figures toward the upper right corner. The other begins with the large male figure in the lower right quadrant and continues through

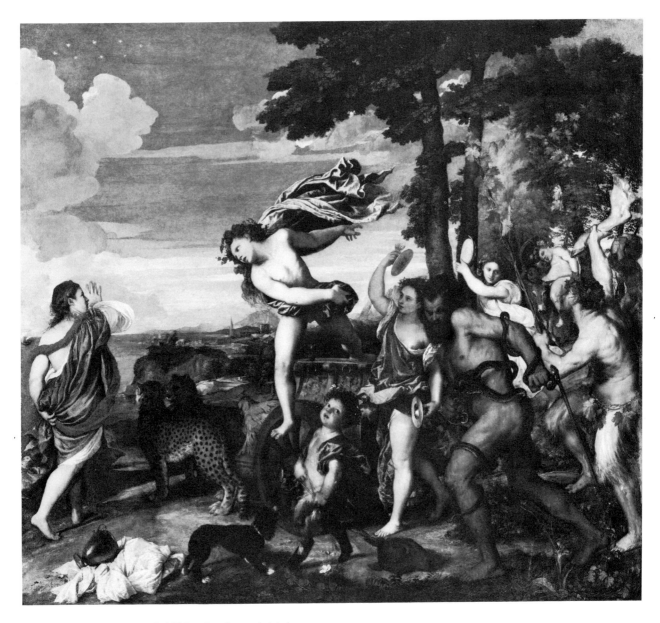

Figure 6.25 Tiziano Vecelli, called Titian, *Bacchus and Ariadne,*
1523.
Oil on canvas; 69 × 75 in.
The National Gallery, London.

the inclination of Bacchus's body toward the upper left
corner. In effect, a large **X** is produced. In terms of basic
elements, this diagonal linear movement, with its new
and dynamic treatment of space, was the mannerists'
most significant stylistic characteristic.

In a later work entitled *Venus and Adonis* (colorplate
31), Titian subdued the turbulent motion of his earlier
painting of Bacchus and Ariadne by bringing two main
figures close to the viewer. Their large, softly glowing
forms dominate the picture space with a sense of calm

motion. The inclination of both body axes maintains a
vitality of movement, but the size of the figures and soft
colors tend to retard any feeling of violent action. The
treatment of light in the sky and its reflection off the fig-
ures, and the appearance of the leashed dogs, balanced
by the sleeping figure in the left middleground, con-
tribute to the quiet warmth of the scene. Titian's work
represents a significant break from the balance and sta-
bility of the High Renaissance.

Figure 6.26 Correggio (Antonio Allegri), *Mercury Instructing Cupid before Venus,* 1525.
Oil on canvas; 35¾ × 61 in.
The National Gallery, London.

Figure 6.27 Foreshortening is used to portray anatomical forms in perspective.

Titian's rendering of the nude form is echoed in *Mercury Instructing Cupid before Venus* (fig. 6.26), a sensual work by the Italian painter Correggio (koh-reh′-joh) (1494–1534) named after his Parma village in North Italy. Like Titian, he chose to leave the High Renaissance symmetry behind. The powerful forward thrust of these three mythological characters is the result of the contrast between the dark background and the brightly glowing nude bodies. The realistic appearance of human bodies relies less on linear perspective and more on careful rendering of overlapping shapes and of smaller shapes receding in space. Notice how foreshortening is used to portray anatomical forms in perspective (fig. 6.27). Unlike his mannerist contemporaries, Correggio painted figures realistically. Venus's eyes stare directly into ours, amplifying the sensuousness of the portrait. All three figures are rendered with smooth curves, and the result is similar to that achieved by Titian. However, Correggio has adopted a measure of Leonardo's sfumato so that the contrast between light and dark has been subdued.

Figure 6.28 Bronzino (Agnolo di Cosimo), *An Allegory*, ca. 1550.
Oil on panel; 61 × 56¾ in.
The National Gallery, London.

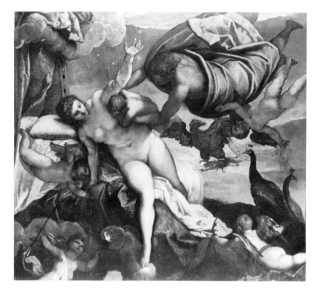

Figure 6.29 Jacopo Tintoretto, *The Origin of the Milky Way*,
1577–78.
Oil on canvas; 50¼ × 65 in.
The National Gallery, London.

Tintoretto was extravagent, capricious, quick, and
determined, with the most terrific imagination in the
history of painting.

Giorgio Vasari

Compare the treatment of nudes by Titian and Cor-
reggio with those in Bronzino's (brohn-zee'-noh)
(1502–72) complex painting *An Allegory* (fig. 6.28).
Bronzino's nudes do not glow with the warmth of soft,
real flesh, but rather resemble cold marble. So, what
could have been an erotic presentation of two very sen-
sual figures is actually cold and emotionally detached.
Furthermore, the figures are in unnatural positions: the
head of Cupid looks almost as if it had been detached
from his body—typical mannerist distortion. But much
more obvious is the mannerist's predilection for allegory,
in which symbolic objects help to portray a unified theme.
The theme of this allegory is, simply put, the folly of
love, hate, and jealousy uncovered by time. Father Time,
at the top, is drawing back his rich blue curtain re-
vealing Cupid rather lasciviously embracing his mother,
Venus. The wretched figure to the left of Cupid is Envy.
Fraud and Folly frame the composition on the right.
Other symbols are less obvious. For example, Fraud's,
or Deceit's, hands have been reversed, and the masks on
the floor seem to symbolize falseness. Bronzino's space
is limited to a shallow frontal plane that is completely
filled with figures and objects. His composition seems to

maintain an overall circular rhythm in brightly lit forms
at the front of the picture plane. The darker figures di-
rectly behind this circular pattern seem to extend and
support that basic design. Notice the skillfully painted
hands and feet—another mannerist device.

The Origin of the Milky Way (fig. 6.29) by Venetian
Jacopo Tintoretto (teen-toh-reh'-toh) (1518–94) is based
on yet another dramatic mythological tale. The story here
is relatively simple: Hermes takes the infant Hercules to
the sleeping Hera's breast, whose milk was thought to
hold the power of immortality. She awakens from her
celestial bed with a start and her milk spills out into
space, creating the Milky Way. The characters in this
theatrical setting are arranged in dynamic opposition.
The downward diagonal formed by the figure of Hermes
is countered by the opposing diagonal of Hera's body.
The axis lines of the small angelic creatures are inclined
toward the central figures. Nearly all the objects in this
painting are swirling with rhythmic motion, which takes
place in a shallow plane. The draperies of the bed and
the garments seem to limit the sense of open space in
this scene.

Figure 6.30 Albrecht Altdorfer, *Landscape with a Footbridge,* ca. 1520(?).
Oil on parchment on panel; 16½ × 14 in.
The National Gallery, London.

Figure 6.31 Pieter Bruegel, the Elder, *The Adoration of the Kings,* 1564.
Oil on panel; 43¾ × 32¾ in.
The National Gallery, London.

Trends in the Mannerist Tradition

For a moment, let's leave the world of allegory, nude figures, and classical revival and move to one of Dürer's followers in Germany, Albrecht Altdorfer (ahl'-brekt ahlt'-dorf-er) (1480–1538). His *Landscape with a Footbridge* (fig. 6.30) represents one of the first, if not the very first, pure landscape paintings in European art. It displays Altdorfer's skill in the use of color and his sense of deep space. For example, the crystalline yellow-orange rocks in the lower right corner are complementary to the rich blue of the sky above. Looking through the open space beneath the dark bridge, we see a rich, verdant valley in front of a multihued mountain and the bright sky beyond. The alternation of hues and value creates a definite sense of distance. Altdorfer's somewhat fantastic trees and foliage are reminiscent of Oriental landscape painting, which could well have been the inspiration for such unusual treatment. His understanding of light and atmospheric effects resulted in landscapes that evoke specific moods without incorporating human figures.

A Flanders painter of exceptional skill, Pieter Bruegel, the Elder, (bruh'-gel) (1525–69) distorted the players'

faces in his artistic dramas to convey general commentaries about humanity. Except for the handsome faces of Mary and Jesus, all the other characters in *The Adoration of the Kings* (fig. 6.31) are ugly. Naturally, the contrast heightens the beauty of the holy pair.

Bruegel, like his predecessor Bosch, often depicted the crude, primitive faces and behavior of peasants. And the similarities to Bosch and his *Christ Mocked* (fig. 6.14) do not end there. The typically mannerist arrangement of figures in a crossed diagonal is evident in the *Adoration* by Bruegel and in *Christ Mocked* by Bosch. We can assume that the popularity of crossed-diagonal designs in this period resulted from a concern for the tension and dynamic motion inherent in such an opposition of forces. Allow your eye to follow the strong diagonal from the kneeling king in the lower left corner up through the central figures, including Joseph. Note that the scepter in the foreground is also helping your eye to move in that direction. The opposing diagonal leads from the folds in the black king's garment, along the contour of Mary's robe, and into the group of people in the upper left corner.

Figure 6.32 El Greco (Domenikos Theotokopoulos), *Christ Driving the Traders from the Temple*, ca. 1600.
Oil on canvas; 41¾ × 51 in.
The National Gallery, London.

Also like Bosch, Bruegel cast some of his drama in shallow space, preferring to confine our attention to the action of well-defined characters. We know, of course, that both artists were also interested in deep space and dignified expansive landscapes. But in these cases, the intimacy and importance of the moment were overriding concerns of both artists. Bruegel's relatively flat rendition of facial contours exaggerates a subject's distinctive features and thus tends to produce a comical or even grotesque appearance, approaching **caricature.** Caricatured figures crowd Bruegel's detailed compositions, giving us an often witty narrative picture of the sixteenth-century Netherlands.

El Greco (el grek′-oh) (1541–1614), the last of the great mannerists, came to Spain from Greece and although his name was Domenikos Theotokopoulos, he was dubbed "El Greco," The Greek. Although he employed motifs and techniques similar to those of Michelangelo, Titian, and Raphael, El Greco was nonetheless one of the most individual of all artists. His paintings reveal a rough-brushed application of paint, as if the works were not really finished. The resulting rough texture, along with brightly sparkling lights distributed across the canvas, lend a vibrancy of color and motion unlike anything seen in the works of his contemporaries. El Greco's elongations and odd distortions of the human figure are not as obvious in his *Christ Driving the Traders from the Temple* (fig. 6.32) as in so many of his other religious paintings. We can see, however, the energy that pulsates from the twisting gesticulations of every figure in the composition. The body of Christ, in particular, is seen in a position of spiraling torsion, about to spring back. The figures are thus imbued with vitality even though they appear to have been frozen in midaction. The faces generally have a calm, pious look: Jesus is flogging one of the perpetrators with apparent impassivity. The figures in most of El Greco's paintings have an almost detached look—their faces turned toward heaven, their sculptural white bodies rippling with knotted muscles.

Certainly, this painting is not naturalistic in the sense that anything has a true-to-life look about it. Even the sky in the distance is oddly distorted with streamer-like clouds, adding to the energy of the scene. However, El Greco, like many artists, portrayed something beyond reality by using abstracted subject matter. His own mystical religious fervor is expressed in the luminosity of the garments reflecting an unearthly light. El Greco's vitality of rough, unfinished textures, his calm restraint and containment of action within the picture plane, together with his sense of movement, paved the way for the excitement and drama that was to characterize art of the baroque period.

SUMMARY

The Renaissance period in art is typically divided into three distinct movements: Early Renaissance, High Renaissance, and Mannerism. The early period is characterized by the universal adoption of the newly discovered principles of linear perspective. Other features that deviated from the medieval style were the expanded use of secular themes and the revival of traditions from classical antiquity.

Portraiture reached its peak during the High Renaissance, especially in works by Leonardo da Vinci, Michelangelo, and Raphael. These three giants are generally regarded as the greatest artists of the period. Leonardo, the Renaissance man; Michelangelo, the master sculptor; and Raphael, perhaps the most gifted painter of all time, exemplify the enlightenment of the period. Discoveries and developments in artistic techniques resulted in monumental masterpieces that, to this day, serve as standards of excellence for all art. For example, the discovery of oil paint, with its ability to blend hues, helped artists of the period perfect the skill of portraiture.

Mannerism is less a distinct Renaissance style than it is a transition or bridge to baroque art. With the new-found freedom of individual expression that soared to unprecedented heights, artists in the shadow of the three masters of the High Renaissance boldly sought new methods of making art. Particularly in painting, a new interest in portraying motion, sensuality, and allegory was becoming evident. Landscape painting emerged as a definitive art form, and the use of distortion and exaggeration in figure painting appeared more profusely.

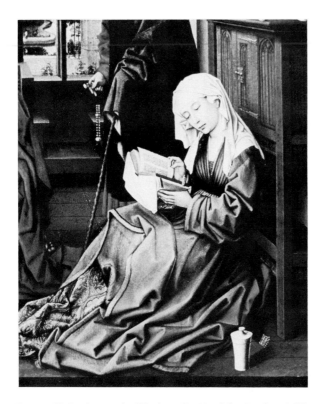

Figure 6.33 Rogier van der Weyden, *The Magdalen Reading,* 1438.
Panel; 24¼ × 21½ in.
The National Gallery, London.

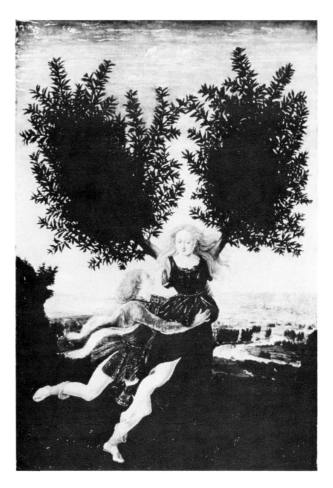

Figure 6.34 Antonio Pollaiuolo, *Apollo and Daphne,* ca. 1470–75.
Tempera on panel; 11½ × 7¾ in.
The National Gallery, London.

El Greco is sometimes singled out to exemplify the mannerist tradition. His rough textures, radiant light, irrational proportions, and unique distortion of the human figure, deviated from conventional painting techniques, but proved to be powerful modes of expression. During an age of humanism, El Greco chose to devote himself to religious subject matter, evidence of his strength of individuality and personal vision. In a sense, El Greco represents the end of an era, the last of the mannerists at the close of the Renaissance, and the last of the profoundly religious painters.

VIEWING EXERCISES

1. Describe the treatment of actual and implied line in each of these three Renaissance paintings: *The Magdalen Reading* by Rogier van der Weyden (fig. 6.33), *Apollo and Daphne* by Pollaiuolo (fig. 6.34), and *Allegory of Love, I* by Paolo Veronese (fig. 6.35).

2. Each of these artists has provided his composition with a predominant shape to which other elements relate. Describe the compositional design of each work.

3. How does the use of line and design affect the resulting motion in each work?

4. Describe the role of the subject matter in the aesthetic message of each work.

5. Into which subperiod of this era—Early Renaissance, High Renaissance, or mannerism— would you place each of these works, and what stylistic elements would support each of your selections?

6. In Lucas Cranach's unusual painting *Close of the Silver Age (Jealousy)* (fig. 6.36), describe each of the following components in terms of their function in the composition.
 a. the use of nudes
 b. the wall of dark foliage directly behind the figures
 c. the rock formations in the background
 d. the light value
 e. the rhythm

Figure 6.35 Paolo Veronese, *Allegory of Love, I,* ca. 1585–90. Canvas; 6 ft. 2½ in. × 6 ft. 2½ in. The National Gallery, London.

Figure 6.36 Lucas Cranach, *Close of the Silver Age (Jealousy),* ca. 1522 (?). Oil on panel; 20¼ × 14 in. The National Gallery, London.

7. Procure a recording of any of the madrigals by John Wilbye (will'-bee), William Byrd (bird), or Thomas Morley (mor'-lee) and, as you listen, compare their style with Titian's *Bacchus and Ariadne* (fig. 6.25).

8. Look back through all the illustrations of this chapter and select a few examples of Italian painting and a few paintings from Northern Europe. Describe some of their more obvious differences in style.

STUDIO EXERCISES

Suggested media and supplies: sketchbook; pencil; black charcoal, white and colored chalk, or conté crayon

1. To better appreciate the drawing skills that Renaissance painters utilized in rendering drapery, hang a solid piece of colored cloth from one point (or axis)—a nail, a single hook, or a similar pointed object. With pencil and paper draw a continuous, unending line that represents the outside and inside contours of the hanging cloth. Do not lift the pencil from the time you start until you are finished drawing the entire draped cloth.

2. Hang a cloth from each of two points and allow it to drape in the middle. Draw the outside and inside contours as in exercise 1. Look for the light and dark areas, then add shading with pencil to simulate the folds of drapery.

3. Choose a small section of drapery in Michelangelo's painting *The Entombment* (fig. 6.19). Redraw that part in black chalk or conté crayon, and add shading by rubbing the color to make it lighter or darker and to show the solidity of the draped form.

4. Compose two landscapes in chalk and create two different moods or times of day using light and shade. One should be in black and white and the other in full color, but do not include human figures or synthetic objects. Limit your subject matter to natural forms.

RESPONSES TO VIEWING EXERCISES

1. Since each of these paintings represents different time periods in the development of the Renaissance style, it is natural to expect the treatment of line to be varied. Rogier's treatment of line is reflected for the most part in the folds of cloth and in the furniture and windowsill. The lines are quite angular, particularly in the folds of the garment at the bottom of the picture. Pollaiuolo's painting of *Apollo and Daphne* differs in that the treatment of line is more curvilinear and graceful. Our eyes are drawn naturally toward the lower left quadrant of the painting, then curvilinear forms draw our gaze to the center and up to the "arms" of Daphne, who is about to be transformed into a tree. Veronese, on the other hand, used broad, sweeping curvilinear lines. The central figure establishes a diagonal line from the lower left to the upper right corners, and the contours of the trees seem to reflect that sweeping curve.

2. Each of these paintings features a large shape, or group of shapes, that dominates the space. In Rogier's painting, the figure of the Magdalen nearly fills the entire space of the canvas. Her light green garment contrasts with the dark blue robe in the background, and thus thrusts her figure closer to the viewer. Pollaiuolo's painting is very similar in that the two figures, plus the two tree branches that form Daphne's arms, dominate the composition. However, in this case, the out-of-doors setting with the distant landscape tends to provide the composition with a feeling of infinity that is not felt in Rogier's interior. Veronese supplied three large figures and several smaller shapes, including the two cherubs at the bottom and the tree trunks at the top. Beyond these objects in the foreground is empty space. Obviously, Veronese decided not to rely on a relationship of foreground shapes supporting shapes in the distance. Deep space was not one of his concerns here; rather, he emphasized the interaction of opposing body axes and the dramatic, sweeping, curvilinear quality of contours.

3. There is always a direct relationship between motion, the use of line, and design. In Rogier's work, the angular quality represents a confined movement in the center portion of the painting—roughly, the face of the Magdalen and her book. Our eyes are taken around the subject in a rather distracting way. We see how Pollaiuolo used the curvilinear quality of his line to create a movement that reflects the excitement and activity of the scene—the mythological creature in the midst of transformation from human to tree. Line here contributes to that sense of activity. The sweeping contours in Veronese's *Allegory* contribute to the dramatic power of his painting. The action is, in a way, compressed toward the center of the scene by the angle of the trees above that seem to "bend" the movement toward the central figures.

4. In Rogier's exuberance and eagerness to display his masterful painting techniques, he used the angular quality of line to provide his meditative subject matter with a sense of activity. This activity is almost antithetical to his aesthetic message, which in this case is the relationship between the sophisticated charm of the Magdalen and her dignified aura in a simplistic, everyday environment. The artist has used cloth folds and linear perspective to create a composition of contained conflict caused by opposing linear qualities. Polliauollo's subject matter was taken from mythology and portrays the excitement and motion in a dramatic moment of transition. Veronese boldly placed his central figure, a nude woman, with her back to the viewer. This inventive positioning of the figure, whether intentional or not, seems to involve the viewer more actively in the drama of the moment. It is as if we were looking over the woman's shoulder and helping her with her dilemma or perhaps even taking part in it.

5. Rogier's very formalistic and classical painting comes from the Early Renaissance period. Pallaiuolo's symmetrical work is indicative of the High Renaissance, particularly in his use of slightly inclined diagonal figures. Veronese is more of a mannerist in the way he treats sweeping, curvilinear forms and motion.

6. All ten of the figures in Cranach's painting are completely nude. Such a large number of nudes in a single painting is at first confusing, but closer examination reveals that they are arranged in a circular pattern, and their nudity enhances the unity in the painting. The foliage directly behind the nudes serves as a screen to separate the foreground from the background. The rock formations in the background lean more toward fantasy than reality and thus serve to create a sense of space and distance. The light in the foreground seems to have no specific source, whereas the light on the rock formations in the background seems to enter from the left. The nudes cast no shadows but glow from an internal source of light. The entire painting has two kinds of rhythm. The foreground figures in the circle create a continuous curvilinear movement around the central nude figure. The rock formations are more angular and provide a complete contrast to the graceful rhythms in the foreground.

7. The subject matter both in the madrigals and in the Titian is taken from secular sources. The full chords in the madrigals' harmonies can be compared with the depth achieved by Titian through aerial and linear perspective. Rhythmic vitality in both works is different from that of the preceding period. In the madrigals, a regular, recurring accent or beat helps listeners feel a driving rhythm, while the diagonal arrangement of figures in the painting, along with alternating values, creates a visual rhythm.

8. Depending on which works are selected for comparison, you may find some of the following differences in style:
 a. a greater interest in the South in symmetrical balance.
 b. less interest in the North in idealized beauty in favor of stark reality and humanistic qualities of subjects, especially in portraiture.
 c. greater interest in some Northern painters, like Bosch, in grotesque fantasies as subject matter.
 d. an absorbing interest in the North, especially in Bruegel, in achieving a sense of deep space in naturalistic landscapes, not so much from the linear perspective popular in the South as from a series of interactive planes. (See Bruegel's *Hunters in the Snow* and *The Harvest* and Dürer's *Landscape with a Footbridge*.)

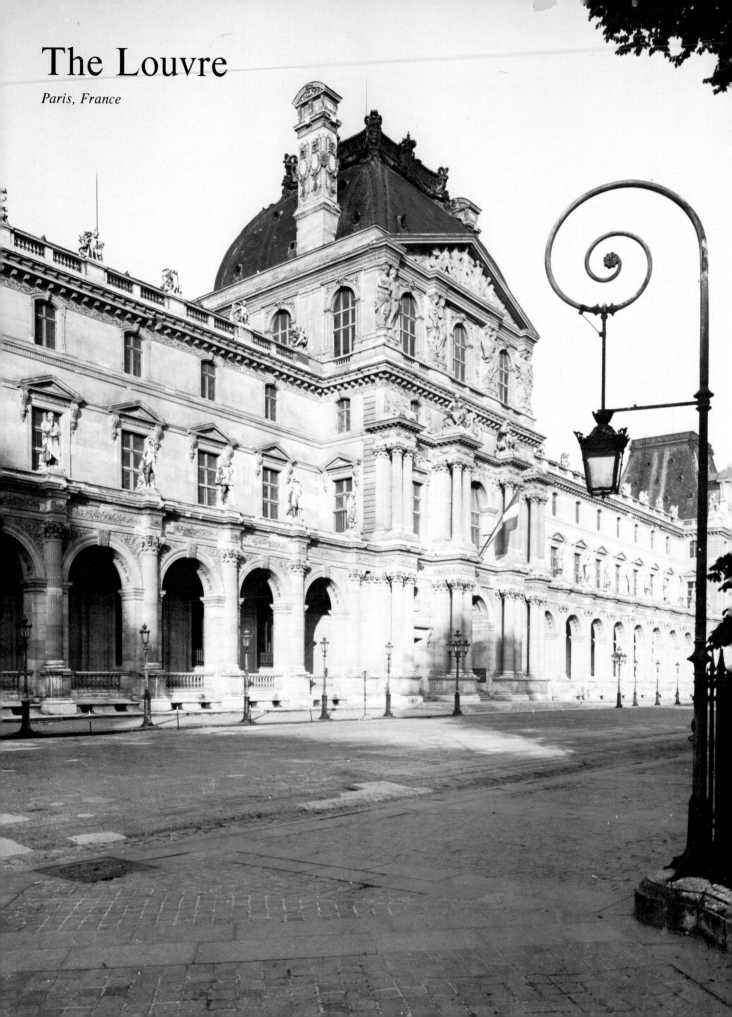

The Louvre

Paris, France

Tour 7

The Baroque Period in Europe

The Gallery

Located in the heart of Paris, the Louvre is one of the largest and most beautiful museums in the world. Originally a king's palace, the Louvre has housed royal art treasures ever since the thirteenth century. It did not become an official museum until 1793, just after the French Revolution. All royal buildings became the property of the French people after the Revolution, and the Louvre was chosen to exhibit the vast art collection that also suddenly belonged to the people. During the next few years, especially as a result of Napoleon's conquests, the collection of art grew at an extraordinary rate.

The present vast collection includes some of the most famous paintings in the world, such as the Mona Lisa; sculptures; drawings; furniture; art objects; and antiquities. Most of its paintings date from the fifteenth to the nineteenth centuries. The strength of the painting collection encompasses the Renaissance, baroque, and neoclassical style periods. Twentieth-century art pieces are noticeably missing from the collection. (However, modern art is on view in any number of galleries in Paris, including the Musée National de l'Art Moderne, established in 1937 and located near the Eiffel Tower.)

Cameras without flash bulbs are welcome at the Louvre. Visitors enjoy the opportunity to view at close range all the paintings and sculptures with the exception of the most valuable treasure, the *Mona Lisa,* which was recently placed behind glass after the Louvre received anonymous threats of mutilation.

Typical of the great museums, the Louvre is large; plan to spend at least four to eight hours, preferably over a two-day period. Even then you may not see everything. It is rumored that Art Buchwald "did" the Louvre in less than twenty minutes—in running shoes with a taxi waiting. Some people spend that much time in the Rubens room alone.

One of the Louvre's great strengths is its ability to display extremely large paintings to best advantage. The great work by Jacques-Louis David *Coronation of Napoleon I at Notre Dame* measures 20'4" × 32' and seems to dwarf gallery visitors. But this work is not the largest; one of Charles Le Brun's great canvases, *Alexander and Porus,* measures 15'5" × 41'6". Indeed, it would take gymnasium-sized rooms to allow the viewer to see the entire canvas in a single glance. Thus the Louvre is certainly the right place for such monumental works of art.

Tour Overview

The baroque style period, some would say, is in many ways an extension and expansion of the Renaissance period. However, the collective style of baroque painters, sculptors, and architects is quite distinctive from that of the Renaissance. This drastically new style developed in the late sixteenth century and continued well into the eighteenth century—a period of nearly two hundred years. Our first reaction might well be to question how a single style could endure over so long a period of time. In a strict sense, it did not: there were several trends, many changes, and even conflicts as the new style developed throughout western Europe. However, an overall attitude toward artistic expression encompassed all the art of the baroque period and was clearly different from that of the Renaissance and from the neoclassical era that was to follow. Recall that our survey of style is based on the point of view that emphasis on form and feeling alternates from one style period to the next. The baroque style is most certainly one that emphasizes feeling over form, whereas the Renaissance style emphasized form over feeling.

Figure 7.1 Fra Andrea dal Pozzo, *The Glorification of St. Ignatius,*
1691–94.
Ceiling fresco, Sant' Ignazio Church, Rome.
Scala/Art Resource, NY.

THE BAROQUE STYLE

Baroque was originally a derogatory term, perhaps
coming from the Portuguese word for a deformed pearl.
Whenever people speak about anything as being "ba-
roque," they are most likely referring to profuse elabo-
ration and ornamentation, such as that found in the
ceiling paintings of palaces and churches of the period
in Germany, Austria, and Italy. These typical examples
of unbridled exuberance and turbulent motion, coupled
with bright coloration, are breathtaking to artist and
nonartist alike. In *The Glorification of St. Ignatius* (fig.
7.1) by Fra Andrea dal Pozzo (poht'-zoh) (1642–1709),
the artist's intent was to overwhelm the viewer with the
continual motion of the composition and to open up the
ceiling of the nave by an illusion of vast space leading
up and out of the building toward infinity.

This work provides us with many clues that will help
us understand baroque art. Baroque artists seemed to be
concerned about the ultimate involvement of viewers in
comprehending the content of their artworks. They ap-
peal to our eye through the use of extravagant visual
splendor and grand, sweeping scale. They appeal to our
feelings through the use of dramatic representation of
emotions, violent activity, dynamic themes, realistic or
lifelike figures, intense hues, and high contrasts in value.
Part of the drama in Pozzo's ceiling is brought about
through **illusionism.** Those columns and arches are

painted in; they are not real. The illusion of the opening
up of space, of drawing the viewer up and out of the nave
and toward infinity, is nothing short of theatrical.

Much of the emotional appeal in baroque work is
achieved by "opposition of forces." This phenomenon can
best be seen in high contrasts of value, opposing curvi-
linear contours, and the diagonal axis lines that we saw
as implied line in Tiepolo's *Apollo Pursuing Daphne* in
Tour 1 (see fig. 1.21). Opposing forces create a dynamic
tension for viewers and thus heighten their sense of emo-
tion and involvement in the work.

The production of art in all forms became more pro-
lific in the seventeenth century. Early in that period,
Roman Catholic clergy of the Counter-Reformation in-
creased commissions in an attempt to strengthen the
church. Later, demand for art came from the general
public whose income had increased, as had the value of
paintings and prints. Throughout the period, artistic pa-
tronage shifted from the church to the aristocracy, and
since art was considered a symbol of wealth, commis-
sions from wealthy people provided artists opportunities
to earn very good livings.

The baroque period produced great quantities of art
objects of unparalleled beauty that reflect an unmatched
exuberance for life. With the death of the Renaissance
giants—Leonardo da Vinci, Michelangelo, Raphael, Ti-
tian, and Dürer—and with the impetus provided by the
innovations of the mannerists, the baroque artists of the
seventeenth-century reached new heights of intense ar-
tistic expression.

Figure 7.2 The baroque spirit reflected in the columns of the
Louvre, East Front, Perrault's Colonnade.
Cliché des Musées Nationaux–Paris.

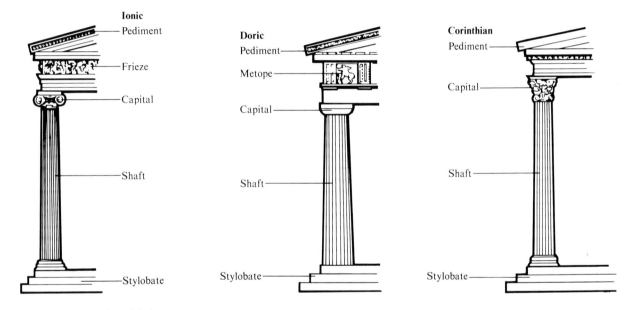

Ionic
— Pediment
— Frieze
— Capital
— Shaft
— Stylobate

Doric
Pediment—
Metope—
Capital—
Shaft—
Stylobate—

Corinthian
Pediment—
Capital—
Shaft—
Stylobate—

Figure 7.3 The Greek orders of design.

CHARACTERISTICS OF BAROQUE ARCHITECTURE

We sense the spirit of the baroque period from the moment we approach the Louvre. Before going inside, it may be well to consider why the period is reflected so characteristically in its architectural style. The architectural design of the east front displays a new dynamism we will see later in baroque painting and sculpture. Notice how the columns are spaced in pairs, creating a distinctive rhythm (fig. 7.2). The **capitals** are of the elaborate **Corinthian order,** which fits in well with the baroque style. Compare the decorative leaf motifs used on the Corinthian column with the quiet, formal, classical dignity expressed in structures of the **Doric** and **Ionic orders** (fig. 7.3). Most significantly, the columns of the east front are free-standing—set apart from the wall behind them. This creates a stunning effect of light and shade, a sense of drama, and an illusion of depth quite different from the effect of classical architecture. At the same time, as we will note later in the tour, another view of the Louvre will reveal a classical dimension (see p. 178).

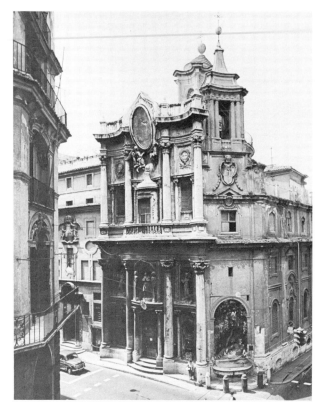

Figure 7.4 The baroque style in Italian architecture. Francesco Borromini, Church of San Carlo alle Quattro Fontane, Rome, 1667. Scala/Art Resources, NY.

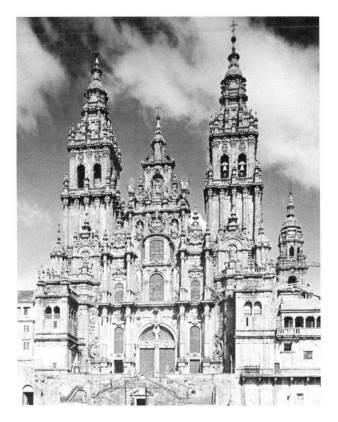

Figure 7.5 Elaborate ornamentation in baroque Spanish architecture. Facade of the Cathedral de Compostela in Galicia, Spain, 1667–1750.
Photo courtesy of the National Tourist Office of Spain.

In Rome, architectural design in the seventeenth century began to be characterized by opposing convex and concave contours and by elaborate ornamentation—in the same vein as Pozzo's ceiling painting. The continued use of deep impressions and open spaces provided a heightened sense of light and shade. The facade of the Church of San Carlo alle Quattro Fontane (fig. 7.4) designed by Francesco Borromini (boh-roh-mee'-nee) (1599–1667) reveals the architect's interest in the contrasts of convex and concave curves and in the dynamic quality of diagonals. Notice the 45-degree angle of the corner tower. We can also see the deep impressions in the facade and the open spaces in the tower, both of which were designed to take full advantage of Italy's perpetual sunlight.

In Spanish architecture, we can again identify the use of deep impressions and open spaces in the Cathedral of Santiago de Compostela at Galicia (fig. 7.5). But the most striking baroque feature of this magnificent structure is the elaborate ornamentation of the facade which, again, is all the more dramatic in sunlight. It is as if the architect's purpose had been to create a visual splendor with more emphasis on eye appeal than on function. Both churches seem to invite our eyes to wander over their surfaces, to follow the varieties of motion and surface activity in a design that uses every square foot to express the exuberance of the era.

CHARACTERISTICS OF BAROQUE SCULPTURE

The baroque spirit brought about a fusion of the arts. Never before, or since for that matter, had the arts been so interrelated. Interest in theater spawned the invention and rapid development of opera in Italy around 1600. Opera is the most composite of all art forms: a mixture of instrumental and vocal music, theater, set design, and dance. Architects were also brought into this new arts arena as the need for opera houses arose. International interest in the arts was manifested in many pieces of paintings, sculpture, and architecture throughout the period.

Nowhere in baroque art is the sense of drama or theater more evident than in the sculpture *The Ecstasy of St. Teresa* by Gianlorenzo Bernini (jahn-loh-rehn'-zoh bayr-nee'-nee) (1598–1680), the most prominent and gifted sculptor of the period. The work (fig. 7.6) is ensconced in an altarpiece in one of the chapels of the Church of Santa Maria della Vittoria in Rome. The linear direction quickly draws our eye to the face of Saint Teresa, which is highly expressive of her ecstatic agony. We can see that her face resembles one of portraiture rather than an ideal. As our eyes wander around the entire scene, we soon become aware of the unique position

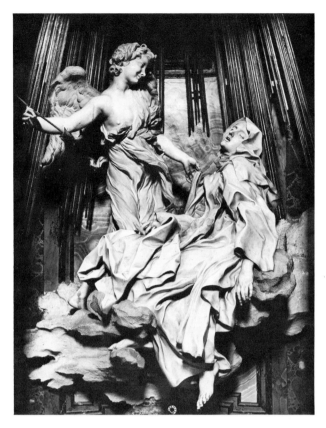

Figure 7.6 Gianlorenzo Bernini, *The Ecstasy of St. Teresa,* 1645–52. Cornaro Chapel, Church of Santa Maria della Vittoria, Rome.
Marble; life-size.
Anderson/Art Reference Bureau.

Cross-section of a typical sculptured surface showing undercuts at different locations.

Cross-section of a typical sculptured surface showing no undercuts that create dark shadows on reflected surfaces. The sculptor avoids creating unwanted shadows by carving surfaces at nearly right angles to allow light to strike both sides of the form.

Figure 7.7 Undercutting.

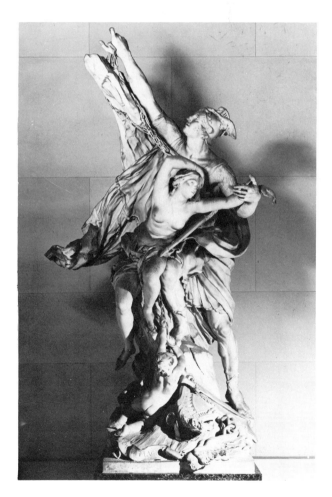

Figure 7.8 Pierre Puget, *Perseus Freeing Andromeda,* 1684.
Marble; 126 × 42 in.
Louvre. Cliché des Musées Nationaux–Paris.

of the two figures in the midst of a drama on what resembles a small theatrical stage in the middle of a proscenium arch. Light streaming down from above the "stage" is imitated and enhanced by sculpted light rays above and behind the two figures. Small figures to either side seem to assume the role of the audience.

Now look closely at the folds in the garments of the two figures and the cloud form that seems to support them. The apparent high contrast in value between the lights and darks results from the process of **undercutting** around the shapes. The sculptor has made deep cuts under the surface rather than at right angles (fig. 7.7). Using this technique, Bernini attempted to transform marble into robe and cloud, another example of illusionism. Bernini's concern in portraying a dynamic piece of cloth serves to enhance the drama's powerful message. It is no accident that Bernini's *St. Teresa* is so important to the church's architecture. Nor is it accidental that the work is related to theater and painting, both of which are meant to be viewed from one particular position.

Many sculpted works in the Louvre accurately reflect the baroque style. *Perseus Freeing Andromeda* by Pierre Puget (poo-zhay′) (1622–94) is full of sweeping diagonal axis lines (fig. 7.8). Undercutting is also used here

to create bold contrasts of light and shade. The eye moves from the base toward the top, and from the lower right to the upper left. Such eye movement is basic if we recall our experience when viewing David Smith's nonobjective sculpture *Cubi I* in Tour 2 (see fig. 2.41). Our eyes moved in a sweeping S curve from the larger cubes at the base to the smaller ones at the top. Realistic figures were not necessary for our eyes to travel in this way, and in this narrow sense these two otherwise very different types of sculpture are similar.

Much of the sculptured works from the baroque period appear as composites—two or more figures encountering one another in some type of dynamic opposition. The axis of each figure, and even of each part, oppose each other. Even where only one figure appears, there is often the implication that it is constructed in opposition to another unseen figure, so the tension is still apparent. Imagine that the Puget sculpture incorporated only one figure, Perseus alone. Even though the diagonals would not be entirely lost and the undercutting would still be evident, the work would become more the study of a figure rather than what was originally intended—a forceful drama involving human interaction. The sculptor stopped the action to capture a fleeting vision of a moment in time.

RUBENS: A MASTER OF BAROQUE PAINTING

The most baroque painter, Peter Paul Rubens (roo'-bens) (1577–1640) diligently studied the Italian masters and borrowed the sculptor's technique of duplicating human anatomy. Close examination of anatomy in Ruben's *Disembarkation of Marie de Medici* (colorplate 40) proves that Rubens was familiar with bone structure and musculature. This painting is about the jubilation over Marie's safe arrival following a long sea voyage; it is *not* about nude bodies, strange creatures from the sea, or even about Marie herself. Rubens reflected the excitement of the occasion by using turbulent curves, opposing diagonals, and vivid colors that virtually leap from the painting and envelop the spectator. The painting is about transforming the ordinary into something splendid; it is about reframing the life of Marie to make every event of her life look as though it were part of some grand scheme that only Olympian gods could have conceived. This is what Rubens, in his supreme objectification, could accomplish.

The distortion of human anatomy in the female sea creature (the lower right sector of the painting) should not surprise or distract us from seeing the message here.

Figure 7.9 Peter Paul Rubens, Studies for *The Kermis (The Village Fair)*, detail ca. 1629–32.
Courtesy of the Trustees of the British Museum.

I am by natural instincts better fitted to execute very large works than little curiosities. I have never lacked courage to undertake any design, however vast in size or diversified in subject.

Peter Paul Rubens,
1621 letter

Even though we know that backs cannot bend that way and that we cannot really see a person's buttocks and navel at the same time, the emphasis is on motion and emotion. The composition resembles a stage set with the action taking place directly in front of the viewer. Rubens generally disregarded deep space in favor of foreground activity. The painting becomes all the more dynamic with the use of diagonal axis lines in the sea creatures, in those people on the right who are greeting Marie, and in the herald angel floating above the scene. What a glorious scene it is! It is not hard to imagine a whole studio of assistants working on these large canvases under Ruben's masterful eye.

The quick sketches in figure 7.9 reveal Ruben's ability to create powerful, complete compositions with a few deft strokes. His love of Titian is portrayed in the vitality of

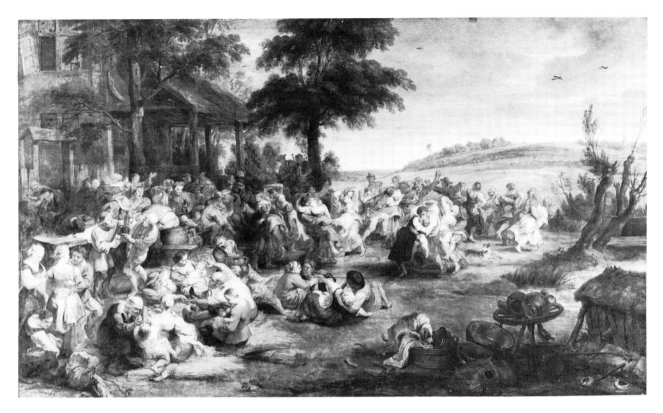

Figure 7.10 Peter Paul Rubens, *The Kermis (The Village Fair)*, ca. 1635.
Oil on wood; 58⅝ × 102¾ in.
Louvre. Cliché des Musées Nationaux–Paris.

movement found in the final rendering of *The Kermis* (*The Village Fair*) (fig. 7.10). Portraying the gaiety and excitement of this bawdy country scene, the figures are intertwined, the contours curvilinear, and the axis lines diagonal. Rubens, who also emulated Bruegel, his Flemish predecessor, borrowed the group of figures in the center of the sketch directly from Bruegel's *The Wedding Dance* (see figure 2.8).

In his painting *The Tournament* (fig. 7.11), Rubens subdues the foreground action by the staid landscape behind it, by emphasizing the emotional impact of the dark, shadowy castle and the powerfully brooding sky. In his landscapes, Rubens creates impressions of nature in motion with hazy horizons, turbulent skies, vibrant colors and unfinished rough brushstrokes.

We see in these three Rubens paintings, a baroque compositional technique significantly different from that used by the Renaissance artists. Renaissance painters usually designed symmetrical compositions around a central figure. There is no central figure in *The Tournament* or *The Village Fair*. Nor is there one to be found in *The Disembarkation of Marie de Medici* due to the turmoil below and forward in the picture. Instead there is a dynamic interplay of several figures with tension

Figure 7.11 Peter Paul Rubens, *The Tournament,* ca. 1635–40.
Oil on canvas; 28¾ × 42½ in.
Louvre. Cliché des Musées Nationaux–Paris.

produced by the asymmetrical arrangement of forms. As you view more and more works from the baroque period, you will become increasingly aware of the off-center placement of forms. The result is a dynamic interchange between forces rather than the more static treatment involving a central figure.

While Rubens was expanding aspects of reality in his attempt to portray something more expressive, another stylistic trend, called baroque realism, was developing. The first and most important aspect of realism in baroque art is the attention to detail. The second aspect, and one which is related to the first, is the representation of mundane, real-life people and objects in realistic settings. As a matter of fact, one of the most influential painters of the period, Michelangelo da Caravaggio (kah-ruh-vah'-joh) (1573–1610), was accused of pulling a pale and bloated corpse from a river to use as a model, all for the sake of realistic results.

Caravaggio portrayed Apostles and other Biblical figures as real peasants and disheveled old men. We see a number of the period's style characteristics in Caravaggio's famous painting *The Death of the Virgin* (fig. 7.12). We are at first struck by the stark contrast between the highlighted figures in the foreground and the blanket of darkness behind them. The scene could well be a dramatic moment in a stage play. The light, almost of spotlight intensity, illuminates the Virgin and her mourners from stage right. The light thrusts the figures forward and gives Caravaggio's work a vitality and drama markedly different from the mannerist tradition. One of the most telling new uses of this kind of light was the powerful chiaroscuro, or modeling, of the figures' features. These intense light-dark contrasts strongly influenced later artists including Rembrandt. While the mannerists portrayed an idealized representation of a person, perhaps drifting on a cloud, Caravaggio and his contemporaries were more likely to paint a person from life—a model with human flaws—in everyday surroundings.

Severe flesh-and-blood realism and light contrasts are seen in *Judith and Maidservant with the Head of Holofernes* from the Detroit gallery (see fig. 2.4). Artemisia Gentileschi, one of the most influential Italian baroque artists, trained under her father, as was the custom of many women artists. Her strong female figures show calm courage and echo her own revolutionary role as a woman whose mastery and originality of painting were respected and copied.

Like Caravaggio and Gentileschi, Georges de La Tour (1593–1652) also manipulated light, but its source was usually within the picture plane itself and thus contributes even more to the natural look of the setting. In his *Christ with St. Joseph in the Carpenter's Shop* (colorplate 35), the only light emanates from the candle held by the boy. Again, we find the two figures thrust forward by the blanket of darkness behind them. We witness the strong chiaroscuro on Joseph's head and arms; we are impressed with the high contrast between the bright light

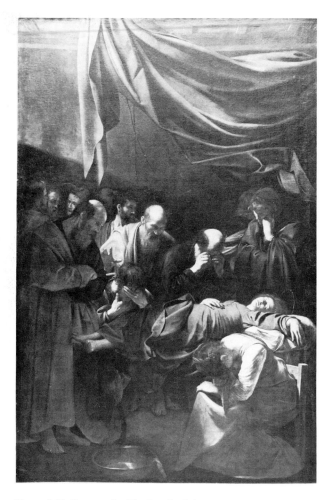

Figure 7.12 Caravaggio, *The Death of the Virgin,* 1605–6. Oil on canvas; 145¼ × 96½ in. Louvre. Cliché des Musées Nationaux–Paris.

on Jesus' face and the dark background. No halos or heavenly hosts are found floating about these down-to-earth figures.

The depiction of characters bathed with artificial indoor light is fairly typical of the period. In Rembrandt's (1606–69) *Self-Portrait* (fig. 7.13) (one of nearly one hundred self-portraits he painted), the light is concentrated on the face and the cap. All other light and coloration are subdued so that the artist's facial expression comprises the entire aesthetic message of the painting. The total effect is similar to the dramatic results that Caravaggio and La Tour achieved with light. Notice, too, the off-center position of the face, balanced subtly in the lower half of the canvas by the artist's hands and palette.

One of the most important differences between Rembrandt's use of light and that as used by Caravaggio and La Tour is Rembrandt's indefinite source. It is difficult, for example, to pinpoint the source of light in Rembrandt's painting *Christ at Emmaus* (colorplate 37). At first, we might observe the light beaming into the room

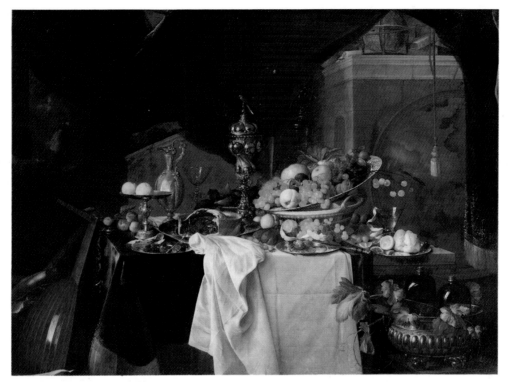

Plate 38 *A Table of Desserts,* Jan Davidsz de Heem.
1640. Canvas, 58.7 × 79.9 in. (149 × 203 cm.).
Louvre, Paris. Cliché des Musées Nationaux, Paris.

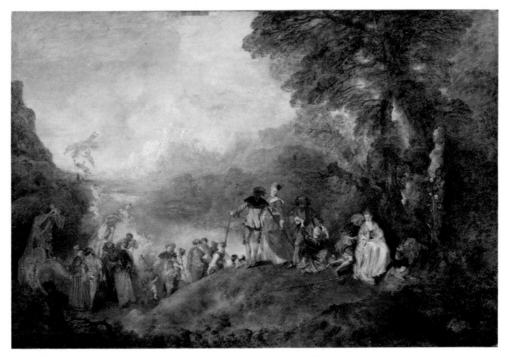

Plate 39 *The Embarkation for the Island of Cythera,* Jean Antoine Watteau.
1717. Canvas, 51 × 76½ in. (129.5 × 194.3 cm.).

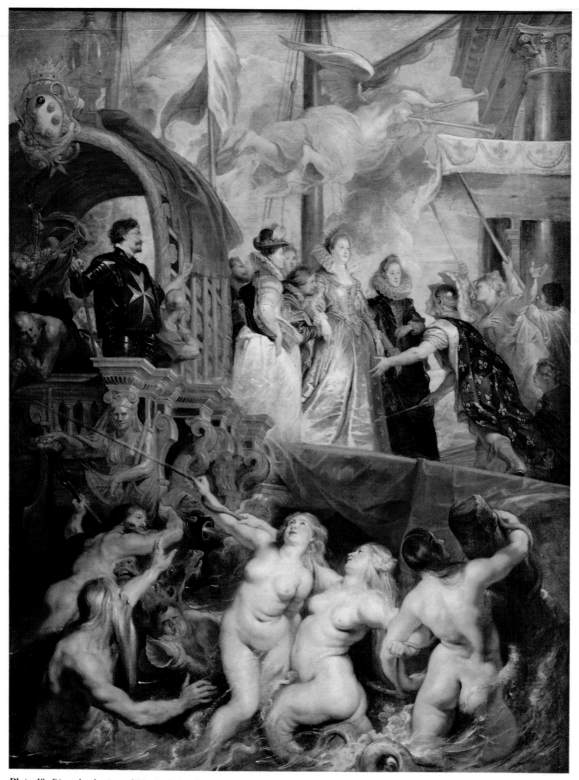

Plate 40 *Disembarkation of Marie de Medici,* Peter Paul Rubens.
1622–25. Panel, 155½ × 116¼ in. (3940.8 × 295.3 cm.).
Louvre, Paris. Cliché des Musées Nationaux, Paris.

Figure 7.13 Rembrandt van Rijn, *Portrait of the Artist at His Easel*, 1660.
Canvas; 111 × 90 cm. Louvre. Giraudon/Art Resource.

Figure 7.14 Rembrandt van Rijn, *Portrait of a Man*, ca. 1654–58.
Reed pen, brown ink with touches of white; 9¾ × 7½ in.
Louvre. Cliché des Musées Nationaux–Paris.

from the left, but the light on the figures seems to be coming from another source. In fact, there almost seems to be a luminosity that pervades the scene. This rather ambiguous glow, which precludes the dramatic chiaroscuro and sculpting of forms, places more emphasis on the contrast between supernatural and realistic elements. We conclude that the light in the room seems to be coming from two sources—the left, outside the picture plane, and also from Christ's face, which exudes a kind of inner light. Even if Rembrandt had not provided that stylized halo, we can see that shadows, subtle as they are, fall away from the face of the central figure.

Incidentally, the point of interest in this painting is not at the center of the composition. Baroque painters definitely preferred asymmetrical balance and adherence to the conventions of the golden section. The realism exemplified by the mundane surroundings and ordinary people is also quite obvious here. The blending of everyday life with spiritual references transforms Rembrandt's paintings into significant religious experiences, especially for the simple folk of the seventeenth-century Netherlands who, unlike those of earlier times, were thus able to identify with the painted holy personages.

Frans Hals (frahns hahls) (1581–1666), one of Rembrandt's most gifted contemporaries, specialized in portraiture, which became extremely popular in the Netherlands in the early 1600s. His internationally acclaimed masterpiece *The Gypsy Girl* (colorplate 36) is one of the finest examples of that period's portrait painting. Hals's lively attention to surface detail is quite obvious. We can also observe at first glance the richness of color tonality achieved despite a limited palette. Close examination reveals exuberant brushstrokes, controlled, yet flamboyant enough to capture the spontaneity of the subject's energy and vitality. This brush technique complements the more obvious features of the subject matter: the sidelong glance, the décolletage, the coquettish smile. All of these elements contribute to the feeling tone of the work.

It was not uncommon for both Rembrandt and Hals to mix fine detail and broad, quick brushstrokes in the same painting. A somewhat exaggerated example of this technique—a baroque innovation—is seen in Rembrandt's pen sketch *Portrait of a Man* (fig. 7.14). The artist wanted to carefully render the man's facial features, but also wanted to keep the remainder of the portrait simple and free. So he used firm, bold lines to express the figure's hat, coat, and even his hands.

Figure 7.15 Gesture is the use of spontaneous line to express the essence of a subject.

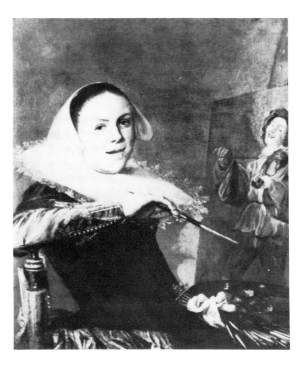

Figure 7.16 Judith Leyster, *Self-Portrait*, ca. 1635. Oil on canvas; 29⅜ × 25⅝ in. National Gallery of Art, Washington.

All of Rembrandt's sketches contain some of this starkly simple yet effective use of spontaneous line. Artists from that time forth have recognized the value of his unique form of gestural drawing. **Gesture** is the term given to this technique of capturing the expressive energy of a subject rather than rendering an exact, detailed image (fig. 7.15). It combines all the art components into swiftly drawn marks tracing the artist's feelings. The lines of the painting or drawing attempt to capture the essential character of the object, whether it is a cloud, a tree, an ocean wave, or a piece of architecture.

Judith Leyster (Lie'-ster) (1609–60) one of Frans Hals's more brilliant students, completed several paintings in her early twenties that were, for years, falsely labeled as Hals's. Her delicate swift brushwork and intricate compositions, as displayed in her self-portrait (fig. 7.16), make her distinct from her mentor. Her **genre paintings** (zhahn'-ruh)—that is, works depicting specific types of everyday environments—many of them of musicians, confirm a style of her own; yet many of her portraits are often confused with those of other seventeenth-century masters.

Realistic portrayal challenged all baroque artists. Jan Davidsz de Heem (haym) (1606–84), whose large painting entitled *A Table of Desserts* (colorplate 38) epitomizes sparkling realism. The effect of bright colors and glistening highlights moves this elaborate collection of food and objects beyond reality into an ideal world that exists only in the artist's imagination. The food is too picturesque to be eaten and the lute too fine to be played.

THE RISE OF CLASSICISM IN THE BAROQUE PERIOD

In the midst of baroque flamboyance, we find a new development—one that seems contrary to the style of Rubens and his contemporaries—of a parallel style of classical restraint and idealized beauty. This style is inherent in the east front of the Louvre. The symmetrically balanced proportions and overall parallel lines of the columns create a total effect of simplicity, restraint, and order—all elements of classical architecture. This order and simplicity supplies a stronger sense of mass than do the more elaborate baroque buildings. In the center entrance of the Louvre, we see the popular classical pediment, or gable, supported by eight columns. This device, patterned on the facade of the Pantheon (fig. 7.17) appears in architecture everywhere. We shall see how passionately architects continue to follow the early Greek and Roman models as we progress to our tour of the Metropolitan Museum, where we will see works of the classical period.

Art that can only be described as "classical" was being refined by French painters Louis Le Nain and Nicolas Poussin. Le Nain (luh-nan') (1593–1648) was one of the most important French painters of his time. Two of his

Figure 7.17 The classical pediment of the Pantheon, Rome, A.D. 118–125.
Alinari/Art Resource, NY.

genre paintings reflect Caravaggio's brand of light and value. *The Forge* (fig. 7.18) depicts a small group of peasants standing complacently near a forge, which supplies the only light for the scene. Bold contrasts, chiaroscuro, and mundane surroundings are in keeping with the realistic heritage established by Caravaggio. There is something about this painting, however, that leads off in another direction—one that, along with realism, stands in opposition to the baroque qualities we have examined thus far. We can see none of the turbulent movement that seethed in Rubens's paintings. On the contrary, Le Nain's figures stand motionless with a kind of classical dignity amid horizontal and vertical lines. There is no display of motion, and unlike Rubens's mythical satyrs and sea creatures, none of the figures are ambiguous. The figures are not intertwined or wildly thrashing about, but instead are somewhat stoic and austere, as if to plead for our intellectual curiosity rather than our emotional involvement.

It was Le Nain's countryman and contemporary Nicolas Poussin (poo-sa′n) (1594–1665) who was to become the greatest French painter of the seventeenth century. Poussin brought baroque classicism to its most sophisticated level of development. If we remember that classical art includes interest in ideal beauty, clarity, intellectual precision, and simplicity, we cannot only better comprehend Poussin's works, but we can also appreciate

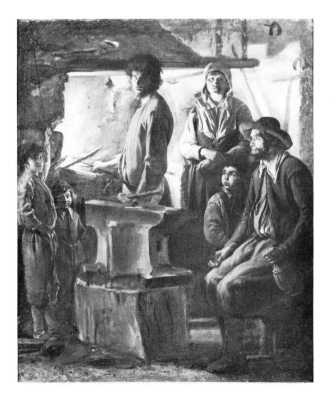

Figure 7.18 Louis Le Nain, *The Forge,* ca. 1641.
Oil on canvas; 27⅛ × 22½ in.
Louvre. Cliché des Musées Nationaux–Paris.

Figure 7.19 Nicolas Poussin, *Landscape with the Burial of Phocion,*
1648.
Oil on canvas; 70½ × 47 in.
Louvre. Cliché des Musées Nationaux–Paris.

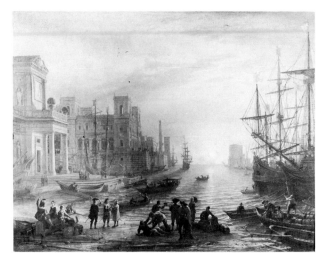

Figure 7.21 Claude Lorrain, *A Seaport at Sunset,* 1639.
Oil on canvas; 40½ × 53½ in.
Louvre. Cliché des Musées Nationaux–Paris.

Figure 7.20 Nicolas Poussin, *The Arcadian Shepherds,* ca. 1655.
Oil on canvas; 33½ × 47⅝ in.
Louvre. Cliché des Musées Nationaux–Paris.

The first requirement, fundamental to all others, is that
the subject and the narrative [of a painting] be grandiose,
such as battles, heroic actions, and religious themes.

Nicolas Poussin

his courage to work in opposition to the stylistic tide of
the baroque movement. Many of Poussin's works are
classified as *ideal landscape paintings,* so named be-
cause they follow a set of conventions or painting prac-
tices. This is the reason that so many landscapes of that
time look alike. They all seem to have the same general
arrangement: a group of large trees on one side and a
smaller group on the other; a background that nearly al-
ways includes a set of classical buildings; and in the fore-
ground, a small group of idealized figures, such as the
mythological characters in Poussin's *Landscape with the
Burial of Phocion* (fig. 7.19). This landscape resembles
another of his paintings called *Flight to Egypt* (not in
the Louvre), which depicts biblical characters in the
foreground. Poussin's use of strong contrasts, sharp con-
tours, and precise order is evident in these paintings.

The presence of ancient Grecian and Roman figures
in some of Poussin's works is evidence of his high regard
for classical ideals. *The Arcadian Shepherds* (fig. 7.20)
have the look of Grecian statuary; the robe of the figure
on the right looks more like carved marble than cloth
painted with a brush. The shepherds' pose is classical in
attitude and their look is stoic, devoid of any emotion.
The faces of these peasants are more idealized than true-
to-life. The composition, with its absence of motion, re-
sembles a moment frozen in time. The arrangement of
shapes in the foreground is basically symmetrical, al-
most as if to tell us that this is a well-ordered design and
that we should respond to its order and simplicity with
all the intellectual restraint that went into its concep-
tion.

Poussin's only rival in the realm of ideal landscape
painting was Claude Lorrain (loh-ran') (1600–1682),
also a Frenchman. However, with careful analysis, it is
easy to distinguish Lorrain's landscapes from Poussin's.
Lorrain, like Poussin, constructed imaginary scenes from
notes and sketches of nature. One of his favorite subjects
was the seaport at dusk. *A Seaport at Sunset* (fig. 7.21)
bears the same title as another of his paintings at the
Detroit Institute of Art (see fig. 2.30). Both paintings
are bathed in the hazy light of dusk and both feature
towering shapes in the middleground and foreground.

Figure 7.22 Henri Nicolas Cousinet, Chocolate Pot of Marie Leczinska, 1729–30.
Silver-gilt; 6½ in.
Louvre. Cliché des Musées Nationaux–Paris.

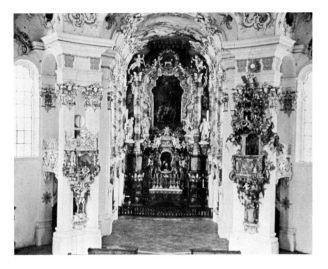

Figure 7.23 Rococo ornamentation in Bavarian Church architecture. Domenikus Zimmerman and Johann Zimmerman, Pilgrimage Church at Die Wies, Bavaria, 1745–54.
Scala/Art Resource, NY.

These shapes are dramatically silhouetted against bright sunlight in the distance. It is Lorrain's treatment of light that identifies his landscapes. The hazy atmosphere of the setting sun softens the contours of the foreground figures and creates a land of enchantment, one that is certainly delightful to behold.

THE ELEGANCE OF THE ROCOCO

Beginning around 1700 in France, a more graceful and frivolous tone appeared in art. This new art was called rococo and seemed in direct opposition to the powerful movement and the dramatic emotion of Bernini and Rubens. The term is derived from the French word *rocaille* (roh-kah′-ee), meaning rockwork, but which actually applies to irregular rock and shell, and to decorative garden walls. The artistic manifestation results in elaborate decoration with delicate curves and light pastel and gold colors. The design is usually asymmetrical or irregular.

The chocolate pot of Marie Leczinska (leh-shin′-skah) (fig. 7.22) is typical of the period. The highly decorative legs and spout are shaped like dolphins, which was not unusual considering the rococo period's fascination for marine motifs, especially shells. The handle of the pot is far too large for balanced proportion, but this distorting of design without regard for formal symmetry was a prominent feature of the rococo. Also typical of the style is the superfluous look of the scrolls and flowers creating the intricate ornamental filigree that transforms such an ordinary utensil into a work of art. The purpose of this ornamental piece seems almost inconsequential.

Who were the consumers of this elegantly "irresponsible" art? Baroque art, as we have seen, had a very wide appeal across the social spectrum from kings and bishops to commoners. Rococo art, on the other hand, was meant to be appreciated by the elite. This applied to rococo music as well in the delicate harpsichord sonatas of Domenico Scarlatti (skahr-lah′-tee) and Francois Couperin (koo-payr-an′), and in the chamber music of C. P. E. Bach, which were favored over the ponderous works of Bach's father, Johann Sebastian. The elder Bach's instrument, the organ, was well-suited to the performance of baroque music, which was powerful, monumental, and religious. Rococo music and art were not intended to be serious; nor were they meant to be particularly religious. The Pilgrimage Church at Die Wies (dee vees) in Bavaria (fig. 7.23) is one of the most highly decorative places of worship in the world, but the breathtaking beauty of its interior is not so much related to any religious sensibility as it is to its own delightful, whimsical beauty.

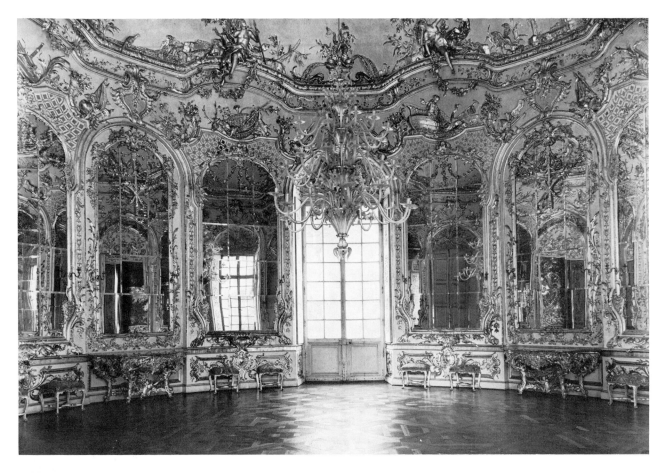

Figure 7.24 The plant motif in secular rococo architecture. The Hall of Mirrors, The Amalienburg, Schloss Nymphenburg, Munich, 1734–39.
Bildarchir Foto Marburg/Art Resource, NY.

In fact, the church at Die Wies can successfully compete with the secular Hall of Mirrors in the Amalienburg, Schloss Nymphenburg, Munich (fig. 7.24), which is called a "pleasure pavilion." The hall's whirling ovals and colorful ornamentation are certainly no fancier or more elaborate than that found at Die Wies. Interestingly enough, both buildings have quite plain and ordinary exteriors, making one's entrance into them all the more a surprising and fantastic experience.

We see in the Hall of Mirrors another rococo motif—plants. The **arabesque** quality of intertwined flowers, leaves, and vines supplied rococo artists with the kind of subject matter that allowed them to express their distinctively decorative style.

Considered one of the greatest rococo painters, Antoine Watteau's (wah-toh′) (1684–1721) chalk drawing *Half-Nude Woman* (fig. 7.25) wonderfully expresses sophisticated grace and beauty. The attitude of the head and shoulders and the graceful arch of the arm, wrist, and even the fingers are the epitome of the rococo spirit.

This simple drawing not only expresses the charm and intimacy of the period, but it also exhibits the supreme mastery of the artist. There is a hint of Rubens's influence on Watteau's technique of rendering the human flesh as soft and full-bodied, notwithstanding the limited medium of red and black chalk.

One of Watteau's most important paintings, *The Embarkation for the Island of Cythera* (colorplate 39), communicates to the viewer the frivolous charm that captured the imagination of the leisurely rich of eighteenth-century France. All elements in this popular painting serve to enhance its dreamlike fantasy world. The hazy golden light radiates nothing but the giddy happiness of loving couples. The warm, vague light and playful flying cherubs transform the scene into an imaginary land of goodness, where only polite people and gentle animals exist. This was beauty for the rococo sensibility—a pretty picture of gallant couples on a pilgrimage to the mythological Isle of Love.

The voluptuous curves of the female nude form was the most favored subject among rococo painters.

Figure 7.25 Antoine Watteau, *Half-Nude Woman,* eighteenth century.
Red and black chalk on yellow paper; 11 × 9 in.
Louvre. Cliché des Musées Nationaux–Paris.

Figure 7.26 Antoine Watteau, *The Judgment of Paris,* 1720–21.
Painted on wood; 18 × 12 in.
Louvre. Cliché des Musées Nationaux–Paris.

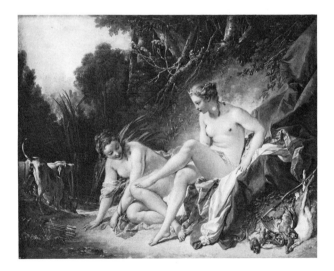

Figure 7.27 François Boucher, *Diana Resting after Her Bath,* 1742.
Oil on canvas; 22 × 28¾ in.
Louvre. Cliché des Musées Nationaux–Paris.

Watteau's *The Judgment of Paris* (fig. 7.26) centers on the goddess Aphrodite (afro-dite'-ee) and her overwhelming beauty. Watteau and others that followed him were fond of the S-curve, or the double S-curve, and its ability to supply paintings with sensuous charm and capricious motion. Aphrodite's right side and her tiny attendant are heavily outlined in order to enhance our view of the S-curves. There is an air of wistful tenderness, or quiet, unemotional languor among the figures in this misty scene. The painting's success rests in the lack of fine detail, the resulting feeling of spontaneity, and the use of soft, pale colors—often pinks, whites, light greens, and cool blues.

Watteau exerted a telling influence on François Boucher (boo-shay') (1703–70). The flesh tones in Boucher's *Diana Resting after Her Bath* (fig. 7.27) are striking when placed against the surrounding foliage. Most rococo paintings are set outdoors in an idyllic, imaginary place or in a conventional landscape with imaginary figures, such as in this Boucher. Typically, the facial expressions of Boucher's rococo figures reveal delicate and playful emotions, rather than the agonized ecstacy as we found in the sculpture of Saint Teresa (see fig. 7.6). It's amazing how realistic this picture seems at first glance, yet the nude bodies are almost devoid of the modeling effects of chiaroscuro so typical of the baroque painters.

Figure 7.28 Jean-Honoré Fragonard, *The Bathers,* 1772–75.
Oil on canvas; 25¼ × 31½ in.
Louvre. Cliché des Musées Nationaux–Paris.

Boucher's pupil, Jean Honoré Fragonard (frah-goh-nard') (1732–1806), was also influenced by Watteau. *The Bathers* (fig. 7.28) is painted in the same pink, apple green, pale blue, and white hues that characterize rococo. The profusion of curvilinear contours and diagonal axis lines are the painting's most outstanding feature: There is not a single straight line on the entire canvas. The result is a light, airy quality to the nebulous nudes, who seem to sway in the breeze like the surrounding trees. No one grows old or bored. In such a playful, delightful world, could one imagine the presence of a snake, a tempestuous sky, anything suggesting ugliness, sorrow, or revolution?

In the midst of all the rococo period's frivolity and playful themes, a genre painter of considerable ability emerged. Following the lead of the Dutch realists, Jean-Baptiste-Siméon Chardin (shahr-dan') (1699–1779) concentrated on everyday events among middle-class people of his time. He shunned the artificial and captured transitory reality in a still life of food about to be consumed, in a painting of a boy blowing a bubble about to burst, or of a girl pausing for a moment before putting away her purchases as in *Girl Returning from the Market* (fig. 7.29). Chardin's intent was to portray life, real life, as he witnessed it about him. The glass dish in the left foreground is, therefore, no small detail. Its purpose is not merely to supply a measure of balance to the composition (which it does) but also to reinforce the impression that this is a view of a *real* household in which such things as the dish are likely to be seen on the floor.

Figure 7.29 Jean-Baptiste-Siméon Chardin, *Girl Returning from the Market,* 1739.
Oil on canvas; 18 × 14½ in.
Louvre. Cliché des Musées Nationaux–Paris.

Chardin's artistic mastery can be seen here in his treatment of color and light. The nearly monochromatic selection of hues and the soft luminous glow of light elevate this work well above the ordinary.

Rococo sculpture reflects some of the spirit found in the more frivolous paintings of the period. Antonio Canova's (cah-noh'-vah) (1757–1822) *Cupid and Psyche* (fig. 7.30) is based on the myth in which Cupid revives Psyche from death. Their wistful pose matches their facial expressions. The bodily contours, when compared with Bernini's or Puget's sculptures, seem softened, and the smooth musculature lacks the sinuous strength of earlier masters. Indeed, this piece could well have been made of porcelain and is reminiscent of the ideal beauty found in the statuary of classical antiquity. This statue has the same look of playful melancholy found in Boucher's nudes as well as those by Watteau. The sculptural form is open and, as in the paintings, the artist has captured the realistic look of the human body with soft graceful lines. Recall the strong musculature and implied power in earlier baroque sculpture and compare that compressed energy with the quiet elegance of Canova's sculpture. In such developments, along with the simplicity in Poussin's works, lies the key to the development of the neoclassical style that followed.

Figure 7.30 Antonio Canova, *Cupid and Psyche,* 1787–93.
Marble; H. 61 in.
Louvre. Cliché des Musées Nationaux–Paris.

SUMMARY

Deeply rooted in the Renaissance, the baroque style seems nonetheless to deviate from that tradition while retaining the Renaissance standards of excellence. The deviations occurred mainly in terms of an unbridled exuberance for life manifested in elaborate ornamentation, turbulent motion, and high drama. Emphasis was on visual splendor, sweeping scale, and dynamic themes. Much of the emotional appeal in baroque art is generated by a dynamic opposition of forces—strong contrasts in value and linear direction and in the tendency toward asymmetry.

Bernini, one of the first and among the greatest baroque masters, expressed, especially in his architectural and sculptural works, the emotional dynamism that set the tone for the period. In the years that followed Bernini's astonishing success in Rome, other sculptors, Puget, for example, continue to employ diagonal, curvilinear contours that expressed tension and swirling activity.

The most individualistic painter of the era was Rubens, whose grand-scale works epitomize the early baroque spirit. He had the courage to distort reality, to blend realism with fantasy, to paint nudes with lusty opulence, and to invest his paintings with powerful feelings.

Light became an obsession with the baroque realist artists such as Caravaggio, La Tour, and Rembrandt. Light was used by all three to emphasize central figures and to provide stark, dramatic contrasts in value. Yet with all this dynamism, realism was becoming the mode. Franz Hals, like Rembrandt, invested his portraits with a refined surface detail that, combined with a free brushstroke, makes his paintings sparkle with the spontaneity of life.

Baroque classicism seems almost contradictory. In fact, classical treatment of ideal beauty, clarity, and simplicity ran against the tide of the baroque movement during its initial stages. While Le Nain led the way with his mundane genre paintings, Poussin brought baroque classicism to its most sophisticated level. The movement is characterized by the ideal landscape paintings of both Poussin and Lorrain.

The baroque style had one last fling in the frivolous fancy of the rococo. Maintaining the elaborate decorative quality and flair of the high baroque, rococo artists appear to have been entranced by dreams of a happy, carefree world of make-believe. Delicate curves, light pastel hues, and fanciful themes dominated paintings, sculpture, and porcelain (a newly discovered art form). Rococo art appealed especially to the refined tastes of the elite in eighteenth-century Europe, whose ideas about art leaned toward the unemotional languor of sensuous charm and prettiness.

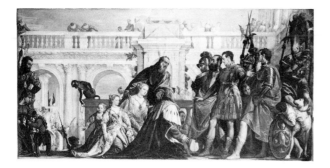

Figure 7.31 Paolo Veronese, *The Family of Darius before Alexander.*
Oil on canvas; 7 ft. 8 in. × 15 ft. 6 in.
National Gallery, London.

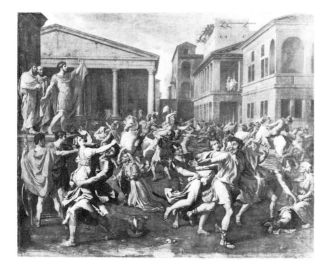

Figure 7.32 Nicolas Poussin, *The Rape of the Sabine Women,* ca. 1630–36.
Oil on canvas; 62⅝ × 81⅛ in.
Louvre. Cliché des Musées Nationaux–Paris.

VIEWING EXERCISES

1. The paintings by Paolo Veronese, *The Family of Darius Before Alexander* (fig. 7.31); by Rubens, *Disembarkation of Marie de Medici* (colorplate 40); and by Poussin, *The Rape of the Sabine Women* (fig. 7.32), appear at first glance to be somewhat similar. All three compositions incorporate large numbers of people and beasts in outdoor scenes. Describe their differences and how they fit into the development of the baroque style.

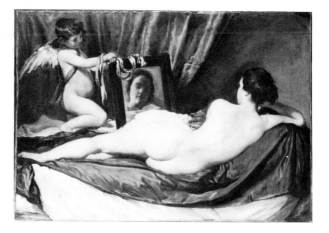

Figure 7.33 Velasquez, *The Toilet of Venus,* ca. 1649–51.
Oil on canvas; 4 ft. ½ in. × 5 ft 9¾ in.
National Gallery, London.

2. Nude women were popular subjects for baroque painters. How is the subject in Diego Rodriquez de Silva Velasquez's (vel-ahs′-kwez) painting *The Toilet of Venus* (fig. 7.33) unique? What is the significance of the winged creature and the mirror?

3. Find a recording of Bach's *Mass in B Minor* and listen to the "Et Resurrexit" section. Compare its strong baroque qualities with the Pozzo ceiling painting (see fig. 7.1).

STUDIO EXERCISES

Suggested media and supplies: sketchbook; pencil; tracing paper.

1. Make a pencil sketch of the chocolate pot by Cousinet (fig. 7.22). Continue to move your pencil around the page and allow linear motifs to grow out of the original shape until all the space of your page is filled. These motifs should echo the essence of the chocolate pot and should create a consistent pattern. With a contrasting colored pencil, search out and retrace another design from the pattern of lines filling the page.

2. Pierre Puget's sculpture *Milo of Crotona* (fig. 7.34) displays the axis lines that suggest curvilinear swirling motions (fig. 7.35) not unlike those of some baroque paintings. With tracing paper, sketch other works in the tour and record ten examples in which similar curvilinear movements exist. The lines will be nothing more than a record of how your eyes followed the painted or sculpted forms. (Refer to this accomplishment in the Watteau nude of figure 7.25.)

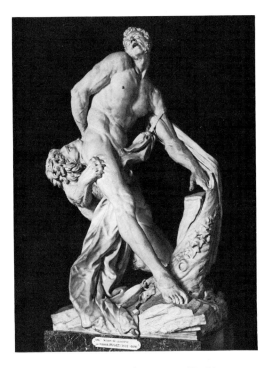

Figure 7.34 Pierre Puget, *Milo of Crotona*, 1671–83. Marble; H. 8 ft. 10½ in. Louvre. Alinari/Art Resource, NY.

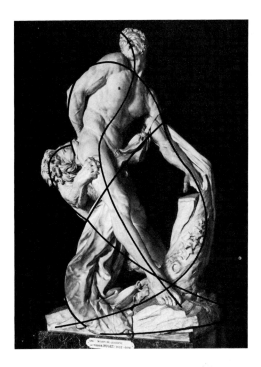

Figure 7.35 Implied-axis lines in Puget's *Milo of Crotona*. Louvre. Alinari/Art Resource, NY.

RESPONSES TO VIEWING EXERCISES

1. Generally, the difference between the three paintings is one of mood and intensity. Veronese is obviously making a simple, though powerful, statement of a historical event. The nod to classical antiquity can be seen in the Roman architecture and the attire of Alexander and his attendants. The bold intensity of the foreground figures contrasts sharply with the subdued figures behind the balustrade at the top of the picture. The result is more decorative than dramatic and more detailed than accurate, according to a true depiction of full light and shade.

Rubens's painting is quite the opposite. His interest was in motion and activity; not in the historical accuracy of the event, but in its emotional impact. Detail was used to enhance the overall quality of motion rather than an end in itself. Compare, for example, the detail of the garments in each of these works.

Poussin's painting reflects baroque classicism in its antique Roman subject, an actual event of about 300 B.C. Note the classical architecture and attire. For all its apparent activity, this painting lacks the fluid motion of Rubens's work. The solid buildings that occupy half of the picture play a major role in controlling movement. Many of the more prominent figures are posed in statuelike

stances that resemble a freeze-frame. Even the most frenetic figures seem frozen in midmotion and do not really possess the energy of Rubens's twisting, turbulent bodies.

2. A conflict of dimensions occurs in the juxtaposition of human and mythical beings that constitutes the emotional content of the painting. The mirror, while not reflecting accurately the face of Venus, brings her visage closer to the viewer as if to make our involvement in the work more intimate. The face in the mirror is slightly blurred, as are other objects in the painting, bringing a sense of shimmering vitality to the composition. Recall the mixing of fine detail with blurred areas in the works of Rembrandt and Hals. As close as her face seems to be to the viewer, Venus remains aloof and impersonal— quite the opposite effect of the warm humanism reflected in Frans Hals's *The Gypsy Girl* (colorplate 36).

3. Both works possess the strong turbulent motion of the high baroque period. Both are highly ornamented, grandiose in proportion, and use emotionally charged religious subject matter. Bach uses quickly ascending melodic passages and fast tempos to represent the Resurrection. His use of overlapping voice parts creates an agitated movement just as Pozzo's overlapping shapes create a texture that suggests the same kind of tumultuous activity.

The Metropolitan Museum of Art

New York, New York

Tour 8

The Nineteenth-Century Revolution

The Gallery

The Metropolitan Museum of Art is among the newest of the great museums, celebrating its one hundredth anniversary in 1980. Yet, its collection contains some of the most important artworks in the world, and its holdings make it the largest collection of art in the Western Hemisphere. The building, an imposing structure, stands on the east side of Central Park in New York City.

Like most of the large public museums, admission to the Metropolitan's vast collection is nominal, and visitors may set their own fee. The museum is so accessible and attractive that it has become one of the most important tourist features of the city. It boasts better attendance from New Yorkers than baseball games. This is not surprising considering the number and quality of special exhibitions that are held on a regular basis. These are, of course, in addition to the museum's permanent collection, which merits repeated viewings. The permanent collection spans the entire history of art, from ancient beginnings to the present. Especially numerous are the holdings in ancient Egyptian artifacts, in nineteenth-century neoclassical and romantic works, and in American Art.

Tour Overview

The eighteenth century in Europe was one of the most disruptive periods in the history of civilization. The Industrial Revolution enabled the middle class to accumulate wealth and thus vie for power with the aristocracy. The success of the American Revolution shook the whole foundation of Europe and no doubt inspired the French Revolution, which lasted until the end of the century and ultimately led to the rise of Napoleon. A revolution in learning and science was also taking place and served to establish a new intellectual climate throughout the Western world. With these cataclysmic changes, the carefree and frivolous spirit of the aristocratic rococo

soon fell into disfavor. As a reaction against that expression of mindless hedonism, artists turned once again to the solid traditional values found in classical antiquity. They had a new market for the artworks among the rising middleclass, who could now afford such luxuries.

NEOCLASSICISM: A REVIVAL OF ANTIQUITY

Neoclassical art's distinctive style borrows a softness of glowing visual texture from the rococo and mixes it with the noble grandeur of Roman antiquity. It contains profound devotion to Greek heroes but attempts to combine it with, and apply it to, contemporary life. The frivolous, decorative style of the rococo is abandoned in favor of a more simplified expression of serious subject matter. The cluttered look in paintings by Watteau, Boucher, and Fragonard gives way to stark, austere settings in which nothing beyond orderly necessity is expressed. The so-called economy of means becomes an aesthetic byword.

Light receives a new treatment in neoclassical painting. Instead of the richness and warmth of rococo paintings, we now experience a pristine clarity of light and shadow. Chiaroscuro is reduced to a sharpness of modeling resembling sculpture. In neoclassical sculpture, we see most clearly the reverence for antiquity. The formal poses and quiet, controlled grace of classical Greece are eloquently recaptured in the works of neoclassical sculptors Jean-Antoine Houdon and Antonio Canova.

The revival of classical antiquity became an obsession. The hard-working middle class could identify with classical virtuous behavior and strong sense of duty. The well-to-do upper classes began to construct buildings of classical proportions and even replicated Greek and Roman ruins in an attempt to recapture the beauty, severity, and mystery of antiquity. Paintings of ancient ruins became popular as well. Hubert Robert's (1733–1808)

◄ *The Metropolitan Museum of Art, Exterior: Fifth Avenue, View to North. The Metropolitan Museum of Art, Photograph Robert Gray*

189

Figure 8.1 Hubert Robert, *The Portico of a Country Mansion.*
1773; oil on canvas; 80¾ × 48¼ in.
The Metropolitan Museum of Art, Bequest of Lucy Work Hewitt, 1935.

Figure 8.2 Arc de Triomphe du Carrousel, a copy of the original
Roman structure, the Arch of Constantine.
© Arch. Phot./S.P.A.D.E.M., Paris/V.A.G.A., New York, 1985.

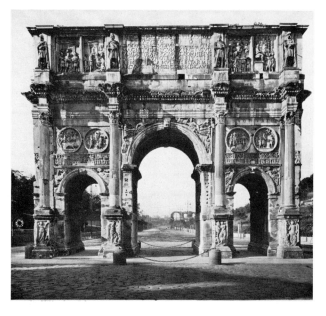

Figure 8.3 Arch of Constantine, Rome. Early fourth century A.D.
Anderson/Art Reference Bureau.

The Portico of a Country Mansion (fig. 8.1) is a product
of the artist's visit to Italy. Curiously, it was ruins, not
original, intact versions of these ancient buildings, that
fascinated the art connoisseurs of the day.

Napoleon himself is credited with fostering **neoclas-
sicism,** a style named for the revival of classical antiq-
uity. In his fervent wish to emulate the Roman Caesars,
he built several reproductions of Roman monuments.
Located in the courtyard of the Louvre, for instance, the
Arc de Triomphe du Carrousel (fig. 8.2) is almost an
exact copy of the Arch of Constantine in Rome dating
from the early fourth century A.D. (fig. 8.3). La Made-
leine in Paris (fig. 8.4) is modeled after the smaller
Maison Carrée (meh-zohn cah-ray′) a temple built in
Nimes, France in 16 B.C. (fig. 8.5). The Pantheon of
Rome was not only copied; the new model in Paris was
even given the same name as its classical original (fig.
8.6).

The neoclassical revival of antique ideals was highly
influential in eighteenth- and nineteenth-century archi-
tecture in Europe and in the United States. Thomas
Jefferson's Monticello at Charlottesville, Virginia, is
patterned after the Pantheon, and other examples of
classical architecture include the Capitol in Wash-
ington, D.C., the Virginia State Capitol, and many of
the museums we have visited on our tours.

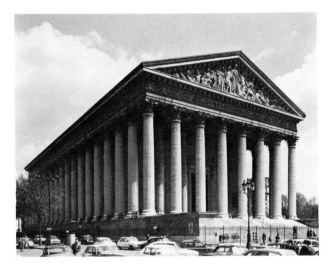

Figure 8.4 Facade, La Madeleine, modeled after the Maison Carrée.
© Arch. Phot./S.P.A.D.E.M., Paris/V.A.G.A., New York, 1985.

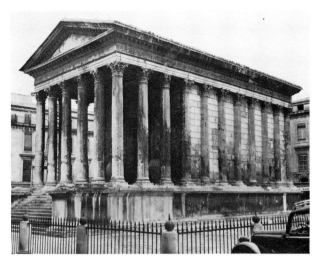

Figure 8.5 Maison Carrée, Nimes, France. 16 B.C.
Bildarchir Foto Marburg/Art Resource, NY.

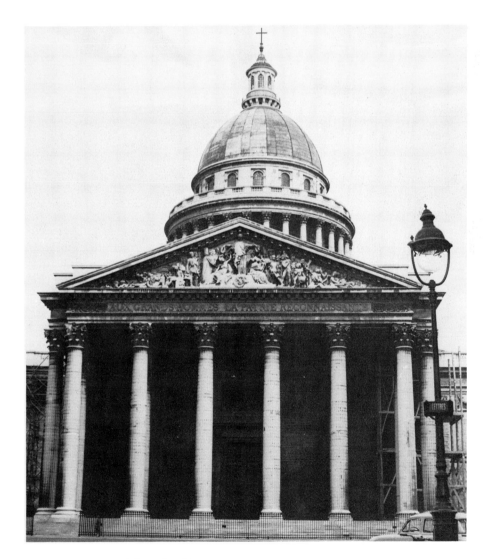

Figure 8.6 The Pantheon in Paris. A copy of the ancient Roman
structure.
Bulloz/Art Reference Bureau.

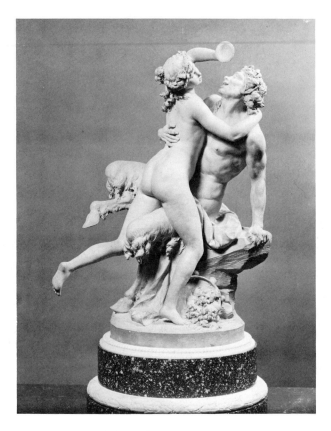

Figure 8.7 Claude Clodion, *The Intoxication of Wine.*
Terracotta; H. 23¼ in.
The Metropolitan Museum of Art, Bequest of Benjamin Altman, 1913.
(14.40.687)

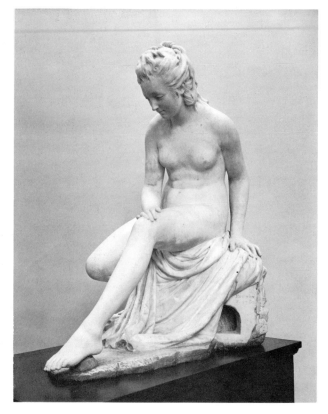

Figure 8.8 Jean Antoine Houdon, *The Bather.*
Marble; H. 47 in.
The Metropolitan Museum of Art, Bequest of Benjamin Altman, 1913.
(14.40.673)

Neoclassical Sculpture

The best way to observe the radical change from the witty frivolity of the rococo to the simple objectivity of the neoclassical style is to compare two sculptures from the late seventeenth century. Claude Clodion's (kloh-dee-ohn′) (1738–1814) *The Intoxication of Wine,* depicting the encounter of a satyr and a bacchante (sat′-er and bah-kahn′-tay) (fig. 8.7), typifies the theme of orgiastic revelry that captivated the polite societies of France. The same fussy textures and superficial subject matter can be seen in the paintings of Boucher and Fragonard. The art was most certainly born out of pure pleasure, appealing to the senses more than to the intellect. The subjects, a satyr and a bacchante, are themselves the embodiment of licentiousness: a satyr was a lecherous woodland demon, and a bacchante was a priestess to the Greek god of wine. Their twisting, erotic embrace suggests the wild motion of a bacchanalian feast.

On the other hand, Jean-Antoine Houdon's (zhahn-ahn-twahn hoo-dohn′) (1741–1828) sculpture *The Bather* (fig. 8.8) bears a quiet simplicity of line and texture. The position of the body conveys the idea of rest, and its lines are smoothly sculpted in a comparatively closed form. The drapery upon which the figures rests

has the same clean lines as that found in *The Three Fates* from the Parthenon's frieze (see fig. 4.38). The mood of *The Bather* appears to be contemplative as opposed to the mindless folly depicted by Clodion.

Perhaps the most prominent sculptor of the new period was Antonio Canova, the Venetian brought to Paris by Napoleon. One of Canova's earlier works, *Cupid and Psyche* (see fig. 7.30) reveals an affinity to rococo charm and elegance in its graceful lines and the unique positioning of the two figures to form a large X. However, except for the rococo sensuality, this work contains elements of the neoclassical style: clean sweeping lines, classical subject matter, and simplicity. Canova's more classical sculpture, *Perseus Holding the Head of Medusa* (pehr′-see-us) (fig. 8.9) also uses subject matter from antiquity, but here we see the heroic pose of a Greek god, shown nude to symbolize his divinity. Without the cloth that Canova added to support his larger-than-life figure, this work could easily be mistaken by the casual observer for an ancient Roman copy of Greek sculpture. All the classical elements are evident here: simplicity with none of the bulging musculature of the baroque; cool objectivity without the prettiness of the rococo; and lack of the emotion generally to be considered romantic.

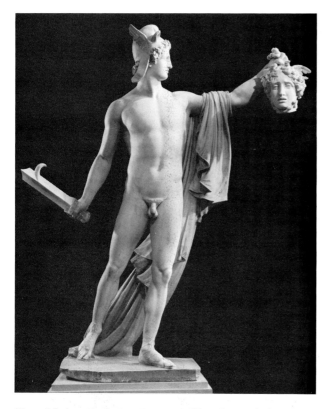

Figure 8.9 Antonio Canova, *Perseus Holding the Head of Medusa.*
Marble; H. 86⅝ in.
The Metropolitan Museum of Art, Fletcher Fund, 1967. (67.110)

Neoclassical Painting

The most prominent painter of the neoclassical style, Jacques Louis David (zhahkloo-ee dah-veed′) (1748–1825) found immediate fame with his trend-setting painting *The Death of Socrates* (colorplate 41). Posed like statuary, the figure of Socrates resembles Canova's Perseus—it is frozen in an erect, motionless posture. The finely detailed description of objects does not interfere with the stark, almost spartan, simplicity of composition. The figures are identifiable from true accounts of the event: the attires and hair styles, as well as the walls and the Roman arch in the background representing the prison, are the result of David's careful study of the locale and period, roughly 400 B.C. The lines in this work are mainly horizontal and vertical, which lend a great deal of stability to the composition. The light is dramatic enough to heighten the prominence of the central figure, but the modeling effects of chiaroscuro are minimized. Painted just two years before the beginning of the French Revolution, we can see how David's masterwork of the self-sacrificing hero captured the imagination of a restless middle class striving for liberty, equality, and fraternity.

David's brilliant skills were soon recognized by Napoleon, who became David's patron. Many of his portraits of Napoleon that were seen round the world were

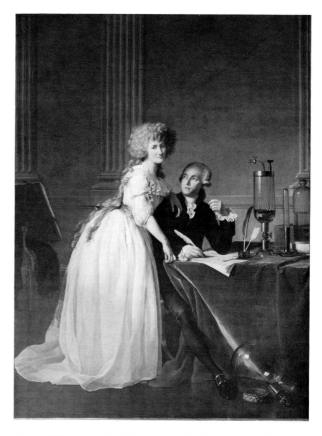

Figure 8.10 Jacques Louis David, *Antoine Laurent Lavoisier and His Wife.*
102¼ × 76⅝ in. (259.7 × 194.6 cm.) S/D: 1788.
The Metropolitan Museum of Art, Purchase, Mr. and Mrs. Charles Wrightsman Gift, 1977. (1977.10)

the result of David's devotion to his new ruler. In fact, David became a rather avid portraitist. His portrait *Antoine Laurent Lavoisier and His Wife* (ahn-twahn lawrawnt lah-vwah-zee-ay′) (fig. 8.10) remains faithful to the neoclassical ideal. Compared to *Socrates,* this painting is less formalistic; the casual posture of Madame Lavoisier and the snapshot pose of Monsieur Lavoisier obviously express a more informal glimpse into the private life of one of the most important scientists of the age. Amid the vertical lines of the table, the chemistry equipment, and the background wall, we see an interesting contrast of diagonal lines created by the man's leg and the tablecloth. Beyond those small exceptions, the neoclassical style literally shines through: the glistening light reflected in the large glass beakers, the sculpturesque highlighting of both figures, faces, and the hard-edged contours. While David displays his typical attention to detail, exemplified by the shadow of the lady's scarf on the back of her dress, he minimizes the number of objects. There are only enough to identify the man's profession and supply balance and interest to the composition.

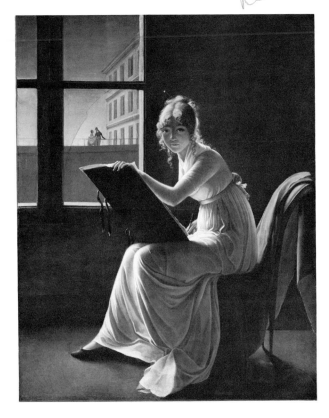

Figure 8.11 French Painter Unknown (about 1800), *Portrait of a Young Woman,* called *Mademoiselle Charlotte du Val d'Ognes.*
63½ × 50⅝ in. (161.3 × 128.6 cm.)
The Metropolitan Museum of Art, Bequest of Isaac D. Fletcher, 1917. Mr. and Mrs. Isaac D. Fletcher Collection. (17.120.204)

Figure 8.12 Jean Auguste Dominique Ingres, *Portrait of the Princesse de Broglie.*
Oil on canvas; 47¾ × 35¾ in. (121.2 × 90.8 cm.).
The Metropolitan Museum of Art, Robert Lehman Collection, 1975.

David's popularity inspired many stylistic imitators, called "followers." The gleaming *Portrait of a Young Woman,* called *Mademoiselle Charlotte du Val d'Ognes* (dohn'-yeh) (fig. 8.11), once thought to have been painted by David himself, has since been thought to be by one of his students, Constance Marie Charpentier (shar-pen-tyay) (1767–1849). Despite the sweeping curvilinear structure of the figure, her draped chair, and the diagonal of her portfolio, this painting is strongly neoclassical. The curves are balanced equally by the horizontals and verticals of the room and the architectural background. The woman's gown is patterned after ancient Greek sculpture, and the stark simplicity of composition is the essence of classical style. But it is the treatment of light that elevates this painting to a position of importance. Up to this time artists had rarely brought light into a painting from *behind* their figures. This artist skillfully used reflected light from the surface of the sketch pad to highlight the woman's face. The resulting contrast of luminous light against a very dark wall behind the figure creates clean, hard contour lines. So with all the attention to exact detail, the portrait is less than lifelike because the cool, sculpted lines detract from any sense of reality. This work is more a portrait of glowing light than of an attractive woman.

The other artistic giant of the neoclassical period was David's younger contemporary, Jean Auguste Dominique Ingres (zhahn oh-goost doh-mee-neek angr) (1780–1867). The two artists shared not only an astonishing skill with the brush, they also agreed on a classical simplicity of line. Ingres, a draftsman, was also a great portraitist. Perhaps his best-known subject is an unknown odalisque, or harem concubine, rendered first in a painting with shades of gray and then in a multihued oil painting (the latter is housed in the Louvre). Ingres titled his first version *Odalisque in Grisaille* (oh'-di-lisk) (colorplate 44) and it came to be viewed as his most neoclassical work. As if the gray tones did not themselves supply the painting with the cold look of sculpture, Ingres created the whole composition around the single sweep of a large curved line extending from the top of the woman's head, down her gracefully curved back, and up the curtain being held by her hand. Again, the very dark background creates extremely hard contour lines that resemble sculpture.

This woman is not the warm, sensual creature found in Boucher's paintings or one of Fragonard's frolicking beauties. Only the faintest pink accents and modeling of light and shade suggest bodily configuration; only the strongest imagination could picture her as a real person.

Figure 8.13 William Blake, *Nebuchadnezzar*.
Color Print; 17⅝ × 24⅜ in (448 × 619 mm.).
The Tate Gallery, London

Beauty is truth, truth beauty, that is all ye know on
earth, and all ye need to know.

John Keats,
Ode to a Grecian Urn

The subsequent full-color version in the Louvre is more
true-to-life, due in part to the warm flesh tones and the
breaking of contour lines with a feather fan that, along
with the curtain, is held in the woman's right hand and
partially covers her leg. But both paintings maintain hard
contours and minimize chiaroscuro, and both are strongly
neoclassical. Only the selection of exotic subject matter
suggests the new romantic style that was developing in
French painting and sculpture.

But before we continue our tour into the romantic age,
we should pause to examine the exquisite painting by
Ingres, *Portrait of the Princesse de Broglie* (brohl-yee)
(fig. 8.12). Considered among the best of his portraits,
this fine work displays Ingres' astounding mastery of
technique. Yet, with all of its stunning visual qualities,
the subject is kept at a distance. Her cold stare comes
from sculpted eyes and her face is outlined with the dark
edge of a severe hairline. As with many other portraits
of the period, extreme contrasts of figure-ground prevail.
The result is brilliant, almost breathtaking in its lumi-
nosity, but remains as cooly objective as the famous
sculpture *Venus de Milo* that stands in the Louvre, for-
ever aloof from the crowds of people that throng before
it everyday.

ROMANTICISM

Following the deposition of Napoleon in 1815, emphasis
in the arts shifted measurably from neoclassical ideals
toward increased feelings, tone, exoticism, and fantasy.
In the visual arts, this shift was manifested in more in-
tense colors, implied motion, and bizarre themes. The
lofty, impersonal art of the neoclassical elite gave way
to a more personal and intimate expression by romantic
artists.

From the 1830s through the nineteenth century, a new
style known as **romanticism** emerged partly as a reaction
against the overpowering influence of classicism and the
resulting subordination of feelings and subject matter.
"Romantic" connotes that which is not real or that which
is imaginary. Romanticism was thus manifested in nine-
teenth-century art in subjects that were sometimes real,
but primarily exotic and mysterious. The artist's imag-
ination became more important than dazzling displays
of artistic virtuosity.

An English poet and engraver named William Blake
(1757–1827), trained in the classical style and influ-
enced by Michelangelo, represents romantic art. His vivid
imagination and religious fervor led to a number of en-
gravings or etchings based on biblical themes. His *Neb-
uchadnezzar* (fig. 8.13) was intended to describe the story
of the Babylonian king who was punished for his lack of
faith by becoming a beast of the field. The figure in the
painting is a strange combination of man and animal,
and the face expresses the terror and anguish of insanity.

Figure 8.14 Théodore Géricault, *The Raft of the Medusa.*
1818–19. 16 ft. 1 in. × 23 ft. 6 in.
The Louvre, Paris. Alinari/Art Resource, New York.

Like one of the characters from his biblical dramas, Blake thus "prophesied" romanticism's predilection for imaginative subject matter and emphasis on inner vision rather than on reason.

The tone of the romantic period was set by the young artist Théodore Géricault (jeh-ree-coh') (1791–1824) whose powerful painting *The Raft of the Medusa* (part of the Louvre's collection) represents the true-to-life events of a disaster at sea (fig. 8.14). The agony of the victims in this drama is expressed in the writhing diagonal lines that sweep from the lower left corner to the young man at the top right, who sees a faint hope of survival in the ship on the distant horizon.

Heroism was as much an ideal for the romanticists as it was for the neoclassicists. However, the romantic hero was not so much the conquering despot or the brilliant scientist, but more often the starving poet in his poor garret writing great verse to his last breath. The stiff, formal poses of neoclassical art were abandoned for more powerful curvilinear contours and diagonal lines.

Romanticism in Sculpture

Sculpture in the nineteenth century began to develop along at least two diverse lines. Following more directly in the romantic tradition, Jean-Baptiste Carpeaux (zhahn-bahp-teest kahr-poh') (1827–75) carved a composite work from plaster, *Ugolino and His Sons* (oo-goh-lee'-noh) (fig. 8.15). The death by starvation of the imprisoned Ugolino and his sons is recounted in Dante's *Inferno.* The work is displayed at the Metropolitan in the middle of an anteroom so that viewers can walk around it to better sense its continuous motion. The figures are intertwined so that curved lines seem to weave in and out of a circular pattern, reminiscent of the cantos of Dante's telling of Ugolino's death.

Compare Carpeaux's work with Edgar Degas's (day-gah') (1834–1917) dainty sculpture *Ballet Girl,* or *Little Dancer, Aged Fourteen* (fig. 8.16). Here, quiet, sensuous beauty replaces the heavy emotion found in Carpeaux. Degas also added to his bronzed figure a real tutu and a satin hair ribbon, something of an innovation for nineteenth-century sculpture. Without the strong-feeling tone

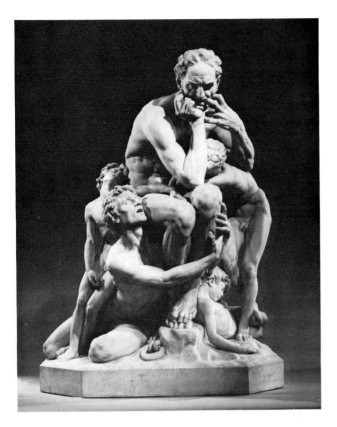

Figure 8.15 Jean-Baptiste Carpeaux, *Ugolino and His Sons.*
Paris, 1865–67 (after a model completed in Rome, 1860–61)
The Metropolitan Museum of Art, Funds given by the Josephine Bay Paul
and C. Michael Paul Foundation, Inc., and the Charles Urick and Josephine
Bay Foundation, Inc. and the Fletcher Fund, 1967.

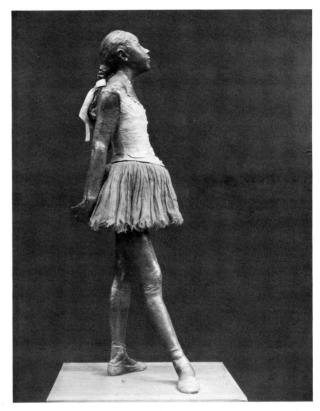

Figure 8.16 Edgar Hilaire Germain Degas, *Ballet Girl: Aged fourteen* (Petite danseuse de quatorze ans).
Bronze; H. 39 in.
The Metropolitan Museum of Art, Bequest of Mrs. H. O. Havemeyer, 1922.
(29.100.370)

of earlier works, this sculpture concentrates on beauty of line and fluidity of form. It is, in a sense, a return to the purest of artistic elements—it is more an expression of art with a classical emphasis than one of a romantic emphasis. (We shall return to Degas in Tour 9 when we examine, in his paintings, the enormous contribution he made to the impressionist movement.)

Romanticism in Painting

Géricault's pupil Eugène Delacroix (dehl-eh-krawh′) (1798–1663) advanced the romantic tradition that his teacher had established. One of Delacroix's early works, *Conversation Mauresque* (colorplate 45), represents the fashionable fascination with exotic subject matter. This small pencil drawing was finished with vivid watercolors. The warm informality of these subjects can be compared with the informality in David's portrait of Lavoisier and his wife, but all the icy stiffness of David's technique is missing in the Delacroix. These realistic Moors seem about to move as they continue their casual discussion. The presence of vague horizontal and vertical lines do not stifle this implied sense of activity.

In nature all is reflection, and all color is an exchange of reflection.

Eugene Delacroix

Motion is as much an integral part of romantic art as it is in baroque art. Delacroix's later oil painting *The Abduction of Rebecca* (colorplate 47) was based on a theme in Sir Walter Scott's novel *Ivanhoe* and was inspired by Rubens's famous painting *Rape of the Daughters of Leucippus* (loo-sip′-us), located in the Alte Pinakothek (ahlt-eh pee-nah-kohtek), Munich. Delacroix expresses frantic activity with his interlocking curves and with the swirling fire and smoke in the background. The colors in this emotionally charged painting are warm earth tones that are made more brilliant with patches of reds scattered about. Color, to Delacroix, was a necessity. Nothing in this painting is static; all objects are in a state of motion. The buildings are ablaze and even the discarded objects in the foreground "run" off the edge of the painting.

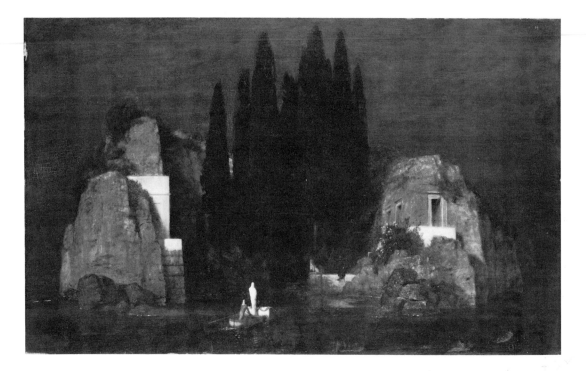

Figure 8.17 Arnold Böcklin, *Island of the Dead.*
Oil on wood; 29 × 48 in. (73.6 × 121.9 cm.)
The Metropolitan Museum of Art, Reisinger Fund, 1926. (26.90)

A very important aspect of this painting is the artist's brush technique. As we compare it to the deftly finite touch of neoclassicists David and Ingres, we can see that Delacroix applied his paint in rough, heavy strokes somewhat in the style of Rubens. The resulting rugged textures accentuate the sense of action that we feel in this powerful statement. Feelings were central to Delacroix's message, rather than the subject itself. It was not necessary, therefore, for him to depict the characters in his dramas with exactness, but rather to express the emotion involved in the event. The spontaneity of quick brushstrokes heavily laden with paint provided the desired results. Delacroix likened his work, with its broad, shaggy outlines, to the back side of a tapestry. This is exotic, passionate romantic art in all its splendor.

The romanticists preoccupation with the mysterious and bizarre world of the artist's imagination is well illustrated in the painting *Island of the Dead* (fig. 8.17) by Arnold Böcklin (boek'-lin) (1827–1901). Strong contrasts in this highly symbolic work create the dismal, foreboding atmosphere of its unworldly subject. The composer Rachmaninoff's tone poem of the same title creates with music the same gloomy atmosphere Böcklin created with paint.

The colorful, romantic hero Francisco de Goya (1746–1828) possessed a tempestuous temperament and was plagued, like his contemporary Beethoven, with deafness. Goya, with his scandalous love affairs and furious intensity, was Spain's appointed court painter and created many ruthlessly candid portraits of its arrogant rulers. He displayed a penchant for an aspect of romantic art called the "strangeness of beauty." Some of his works are totally shrouded in dark mystery as though he dared the world to discover meaning in his unearthly subjects. Almost as if to presage *surrealism,* Goya painted several works utilizing imaginary subject matter. *The Colossus* (fig. 8.18) measures only the size of a piece of typing paper. Even without the presence of other objects that could help identify the size of the subject matter, it is clearly a picture of a giant looking over his shoulder at the viewer in brooding wonderment. This strangeness of beauty became one of the most identifiable romantic characteristics.

Goya also established himself at the leading edge of a new kind of realism, one that would come to express the harsh, cold difficulties of life. Goya completed many works showing the horrors of war. But it wasn't so much the exact duplication of an event that concerned Goya so much as the bitter truth expressed by the deed itself. There is almost a crude quality in the figures, but the artist's point was the atrocities, not detail. These were the grim realities of the time, and Goya's aim was to arouse his fellow Spaniards to action by facing the events happening around them. *Y No Hai Remedio (And there is no remedy)* (fig. 8.19) is based on actual events that occurred in Spain during the Napoleonic Wars. Goya

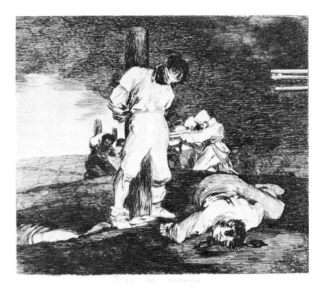

Figure 8.19 Francisco de Goya, *Y No Hai Remedio* (*And there is no remedy*), from *Los Desastres de la Guerra.*
Etching, fourth state.
The Metropolitan Museum of Art, Schiff Fund, 1922. [22.60.25(15)]

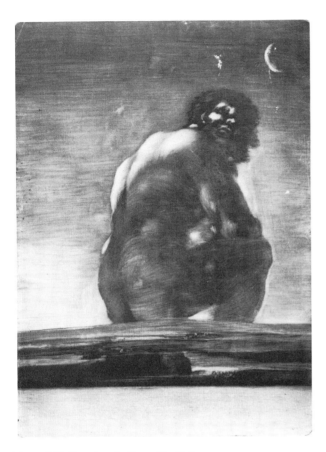

Figure 8.18 Francisco de Goya, *The Colossus.*
Aquatint; 11 5/32 × 8⅛ in.
The Metropolitan Museum of Art, The Harris Brisbane Dick Fund, 1935.
(35.72)

REALISM IN THE NINETEENTH CENTURY

thought it was important for his contemporaries to face the bleeding corpses, the bound prisoners being shot by a firing squad, and the most prominent figure in the group waiting ignominiously for death. This work was executed with a new process called **aquatint,** which supplied an etching with varying degrees of tonality, similar to the ranges of value in painting.

Goya's skill as a painter is evident in one of his finest works, *Majas on a Balcony* (mah'-hahs) (colorplate 46). At first glance, we see two attractive ladies dressed in the fine Spanish attire of the period. But the ominous presence of two shadowy figures in the shallow background pulls this picture out of the realm of rococo prettiness and places it squarely in the mainstream of romanticism. What does it mean? Surely with such strong contrasts between dark and light, between decoration and plainness, between beauty and ugliness, Goya was making a statement about life itself. Is he perhaps saying something similar to what Blake wrote in *The Marriage of Heaven and Hell:* "Attraction and Repulsion, Reason and Energy, Love and Hate are necessary to Human Existence"?

While the themes of fantasy, imagination, and human passion abounded in romanticism, the penchant for realism continued. From the genre paintings of Chardin, through the meticulous imitation of nature in the neoclassical period, to Goya's shocking face-to-face view of life in all its sordid actuality, realism maintained its favor with selected nineteenth-century artists.

Goya's brand of realism was revitalized in the works of Honoré Daumier (oh-nor-ay doh-myay') (1808–79). Rather than concentrating solely on the violence and gore depicted by his predecessor Goya, Daumier's subjects focused on qualities and experiences of ordinary life. His subjects are relevant today in that they portray common everyday situations. His compassion for people can be seen in one of his favorite themes drawn from the travelers in railways and carriages. They offered Daumier an opportunity to depict human beings in real-life situations. One such version was the unfinished painting *Third Class Carriage,* (colorplate 43). Lines used for enlarging sketches are still visible on the canvas. Although some of the passengers are engaged in conversation, others seem oblivious to one another. Daumier was more interested in social criticism and in portraying the realities of man, than in creating formal and traditional subjects from history or fiction. As his contemporary Louis Daguerre (loo-ee dah-gair) was perfecting the chemical photographic process, Daumier deliberately chose to present his figures in a sketchy, unposed,

Figure 8.20 Gustave Courbet, (1819–1877) *Young Ladies from the Village* (*Les Demoiselles de Village*).
Oil on canvas; 76¾ × 102¾ in.
The Metropolitan Museum of Art, Gift of Harry Payne Bingham, 1940.

Figure 8.21 George Caleb Bingham, *Fur Traders Descending the Missouri.*
Oil on canvas; 29 × 36½ in.
The Metropolitan Museum of Art, Morris K. Jesup Fund, 1933. (33.61)

The art of painting can consist only in the representation of objects visible and tangible to the painter . . . show me an angel and I'll paint one.

Gustave Courbet

The folk artist is rightly called an artist, but he or she is a maker rather than a creator, a selector rather than a composer, and an adjuster rather than an inventor.

Jeremy Kingston

unphotographic manner. By drawing on a porous stone with a greasy crayon, Daumier was able to print large numbers of **lithograph** drawings, many of which illustrate his mocking satire that was intended to stir the emotions of citizens in Paris. It is the simplicity achieved by a virtuosity with line that helps convey his many faceted talents as artist, cartoonist, and journalist.

Gustave Courbet (goos-tahv koor-bay') (1819–77), another strong advocate of the working class, established his own brand of realism that was different from that of either Goya or Daumier. Courbet was fond of painting ordinary scenes of everyday life around his native French countryside exactly as he saw them. He never painted imaginary, symbolic creatures or objects. Courbet's subjects were real people, animals, or landscapes rendered as close to their natural look as possible. One of Courbet's own favorite compositions was his pastoral scene titled *Young Ladies from the Village* (fig. 8.20). There is nothing about this picture that is out of the ordinary; it could very well have been a photograph. Courbet's aim was to reproduce this insignificant moment in time exactly as he saw it. Careful examination will reveal his technical skill. Courbet's penchant for using thick layers of paint, sometimes applied with a palette knife, and his suggestions of detail rather than precision, influenced the development of style for an entire century of painters to follow.

American Landscape Painters

The romantic period saw an impressive array of American artists who, inspired by their European contemporaries and spurred by a growing interest in art among other Americans, began to produce a solid body of important works. Their art is almost patriotic in its reverence for the naturalistic splendor of the new frontier. George Caleb Bingham's (1811–79) refreshing oil painting *Fur Traders Descending the Missouri* (fig. 8.21) is nothing short of a portrait of typical fur traders and their beautiful surroundings in a new country. The quietly flowing river and mist-shrouded background establish the mysterious aura of the stiffly posed occupants of the canoe. The rest of the world, including inhabitants of the eastern United States, was fascinated by frontier life and its storybook characters. This painting is a unique blend of romanticism and the simplicity, clarity, and immobility of neoclassicism.

America's breathtaking scenery inspired a specific genre of paintings whose subjects were the monumental landscapes of nature, unspoiled by the ravages of civilization. Nature was an abiding concern for the romantics and of many monumental landscapes, Thomas Cole's (1801–48) *Oxbow* (fig. 8.22) is among the most elaborate. Although Cole is said to have painted it from memory, the scenery is a real place: a bend in the Connecticut River. The subject matter, except for a nearly

Figure 8.22 Thomas Cole, *Oxbow* (*The Connecticut River near Northampton*).
Oil on canvas; 51½ × 76 in.
The Metropolitan Museum of Art, Gift of Mrs. Russell Sage, 1908. (08.228)

invisible individual in the central foreground, is nature: the twisted tree framing the river far below and the misty hills on the distant horizon. The grandiose feeling of deep space is enhanced by the atmospheric effects of ever-lighter intensities in the distance. The storm is idealized to add a dramatic element to an otherwise realistic portrait of nature. Most of these typical landscape paintings are relatively large, about six to ten feet long, so that viewers standing but a few feet away can feel enveloped by the composition.

Another group of artists in nineteenth-century America deserve special mention. They are called "natives" or American "primitives" because of their lack of professional training and their resulting naive paintings. Such works may be called "folk art," which, like folk music, is basically simple art often about rural settings. Images are frank and bold but lack realistic proportions and traditional refinements. These direct and honest statements of aesthetic eloquence have always appealed to viewers. Edward Hicks (1780–1849) is one of the most famous American folk artists, largely due to the effective painting *The Peaceable Kingdom* (fig. 8.23). Inspired by the beauty of his native Pennsylvania, the utopian peace of the Kingdom of God is expressed with frank, bold figures that are carefully arranged. As if watching a play, we suspend our disbelief so that we can appreciate the simplicity of his vision.

Figure 8.23 Edward Hicks, *The Peaceable Kingdom*.
Oil on canvas; 17⅞ × 28⅞ in.
The Metropolitan Museum of Art, Gift of Edgar William and Bernice Chrysler Garbisch, 1970. (1070.283.1)

Figure 8.26 Jacques Louis David, *The Oath of the Horatii.*
Oil on canvas; 131 × 167¼ in.
The Louvre, Paris.

VIEWING EXERCISES

1. The painting *The Oath of the Horatii* (hoh-ray'-shee-ai) (fig. 8.26) by Jacques Louis David is located in the Louvre. What visual elements in the work contribute most strongly to its neoclassical quality?

2. Identify the landscape painting in colorplate 42 by determining the artist's style and nationality.

3. Turner's famous painting *The Lake of Zug* (fig. 8.25) contains many clues that help identify its nineteenth-century style. Discuss these clues and their influence on subsequent stylistic developments.

4. Locate a recording of any of Haydn's string quartets. As you listen, compare its style with David's masterpiece *The Death of Socrates* (colorplate 41).

5. Compare the romantic characteristics in Géricault's *The Raft of the Medusa* (fig. 8.14) or Carpeaux's *Ugolino and His Sons* (fig. 8.15) with Liszt's symphonic poem *Les Préludes.*

6. Even in its unfinished state, Daumier's *Third Class Carriage* (colorplate 43) reveals his intention to dramatize a somber scene in the car. Discuss how he used light, dark, and color to create a work that informs rather than offends.

STUDIO EXERCISES

Suggested media and supplies: sketchbook or drawing paper; pencil; watercolor or colored pencils; brush; scissors; pen and ink; soft sculpture medium.

1. Examine once again the pencil and watercolor painting by Delacroix, *Conversation Mauresque* (colorplate 45). Make your own pencil sketch of an ordinary subject. When finished, complete your work by adding small patches of color (use semimoist pan watercolors or colored pencils).

 Put your painting aside and, on a clean sheet of paper, do the work again by reversing the process—begin with the small patches of color and add the penciled outlines later. All of us, since early childhood, have colored in pictures, but rarely are we asked to paint *without* lines, to perceive color areas without the distractions of line and subject. This exercise will give you some idea about how the increased interest in color relationships occurred among nineteenth-century artists.

2. We saw how Goya made statements about life and society in figure 8.19. Select magazine cutouts or objects you have drawn and arrange them in a composition in such a way as to make a social or cultural comment. Use no words or letters of any kind.

3. Choose a subject from a biblical passage or religious concept, such as the Trinity or the burning bush. Begin a composition with a pencil drawing, followed by an ink and watercolor drawing over the sketch (refer to the technique used by Blake in fig. 8.13).

4. Goya often used subject matter of an imaginary or mysterious nature. Carve from a soft material, or sculpt from a chunk of plaster, a small work (no taller than eight inches) that represents an unearthly and imaginary creature.

RESPONSES TO VIEWING EXERCISES

1. *The Oath of the Horatii* is based on an ancient Roman story, so the subject matter itself is neoclassical. Contributing to the neoclassic style are the elements of line, light, and composition. Most of the lines in this painting are perpendicular or horizontal. The hard contour lines in both figures and architectural background lend a sculpturesque stability. The frozen stance of the men adds even more to the cool, objective quality usually found in neoclassical art. The clarity of light, which enters from a single source left of the picture plane, creates high contrasts of color intensities on the foreground figures. The figures immediately behind are shrouded in relatively dark tones, as are the columns and arches in the background.

2. This large work, over six feet high and ten feet long, is one of the monumental landscape paintings by nineteenth-century American artists. It is *The Rocky Mountains* by Albert Bierstadt (beer'-shtaht). Like others of this genre, the scene is an actual western location, but rendered with composition, clarity, and beauty of color that were not possible with photography. With its peaceful Indian campground and the purple mountain majesties, this surely is one of the most patriotic paintings of its type.

3. Turner's *The Lake of Zug* (fig. 8.25) is also a real place in Switzerland, but it is obvious that his interest here is not in the locale. The emphasis is on light, its reflection off the surface of the water, and how it creates movement and radiance in the sky. Every object in the picture is reflected in the water; it seems as though Turner brought light down from the sky, through the objects, and into the water. His subject is light and color, the same elements that were to captivate the imagination of the impressionists in the last few decades of the nineteenth century.

4. Both works emphasize form and classical restraint over emotional content. Haydn used only simplified musical statements and David stated only what was necessary to express the essence of an idea. Both works were conceived and meant to be perceived on a rational basis—an intellectual approach rather than an emotional one. The result of such economy of means is a clarity of statement in which purity of form reigns supreme.

5. In both art and music, the proportions of these works seem expanded in the search for the unattainable. These works contain broad sweeping lines that are full of emotion, particularly hope and despair. Specifically, Liszt uses long, pompous melodies and grand harmonies in his musical version of the poem *Les Préludes*. The poem's theme is that life is but a prelude to an unknown song whose first note is sounded by death. This must certainly be the ultimate romantic theme!

6. Daumier apparently developed an **underpainting** (unfinished work) that emphasizes a dramatic light source focused on the woman with a child. The darks in the top hats and deep shadows of the carriage are distributed around this dominant focal center in the foreground. The blank stares and obvious poverty are heightened by prominent earth tones and balanced by soft accents of green.

The Art Institute of Chicago

Chicago, Illinois

Tour 9

A Search for New Standards

The Gallery

The Art Institute of Chicago is located on Michigan Avenue near the world famous Loop. The museum requires an admission fee, but visitors may use their own discretion as to the amount they can afford to pay. There are restaurants, sales galleries, and a museum store, among other services. Like most of the large museums, the Art Institute provides film and slide programs on art and artists as a public information service. Lectures and guided tours are also available, along with special exhibitions on selected artists or style.

The museum's collection spans the entire history of art, but its strength lies in art of the last one hundred years. The collection of impressionist and postimpressionist art is superb. In fact, the Art Institute can boast one of the most important collections of this type in the Western Hemisphere. On our tour, we shall see some of the most exemplary artworks of the era. The overall strength of the collection demonstrates the strong public support of the Art Institute by the people of Chicago and by the large number of tourists who visit the museum every day.

The Art Institute appears to be the only museum of all our tours to have a school of art and design offering both bachelor's and master's degree programs and selected programs for nondegree students. The school also includes a Poetry Center and a Visiting Artists and Thinkers Program, both of which offer series of events open to the public.

Tour Overview

The nineteenth century encompassed no less than five different tendencies in art: neoclassicism, which lasted until about the third decade; romanticism, which overlapped the former and continued throughout most of the period; realism, which ran parallel with romanticism; impressionism, which spanned the mid-1860s to 1880s; and postimpressionism, which began to develop in the last two decades of the century.

Impressionism evolved slowly from roughly the 1850s through the 1860s and culminated in the 1870s. Basically, the new style was a reaction (as usual) against the morality imposed by the neoclassicists and the mystery of the romanticists. But the use of color and movement by the romanticists was not lost on the impressionists. Indeed, as we will see on this tour, there were a number of artistic trends and events during the first half of the century that contributed strongly to the development of impressionism.

THE RISE OF IMPRESSIONISM

Impressionism was born out of the revelations and rebellions of several artists in the first half of the nineteenth century. We have seen how Constable's treatment of natural light affected the style of subsequent artists. The innovations in color and brushwork in Delacroix's paintings were adopted by the impressionists. And, as we saw in Tour 8, Turner's fascination with light at the expense of detail in the subject matter captivated the attention of painters in the second half of the century.

Figure 9.1 Gustave Courbet, *The Rock at Hautepierre*.
Oil on canvas; ca. 1869; 31½ × 39½ in. Emily Crane Chadbourne Fund.
© The Art Institute of Chicago. All Rights Reserved.

Figure 9.2 John Constable, Sketch for *The Haywain*.
Oil on canvas; 54 × 74 in.
Victoria and Albert Museum, London.

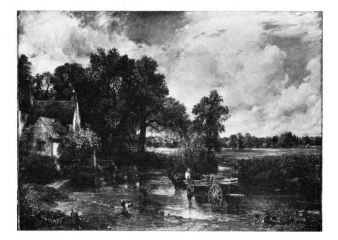

Figure 9.3 John Constable, *The Haywain*.
Oil on canvas. The final oil painting based on the sketch in figure 9.2.
51½ × 73 in.
The National Gallery, London.

The simplicity evident in Gustave Courbet's oil painting *The Rock at Hautepierre* (oht-pyayr′) (fig. 9.1) was greatly admired by the impressionists. Considered a realist, Courbet managed to portray landscape with a directness and sincerity that found its way into the hands of the impressionists. Without resorting to idealism, bold coloration, or fussy detail, Courbet expressed a warmth and personal touch that are rare in landscape painting. His use of ordinary subject matter and rough textures creates a look of spontaneity and vitality that earns him a place as immediate precursor of the impressionist style.

The Influence of Delacroix, Constable, and Turner

Of primary importance to impressionist painters were Delacroix's pioneering experiments in the use of color. He discovered that the juxtaposition of small patches of saturated complementary colors increased their intensities. Delacroix's experiments inspired a scientific study of color, and this new knowledge was put to use by both the impressionists and postimpressionists.

The relationships of light and color had already been exploited by John Constable (1776–1837) as early as 1820. The sketch for his final oil painting, *The Haywain,* illustrates the outdoor note-taking he used to capture the temporary reflections of light on clouds, fields, and water. Compare this sketch (fig. 9.2) with his careful studio rendering of the same subject (fig. 9.3). These works were available for study to the French impressionists who often journeyed across the English Channel to see paintings

by both Constable and Turner. It was Constable's quick oil sketches that most fascinated the impressionists, coupled with the fact that they were painted outdoors. They saw the lack of detail as an advantage because it reduced the distraction from the more important features of the scene—light and movement. The Constable sketch is more unified than the final oil because of its limited palette, and the flickering light in the clouds creates a sensation of motion.

It was also Constable who painted his shadows with colors of the spectrum rather than black or gray, which added more vibrancy to his compositions. This technique was employed by the impressionists and eventually led to an avoidance of black and even earth colors because they do not transmit light as do the spectrum colors.

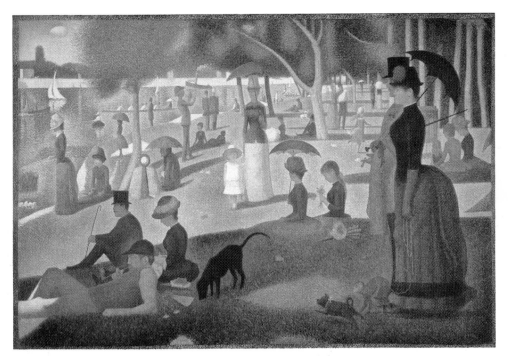

Plate 52b *Sunday Afternoon on the Island of La Grande Jatte,* (detail), Georges Seurat.

Plate 52a *Sunday Afternoon on the Island of La Grande Jatte,* Georges Seurat.
1884–86. Oil on canvas, 81 × 120⅜ in. (205.7 × 305.7 cm.).
The Art Institute of Chicago, Helen Birch Bartlett Memorial Collection.

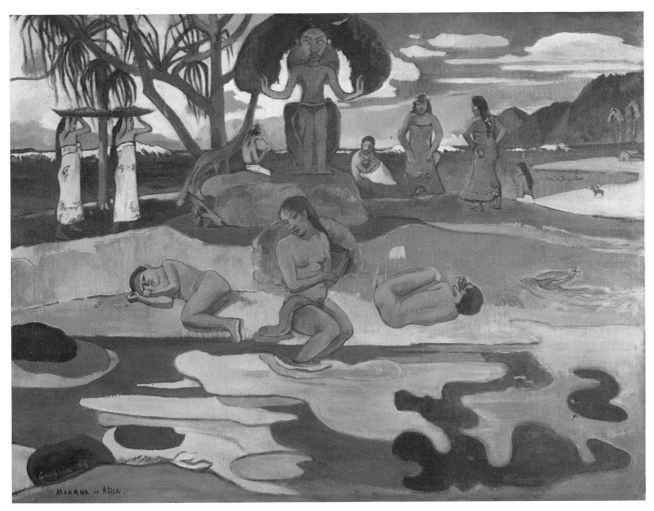

Plate 53 *The Day of the God,* Paul Gauguin.
1894. Oil on canvas, 27⅜ × 35⅝ in. (69.5 × 90.5 cm.).
The Art Institute of Chicago, Helen Birch Bartlett Memorial Collection.

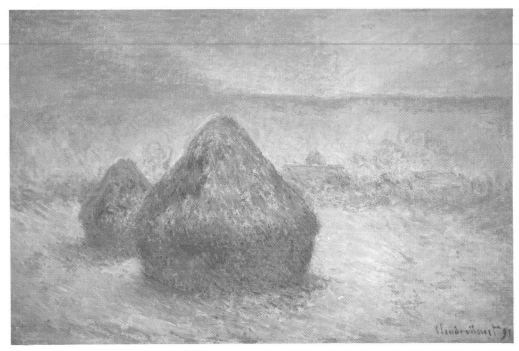

Plate 54 *Grainstacks, Snow, Sunset,* Claude Monet.
1891. Oil on canvas, 25½ × 39½ in. (64.8 × 100.3 cm.).
The Art Institute of Chicago, Potter Palmer Collection.

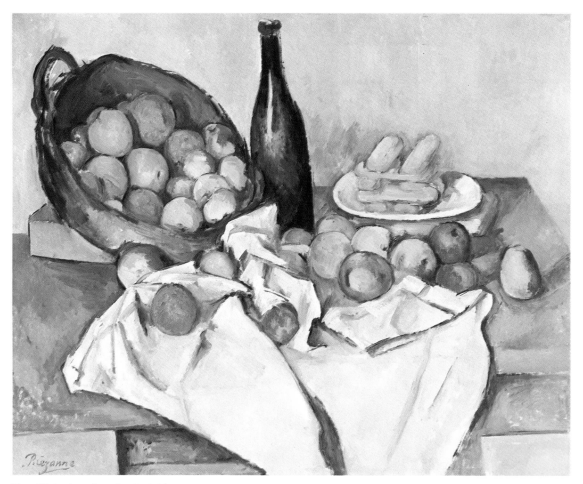

Plate 55 *Basket of Apples,* Paul Cézanne.
1890–94. Oil on canvas, 25¾ × 32 in. (65.4 × 81.3 cm.).
The Art Institute of Chicago, Helen Birch Bartlett Memorial Collection.

Figure 9.4 Joseph Mallord William Turner, *Valley of Aosta—Snowstorm, Avalanche, and Thunderstorm.*
Oil on canvas; 1836–37; 36¼ × 48 in. Frederick T. Haskell Collection.
© The Art Institute of Chicago. All Rights Reserved.

Figure 9.5 Jean-Baptiste Camille Corot, *View of Genoa.*
Oil on paper, mounted on canvas; 1834; 11⅝ × 16⅜ in. Mr. and Mrs. Martin A. Ryerson Collection.
© The Art Institute of Chicago. All Rights Reserved.

The Focus on Light and Color

Constable's habit of sketching out in the open became a creed with the impressionists. The studio was often abandoned for the open air where light could be fully realized. The single most important contribution to the development of art over the past century was the impressionists' discovery of the new relationship of light and color. It was the subtle variations in color painted with short brushstrokes that determined for them the differences in light and shadow. Light thus found new meaning in art as impressionists approached their canvases with near reverence for the colors of the light spectrum.

This new method of apprehending light held other implications as well; since impressionists were concerned with fleeting glimpses of reality, they knew they must attempt to capture images at a given moment as if seen at a glance from a carriage window. They painted very quickly and thus did not always render details realistically. Movement for impressionists was not represented with the sweeping grandeur of Delacroix or Géricault, but rather with the shimmer of light on a pond or the transient glow of the sun reflected off moving clouds. Light was also used by the impressionists for modeling—not by using the realistic effects of chiaroscuro (the hallmark of the Renaissance), but by using short, bold brushstrokes moving in opposite directions.

The Art Institute owns one of Turner's most spectacular paintings, *Valley of Aosta—Snowstorm, Avalanche, and Thunderstorm* (fig. 9.4). The impressionists were intrigued by the vibrant effects of the sun shining through the snowstorm and reflecting off the landscape.

However, the grand sweep of line combined with the violence of nature is purely romantic in appeal. Turner most probably finished this painting in the studio using sketches made during his visits to the Italian Alps. Turner also maintained an immediacy that makes it seem to us as though he had actually hurriedly painted this powerful statement on the spot before the storm could engulf him and carry away his canvas.

The Influence of the Barbizon School

The choice of subject matter by Constable and Turner contributed to the impressionists' predilection for painting outdoors. It was the **Barbizon School** (bar′-beh-zohn) of painters, however, that contributed most to the impressionists' preference for landscapes. Named after their gathering place, the village of Barbizon, this small group spent their days in and around the nearby forest of Fontainebleau painting hundreds of pictures. This concentration on a single genre resulted in a new feeling for landscape: an idyllic awareness—or one might say, an impression—of nature.

Associated with the school was Jean-Baptiste Camille Corot (koh-roh′) (1796–1875), whose landscape paintings concentrate on the visual effects of light and atmosphere on forms in nature. His small oil sketch *View of Genoa* (fig. 9.5) gleams with the brightness of the Mediterranean sun, and possesses a luminous quality. Corot was interested in accurate depictions of everything he saw, including objects and atmospheric light, a quality that is obvious even in what appears to be quickly rendered works such as this.

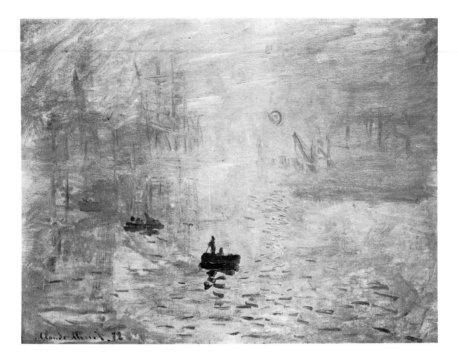

Figure 9.6 Claude Monet, *Impression: Sunrise.*
Oil on canvas; 19⅝ × 25½ in. Owned by Musée Marmottan, Paris.
SCALA/Art Resource, New York.

The Salon des Refusés

The nineteenth-century **Salon** (sah-lohn′) was an official annual exhibition of paintings. Because the Salon's exhibition was juried or selected by the Academy, a learned society of art critics who at that time held to the rigors of tradition, many works by the painters adopting new methods were refused. In response to general outcry, the *Salon des Refusés* (ray-fuh-zay) (Salon of Refusals) was established by the government under Napoleon III. In other words, it was an event at which all those hundreds of paintings considered unacceptable by the Salon could be exhibited to the public and critics alike. The first of such exhibitions in 1863 proved to be merely an occasion for ridicule and was discontinued. However, Monet, Renoir, and their colleagues soon established their own exhibitions and quickly attracted the attention of art critics. The impressionists gained some recognition in 1874 at a private showing containing Claude Monet's (moh-nay) (1840–1926) *Impression: Sunrise* (fig. 9.6), owned by the Musée Marmottan (muh-zay′ mahr-mah-tawn′) in Paris. From that time on, the movement came to be known as "impressionism".

Monet's sketchy painting of the harbor at Le Havre is nearly devoid of concrete subject matter. We can see the sun, its reflection on the water, and foggy apparitions of boats and distant landscape. While this is not Monet's most impressionistic painting, it contains definite impressionistic elements: vague contours, small strokes of color, and above all the depiction of light at a specified time of day. Although the critics disdainfully proclaimed the painting unfinished, Monet had never intended a detailed, "finished" picture. He painted exactly what he wanted the spectator to see: a fleeting glance of reality. In this regard, we can say that Monet is often considered the most typical representative of the impressionist style.

Although Édouard Manet (mah-nay′) (1832–83) did not work among the mainstream impressionists, he eventually came to paint in a similar way and most certainly exerted an influence on the development of the movement. It was Manet's controversial painting (not pictured) *Dejeuner sur l'Herbe* (day-juh-nay sür layrb) that drew the most heated criticism during the Salon des Refusés of 1863. The picture's subject matter was the object of critics' harsh derision: a nude woman seated in the woods with two fully clothed French gentlemen. Manet's style in this work was based on a realistic rendering of human figures set apart from the background in bold contours. But with what was then considered such repugnant subject matter, the public found it difficult to appreciate Manet's style. Manet's bold approach to art and his plight at the Salon des Refusés made him something of a hero among his younger colleagues, who were to become the main body of impressionists. One of Manet's earliest impressionist paintings is his *Race Track Near Paris* (fig. 9.7) painted in 1864. This most certainly portrays a fleeting moment captured during an exciting event where the movement of the horses is implied by the clouds of dust that partially blot out their legs.

Figure 9.7 Édouard Manet, *Race Track Near Paris*.
Oil on canvas; 1864; 17¼ × 33¼ in. Potter Palmer Collection.
© The Art Institute of Chicago. All Rights Reserved.

Matisse is supposed to have said, "Manet is a man born
to simplify art."

The background is but a misty blur with bright light near
the horizon. The crowds of people on either side of the
track are expressed by frothy splotches of color. These
are the elements of impressionist paintings—the play of
light and color off objects that suggest motion and fleeting
visions of the real world. Manet employed the popular
technique of sketching these scenes and then completing
the final work in the studio. Especially in this case, Manet
managed to retain the spontaneity of the moment by
avoiding detail.

A later work by Manet illustrates the influence of the
mainstream impressionists on his painting technique. In
his *Le Journal Illustré* (luh zhoor-nahl′ ee-loos-tray′)
(fig. 9.8), Manet employs an extremely improvisational
brushstroke. It is as though he deliberately used a brush
too large to depict finite reality. Quick, imprecise strokes
provide a quality of freshness and informality that is
commensurate with the subject, an ordinary woman
reading on a bright sunny afternoon. This is typically
delightful impressionist fare—little emotional involve-
ment (the woman's face is entirely expressionless) and
minimal symbolism to challenge the intellect.

Figure 9.8 Édouard Manet, *Le Journal Illustré*.
Oil on canvas; 1878 or 1879; 24¹/₁₆ × 19⅞ in. Mr. and Mrs. Lewis Larned
Coburn Memorial Collection.
© The Art Institute of Chicago. All Rights Reserved.

Figure 9.9 Claude Monet, *The Cliff Walk (Etretat).*
Oil on canvas; 1882; 25¾ × 32¼ in. Mr. and Mrs. Lewis L. Coburn
Memorial Collection.
© The Art Institute of Chicago. All Rights Reserved.

Figure 9.10 Claude Monet, *On the Seine at Bennecourt*
(*Au bord de l'eau, Bennecourt*).
Oil on canvas; 1868; 31⅞ × 39½ in. Potter Palmer Collection.
© The Art Institute of Chicago. All Rights Reserved.

Monet: Leader of Impressionism

Claude Monet is without question the most consummate impressionist painter of his time. His devotion to nature and the influence exerted on him by Courbet can be observed in Monet's oil painting *The Cliff Walk* (fig. 9.9). The strongly asymmetrical arrangement of basic shapes—cliffs, sea, sky—is reminiscent of Courbet's *The Rock at Hautepierre* (fig. 9.1). But how different the two paintings are! Monet's seascape is alive with fluttering, wispy motion caused by the application of short brushstrokes of variegated color patterns. The genial touch of the two human figures adds warmth and relative proportion to what, without them, would have been a rather uninteresting painting.

One of Monet's early works, *On the Seine at Bennecourt* (*The River*) (fig. 9.10), was painted during the time when he and Renoir were working together. Indeed, some of their paintings during this time are difficult to distinguish from one another. The composition of *On the Seine* seems oddly cluttered by the overwhelming amount of foliage in the foreground. The foliage does, however, serve to focus our attention on the river, and we must consider that Monet's real subject here was probably the reflections on the water rather than the water itself, or even the freely painted figure of his wife, Camille, and the boat that occupy so much space in the foreground. Even at this early stage, Monet was subduing detail of subject matter in favor of larger, relatively flat areas of color. Close examination will reveal that the tree leaves and flowers are but single brushstrokes or, in some cases, just touches of white or yellow paint. The tree trunks, relatively flat areas that seem to darken slightly toward the top, lack the feeling of volume because no attempt at

Without Monet, we would all have given up.

Pierre-Auguste Renoir

modeling was made. The boat is extraordinarily accurate in its general depiction of contour, but it was rendered with an economy of strokes. Can we imagine what would be lost if precise depiction of each object had been provided? Monet doubtless calculated that viewers' attention would be distracted from the more important consideration, namely the play of light on the water.

Monet's Serial Painting

Among the most popular topics regarding Monet's artistic development is his discovery of serial painting. His fascination with light and its constantly changing effects as it reflects off objects led him to paint the same scene at different times of the day or in different seasons of the year. We saw some of the results of this approach in Tour 1 at the National Gallery in Washington, D.C. (*Rouen Cathedral*) (roo-awh') (see fig. 1.40). Monet's first group of serial paintings began with haystacks near his home in Giverny. The story is told that he was painting a haystack when the light shifted and he suddenly realized he must now begin another canvas because this picture was different from the one he had started. There were instances in which several canvases were begun, some completed, in the space of a single day—all of the same subject. Now we can begin to understand why there are so many paintings by Monet of similar subject matter in galleries and museums all over the world. We shall examine two of Monet's haystack paintings that are in the Art Institute's collection.

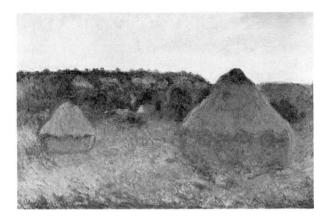

Figure 9.11 Claude Monet, *Grainstacks, End of Day, Autumn*
(*Deux Meules, declin du jour, automne*).
Oil on canvas; 1891; 25½ × 39¼ in. Mr. and Mrs. Lewis L. Coburn
Memorial Collection.
© The Art Institute of Chicago. All Rights Reserved.

Figure 9.12 Claude Monet, *Waterlilies.*
Oil on canvas; 1906; 34¾ × 36¼ in. Mr. and Mrs. Martin A. Ryerson
Collection.
© The Art Institute of Chicago. All Rights Reserved.

The first painting depicts two haystacks (fig. 9.11) in bright light, set widely apart. The group of houses and clumps of trees in the distance are nearly obscured due to a lack of definition. The haystack on the left is so devoid of shadow that it appears to float above the field, and both haystacks glow vividly with bright reds and vermilion. In fact, the entire work consists mainly of broad areas of lightly hued colors and spongy contours. The time of day is not readily apparent unless we look at the title, but the absence of clearly defined shadow indicates that it could be either just before dawn or just after sunset. The time of year must be late summer or early autumn because of the green foliage in the foreground.

The second in the series is more clearly defined by title: *Grainstacks, Snow, Sunset* (colorplate 54). The shadows are heavier here, indicating that the sun has not yet fallen below the horizon. The whitened hues over the surface indicate that Monet painted this one in the wintertime. In both works we can appreciate the absence of dark tones; this is a celebration of light and an example of the expressive power of spectrum colors.

Another feature of Monet's serial paintings is illustrated in these two selected works. He varied the composition as well as the light with each rendition. The second painting (colorplate 54) is, like the first, of two haystacks, but in this one the two are overlapping and placed to the left in the design. Balance is maintained by the red-orange sky that is relegated, for the most part, to the right side. Again, detail is sacrificed for the immediacy of the moment. Like his earlier work, *Impression: Sunrise,* forms here are rendered with a quick deft touch of the brush—dabs of paint that again suggest familiar forms that we recognize at a glance.

Monet's most famous series of paintings were completed near a pond at Giverny, and are referred to as the waterlilies paintings. To Monet, the pond was forever changing. These paintings represent the very essence of impressionism, thorough studies of light in which the subject is merely a means to that end. Monet's earliest paintings of the pond include a Japanese footbridge, which provides a sharp linear contrast to an otherwise nonlinear composition. Our attention is directed toward the water, however, to the ethereal, floating waterlilies and their reflections.

The brush technique used to depict the lily pads and blossoms in his *Waterlilies* (fig. 9.12) is noteworthy. Monet represented the plants with small frothy areas of bright colors, indistinct patches of light blues and greens and a broad spectrum of hues. The waterlilies pictures have eliminated the familiar horizon seen in most landscapes; here we look down on the surface of the pond and see the sky and light only in reflection. Monet invites us into a glistening, serene dream world. Even without a horizon, we perceive some distance as our eyes move to the top of the picture because Monet used greater intensities and stronger contrasts in the foreground. Because the painting shows the reflection of blue sky and the trees that line the pond's banks, there is a prevalence of cool hues. We see in this painting another trend in the series: a tendency toward greater simplicity, a factor that allows us to concentrate even more intently on the play of light on the water. Monet was so fascinated with light as subject matter that he once said he would have preferred to have been born blind so that when he could see for the first time, without knowing one object from another, he would see each object only in terms of light.

Figure 9.13 Pierre Auguste Renoir, *Lady Sewing.*
Oil on canvas; 1879; 24¼ × 19⅞ in. Mr. and Mrs. Lewis L. Coburn
Memorial Collection.
© The Art Institute of Chicago. All Rights Reserved.

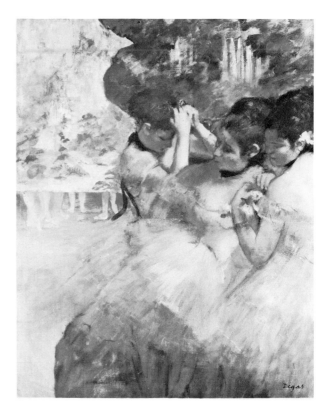

Figure 9.14 Edgar Degas, *Dancers Preparing for the Ballet.*
Oil on canvas; ca. 1878 or 1880; 29³/₁₆ × 23¾ in. Gift of Mr. and Mrs.
Gordon Palmer and Mr. and Mrs. Arthur M. Wood and Mrs. Bertha P.
Thorne.
© The Art Institute of Chicago. All Rights Reserved.

THE EXTENSION OF IMPRESSIONISM

Renoir Monet's painting companion, Pierre Auguste
Renoir (pyayr oh-goost ren-wahr') (1841–1919) was
more interested in human subjects than he was in land-
scapes. Curiously, however, Renoir treated his figures al-
most as dispassionately as Monet did his haystacks.
Renoir's oil painting, *The Rowers' Lunch* (colorplate 50),
looks a good deal like a Monet, especially if we look be-
yond the figures to the vague apparitions of the boat, the
river, and the misty background. And it is fairly easy for
us to look beyond these figures because their faces are
hazy and somewhat nondescript. The clothing on all three
figures merely suggests form and relies on viewers to fill
in details with their imaginations. The trellis frames be-
hind the foreground subjects are thinly latticed to allow
light to flood the party.

Renoir was particularly fond of capturing leisurely,
flirting fun—the joy of life. In his mildly sensual oil
painting *Lady Sewing* (fig. 9.13), Renoir uses two of his
favorite subjects—a beautiful young woman and flowers.
However, as in most of his work, the real subject is the
broad spectrum of colors enlivened by natural light. In
addition to indistinct contours, most of which languor-
ously fade from one form to the next, Renoir used vague

forms and a woman's expressionless countenance. The
flowers are of no recognizable species and the vase is
nearly amorphous. The dark shadows consist of deep
blues and violets rather than the traditional use of grays
and blacks. This is typical Renoir; most of his personal
style is evident in this simply stated piece which is un-
equivocally impressionistic.

Degas Edgar Degas (1834–1917) painted his *Dancers
Preparing for the Ballet* (fig. 9.14) at about the same
time that Renoir finished his *Lady Sewing.* Perhaps that
accounts for many similarities in these two works. Degas,
like Renoir, chose to portray a relaxed moment in time,
rather like a photograph. The ballet became a frequent
subject of Degas's later paintings, and many of them
portrayed the more incidental occurrences of the art—
casual backstage scenes, lessons, and practice sessions—
rather than the more heroic graceful concert perfor-
mances.

The informality of the scene, the figure at the right
partially cut off by the frame and the open space at the
left seem to draw us into the picture plane. The feathery
lightness of the gowns is expressed with rough, unfin-
ished brushstrokes, as it was in Renoir's work. The cur-
tain and scenery are lost in broad smudges of paint meant

Figure 9.15 Camille Jacob Pissarro, *On the Banks of the Marne, Winter.*
Oil on canvas; 1866; 36⅛ × 59⅛ in. Mr. and Mrs. Lewis L. Coburn Memorial Fund.
© The Art Institute of Chicago. All Rights Reserved.

A painting is a thing which requires as much knowing, as much malice, and as much vice as the perpetration of a crime. Make it untrue and add an accent of truth.

Elizabeth G. Holt

only to suggest the setting. One of the major differences between this painting and all previously mentioned impressionist works is that Degas used artificial light as opposed to natural light. However, artificial light does not, by itself, disqualify *Dancers* as impressionist; the delicacy of line, the pastel-like hues, and the subject matter are all true to the style.

Another of his works, *The Millinery Shop* (colorplate 51), also uses artificial light but employs vivid coloration. The contrasting hues and values are more distinct in this painting. Bolder contrasts result, and we can see here the beginning of a trend that was to develop fully with the postimpressionists—the use of more solid forms and harder contours. Detail is obscured in a way not found in most other impressionistic works: there is deliberate distortion of perspective and the composition comprises flat ornamental planes, similar to Japanese screens and prints. Degas was interested in the top of the table only as an area in his compositional design, not as a correctly drawn piece of furniture. We seem to be

gazing down on the scene; the table would not loom up at the top corner if we were merely standing beside it. Such distortion or, more properly, liberty taken with the portrayal of objects, was to become extremely popular with artists from that time on. Unlike the composition of most impressionist paintings that were more casually composed, Degas's *Millinery Shop* has a more formal look with a unique angle of vision. But, somehow it does not lose its improvisational appearance. Notice the unfinished scarf in the picture's center, the remarkably incomplete rendering of the woman's right arm, and the quickly painted background where visual resolution is left to the eye and imagination of the viewer.

Pissarro Camille Jacob Pissarro (kah-meel pee-sah'-roh) (1830–1903) is considered one of the leaders of impressionism even though his early works were far from the ideal impressionistic mode. Two of Pissarro's paintings, one early and one late, demonstrate how thoroughly he moved from the traditional style to a complete espousal of the techniques of Manet and Monet. Painted in 1866 when Monet and Renoir were still in their early development, Pissarro's *On the Banks of the Marne, Winter* (fig. 9.15) retains the dark tones and flat broad areas of Courbet and Manet. The dark tones are nicely contrasted with bright lights in the sky and those reflected off the buildings. The large flat areas are pleasingly arranged in patterns that are both balanced and

interactive. The bright sky on the right side is counter-balanced by the large dark hill on the left, and the buildings are balanced by the path on the left leading back in perfect linear perspective to the base of the hill. Other more subtle contrasts include the vertical lines of the trees breaking up the path's diagonal line, while the horizontal patches of the field in the foreground relieve the broad uniformity of the area. The same effect holds true for the sky—the clouds have a compositional function as well as one of realistic depiction of landscape.

The evidence of Pissarro's stylistic growth in his *Woman and Child at the Well* (fig. 9.16) is striking. While remaining true to his earlier concern for solid forms, Pissarro has now freed them from their former flatness. This mature style, well within the impressionist manner, was accomplished primarily with a new brush-stroke. While the early works were constructed with broad strokes, the later ones were rendered with what might be termed a split, or divided, stroke. All of the shapes in this painting are made with small, dappled touches of several hues. This approach implies impasto, or heavy, multiple layers of paint. In this case, the result is a composition filled with sparkling facets of light. Those tiny dabs of paint also help to convey the sense of form somewhat in the manner of Seurat's pointillism technique (see p. 222). It is a major achievement to be able, as Pissarro has done here, to build solid forms without resorting to hard contours. This painting is a supreme example of the perfect interaction between unity and variety.

Cassatt Mary Cassatt (kah-saht') (1845–1926) was part of a small group of American artists who, along with John Singer Sargent and James Abbott McNeill Whistler, traveled to Europe during the heyday of impressionism. All three were to be influenced by the new style, but it was Mary Cassatt who was to become the most impressionistic and perhaps the most significant American artist of her generation.

It is well known that many of the painters of the French school were influenced by methods incorporated in Japanese printmaking (see Tour 5). One of the most important Japanese influences was the high-positioned point of view, similar to that already observed in Degas's *The Millinery Shop.* One purpose of such a viewpoint is to maintain an objectivity in an otherwise intimate situation; we are able to observe this ordinary event without becoming involved in it. Cassatt maintains this impersonal distance in her painting *The Bath* (colorplate 48). Emotional intensity is deemphasized in all the works we have seen on this tour, and for good reason: we must not be distracted from our perception of the effects of light

Figure 9.16 Camille Jacob Pissarro, *Woman and Child at the Well.* Oil on canvas; 1882; 32 × 26 in. Potter Palmer Collection. © The Art Institute of Chicago. All Rights Reserved.

From Degas (with whom Cassatt had a forty-year friendship), Cassatt learned to use pastels in vibrating layers of color. . . . Like him, she framed her compositions from unusual angles of visions, cropped the image as in a snapshot, and captured her subjects in unposed, natural, and relaxed gestures. There is, however, a warmth and optimism in Cassatt's work that contrasts with the cynicism and pessimism of Degas.

Charlotte Streifer Rubinstein

and color. In this picture we are thus able to concentrate more on the areas of bright coloration and on how they interact to produce an interesting and fluid composition.

As skilled as Cassatt was in drawing, we are puzzled as to why the woman's left hand is so large or why her lap is so expansive. Perhaps she meant to diminish the size of the child by placing that huge hand across her middle; perhaps she meant to provide a large frame (the lap) around the child to imply strong motherly support. At any rate, it is likely that most viewers are not aware of such distortions because they see relationships of shapes and volumes rather than the forms in isolation. It is this aspect of the painter's skill that we appreciate.

Figure 9.17 Some impressionist sculpture retains an improvisatory look due to its unfinished state. Auguste Rodin, *Balzac.*
Plaster; H. 9 ft. 10 in. Musée Rodin, Paris.
© Arch. Phot./S.P.A.D.E.M., Paris/V.A.G.A., New York, 1985.

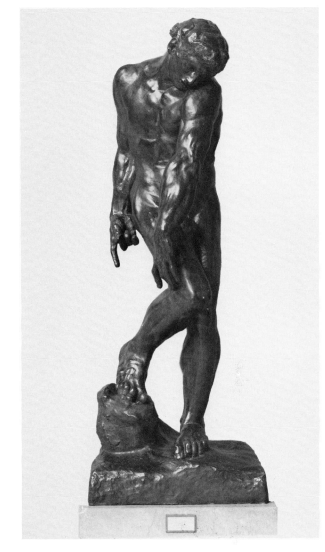

Figure 9.18 Auguste Rodin, *Adam.*
Bronze; 1881; H. 6 ft. 6 in.; base, 30 × 29 in. Gift of Robert Allerton.
© The Art Institute of Chicago. All Rights Reserved.

Impressionist Sculpture

Impressionism mainly applies to the two-dimensional arts, but it also influenced sculpture. Auguste Rodin (roh-dan′) (1840–1917), following many of Michelangelo's sculptural techniques, considered the effects of light as it reflected off the surface of his works. One of the facets of Michelangelo's style that Rodin adopted was leaving part of the work totally unfinished. The contrast between smoothly polished portions and rough craggy areas heightened the sensuous fleshlike quality of the total piece. In understatement and indefinite contours, Rodin's work is aligned with the unfinished, improvisatory nature of impressionist paintings and drawings. Rodin's *Balzac* (fig. 9.17), which is not at the Institute, is made

of plaster and stands nearly ten feet tall. Most of the figure is wrapped in an amorphous cloak whose shape is only vaguely suggested. For that matter, the head and features of the famous novelist are not clearly defined either. Perhaps Balzac's ghostly glower recalls more of the romantic spirit, but the unfinished, sketchy look of the total figure commands most of the viewer's attention.

In his life-size bronze sculpture *Adam* (fig. 9.18), Rodin allowed the rough, bumpy surface of the clay model to show through in the final bronze cast. Rodin presented the essence of Adam, a fleeting vision of a person, rather than an attempt at correct anatomy.

POSTIMPRESSIONISM

The style of the group of painters who followed the impressionists was designated **postimpressionism.** Their style is distinctively different from the impressionists' in several ways. While a regard for light and its effects on color are maintained, we see in postimpressionists' works far more intense hues and a return to stronger contours. We also see, especially in the works of Seurat, a radical new interest in the solidity of forms and an extension of the experiments with color. Their interest in the durability of their artworks led to a general discontinuance of the quick sketch in favor of careful and tedious studio reworking of paintings sometimes taking months to complete.

A greater use of emotional expression and symbolism began to appear in the works of van Gogh and Gauguin during their mature years. The influence of the impressionist treatment of light and color was nonetheless still present; van Gogh was especially fascinated with the effects of sunlight, and Gauguin's rich colors were derived from the impressionists. Cézanne, although something of an individualist, modeled his landscapes after the impressionists' use of short brushstrokes and pure colors.

Toulouse-Lautrec captured shadowed Parisian nightlife with strong, flat surfaces of color reminiscent of Japanese painting. His famous paintings of the Moulin Rouge are indicative of his desire to use color in new ways and to combine graceful line with bold diagonals. Lautrec's brilliant colors and enthusiasm for poster design opened the door to a new world of art. He, along with Cézanne and his multifaceted areas of bright colors, helped create an atmosphere for the experimentation about to shape twentieth-century art.

The Contributions of Cézanne

Paul Cézanne (say-zahn') (1839–1906), the oldest of the postimpressionists, is also considered their leader. He actually worked extensively with the impressionists, but his mature works prove that he did not accept the idea of fluid unity of surface motion and transient light. He was more interested in the structure and solidity of objects than the effects of light. We can see in his *The Gulf of Marseilles, Seen from l'Estaque* (fig. 9.19) the reduction of landscape objects to elemental, geometric essences; he once said, "Treat nature by the cylinder, sphere, and cone." The buildings in the foreground thus stop the movement because their rigidity gives stability to the composition and contrasts with the sinuous patterns in the distant hills. It is clear from this work that

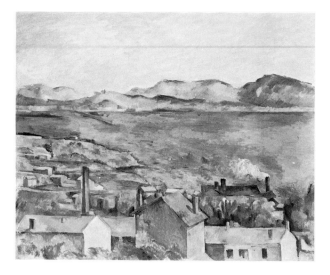

Figure 9.19 Paul Cézanne, *The Gulf of Marseilles, Seen from L'Estaque.*
Oil on canvas; 1891; 31¾ × 39¼ in. Mr. and Mrs. Martin A. Ryerson Collection.
© The Art Institute of Chicago. All Rights Reserved.

Cézanne paid close attention to each individual part of his paintings as each part relates to the whole.

Tiny facets of color provide rich textural surfaces relieving shapes of their stark simplicity. This treatment of small areas is seen in brilliant, sparkling color in his later work *Basket of Apples* (colorplate 55). Without the realistic detail found in earlier still lifes such as Jan Davidsz de Heem's lush painting *A Table of Desserts* (colorplate 38), Cézanne nonetheless produced a universally appealing masterpiece. We see more than merely something to eat; we see how apples can be used to express color relationships and to interact with other shapes. We, like the impressionists, can also experience how color is used to define form. Cézanne found that the more intense the reds in individual apples, the more they appeared as spherical forms rather than as flat shapes. Cézanne modeled colors and planes to create direct statements of raw, forceful power. Even without extensive artistic background, the untrained eye can sense the artistic merit of this fine painting. The many imperfections in what is considered to be "correct" drawing should not, at this point, bother us. "But what," you may say, "of the table top? It rears up and doesn't even come together across the back, and the bottle leans as if it were about to topple over!" True. There is virtually nothing in this painting that looks real in a natural setting. More than likely, these deviations and deliberate, radical distortions signaled the beginnings of abstract art in the twentieth century. Cézanne's innovative theories of space, color, and form provided a new reality for the easel painter.

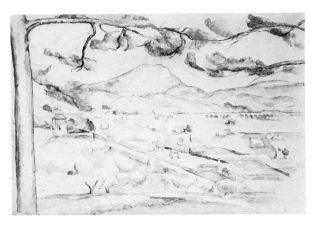

Figure 9.20 Paul Cézanne, *Montagne—Sainte-Victoire.*
Watercolor; 13⅝ × 20⅞ in. Gift of Marshall Field.
© The Art Institute of Chicago. All Rights Reserved.

To further prove the point, we shall examine a painting of Cézanne's favorite subject, *Montagne Sainte-Victoire* (mohn-tah-yah san-veek-twahr) (fig. 9.20). As in most of his paintings of this undistinguished landmark, the mountain itself is a rather large shape and thus should not look so distant. How has Cézanne accomplished this distance and yet integrated it with other features in the composition? Color is certainly a key to the answer and so is the positioning of reference points. The tree is a valuable, close reference point; it runs boldly off the top and bottom of the picture plane and its branches fill the entire expanse of sky. The colors serve to establish many planes that create this sense of depth, as we learned in Tour 1. Cézanne balanced cool distant areas with warm flecks of color to bring the near and far into closer harmony.

Color also defines the undulating structure of the mountain itself, rather than using full light and shade as the Renaissance artists did. Touches of color have been applied, somewhat in the divided brushstroke of the impressionists, to suggest the solidity of bulges and gullies on the mountain's slopes. These were usually not the actual colors of the subject, called **local color,** but were rather adjusted in terms of the composition's needs.

For Cézanne, the purpose of composition in painting was to transform objects from the three-dimensional space of nature onto a two-dimensional surface. In terms of this basic objective, he first had to be concerned with the way solids and voids interacted on the canvas, much as Calder was concerned with the way open spaces, and solid steel shapes interacted in his sculpture (see fig. 2.38). Cézanne felt that subject matter and surrounding space should fuse within the limits of the composition.

Design and color are not distinct and separate. As one paints, one draws. The more the colors harmonize, the more the design takes form. When color is at its richest, form is at its fullest.

Paul Cézanne

One way to create this feeling was to give as much attention to ground, or open spaces, as to figures, or solid areas. Be assured that Cézanne was as aware of the shapes of the negative spaces between the tree branches as he was of the branches themselves. The fusion of solids and voids was further heightened by the way he rarely used contour lines to define shapes. With no outlines, the eye is free to move in and out of shapes and is not confined within individual units of the painting. This also has the effect of merging the foreground, middleground, and background.

Other Masters of Postimpressionism

Paul Gauguin (goh-gan′) (1848–1903) and Vincent van Gogh (van goh′) (1853–90) transformed subject matter from the impressionists "light and color" to the expression of inner, subjective feelings. Both used bold colors (largely the primary hues) and both employed symbolism and emotional expression in their works.

Van Gogh Van Gogh, like his impressionist friends, was fond of ordinary, familiar subjects: sunny landscapes in Holland, trees, flowers, and the starkly simple interior in his *The Bedroom at Arles* (colorplate 49). We are immediately taken with the large areas of gleaming yellow, van Gogh's favorite color. We hardly notice the bright accent of intense red that has been carefully placed beside the yellow to make it more brilliant. If you block out the red, you can see how important an area it is to the total vibrancy of the painting. That color trick is only one of the many devices that van Gogh used in this work to heighten the drama in an ordinary scene. Look again at the exaggerated perspective of the floor, the chair on the left, the window, and the pictures on the right wall. Is it all wrong? Keep in mind the subject—a simple bedroom, no people, nothing of special interest. Odd, in fact, that he would have chosen to paint it at all. But with that distorted perspective heightened by bold outlines, van Gogh pulls viewers right into the vivid, emotional world of his artistic imagination.

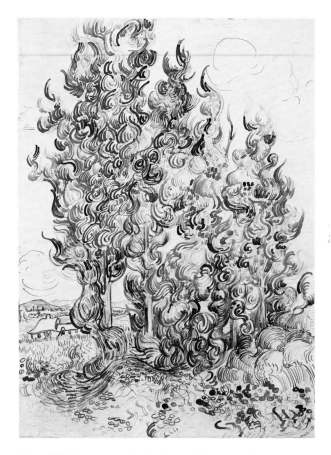

Figure 9.21 Vincent van Gogh, *Grove of Cypresses*.
Pen and ink over pencil; 1889; 24⅝ × 18¼ in. 626 × 465mm. Gift of Robert Allerton.

I want to paint men and women with that something of the eternal which the halo used to symbolize. And in a picture I want to say something comforting as music is comforting. I want to paint men and women with that something of the eternal which the halo used to symbolize, and which we seek to give by the actual radiance and vibration of our colorings. . . .

*Vincent Van Gogh,
letter to his brother Theo*

A similar personal involvement occurs as we view van Gogh's *Grove of Cypresses* (fig. 9.21). Since this drawing is "ink and reed pen over pencil," it is clear that this picture began as a pencil sketch and was then carefully worked out with pen and ink. The wildly swirling trees are deliberately distorted. Our expectation of the way trees should look conflicts with van Gogh's interpretation; the trees are on fire. Van Gogh's intense spiritual quest found its way into every luminescent penstroke. It was this desire of artists to pictorialize their feelings that inspired the expressionistic movement that followed.

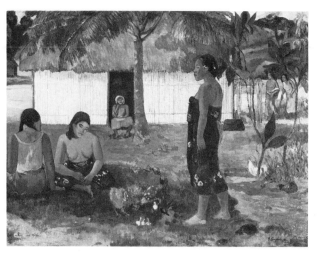

Figure 9.22 Paul Gauguin, *Why Are You Angry?* (*No te aha oe riri*).
Oil on canvas; 1896; 37⅜ × 51 in. Mr. and Mrs. Martin A. Ryerson Collection.

Gauguin Like van Gogh, Gauguin searched for an inner emotional world away from the demands of Western civilization. Gauguin spent his last years on the Polynesian Islands where the exotic mysteries of the natives' customs, religion, and legends were expressed in his works. In his painting *The Day of the God* (colorplate 53), objects not only are represented as symbols, such as the pagan god at the very top, but the entire work is a prototype of the peaceful idyllic existence of the Polynesian people. It is Gauguin's technique in this work, however, that is so important in the development of twentieth-century art. The shapes are nearly all the same size, and with the broad application of primary colors, the entire work appears flat. The three main figures in the center of the picture plane are oddly mirrored in the lower portion, which, unlike the upper portions, is totally abstract. These abstract forms, and the realistic forms as well, are arranged in alternating planes of dark and light values. The result is decorative, made all the more so by the absence of shadows. We can begin to see in this work how abstraction tends to bring the entire canvas forward so that the feeling of depth is lost. Notice how the realistic scene at the top of the picture plane retains depth and distance while the more abstract portion in the foreground takes on a flat look.

Perhaps a more typical example of Gauguin's composition is found in his painting with the strange title *Why Are You Angry?* (fig. 9.22). According to the artist, the title refers to the disgruntled woman seated in the doorway of the hut. However, our interest here is in the design—figures and objects distributed fairly equally over the entire surface of the canvas. Again, the lack of

Figure 9.23 Henri de Toulouse-Lautrec, *At the Moulin-Rouge.*
Oil on canvas; 1892–95; 48½ × 55⅜ in. Helen Birch Bartlett Memorial
Collection.
© The Art Institute of Chicago. All Rights Reserved.

Figure 9.24 Henri de Toulouse-Lautrec, *In the Circus Fernando:
The Ring-Master.*
Oil on canvas; 1888; 38¾ × 63½ in. Joseph Winterbotham Collection.
© The Art Institute of Chicago. All Rights Reserved.

distinct shadows gives the painting a decorative appearance. Like so many of Gauguin's works, this painting was, in its original state, probably more brilliant in coloration. It is likely that Gauguin's improperly primed canvases, humidity, sun, salt air, and the mineral spirits he used may have caused his paintings to fade with the passage of time. Gauguin seems content with ordinary subject matter as a means of conveying the peace found among the Polynesian people which contrasted so dramatically with the personal trials he suffered in Europe.

Toulouse-Lautrec The tragic and short-lived career of Henri de Toulouse-Lautrec (on-ree de tooo-loos'-loh-trek') (1864–1901) is now as well known as van Gogh's. A pariah in the aristocratic class of his family, Lautrec won tentative acceptance among the entertainers and prostitutes of Parisian nightlife and the circus. One of the most famous night clubs of the time was the Moulin Rouge (moo-lan roozh), where Lautrec spent many an evening sketching the cancan girls, the ladies of the evening, and the carousing public. His most popular painting was conceived in such an atmosphere: *At the Moulin-Rouge* (fig. 9.23). The subjects are real people that Lautrec knew and observed, including himself (the short bearded man in the background). His intent was not just to picture these people as a kind of memento of the time but to portray the status of life at the tawdry lower levels. These expressionless caricatures are thus only prototypes meant to symbolize the conditions of life during the Gay Nineties.

Lautrec's composition is dramatically forward-looking; the prominent figure in the foreground is, strangely, half out of the picture plane. Her face glows with unearthly color in the bright footlights. She seems about to brush past us as if, as in van Gogh's painting of his bedroom, we were actually in the room. Lautrec's perspective, too, is distorted in order to draw us into the composition. The strong diagonals formed by the balustrade and the floorboards create a large V shape containing most of the figures in the composition. These heavy straight lines are then softened by the ornate linear patterns of the chairs, the dress of the figure in the foreground, and the other figures who seem nestled together in a swirling mass of short, curved lines. Like Gauguin and van Gogh, Lautrec created a highly imaginative work integrating broad areas of vivid color with abstract line and forms. Unlike his two contemporaries, however, Lautrec brought his art into the eerie atmosphere created by artificial light, which indicates the strong influences by the impressionists and their preoccupation with sunlight.

Further proof of Lautrec's creative use of exaggerated perspective is seen in his lively painting *In the Circus Fernando: The Ring-Master* (fig. 9.24). We are part of the crowd and our vantage point looks down on the performers and cuts off other spectators and the clown at the left side of the picture. The matter-of-fact expression on the faces of the ringmaster and the equestrienne is typical of both impressionist and postimpressionist schools. The decorative appearance of this painting is achieved mainly with the broad, flat, white area that comprises the floor of the ring. This flat, decorative use of shapes with prominent silhouettes was derived from

Lautrec's admiration of Japanese prints. Compare this painting with the prints in Tour 5. The comparison with Japanese printmakers is further strengthened by Lautrec's own innovations in lithography. His posters printed to advertise the attractions at the Moulin Rouge are now accepted as legitimate works of art. Another interesting feature is Lautrec's use of heavy contour outlining, which almost looks like the technique of comic strips. Note especially the ringmaster's hand and the whip; both are made only with a few quickly drawn lines—there is no coloration or modeling. This technique, plus the large flat areas, is reminiscent of Lautrec's celebrated posters.

Seurat The most famous painting at the Art Institute is *Sunday Afternoon on the Island of La Grande Jatte* (lah grahnd jaht) (colorplate 52a) by Georges Seurat (soe-rah′) (1859–91). Faithful to the impressionists' love of outdoor subjects and their fascination with the effects of sunlight, Seurat portrayed a quiet afternoon in the park. He also adopted the impressionists' divided brushstroke and took it one step further. Instead of dividing the brushstroke, he placed tiny dots of varying colors next to one another as he went about constructing solid forms. Seurat called the effect **divisionism,** but the technique is now widely known as **pointillism,** named after the countless "points" of color that constitute his compositions.

Pointillism embraced two new artistic theories. First, although it was widely known that the juxtaposition of colors causes greater intensities, paintings prior to this had not been constructed in such a painstakingly methodical manner. Second, the placement of dots, if small enough, were thought to cause the eye to "mix" the colors and thus create new color perceptions. In other words, Seurat was forcing the viewer's eye to mix the colors rather than mixing them beforehand on his palette. The intensities of primary colors are thus retained. For example, by placing tiny dots of red and yellow close together, we viewers are supposed to see orange. Whether or not these experiments with color prove that our recognition of color is true, hues are conditioned by the juxtaposition of other hues (see detail, colorplate 52b). Seurat's large and impressive canvas glitters with the meticulous application of dots of color. Some of the contours at close viewing range may blend softly from one form to another as one group of dots runs into another. But, as we step away from the picture, the forms solidify, frozen forever in their stiff vertical postures. Movement is reduced to a shimmer of light as if reflecting off colorful statuary. It is this major breakthrough that separates Seurat's masterwork from those of his impressionist contemporaries and provides yet another avenue of expression for artists.

SUMMARY

In 1863, the inner circle of traditional Parisian artists and critics opened the door for one of the most significant revolutions in the history of art by establishing the Salon des Refusés. The rejection of Manet's *Dejeuner sur l'Herbe* won for him the admiration of his colleagues and became the impetus for the now-famous 1874 exhibition that included Monet's *Impression: Sunrise*. Without intending it, Monet's painting was dubbed "an impression" and so established a new style of art.

The name also described the style's method and common subject matter: impressions, or fleeting glances of reality in which the emphasis shifted from traditional subject matter to the effects of light and color. Detail and bold outlines were ignored in favor of divided strokes of color. Paintings seemed unfinished, almost as if the play of light on objects was captured and then the painting was stopped. Sculptures captured only the essence of the subject, and the detailed work of the final stages was left unfinished. The unfinished and indefinite contours and surface of Rodin's sculptures are similar to the understatements of impressionistic painting and drawing.

Although the beginning of impressionism can be traced to a single event in 1874, the style began to evolve much earlier—in various forms and in the hands of many artists. The English artists Constable and Turner discovered the advantages of leaving the studio and recording the beautiful effects of light and shadows in the out-of-doors. The romantic artist Delacroix used color in divided strokes for more dramatic results, and the Barbizon painters, including Corot, established landscape as their most favored subject matter. Courbet's influence can be traced to his treatment of commonplace subject matter, directly and sincerely portrayed.

Monet is the undisputed leader of the impressionists. In particular, his obsession with the play of light and atmosphere at various times of the day and year prompted him to paint a particular scene repeatedly in order to capture those unique effects. Known collectively as serial painting, Monet's later works are studies of light as it reflected off objects in his environment. Other impressionist artists include Monet's painting companion, Renoir; the sculptor Rodin; and the American Cassatt; Degas; and Pissarro.

Postimpressionism was a name coined by a group of artists in reverence to their impressionist predecessors. Cézanne, the new style's initiator and the man called by many the father of modern art, employed a system of modeling forms with facets of color. Divided strokes of

color, or "divisionism," was taken one step further by van Gogh with heavy impastos and brilliant hues. From divisionism, Seurat developed "pointillism," which utilized tiny dots of intense, unmixed colors. Gauguin and Toulouse-Lautrec used decorative color in their paintings of real people in specific locales that exaggerated perspective and vivid color to portray the tenor of the time and setting. While postimpressionism drew away from the tenets of Monet's brand of impressionism, the new style's emphasis on subjectivism set the stage for expressionism, which was to emerge in Germany during the first decade of the twentieth century. We shall see how expressionism compares with impressionism on our next tour.

VIEWING EXERCISES

1. Compare the two paintings in figures 9.25 and 9.26 and determine which is the more impressionistic. Discuss the reasons for your choice.

Figure 9.25 Claude Monet, *A Morning on the Seine*.
Oil on canvas; 1897; 34½ × 35¼ in. Mr. and Mrs. Martin A. Ryerson Collection.
© The Art Institute of Chicago. All Rights Reserved.

Figure 9.26 Vincent Van Gogh, *Garden of the Poets*.
Oil on canvas; 1888; 28⅝ × 36¼ in. Mr. and Mrs. Lewis L. Coburn Memorial Collection.
© The Art Institute of Chicago. All Rights Reserved.

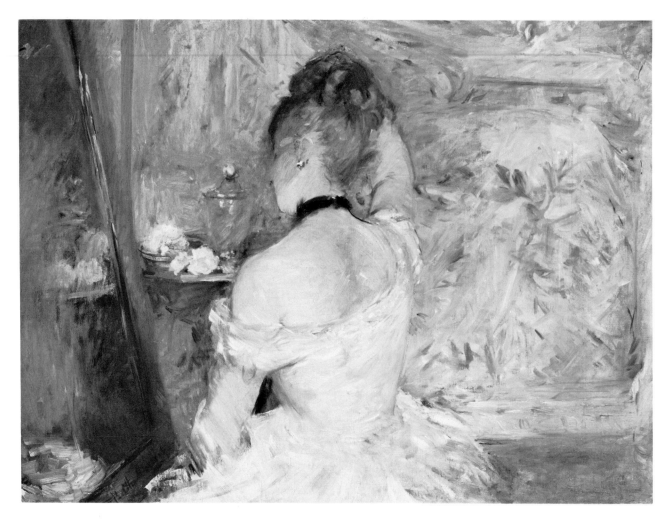

Figure 9.27 Berthe Morisot, *Lady at Her Toilette*.
Oil on canvas; about 1875; 23¾ × 31¾ in. Stickney Fund.
© The Art Institute of Chicago. All Rights Reserved.

2. Berthe Morisot (1841–95) was one of France's leading impressionist painters. *Lady at Her Toilette* (fig. 9.27) represents her style. What features of the painting are most indicative of the impressionist period?
3. Examine the painting by Monet, *The Cliff Walk* (fig. 9.9), determine what large geometric shape was used to develop the composition, and identify its placement.
4. Procure a recording of Claude Debussy's *Reflections in the Water* (*Reflets dans l'eau*) and, as you listen, notice the many ways its style parallels that of Monet's *Waterlilies* (fig. 9.12).

STUDIO EXERCISES

Suggested media and supplies: tracing paper; watercolor; brush; scissors; pencil; pastel or colored chalk.

1. Select two paintings from the Chicago tour and, by using tracing paper over the works, draw the major outlines of the composition of each. Using any watersoluble medium, color the shadows of your tracing with blacks and grays. (With watercolor, the black may be rendered lighter by adding water.) Fill in the shadows of a second tracing with blues, violets, and greens. Observe the vibrancy in the second effort, and note its similarity to the effects achieved by Lautrec in bringing out color in the shadows.

Figure 9.28 Cropping device.

2. There are four steps to the following exercise:
 a. Make a pair of L shapes out of two pieces of heavy paper that will serve as a viewfinder for this exercise (fig. 9.28).
 b. Place the viewfinder over any painting on the Chicago tour and, by moving the L pieces around and making the opening larger and smaller, find a composition that "works" as well as that of the original painting. As we learned in Tour 4, this, in effect, is "finding a painting within a painting."
 c. Lay a piece of tracing paper over the exposed part and trace the compositional lines isolated within the limits of the viewfinder. Remember that the composition may be totally abstract and that objects may be "lost" due to the cropping of recognizable clues. Instead of tracing, you may wish simply to draw what you see in the viewfinder.
 d. Add color and value to your drawings using a palette other than that in the selected work of art.
3. Using colored chalk, create your own version of *Waterlilies* (fig. 9.12) without making any prior pencil drawing.
4. The still-life objects in the Cézanne (colorplate 55) have often been used by artists. Wine bottles, fruit, baskets, drapery, and tables have always been popular choices for subject matter in painting. In this exercise, try using only *one* apple, a bottle, a basket, a piece of cloth, and a table as subject matter for a composition. You may arrange them in any way you desire, and they may change size as you see fit. You do not necessarily need to use the scale shown in the Cézanne, and any medium and size may be used.

RESPONSES TO VIEWING EXERCISES

1. Both paintings are landscapes that feature, for the most part, foliage and sky. Both were treated with divided brushstrokes and both seem to emphasize elements other than pictorial reality. The misty painting is by Monet: *A Morning on the Seine* (fig. 9.25); and the grassy meadow is van Gogh's *Garden of the Poets* (fig. 9.26). Because of the vast difference in detail and outlining, it seems rather obvious that Monet was attempting to portray the way light was breaking through a foggy area near the river. Van Gogh, with a reverence for light, nonetheless painted trees, grass, and flowers as subject matter. Even though both artists often reduced subject matter to mere suggestions, they were careful to not let the subject matter disintegrate.

2. Morisot's subject is turned modestly away from the viewer, and the room's features and contents are generally lost in a blur. The rough brushstrokes cause contours to blend and bring all portions of the canvas together into a single, unified statement. This painting also illustrates Degas's influence on Morisot's style (see fig. 9.14).

3. Monet developed and repeated the shape of a triangle in *The Cliff Walk*. The dark shadows of the cliffs, the pointed promontory where the two figures stand, and the sailboats all are made in the rough shape of a triangle. This subtle design element helps to unify the painting.

4. Debussy's dynamic (loud and soft) proportions are muted, as are Monet's colors. The subject matter of both works is the reflection of light off the surface of water. Both melodic line and graphic line are subdued in favor of the effects of harmony and color. The lack of stark contrasts in the painting may be compared with the lack of driving rhythm in the piano piece; movement in both works is reduced to a shimmer. It cannot be mere coincidence that both Monet and Debussy lived at the same time in the heart of France. The style of art and music they developed is characterized by understatement, lyric line, and glittering facets of light and color.

The Museum of Modern Art

New York, New York

Tour 10

Breaking with Tradition

The Gallery

The Museum of Modern Art is located at 11 West Fifty-third street in New York City. Just over fifty years old, the museum has grown to become the world's most important repository of twentieth-century art. It has grown so rapidly, in fact, that in 1984, a new six-floor wing was added, existing buildings were renovated, and the Garden Wing that faces Fifty-fourth Street was enlarged. These alterations more than doubled the original gallery space.

Most museums hold such a vast number of artworks that it is impossible to display all of them at any one time. The permanent collection at the Museum of Modern Art, for example, is so large that, just prior to the expansion plan, only about 15 percent of the total number of works could be displayed.

This brings up an interesting point. In our time, quality art is being produced by large numbers of artists—more than ever before throughout the entire history of art. Assuming that most of these artworks accumulate (very few are destroyed), they will join an already prodigious number of existing artworks. This poses many problems, one of which is deciding what to do with them. Another is judging which among them are to be called great masterpieces.

The Museum of Modern Art essentially deals with about the last one hundred years of art. Most people place the beginnings of modern art in the 1880s or as early as Manet. However, most of the museum's space serves the art from World War II to the present. MOMA is committed to all the challenges presented by the innovations and fertile imaginations of twentieth-century artists. Unlike the palatial interiors of many larger museums, MOMA's ceilings are lower, the spaces narrower, and small pieces of art appear more intimately at home. Some areas are carpeted for a quieter environment; other areas have wooden floors, lending themselves better to large floor installations. MOMA's art collections go beyond painting and sculpture to include design, photography, prints, illustrated books, drawings, film, and video. The museum is dedicated to providing opportunities for viewing and understanding the art of our time.

Tour Overview

For a variety of reasons, the term *modern art* no longer carries any specific meaning and thus cannot describe a century full of diverse trends and styles, most of which contain the suffix "ism." On this tour, we will encounter examples of fauvism, expressionism, futurism, cubism, and surrealism. Many of these styles overlap, most are influenced by one or many of the others, and we find the individual styles of several artists changing from one "ism" to another. Pablo Picasso, for example, began as a realist, but after working with the postimpressionists, he discovered that cubism was a more effective mode of expression for his evolving style. He subsequently returned to realism, and finally progressed to a style even more abstract than cubism, which encompassed expressionism, surrealism, and, in terms of brush technique, even pointillism.

Picasso typifies twentieth-century artists' search for new avenues of expression. The modern age became one of endless experimentation. While difficult to summarize such diverse and plentiful discoveries, at least one major achievement can be identified: artists became more and more convinced of the power and validity of individual expressiveness. A new brand of freedom accompanied these released feelings and resulted in a shift of emphasis from subject matter to the actual process of creation which became an end in itself. Line, form, and color expressed feelings and made statements rather than merely the means of expressing subject matter.

Igor Stravinsky once said that the activity of composing music was more important to him than the final composition. So it is with visual artists; to some, the *process* of painting is more important than the finished work of art. Indeed, some so-called artworks have been designed to fall apart, disintegrate, or be torn down soon after completion. Consider ice sculpture or the famous *Running Fence* by Christo, which had a predetermined life expectancy of only two weeks (see Tour 11).

Such diversity and radical changes in aesthetic philosophy have led to some confusion for modern gallery visitors. For example, it is very difficult for some to view

> In his own words, Matisse desired "to study each element of construction separately: Drawing, color, values, composition; to explore how these elements could be combined into a synthesis without diminishing the eloquence of any one of them by the presence of the others."

> Instead of establishing a contour, and then filling it with color . . . I draw directly in color.
>
> *Henri Matisse,*
> *explaining his collage technique*

a painting or sculpture with no identifiable subject matter. But for those with open minds and courage to explore its derivations and developments, twentieth-century art holds great potential for artistic enjoyment. In any case, we must be as careful on this tour as we have in past tours never to ask, What is it?, but rather, What is it about? or What is the artist saying to us?

TWO MAJOR TRENDS: FAUVISM AND EXPRESSIONISM

Twentieth-century art was launched in the form of two important stylistic developments: expressionism, which developed in Germany, and fauvism (foh'-vism), centered in France. Both schools of art seemed an outgrowth of such postimpressionists as van Gogh. For the expressionists, van Gogh's emotionally charged content had a special appeal, while his use of heavy paint and vivid colors was adopted by the fauvists.

Van Gogh's most famous painting, *The Starry Night* (colorplate 59), exhibits the kind of tension that caught the attention of the expressionists. The rolling, billowing clouds look more like a storm-tossed sea than a starry night. The left-to-right "waves" are accented by strangely glowing stars and the highly stylized moon. The vertical shapes created by the swirling cyprus trees and the church steeple contrast with the strong horizontal curves in the sky. The fauves were attracted by the colors of *The Starry Night,* which are as unnatural as the lines. Ordinary night scenes do not glow with van Gogh's intense yellows, greens, and blues.

The Fauves' Experiments with Color

The use of blazing color for its expressive power fascinated a group of French painters led by Henri Matisse (1869–1954) and earned them the derogatory nickname *fauves* (fohvs), a French word meaning "wild beasts." In his revolutionary painting *The Red Studio* (colorplate 60), Matisse illustrates his preference for bold, vivid colors. Red permeates the entire canvas, and the large scale of the painting further emphasizes its visual impact. Like Gauguin's *The Day of the God* (colorplate

53), Matisse's painting takes on a flat decorative appearance. There is only a hint of perspective that suggests depth and an interesting division of space in which the contents are not painted as three-dimensional objects. The work depicts a room full of Matisse's paintings actually rendered in their original colors. For all its reference to self-identity, this is more a picture about the color red and the way other colors relate to it within the same composition.

The fauves were, for the most part, not as interested in expressing the emotions of the human imagination as were the expressionists. They seemed content to retain the simplistic subject matter of the postimpressionists and exploit further color possibilities. In reaction to the expressionists, Matisse said:

> To my mind, expression is not a matter of passion mirrored on the human face or revealed by a violent gesture. When I paint a picture, its every detail is expressive. The place occupied by figures or objects, the empty spaces around them, the proportions, everything plays a part.[1]

Of the impressionists he said:

> A rapid rendering of a landscape represents only one moment of its appearance. I . . . prefer to discover its more enduring character and content, even at the risk of sacrificing some of its more pleasing qualities.[2]

In other words, Matisse reduced subject matter to the barest essentials. With a stroke, he could create a face, or a piece of fruit, or the shape of a body. Yet these shapes were not created without thought. "An object must be studied for a long time before one can reproduce its symbol," he said. Besides using basic shapes, he brought his forms to the very front of the picture plane. His *Dance* (*first version*) (fig. 10.1) ignores perspective altogether and attempts no implied depth by making all the nude dancers in the circle the same size. The coloration too is simplistic. Only three basic colors are used: blue, green, and pink flesh tones in broad flat areas. The result is a highly decorative work that emphasizes a circular design with alternating rhythms of solid form and open space. When he was over eighty and no longer able to work at his easel, Matisse began cutting and manipulating colored pieces of paper, creating beautiful collages (see colorplate 13).

1. John Russell, *The World of Matisse* (New York: Time-Life Books, 1969).
2. Ibid.

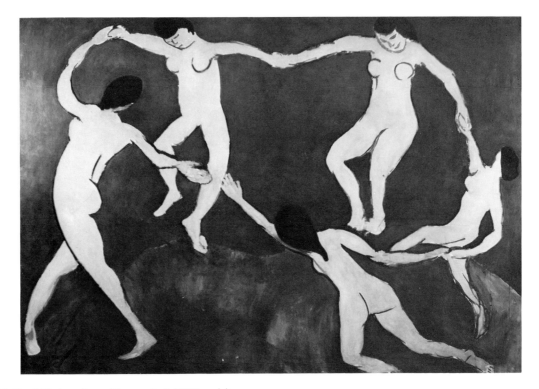

Figure 10.1 Henri Matisse, *Dance (first version)*. (1909, early)
Oil on canvas, 8 ft. 6½ in. × 12 ft 9½ in.
Collection, The Museum of Modern Art, New York. Gift of Nelson A.
Rockefeller in honor of Alfred H. Barr, Jr.

Comparing *Dance* with another of his works provides us with an excellent opportunity to see how Matisse visualized the alternation of form and space. His sculpture *La Serpentine* (lah sehr-pan-teen) (fig. 10.2) uses similar rhythms to those used in *Dance*. Again, detail is sacrificed for a total design effect. We are urged to look as carefully at the spaces *between* the forms as we do the simply rendered arms, torso, legs, and pedestal. In both works we see Matisse's preoccupation with the simplification of the human form. While the model found her likeness ugly, it accomplished what Matisse wanted. Imagine the painting as sculpture and the sculpture as a painting; the spatial relationships are actually quite similar.

Closer than Matisse's *Dance* to the fauves' ideal concept of vivid color is the painting *London Bridge* (colorplate 57) by Matisse's friend and fellow countryman, André Derain (deh-ran') (1880–1954). A sparkling display of colors—reds, greens, blues, and yellows—are used to depict this London landmark. But, unlike Matisse's *Dance,* Derain has invested true Renaissance perspective in his design, which supplies more of the realistic look characteristic of van Gogh. Derain's brush technique is also similar to van Gogh's, particularly the staccato rhythm of wide, rough strokes for the water. Very little attempt at detail has been made; indeed, except for linear perspective, the subject is rather simply drawn.

Figure 10.2 Henri Matisse, *La Serpentine*. (1909)
Bronze, 22¼ in. high, at base 11 × 7½ in.
Collection, The Museum of Modern Art, New York. Gift of Abby Aldrich
Rockefeller.

As was the case with Matisse, detail is less important to Derain than pure color: in his own words, Derain's guiding principle was "color for color's sake." However, we can also see in this painting that Derain was looking beyond the powerful effects of color alone toward the role that color plays in modeling and investing a shape with form and substance.

Figure 10.3 Kaethe Kollwitz, *Death Seizing a Woman.* (1934) Plate IV from the series; *Death.* (1934–36)
Lithograph printed in black. Composition: 20 × 14 7/16 in.
Collection, The Museum of Modern Art, New York. Purchase Fund.

Figure 10.4 Ernst Ludwig Kirchner, *Street, Berlin.* (1913)
Oil on canvas, 47½ × 35⅞ in.
Collection, The Museum of Modern Art, New York. Purchase.

The German Expressionists

Despite the unsavory connotation of their name, the fauves were interested in subject matter that was relatively peaceful and impersonal. The expressionists, on the other hand, used as their subject the imagination. At a time and in a place that nurtured the theories of Sigmund Freud, particularly the symbolism of dreams and the powerful effect of unconscious processes on conscious behavior, the expressionists often concentrated on the human personality and psychic anguish: the dark, brutal, ugly and distorted aspects of life.

Edvard Munch's (moonk) (1863–1944) depiction of the inability of people to cope with their environment is the subject of one of his famous series of paintings and lithographs titled *The Scream* (see fig. 1.60). Although he was Norwegian, Munch became the inspiration for the development of the German school, where exaggeration and distortion expressed the depravity and hopelessness of the human condition. If we realize this is a picture, not of a person or of a specific place, but of a *scream,* and of the conditions that instigated it, we come close to understanding Munch's message. The spirit of expressionism is also felt in Kaethe Kollwitz's (keh'-teh kohl'-vitz) (1867–1945) haunting lithograph *Death Seizing a Woman* (fig. 10.3). Like Munch's *The Scream,*

I was walking along a road. The sun set. I felt a tinge of melancholy. Suddenly the sky became a bloody red. I stopped and leaned against the railing, dead tired, and I looked at the flaming clouds that hung like blood and a sword over the blue-black fjord and the city. I stood there, trembling with fright. And I felt a loud, unending scream piercing nature.

Edvard Munch,
describing his experience preceding his work The Scream

Kollwitz's picture of life's pain and suffering is expressed in nightmarish proportions. As a feminist and a socialist, Kollwitz concerned herself with poverty and injustice wherever she found it. As did Munch, she lived through two world wars and spoke for the grieved souls that war leaves in its wake. Both artists were denounced by Hitler as "degenerate."

Munch's distorted perspectives are much like those seen in Ernst Ludwig Kirchner's (kersh'-ner) (1880–1938) *Street, Berlin* (fig. 10.4), a more typical example of expressionism. Here he has abandoned the fauves' use of color in favor of darker tones, even black. Sharp, angular lines provide his human characters with a sinister look. His masterful use of line is seen throughout the

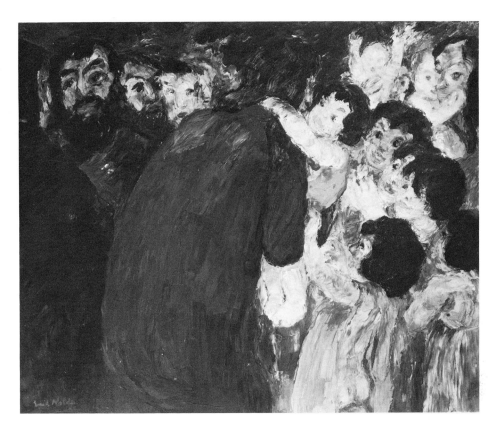

Figure 10.5 Emil Nolde, *Christ among the Children.* (1910)
Oil on canvas, 34⅛ × 41⅞ in.
Collection, The Museum of Modern Art, New York. Gift of Dr. W. R.
Valentiner.

composition. Notice how swift brushstrokes can instan-
taneously suggest so much: the sideburns on the male
figure, the suggestion of trousers and shoes, and the
makeup and hairdo on the face of the central female.
The isolation of the individual in society is still the theme,
but where we saw it before as a pathetic societal plight,
Kirchner now portrays it as an evil. Such is the power
of line as an expressive element. Recall his *Nude Woman
in Tub* (see fig. 1.35) where distorted, angular lines por-
trayed woman as something repugnantly ugly.

Bridge to the Future
Kirchner is given credit for organizing in the early 1900s
the small band of German painters and sculptors known
as *Die Brücke* (dee broek'-eh) (The Bridge). They saw
themselves as a connecting link between nineteenth-cen-
tury art and whatever was to come in the new age; a link,
perhaps, between emotion and nature. They admired
primitive art, used color rather arbitrarily, and applied
aggressive brushstrokes for expressive distortion.

Some of the most outstanding examples of the
brooding passion of expressionism were created by Emile
Nolde (ay-meel' nohl'-deh) (1867–1956). In Tour 1, we
saw Nolde's woodcut, *The Prophet* (see fig. 1.61). Typ-
ically expressionistic are the angular linear quality of

bold contours, the stark simplicity of statement, and the
heavy contrast of black against white caused by the
sharply incised edges cut into the wood block. We should
also take note of the moody expression made poignant
by the downward turn of the eyes and mouth. All the
cares of the world seem to stare out at us through sad,
hypnotic eyes. The raw power of the emotion repre-
sented here is produced by broad black lines set against
large white areas.

Nolde believed in the spontaneity of painting rapidly,
but for different reasons than those of the impressionists.
Some of his oil paintings were heavily laden with im-
pasto in order to portray an emotional quality. His *Christ
among the Children* (fig. 10.5) not only conveys the mo-
tion and excitement of the crowd, but also the emotional
difference between the glum disciples on the left and the
unrestrained gaiety of the children. These emotions are
underscored by Nolde's skillful use of vivid colors. The
disciples are cloaked in dark hues while the children are
brightly clothed in glowing reds. Even the skin tones are
distinctly different to reflect this contrast of mood. But
with all the attention given to the figures on either side
of the composition, the large figure of Christ looms in
the center of the composition in approximately equal

Figure 10.6 Georges Rouault, *Christ Mocked by Soldiers.* (1932)
Oil on canvas, 36¼ × 28½ in.
Collection, The Museum of Modern Art, New York. Given anonymously.

Figure 10.7 Paula Modersohn-Becker, *Self-Portrait on Her Fifth Wedding Anniversary.* (1906)
Oil on canvas.
Private Collection. Courtesy Galerie St. Etienne, New York.

proportion to the other two areas. Part of Nolde's skill as an artist rests in his ability to control all these basic features of the design while finishing the work with quick, bold brushstrokes.

Georges Rouault (roo-oh') (1871–1958) was a French artist who, as a youth, worked as an apprentice to a stained-glass maker, and it is quite likely that this experience influenced the development of his mature painting style. His *Christ mocked by Soldiers* (fig. 10.6) is characterized by segmentation of forms and heavy black outlining resembling stained-glass leading. Nolde's intense religious themes were shared by Rouault, who enhanced the emotional power of this particular painting by Christ's bent figure and closed eyes. Rouault's use of bold intensities—midnight blues, vibrant greens, and reds as they glow when set against black—reveals his affinity to the fauves.

Other features of Nolde's technique are also present in Rouault's work. Heavy impasto applied with dry brush allows the layers of paint to show through for a heavy textured look. The features of the background figures are masklike contrasting with the somewhat more lifelike face of Christ.

Other painters, working in isolation from the fauves but with other expressionist groups, came to expressionism by various and often original routes. Paula

Modersohn-Becker 1876–1907, a Northern German artist who was familiar with Cézanne and Gauguin as well as other postimpressionists, made on her own a transition to a style reminiscent of the women Picasso later painted. Modersohn-Becker's forward-looking, expressionistic subject matter included pregnant women, old peasants, and poverty. Her *Self-Portrait on Her Fifth Wedding Anniversary* (fig. 10.7) with its great, gentle eyes, was painted just one year before her untimely death. Her portrait stares directly at the viewer as if to express her own bold individuality. Her style of painting can also be likened to Picasso's *Les Demoiselles d'Avignon* (see fig. 10.11) and to his *Head of a Woman* (see fig. 10.12).

The Blue Riders
Another group of expressionist artists, who followed close on the heels of The Bridge, named their first exhibition *Der Blaue Reiter* (dehr blah-eh reye'-ter) (The Blue Rider) after a painting of the same name by the Russian exile, Vasily Kandinsky (vah-see-lee kahn-din'-skee) (1866–1944). The influence of the fauves is clear in

The impact of an acute triangle on a circle produces an effect no less powerful than the meeting of the fingers of God and Adam in Michelangelo's *Creation*.

Vasily Kandinsky

Kandinsky's vivid canvases; recall his *Blue Mountain* in Tour 3 (colorplate 17). With no attempt at realistic depiction of familiar forms, Kandinsky presents a pattern of intensely colored forms. He believed that such elemental statements alone could elicit feelings in the viewer.

Kandinsky's style progressed further and further away from representational art. In his later paintings, he abandoned recognizable subject matter altogether. He painted a series of four panels identified simply by number; since they are pictures of nothing in particular, we can call them "mood" pieces. Kandinsky painted them as he felt at the moment, and we are expected to view them in the same way (see *Painting no. 198,* colorplate 56). This picture should inspire us to ask, How does it make me feel? rather than, What is it supposed to represent? This is the expressionistic dimension of the work, and it was this degree of abstraction that paved the way for one of the most significant developments in the twentieth century: abstract expressionism, which was to take shape in the 1940s (see Tour 11).

Franz Marc (mark) (1880–1916) was the other leading painter in the Blue Rider group and was actually the one who organized the first *Blaue Reiter* exhibition. Marc specialized in animal anatomy; most of his paintings contain animals as basic subject matter. However, it was the unique relationship between line and color that distinguished Marc's work. Evidence of Marc's blend of graceful curves with vivid, unnatural color was seen in *Yellow Cow* (colorplate 15) in Tour 3. The color yellow held a special meaning for Marc, as was the case with Kandinsky and van Gogh. For one thing, yellow advances boldly toward the viewer, and the graceful curves of the cow's contour seem to enhance that sense of forward thrust. Other linear elements of the cow are echoed in the trees and distant hills.

Armed with the theory that color was symbolic, Marc produced a large body of animal paintings in vivid colors. His *Animals in a Landscape* (see fig. 2.24) reflects his belief that animals possess an affinity with the physical world. The bold, unrealistic colors of both animals and landscape are fused in a harmonic unity. The linear quality of the cows sweeps dramatically throughout the angular forest. Marc also had a special affection for horses, and produced many paintings similar to this in which they are depicted as elegant convex forms in deep lustrous blues.

Figure 10.8 Umberto Boccioni, *Unique Forms of Continuity in Space.* (1913)
Bronze (cast 1931), 43⅞ × 34⅞ × 15¾ in.
Collection, The Museum of Modern Art, New York. Acquired through the Lillie P. Bliss Bequest.

THE FUTURISTS

At about the same time that the artists of the Blue Rider group were first exhibiting, a significant, if short-lived, movement was developing in Italy. The new group dubbed themselves the "futurists" because they believed that art should be forward-looking, ignore the traditions and conventions of the past, and search for a new dynamism that would truly express the tenor of modern technological society. The futurists are associated with the expressionists because their works possess an extraordinary degree of emotional power. Fortunately, no one took seriously their proclaimed edict to *burn down all the museums* in order to destroy the art of the past and so create a new art from the inspiration of the machine age. To the futurists, the great museums were like cemeteries where motionless, dead works sleep forever.

A bronze sculpture by Umberto Boccioni (oom-behr′-toh boh-chee-oh′-nee) (1882–1916) expresses the restless energy of a person in perpetual motion. The title alone, *Unique Forms of Continuity in Space* (fig. 10.8), suggests motion. The success of Boccioni's work is found

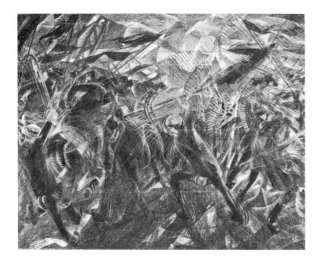

Figure 10.9 Carlo Carra, *Funeral of the Anarchist Galli.* (1911)
Oil on canvas, 6 ft. 6¼ in. × 8 ft. 6 in.
Collection, The Museum of Modern Art, New York. Acquired through the
Lillie P. Bliss Bequest.

Filippo Tommaso Marinetti, who called himself "the
caffeine of Europe" and coined the term "Futurism"
wrote in 1909: We intend to sing the love of danger, the
habit of energy and fearlessness. Courage, audacity, and
revolt will be the essential ingredients of our poetry. We
affirm that the world's magnificence has been enriched by
a new beauty; the beauty of speed . . .

in the blend of mechanical curves with the rapidly moving
human form. The piece looks as though it moves right
before our eyes, yet we can glance down at the solid
bricklike shapes at the base and be assured that no real
movement is taking place. The trick is in the broken con-
tours and the shifting planes that simulate the natural
blurring effect of real movement. Multiple-image pho-
tography creates similar effects, as does photographing
fast-moving objects. This high point of perfection was
reached only after Buccioni's long and careful study of
motion and the mechanics of rendering it on a two-
dimensional surface.

Italian painter Carlo Carra (cah'-rah) (1881–1966)
achieves motion in his *Funeral of the Anarchist Galli*
(fig. 10.9) using striations to create parallel lines that
seem to cause contours to vibrate. Lines are mainly di-
agonal, and color areas are broken into pieces—both
these techniques contribute to the violent activity of the
scene. Carra thus achieves his goal to involve the viewer
in a sense of action rather than to concentrate on the
figures or forms. The subject here, as in the Boccioni, is
violent motion.

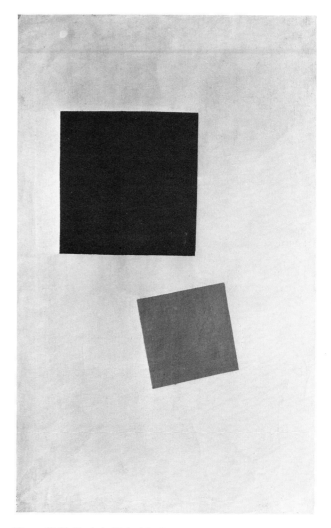

Figure 10.10 Kasimir Malevich, *Suprematist Composition: Red
Square and Black Square.* (1914 or 1915?)
Oil on canvas, 28 × 17½ in.
Collection, The Museum of Modern Art, New York.

When you see a fish . . . you think of its speed . . . its
floating . . . I just want the flash of its spirit.

Constantin Brancusi

A Russian painter who aligned himself with the fu-
turists was Kasimir Malevich (kas'-eh-meer mah-lay'-
vich) (1878–1935). His painting *Suprematist Compo-
sition: Red Square and Black Square* (fig. 10.10) is one
of a series of nonrepresentational paintings whose titles
begin with "Suprematist Composition." To Malevich, the
supreme work of art represented pure feeling, and to ac-
complish this goal, any reference to the real world must

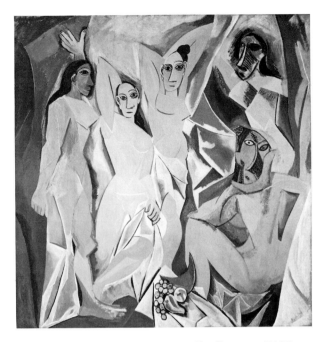

Figure 10.11 Pablo Picasso, *Les Demoiselles d'Avignon.* (1907) Oil on canvas, 8 ft. × 7 ft. 8 in. Collection, The Museum of Modern Art, New York. Acquired through the Lillie P. Bliss Bequest.

There is no such thing as abstract art. You must always start with something.

Pablo Picasso

not stand in the way. Another of his works in the Museum of Modern Art is *Suprematist Composition: White on White,* in which a square of white is superimposed at a slight angle over another square of white. One is distinguished from the other only by a slight change of value and faint contours.

The sudden leap from representational to nonobjective art thus set the stage for bold experimentation that was free of the traditions of the past. To that extent, the futurists' creed was realized; but as World War I came to an end, the movement collapsed, as everyone, including artists, looked for more peaceful means of expression. However, the futurists' predilection for motion has remained alive in one form or another to this very day.

A sculptor, influenced by Rodin and inspired by the futurists, but one who defied any association with them, was the Rumanian Constantin Brancusi (brahn-koo'-zee) (1876–1957). In fact, Brancusi was so individualistic that

No painting ever looked more convulsive. None signalled a faster change in the history of art. Yet it was anchored in tradition, and its attack on the eye would never have been so startling if its format had not been that of the classical nude; the three figures at the left are a distant but unmistakable echo of that favorite image of the late Renaissance, The Three Graces.

Robert Hughes,
on Picasso's Les Demoiselles d'Avignon

he defies classification. As we saw with his *Bird in Space* in Tour 1 (see fig. 1.24), motion, especially as it relates to flight, fascinated him. And to express motion, Brancusi gradually reduced his forms to pure essences. He found those pure essences in uncomplicated shapes: an egg, a fish, a blade of grass.

THE DEVELOPMENT OF CUBISM

Originally inspired by Cézanne, creating the illusion of three-dimensional space by using color planes and volumes was adopted by a group of painters and sculptors led by Pablo Picasso (1881–1973) and Georges Braque (brahk) (1882–1963). Cubism embraces the theory that all natural forms are reducible to simple geometric shapes. At least part of the theory involved the presentation of forms that could somehow be viewed simultaneously from several different perspectives. Such geometric abstractions led a critic to refer to the style as "cubist," and the name stuck.

Picasso is credited with initiating the cubist style with his trend-setting work *Les Demoiselles d'Avignon* (lay duh-mwah-zel' dah-veen-yohn') (fig. 10.11). Picasso began painting this in 1906, the year Cézanne died. *Les Demoiselles* shows his interest in both Cézanne's planes and African sculpture. The two women on the right side seem to be wearing tribal masks, one of which shows both frontal and profile views. The woman on the left is shown in profile, yet her eye, in the ancient Egyptian style, is painted from a frontal view. Throughout the composition, Picasso segmented the forms into geometrically conceived shapes that are strongly linear and sharply angular. Even the curves are formed into sharply pointed swords. The abstraction of human forms creates a relatively flat surface, save for the thrusting forward of the pink nudes set against the darker, blue, negative spaces. The disturbing faces are perhaps the most striking feature of this powerful work.

The cubist treatment of interactive planes resembling geometric forms appeared in sculpture as well. Picasso's *Head of a Woman (Fernande)* (fig. 10.12) was constructed with flat areas that reflect the light in different ways as the sculpture is viewed from various angles. The character of the visage is thus altered significantly from one viewpoint to another. The piece, by virtue of its angular facets, urges the viewer to move around it and observe these changes. Here again, one might imagine that the head had been made of smaller pieces and later assembled in this unusual angular way.

Picasso combined his own cubist style with the grim subjective realities of expressionism to produce his most powerful masterpiece, *Guernica* (gwayr-nee'-kah) (fig. 10.13), which is now located in Spain. Intended to protest the senseless bombing of the small town of Guernica during the Spanish Civil War, Picasso chose the stark, chilling effects of black, white, and shades of gray for his palette. The distortion of men, women, children, and animals reflects the agony and total devastation of saturation bombing. According to the artist, the newspaper horse represents the tormented Spanish people; the bull, darkness and brutality. The light bulb and lamp at the top of the mural are symbolic, perhaps of hope or truth, both of which are dimmed by the horrors of war. The impact of this large work is unyielding. Its scale and lack of spectrum colors are riveting, and every face is contorted with excruciating pain. But, notice the one lone flower, lower center, springing from the broken sword.

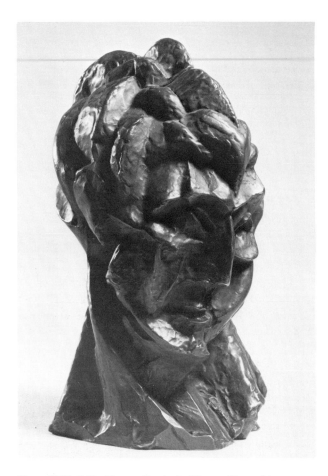

Figure 10.12 Pablo Picasso, *Head of a Woman (Fernande)*. (1909, fall)
Bronze, H. 16¼ in.
Collection, The Museum of Modern Art, New York. Purchase.

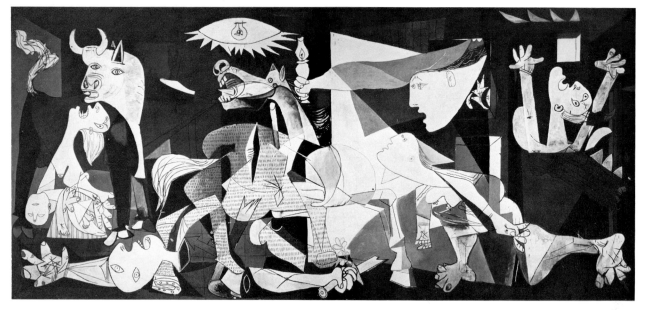

Figure 10.13 Pablo Picasso, *Guernica,* mural (1937)
Oil on canvas, approx., 11 ft. 6 in. × 25 ft. 8 in.
© S.P.A.D.E.M., Paris/V.A.G.A., NY, 1985.

The angular segmenting of shapes and figures to form planes reflects the cubist style. Interestingly, the high degree of abstraction does not seem to soften the impact of our identification with the real-life agony of the distorted figures.

Analytic and Synthetic Cubism

Cubism appeared in two phases. The first, called "analytical," is characterized by a very limited palette and a restructuring of real objects, which are fragmented and transformed into interactive planes producing simultaneous viewpoints. These planes are usually arranged in alternating patterns of light and dark values. Analytical cubism is typified in Braque's *Man with a Guitar* (fig. 10.14), in which pieces of a man's figure and a guitar appear to have been reassembled to form a new kind of artistic reality.

Another work, this one by the Lithuanian sculptor Jacques Lipchitz (zhahk lip-chits) (1891–1973), bears not only the same title as the Braque painting, but also

If a piece of newspaper can become a bottle, that gives us something to think about in connection with both newspapers and bottles. . . . This strangeness was what we wanted to make people think about because we were quite aware that our world was becoming very strange and not exactly reassuring.

Pablo Picasso

the same division of planes. In Lipchitz's *Man with a Guitar* (fig. 10.15), the extreme vertical posture of the man is counterbalanced by small diagonals and curves. It is obvious that a sculpture such as this loses some of its visual impact when viewed from only the one photographed angle.

The second phase of cubism was called "synthetic" because the works *began* as fragments or unrelated pieces and were then assembled to represent something altogether different from the original. Juan Gris (wahn gree) (1887–1927) is largely responsible for this development,

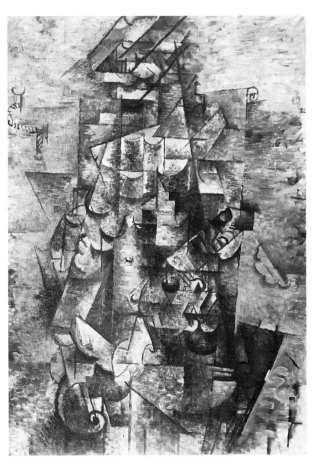

Figure 10.14 Georges Braque, *Man with a Guitar.* (1911)
Oil on canvas, 45¾ × 31⅞ in.
Collection, The Museum of Modern Art, New York. Acquired through the Lillie P. Bliss Bequest.

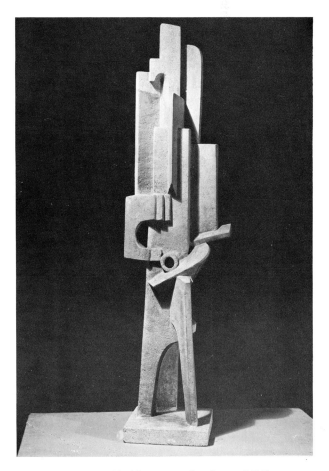

Figure 10.15 Jacques Lipchitz, *Man with a Guitar.* (1915)
Limestone, 38¼ in. high, at base 7¾ × 7¾ in.
Collection, The Museum of Modern Art, New York. Mrs. Simon Guggenheim Fund.

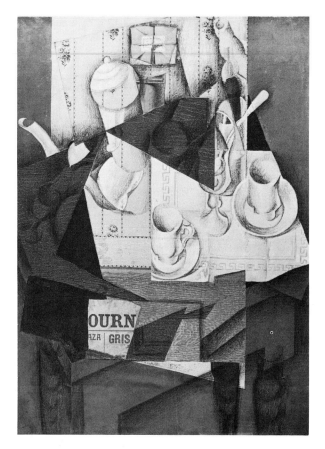

Figure 10.16 Juan Gris, *Breakfast.* (1914)
Pasted paper, crayon, and oil on canvas, 31⅞ × 23½ in.
Collection, The Museum of Modern Art, New York. Acquired through the
Lillie P. Bliss Bequest.

Figure 10.17 Kurt Schwitters, *Picture with Light Center.* (1919)
Collage of paper with oil on cardboard, 33¼ × 25⅞ in.
Collection, The Museum of Modern Art, New York. Purchase.

When asked "What is art?" Schwitters responded:
"What isn't?"

which is best represented in his collages. Gris's *Break-fast* (fig. 10.16) is a composition of common materials—pasted paper, crayon, and oil on canvas. Although collages may suggest depth, depending on the manner in which space and flat shapes are treated, Gris's table tilts up in the same distorted fashion as that in Cézanne's *Basket of Apples* (colorplate 55).

Like Cézanne, Gris was concerned more about the relationships of solids and voids and design factors than he was about realism. One of these new relationships is the transparency of forms. It seems as though we are able to see through the table and the objects resting on top of it, creating a new kind of depth, not of distance but of three-dimensionality. This new and unique method of treating space helped to stimulate a universal fascination for collages. It was as if the shapes had been given an identity in and of themselves.

German artist Kurt Schwitters (shwit'-ters) (1887–1948) was a most skillful cubist-inspired artist. His remarkable collage of paper with oil on cardboard, *Picture*

with Light Center (fig. 10.17), proves how a successful art product can result from found objects such as bits of paper, ticket stubs, cigarette wrappers, and the like. Schwitters assembled a pleasing balance of curved contours mixed with diagonal straight lines. Not a single horizontal or vertical line can be found in the web of intersecting linear contours.

Other Cubist Forms of Painting and Sculpture

Influenced by both cubism and the futurists' fascination for machines, Fernand Léger (fer-nan' leh-zhay') (1881–1955), a Frenchman, created many canvases inhabited by large mechanical people. In his oil painting *Three Women* (fig. 10.18) the hard contours and mechanical modeling of the three figures make them look more like machines at rest than nude women. Even

Figure 10.18 Fernand Léger, *Three Women.* (1921)
Oil on canvas, 6 ft. ¼ in. × 8 ft. 3 in.
Collection, The Museum of Modern Art, New York. Mrs. Simon Guggenheim Fund.

though parts of the figures' bodies appear to have been removed and then casually placed back near the spot from which they came, there is a clockwork precision, a smooth, static contentment at work here. This feeling is probably caused by a predominance of vertical and horizontal lines and enhanced by the figures' lifeless stares aimed directly at the viewer. The perspective envisioned by Renaissance artists is gone. Tables tilt unrealistically and distorted objects in the room are merely pieces in a large decorative design.

We have discussed at some length and in varying contexts the artist's use of distortion, exaggeration, and omission in artworks to emphasize certain features over others. An example of such artistic license can be seen in a small cubist sculpture by the Russian-born Parisian Alexander Archipenko (ark-i-pen'-koh) (1887–1964) titled *Woman Combing Her Hair* (fig. 10.19). Standing in the classical contrapposto position, the figure has no head or left arm. Archipenko did not need the arm for his expression of a graceful form, just as *Venus de Milo* fares quite well without either of hers. The head, however, is another story; it appears as a shaped, empty space by virtue of the position of the right arm. Here is a highly visible example of the function of empty space or omission. Notice how that space interacts with the other enclosed space between the figure's lower legs.

The relationship between curved contours and flat areas reveals the cubist style. Comparing this sculpture with *Les Demoiselles d'Avignon* (see fig. 10.11), we can imagine that Archipenko's *Woman* had stepped out of Picasso's painting. The interactive planes—the main substance of cubism—are common to both works.

Figure 10.19 Alexander Archipenko, *Woman Combing Her Hair.* (1915)
Bronze, H. 13¾ in.
Collection, The Museum of Modern Art, New York. Acquired through the Lillie P. Bliss Bequest.

Figure 10.20 Marcel Duchamp, *The Passage from Virgin to Bride.*
(Munich, 1912 July–August)
Oil on canvas, 23⅜ × 21¼ in.
Collection, The Museum of Modern Art, New York. Purchase.

Dada means "to get away from *cliches*—to get free."

Marcel Duchamp

A twentieth-century artist who combined the ideas of cubism and futurism with the amazing effects of multiple-image photography was Marcel Duchamp (mahr-sel doo-shawn') (1887–1968). The purpose of *The Passage from Virgin to Bride* (fig. 10.20) is to portray a person in transition. The result is a series of images composed of many small planes, lines, and compatible colors. The arrangement of diagonal lines creates a movement from left to right, the direction suggested by what may be interpreted as bent legs in the lower half of the picture. The painting portrays abstract figures reduced to simple essences. They are flat, segmented areas of color connected by the linear depiction of motion.

THE DADA MOVEMENT

A new art movement started in a Swiss cabaret during World War I. The place was Zurich and the man credited with the genesis of the **dada** movement was a poet by the name of Hugo Ball. As producer of his new "cabaret," he featured poetry readings, music, and art exhibitions in a saloon. It was an immediate success because the time was ripe for protest against an insane society that had perpetrated yet another brutal war.

The protest took the form of ridicule. If society was insane, what better way to parody it than to produce insane art? One of Duchamp's "artworks" was nothing more than a urinal turned upside down and labeled *Fountain.* In this unusual position and with another name, we might not immediately recognize the object.

Figure 10.21 Marcel Duchamp, *To Be Looked At (From the Other Side of the Glass) with One Eye, Close To, for Almost an Hour.* (Buenos Aires, 1918)
Oil paint, silver leaf, lead wire, and magnifying lens on glass (cracked), 19½ × 15⅝ in., mounted between two panes of glass in a standing metal frame, 20⅛ × 16¼ × 1½ in., on painted wood base 1⅞ × 17⅞ × 4½ in.; overall height 22 in.
Collection, The Museum of Modern Art, New York. Katherine S. Dreier Bequest.

Figure 10.22 Jean Arp, *Collage Arranged According to the Laws of Chance.* (1916–17)
Torn and pasted papers, 19⅛ × 13⅝ in.
Collection, The Museum of Modern Art, New York. Purchase.

Was Duchamp telling us to see the artistic quality in an ordinary object, or was he making fun of art or of art connoisseurs? It seems clear that dadaists were saying to the world: Pause for a moment and look at this object the way an artist looks at it. The art of dada, a nonsense word, became "nonart" and was meant to break down traditionally held assumptions about art and, at the same time, about morality. It was an attempt to startle an indulgent people into taking a new look at themselves and, in particular, at the world of art. It was as though artists suddenly burst out of the bonds of tradition and were enjoying a total, unrestrained freedom of expression.

One of the best examples of the early manifestations of dada is Duchamp's work strangely titled *To Be Looked At (From the Other Side of the Glass) with One Eye, Close To, for Almost an Hour* (fig. 10.21). Duchamp's assemblage of oil paint, silver leaf, lead wire, and lens on cracked glass appears to be without sense or meaning.

The title sounds more like a way of viewing the work than a description of content. The artist seems to be asking us to take a look at how absurd we are. The dadaists, however, were not saying that their work was nonsense; they were more likely to declare their art was without sense, which carries greater implications.

The careful construction of *To Be Looked At* is contrasted with the accidental pattern of broken glass that seems to fall into perfect balance with the more precise elements of design. This experiment in glass and wire represents at least two techniques that captivated the attention of dada artists: **chance** and **ready-mades.**

Chance, or the random ordering of elements in a work of art, allowed for even greater freedom of expression because it took the practice of art beyond the manipulative control of the artist. German-born Jean Arp (zhahn ahrp) (1887–1966) allowed the pieces in his *Collage Arranged According to the Laws of Chance* (fig. 10.22) to fall into place at random. However, since it is unlikely that all these torn bits of paper fell in such a near-perfect vertical arrangement, Arp no doubt moved them around slightly until the result was satisfying.

Figure 10.23 Man Ray, *Indestructible Object (or Object to Be Destroyed)*. (1964)
Replica of 1923 original Metronome with cutout photograph of eye on pendulum, 8⅞ × 4⅜ × 4⅝ in.
Collection, The Museum of Modern Art, New York. James Thrall Soby Fund.

Figure 10.24 Marcel Duchamp, *Bicycle Wheel*. (New York 1951. Third version, after lost original of 1913)
Assemblage: metal, wheel, 25½ in. diameter, mounted on painted wood stool, 23¾ in. high; overall, 50½ in. high.
The Sidney and Harriet Janis Collection. Gift to the Museum of Modern Art, New York.

All chance art contains an element of control even if that control is limited to the artist's final determination that an artwork is finished. The same is true of chance music. In a piece by John Cage titled *Imaginary Landscape no. 4,* twelve radios are simultaneously turned on for a designated time span. Whatever happened by chance to be picked up by the twelve different radios at the moment of performance became the "musical" content.

Ready-mades consist of preexisting objects that artists reassemble or redefine so that they assume a new function and meaning. This reinterpretation of real, recognizable objects is an important aspect of the appreciation of modern art. Dadaists who dabbled in ready-mades challenge our sensibilities to reinterpret a familiar world. Man Ray (1890–1976) attached the cut-out photograph of a human eye to the pendulum of a metronome and named it *Indestructible Object (or Object to Be Destroyed)* (fig. 10.23). Duchamp, who once hung a snow shovel and named it *In Advance of a Broken Arm,* assembled a bicycle wheel to the top of a wooden stool and called it simply *Bicycle Wheel* (fig. 10.24). The original objects became part of new, composite objects whose meaning shifted from the workaday world to the realm of art. Part of the fascination of these works lies

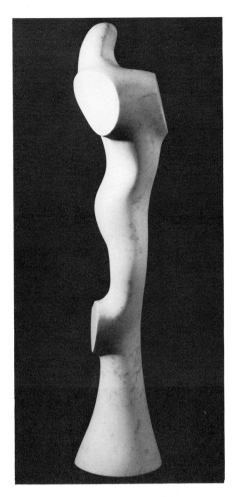

Figure 10.25 Jean Arp, *Floral Nude.* (1957)
Marble, 47¼ in. high, 10½ in. diameter at base.
Collection, The Museum of Modern Art, New York. Mrs. Simon Guggenheim Fund.

in the knitting together of completely unrelated elements and the resulting contrast of both formal and functional qualities.

As strange as the titles ascribed to their works may first appear, dada artists often meant for them to play an important role in the interpretation of their works. Without the title *Floral Nude* (fig. 10.25), Arp's sculpture would be more difficult to understand. Given the title, we at once realize that we are looking at a **biomorphic** form, a form resembling parts of human bodies, but the reference to flora is not clear. Its most obvious characteristics are softly undulating curves and the smooth texture of marble. Other significant features include the contrast of flat surfaces with rounded contours, the basic unity of design elements, and the polite nod to *Venus de Milo.* The graceful contour of *Floral Nude* is typical of Arp who was especially fond of smooth, rounded forms.

The mind which plunges into Surrealism relives with burning excitement the best part of childhood . . . where everything conspires to bring about the effective, risk-free possession of oneself.

Andre Breton,
a leader of the Surrealistic movement

SURREALISM

Dada was doomed to a short life. As nihilists, the artists were opposed to their own existence along with that of all other institutions and traditions. But on the heels of dada's demise during the early 1920s came **surrealism,** a name derived from the French word *surrealisme,* meaning beyond reality. Coined during World War I, the word was generally adopted in the 1920s to describe art that was strange and fantastic. Its subject matter is based on artists' conceptions of the world of dreams where realistic objects appear in bizarre situations.

In a sense, surrealism took its lead from dada and became a protest against rationality and logical thought. Influenced by Sigmund Freud's (froyd) theory of psychoanalysis that utilized free association and dream interpretation, the surrealists turned to the unconscious world of dreams for their mode of artistic communication. The result was often deliberately absurd; at other times, strangely disquieting, as dreams can sometimes be. The idea actually freed the artist's imagination beyond anything envisioned in the past. The viewers' fascination with surrealistic art is the seemingly endless range of possibilities for subject matter. No longer limited to landscapes, portraiture, or even Greek divinities and biblical subject matter, the new group was now free to delve deep into the human psyche and express concepts never before imagined.

By its very nature, the content of surrealism is often obscure. Without highly descriptive titles and occasional program notes left by the artist, viewers are often puzzled by images that could well have come from the wild thoughts of an insane person. On the other hand, some viewers will be relieved to learn that recognizable subject matter, albeit somewhat weird in appearance, has returned. Depth and perspective, sometimes seeming to reach into infinity, is more pronounced than in cubism or futurism. The modeling effects of chiaroscuro were also revived by the surrealists to such an extent that some of their human figures look super realistic. However, the style is seen in both representational and abstract art as well. We should remind you of the distinction between *nonrepresentational* art, with no recognizable subject matter, and *abstract* art, with recognizable but distorted subject matter.

Credited with inspiring surrealism, long before the style had been organized or given its catchy name, was the Greek-born artist Georgio De Chirico (jor'-joh duh kee'-ree-koh) (1888–1978). His style is seen at its best in paintings like *The Delights of the Poet* (fig. 10.26). He chose the word *metaphysical* to describe his strange, dreamlike images. Many of De Chirico's favorite devices are present in this haunting picture: a broad landscape with bright side light and sharply defined shadows; gloomy colonnades with rapidly diminishing perspective to accentuate depth; symbols like the fountain, the lone figure, the clock, and, a recurring favorite, the puffing train in the distance. Even though we cannot see the horizon, we sense a feeling of far distance with gradually lighter values at the horizon. The openness and the sense of enclosed space in the major portion of the composition is achieved by high contrast of the large open courtyard surrounded by dark shadows. The artist quickly draws our attention by sharp linear angles, up to the wandering lone figure on the right and then to the train.

De Chirico filled many of his compositions with a disturbing quality of foreboding mystery, as if something untoward were about to happen to the inhabitants of his dreamworld. It's always late afternoon and the shadows telegraph a message of impending doom.

A number of selected works at the Museum of Modern Art illustrate the diversity of bizarre subject matter that sprang from the imaginative minds of the surrealists. In Spain, Joan Miró (zhahn mee-roh') (1893–1983), like so many other surrealists, startled his viewers with a blend of pure fantasy and just enough reference to the real world to create visual shock. Such is the case with his *Person Throwing a Stone at a Bird* (fig. 10.27) in which a one-eyed, one-legged, armless creature in ghostly white shares a nightmarish landscape with a sticklike bird. These simplified forms, in a world where color dominates the objects, were Miró's reality. This painting is an expression of the mystery of people and their relationships with an enigmatic universe.

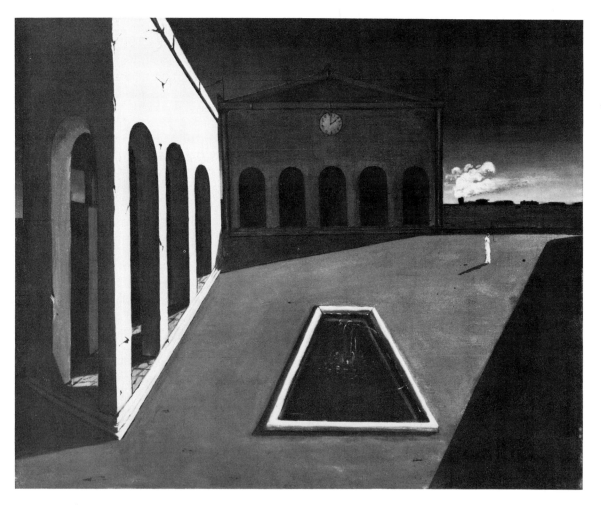

Figure 10.26 Georgio De Chirico, *The Delights of the Poet.* (1913)
Oil, 27⅜ × 34 in.
Collection of Mr. and Mrs. Leonard C. Yaseen.

Empty space, empty horizons, empty plains, everything that is stripped has always impressed me.

Joan Miró

Belgian artist René Magritte (reh-nay mah-greet') (1898–1967) was more likely to paint simple, highly realistic images that startle viewers because of their impossible contexts. His painting *The False Mirror* (fig. 10.28) is an exact, magnified rendering of a human eye with an enlarged iris that consists of blue sky and fluffy clouds. The human eye itself is a captivating subject, but when it covers the entire canvas and is invested with the unsuspected open space of the sky, it takes on new meaning. Our vantage point is not apparent at first due to the surprise of looking at the world through another's eye. Magritte allows us to shift from being the viewer to seeing backward into ourselves.

Figure 10.27 Joan Miró, *Person Throwing a Stone at a Bird.* (1926)
Oil on canvas, 29 × 36¼ in.
Collection, The Museum of Modern Art, New York. Purchase.

Figure 10.28 René Magritte, *The False Mirror.* (1928)
Oil on canvas, 21¼ × 31⅞ in.
Collection, The Museum of Modern Art, New York. Purchase.

Figure 10.29 Meret Oppenheim, *Object*. (1936)
Fur-covered cup, saucer, and spoon; cup, 4⅜ in. diameter; saucer, 9⅜ in.
diameter; spoon, 8 in. long; overall height 2⅞ in.
Collection, The Museum of Modern Art, New York. Purchase.

The difference between a madman and me is that I am
not mad.

Salvador Dali

The surrealists were just as outrageous in their be-
havior as they were in their art. One of them ate spiders
to shock his onlookers, and Spanish painter Salvador Dali
(dah'-lee) (b. 1904) is said to have lectured at the Sor-
bonne standing with one bare foot in a pan of milk! Art
was the outgrowth of such behavior—the graphic rep-
resentation of the fantastic world of inner consciousness.
It seemed as though both dadaism and surrealism tried
to shock the world into realizing the existence of another
dimension of our world. Dali used for shock value the
juxtaposition of real objects in unreal situations.

The most famous surrealist painting of all time is
Dali's *The Persistence of Memory* (colorplate 58). Barely
larger than a standard sheet of typing paper, this tiny
painting seems larger than life; the horizon stretches out
to infinity as the extremely dark foreground fades into
near white in the distance. But we cannot for long take
our eyes off the fantastic forms in the foreground:
watches that melt and hang limply from a barren tree,
from an unlikely geometric terrace, and over a dead, un-
worldly creature in the center of the picture. What does
it all mean? It means whatever viewers decide for them-
selves. After all, Dali never explained to his students why
he lectured to them with one bare foot in a pan of milk;
they supplied their own meanings. Like Magritte's
paintings, Dali's realistic rendering of the objects—both
natural and supernatural—is partly responsible for the
powerful visual impact.

German artist Meret Oppenheim (meh-ray ah'-pen-
haheem) (1913–85) understood the startling effects of
combining incongruous objects for a revolting result and
took it a step further. Her ready-made sculpture *Object*
(fig. 10.29), or *Luncheon in Fur,* is composed simply of
a cup, saucer, and spoon covered with fur; an absurd table
setting that has become a symbol of the surrealistic
dream world.

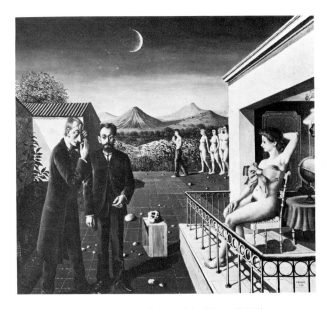

Figure 10.30 Paul Delvaux, *Phases of the Moon.* (1939)
Oil on canvas, 55 × 63 in.
Collection, The Museum of Modern Art, New York. Purchase.

Other Surrealist Tendencies Emerge

De Chirico and the surrealists wielded a great deal of influence on artists who borrowed bits and pieces of their style but who did not accept surrealism entirely. Some of those artists set up a tension by opposing the forces of real and imaginary worlds as the basis for the fascination of fantasy in art.

Another Belgian, Paul Delvaux (del-voh') (b. 1897), painted naturalistic forms in odd settings often depicting dream worlds. His oil painting *Phases of the Moon* (fig. 10.30) pictures complacent men and women, the former clothed and the latter nude, all of whom seem entirely accepting of the fantastic circumstances in which they are found. In a courtyard where perfect Renaissance perspective is evident, highly realistic figures wander about as in a dream. After we viewers become adjusted to the human characters in their strange division of attire, we can begin to analyze some of the unusual treatment of light and shadow. The light on all the forms seems to be entering from the left, but the moon is in a phase in which the sun should be shining from the right. This conflict of light sources, the ambiguity of daylight and moonlight, and the contrasts of naturalism and fantasy together with human beings in unnatural situations all create a compelling tension for the viewer.

Figure 10.31 David Alfaro Siqueiros, *Echo of a Scream.* (1937)
Duco on wood, 48 × 36 in.
Collection, The Museum of Modern Art, New York. Gift of Edward M. M. Warburg.

David Alfaro Siqueiros (si-keer'-ohs) (1896–1974) used fantasy to heighten the dramatic impact of his symbolic paintings. His involvement in social problems in Mexico City resulted in works containing political statements. His position on the insanity of war is clear in his painting *Echo of a Scream* (fig. 10.31). In a wasteland of twisted metal and total devastation, a baby clad in a striking red garment sits alone and screams. But to amplify the tragedy, Siqueiros has superimposed and enlarged the child's head, so that it, the only portion out of context in the composition, becomes the overwhelming center of attention. More like an amplification of a scream than an echo, Siqueiros created a powerful protest statement with a depiction of agony, death, and destruction.

Figure 10.32 Paul Klee, *Twittering Machine.* (1922)
Watercolor, pen and ink, 16¼ × 12 in.
Collection, The Museum of Modern Art, New York. Purchase.

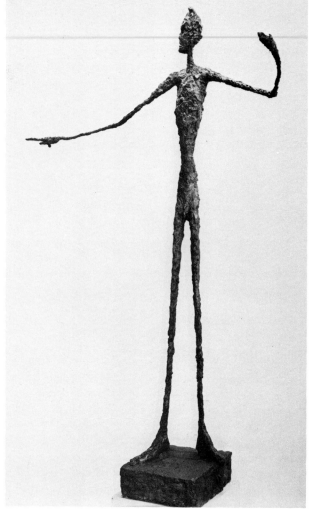

Figure 10.33 Alberto Giacometti, *Man Pointing.* (1947)
Bronze, 70½ in. high, at base 12 × 13¼ in.
Collection, The Museum of Modern Art, New York. Gift of Mrs. John D.
Rockefeller 3rd.

Many consider the tiny watercolors by Swiss-born artist Paul Klee (klay) (1879–1940) to be absurd, child-like drawings of fantastic subjects. Perhaps we might rather assume that they are based on a supreme economy of means. Klee's rich imagination is seen at its best in his *Twittering Machine* (fig. 10.32). The artist asks us to imagine that this purposeless machine does really work; by turning the crank, the birds' heads will move and begin to twitter. We can "hear" the mechanical music. Musical rhythms and cryptic, symbolic hieroglyphs pepper Klee's paintings. Through his imaginative use of fantasy, *Twittering Machine* subtly mocks the machine age.

Klee's sparse linear technique is typical of a number of his works, many of which are smaller than this page. Klee rendered the natural world in exact, close-up detail, often creating a whimsical child's Garden of Eden. However, his ever-changing style, in the last fifteen years of his life, moved toward total abstraction and nonrepresentational art. Only the titles of what appear to be nonrepresentational works help us to classify some of

them as abstract art. *The Current Six Thresholds* (see fig. 3.36) first appears to be simply a pattern of geometric blocks of various sizes. But with the help of the artist's letters, we know that this painting and others were inspired by his view of the Valley of the Kings in Egypt. As he described it: "The polyphonic interplay between earth and atmosphere has been kept as fluid as possible." The blocks are no longer simply geometric patterns but can be perceived as representing natural objects.

Alberto Giacometti (jah-koh-met'-tee) (1901–66), Swiss-born like Klee, was at one time a surrealist. However, he soon developed an individual style of sculpture that was both intense and haunting. In the last two decades before his death, Giacometti produced a number of works that portray people as roughly textured stick figures. His *Man Pointing* (fig. 10.33) is typical; space seems to overwhelm the spindly mass, as if to underscore the insignificance and isolation of our existence.

Figure 10.34 Georgia O'Keeffe. *Yellow Hickory Leaves With Daisy* (1928).
Oil on canvas, 30⅛ × 40 in. (77 × 102 cm).
Courtesy of Art Institute of Chicago, Gift of Georgia O'Keefe to the Alfred Stieglitz Collection.

Everyone has many associations with a flower—the idea of flowers . . . so I said to myself—I'll paint what I see—what the flower is to me but I'll paint it big and they will be surprised into taking time to look at it . . . I have used these things (flowers, sea shells, rocks, wood, white bones) to say what is to me the wideness and wonder of the world as I live in it.

Georgia O'Keeffe

Defying classification in a particular style because her break with tradition was not so severe, American artist Georgia O'Keeffe (1887–1986) became one of America's best known painters. Often expressing puzzlement over constant attempts by critics to interpret her works, she admonished, "I paint what I see." However, O'-Keeffe intensified her unique selection of images—rocks, skulls, flowers—beyond mere illustration by isolating them, enlarging them to fill entire canvases, and simplifying their surfaces to produce clear, precise designs. In *Yellow Hickory Leaves With Daisy* (fig. 10.34), displayed at the Art Institute of Chicago, she forces us to focus on dominant leaves and a single bloom; she has transformed trite biomorphic shapes into a monumental statement.

True reality is attained through dynamic movement in equilibrium . . . it is the task of art to express a clear vision of reality.

Piet Mondrian

Neoplasticism

Piet Mondrian (peet mohn'-dree-ahn) (1872–1944) also began his development in Holland painting representational objects. Later he was influenced by cubism and proceeded to modify his style to achieve an eventual resolution of nature in nonrepresentational shapes. Typical of his mature style is his *Composition* (colorplate 61). No real objects are suggested by the title, as we found in Klee. Asymmetrical balance and the relationship of line and color became the most important thrust of Mondrian's aesthetic statements. The hard-edged contours of the canvas surface were achieved with the help of adhesive tape. When entering a room filled with Mondrian's paintings, it is difficult for us to leave behind our expectations to be entertained with things that we recognize. He reduced nature's form to neutral configurations in order to find a more universal language for

Figure 10.35 Naum Gabo, *Spiral Theme*. (1941)
Construction in plastic, 5½ × 13¼ × 9⅜ in., on base 24 in. square.
Collection, The Museum of Modern Art, New York. Advisory Committee
Fund.

artistic expression; he called it **neoplasticism.** So carefully did Mondrian arrange the shapes in his *Composition* that one is no stronger than another; the vivid colors of the red and blue shapes are balanced by the larger white shape on the left and also by the preponderance of white. We should not overlook the heavy black lines and their role in the design of the painting. If at first they seem to function like the lead in stained-glass windows, look again at the bottom of the picture; the line, which actually is a viable shape, runs across only part of the outside edge. This heavier base was needed to balance the bright red and blue shapes in the upper part of the canvas.

Constructivism

Nonrepresentational art was also expressed in sculpture and was termed **constructivism.** Following the lead of the cubists, constructivist sculpture developed more as a treatment of space than of mass. Sculptors expanded their use of traditional materials such as stone, marble, and bronzes cast from clay models to include sheet metal, wire, glass, and plastics. In other words, sculptures in this period were more likely to be "constructed" than carved. Russian artist Naum Gabo (nawm gah'-boh) (b. 1890) developed a spiral, much as Frank Lloyd Wright did in his architectural design of the Guggenheim Museum, in a work called simply *Spiral Theme* (fig. 10.35). In his attempt to totally integrate the space occupied by his work, Gabo used clear plastic material, which became a popular medium for artists who wished to break with the tradition of modeling in clay or sculpting in stone. Like Mondrian's works, no reference to real objects was needed; pure design can be aesthetically pleasing on its own.

SUMMARY

Twentieth-century art is characterized by many diverse trends and styles, most of which emerged as the result of a new freedom of individual expression. Experimentation with the expressive possibilities available in color, light, and unconventional subject matter became the mode. The new age seems to have begun with the fauves' experiments with color and the expressionists' preoccupation with the imagination. Although these approaches to art were inspired by the impressionists and post-impressionists, the deviations were quite pronounced. They stimulated the rise of the Bridge group, the Blue Riders, and especially the futurists, who ignored the past in favor of consciously developing styles that more closely paralleled the new society.

Picasso is considered one of the great leaders of modern art partly for his role in formulating cubism, which attempted to simultaneously portray objects from more than one point of view. His paintings and sculpture during the first decade took on a more geometric appearance due to the use of what artists call "interactive planes." The style developed in two phases: analytic, which began with a subject that was dissected into small, angular pieces then reassembled, and synthetic, in which pieces formed larger masses in the manner of collages.

The dada movement began in Switzerland during World War I as a protest against the decaying morals and aesthetics of European society. Dada, like its name, used various art forms and behavior to express protest through ridicule and absurdity. With the individual freedom of expression now firmly established, nothing was too outrageous for dada artists. The element of chance and the use of ready-made objects seemed appropriate for this avenue of expression aimed at shocking and mystifying the establishment.

Surrealism followed dada and, in many ways, maintained its basic tenets. Spurred by Freud's discoveries in psychoanalysis, surrealists juxtaposed unlikely elements and used fantastic, incongruous subject matter to express concepts of feeling never before imagined.

Surrealism was the point of departure for a group of artists best known for their emphasis on fantastic subject matter. Images among this group range from realistic to abstract. Another group, the neoplasticists, whose leader was Piet Mondrian, chose to distill nature's subject matter into neutral essences in order to communicate in a more universal language. Yet another group of sculptors, called constructivists, influenced by the cubists, worked with new materials such as sheet metal, wire, and plastic to construct or build sculptured forms rather than to carve them from solid blocks. The constructivists became the inspiration for a whole generation of artists to follow.

Figure 10.36 Francis Bacon, *Painting.* (1946)
Oil and tempera on canvas, 6 ft. 5⅞ in. × 52 in.
Collection, The Museum of Modern Art, New York. Purchase.

VIEWING EXERCISES

1. Assume that the large green face of the man on the right side of Marc Chagall's oil painting *Green Violinist* (colorplate 21) is a self-portrait. Discuss the possible meaning of various symbols throughout the composition.

2. What is the basic style of Francis Bacon's (b. 1909) *Painting* (fig. 10.36)?

Figure 10.37 Piet Mondrian, *Broadway Boogie Woogie.* (1942–43)
Oil on canvas, 50 × 50 in.
Collection, The Museum of Modern Art, New York. Given anonymously.

3. How does Mondrian's compositional design in his *Broadway Boogie Woogie* (fig. 10.37) relate to the title of the painting?

4. Compare the style characteristics of the following works:
 a. Munch's *The Scream* (see fig. 1.60) and Arnold Schoenberg's dramatic musical piece, *Pierrot Lunaire.*
 b. Henri Rousseau's famous painting of equatorial African jungle, *The Dream* (located at the Museum of Modern Art) and Igor Stravinsky's *The Rite of Spring.*
 c. Boccioni's painting *States of Mind I: The Farewells* (Arnason: *History of Modern Art*), or Severini's painting *Red Cross Train* (Guggenheim Museum), and Arthur Honegger's symphonic work *Pacific 231.*
 d. Any of Pollock's "drip" paintings and Karlheinz Stockhausen's *Gesang der Junglinge* (geh-sahng der yoong-ling-eh).

5. Contrast O'Keeffe's *Yellow Hickory Leaves with Daisy* (see fig. 10.34) with Frankenthaler's *The Bay* (see fig. 2.45).

STUDIO EXERCISES

Suggested media and supplies: colored paper assortment; scissors; rubber cement; any drawing or painting medium

1. Using colored paper, cut a number of rectangles and squares of different sizes. Glue these to a paper background, possibly 8″ × 8″ or 12″ × 18″. Find a design arrangement that will produce an asymmetrical balance of shape and color in the manner of Mondrian. Use no title or preconceived idea for what it is to represent.

2. Repeat exercise 1 with shapes that are all the same size using a variation of spaces between the shapes to achieve variety, rather than a checkerboard of squares equally filling the ground area. It can be either an asymmetrical or a symmetrical design.

3. Find pictures in magazines that together deal with the theme of "street" (the reference for this is Kirchner's *Street, Berlin,* fig. 10.4). Cut, assemble, and glue the pictures in a composition

describing the theme "street." Use a variety of shapes, sizes, colors, and textures in the composition. This art form has many possibilities for creating pictures with a variety of themes, such as city, farm, computer age, war, etc. Choose one of these or another title that has more meaning for you and create another composition of any size; do not use any other medium in the composition.

4. For this exercise use cut-out color and textures, disregarding the objects on the magazine page. Choose a variety of colors and textures that may prove useful; do not choose on the basis of whether you are attracted to the pictured object. The shapes you cut out will work together if they are related in some way, for example, having a common linear rhythm such as rectangles or squares, circular patterns, or diagonal shapes. The composition will comprise a completely nonobjective design without a literal meaning or message. Look back at how Braque (fig. 10.14), or Schwitters (fig. 10.17) arranged pure shapes in a nonobjective composition.

5. Create a self-portrait using any medium or combination of media. Use one of the styles we have experienced on this tour as a point of departure and create a work that expresses the essence of your character rather than a likeness.

6. Artists often use the styles of other artists as motivation for their own work. In this exercise, choose only the title from any artist's work on the tour and reinterpret it in a completely different composition as a painting, drawing, collage, or montage.

RESPONSES TO VIEWING EXERCISES

1. Chagall's affinity to his home village was expressed in a number of symbolic paintings—this being the most famous of that genre. He remembers his relationship to the animals upon whom the peasants so strongly depended for sustenance. An element of fantasy emerges as Chagall freely portrays one of the peasants floating upside down. The tight design of elements forming a segmented circle in the center of the composition could very well refer to the necessary unity of people, beasts, and nature.

2. Bacon's repugnant subject is a blend of symbolism, fantasy, and expressionism. Amidst hanging meat in a slaughterhouse, Bacon places the grotesque figure of an unknown dictator. The obvious reference to carnage can easily be drawn, and the use of deep reds and purples set against large areas of black provides a sense of terror.

3. Mondrian painted, in his *Broadway Boogie Woogie,* a picture of the rhythm and tempo of New York City. Looking almost like a map, the lights of the city sparkle in pulsating rhythm of repeated shapes and linear patterns. These shapes are smaller than most found in Mondrian's later works, which gives the painting much more of a feeling of vitality and motion.

4. a. Both Munch and Schoenberg based their works on psychological themes. Whereas Schoenberg depicted an insane person by using eerie vocal inflections, Munch pictured humanity's frustration with the environment through distortion, exaggerated perspective, and grim colors. Schoenberg created a style of singing called *Sprechstimme* (shprek'-shtim-eh) by the Germans, a speaking voice investing vocal music with more emotion and drama.

 b. Both works are based on primitive themes in a context of emphasized rhythms. Oddly enough, both works also feature a young woman in dangerous primeval surroundings. Graphic and melodic lines alternate between lyric and angular. Contrasts are bold and often dissonant. Both works illustrate the modern tendency to revolt against the lush sweetness of the romantic tradition. Stravinsky's ballet, when first performed in 1913, was so iconoclastic and contained such radical new sounds that the audience began to riot.

 c. These works, paintings and music, are about the mechanical motion of trains. All reflect the influence of the futurists. Honegger's piece depicts the motion of a train from the first heaving chugs to the final destination, and, like the paintings, the music is more about the motion than about the train itself.

 d. Stockhausen's electronic music possesses the same pointillistic abstraction as Pollock's paintings. Swatches of sonic blips produced by tape recorders and synthesizers match Pollock's technique of splashing pure paint from a can onto a canvas spread out on the floor. We can even imagine Stockhausen's tape recording of children's voices cut up into small pieces and reassembled to form a new abstract "sound picture" of reality.

5. O'Keeffe's interpretation is a distillation of natural forms, even though it appears at first glance to be a detailed rendering of an authentic flower. Frankenthaler does not share the same interest in reproducing nature. However, both share a monumentality—one with delineation of subject matter and the other with color and shapes alone. Both hold an element of mystery and in their own way are equally abstract in concept.

San Francisco
Museum of
Modern Art

San Francisco, California

Tour 11

A Period of Experimentation

The Gallery

In recent years, the San Francisco Museum of Modern Art has significantly expanded its collection of artworks, especially those dating from World War II to the present. The permanent collection generally occupies two galleries, the larger of which exhibits works against simple white walls that minimize visual distraction. The collection is relatively small when compared with museums in the East, but it is an excellent representation of twentieth-century art.

The building, with its impressive beaux arts architecture, is located on the corner of Van Ness Avenue and McAllister Street. In addition to the usual food service and bookstore, the museum operates a reference library and a conservation laboratory where experts work on the restoration and treatment of paintings. Ample space has been reserved for temporary traveling exhibitions so the public may keep up-to-date on trends in contemporary art.

The museum's stated purpose is to collect, preserve, exhibit, and interpret art of the twentieth century. Such goals, coupled with its location next to the Louise M. Davis Symphony Hall and opera house, affords the West Coast one of its most valuable cultural assets.

Tour Overview

The freedom of expression found in the art of the first half of the century continues to influence artists today. The diversity of styles that we experienced in the previous tour is unlike anything that had occurred in the past. That diversity continues. Our problem as art appreciators or as art consumers is one of understanding and attempting to describe such diversity in contemporary art. Among the numerous possibilities, consider the present age as one of experimentation. After all, artists, especially since the last world war, have continually searched for new means of expression, and the groundwork laid by these artists in the first decades of this century most certainly influenced the development of a new form of painting and sculpture in the late 1940s known as abstract expressionism.

In recent years, the number of government grants for projects in the arts indicates a national concern for nurturing artistic talent and endeavors. Some of the major projects have attracted the attention of news media, and consequently public awareness of the arts has reached unprecedented levels. Museums throughout the world have recognized their role in the education of the general public about contemporary art.

On this tour we shall see the extremes of nonrepresentational art and total realism; we shall see the influences of cubism, surrealism, and dada; we shall see a complete break from traditional views and styles in minimalism and conceptual art; we shall begin to understand the wave of the future in art.

ABSTRACT EXPRESSIONIST PAINTING

The first major style to emerge after World War II was **abstract expressionism.** Although the title implies some sort of fusion between abstract art and influences of expressionism, the style is much more complicated than that and rather difficult to isolate. In the first place, all styles to emerge after impressionism have had some effect on the development of abstract expressionism. Artists generally grouped as abstract expressionists fall into two broad categories—action painters and color-field painters.

Action Painters

Action painters were labeled by virtue of the manner in which they applied paint to canvas, and **action painting** refers to the actual motion of the artist's body as he or she manipulated the materials. The results, or finished products, thus vie for importance with the artistic process, and these products range from abstracted figures to nonrepresentational images.

On the floor, I am more at ease. . . . Since this way I can . . . literally be *in* the painting. This is akin to the method of the Indian sand painters of the West.

Jackson Pollock

One of America's most famous painters, Jackson Pollock (pah'-luhk) (1912–56), arrived at his mature style during the late 1940s. Typical of his works at that time are his so-called "drip" paintings (see fig. 1.57) in which a dense web of splattered lines and dots form a rough and intricate surface texture. Pollock's unconventional manner of spreading a large canvas on the floor allowed him to move freely around and even *on top of* the canvas, splashing paint from a can with a brush or stick (fig. 11.1). He continued this process until he had built up thick layers of paint. Elements of chance, intuition, and interaction between the artist and his evolving creation constitute the main ingredients in Pollock's later works. He said:

When I am in my painting, I'm not aware of what I am doing. It is only after a sort of "get acquainted" period that I see what I have been about. I have no fears about making changes, destroying the image, etc., because the painting has a life of its own. I try to let it come through. It is only when I lose contact with the painting that the result is a mess. Otherwise there is pure harmony, an easy give and take, and the painting comes out well.[1]

Chance is certainly an element when paint is flung at a canvas and allowed to remain as it falls. However, the artist usually throws or drips only small amounts of paint at a time, carefully filling the entire canvas with a given color or motif before moving on to another. As more and more paint accumulates, the artist observes the way the materials are taking shape and, by interacting with this evolving creation, adjusts his or her actions to produce a work that can be called emotional as well as lyric in composition.

The final step that Pollock took in this spontaneous process was deciding to establish the outside borders of his painting—unlike conventional artists who fill a canvas of predetermined size and relate all smaller areas to the whole. After studying his finished work for a time, Pollock would cut the canvas around what seemed to him to be the logical perimeter and then attach it to a frame. At the same time, he established the "top-bottom" of his picture, although since he applied paint from every angle, most of his paintings during this period work equally well upside-down or even sideways. The result is a dynamic

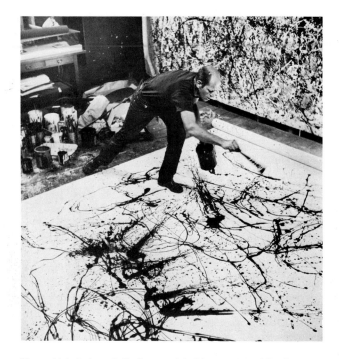

Figure 11.1 Jackson Pollock at work in his Long Island Studio, 1950 Photo: © Hans Namuth, New York, 1983.

"What we need is . . . painters who risk spoiling a canvas to say something in their own way. Pollock is one."

James Johnson Sweeney

and frenetic energy reflecting the artist's "action" in the process of creating the work. We see no recognizable image here, and the title referring to *Lavender Mist* (see fig. 1.57) is of little help in relating the work to the real world. Titles of such works are usually not meant to be descriptive but to distinguish one from another like a catalog number. The viewer's task should be to focus on the rhythm of the implied motion and on the intricate, interwoven textures that constitute the substance of Pollock's unique technique.

Pollock's earlier works are typified by a vibrant painting from 1943 in the permanent collection at the museum, *Guardians of the Secret* (fig. 11.2). The blue, red, and yellow primary hues are accented by black lines in this work laden with marks resembling calligraphy. But even in this early work, we can see Pollock's preference for free, action-oriented brushwork and for a unified statement and consistent technique. Pollock's influence on the new directions in art since World War II has been enormous. This reliance on the individual artist's intuitive strength fascinated a whole generation of artists striving to discover new avenues of expression.

1. Barbara Rose, ed. *Readings in American Art Since 1900* (New York: Holt, Rinehart and Winston, 1975) p. 152.

Plate 67 *Land's End,* Jasper Johns.
1963. Oil on canvas with stick, 67 × 48¼ in. (170.2 × 122.6 cm.).
San Francisco Museum of Modern Art, Gift of Mr. and Mrs. Harry W. Anderson.

Plate 56 *Painting No. 198,* Vasily Kandinsky.
1914. Oil on canvas, 64 × 36¼ in. (162.6 × 92.1 cm.).
Collection, The Museum of Modern Art, New York, Mrs. Simon Guggenheim Fund.

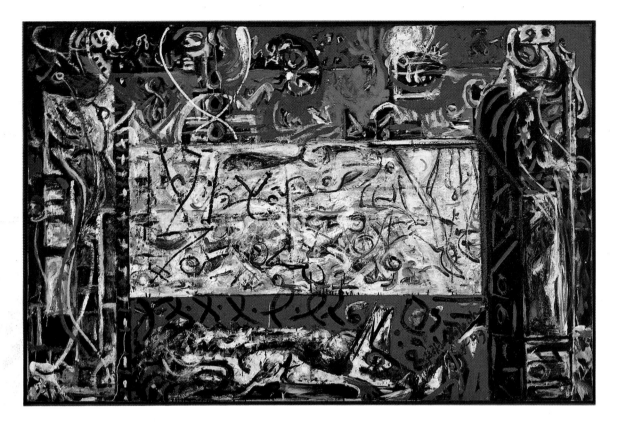

Figure 11.2 Jackson Pollock, *Guardians of the Secret,* 1943.
Oil on canvas; 48⅜ × 75⅜ in. (122.9 × 191.5 cm.).
San Francisco Museum of Modern Art, Albert M. Bender Collection,
Albert M. Bender Bequest Fund, Purchase.

"Writing" the painting, whether in color or neutral tones,
became a necessity for me. I often thought of this way of
working as a performance, since it had to be achieved all
at once or not at all—the very opposite of building up as
I had previously done.

Mark Tobey

Another pioneer of abstract expressionism was Mark
Tobey (1890–1976), who approached his canvas *Written
Over the Plains* (fig. 11.3) in a way somewhat similar to
Pollock. The total space is filled uniformly with white
calligraphic marks approaching the intricate lacework
that we found in Pollock's later paintings. Again, no per-
ception of depth is offered; both artists present their forms
completely on the surface plane, relying almost entirely
on linear intricacy and resulting complex textures for
their statements. Tobey's reference to nature in the title
is evidence of his intent to portray the real world in ab-
straction. However, we are not quite sure whether we are
looking at objects or simply seeing ideas and concepts of
nature.

Figure 11.3 Mark Tobey, *Written Over the Plains,* 1950.
Tempera on Masonite; 30⅛ × 40 in. (76.5 × 101.7 cm.).
San Francisco Museum of Modern Art, Gift of Mr. and Mrs. Ferdinand C.
Smith.

Figure 11.4 Willem de Kooning, *Woman,* 1950.
Oil on paper mounted on Masonite; 36⅝ × 24½ in. (93.1 × 62.3 cm.).
San Francisco Museum of Modern Art, Purchase.

I look at them [the "Women" paintings] and they seem vociferous and ferocious. I think it had to do with the idea of the idol, the oracle, and above all, the hilariousness of it.

Willem de Kooning

Dutch-born American painter Willem de Kooning (b. 1904) supplied viewers with recognizable figures in a series of works he called *Woman* (fig. 11.4). In these paintings he created between 1950 and 1953, distortion is caused by broad, slashing brushstrokes. A closer look at these freewheeling, vigorous strokes reveals a combination of sharply angular and graceful lyric lines. For many viewers, the presence of a recognizable figure is not helpful in the appreciation of de Kooning's style.

Gestural brushstroke was paramount for some of the action painters, and the technique continued in America with Franz Kline (1910–62), who produced a number

Figure 11.5 Franz Kline, *Untitled,* ca 1955.
Oil and gouache on board; 30¼ × 17¼ in. (76.8 × 43.8 cm.).
San Francisco Museum of Modern Art, Anonymous gift.

People sometimes think I take a white canvas, and paint a black sign on it, but this is not true. I paint the white as well as the black, and the white is just as important.

Franz Kline

of paintings characterized by slashing, black brushstrokes on a white ground. His painting *Untitled* (fig. 11.5) offers no clue to meaning; we respond only to quick, nervous gestures rendered with a wide brush and uncompromising contrasts of dark and light. Recognizing the unrestrained power of these bold lines, it would be easy to assume that Kline was out of control of his work. Such was not the case; the larger light areas and the smaller

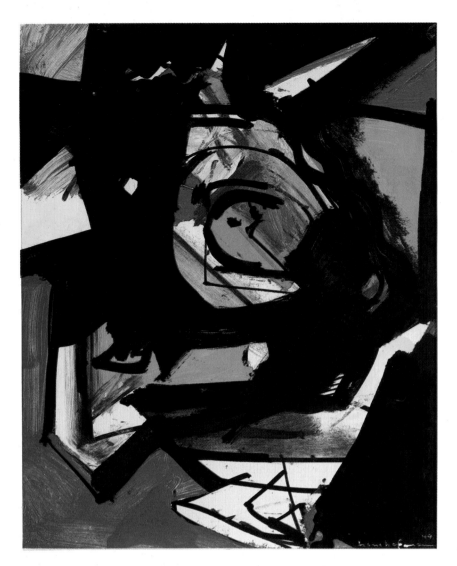

Figure 11.6 Hans Hofmann, *Figure,* 1949.
Gouache on matboard; 17 × 14 in. (43.2 × 35.5 cm.).
San Francisco Museum of Modern Art, Gift of the Hamilton-Wells
Collection.

My work is not accidental and is not planned. The first
red spot on a white canvas may at once suggest to me the
meaning of "morning redness" and from there on I dream
further with my color. You ask, do I make preliminary
sketches? The answer is never.

Hans Hofmann

glittering "windows" of light seem to hold their balance
with the huge expanse of black that fills the major por-
tion of the canvas.

Kline avoided direct imagery. He said, "I don't paint
a given object—a figure or a table; I paint an organi-
zation that becomes a painting. . . ."[2] Those viewers
seeking meaning beyond this simplified statement will

2. Kuh. *The Artist's Voice.*

have to supply their own interpretation. Compare this
painting with Nolde's *The Prophet* (see fig. 1.61); the
same power of expression is present in both works, but
Kline no longer relies on subject matter from nature as
a means of expression.

As we have found in other styles, the works of some
action painters occasionally bear remarkable resem-
blances to one another. The broad sweeps of dark against
light that are characteristic of Kline also appear in one
of Bavarian-born Hans Hofmann's (1880–1966) paint-
ings, *Figure* (fig. 11.6). Hofmann offered a great deal of
visual interest in terms of design, movement, and con-
trast. The basic design of *Figure* is built around an up-
sweeping, curved area of white on the right side and
countered with a broad dark area that plunges in an arc

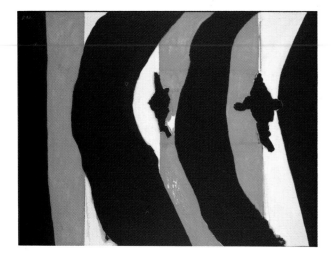

Figure 11.7 Robert Motherwell, *Wall Painting No. 10,* 1964.
Acrylic on canvas; 69 × 92 in. (175.3 × 233.7 cm.).
San Francisco Museum of Modern Art, Gift of the friends of
Helen Crocker Russell.

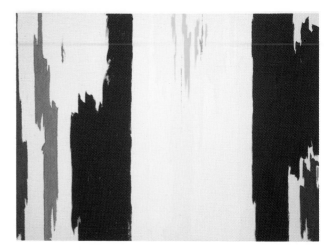

Figure 11.8 Clyfford Still, *Untitled,* 1960.
Oil on canvas; 113 ⅛ × 155⅞ in. (287.3 × 395.9 cm.).
San Francisco Museum of Modern Art, Gift of Mr. and Mrs. Harry W.
Anderson.

I'd rather risk an ugly surprise than rely on things I know
I can do.

Helen Frankenthaler

I never wanted color to be color. I never wanted texture
to be texture, or images to become shapes. I wanted them
all to fuse together into a living spirit.

Clyfford Still

back toward the focal center. The effect is one of pul-
sating energy made all the more frenetic with the infu-
sion of smaller dark lines darting across the light areas.

Action painters often composed as they worked, al-
lowing chance elements or "accidents" to happen, and
building their design around them. This process provides
graphic evidence of the activity and spontaneity of the
act of creation. Viewers are thus urged to respond to the
spontaneity implied by what appears to be random drop-
lets and running paint. Since the artist saw artistic value
in these chance elements, viewers can, if they wish, share
in the event.

Color-Field Painters

Helen Frankenthaler (b. 1928) provided a transition be-
tween Pollock and the color-field painters. Like Ror-
schach's ink blots, her forms can be read many ways.
They evolved from experimentation with the application
of thin color washes onto raw canvas. She stained the
surface rather than applying thick textures with brush
or knife. Broken forms of real or imagined landscapes
unfold across many of Frankenthaler's **color-field paint-
ings,** which currently appear in over seventy public col-
lections. As a color-field painter, she pours or spreads a
shape, stands back and edits it, thus establishing fields
or large areas of color as the center of interest. Her con-
trasts between ragged and straight-edged contours, dark
and light values, reflect the influence of Pollock and his

free rhythms. Her spontaneous applications of comple-
mentary colors—yellow and purple—add grace to the
softly flowing shapes that comprise *Interior Landscape*
(colorplate 65). Like Pollock, Frankenthaler's paintings
reflect her technique of allowing the painting to evolve
during the creative process.

Robert Motherwell's (b. 1915) paintings and collages
reflect a style in which large color shapes are used with
somewhat more control and preplanning than in works
by the action painters. His *Wall Painting No. 10* (fig.
11.7) is typical of his works—large architectural black
forms in vertical arrangements against a lighter back-
ground. Smaller splotches of black floating between huge
curved columns establish a ponderous rhythm that seems
to continue out of the picture frame. Although this
painting is relatively large, the monumental design makes
it seem even larger. Other abstract expressionist works
are also overwhelming in size and, in many cases, these
large-scale works seem to envelop the spectator.

Clyfford Still (b. 1904) is another contemporary artist
who is difficult to classify principally because of his stated
disavowal of any connection to established styles. How-
ever, his *Untitled* (fig. 11.8) is clearly within abstract
expressionist boundries with its freely rendered abstract
images and action-oriented technique. Nonetheless,
Still's interest in the use of color and free imagery moves
him into the category of those who are commonly re-
ferred to as color-field painters. Like Motherwell, Still
often maintains an interest in the vertical arrangement

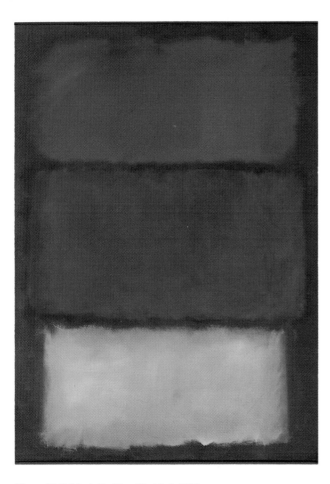

Figure 11.9 Mark Rothko, *Untitled,* 1960.
Oil on canvas; 69 × 50⅛ in. (175.3 × 127.3 cm.).
San Francisco Museum of Modern Art, Acquired through a gift of
Peggy Guggenheim.

> I think of my pictures as dramas; the shapes in the
> pictures are the performers. They have been created from
> the need for a group of actors who are able to move
> dramatically without embarrassment and execute
> gestures without shame.
>
> *Mark Rothko*

of fluid images that contrast starkly with one another.
The ragged columns of black alternate with open white
spaces and seem to rise up and out of the picture plane.
Still creates sparkling light with vivid reds and blues
confined to small areas.

The late works of the Russian-born painter, Mark
Rothko (1903–70), indicate the artist's interest in color
relationships alone as expressive content. He presented
a limited selection of broad areas of color arranged in
stacked rectangular blocks over a contrasting color field.
In his painting *Untitled* (fig. 11.9), Rothko uses two dif-
ferent values of magenta with white over a gray-purple
ground. The relatively large size of the canvas and the
simplicity of blurred geometric forms are indicative of
Rothko's intent to provide viewers with a contemplative

Figure 11.10 Josef Albers, *Homage to the Square,* 1962.
Oil on Masonite; 23¾ × 23⅞ in. (60.3 × 60.6 cm.).
San Francisco Museum of Modern Art, Gift of Anni Albers and the Josef
Albers Foundation.

visual impact. The soft outlines of his forms give the ef-
fect of slowly changing images that seem to merge be-
fore our eyes.

Even more hypnotic in its effect on viewers is Ad
Reinhardt's (1913–67) *#12–1955–56* (colorplate 64).
Within the field of deep, intense color, small squares
emerge as we are drawn into its strangely compelling vi-
sual atmosphere. More geometric than Rothko's feathery
forms, Reinhardt's hard-edged contours have wielded a
considerable influence on artists whose work is now called
geometric abstraction. As we shall see, this influence
found its way into painting, sculpture, and even archi-
tecture.

GEOMETRIC ABSTRACTION IN PAINTING

Several painters and sculptors fall into another stylistic
mode known as **geometric abstraction** quite simply be-
cause their works are composed of geometric shapes and
lines in a composition totally devoid of pictorial reality.
German-born artist Josef Albers (1888–1976) is cred-
ited with having established theories of color and color
relationships in geometric forms long before the style was
clearly defined. He produced a large number of works
he called *Homage to the Square* (fig. 11.10), which con-
sisted solely of several concentric squares. The interac-
tion of color and value creates for the viewer a kind of
subtle motion from the center to the outside edge. Albers

Figure 11.11 Ben Nicholson, *Nov. 21–49* (*Bird*), 1949.
Oil and pencil on canvas; 22 × 27 in. (55.9 × 68.0 cm.).
San Francisco Museum of Modern Art, William L. Gerstle Collection,
William L. Gerstle Fund Purchase.

> The colors in my paintings are juxtaposed for various and
> changing effects. They are to challenge or to echo each
> other, to support or oppose one another. The contrasts,
> respectively boundaries, between them may vary from
> soft to hard touches, may mean pull and push besides
> clashes, but also embracing, intersecting, penetrating.
>
> *Josef Albers*

used to tell his students, "Do less in order to get more."
Notice how much motion is created with a few lines. The
dark brown square in the center seems to move from the
flat surface of the canvas back into space, and then it
reverses itself and moves toward the viewer. Albers spent
many decades experimenting with how color, shape, and
line interact to form the illusion of three dimensions on
a flat surface.

An Englishman, Ben Nicholson (1894–1982), was one
of the earliest geometric abstractionists. His oil and
pencil on canvas, *Nov 21–49* (*Bird*) (fig. 11.11) consists
mainly of a series of graceful lines that seem to enclose
certain geometric forms. Most of the resulting shapes are
softly rendered with pencil shading and harmonious

colors accented with selected small areas of stronger in-
tensities. Nicholson's composition is most satisfying in
terms of its delicate balance between unity and variety.
The compositional design clusters most of the more ac-
tive shapes near the center of the picture plane. Notice
the care that Nicholson took in designing his canvas. The
look of spontaneity could fool spectators into believing
that such works are haphazardly thrown together without
due regard for principles of design. On the contrary, per-
fecting abstract design was a constant concern for Ni-
cholson in all his works.

In stark contrast to Nicholson's small, delicate
painting, many of Al Held's (b. 1928) ponderous works
cover entire gallery walls. Large, bold geometric shapes
sprawl across his canvases. *House of Cards* (fig. 11.12)
seems to reach far beyond the twenty-foot-wide picture
frame. At close range, it engulfs the viewer. In a work
where only nonrepresentational objects fight for viewers'
attention, design configuration becomes the dominant
feature.

Stuart Davis (1894–1964) used flat color areas ac-
cented with heavy black lines in his *Deuce* (fig. 11.13),
which portrays the frenzied rhythms of New York City.
The title refers to the two side-by-side picture planes.

Figure 11.12 Al Held, *House of Cards,* 1960.
Acrylic on canvas; 114¼ × 253¼ in. (290.2 × 643.3 cm.).
San Francisco Museum of Modern Art, Gift of Mrs. George Poindexter.

Figure 11.13 Stuart Davis, *Deuce,* 1954.
Oil on canvas; 26 × 42¼ in. (66.0 × 107.3 cm.).
San Francisco Museum of Modern Art, Gift of Mrs. E. S. Heller.

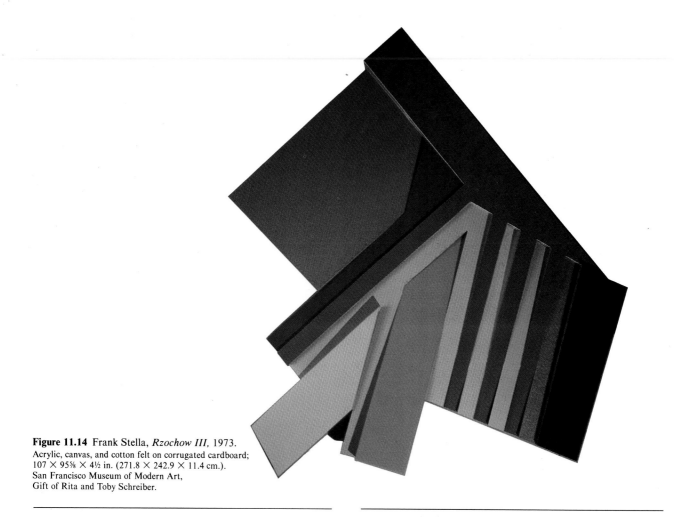

Figure 11.14 Frank Stella, *Rzochow III,* 1973.
Acrylic, canvas, and cotton felt on corrugated cardboard;
107 × 95⅝ × 4½ in. (271.8 × 242.9 × 11.4 cm.).
San Francisco Museum of Modern Art,
Gift of Rita and Toby Schreiber.

The artist is a cool Spectator-Reporter in an Arena of
Hot Events

Stuart Davis

What painting wants more than anything else is working
space, space to grow and expand into, space capable of
direction and movement, space that encourages unlimited
orientation and extension

Frank Stella

Most of Davis's paintings are built around the use of let-
ters and words as subject matter. In this work, we can
imagine the forms to be parts of large words cut from a
billboard and pasted together to form an interlocking de-
sign. It is no accident that Davis's signature appears so
boldly in the upper right-hand corner; he meant it to be
part of his composition. If refrigerator and automobile
companies are not modest, he once pointed out, why
should artists be modest? Notice how the letters balance
the blue strip in the opposite corner.

Davis claimed Seurat to be the "grand artist of all
time." In addition to Seurat, Davis expressed a fondness
for brilliantly colored storefronts and electric signs.
Davis's interest in the symbolic function of letters and
their forms influenced the later development of **lettr-
isme,** or word-art, in which artists build an entire work
on the formation of letters, numbers, and calligraphy (see
Robert Indiana, fig. 11.28).

Frank Stella (b. 1936) claims no levels of meaning in
his work. "What you see is what you see," he once said.

He has become one of the most innovative and imagi-
native of the younger generation of American artists,
noted for changing the traditional rectangular shape of
the canvas to one that repeats the interior shapes of the
paintings. During the 1960s, he combined blazing colors
with large-scale geometric abstractions to produce can-
vases of startling dynamic character. He called one se-
ries *The Protractor* series because of their intersecting
arcs. *Rzochow III* (fig. 11.14) glows with polymer paint,
and the canvas assumes the shape of interlocking diag-
onals of canvas and cotton felt on corrugated cardboard.
His experiments with shaped canvas have resulted in
some of his works looking more like sculpture than
paintings. The outer edges of the "canvas" have become
the contours of his bizarre forms. It is important to know
that this large work is indeed three-dimensional; it stands
out 4½ inches from the wall. In the 1980s, Stella left the
canvas altogether, turning to aluminum, fiberglass, scrap
metal, and ready-made objects for his constructions.

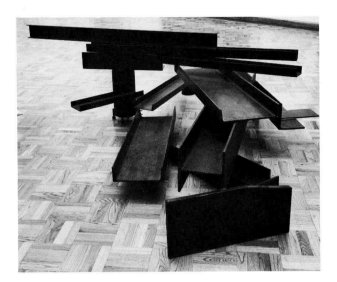

Figure 11.15 Anthony Caro, *Pavane,* 1971.
Steel; 34 × 114 × 111 in. (86.4 × 289.6 × 282.0 cm.).
San Francisco Museum of Modern Art, Gift of Mr. and Mrs. C. David
Robinson.

NEW DIRECTIONS IN SCULPTURE

We can find it rather easy to imagine the influence of
Stella's works on the abstract sculpture of Anthony Caro
(kah′-ro) (b. 1924). Sculpture in the twentieth century
has become more *additive* (the building up of pieces to
form the whole) rather than *subtractive* (the cutting
away of pieces from large blocks of material). Welded
metal has become a favorite medium of sculpture since
World War II because it fits so well into the geometric
abstractionists' idiom. Caro's large chunks of steel in his
Pavane (fig. 11.15) were assembled and welded together
to form intersecting angles in a manner similar to Stel-
la's design. The influence of the action painters is again
evident among sculptors who engage in a building pro-
cess of intuitive interaction with the piece as it evolves.

During the baroque period, sculptors became inter-
ested in fountains because of the added dimension of
flowing water. Similarly, motion or kinetic sculpture has
come to typify recent works by Alexander Calder
(1898–1976), George Rickey (b. 1907), Mark Di Su-
vero (b. 1933), and José de Rivera (1886–1957).
Throughout our tours, we have discussed the relation-
ships of form and space in sculpture, of the way forms
break up the space they occupy. Now we are presented
with the concept of forms that move through space, con-
stantly changing the balance between the two. Calder's
mobiles usually consist of flat biomorphic shapes that are
delicately balanced and allowed to swing about in wide
circles without colliding. Air currents move Calder's
mobiles in the large areas of space they occupy. They
range in size from small, intimate pieces to over-
whelming, architectural monuments like the work at the

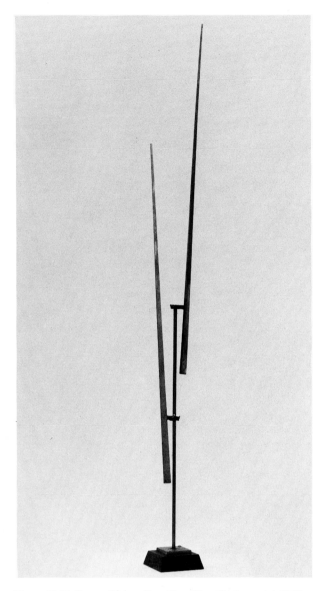

Figure 11.16 George Rickey, *Two Lines Up—Contrapuntal,* 1967.
Stainless steel on wood; 36 × 2 × 3 in. (91.4 × 5.0 × 7.6 cm.).
San Francisco Museum of Modern Art, Gift of Mr. and Mrs. Louis Honig.

National Gallery in Washington, D.C. (see fig. 1.26). The
resulting changes that take place while a viewer stands
in one spot are enhanced by the bright primary colors of
the shapes.

While Calder's hanging mobiles abound with graceful
arcs, George Rickey's motion sculptures are angular
spikes attached to rodlike stanchions. The spikes turn on
swivels in the wind in a way that causes spectators to
wonder why they never collide. Many of Rickey's works
resemble his *Two Lines Up—Contrapuntal* (fig. 11.16),
a seemingly vertical structure without the relief that
could have been provided by the addition of curved con-
tours. But when it begins to move, our eyes trace wide
arcs through space—a contrast of angular forms and
curvilinear motion.

Figure 11.17 José de Rivera, *Copper Construction,* 1949.
Copper; 28⅛ × 21 × 20¾ in. (71.5 × 53.4 × 52.7 cm.).
San Francisco Museum of Modern Art, Gift of Mrs. Henry Potter Russell.

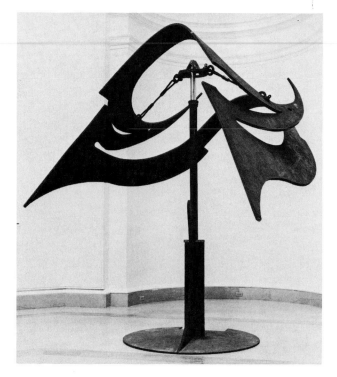

Figure 11.18 Mark Di Suvero, *Ferro,* 1978–82.
Steel; 123 × 162 × 162 in. (312.4 × 411.5 × 411.5 cm.).
San Francisco Museum of Modern Art, Margaret K. Walker Memorial Fund
Purchase with the aid of funds from the National Endowment for the Arts.

I think we are deeply influenced by our methods, our
tools are the way we work.

Mark di Suvero

Other works in the category of motion sculpture de-
pend more on implied motion than on actual movement.
José de Rivera's *Copper Construction* (fig. 11.17) and
Mark Di Suvero's (soo′-veh-roh) *Ferro* (fig. 11.18) seem
to be moving even though they stand still. Rivera's per-
sonal style incorporates a continuous pattern of curved
contours that seem to swirl in a circular pattern, and the
movement is all the more active as viewers walk around
the work or watch it move on its motorized axis. On the
other hand, Suvero's imposing curves depend more
heavily on an interaction with the central vertical post
for contrast. Moreover, a focus is established with planes
that lean toward the central support.

Abstraction in sculpture developed in the 1950s along
the vein of personal expression rather than in stylistic
schools. One of the pioneers in abstraction and who has
the distinction of receiving more public commissions than
any other American sculptor, is Louise Nevelson
(b. 1900) (see her *Homage to the World,* in Tour 2, fig.
2.40). She began assembling "found" wooden objects in
the 1940s, and she claims her "boxes" with their secret,
overlapping spaces, can be viewed as hidden, intimate
aspects of one's self. Her columns and walls evolve with
little or no preliminary planning. Her more recent com-
missions, gigantic welded structures, are cut and bent by

Art is not practical, and shouldn't be practical. Painting
and sculpture . . . are there to make life more
interesting, more wonderful than it would be without
them.

Henry Moore

workmen, as she directs. Her fifty-three foot *Sky Tree*
can be seen at San Francisco's Embarcadero Center.

Another revered sculptor of our time, Henry Moore
(1898–1986), has perfected a very recognizable per-
sonal style based on smooth rounded contours and,
above all, highly refined relationships of solids and voids.
Moore's *Reclining Figure* (see fig. 2.36) illustrates his
unique sculpting of voids. The open spaces take on an
unprecedented importance as the surrounding solid form
seems to serve as a frame in providing a shape for the
holes. Graceful rhythm results as our eyes move across
the form from one opening to the next. The distinctive
shapes of the voids become the focal center of the work,
and yet a balance is maintained between space and total
volume (see Tour 2). Some of Moore's later works reveal
the development of open space to the point that large
gaps separate isolated volumes; spectators can, in some
cases, walk *between* the shapes for an intimate interac-
tion with the work.

Figure 11.19 Isamu Noguchi, *Tiger,* 1952.
Terra-cotta; 10⅛ × 14¾ × 5⅜ in. (25.7 × 37.5 × 13.7 cm.).
San Francisco Museum of Modern Art, Mrs. Leon Sloss Fund Purchase.

Figure 11.20 Judy Chicago, *Untitled (Gameboard and Components #2)*, 1966.
Wood, brass, and latex; 4 × 12½ × 12½ in. (10.2 × 31.8 × 31.8 cm.).
San Francisco Museum of Modern Art, Gift of Diana Zlotnick.

In Japan, light things are handled as if they're heavy;
heavy things as if they're weightless—in this way one
finds an almost complete control over nature instead of
being dominated by it.

Isamu Noguchi

Symbolism plays a strong role in the sculpture of Los
Angeles-born Isamu Noguchi (ee-sah'-moo noh-goo'-
chee) (b. 1904). He lived in Japan from 1906–18. From
the time he was five years old, he has been caught up in
exaggerating and in simplifying form. His *Tiger* (fig.
11.19) is represented only by menacing teeth and a
gaping mouth. Noguchi's tiny form relies on both ab-
straction and simplification of a familiar object for its
symbolic impact.

Minimalism

All three of the following works employ a *minimal*
amount of subject matter repeated in certain ways for
desired effects. Called **minimalism,** this sculpture of the
1960s and 1970s utilizes uncomplicated geometric ob-
jects such as cubes, cylinders, posts, and boxes.

Judy Chicago's (b. 1939) *Untitled (Gameboard and
Components #2)* (fig. 11.20) and Jackie Winsor's
(b. 1941) *#1 Rope* (colorplate 62) are similar in ap-
pearance in that both employ vertical rods over a flat,
horizontal plane. However, each treats space in a dif-
ferent but simplified manner. On a square surface, Chi-
cago arranged dowel-like pegs of alternating heights
separated by various distances. The shape of sur-
rounding space undulates as the eye moves over the top
and around the pegs. Winsor's pegs are thin columns
fastened in the middle with balls of hemp. Her works
characteristically have a tight density that evolves as she

Figure 11.21 Donald Judd, *Untitled,* 1973.
Stainless steel with oil enamel on Plexiglas; 114 × 27 × 24 in.
(289.6 × 68.6 × 61.0 cm.).
San Francisco Museum of Modern Art, Purchased with the aid of funds from
the National Endowment for the Arts and Friends of the Museum.

wraps, twines, and nails layers together. Space is thus
evenly divided through the arrangement of horizontals
and also between the open top and bottom and the dense
area in the middle of the piece. A walk around this cube-
shaped construction will provide viewers with many in-
teresting patterns of space and light as the vertical rods
seem to move behind one another.

Donald Judd's (b. 1928) *Untitled* (fig. 11.21) first
impresses viewers with its total symmetry and unre-
lenting unity of mathematically spaced, stacked boxes.

Gradually, we perceive the resemblance to architecture, especially the balconies of apartment buildings and the vertical arrangement of downtown city architecture. It does, in fact, resemble highrise life in large cities. The imposing size of some of his outdoor sculpture almost forces the viewer to interpret formalistic principles of rhythm, symmetrical balance, unity, and repetition. Judd's work is immediately comprehensible from any viewpoint and pulls our eye in an insistent regular rhythm up and down its literally repeated pattern. His style is reduced to such simple means that we respond not only to the logic of its order, but also to the mystery of its statement.

POP ART

Pop art takes its name and derives its subject matter from popular culture. Although it began in England, it is considered primarily an American movement, and it reached its height in the 1960s. Pop artists made references to many forms of commercial advertising, to famous people, and to familiar, everyday objects such as comic strips, food, or flags. The fascination with pop art is due to its familiar subject matter, coupled with the artists' inventive, altered context.

An example of Roy Lichtenstein's (b. 1923) work *Landscape* (fig. 11.22) recreates a landscape in his typical, hard-edged, flat, impersonal style. Most of Lichtenstein's art is founded on enlarged comic strip images. "It's the (impressive, bold) quality of the images that I'm interested in," he said in 1969. "The kind of texture the dots make is usable to me in my work."

On an earlier tour, we saw Andy Warhol's (b. 1930) reproduction of stacked Coca-Cola bottles as we might see them in a grocery store (see fig. 3.31). Set in an artistic context with variations in color and value, these extremely familiar objects take on new meaning and subtle significance. The exact repetition of an object and its purely surface treatment stand boldly before the viewers as if to demand each viewer's interpretation. With such free association, each analysis can be considered valid; these pop symbols, because of their ubiquitous familiarity, mean something personal to each of us. Therein lies the power in the message of pop art.

Warhol began his career as a commercial artist and seemed attracted to mass products and to like images. He applied the principles of serial repetition of subject matter in a later painting titled *A Set of Six Self-Portraits* (colorplate 63). Each of these self-portraits,

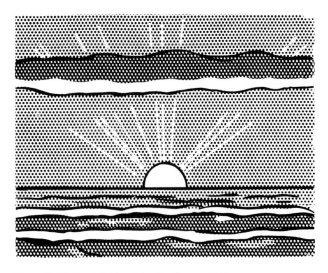

Figure 11.22 Roy Lichtenstein, *Landscape,* 1964. Pencil and tusche on paper; 16⅞ × 21¼ in. (42.8 × 54.0 cm.). San Francisco Museum of Modern Art, Gift of John Berggruen. Photo: Ben Blackwell.

What is Pop Art?
"I don't know—the use of commercial art as subject matter in painting, I suppose."

Roy Lichtenstein, 1963

although of the same **silk-screened** image, is different from the rest by virtue of contrasting color and value. Consequently, each depicts a slightly different character in the subject. Warhol utilized this arresting technique with portraits of such famous people as Marilyn Monroe and Mao Tse-tung, and with such familiar objects as Campbell's soup cans.

An earlier exponent of pop art who actually began as an abstract expressionist, Robert Rauschenberg (rahoo′-shen-berg) (b. 1925) developed a process of combining various real objects with painting from the abstract expressionist's style. As the title suggests, his *Collection* (fig. 11.23) is indeed a collection of odd pieces of material and junk assembled in a relatively flat manner and subsequently unified by the application of thin layers of various colors of paint over the entire surface. In spots, the paint is deliberately thinned so that it can run down over the work in a spontaneous fashion. This particular work resembles a collage as Rauschenberg appears to have pasted bits of papers and other materials to the canvas. Some of his later works became much more three-dimensional, which gradually led to a blurred distinction between painting and sculpture that we have already seen in the works of Frank Stella (see fig. 11.14).

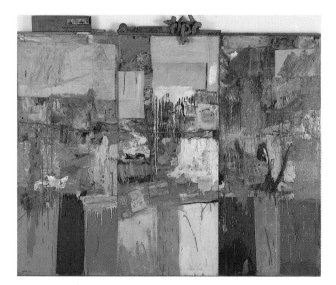

Figure 11.23 Robert Rauschenberg, *Collection* (formerly *Untitled*), 1953–54.
Oil, paper, fabric, and metal on wood; 80 × 96 × 3½ in.
(203.2 × 243.9 × 8.9 cm.).
San Francisco Museum of Modern Art, Gift of Mr. and Mrs. Harry W.
Anderson.

I was bombarded with TV sets and magazines . . . by the
refuse, by the excess of the world. . . . I thought that if I
could paint or make an honest work, it should incorporate
all of these elements, which were and are a reality.
Collage is a way of getting an additional piece of
information that's impersonal. I've always tried to work
impersonally.

Robert Rauschenberg

Claes Oldenburg (b. 1929), like the dadaists, pre-
sents familiar objects isolated from their original con-
text. The strange appearance of two large pieces of
wedding cake, in his *Wedding Souvenir* (fig. 11.24), casts
a new meaning to the rather strange custom of a single
woman's placing a piece of wedding cake under her pillow
so that she may see in her dreams the face of her future
husband. Pop artists select with great care objects from
popular culture that are already laden with meaning.

Later on, Oldenburg experimented with what has
come to be known as *soft sculpture,* adding a strong touch
of humor to his statement. Oldenburg takes his viewers
by surprise by asking such visual questions as: What if
plumbing fixtures were soft and droopy (fig. 11.25)? He
placed an oversized clothespin in Philadelphia and
seemed to ask, Why not? Along with other artists of the
1960s and 1970s, Oldenburg strives to change what the
viewers expect of art.

Figure 11.24 Claes Oldenburg, *Wedding Souvenir,* 1966.
Plaster of Paris; each 6 × 6⅝ × 2½ in. (15.2 × 16.8 × 6.4 cm.).
San Francisco Museum of Modern Art, Anonymous gift.

Figure 11.25 An example of soft sculpture. Claes Oldenburg, *Soft
Toilet,* 1966.
Vinyl, Plexiglas, and Kapok. 50½ × 32⅝ × 30⅞ in.
Courtesy of Claes Oldenburg.

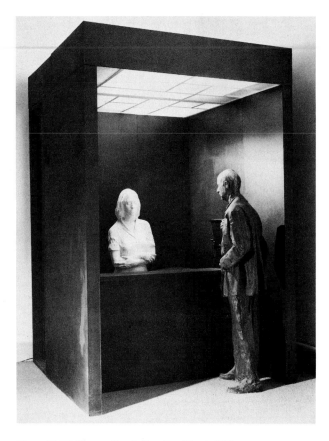

Figure 11.26 George Segal, *Hot Dog Stand,* 1978.
Plaster and wood with acrylic, Plexiglas, stainless steel, and
electrical apparatus; 108¼ × 72¼ × 81½ in.
(275.0 × 182.9 × 207.0 cm.).
San Francisco Museum of Modern Art, T. B. Walker Foundation
Fund and Clinton Walker Fund Purchase.

I do things that are contradictory. I try to make the art
look like it's part of the world around it. At the same
time, I take great pains to show that it doesn't *function* as
part of the world around it.

Claes Oldenburg

Without any direct attempt at social comment, pop
art often suggests powerful meanings. Viewers are thus
urged to pause in the mad rush of today's society and
reflect on the human condition. George Segal (b. 1924)
is best known for assembling life-sized sculpture and re-
lated environmental objects known as assemblages (see
Tour 2). Cast from live models in rough, untreated
plaster, his chalk-white figures can be found at lunch
counters, in ticket booths, or in a *Hot Dog Stand* (fig.
11.26). The loneliness and alienation of people in a busy
society were never so starkly portrayed. Not even Kirch-
ner (see figs. 1.35 and 10.4) captured the isolation and
estrangement we experience in Segal's societal casta-
ways. Although Segal has also worked with color, the

Figure 11.27 Mel Ramos, *Miss Grapefruit Festival,* 1964.
Oil on canvas; 40 × 34 in. (101.6 × 86.4 cm.).
San Francisco Museum of Modern Art, Anonymous gift.

ghostly figures in white plaster provide a penetrating
statement against the actual objects that form their en-
vironment.

Perhaps more than any other pop artist, Mel Ramos
(Rah′-mohs) (b. 1935) most successfully parodies com-
mercial advertising. *Miss Grapefruit Festival* (fig. 11.27)
pictures a bosomy nude nestled up to her sternum in a
large load of grapefruit. Clearly, Ramos is pointing out
the absurdity of the simile and of our sex-oriented mar-
keting. Most advertisements portray unrealistic views of
our society in order to make a product more appealing
to potential buyers. Pop art brings us back to earth by
reminding us that real life is not the way it is pictured
in television commercials.

The aspect of pop art that utilizes and develops num-
bers, letters, and words is known as lettrisme. Certainly,
letters and numbers in the vast amount of printed ma-
terials around us have come to be extremely important
symbols carrying special meaning to our culture. Jasper
Johns (b. 1930) clearly spells out the primary colors in
his large oil painting *Land's End* (colorplate 67). Like
his colleague, Rauschenberg, Johns emerged from the
abstract expressionist school; we can observe elements of
that style in the manner in which paint has been applied
around the stenciled letters. The result is a rather inter-
esting interplay between the precision of the letters and
the free abandon with which the paint was applied to the
remaining portions of the canvas.

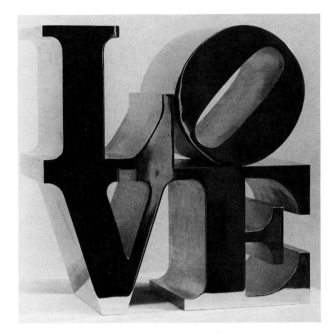

Figure 11.28 Contemporary lettrisme was first used by the cubists who attached such forms as pieces of newspapers or sheet music to collage or painting surfaces. Art forms of the 1960s using typography and other symbols evolved into sophisticated painting and sculpture with meanings ranging from the obscure to the obvious. Robert Indiana, *LOVE,* 1968.
Aluminum; 12 × 12 × 6 in.
Gift of the Howard and Jean Lipman Foundation, Inc. Collection of Whitney Museum of Art, New York.

Figure 11.29 Robert Indiana, *The Fair Rebecca,* 1961.
Oil on canvas; 41 × 39 in. (104.2 × 99.1 cm.).
San Francisco Museum of Modern Art, Purchase.

Robert Indiana (b. 1928) became quite famous for his catchy design of the letters in *LOVE* (fig. 11.28). Stenciled letters found on shipping crates form the enigmatic oil painting, *The Fair Rebecca* (fig. 11.29). Perhaps Indiana expects us to react to the grim name of the original Yankee slaver. Whatever the obscure reference, the subject of this painting is a group of familiar words.

OP ART

Motion has been a concern of many twentieth-century artists influenced by the futurist movement. Both real and implied motion have characterized artworks since World War II. Op art, or more properly, optical art, is so named because certain colors and designs create the illusion of movement on the retinas of our eyes. Though the images of op art are static, they seem to move as we stare at them. A work in the Museum of Modern Art, New York, was painted by Bridget Riley and appropriately titled *Current* (fig. 11.30). The wavy lines are set close together at slightly varied distances. Our eyes cannot focus on so many contour definitions set so closely together, so the image begins to vibrate and optical strain soon occurs.

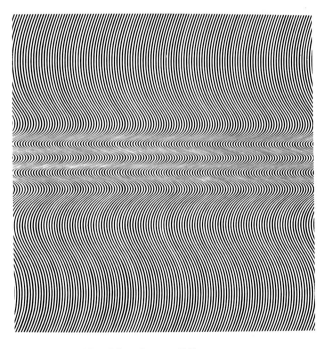

Figure 11.30 Bridget Riley, *Current,* 1964.
Synthetic polymer paint on composition board; 58⅜ × 58⅞ in.
Collection, The Museum of Modern Art, New York. Philip Johnson Fund.

I wanted to have color be the origin of the painting.

Kenneth Noland

A similar but much less painful result occurs when viewing Gene Davis's (1920–85) *Cool Buzz Saw* (colorplate 66). Here, thin vertical bands of intense colors are placed rather uniformly side-by-side with the hard edges that were achieved through the use of masking tape. Again, our eyes cannot fully cope with the juxtaposition of intense colors in such a repeated fashion and the image begins to drift from side to side.

While Davis's color bands appear to float at the very surface of his canvas, *Homage to the Square* (see fig. 11.10) by Joseph Albers (1888–1976) seems to pull its viewer in and out of a deep vortex. The result is perhaps not accurately grouped with optical art, but the design does persist in drawing the eye in and out of the space in the center. The design also alternates between flat surface quality and a nonobjective illusion of depth.

SUPER REALISM IN PAINTING AND SCULPTURE

Although super realism is mainly a phenomenon of the 1970s, it appeared in the mid-sixties in works by such leaders of the style as Malcolm Morley (b. 1931). In 1965, his oil painting of an oceanliner, *Cristoforo Colombo* (not in the San Francisco Museum), startled viewers with its exact photographic reality. Experimentation with new materials, especially polyester and fiberglass, resulted in sculptures, similar to Segal's, made from live-body casts but that look exactly like their human models. Duane Hanson's (b. 1925) *Bus Stop Lady* (fig. 11.31), typical of his realistic style, is a freestanding work looking as if a person had wandered into the frozen food department and become immobile. After being convinced that Duane Hanson's sculptures are not real people, we can speculate on the artist's statement. One interpretation is that this sculpture is the supreme example of very common, ordinary sights in our culture—mirrored images of our own reality.

Since super realist paintings are often made from photographs, the results look more like photographs than the actual object. These artists usually project photographic slides onto a canvas and paint the images in oil or acrylics. Thus, the scale is whatever dimensions the media and materials can accommodate from the projected image. Although the initial appeal of super realism lies in the astonishingly true-to-life image, the

Figure 11.31 Duane Hanson, *Bus Stop Lady,* 1983. Polyester and fiberglass polychrome in oil. Life-size. Photograph courtesy O. K. Harris Works of Art.

intent of the artists is a bit more involved. Morley and his followers soon realized the potential for powerful statement in super realism and shifted from rendering such subject matter as placid oceanliners to closeup images with more intimate messages.

Like the pop art that helped produce it, super realism slices small pieces of life and places them before the viewer like mirrors offering a closeup view of our own existence. James Torlakson (b. 1951) names his *Dutch Masters* (fig. 11.32) after a cigar advertisement. The absence of motion and the crass utilization of those human figures creates a feeling of forlorn abandonment. Super realism's goal as an art form is to reveal the significance and meaning in the commonplace. We cannot ignore the strong possibility that the style may have resulted in part as a reaction against abstract and nonrepresentational art and in response to a public longing for identifiable subject matter.

One thing I find myself very uncomfortable with is the present role of art—its powerlessness. In the Middle Ages art functioned educatively, spiritually. I really believe that art has an incredible capacity to illuminate reality, bring a new perspective and bridge gaps.

Judy Chicago

Figure 11.32 James Torlakson, *Dutch Masters,* 1974.
Watercolor; 16 × 24 in. (40.6 × 61.0 cm.).
San Francisco Museum of Modern Art, Helen Crocker Russell Memorial
Fund Purchase.

CONCEPTUAL ART

Named for a style that emphasizes the *concept* of an art-
work over all other elements, the idea behind a concep-
tual artwork, or the process of constructing it, is as
important as the final product.

In 1978 a sculptural event opened at the San Fran-
cisco Museum of Art and later toured large museums
across the United States. Judy Chicago intended *The
Dinner Party* (fig. 11.33) to be a cultural statement as
well as a work of art. The forty-eight-foot triangular table
symbolizes equality. Three hundred men and women
worked five years to create the place settings symbol-
izing the life and work of thirty-nine notable women
throughout history. Chicago formulated the concept
around what has traditionally been called "women's
craft"—stitchery, weaving, and china painting.

An artist whose monumental and expensive "con-
structions" have attracted attention throughout the world
is Christo Javacheff (b. 1935), a Bulgarian-born Amer-
ican artist. The museum owns some of the preliminary

Figure 11.33 Judy Chicago, *The Dinner Party—Judy Chicago.*
Mixed; 47 ft. per side.
© 1979 Judy Chicago, photo by Michael Alexander.

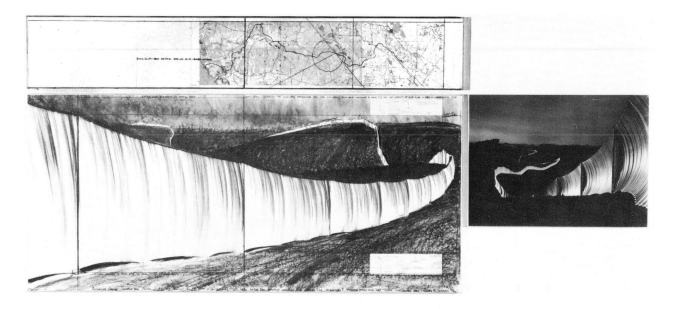

Figure 11.34 Christo, *Running Fence*. Project for Sonoma and
Marin Counties, California, 1976.
(A) charcoal, pastel and pencil drawing on paper, (B) topographical map,
(C) color photograph (enlargement from 35mm slide taken by Jeanne Claude

Christo) (A) 42 × 96 in. (106.7 × 243.8 cm.) (B) 15 × 96 in.
(38.1 × 243.8 cm.).
San Francisco Museum of Modern Art, Gift from the Modern Art Council.

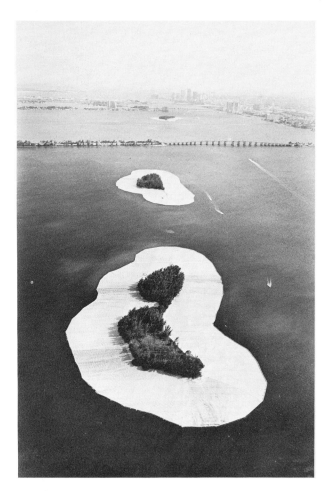

Figure 11.35 Christo, *Surrounded Islands,* 1980–83. Biscayne Bay,
Greater Miami, Florida.
© 1980–83 Christo/C.V.J. Corporation. Photo © 1983 Wolfgang Volz.

sketches, photos, and maps used by Christo to build his
famous project called *Running Fence* (fig. 11.34). This
drawing pictures his concept of a polyester curtain 18
feet tall and running for 24½ miles from inland to the
California coastline. It was designed to last for only two
weeks.

In 1983 eleven islands in Biscayne Bay, Florida, were
encircled with 6.4 million square feet of pink nylon-woven
fabric. Named by Christo *Surrounded Islands* (fig.
11.35), the project cost over three million dollars, and
again, lasted for 14 days. Other projects included the
wrapping of miles of Australian coastal rock formations
and an entire building in Chicago. In 1985 Christo com-
pleted his plan for wrapping the Pont Neuf in Paris (fig.
11.36). The $4 million project, like all his other projects,
was funded by selling sketches of how the wrapped bridge
would look. He was especially delighted with this par-
ticular concept because "people will be obliged to walk
on it . . . I find it extremely poetic."[3] Is this art? Can
we call it art if there is no lasting product?

Christo proves that much of the substance of art ap-
preciation is attitude and receptivity toward artists and
the messages they are attempting to convey. Christo has
brought art out of the museums and galleries and liter-
ally forces the public, through news media, his popular
lectures, and the sheer scale and scope of his projects to
become involved in them. He suggests that life has an

3. *Time,* 26, August 1985, p. 39.

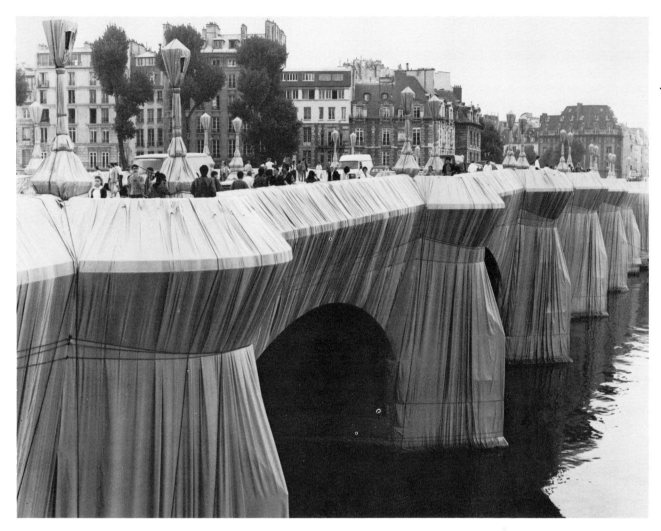

Figure 11.36 Christo: *The Pont Neuf Wrapped,* Paris, 1975–85.
444,000 square feet of woven polyamide fabric, 36,300 feet of rope.
Photo: Copyright Wolfgang Volz.

artistic dimension, and this is but one example of that dimension. Certainly, it is difficult for us to remain complacent as Christo challenges us to reconsider our perceptions of modern art and to comprehend its meaning.

SUMMARY

The work of artists since World War II has been characterized by experimentation. The period was launched by Jackson Pollock, along with Helen Frankenthaler, Mark Tobey, and Willem de Kooning, who developed a style called abstract expressionism. These artists fall into two broad categories: action painters, named for the manner in which they apply paint to canvas, and colorfield painters who use large color shapes and somewhat more control than the action painters. Abstract expressionism became a powerful influence on painting during the last half of the century.

Deviating markedly from the free-wheeling expression of Pollock or Kline, geometric abstraction was introduced by Joseph Albers as a style characterized by hard-edged geometric shapes and lines but that avoided pictorial reality. Lettrisme, which emerged as an off-shoot of that style, sometimes built entire works on the formation of letters, numbers, and calligraphy. Frank Stella introduced the idea of shaping the edges of his canvas to correspond with the interior shapes of his paintings.

Sculpture in this period continued the lead established by earlier constructivists. Inspired by geometric abstraction, sculptors began to build angular, nonrepresentational forms typified by works of Caro and Calder. Calder went on to develop kinetic sculpture, designed to move with air currents; Rivera's work turned on a motorized axis. One of the period's great trends in sculpture was established by Henry Moore, whose abstract, biomorphic figures appear to have been constructed equally from solid materials and open air.

Pop art developed from commercial art techniques and presents viewers with an arresting look at their own way of life. The name pop art itself was derived from the popular culture that it seems to be mocking. Op art was named after the optical effects it produces in viewers. Most of the prominent works in this style use linear configurations or bold colors to "trick" the retinas of our eyes. Images thus seem to vibrate or shimmer because the physical structure of the human retina is not capable of resolving the odd juxtaposition of elements.

In the 1970s, some artists began to portray images in both painting and sculpture with amazing realism. Super realism is only one of many names given to the style. Sculptural likenesses of people, for example, are so lifelike that casual observers often mistake them for the human models from which they were cast.

Conceptual art paved the way for an entirely new way of thinking about art and was perhaps the most revolutionary change that has ever taken place in the way artists approach their work. Conceptual art shifts the emphasis from the object itself toward the idea, or concept, that inspired it. These artworks are often designed to disintegrate or be torn down after a short period of time and are designed for specific sites. They are projects in which the process of making art is most important. The possibilities seem endless, limited only by the free imagination of tomorrow's artists.

VIEWING EXERCISES

1. Compare Willem de Kooning's *Woman* (fig. 11.4) with Ramos's woman in *Miss Grapefruit Festival* (fig. 11.27) and discuss similarities and differences in the treatments of the human figure.

2. Compare Pollock's painting (fig. 11.2) with Torlakson's *Dutch Masters* (fig. 11.32). Within such stylistic extremes, can you find any similarities?

3. Artists often turn their canvases upside down in order to observe objectively the design of their compositions without the distractions of subject matter. Turn the paintings in figures 11.2, 11.6, and 11.11 upside down and sideways and discuss the effects of each position on design features of each work.

4. Listening and viewing: Compare the eerie sounds of Edgard Varèse's *Poème électronique* with Hans Hofmann's *Figure* (fig. 11.6).

STUDIO EXERCISES

Suggested media and supplies: drawing paper; tempera or colored ink; brush; watercolor, pastel or colored pencils; soft sculpture medium.

1. Use tempera or colored ink and create your own "drip" painting in the manner of Jackson Pollock. Drip color from the ends of brushes or sticks onto a small surface. Do not attempt to control recognizable images and do not think of "objects" or preconceive the result while you paint.

2. In Tour 10, we completed a studio exercise dealing with the ways in which artists are motivated by the styles of others. They also use other artists' images as inspiration for works that imitate the feeling and style of artists known for certain popular images. Create a small painting in watercolor, pastel, or colored pencil in the style of Joseph Albers. Do not copy exactly, but extract from his work the necessary shapes, forms, textures, and colors that are identifiable as Albers.

3. Often natural forms such as a rock or a bone were seen by Henry Moore as miniature sculptural units that inspired him to create an elaboration in stone or cast bronze. Find a natural form and carve your own version of it in plaster or soap, or model a three-dimensional, papier-mâché form.

4. Create your own optical art form with lines and shapes using any medium, size, or color. The work must create the illusion of vibrating movement on the surface. (Refer to Bridget Riley's work; fig. 11.30.)

5. Claes Oldenburg presented familiar objects isolated from their original context. Find one that has meaning for you and reconstruct it in an art medium of either two or three dimensions.

RESPONSES TO VIEWING EXERCISES

1. The differences in these two paintings are more obvious than the similarities; however, both works offer spectators a closeup view of a nude woman and both are mildly sensual. On the other hand, Ramos used the technique of the commercial artist while de Kooning's work is more expressionistic. As a result, de Kooning's artwork has a sense of vitality, the meaning is deeper, and it is more expressive than Ramos's, who perhaps wished to provide a mild parody of popular culture.

2. Both the Pollock and the Torlakson are dominated by a large rectangular area in the center of the painting. The hieroglyphiclike designs in the Pollock bear a similarity to the markings on Torlakson's truck even though the messages differ in their levels of meaning.

3. One of the tests of formal design is to turn a picture in various directions and observe whether or not the design "works." After testing several nonobjective works, try turning some of the more realistic pictures upside down and concentrate on their design features alone. This is more easily accomplished with slides, where the realistic subject matter can also be turned out-of-focus to facilitate study of the basic design.

4. Varèse's *Poème* is as abstract as Hofmann's *Figure;* no melody, rhythm, or harmony, as we normally expect to hear in music, are apparent. As Hofmann concentrates on the frenetic motion of his brush, Varèse focuses our attention on the fantastic sonorities of electronic sounds. Both forms reveal a severe shift of emphasis away from a traditional balance of elements toward musical tone in the Varèse, and toward compositional design in the Hofmann.

SUGGESTED READINGS

Anton and Dockstader. *PreColumbian Art and Later Indian Tribal Arts*. New York: Harry Abrams, 1967.

Arnason, H. H. *History of Modern Art: Painting, Sculpture, Architecture*. rev. ed. New York: Harry Abrams, 1977.

Arnhein, Rudolf. *Visual Thinking*. Berkeley: University of California Press, 1980.

Bassett, Richard, ed. *The Open Eye in Learning: The Role of Art in General Education*. Cambridge, Mass.: MIT Press, 1969.

Brown, Milton W., et al. *American Art: Painting, Sculpture, Architecture, Decorative Arts, Photography*. Englewood Cliffs, N.J.: Prentice-Hall, 1979, New York: Harry Abrams, 1979.

Burnham, Jack. *Beyond Modern Sculpture: The Effects of Science and Technology on the Sculpture of this Century*. New York: Braziller, 1968.

Calas, N., and Calas, E. *Icons and Images of the Sixties*. New York: E. P. Dutton, 1971.

Canaday, John. *Mainstreams of Modern Art*. 2d ed. New York: Holt, Rinehart and Winston, 1980.

Canaday, John. *What is Art? An Introduction to Painting, Sculpture, and Architecture*. New York: Knopf, 1980.

Chicago, Judy. *The Dinner Party: A Symbol of Our Heritage*. Garden City, N.Y.: Doubleday, 1979.

Chipp, Herschel B. *Theories of Modern Art: A Source Book by Artists and Critics*. Berkeley: University of California Press, 1968.

Craven, Roy. *A Concise History of Indian Art*. World of Art Series. New York: Oxford University Press, 1976.

De la Croix, Horst, and Tansey, R. G. *Gardner's Art Through the Ages*. 8th ed. vol. 2. Renaissance and Modern Art. New York: Harcourt, Brace, Janovich, 1986.

Elsen, Albert E. *Purposes of Art*. 4th ed. New York: Holt, Rinehart and Winston, 1981.

Feldman, Edmund Burke. *Varieties of Visual Experience*. 2d ed. Englewood Cliffs, N.J.: Prentice-Hall, 1981.

Fine, Elsa H. *Women and Art: A History of Women Painters and Sculptors from the Renaissance to the Twentieth Century*. New York: Pantheon, 1974.

Fleming, William. *Arts and Ideas*. 7th ed. New York: Holt, Rinehart and Winston, 1986.

Friedman, B. H. *Jackson Pollock: Energy Made Visible*. New York: McGraw-Hill Book Co., 1974.

Francis, Frank, ed. *Treasures of the British Museum*. rev. ed. World of Art Library Series: Galleries. Central Islip., N.Y.: Transatlantic Arts, 1975.

Fromme, Babbette Brandt. *Curator's Choice: An Introduction to the Art Museums of the U.S.*, 4 vols. New York: Crown, 1981.

Gombrich, E. H. *Art and Illusion: A Study in the Psychology of Pictorial Representation*. 2d ed. A. W. Mellon Lectures in the Fine Arts 1956, National Gallery of Art Washington. Bollingen Series XXXV.5. Princeton, N.J.: Princeton University Press, 1972.

Harris, Ann Sutherland, and Linda Nochlin. *Women Artists: 1550–1950*. New York: Knopf, 1977.

Hartt, Frederick. *Art: A History of Painting, Sculpture, Architecture*. 2 vols. Englewood Cliffs, N.J.: Prentice-Hall, 1976.

Herbert, Robert L. *Modern Artists on Art: Ten Unabridged Essays*. Englewood Cliffs, N.J.: Prentice-Hall, 1964.

Hirsch, Diana. *The World of Turner*. Library of Art. New York: Time-Life, 1969.

Holt, Elizabeth G. *From the Classicists to the Impressionists: A Documentary History of Art and Architecture in the 19th Century*. New York: Doubleday, 1966.

Honour, Hugh, and Fleming, John. *The Visual Arts: A History*. Englewood Cliffs, N.J.: Prentice-Hall, 1983.

Hughes, Robert. *The Shock of the New: Art and the Century of Change*. New York: Alfred A. Knopf, 1981.

Janson, H. W. *History of Art*. 2d rev. ed. New York: Harry Abrams, 1977.

Kingston, Jeremy. *Art and Artists*. Horizons of Knowledge Series. New York: Facts on File, 1980.

Knobler, Nathan. *The Visual Dialogue*. 3d ed. New York: Holt, Rinehart and Winston, 1980.

Lamm, Robert, et al. *The Search for Personal Freedom*. Brief ed. Dubuque, Iowa: Wm. C. Brown Publishers, 1985.

LaPlante, John D. *Asian Art*. 2d ed. Studies in Art Series. Dubuque, Iowa: Wm. C. Brown Publishers, 1985.

Lee, Sherman E. *A History of Far Eastern Art*. 4th ed. New York: Harry Abrams, 1982.

Lucie-Smith, Edward. *Movements in Art Since 1945*. rev. ed. World of Art Series, London: Thames and Hudson, 1985.

Munsterberg, Hugo. *The Arts of Japan: An Illustrated History*. Rutland, Vt.: Charles E. Tuttle, 1956.

Nelson, Glenn C. *Ceramics: A Potter's Handbook*. 5th ed. New York: Holt, Rinehart and Winston, 1984.

O'Keeffe, Georgia. *Georgia O'Keeffe*. New York: Viking Press, 1977.

Pericot-Garcia, L., et al. *Prehistoric and Primitive Art*. New York: Harry Abrams, Inc., 1967.

Pfeffer, J. *An Inquiry into the Origins of Art and Religion*. New York: Harper & Row, 1982.

Rewald, John. *The History of Impressionism*. New York: Museum of Modern Art, 1973.

Rose, Barbara. *American Art Since 1900*. rev. and expanded ed. New York: Holt, Rinehart and Winston, 1975.

Rubinstein, Charlotte Streifer. *American Women Artists: From Early Indian Times to the Present*. New York: Avon, 1982.

Russell, John. *The World of Matisse*. Library of Art Series. Alexandria: Time-Life, 1969.

Schiff, Gert. *Picasso: The Last Years 1963–1973*. New York: Braziller, 1983.

Segy, Ladislas. *African Sculpture Speaks*. 4th rev. ed. New York: Da Capo, 1975.

Shahn, Ben. *The Shape of Content*. Charles Eliot Norton Lectures Series. Cambridge, Mass.: Harvard University Press, 1957.

Smagula, Howard J. *Currents: Contemporary Directions in the Visual Arts*. Englewood Cliffs, N.J.: Prentice-Hall, 1983.

Sullivan, Michael. *The Arts of China*. 3d ed. Berkeley: University of California Press, 1984.

Walker, John. *National Gallery of Art*. rev. ed. New York: Harry Abrams, 1984.

Wingert, Paul S. *Primitive Art: Its Traditions and Styles*. New York: New American Library, 1965.

Young, Mahronri Sharp. *The Golden Eye: Magnificent Private Museums of American Collectors*. New York: Scala Books, 1983.

PART III:
A WORLD TOUR

I N THE BROAD VIEW, the development of style has become more varied in modern times. Comparing Tour 6 with Tour 10, for example, we note that the style of Renaissance artists was relatively consistent, while artists during the first two decades of the twentieth century were simultaneously experimenting with no less than half a dozen different styles. Such a stylistic range was actually signaling the importance of *personal* style in art and the corresponding tendency toward deviation from "schools." Each individual artist in our time seems bent on establishing a personal style that defies classification. We appear to have as many manners of expression as there are artists. And, while such diversity may seem stultifying when trying to understand it, we would perhaps be better off reveling in its variety and in seeing how present concerns are linked with the past.

But variety of style and profusion of artworks are not our only concerns here. In Part III, we shall see that art is no longer confined to museums and galleries but rather is presented directly to the people. Consequently, more people than ever before are exposed to art. Surrounding us daily are examples of how design is influenced by art—in everything from the Oriental slit skirt of women's fashion to the revival of classical architecture in contemporary structures. Commissions for large sculptures to grace public entryways and foyers are multiplying in significant numbers, bringing new and often controversial works of art in plain sight of everyone.

Part III, then, does not consist of tours to museums but rather "field trips" to art of the new age. The objects themselves may be as gigantic as skyscrapers (in fact, some *are* skyscrapers) or as small as a video scanner for computer graphics that can be viewed by anyone with a TV set.

It was inevitable. As the middle classes have grown larger and wealthier, art has become less a commodity only for the aristocratic elite. As information processing and dissemination has become more sophisticated, the average person has come to experience art more intimately than ever before. In other words, the public has become ready for the great migration of art from museums to industrial plazas and open country. The public is apparently ready as well for the divergence of artistic expression, no matter how unconventional. Perhaps we have always been ready.

This tour will also lead us through an examination of artworks from times and places "outside the mainstream" of Western Civilization. Tribal art (for want of a better term) of Africa, Oceania, and the Americas was never conceived for exhibition in galleries or museums. Indeed, tribal artisans were mainly concerned with the function of such objects in societal ritual. Yet, their artistic value cannot be denied, even though we are relegated to viewing them with a Western bias. That is to say, their artworks possess both a functional and a formal dimension. And as we come to understand tribal art, many parallels can be drawn between Western art of the new age and that of old world, primitive societies.

Ever since 1962, when Rachel Carson drew international attention to environmental concerns with her book *Silent Spring,* artists have shown a growing interest in environmental art. Perhaps it stems all the way back to the romantic reverence for nature around the turn of the nineteenth century. For our purposes, we shall visit various sites where artists have created artworks specifically designed for a particular environment, and where the surroundings play a crucial role in the expressive qualities of the art object itself.

SITE SCULPTURE

Having been introduced to conceptual art by Christo, we are now ready for a tour of site sculpture—three-dimensional works permanently designed for a specific location and containing many of the overtones of conceptual art. Conceptual art can be thought of as environmental whenever objects such as Christo's *Running Fence* or *Surrounded Islands* are so closely integrated with their environment. But unlike Christo's work, which was created for a limited time span, site sculpture is meant to remain in a certain place and interact with that location. Not only are site sculptures made to blend with a particular environment, reflecting the surroundings and adding something to them, but many, like the ancient Stonehenge, are situated in line with the rising sun or planets and stars. Site sculpture is not new. Many of the great monuments of the past—the pyramids, Gothic cathedrals, and memorial sculpture—were designed for specific locations. Some scholars even speculate that the construction of certain cathedrals was aligned with the rising sun. Remember that architecture may be thought of in terms of sculpture.

To see site sculptures in all their original artistic flavor, viewers must go to the site and relate physically and perceptually with each work. It is this interaction that is the most critical feature of the artistic statement. Photographs of these sculptures can, therefore, never relate the artists' full message.

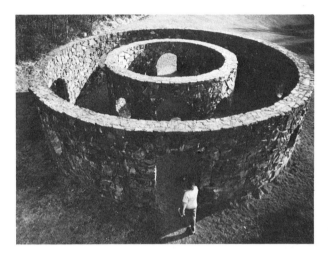

Figure 12.1 Nancy Holt, *Rock Rings,* 1977–79, Bellingham, Wash. Stone, mortar, concrete; outer diameter 40 ft., inner diameter 20 ft. Western Washington University.
Photo by John Klicker.

One has the sense of being in a secret garden, from which it is possible to look out without being seen.

John Beardsley,
describing Rock Rings

Nancy Holt's (b. 1938) site sculptures typically contain openings that invite spectators to peer through and view the universe beyond. In so doing, the picture of reality is altered to varying extents—somewhat as all art changes our perception of reality. *Rock Rings* (fig. 12.1), commissioned by Western Washington University, consists of two concentric stone and mortar walls with arched doorways and rounded "windows." The urge to walk in and through the structure is irresistible. But it is most important that we recognize the placement of this structure within its forest setting. We must be aware of Holt's intent in the positioning of all those openings and that we see the structure from the outside and perceive the surrounding environment from inside as we peer through the openings. It was also no accident that the arches were

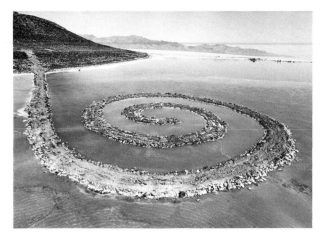

Figure 12.2 Robert Smithson, *Spiral Jetty*, 1970.
Black rock, salt crystals, earth, and red water (algae); coil 1500 ft. (457.2 m.) long, 15 ft. (4.57 m.) wide. Great Salt Lake, Utah. © Gianfranco Gorgoni/ Contact, New York.

> As I looked at the site, it reverberated out to the horizons only to suggest an immobile cyclone while flickering light made the entire landscape appear to quake . . . a spinning sensation without movement. . . . From that gyrating space emerged the possibility of the *Spiral Jetty*.
>
> *Robert Smithson*

Figure 12.3 Exterior and interior of a nautilus shell.
© Bob Coyle.

aligned with the North Star. Since she completed her first major work in 1976, the artist has provided us with means of focusing our perceptions, as if to say to us, "Here, let me help you to see this setting with greater depth and with more intense meaning."

Robert Smithson's passion for geology and concern for the environment and land reclamation led to the 1970 construction of *Spiral Jetty* (fig. 12.2). This earthwork jutted out a quarter of a mile into the brine of Utah's Great Salt Lake. When the water was below the 1970 level, people could walk on it, caught in its remote, symbolic maze. The desolation of the site appealed to Smithson. "A bleached and fractured world surrounds the artist," he wrote in 1968. "To organize this mess of corrosion into patterns, grids and subdivisions is an aesthetic process that has scarcely been touched."

Like his wife, Nancy Holt, Smithson so carefully integrated his works with their environmental settings to the point that work and environment became accepted as one. This manner of coexistence might be compared to nature's design of a simple sea shell. The complex repetition of chambers inside a nautilus is dramatically contrasted with the smooth and simple surface of its outer shell (fig. 12.3). Interior and exterior fuse as one, much the same as the sculpture and surrounding environment fused in the *Spiral Jetty*.

Although Smithson abandoned the conventional artist's tools and materials and replaced them with bulldozers and dump trucks, he was nevertheless concerned with artistic concepts. Design is certainly obvious in *Spiral Jetty*, and so is color since Smithson took great pains to locate a portion of Utah's Great Salt Lake that teems with *red* algae, coloring the water pink. The white salt crystals that formed around the jetty's contoured edges accented its black basalt.

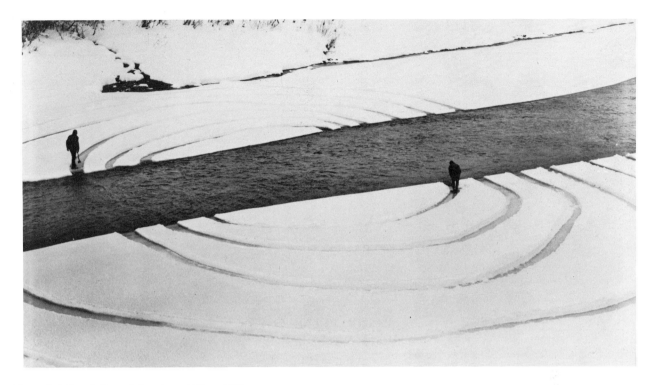

Figure 12.4 Dennis Oppenheim, *Annual Rings 1968*.
Size: 150 × 200 ft. Location: U.S.A./Canada boundary at Fort Kent, Maine and Clair, New Brunswick. Schemata of annual tree rings severed by political boundary. Time: U.S.A. 1:30 P.M. Time: Canada 2:30 P.M.
Courtesy Dennis Oppenheim.

IMPERMANENT ART

In addition to teaching us that art can be conceptual as well as site-bound, Christo introduced to us the idea that art need not be permanent. Despite construction costs of millions of dollars, it can appear and disappear in a matter of weeks. We have thus come to realize that our *perception* of art is far more important than the art *object*. Some impermanent works consist of ice, snow, sand, or earth and are meant to fade away naturally with changes in the natural environment.

Sometimes the works disappear more quickly than planned. An earthwork at a large midwestern university was planned to disintegrate slowly with the wind and rain, but alert maintenance personnel "perceived" the mound of earth as nothing more than it appeared to be, so they hauled it away! And that's all right; in one way or another, the work was meant to be done away with.

Dennis Oppenheim's (b. 1938) *Annual Rings* (fig. 12.4) was produced in 1968 by plowing paths in the snow bordering a river on the United States–Canadian border. The rings were the width of a snow shovel, and the pattern was inspired by the annual rings in the cross section of a tree. So, in addition to our fascination with the temporary nature of the work, we may also be attracted to the combination of widely diverse elements: tree rings are not normally associated with patterns in the snow. And, as temporary as *Rings* was, the design related directly to an aspect of time.

Without seeming to defend Oppenheim's effort as art, it must be assumed that Oppenheim was expressing a *concept* of art. In that sense, the art object is deemphasized in favor of the concept. In fact, we could compare *Rings* to some of the artifacts made by primitive tribal people and could actually say that *Rings* is more "artistic" than, let us say, a ceramic pot because the former reflects pure artistic intent while the latter's purpose was primarily utilitarian. However, artistic qualities are inherent in both avenues of expression because, depending on the circumstances surrounding the artwork, both are valid artistic statements.

People commonly think of art as the permanent works found in galleries and museums. But Oppenheim, Holt, Smithson, and others have brought art into the environment and integrated it with elements in everyday surroundings. And just as many of those natural elements undergo change, so do the impermanent art projects that have become a part of the natural world.

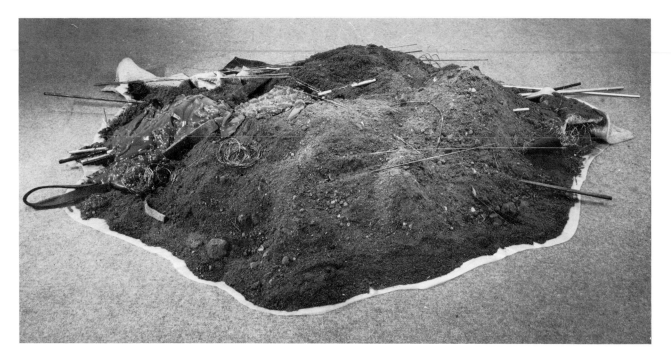

Figure 12.5 Robert Morris, *Earthwork*, 1968.
Earth, peat, brick, steel, copper, felt, aluminum, brass, zinc, and grease.
Approximate size: 2 × 5 × 7 ft.
Photograph courtesy of Leo Castelli Gallery, New York.

EARTHWORKS

Earthworks are particularly representative of the integration of artistic concepts with natural, outdoor materials. Although earthworks are most often constructed out-of-doors so that they may disintegrate with the erosion of wind and rain, some are installed in galleries for a specified period of time and then taken away or otherwise discarded. The "object" cannot ordinarily be sold like a painting, but a certain amount of income is usually realized by charging admission to the exhibition. Furthermore, such an object cannot be viewed as a painting. The formal principles involved in viewing a painting do not apply to earthworks because these artists place so much emphasis on the physical material of their work that elements such as value, line, and formal design are not relevant as criteria for judgment.

Robert Morris's (b. 1931) *Earthwork* (fig. 12.5) is a formless mound of earth garnished with bits of metal, bricks, and grease. Strangely, the earth, universally familiar to all, takes on new significance when brought into the formal atmosphere of the art gallery. The subtle contrasts provided by added elements are minute when compared to the startling effect of bringing a heap of common earth into such an orderly place.

SUMMARY

Environmental art incorporates the relationship of the work and its surroundings. On this tour, we have been concerned with site sculpture, impermanent art, and earthworks. Although it is sometimes difficult to distinguish appreciable differences between the three, each has been designated according to specific emphases.

Site sculpture is a fairly recent development that grew out of the need to find an appropriate location for monumental works. Scale was only one of the primary elements in site sculpture; as size increased, artists tended to surround viewers with a full experience of the work. We were to become, in a sense, enveloped by them and perhaps interact with them on a more intimate basis.

Impermanent art is an aspect of environmental or conceptual art in which the objects are designed to disintegrate, fall apart, or be dismantled in a relatively short period of time. Ice sculpture and earthworks both fall into this category; however, earthworks have a unique appeal due to what we may call a "revised" set of viewing principles. Since such works are often formless and without reference to recognizable concepts, viewers are usually puzzled about the artistic intent. It is the *concept* that must prevail. Our task is to recognize the concepts and to appreciate their aesthetic message.

VIEWING EXERCISES

1. Picture yourself walking into the outer ring of Holt's *Rock Rings* (fig. 12.1). Turn left or right, then stop after a few steps. What do you imagine your feelings would be at this spot? What do you think you would see?

2. Examine *Spiral Jetty* (fig. 12.2) and imagine you are looking at the real thing. What other shapes would have been just as acceptable as spirals on this section of the lake?

STUDIO EXERCISES

Suggested media and supplies: sketchbook; pencil; scissors; rubber cement; light-weight cardboard or a deck of cards.

1. Find the most likely spot in your surroundings that could use some form of site sculpture. Look for a place that is empty and uninteresting—one that seems to cry out for something besides empty space or flat ground. Make some notations in your sketchbook describing in words or drawings what you would do with this area. (Assume that money is no object.)

2. We are all familiar with common forms of impermanence, such as snow figures, soap figures, sand castles, or even a house of cards. Even though these objects are not usually considered artistic, they could become so with imagination and skill. Using a deck of cards, or cardboard cut in a variety of shapes, stack the pieces in a post-and-lintel fashion or fold and lean the cards to create as intricate a monument as possible (do not glue). Take a picture of the result to be shared with others before it tumbles down.

3. Using miscellaneous materials, create a formless heap that is your answer for an earthwork (an earthwork does not always have to be a pile of dirt). A photographic record of your project is optional (but later on, you'll wish you had taken a picture of it).

4. Using any type of paper, fold, crease, cut, or paste to create a three-dimensional sculpture that represents an interpretation of a "spiral jetty." The work may be hung in midair or laid on a flat surface without moving parts.

RESPONSES TO VIEWING EXERCISES

1. Impressions would vary from loneliness to fear as one steps into the concrete rings. The curving walls would seem to lure one into the circular path and into the openings between outer and inner rings. It would be one of the few times one felt as though one experienced a piece of sculpture from the inside.

2. The screwlike design of the earth and rock could have taken the form of any number of shapes. In 1970, the concept was so unique that *Spiral Jetty* would have been nearly as noteworthy if it had been constructed on land. It could also have been constructed in the shape of a half circle, pyramid, square, or any other geometric configuration.

Tour 13 Technological Art

Artists have utilized advances in technology since the beginning of time. We tend to forget the technology involved in making brushes, in manufacturing oil paint, or casting bronze. We even take for granted artists' use of newer materials, such as plastics and acrylic paint. It should be easy for us to imagine other technological tools in the hands of the artist—cameras, neon lights, laser beams, and computers.

The old question as to whether or not photography should be considered an art form can be answered "yes" when the person behind the camera brings an aesthetic intent to the process. Technology and art are united when the artist *uses* the tool (camera) to produce images that are as valid an artistic expression as the paintings in the Louvre. If we can be open to a rather liberal definition of art based on artistic intent, then there need be no limitations on the tools and materials used by the artist. If we can come that far in our acceptance of art, the conceptualists have had their way: all of life has an artistic dimension that is available to those who are receptive and sensitive to it.

PHOTOGRAPHY AS ART

The art of photography can be traced all the way back to Leonardo da Vinci, but we usually date the beginning of permanent photographic images with Louis Daguerre and the early 1800s. As technology improved, photographers began creating illusions of depth and recording people, places and events in unique, expressive ways.

You come across a phenomenom in nature that you can visualize as an image. Then, if you have the craft, you proceed to make it. Without failure.

Ansel Adams

Ansel Adams (1902–84) offered viewers astonishing visual images of nature that, even in black and white, are somehow more striking than the real thing. In *Moon and Half Dome,* the photograph that introduces this chapter, Adams has exhibited the techniques of the landscape artist: he selected subject matter and subsequently manipulated materials and techniques to produce the desired product. The sharp contrasts in this particular picture are achieved by manipulating both the exposure and the development of the negative; the result is almost three-dimensional. Adams no doubt saw the scene over a period of time, and he probably remembered the changes in light and various points of view. Had he been a painter, all these elements would have become part of the picture. So, although Adams chose the moment to release the shutter, his camera recorded only that particular instant in time and in that limited frame.

Adams had an uncommon reverence for the land, especially the vast and monumental scenery of the American West. Only a high regard for nature could have prompted such warm, emotional images of such impersonal subject matter as mountains, sky, and moon. It is this personal interaction between artist/photographer and subject that determines, in large measure, the quality of the artwork. Quality in all art often depends on the masterful integration of content with technique. Adams successfully blended the content with his pace-setting darkroom processing.

◄ *Ansel Adams.* Moon and Half Dome, Yosemite Valley, California, 1960. *Photography by Ansel Adams. Courtesy of the Ansel Adams Publishing Rights Trust. All rights reserved.*

Photography has sometimes combined art with social comment. In Margaret Bourke-White's (1906–71) photograph *Flood Victims* (fig. 13.1), two contrasting views of America are juxtaposed in a disturbing statement about the realities of life. A billboard portrays the ideal American family—beautiful people; two children, a boy and a girl; and the family dog—gaily cruising along in their new automobile without a care in the world. Partially obscuring this idyllic portrait stands a line of forlorn flood victims waiting for a handout of food. Bourke-White's photographic comment speaks more eloquently

than any amount of oratory about the incongruities in our standard of living, not only during the 1930s but today as well. This blend of art and social comment is reminiscent of Goya's protest of the Spanish Inquisition and Daumier's stronger-than-life portrayal of the lower classes in nineteenth-century France (see Tour 8).

LIGHT SCULPTURE

While Adams and Bourke-White worked with light as seen through a camera lens and processed on film, other artists used light itself as their expressive medium. Much of the initial work in light sculpture was done with neon and fluorescent light. Neon lights are bent and shaped into a limitless number of forms while fluorescent tubes glow with an insistent, even quality. These characteristics led Dan Flavin (b. 1933) and his contemporary, Varda Chryssa (b. 1933), to construct hauntingly appealing sculptures that glow in the dark recesses of gallery rooms. Flavin's *Untitled (In Memory of My Father, D. Nicholas Flavin)* (fig. 13.2) consists of an alternating series of circular and vertical fluorescent lights in a uniform blue color. The monumental size of Flavin's structure allows spectators to be enveloped in the experience, and to become personally involved in its expression. The regularly repeated rhythms are similar to those found in Donald Judd's stacked boxes (see fig. 11.21); the style in both is clearly minimalist. It is also noteworthy to

Figure 13.1 Margaret Bourke-White, *Flood Victims,* Louisville, Kentucky, 1937.
Life Magazine © 1937 Time Inc.

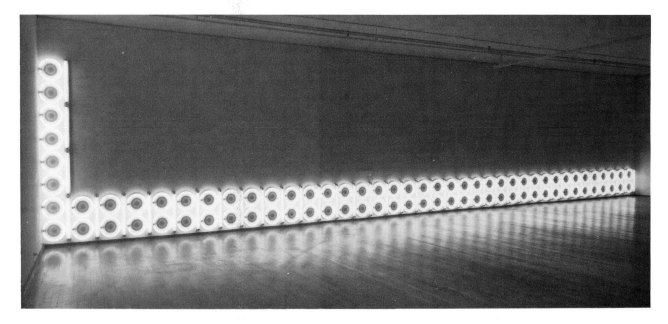

Figure 13.2 Dan Flavin, *Untitled (In Memory of My Father, D. Nicholas Flavin),* 1974.
Fluorescent light; 8 × 48 ft. Photo courtesy of Leo Castelli Gallery, New York.

compare Flavin's lines of light with lines in painting; whereas Flavin's lines are extremely light in value, they not only advance toward the viewers, they fairly leap out at us in an astonishing contrast to surrounding dark areas. Artificial light of the type used by Flavin is loaded with powerful symbolic meanings; his light surrounds and stimulates us just as city lights do on every main street in the world. Flavin builds on this phenomenon and so does Chryssa, a Greek artist who also uses the symbolic properties of artificial light in her work.

While Flavin's light structures tend to be modeled along straight lines, Chryssa often adapts the curvilinear mode of neon lights to her works. When she first visited New York, she was overwhelmed by Times Square. "Believe me," she said, "when I say there is wisdom, indeed, in the flashing lights of Times Square." Neon light became sculpture for Chryssa. In the mid-1960s, she completed a major work called *The Gates of Time Square.* In it, she brought together several artforms: assemblages, neon tubes, and reworked commercially lettered signs. In a similar vein, composed entirely of curved and bent neon tubing, her *Study for the Gates No. 15 (Flock of Morning Birds from "Iphigenia in Aulis" by Euripides)* (fig. 13.3) utilizes repeated horizontal layers of black neon tubing positioned on a large box containing a timer that turns electric power on and off. The title of her work suggests that she developed the idea from her earlier work that parodied neon advertising and extended one of the forms into an unending flow of thin, tubular light. This structure is, like Flavin's, minimalist, but in other subsequent works, Chryssa also borrowed from lettrisme for subject matter.

LASERS

Recent developments in lasers have afforded artists yet another tool by which new and unique images may be created. The word *laser* itself is an acronym standing for **L**ight **A**mplification by **S**timulated **E**mission of **R**adiation. Or in the grandest of oversimplifications, lasers are concentrated beams of light that are capable of functional tasks ranging from delicate eye surgery to cutting through metal. They are also capable of a full range of color, which pleases both artist and spectator alike—hundreds have witnessed entertainment-oriented light shows like the one at Stone Mountain, near Atlanta, Georgia (fig. 13.4).

Some artists, such as performer Laurie Anderson (also a musician), combine laser technology with other electronic imagery to create what is called "performance art." Like the impermanent art discussed in Tour 13, performance artists create active sound and visual events designed to be fleeting and momentary.

The discoveries of yesterday should not become the Mannerisms of tomorrow. A new logic should be found. The mind must always be of "today."

Chryssa

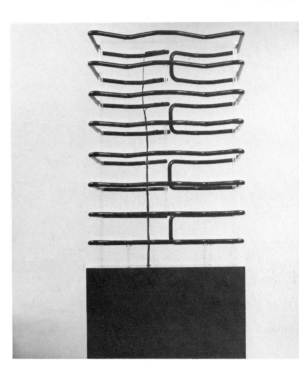

Figure 13.3 Chryssa, *Study for the Gates No. 15 (Flock of Morning Birds from "Iphigenia in Aulis" by Euripides),* 1967. Black glass neon tubing with timer; 62 × 35½ × 29⅜ in. Hirshhorn Museum and Sculpture Garden, Smithsonian Institution.

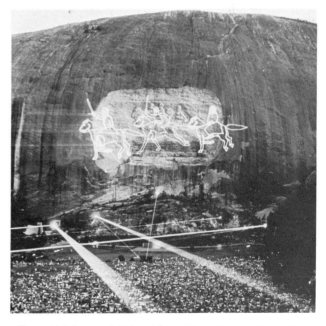

Figure 13.4 Laser animation at Stone Mountain near Atlanta, Ga. © Chuck O'Rear/West Light.

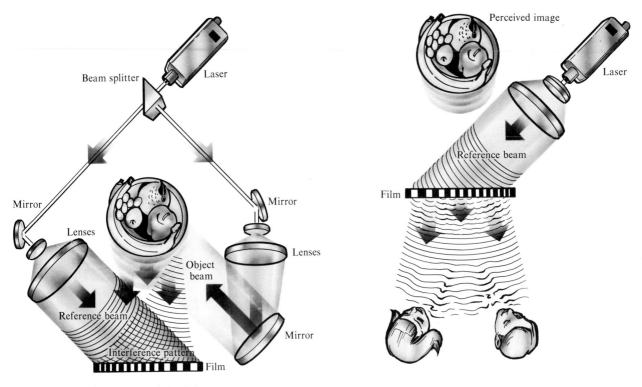

Figure 13.5 Making a laser transmission hologram.
Diagram by Pierre Mion. © National Geographic Society

HOLOGRAPHY

The now famous cover picture of the *National Geographic*'s March 1984 issue featured the faint image of an eagle. Closer inspection, while slowly moving the picture from side-to-side and up and down, reveals a three-dimensional image in ever-changing, brilliant hues. A viewer's first impulse is to run a finger over the silvery surface to verify that it is two-dimensional. As the editors of the *National Geographic* put it, the eagle was a "laser-sculpted image."

Called *holograms* because they are indeed the "complete message" of their portrayed object, these amazing images are composed entirely of focused light. The focused light is actually the split beam of a laser, one half of which is focused on photographic film (reference beam) while the other half is focused on the object and reflected onto the same film. The two split beams intersect and thus create an interference pattern that records all surfaces of the object onto the film. When the reference beam is directed through the processed film, the object is seen as if it were floating in space behind the film—just as it was originally photographed (fig. 13.5).

The Museum of Holography in New York City, located at 11 Mercer Street, contains a variety of holograms. Some of these works have the added dimension of motion, such as *Big Bird* (fig. 13.6). The images are

so real that spectators are tempted to reach out and touch the three-dimensional "object" that appears to be floating in free space. Although the *Big Bird* work is projected with laser light, some types of holograms can be viewed in ordinary light, such as the eagle on the cover of the *National Geographic*.

Some people might say a hologram is a "neat trick," but is it art? It may be too soon for such judgments because artists have not experimented with this new medium long enough to have produced a substantial body of work. On the other hand, the medium does not determine the quality of work so much as the skill of the artist does. Certainly the hologram has as much capacity for creativity as its first cousin, the photograph.

People were once skeptical of photography as art, as well. Alfred Stieglitz, whose sensitive images of his wife Georgia O'Keeffe are legendary, explained the creative "art" photo this way:

"When I have a desire to photograph, I go out in the world with my camera. I come across something that excites me emotionally and esthetically, I'm creatively excited. I see the picture in my mind's eye and I make the exposure and I give you the print as the equivalent of what I saw and felt."[1]

Whether they use brushes and paint, a camera lens, laser beam, or computers, artists create the equivalent of what they see and feel and offer it to us.

1. *Art News,* Summer 1984.

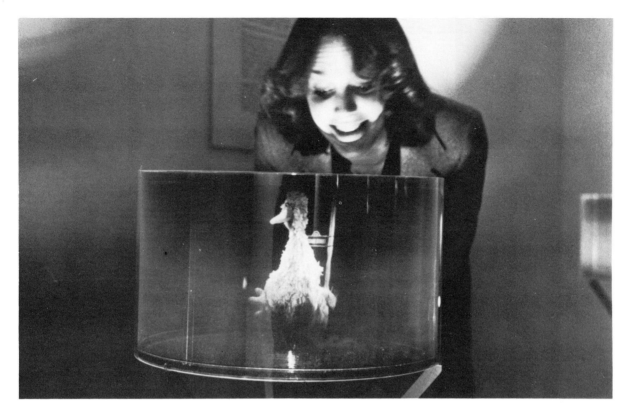

Figure 13.6 *Big Bird.*
The Museum of Holography.

COMPUTER ART

Computer artists are concerned with such problems as creating images with light value, color, form, and texture. Sound familiar? Artists have dealt with these elements since the beginning of time. So then, what is different about computer art? Computers are not electronic brains; they can only respond to instructions from the artists. The computer, however, is capable of performing complicated programming that does much of the work for the artist and that produces most of the final results on video monitors or animated films.

Computer images must begin as programs—the "logic" behind the computer's ability to plot and project. Basic linear movements can be made with a stylus over an electronic tablet or a "mouse" on a flat surface (fig. 13.7). The computer translates these movements into digits and, by means of the program, are "resolved" into images that may be three-dimensional, textured, and in full color.

In essence, computer art is achieved by numbers. Information about desired images is fed into the computer's memory bank, calculated according to its program, and eventually translated from numbers into video signals displayed on a TV screen. The basic process can be

Figure 13.7 A computer artist can program basic lines by using a "mouse".
© Bob Coyle.

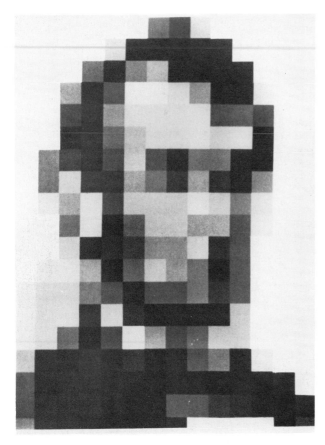

Figure 13.8 Leon D. Harmon, *Computer Cubism?*, 1971.
Courtesy AT&T Bell Laboratories.

Ever since our ancestors finger painted in ochre on the walls of caves, the technology of art has been improving. Chisels, brushes, paints, canvas, pencils, pastels, forges, foundries, kilns, and cameras all are products of technology. When our species wishes to make something beautiful, it first constructs tools . . . a new tool has arrived: the electronic computer, able to store, access, and manipulate large amounts of data, large numbers of picture elements.

Carl Sagan

compared to pointillism, the technique of painter Georges Seurat (see Tour 9) whose artworks were created with thousands of tiny dots of paint, each identifiable by color and intensity. Newsprint photos are also resolved by using tiny dots of black on white to create images. Computers can send and receive such images by assigning a numerical value to the dots (say 0–9) and translating the numerical value back to shades of gray. This was the process used in transmitting pictures from the first moon landing back to earth.

Figure 13.9 Paul Heckbert, *Morphine Molecule*.
© Paul Heckbert/New York Institute of Technology.

Like Seurat's color-dots, the TV picture tube is divided into **pixels** (picture elements), or tiny squares formed by the intersection of horizontal and vertical lines on the screen. The more lines, the more pixels, and the better the picture resolution. Compare an early experiment in computer graphics with a more recent attempt. Leon Harmon's 1971 portrait of President Lincoln, *Computer Cubism?* (fig. 13.8), was made with only 200 squares, each with an assigned value of gray. Viewers may have to squint at the image or view it from a distance before the picture resolves.

With a substantial increase in units, or pixels—let us say up to nine million—a more realistic image is possible. Paul Heckbert created a picture of a *Morphine Molecule* complete with soft shadows as if the image had been lighted from above (fig. 13.9). Imagine how painstaking such a process becomes when each small facet of reflected light off each sphere must be created separately with hundreds of individual pixels and their assigned numerical values corresponding to their proposed light values.

Once the computer is programmed, it is relatively easy for the artist to produce images; each of the pixels is represented in the computer by a number for color and intensity and thus becomes a factor in a process of mathematical calculation. In short, each task performed by the computer is assigned a numerical value; the more tasks involved in a given image or picture, the more numbers, and hence the more time needed to complete the total number of tasks. Programming can also prepare the computer for random operations that, along with the selective process of the artist, compare reasonably with any of the conventional artistic techniques like painting, drawing, and sculpting.

Figure 13.10 David Zeltzer and Donald Stredney, *Jumping George.*
Data Generation by Donald Stredney, Cranston/Csuri Productions; Motion
Control by David Zeltzer, The Media Laboratory, Massachusetts Institute of
Technology.

As we all know, motion is one of the most important added features of computer art. In a fascinating demonstration of the technique, David Zeltzer and Donald Stredney built *Jumping George* (fig. 13.10). The skeletal figure moves by means of a series of programmed skills. In this case, George jumps by first squatting, pushing off while swinging his legs forward, and finally landing in a position similar to the starting squat. Walking is achieved in the same sequential manner, bone-by-bone, step-by-step.

Computer art is used extensively as computer-assisted design in medicine and industry, as well as in television commercials, logos, and motion pictures. In time, virtually all of the movie sets and scenery will be

> Whatever devices are invented in the future, if history has taught us anything, we can be sure that the artist will be there to use, modify, or subvert the devices for the creation of beauty.
>
> *Melvin Prueitt*

realized by computers. Even now it is difficult to distinguish between computer-programmed images and pictures of the real thing. Computer images can be "frozen" and printed, or interacted with, as in flight simulators. Unlike the camera, the computer can generate, manipulate, and transform the image.

SUMMARY

Technology in art refers to the manufactured materials and methods that provide artists with the tools necessary to make art. Technological art encompasses mechanical and electronic devices such as cameras, electric lights, lasers, and computers.

Photography, which includes cinematography, has been with us for well over 150 years. Its artistic value depends on the aesthetic intent of the photographer. Its special and quite unique appeal comes from its ability to capture a subject at a precise moment in time exactly as the image appeared or to amend the image in the developing process.

Instead of using reflected light, light sculptures are composed of artificial light fixtures designed to be viewed directly. Like pop art, light sculpture tends to be symbolic because of our countless cultural associations with various forms of artificial light. The elements of high contrast and intensity also are utilized to great advantage, along with a degree of minimalism.

Light amplified and intensified, by lasers, has become a tool for artists. Spectacular laser animations with a full range of color have been developed. Lasers are also the basis for the creation of holograms—three-dimensional light sculptures. Seen by many for the first time in the motion picture *Star Wars,* holography is now a widely accepted art form. The word *hologram* means "complete message" and was coined for these three-dimensional images because they tend to depict objects exactly in their three-dimensional original state—from 360 degrees.

Among all the mechanical and electronic devices, the computer seems to possess the greatest potential for extending the range of artistic possibilities. Computers are capable of incredibly lifelike images by assigning light values and hues numerically to thousands of tiny TV picture elements called "pixels." Extensive use of computer-generated images has been made in industrial design, medicine, and in television commercials, logos, and motion picture production. The computer's full range of possibilities may never be exhausted.

VIEWING EXERCISES

1. Most would agree that the value of a work of art can be diminished by poor technique even though the content is well conceived. Conversely, a work representing a weak perception of the subject but with a masterful technique would likewise lack merit. Ansel Adams united both technique and content in his startling photographs. Discuss the compositional aspects of the photo on page 286 that makes it as "artistic" as any painted landscape.

2. Imagine a neon sign that is somewhat similar to one of the neon light configurations by Don Flavin or Chryssa. What are some of the differences between a neon sign and light sculpture?

STUDIO EXERCISES

Suggested media and supplies: cardboard, scissors, glue.

1. Collect magazine photos that illustrate contrasting views of American life. Cut, arrange, and glue the photos on a cardboard surface so that they fit and work together both as shapes and as a social statement (see fig. 13.1). Collect magazine photos of architecture and objects found in cities. Cut, arrange, and glue shapes to form a collage that has a city theme. Other themes could be explored as well.

2. Look through family photographs and find one that works compositionally and one that doesn't. In both cases, explain why and describe what should have been done differently to make each better. Select the one that doesn't work and prepare a sketch that improves the composition.

3. Discuss why you feel the sketch you made in exercise 2 improved the composition. Find subjects in your immediate surroundings and take photographs employing the principles you used to correct the family photo.

4. Develop a sketch for a neon sign that would make an artistic statement as well as a social comment. Compare your ideas with the class to determine how well your sketch reflects your intent.

RESPONSES TO VIEWING EXERCISES

1. Adams tried to see his subject as the camera saw it. He framed the scene in the viewfinder and his design sense made him aware of the balance of shapes. Then he chose the time of day that produced the most dramatic source of light on the subject. The photograph didn't just happen; it was caught on film because of Adams's sensitivity to nature and his ability to visualize the arrangement of natural forms and light at their best. In addition to this artistic perception, Adams was also meticulous in choosing a unique type of development and the correct type and speed of film.

2. One of the major differences between neon signs and light sculpture is the intent behind each. Signs are made to advertise, and artworks are made to communicate aesthetic messages. In Flavin's case, as well as Chryssa's, light sculptures are laden with symbolism and, in a sense, comment in an artistic way on the impact of neon signs in our environment.

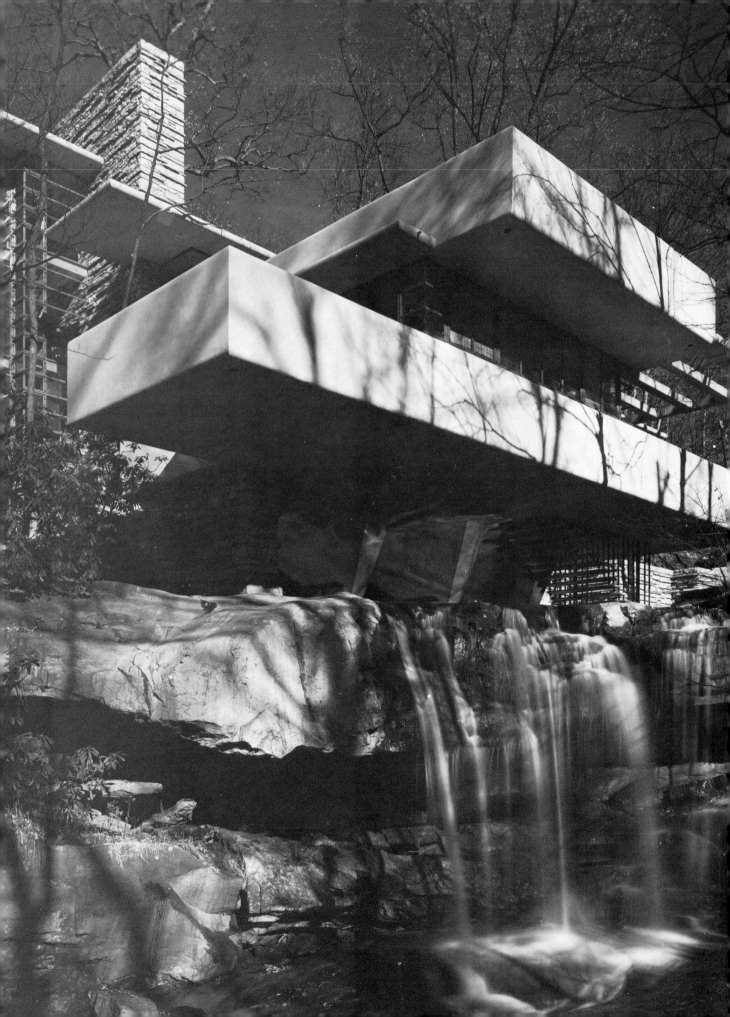

Tour 14

Twentieth-Century Architecture

Though art historians could provide a wealth of information, our purpose here is not to focus on the history of architecture. Rather, this tour selects five major architectural monuments from three continents, primarily to show their merits as artworks. The five selected artworks are significant not only because of their diverse styles, but also because of the way function relates to their artistic dimension. And, as art appreciators, we should be concerned with the visual effectiveness of architecture and its place in the natural environment. We will examine these aspects of the five artworks in attempting to gain insights that will help us become informed observers and consumers of architecture.

The planning involved in an architect's creative process is similar to that used by other visual artists. Their design procedure often includes models, preliminary sketches, computer-assisted graphics, and a host of technical notations related to everything from placement of a staircase to the direction of sunlight. Finally, the process evolves to the more mechanical duties of producing blueprints and taking bids from construction firms. We need to remember that modern architecture is a highly specialized area of the fine arts. It demands that the architect reconcile artistic form with principles of engineering, function, building materials, and construction methods.

Architecture can be viewed in nearly the same manner as sculpture, but since we, of course, do not live or work inside sculpture, there will also be significant differences between the two. In order to first see them as pure sculptural forms, we need to examine this group of architectural monuments as a whole, disregarding comparative age, scale, or size of the buildings. Let us pause before the following structures and make general comparisons and contrasts:

Frank Lloyd Wright (1867–1959), Kaufmann House, "Fallingwater," Bear Run, Pennsylvania

Ludwig Mies van der Rohe (mees van' der roh'-uh) (1886–1969), Seagram Building, New York City.

Le Corbusier (luh kor-boo-zee-ay') (1887–1965), Chapel of Notre-Dame-Du-Haut, Ronchamp, France.

Pietro Belluschi (pyay'-troh bell-oos'-kee) (b. 1899), Saint Mary's Cathedral, San Francisco, California.

Jorn Utson (yern oot'-sun) (b. 1918), Sydney Opera House, Sydney, Australia.

STYLISTIC ANALYSIS OF FIVE STRUCTURES

New directions in design and construction stemming from the advances made by all five of these architects have gained world-wide recognition. Specifically, Mies van der Rohe, Frank Lloyd Wright, and Le Corbusier provided much of the impetus for explorative design and innovative construction in which the practical concerns of architecture were fused with those of sculpture. Mies and Corbusier became followers of a new wave of architecture developed in the 1920s called the **International Style,** which was known for major architectural innovations. In the late 1940s Le Corbusier, the Swiss painter-architect (whose real name was Charles Édouard Jeanneret-Gris), suggested the slab shape of the Secretariat Building of the United Nations complex in New York City, and the International Style was launched in America. With the use of structural steel and reinforced concrete, architects were able to eliminate outside support walls of a building. This allowed greater flexibility in design: exterior walls of glass allowed more light to enter the building and doors were enlarged for better access. Decorative elements, which would have disturbed a building's classic simplicity, were avoided in the new style.

◄ *Frank Lloyd Wright. Kaufmann House, "Fallingwater," Bear Run, Pennsylvania. Photo by Bill Hedrich, Hedrich-Blessing.*

297

Another important feature of the International Style was its emphasis on space in relationship to mass. Whereas Gothic cathedrals concentrated on massive structural supports, the new style placed smaller steel supports in various ways to open up space—to allow us the feeling of interacting with the outside environment from within, while reflective glass creates constantly changing patterns from without.

By looking at the entire shape of the Seagram Building (figs. 14.1 and 14.2), we become conscious of its symmetry and the absence of unessential, decorative elements. Mies's axiom held great philosophical significance for architects who felt that minimizing the use of unimportant decorative elements was necessary for pure simplicity. In the Seagram Building, a classic among glass skyscrapers, Mies created a design in which the interior and the exterior work as a single, unified whole.

Even the doorknobs in the building were designed with a concern for form following function. The expression "form follows function" was coined by the American architect Louis Sullivan (1856–1924). Sullivan taught his young assistant, Frank Lloyd Wright, that the form of a structure is interdependent with the function it serves. Sullivan recognized the functional form of the steel frame and ushered in a world of skyscrapers.

Belluschi adopted this relationship in Saint Mary's Cathedral, in which religious and structural concepts are fused. It is not coincidental that the design was the first to be based on the Second Vatican Council directive that the people should be in closer proximity with the priest and the altar. Instead of the long and narrow approach to the altar found in the great cathedrals of the past, the congregation surrounds Saint Mary's altar (see fig. 14.10).

Less is more.

Mies van der Rohe

With me, architecture is not an art, but a religion, and that religion but a part of Democracy.

Louis Sullivan

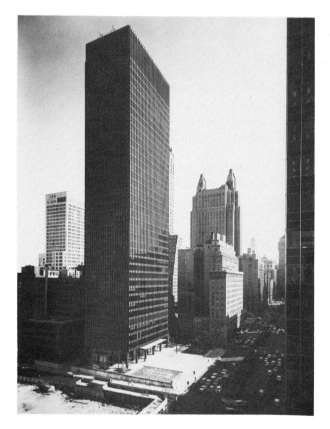

Figure 14.1 Ludwig Mies van der Rohe: Seagram Building, New York City.
Ezra Stoller/Esto. Courtesy Joseph E. Seagram & Sons, Inc.

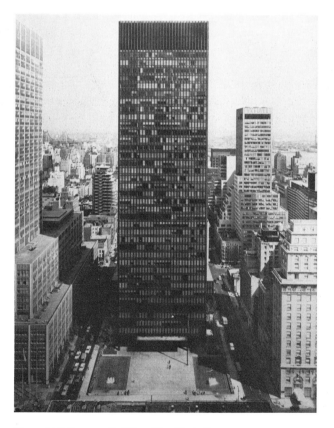

Figure 14.2 Seagram Building, New York City.
Ezra Stoller/Esto. Courtesy Joseph E. Seagram & Sons, Inc.

We should recognize architects' efforts in following the principle of classical restraint, or economy of means, that was so important in the development of neoclassical art (see Tour 8). Wright addressed this principle by using many rectangular forms interlocked asymmetrically and projected into space. This system of construction, called a **cantilever,** requires vertical supports at one end of a projecting slab (fig. 14.3). The projections are made of concrete formed around steel rods and mesh, which combined with the strength of larger structural steel beams, is called **reinforced concrete.** This twentieth-century innovation has allowed a great deal of flexibility for the precasting of free forms, especially flowing curvilinear motifs like those seen in the Chapel of Notre-Dame-du-Haut and in the Sidney Opera House.

Wright designed buildings with landscape in mind. He called this site-structure marriage "organic" architecture. The location of the cantilevered Kaufmann House, for example, with its waterfall in a cliffed, wooded area (see p. 296) was a factor in the building's asymmetrical design. The design of the structure itself included glass walls that allowed the interior and exterior to interact (fig. 14.4). Le Corbusier and Belluschi also had the advantage of distinctive settings. In each example, a hilltop increases the effectiveness of the work.

Typical houses have a tendency to "huddle". . . and to tip everything in the way of human habitation up edgewise, instead of letting it lie comfortably and naturally flatwise with the ground.

Frank Lloyd Wright

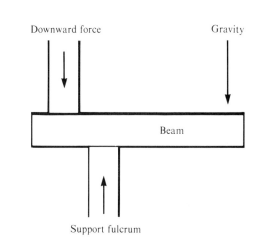

Figure 14.3 Cantilever construction.

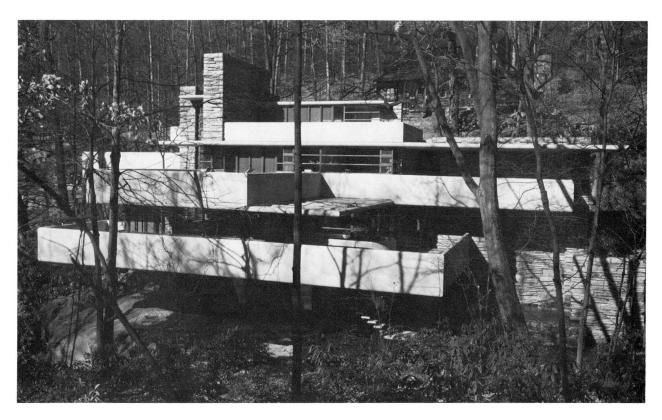

Figure 14.4 Frank Lloyd Wright: Kaufmann House, "Fallingwater," Bear Run, Pennsylvania.
Photo by Bill Hedrich, Hedrich–Blessing.

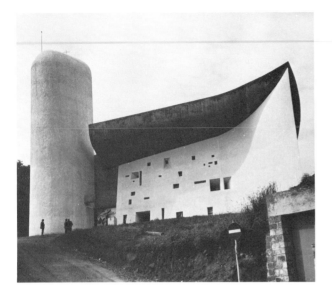

Figure 14.5 Le Corbusier: Chapel of Notre-Dame-du-Haut, Ronchamp, France.
Lucien Hervé, Paris.

Both buildings are invested with dramatically upward-sweeping contours, but the Chapel of Notre-Dame-du-Haut (fig. 14.5) is basically an asymmetrical form while Saint Mary's (fig. 14.6) is a paragon of stark symmetry.

The famous sculptural forms of the Sydney Opera House seem to reflect, through the rhythmic curves of the roof, the musical sounds emanating from within. Jorn Utson, a Danish architect, won the 1956 design competition for the new opera house; it took thirteen years to build. Precast concrete forms were placed asymmetrically on low platforms extending into Sydney Harbour like a huge pier. The repetition of white, ceramic-tiled, sail-like forms unfolding in space imparts a feeling of billowing movement (fig. 14.7). The larger to smaller gradation of exterior shapes of the opera house, with their impressive simplicity, makes a complex engineering problem look easy. The reinforced concrete roof alone weighs 157,800 tons; there is nothing simple in planning such a free-flowing structure that will not crumble under its own weight. The fronts of the shells are covered in all with about 2,000 panes of tinted glass over an expanse of 67,000 square feet. In considering the great amount of light that streams into the structure, we must conclude that light was one of the architect's major concerns.

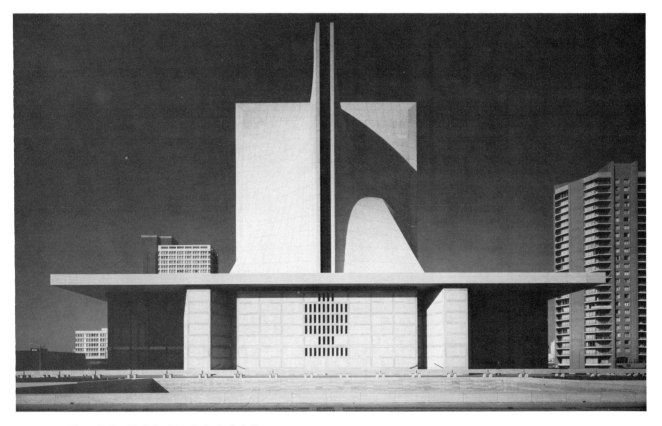

Figure 14.6 Pietro Belluschi: Saint Mary's Cathedral, San Francisco, California.
Photograph © Morley Baer.

THE IMPORTANCE OF LIGHT

Architects work with the use of both artificial and natural light, as do sculptors who must take into account available light sources and how they will strike the finished form. Specifically, architects often place walls of glass or windows in relation to the sun. In order to make both space and solid forms come to life, Le Corbusier controlled the amount of light entering his Notre-Dame-du-Haut by designing a pattern of rectangular openings in the walls (fig. 14.8). From the outside, the openings appear as small rectangles arranged in an asymmetrical random pattern. From the inside, however, we can see the way in which they were planned to work together and open up through thick masonry walls into wide windows; these areas are called "splays," and some are large enough to be rooms (fig. 14.9). Le Corbusier felt that traditional stained glass obscures the building's natural surroundings. Consequently, he used a combination of colored transparent glass and clear glass, allowing people inside to view exterior images accented by color.

Sunlight filters through the surrounding landscape and creates changing patterns on all parts of the many levels of Wright's Kaufmann House. Wright also had to balance the shadows created by the rectangular forms themselves as the sun changed its position. Entire walls of glass permit a natural illumination. Light is no less important in the Seagram Building, whose gray and amber-tinted glass mirrors the surrounding skyline. In fact, the entire lighting system was designed to be just as impressive after dark with reflective ceilings that, from the outside, seem to glow.

Figure 14.8 Axonometric drawing of the Chapel of Notre-Dame-du-Haut showing modular wall openings.
Courtesy Le Corbusier Foundation, Paris. Lucien Hervé, Paris.

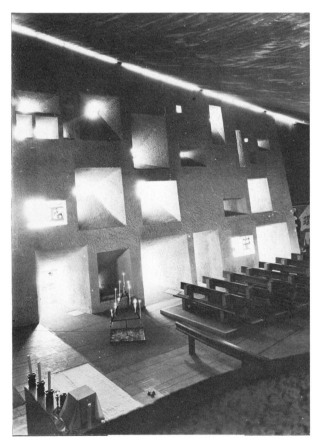

Figure 14.9 Le Corbusier: Chapel of Notre-Dame-du-Haut (interior).
Lucien Hervé, Paris.

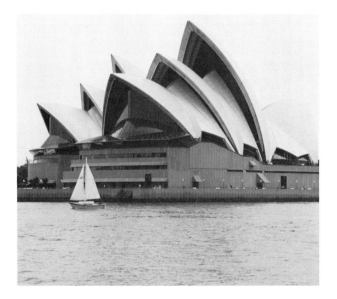

Figure 14.7 Jorn Utson: The Sydney Opera House, Sydney, Australia.
Australian Tourist Commission.

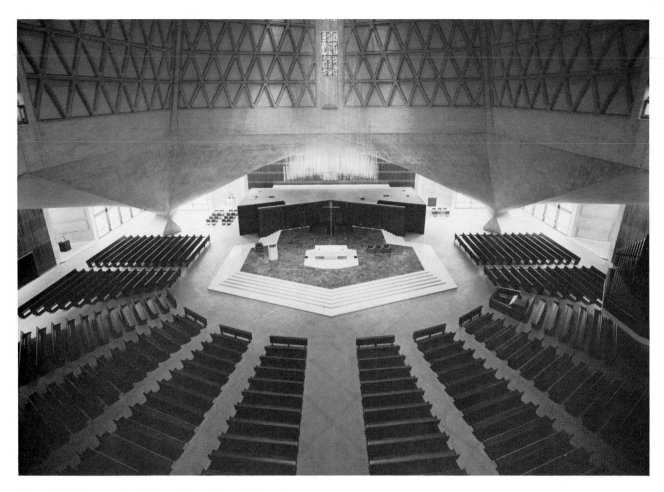

Figure 14.10 Pietro Belluschi: Saint Mary's Cathedral, interior.
Baldacchino by Richard Lippold and altar.
Photograph © Morley Baer.

THE USE OF TEXTURE

Saint Mary's illustrates the collaboration between architect and artist. The famous artist Gyorgy Kepes (b. 1906) designed the stained-glass windows, which are 6 feet wide and 130 feet long. Sculptor Richard Lippold (b. 1915) was commissioned to create a **baldacchino** (canopy) (fig. 14.10) over the altar. The vertical repetition of the aluminum rods that seem to hang without support from the cupola adds an interesting focal center for the interior. The rods also provide a shimmering textural quality not usually seen over traditional altars.

The textural effect of the triangular acoustic tiles encircling the canopy is even more dramatic. These repeated geometric shapes are placed in opposition to the curved, upward-flowing lines of the 190-foot cupola (fig. 14.11) that in turn are set against the smooth surfaces of the massive, concrete, support piers below, also forming a triangular motif. We can assume that the triangular motif may have been selected to represent the Trinity.

These distinctly different art forms in this setting provide dynamic foils for one another. The exterior of Saint Mary's is covered with square and rectangular pieces of travertine marble, creating a smooth, quiet texture that contrasts with the unrestrained variety of the interior.

The Chapel of Notre-Dame-du-Haut is also texturally dramatic. Exterior contrasts are immediately evident between the roof striations and the smooth outer walls. This textural opposition is continued on the interior where ceiling striations work as a foil against the coarse, sprayed mortar walls. Light streams in from an open space between the side walls and the roof and also from the windows creating constantly varying shadows on the walls' textured surfaces.

Notice how the window coverings create everchanging intervals of dark and light units as a result of all the human activity inside the Seagram Building. The effect of these exterior changes is heightened by the "wet look" of reflective glass. The Seagram Building can be appreciated even more by visiting the actual site, because it is set back from the street to allow viewers a wider field of vision.

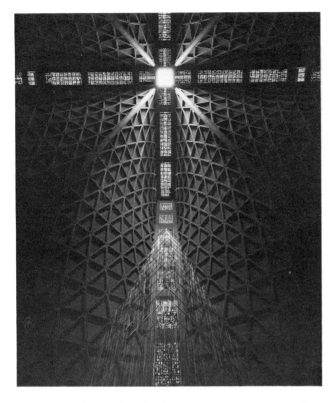

Figure 14.11 Pietro Belluschi: Saint Mary's Cathedral, interior of cupola.
Photograph © Morley Baer.

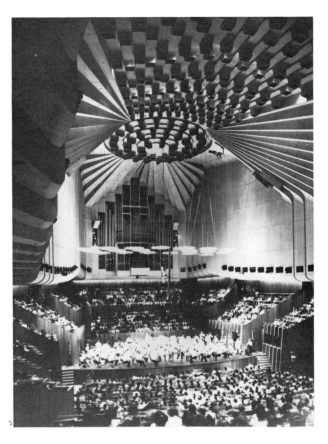

Figure 14.12 Jorn Utson: Interior of the Sydney Opera House, Concert Hall.
Australian Information Service.

The roof of the Sydney Opera House displays an exterior mosaic-like texture created by over a million ceramic tiles. Texture on the inside is both decorative and functional; it serves to disperse sound waves to improve the acoustics of the hall (fig. 14.12).

Texture is applied to Kaufmann House with patterns of shadows cast from nearby trees and foliage and reflected against the flat shapes of the cantilevered decks. Textural contrasts are provided by the natural site and the smooth, dominant horizontal planes. Further contrast occurs between the rough rectangular column of cut stone set against the smooth horizontal decks.

SUMMARY

Technological developments affect the visual appearance of architecture nearly as much as they affect the functional design. The cantilever and reinforced concrete are only two of the most obvious discoveries that have allowed architects to create works with strong visual appeal as art objects. Texture, light, balance, contrasts of various kinds are concerns of architects and artists alike. And, as we have seen in architecture of the past, the style of these monuments reflects the art of the times. Above all, we should remember that architecture is an art form and is thus subject to all the viewing methods applied to the other visual arts.

VIEWING EXERCISES

1. How is the composition of Mondrian's painting *Composition* (colorplate 61) similar to that of Wright's Kaufman House?
2. Look around the building you are presently in and find an example of form not following function. Explain why you feel the architect was not concerned with this principle, or why it was not important in the example you cite. Among the things you use in everyday living (chairs, tables, lamps, etc.), find an example in which the designer stressed the form-function principle.
3. Compare the difference in need and purpose for lighting between Notre-Dame-du-Haut and the Seagram Building.
4. Consider why Utson used 2,000 panes of glass in 700 different sizes to cover the open ends of the shells of the Opera House, instead of using larger glass coverings.

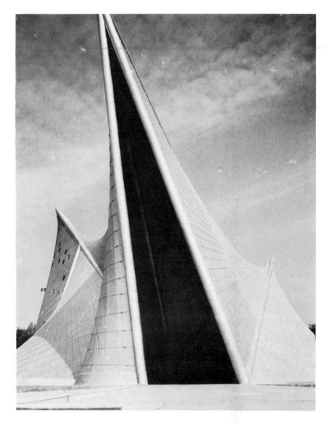

Figure 14.13 Le Corbusier: The Philips Pavilion, Brussels World Fair, 1958.
Lucien Hervé, Paris.

le Corbusier's Notre-Dame-du-Haut (see fig. 14.8) and Picasso's *Les Demoiselles d'Avignon* (see fig. 10.11).

9. Varèse's exotic electronic piece *Poème Electronique* was composed to be played on magnetic tape over 400 loudspeakers inside Le Corbusier's Pavilion at the 1958 World's Fair in Brussels (see fig. 14.13). How are the two works related in terms of sight and sound?

STUDIO EXERCISES

Suggested media and supplies: paper or cardboard, glue, paint.

1. Create a miniature architectural model with small identically sized boxes or cubes made from folded paper or cardboard. Stack or glue the pieces together to form a symmetrically balanced skyscraper. Architectural details or painted surfaces may be added to the separate "modules" if desired.

2. Use the same material as above and create an asymmetrical, cantilevered model of a house. Ready-made modules, such as small cereal boxes, may be used and then painted. Note the repetition of equal-sized modules used in the Seagram building that create rhythm and overall unity.

3. Imagine Mondrian's painting *Composition* (colorplate 61) to be a plan for one floor of a residence. Draw the lines and shapes larger; designate each room; and indicate windows, doors, and other architectural details. Compare your plan with others in your class and discuss the merits of design in terms of space utilization, traffic flow, and so on. If time and materials permit, you can build a three-dimensional model by erecting walls of cardboard with window and door openings and painted details.

4. Le Corbusier's Philips Pavilion in Brussels (fig. 14.13) contained four rooms supplied with piped-in music. Design a floor plan for an exhibition hall composed of only four shapes, any size, that touch one another on at least one junction. What music would you select to be played throughout your make-believe hall that would enhance the viewers' visit? Play the music and discuss the rationale for your rooms' design with the class.

5. Compare Le Corbusier's Notre-Dame-du-Haut and Wright's Kaufmann House with Nancy Holt's *Rock Rings* (see fig. 12.1) in terms of the relationship between people inside the structures and the outside environment.

6. In site sculpture, one of the artist's primary goals is to create art that works effectively with its environment. Consider whether this goal was achieved with the Kaufmann House.

7. Look at the interior of Notre-Dame-du-Haut (see fig. 14.8 and 14.9) and imagine all window openings of equal size, placed in rows. Why is Le Corbusier's arrangement more interesting?

8. Listen again to a recording of Stravinsky's *Rite of Spring*. Remembering that this work premiered in Paris in 1913 when romantic music was at its zenith, try to imagine the impact of Stravinsky's piece and how it compared with the innovations of

RESPONSES TO VIEWING EXERCISES

1. Mondrian's painting is based on an asymmetrical arrangement of stripes and solid block shapes. This same principle of balance was used by Wright in the Kaufmann House. Time and careful attention to shapes, line, and color were as much a part of the Mondrian as they were in the design of Kaufmann House.

2. Although the building you are now in may be full of examples of form not following function, remember that it might not always be possible or desirable to follow this procedure. In looking around, you might be surprised by the lack of harmony between the outside style and the inside of the building. The outside may be warm and inviting, while the inside is cold and impersonal. Large, wasted spaces inside may have been necessary to accommodate what looks impressive from the outside, such as walls of glass or ornate doors serving only as decoration.

 Our everyday articles of clothing, dinnerware, furniture, and automobiles have been designed by artists who, to some degree, considered form and function. On the other hand, you may at this minute be sitting on a chair that is giving you a backache. Consider the high cost of design, the resulting need for mass production, and the rising material costs needed to make the chair a comfortable seat for the human body, and you have an idea why design is sometimes compromised for the sake of profit.

3. Interior light in the chapel is primarily used to enhance its spiritual quality. If Le Courbusier had used a wall of glass, it would probably have overpowered the congregation, the direct light making the interior less intimate for worshipers. The Seagram Building's purpose is different in that light was needed for thirty-eight floors of offices and service areas where hundreds of people work daily.

4. The cost of breakage and replacement of glass is only one reason for dividing the open shells into many panes. An important aspect was the visual excitement created by the repetition of many different sizes of glass units which, at the same time, break up entering light to avoid harsh glare.

5. Le Corbusier used transparent glass in Notre-Dame-du-Haut because he wanted the congregation to maintain visual touch with passersby and with movements of trees and clouds outside. Wright also considered such an allowance in Kaufmann House, where visual access to the site was provided through vertical interior walls. This idea is similar to Holt's *Rock Rings* (see fig. 12.1), where openings also invite the spectator to maintain visual communication with the outside.

6. Imagine the architect's many problems in building a house over a waterfall! Wright's style of blending architecture with its natural surroundings culminated in the Kaufmann House, where nature becomes one of the components of the architectural structure. His aim was to create new architectural structures that reflect the organic quality of nature (i.e., log cabins blend better with the forest than brick houses).

7. A symmetrical arrangement of openings, all the same size and in rows, would conflict with the overall asymmetrical configuration of the building itself. Nothing in the design of the chapel is symmetrical—no two walls are alike, and the roof and bell tower are placed off the central axis. Compare it with the symmetrical Seagram Building and Saint Mary's Cathedral.

8. Audience members were so disturbed over the strange new sounds in Stravinsky's work that they actually began to riot. Stravinsky came to be known for his trend-setting advances in music composition, just as Le Corbusier and Picasso did in the fields of architecture and art.

9. Le Corbusier's Philips Pavilion comprises four large rooms imitating the four chambers of a cow's stomach. Varèse's music piped throughout the odd configuration completes the production of an eerie, other-world sensation. Both works are unconventional, bordering on the fantastic; both seem formless according to traditional rules of architecture and music. Yet both works possess form, mainly through the repetition of certain basic features—the tilted peaks of the Pavilion and short motifs in the music.

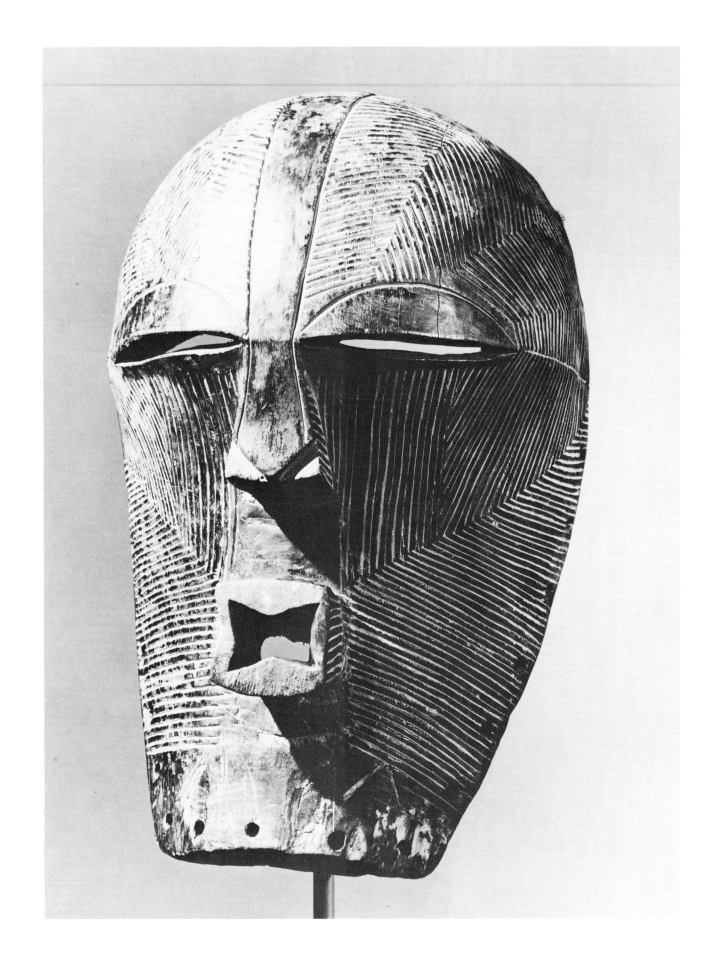

Tour 15

Outside the Mainstream: An Introduction to Tribal Art

During previous tours, we witnessed various style changes occurring over thousands of years in civilizations throughout the world, but humankind's need to create has never changed. In that regard, anonymous tribal artists, similarly inspired, have created works exhibiting mature artistic qualities as refined as those found anywhere. This tour will illustrate the values and traditions of the art of diverse tribal cultures from Africa, from Oceania, and from the Americas. The widely separated origins and various cultural and religious motivations have resulted in art forms that are unknown to those of us who may be familiar only with the famous artworks and popular art trends of our own culture. Our perception of tribal art will have deeper meaning if we look at each work with the same care and receptiveness that we would give to any artistic production: to see the work as revealing the depth of the tribal artist's awareness and sensitivity to beauty.

> "Primitive art forms should be recognized for what they are, the expressions of deeply rooted art traditions which dictated to a great extent the basic designs that the professionally trained primitive artists were required to follow. In other words, it was specified that an art form, commissioned for a specific practice, agree in general with the forms traditionally used. Primitive art is, therefore, not a free, uncontrolled and untutored creation."[1]

When we view tribal art as a curiosity, we tend to think in terms of *we* and *they*. This is a normal human response to things we don't understand. One way to encourage a better understanding of this work is to think of its similarities to Western work rather than its obvious differences.

Tribal art is not as different from art as we know it as one might first suspect. The artisans have distorted and exaggerated forms just as Occidental and Oriental artists have done throughout recorded history. They have used symbolism in art; they also have transformed and idealized nature. The artisans were probably trained in tribal traditions and by apprenticeships similar to the way most artists learn their craft. The major differences between art as we have come to know it and the art of tribal societies is the intimate association between art and function in daily living. Consequently, the appreciation of tribal art may demand more on our part as viewers of these objects that are isolated in museums from their cultural settings. Therefore, while our main concern here is to attempt to understand their artistic qualities, we will devote some of our study to the various functions of tribal art.

Some of these earlier "primitive" art traditions influenced twentieth-century Western art; unfortunately, due to Western influences on tribal societies, many art forms have now disappeared or deteriorated. Museums throughout the world have preserved earlier tribal art and offer us an opportunity to experience the rich artistic drama and imagery that people have enjoyed for centuries.

AFRICAN TRIBAL ART

African people comprise many tribes and linguistic groups (fig. 15.1). Their art encompasses dance, music, costuming, body decoration, storytelling, rock painting, monument sculpture, and architecture. Because of the abundance of wood, shells, and natural fibers, much of what we call African tribal art is extremely perishable, and what we see in museums may date only from the nineteenth and twentieth centuries. This part of the tour presents some of the best-known sculptural forms associated with African tribal life.

1. Paul S. Wingert, *Primitive Art: Its Traditions and Styles* (New York: New American Library), p. 9.

◄ Songe Tribe Mask.
Wood, paint; H. 17½ in.
The Metropolitan Museum of Art, The Michael C. Rockefeller Memorial Collection, Bequest of Nelson A. Rockefeller, 1979.

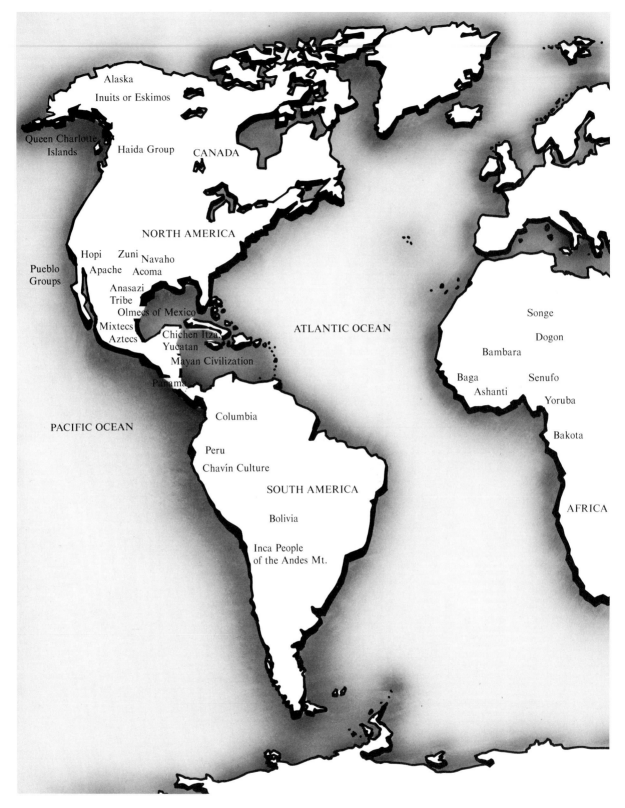

Figure 15.1 World Tour of Tribal Art.

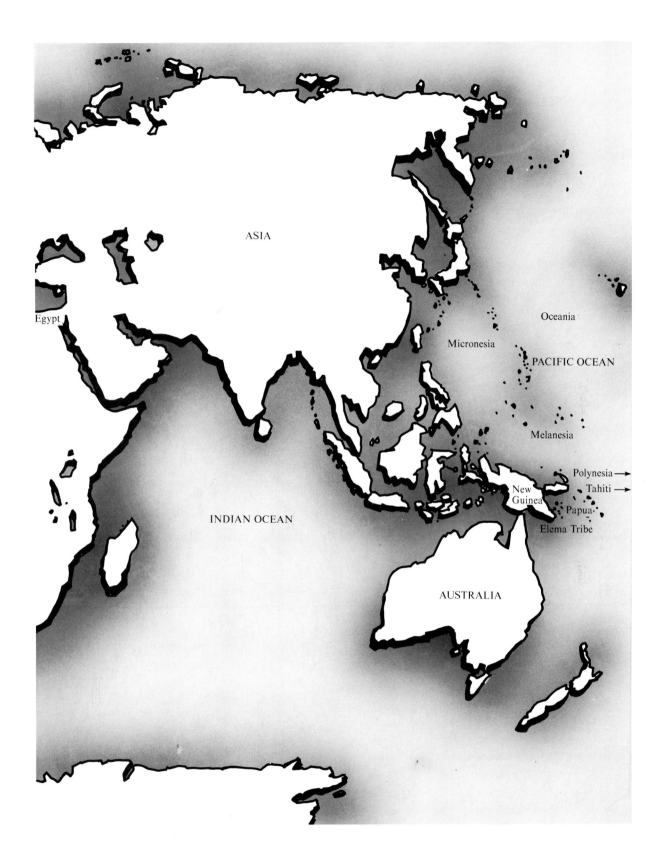

ASIA

Egypt

Oceania

Micronesia

PACIFIC OCEAN

Melanesia

Polynesia →

Tahiti →

New
Guinea

Papua

Elema Tribe

INDIAN OCEAN

AUSTRALIA

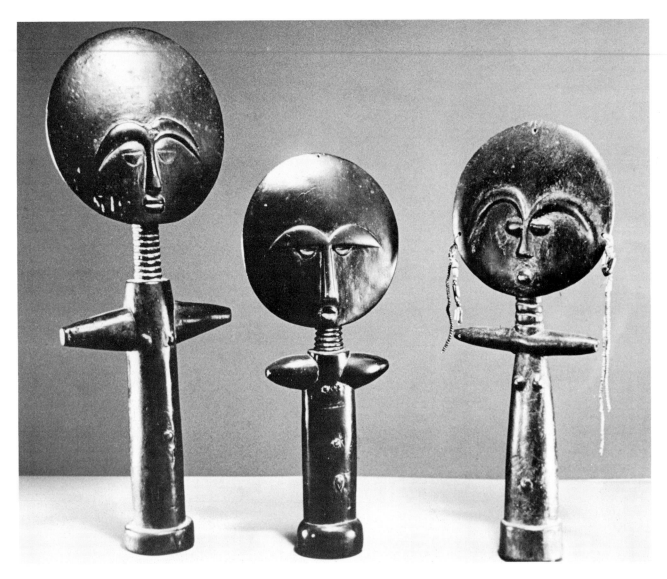

Figure 15.2 Ashanti Fertility Dolls. *left*, 15½ in.; *center*, 11¾ in.; *right*, 12½ in.
Lee Boltin Picture Library.

The Fetish

A fetish is a type of ritual sculpture common to most African social groups and is thought to generate magical powers; it is most often used either to ward off evil spirits or to attract the good. In some tribes fertility dolls, like the *Ashanti Fertility Dolls* in figure 15.2, were given to pubescent girls or to expectant mothers to ensure the birth of healthy, normal children.

It is interesting to note the consistent design in these dolls. Each one is a bit different in size and detail, yet all are based on a similar symbolic treatment of head, neck, and body. Their simplicity makes them easy to carry about in loin cloths or to hang around the neck.

Appearing in human or animal form, a fetish can support material such as teeth, claws, hair, bile, or excreta, which are used to activate the magical forces held within the figure. Metal pieces or nails were inserted into the *Nkonde Nail Fetish* (fig. 15.3), possibly to fulfill a wish or to inflict pain. The person driving the nail then assumes the strength thought to be held within the figure. Like most African sculpture, neither the nail fetish nor the fertility doll represent a specific personality or a particular age level; rather, their subjects are idealized by reference to their entire life span.

Other fetishes cure diseases, guard homes, and protect young people. It is believed that some fetishes can house evil spirits that will inflict harm on enemies, spread diseases, or devour those in disfavor.

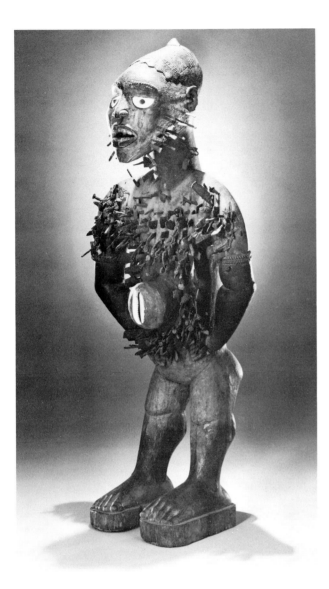

Figure 15.3 Nkonde Nail Fetish (1875–1900).
Wood with screws, nails, blades, cowrie shell; H. 46 in.
Founders Society Purchase, Eleanor Clay Ford Fund for African Art, Detroit
Institute of Arts.

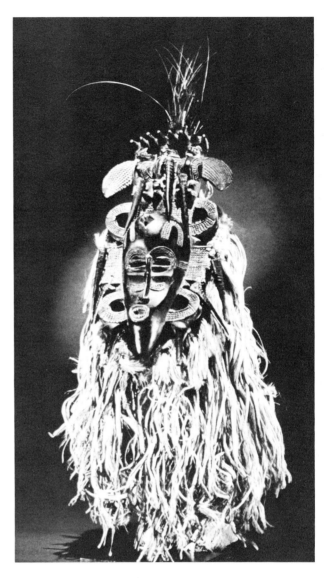

Figure 15.4 Mask of the Senufo Tribe, Ivory Coast.
Wood, other materials; H. 14⅛ in.
Lee Boltin Picture Library.

Masks and Headdresses

A universal art form throughout Africa, Asia, and the
Americas since prehistoric times has been the ritualistic
mask. In Africa, masks were worn by warriors and were
also parts of the essential costumes of tribal dances and
various rituals.

Many masks were carved for specific functions: an ex-
orcist would wear a mask used only in the ritual of ex-
orcism, a different type of mask would be used in
initiation ceremonies, and still other types for funeral and
agricultural rites. A mask was designed to raise the
wearer's courage, to instill fear in the enemy, to repel
evil forces, and to allow both the wearer and observers
to confront hidden spiritual forces. Mask styles are as
varied as their uses and range from natural portrayals
to abstract and geometric images of either animal or
human forms. Except for the masks occasionally used by
secret societies of women, tribal masks were carved and
used exclusively by the men of the tribes. A considerable
number of masks had straw or raffia (palm leaf fiber)
tied to them, and some had a costume attached that cov-
ered the entire body during ritual dances. The wearer of
a mask such as the *Mask of the Senufo* (sen-oo′-foh)
Tribe (fig. 15.4) not only assumes the role of the spirit
being portrayed but, in effect, subjugates his own per-
sonal identity and becomes the spirit. The lavish use of
native materials combined with naturalistic and sym-
bolic forms is typical of the region. Textural designs on

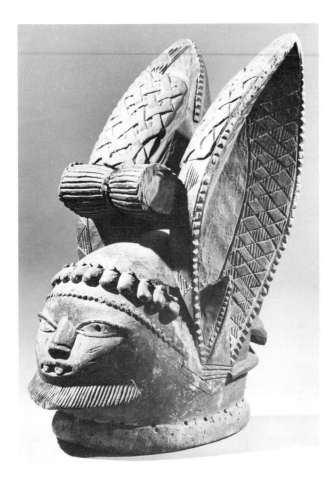

Figure 15.5 Yoruba Headdress, Nigeria.
Wood, paint, nails; H. 15⁴/₅ in.
The Metropolitan Museum of Art, The Michael C. Rockefeller Memorial
Collection, Bequest of Nelson A. Rockefeller, 1979.

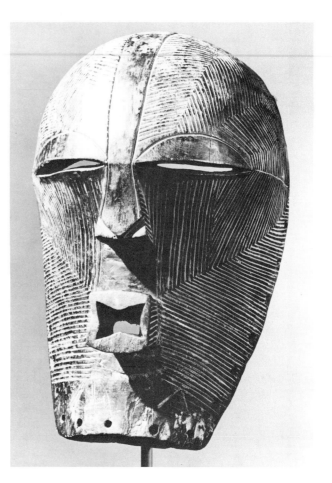

Figure 15.6 Songe Tribe Mask.
Wood, paint; H. 17½ in.
The Metropolitan Museum of Art, The Michael C. Rockefeller Memorial
Collection, Bequest of Nelson A. Rockefeller, 1979.

"Most works of [primal] art show a highly satisfactory combination of form and content. However, it is true that contemporary observers are more likely to derive enjoyment from the form, since the content is lost in the symbolization of the culture in which the work was created.

Robert Bruce Inverarity

the temple and cheeks of the mask may represent incisions on the flesh of the wearer that are known as **scarification.** Scars or tattooed lines and shapes are often traditional symbols of tribal rank. Notice how the use of repeated semicircles in horns, forehead motifs, eyebrows, mouth, and so on, serve to focus our attention on the face.

Ritual masks assumed many forms throughout Africa but can be divided into two formal categories: the face mask and the head covering, which could be either a helmet, a cap, or a hood that covered the entire head.

The *Yoruba* (yah-rah-bah) *Headdress* (fig. 15.5), used by a secret society of this large tribe in Nigeria, was worn like a cap. A variety of decorative accents are distributed over the entire surface. Many different sizes of notches, knots, lines, coils, and other shapes play against one another to create a well-balanced and harmonious composition.

The *Songe* (sohn-gay) *Tribe Mask* (fig. 15.6) is characteristic of a bold, simplified design motif that probably influenced artists in the cubist movement (see fig. 10.12). In the Songe face mask, the sculptor filled incised parallel grooves with white pigment, which accent the simple, yet powerful, geometric planes dividing the face shape. Imagine the difference in the mask had the sculptor not used the striations. Would it be equally as grotesque? Would flat planes, without the arresting impact of the repetitive lines, be as effective?

A costume covering the body was attached to holes below the chin line and added to the mask's already terrifying appearance. Similar holes appear in the headdress of figure 15.5 and were used to attach raffia and

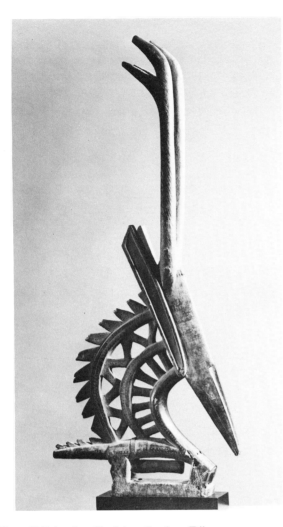

Figure 15.7 Antelope Headpiece. Bambara Tribe.
Wood; H. 35⅔ in.
The Metropolitan Museum of Art, The Michael C. Rockefeller Memorial
Collection, Gift of Nelson A. Rockefeller, 1964.

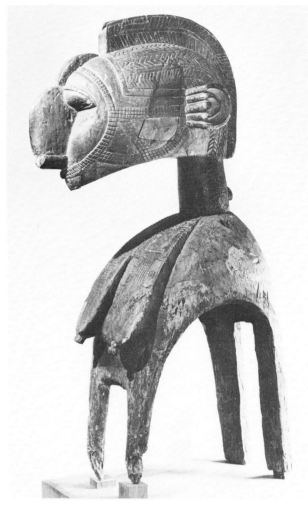

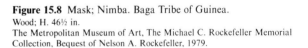

Figure 15.8 Mask; Nimba. Baga Tribe of Guinea.
Wood; H. 46½ in.
The Metropolitan Museum of Art, The Michael C. Rockefeller Memorial
Collection, Bequest of Nelson A. Rockefeller, 1979.

crocheted coverings forming a complete ceremonial unit. In fact, many materials—hair, shells, feathers, teeth, horn, glass, fabric, or metal—were added to masks to heighten their decorative and dramatic expressiveness.

Another sculptural form, the headpiece attached to a woven cap, was used on various tribal occasions by the Bambara (bahm-bahr′-ah) tribe in Mali. The *Antelope Headpiece* (fig. 15.7) is identified by its bold, angular, semiabstract form that employs a pierced, zigzag pattern. This type of Bambara sculpture combines qualities of natural and abstract forms, no two of which are identical. In some, the horns are carved in a horizontal position rather than in a vertical one. In this mask the diagonal repetition of lines in the open chevron (∧) pattern on the neck are repeated on the mane, ears, head, and horns. The simplicity of this headpiece belies its ingenious artistic value; the proportions of individual parts provide a linear grace and exceptional compositional

balance. In all the other works on this tour, we will see the results of similar intuitive judgments on the part of tribal artisans; works that display highly refined aesthetic sensibilities.

Ritual sculptures were sometimes so large that they had to be worn on the shoulders, such as the *Mask from the Baga* (bah′-gah) *Tribe of Guinea* (fig. 15.8). This ponderous figure is representative of some of the most awesome and sexually charged sculptures in African art. It is said to have a hypnotic effect on witnesses when worn during ritualistic ceremonies. The sculptor's attention to the form was one of frontality, angularity, and symmetry. To show power in such works, sculptors made some parts of larger proportions, such as the head, ears, and nose. Like other African sculpture, this ritual mask was intended to invoke spiritual beings as well as to impress human spectators.

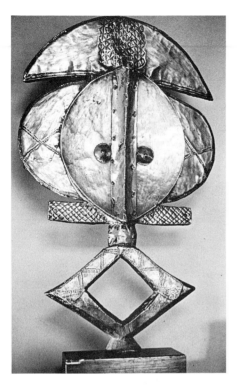

Figure 15.9 Gabon–Bakota Reliquary Figure.
Wood covered with strips of metal.
Lee Boltin Picture Library.

The Grave Figure

A form of African sculpture that serves as a **reliquary** (rel′-i-kwar-i), or a grave figure, is placed above a container holding the bones of an ancestor and serves as a guardian to deter evil spirits from entering the remains. The *Gabon-Bakota Reliquary Figure* (fig. 15.9) is of wood partially covered with flattened copper and brass sheets that have been treated by **repoussé** to accent portions of the face, the neck, and the lozenge-shaped body. Figures that have convex faces are said to indicate males while those with concave faces indicate females. The line motifs we observed on the Songe mask (fig. 15.6) and on this grave figure are similar. On both, the repetitive lines are not only used as surface decoration but form shapes or areas accentuating their symmetrical pattern. The angular lozenge shape on the lower portion of the figure is in direct opposition to the lyric curvilinear shapes of the upper portion. The artist unified the creation by echoing diagonals of the lozenge in the striations of the face and headdress. Reduction of the facial features, or indeed any aspects of the human form, to their basic components is, as we know, a common practice among abstract artists. By some Western standards, these Bakota figures are among the most abstract of African artworks.

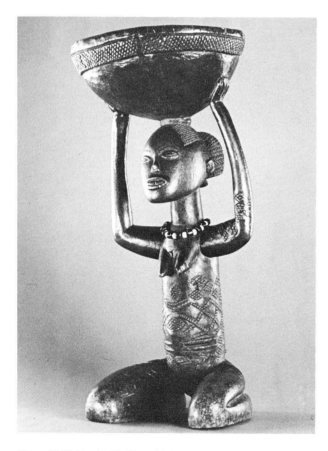

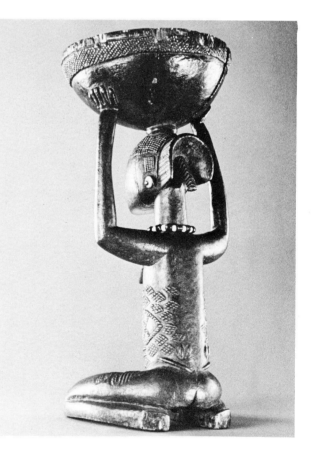

Figure 15.10 Stool with Caryatid, Luba Tribe, Zaire.
Wood, glass beads; H. 23¼ in.
Lee Boltin Picture Library.

Looking at African Sculpture

In other tours we discovered the nearly universal sculptural technique of proceeding sequentially from the elimination of larger, general chunks to the smallest detail-oriented pieces. African carvers accomplished this technique by chipping large pieces with the arched blade of an *adze* and by using a knife to cut the smaller details.

Try to visualize the carving process. The two views of the wood *Stool with Caryatid* in figure 15.10 make it easier to focus on one contour edge at a time, just as the sculptor worked on the piece, turning it from side to side. Allow your eyes to "touch" the edge of the figure and follow the sculpting process. If the figure were to revolve, you would continue to see new contours taking shape and thus share firsthand in the way the work evolved.

A *Helmet Mask* called a "firespitter" from the Senufo Tribe of the Ivory Coast is a typical example of the skill and aesthetic sensibility of traditional African artisans (fig. 15.11). A burning piece of tinder was placed in the jaws of the firespitter helmet that, blown at by its wearer, discharged smoke and sparks through the mask. A cape of fiber or cloth, similar to those attached to other mask forms, was added to conceal the dancer's body.

The individual parts of the mask composed of animal and human elements are combined in a bold, yet subtle, pattern of contrasting shape relationships (fig. 15.12). A dominant direction is created by the curved horns (line *A*) and leads our eyes downward to a series of striations connected to a rounded triangular shape on the forehead. Perched on top, a bird's beak (line *B*) points in the

African sculpture is marvelously varied. Each of the many tribes that carve does so in its own identifiable style, and sometimes in several. Although generalizations about such a vast and diverse output are dangerous, one characteristic links most of the carvings—a bold disregard for realism.

David Attenborough

same direction toward the forehead, thus connecting the horns, head, and bird in a flowing harmony. The overall distribution of texture on the horns and tusks serve to bring the compositional parts together. Notice how the careful arrangement of small, angular, line accents on the forehead shapes and eyelids are used to relieve the stark simplicity of the larger shapes: skull, ears, and mouth. Note also how the curved shapes of the jaw (lines *D* and *E*) move in opposition to the curves of the horns (line *A*). See how the curved shapes and directions of the two tusks combine to allow the top and bottom halves to form a composite unit (line *C*). Why would the sculptor carve the tusks into various flat and curved planes, rather than reproduce a more realistically rounded shape? Perhaps it was because viewers would see the continuous interplay between flat and curved planes as the mask was turned from side to side. The actual work would expose additional views containing dynamic yet subtle changes of shapes and planes that are not visible in a photograph.

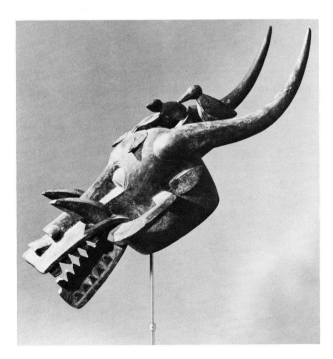

Figure 15.11 Helmet Mask, Senufo Tribe, Ivory Coast.
Wood, paint; L. 35⅝ in.
The Metropolitan Museum of Art, The Michael C. Rockefeller Memorial Collection, Bequest of Nelson A. Rockefeller, 1979.

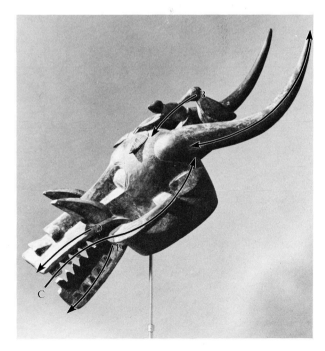

Figure 15.12 An analysis of the Senufo helmet mask showing the directive forces of the composition.
The Metropolitan Museum of Art, The Michael C. Rockefeller Memorial Collection, Bequest of Nelson A. Rockefeller, 1979.

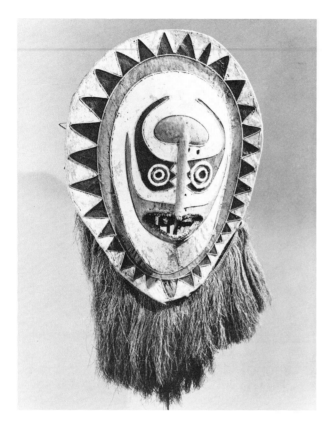

Figure 15.13 Helmet Mask, Papua Gulf, New Guinea.
Bark, raffia, paint; H. 37¾ in.
The Metropolitan Museum of Art, The Michael C. Rockefeller Memorial
Collection, Gift of Nelson A. Rockefeller, 1958.

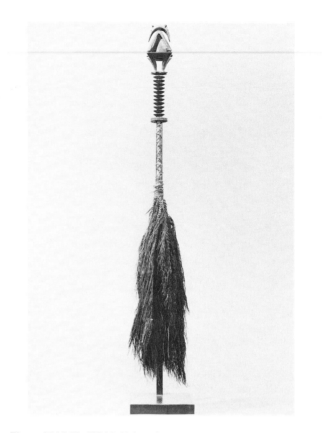

Figure 15.14 Fly Whisk, Polynesia, Austral Islands.
Wood, fiber, sennit; H. 32 in., W. 5⅛ in.
The Metropolitan Museum of Art, The Michael C. Rockefeller Memorial
Collection, Bequest of Nelson A. Rockefeller, 1979.

Primitive sculpture has never been surpassed.

Pablo Picasso

Works of African artists played an important role in
the development of twentieth-century art. The sculpture
was admired and collected by Western artists for its rich
simplicity and sheer technical proficiency, as seen in the
work on this tour. Picasso expressed a passion for Af-
rican tribal art and, in fact, placed its artistic merit above
that of the Egyptians. Many of his early figure paintings
and still lifes resemble the refinement of African design
(see *Les Demoiselles d'Avignon* located in the Museum
of Modern Art in New York, fig. 10.11). Modigliani was
also impressed by the bold reductions of the human form
to essential shapes; he too believed that artistic purpose
was more important than physical beauty. His *Head of
a Woman* (colorplate 4) reflects the geometric shapes he
adopted from African figure sculpture (see fig. 15.6).
Braque and Léger also reflected the charm of tribal Af-
rican art by using angular and flat planes in their cubist
works (see Tour 10).

OCEANIC ART

Oceania is a geographical term that encompasses the
thousands of islands in the South Pacific (see fig. 15.1).
Micronesia, Polynesia, and Melanesia are the three gen-
eral cultural areas, and although it would be misleading
to generalize about their art, there is a curious stylistic
unity among them. Art achieved its full meaning in is-
land ritual, just as it did in Africa. By standing in front
of a mask in a museum showcase, one can only imagine
the mask's original surroundings with palm trees, the
scents of lush foliage, and the sound of ocean surf. The
Helmet Mask (fig. 15.13) from the Papua Gulf area of
New Guinea, which depicts a demon or a deceased
person, was worn by a dancer of the Elema tribe moving
to mystical rhythms in solemn processions. We might
speculate as to why this mask "reads" as a face in both
upright and upside-down positions. The painted and
stitched designs are skillfully arranged to form a sym-
metrical pattern of dark and light shapes that give the
illusion of eyes, nose, and mouth from either viewpoint.
Could it have been the intent of the artist to show a face
to both earthlings as well as to heavenly spirits? Typical

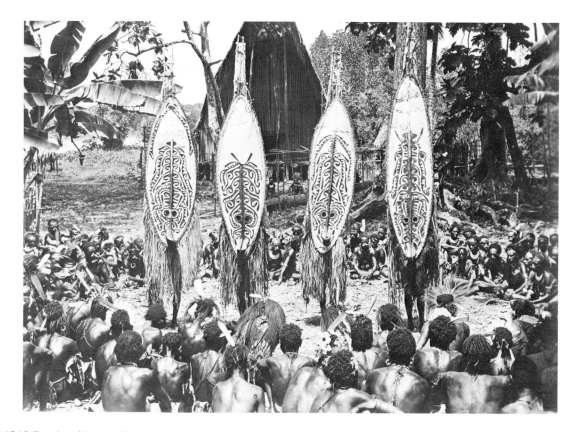

Figure 15.15 Exterior of Papuan Cult House in New Guinea. During male initiation rites, the men perform a sacred dance wearing masks or "Kaiva-Ku-Kus" and assume the role of oracles. Neg. No. 125285 (Photo: Capt. Frank Hurley). Courtesy Department of Library Services, American Museum of Natural History.

of many Oceanic artworks, the mask is made of basketry with dyed bark cloth stitched to the surface. Bark cloth is called *tapa,* a paperlike material made by pounding the inner bark of the paper mulberry tree. Notice how each unit is designed to interact with a neighboring part. For example, the dark contrasting shapes surrounding the eyes and mouth move upward and define the nose and forehead. The oval shape of the face is repeated in the outside edge of the mask.

The diversity of artworks from the Pacific basin can be seen by comparing the Elema Tribe mask with the handle of a ritual fly whisk from central Polynesia (fig. 15.14). Imagine the great care taken in the elimination of wood from the surface of the original shaft in order to calculate such well-proportioned symmetry of geometric forms at the ends and the exact spacing between the rings on the body of the shaft and between forms at the top itself. All this without the aid of an electrical wood lathe! In order to provide a transition from the double-faced god on top, the sculptor continued the notches down to the first ring. The notching is then resumed on the bottom ring, and the larger rings at the base are also notched so the entire composition can be

> Modern artists understood that primitive imagery was new to Western eyes, but they could only guess at the original meaning and purpose of the tribal objects themselves.
>
> *Cynthia Nadelman*

read as a unit. This is indeed a work exhibiting exceptional craft as well as formalistic beauty.

An interesting parallel between Oceanic culture and our own is found in the treatment of finished works of art. While we Westerners keep our most precious works in galleries and museums, the Papuans, for example, keep their most spectacular pieces in what are termed *cult houses.* Well suited to island environment, cult houses are used only by men as social gathering places and as shrines. Like most architecture, the form of cult houses follows their function—rounded roofs to ward off tropical rains (fig. 15.15) and large open interiors (fig. 15.16) to accommodate crowds of villagers and their most prized artworks.

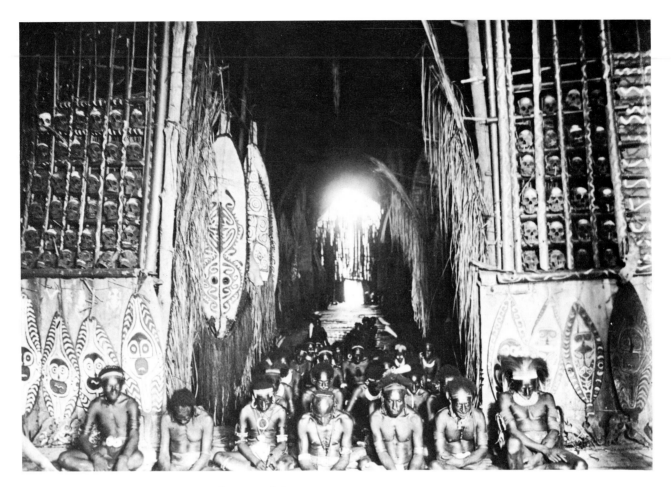

Figure 15.16 Urama Shrines in the Interior of a Papuan Cult House.
Neg. No. 125288 (Photo: Capt. Frank Hurley). Courtesy Department of Library Services, American Museum of Natural History.

INDIAN ART OF THE AMERICAS

Art from indigenous cultures of the Americas, which represent an extensive geographical area (see fig. 15.1) not unlike Africa or the boundaries of Oceania, have been selected for this part of the world tour from south to north, beginning with the civilizations of South America and extending to Alaska. This order of presentation is not intended to imply a chronological development of art in the Americas.

Pre-Columbian Art

Pre-Columbian works span many cultures that flourished prior to the time of Columbus and extended from the Rio Grande south through middle America to the lands of South America. Among others, they include the Olmec, Maya, and Aztec Civilizations.

The Chavín Culture

Long before the Inca people sculpted their stone cities on Andean mountain peaks, earlier artists of the Chavín culture (ca. 1200 B.C.–A.D. 200) carved stone and worked metal in the Peruvian highlands. They also created handbuilt clay vessels identified by handles that double as spouts. Stylized cat figures, such as the jaguar and puma, were often vigorously incised or carved into the pottery. The *Jaguar Vessel* (fig. 15.17), which is shaped like the animal, has the typical stirrup-spout handle. Later on, a double spout was devised, probably to prevent the contents from evaporating and perhaps even to function as a whistle. This double spout became typical of the Chavín culture and of pottery throughout that coastal region.

At this point, we can begin to see a common thread running through all tribal art. In general, the integrity of the original medium was maintained and stylized surface features were incorporated in the final outcome. In the case of the jaguar vessel, the artist "stylized" the

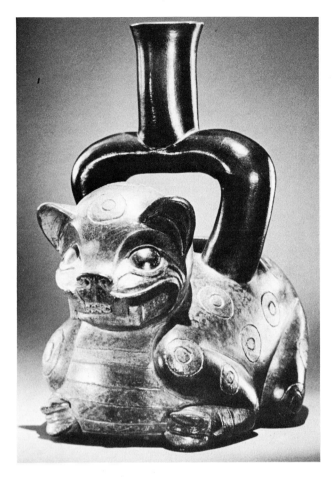

Figure 15.17 Jaguar Vessel, Peru, Late Chavín (700–300 B.C.)
H. 9⅛ in.
Lee Boltin Picture Library

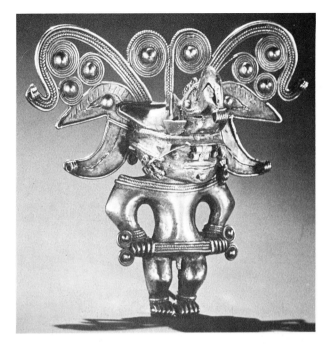

Figure 15.18 Tairona Figure Pendant (Gold of Eldorado)
Cast and gilt, tumbaga; H. 4 ³/₁₆ in.
Museo del Oro. Lee Boltin Picture Library.

spots of the great cat with concentric rings, and exaggerated all the lines of the head to flow in the direction of the nose. Even though the stirrup spout seems "stuck on" or added to the final piece, there seems to have been an attempt to harmonize the functional dimension (the stirrup spout) with the sculptural or aesthetic (the jaguar form).

We have seen sculpture on many other tours simply as an art form that has had little purpose other than its effect on us visually. Most of these sculptural forms were solid, three-dimensional shapes either modeled in clay, carved in plaster, sculpted in stone, or constructed from metal. Though functional in design, Chavín pottery displays techniques or ideas usually depicted in sculpture. The pieces were not only designed to be used as pottery but were often constructed into highly refined and stylized adaptations of selected subject matter of spiritual significance.

Although jade, turquoise, shells, and feathers were used to decorate pre-Columbian art objects, it was the gold that most excited the European conquerors when they arrived in the sixteenth century. Even though much of the gold art was melted down, treasures from the Mixtec (ca. A.D. 900) and later Aztec cultures (ca. A.D. 1500) are preserved in museums. The art of goldsmithing may have spread from Peru and Bolivia through Colombia and Panama to Mexico. The *Tairona Figure Pendant* (fig. 15.18) from Colombia is an example of work cast in a popular gold alloy called "tumbaga," which was thought to contain the power of the sun. The head, large in proportion to the rest of the body, draws our attention to the elaborate, symmetrically balanced headdress. The ornate nature of actual ceremonial robes and headdresses inspired the motifs easily adaptable to malleable metal and wire. Viewers often take for granted the extraordinary technical ability necessary to control the forming processes. In this example, the artist maintained a symmetry of size and shape through hammering, repoussé, or by casting coiled shapes in tight, identical spirals and domes of equal diameter.

Olmec Sculpture

The Olmecs are considered to be the oldest group of people in ancient Mexico. The final dating of the Olmec civilization has not been determined, but we know it flourished as early as 1000 B.C. Their work displays a mastery of media, including stone, jade, and basalt; and pieces characteristically range from minute to the very large. The powerful work of the Olmec sculptors, who

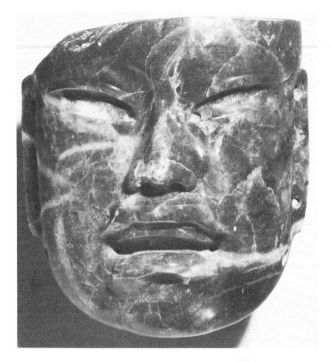

Figure 15.19 Jade Mask (10–8 B.C.).
H. 6¾ in.
The Metropolitan Museum of Art, The Michael C. Rockefeller Memorial Collection, Bequest of Alice K. Bache, 1977.

Figure 15.21 *Presentation Scene,* lintel. Late classic Maya (A.D. 600–900).
Stone, paint; H. 35 in.
Lee Boltin Picture Library.

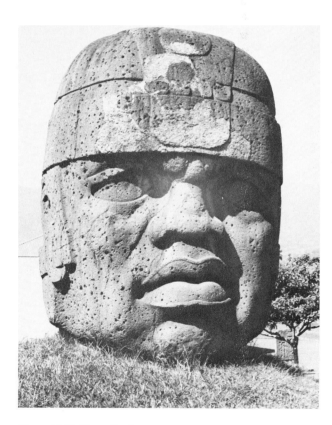

Figure 15.20 Olmec Head.
Museo de Antropologia, Universidad Veracruzana, Xalapa; Ver. Mexico.

created such technical masterpieces as the astonishing *Jade Mask* (fig. 15.19), is as mysterious as the unknown origin and eventual demise of the Olmec culture. The smaller jade mask with its haunting expression is just as masterful in technique as the colossal basalt *Olmec Head* (fig. 15.20), some versions reaching dimensions of ten feet by five feet and weighing over ten tons. Both works also reflect the Olmecs' ability in manipulating hard materials to achieve the soft plasticity of human forms. Like the methods of the ancient Egyptians who moved heavy sections in the building of the Great Pyramids, the Olmec method of transporting such massive stones is obscure.

Comparing the tiny mask with the powerful stone head, we notice that even inside a display case, the feeling of its monumentality is maintained. Viewers find themselves transfixed by the intensity of its noble stare.

Maya Art

Unlike the Olmec free-standing figures, much of the sculpture from the Maya civilization, 600 B.C.–A.D. 1500, is low relief, more architecturally oriented, and often incorporates hieroglyphs (intricately incised symbolic pictures, letters and numbers). Typical Maya reliefs consist of contours cut so cleanly that they give the illusion of sharp lines drawn around closely set figures. Brilliant flat color was used on relief sculpture as well as wall paintings, and elaborately folded bark paper books or codices

Figure 15.22 Castillo, Chichen-Itza, Yucatan.
Lee Boltin Picture Library.

were also colorfully illustrated. The figures in the lime-stone lintel (fig. 15.21) remind us of similar profile figures in Egyptian painting (see fig. 4.24). Although anonymous Maya artists did not title their works, the descriptive title for this sculpture is *Presentation Scene.*

Space is implied even in low relief by the skillful arrangement of overlapping shapes, just as we observed in the Parthenon friezes (Tour 4). Examine any area of the work and find that the artist appears to have "stacked" three-dimensional forms on top of one another. But rather than piling up multiple layers, the process of carving alone suggests overlapping that, in turn, provides an illusion of three-dimensional space.

A majestic Maya pyramid (fig. 15.22) stands in Chichen-Itza (chih'-chen it-zah'), a village in northeastern Yucatan. Called the Castillo, its quadrilateral arrangement of stairsteps leads up to a small temple. While we may be fascinated by its resemblance to the Egyptian mastaba (see fig. 4.17), certain differences become evident, the most obvious of which are the 91 steps of each of the four flights, or 364 steps. Then, if we consider the platform on which the temple stands, the total

of 365 steps corresponds closely to the number of days in the tropical year (two successive passages of the sun through the vernal equinox).

The interior of the temple consists of a very small room because the Mayas used **corbeled vaulting** or post-and-lintel systems of support. The corbel system is a progressive overlapping of rows of blocks that extend inward and upward from the walls. Another feature of these pyramidal structures is that many of them consist of two or three temples within one another. Construction began with a small temple, and then another was built around and over it with enough space left to walk between—a temple within a temple.

Like many of the twenty-one Catholic missions founded by the Franciscans in early California, these pyramids were situated within about a day's journey of one another. Standing at the top of one pyramid, another was in view in the distance. They were not always located in or even near a village. A number of these noble structures were built at the peak of the Maya civilization and remain standing to this day.

Art of the North American Indian

The exhibit in this part of the tour is drawn from a broad range of territory including the lands of the Native American culture of the United States and extending to the Inuit (a word meaning "humankind"), or Eskimo, cultures of the Pacific Northwest. The southwestern regions, including parts of Arizona and New Mexico, were inhabited by an ancient Indian culture called the Anasazi (ah-nah-sah-zee), a word meaning "ancient people." Around A.D. 400 to A.D. 1300, Indian pottery, sculpture, and architecture experienced their greatest development. The North American map (see fig. 15.1) indicates the areas of tribal activity. Many tribes from the Southwest were assimilated into Pueblo groups, some of which were the well-known tribes of the Hopi, Apache, Zuni, and Acoma.

The *Acoma Pueblo Clay Jar* (fig. 15.23) is a striking example of the pottery design employed by these Native American artists. Compare the flat decorative motifs with the modeled decoration on the Yoruba mask (fig. 15.5). The mask, with its variety of decoration, is no less a harmony of parts than the more formal arrangement of the

Figure 15.23 Acoma Pottery (ca. 1885).
Red clay, white slip, black paint; H. 32.7 cm.
Courtesy of the Denver Art Museum, Denver, Colorado.

Figure 15.24 Adobe Construction, Mesa Verde, Colorado
Lee Boltin Picture Library

interlocking, geometric patterns of the vessel. Both the clay jar and the Yoruba mask use independent angular and curvilinear motifs. The distribution of spaces between figure and ground areas in each piece keeps the surface from appearing crowded or "busy." The potter used solid dark shapes against shapes with hatched lines creating a middle value between light and dark. The sculptor of the mask presented much the same type of variation by raising some shapes higher in relief than others in order to capitalize on the effects of light and shade.

Clay was also used by the Pueblo groups as building material. The enduring adobe structures of the American southwest were constructed from the most abundant material available. Clay was mixed with straw and water, formed into bricks, and allowed to dry in the sun. Stacked in rows called **courses,** the bricks slowly rose to one-, two-, or three-story structures that were remarkably suited to group living in a hot, arid climate (fig. 15.24). The thick adobe walls provided ideal insulation from both desert heat and cold.

The architectural design (form) of adobe structures was the result of both the function they served and the

Indian dwellings offered a variety of interactions with the outdoors—the open air . . . the people moved from bare earth through a sequence of such built environments, making themselves "at home" in each of them.

Peter Nabokov

methods and materials used for construction. Compare their boxlike appearance with the graceful curvilinears in the Papuan island cult house or with the dome shapes of the Eskimo igloo.

The Southwest Native Americans are famous for the Kachina (kah-chee'-nah) dolls now gaining popularity among collectors who see their significance in the development of Indian wood sculpture. The dolls were given as gifts to children during tribal ceremonies in order to educate them in the form and symbolic nature of the over three hundred spirits the dolls represent. Some of these supernatural impersonators were sculpted from a solid block, and others were pieced together and decorated with a variety of materials including featherwork and cloth costumes. While Kachinas can be clothed in ritual dress and real plumes, a handsome Hopi example (fig. 15.25) shows that the costume, mask and headdress were painted on the wood forms. Most of the Kachina figures were reduced to their most basic components, and selected geometric shapes and linear design patterns were added to accent the finer features.

In contrast to the human figures just discussed, figures of real or mythological animals also appear in Native American art. Some of these are depictions of creatures encountered on spiritual journeys undertaken by artists of the Northwest. Real or mythological animals represent a large segment of the design motifs carved onto masks as well as totem poles. Like all other tribal art, aboriginal art of the Northwest usually had some functional purpose, as we see in the *Ivory Candlestick Holder* (fig. 15.26). The 2½-inch-diameter work is more impressive than its size would indicate. Many artists work with small-scale pieces using the same process as they would in creating large-scale works. This elegant little piece was apparently carved in the same way the sculptor would have approached a much larger three-dimensional mass: the same sense of wholeness is evident here. Its simplicity is shown in the way the sculptor incorporated the original shape of the ivory into the completed work. Attention is focused on the delicate accents of color on whiskers, eyes, nose, and mouth in contrast to the smooth, white shape of the walrus's body.

The diminuitive walrus represents a style of work echoed in carved and painted, wooden totem pole figures from the Haida (hah-ee'-dah) group of the Queen Charlotte Islands, located off the coast of British Columbia.

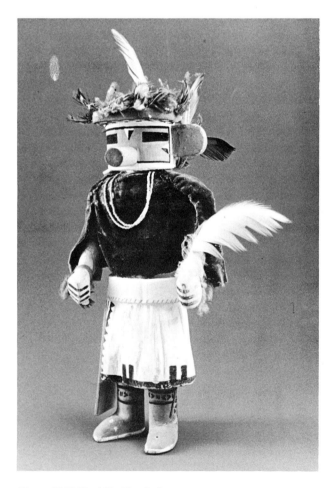

Figure 15.25 Hopi Kachina Doll
Lee Boltin Picture Library

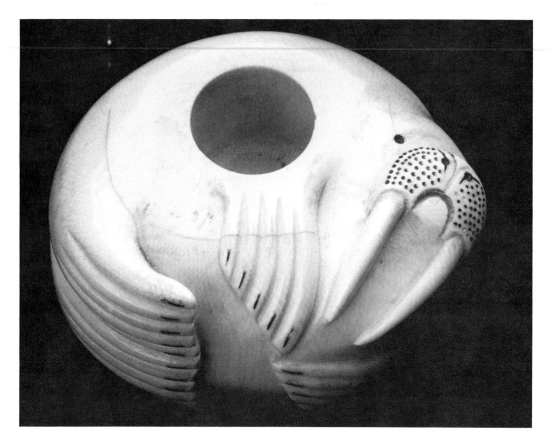

Figure 15.26 Ivory Candlestick Holder, Walrus. Yupik Eskimo
(ca. 1920–30).
University of Alaska VA900–167.

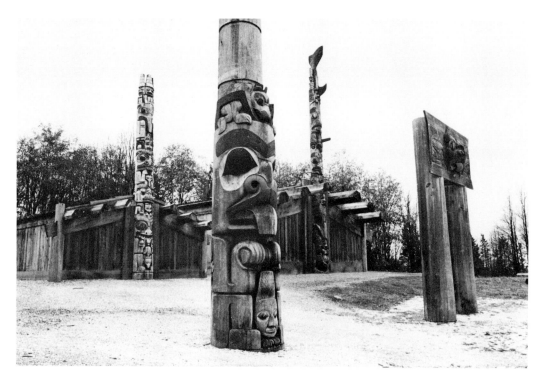

Figure 15.27 Totem Pole, Haida; British Columbia.
The University of British Columbia Museum of Anthropology A50034.

Reaching heights of seventy feet, these typically closed-form compositions represent the social position, wealth, and prestige of the person who commissioned the work. This replica pole (fig. 15.27) shows human and animal figures out-of-proportion; however individual shapes joined closely together create continuity and ensure that the sculptural unit remains intact.

Whether the tribal artists of the Northwest coast were creating house decorations, masks, or blankets, their precision work was often characterized by rounded corners, abstract decorations, animal "abbreviations" of stylized eye and beak motifs; rhythmic lines; and bold symmetry. Part of the reason for this style of execution lies again in an abiding high regard these people held for the materials in their environment. It was as though they were reluctant to blemish the medium as it might have appeared in its natural state. At a time in our own culture when creativity and construction can barely keep apace with destruction, we can only admire these people whose art reflects the integrity of their natural surroundings.

SUMMARY

The far-flung cultures of Africa, Oceania, and the Americas are distinguished by many diverse art styles. Arguments will continue as to how the diffusion of races and accompanying art styles evolved over countless centuries. While unique art forms became characteristic of each widely separated society, a curious consistency also typifies all "primitive" or tribal art. Unlike the art of the Western world, art "outside the mainstream" generally had both a functional as well as a decorative dimension. In most cases, it maintained the natural integrity of the media so that artistic expression blended with the nature of the material itself. Practices in ritual, religion, and tribal tradition constituted the atmosphere in which primitive art was created. The vitality of the dance and the intensity of ritual ceremony provided the inspiration for artists in shaping their forms to suit the occasion. The more we come to understand how tribal art was conceived, the more we can appreciate the separate cultures of which it was such a vital part.

The African work covers a wide scope of art styles used in the social, religious, and cultural lives of the people. Ritual sculpture is represented by fetishes, fertility dolls, masks, headdresses, and reliquaries. African artists discovered ways to achieve unity, coherence, and consistency that influenced the art of the Western world.

Some twentieth-century artists, particularly the cubists, have borrowed style characteristics from African art and adapted them to their own forms of painting and sculpture.

Even though Oceanic art encompasses a vast area of the Pacific basin, consistent stylistic patterns exist among these diverse island societies. Styles range from realistic depiction to abstraction, but all are related to aspects of life and the spirit world.

Pre-Columbian art can be both functional and decorative. Some objects display intricate embellishment while others depict natural or supernatural beings, including animals, human figures, and deities.

Art forms of the Native Americans of North America exhibit a formal use of design patterns, as opposed to Oceanic art that was more "fantastic" and expressive. Native American designs are usually geometric configurations that conform to the outside dimensions of the object. Kachina dolls, a popular art form from the Southwest, were sculpted from solid blocks of wood or pieced together and used in tribal ceremonies to represent spirits. Carving was also a prominent mode of expression among the Eskimos and was created in both open and closed form. Sculptures often reflect the shape of the natural form and sometimes appear as assembled units.

VIEWING EXERCISES

1. Discuss the design features in the *Firespitter Helmet Mask* (fig. 15.11) and relate them to the work of such artists as Picasso, Braque, and Léger during the cubist period. For instance, examine Picasso's *Les Demoiselles d'Avignon* (fig. 10.11) and locate areas in which he included shapes or objects that could be considered as reflecting an African influence.

2. Speculate as to the artist's use of surface decoration on the Bambara headdress (fig. 15.7).

3. Compare the basic design of Native American pottery with today's popular ceramics.

4. Select an artwork from each of the main tribal groups discussed in this tour and find design features common to all.

STUDIO EXERCISES

Suggested media and supplies: sketchbook, pencil, graph paper, three-dimensional medium.

1. Draw in your sketchbook a circle six inches in diameter and redraw the walrus (fig. 15.26) to fit the round format. Use all the parts and pieces in the original design, but do not add any. Change the shapes as necessary to create a different work of art. If you wish, another animal may be selected for this exercise; Eskimos also used sea lions, hawks, owls, hummingbirds, beavers, and bears as subjects.

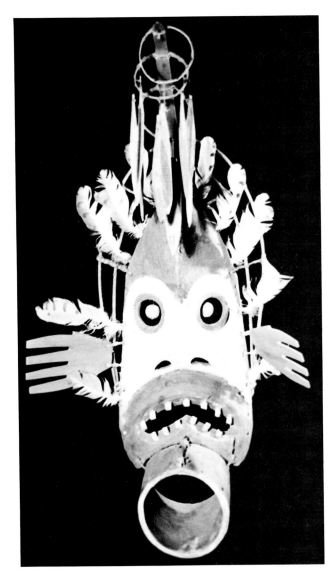

Figure 15.28 Eskimo Kuskokwim River Mask, Alaska. The mask represents Negakfok, the Cold Weather Spirit.
Wood; H. 36½ in.
Photograph courtesy of Museum of the American Indian, Heye Foundation.

2. Find a piece of natural wood, possibly a branch or a piece of driftwood, that may be carved with a knife. Refer to the artist's treatment of the totem pole in figure 15.27 and create one or more creatures from the existing shape of the wood, retaining as much as possible the natural shape and size. The same exercise may be done by chipping a common piece of blackboard chalk with a small pointed carving instrument, like a pin.

3. With square-lined graph paper, create a single-unit, repetitive design with black and white squares that reflects the type of geometric units used in the clay jar in figure 15.23. Be sure that the repeated unit fits together and is capable of repetition around the vessel.

4. Using the *Kuskokwim River Mask* (fig. 15.28) as reference, draw a mask design expressing a violent emotion. Any medium may be used to add value, color, and texture.

5. In this tour we have seen tribal masks that reveal a bold disregard for realism. Try to create a new distortion of realistic features with a lump of clay or self-hardening sculpting medium. Model a small masklike face with the objective of finding new ways to exaggerate human features. Most distortions have already been discovered by Africans and Eskimos, so it will be difficult to create an untried image; but anything goes, so explore freely whatever comes to mind. Strips of newspaper dipped in wheat paste could be used to cover the completed solid mask shape creating a permanent papier-mâché likeness.

RESPONSES TO VIEWING EXERCISES

1. Note the geometric carving of the head parts and the manner in which each section flows into the next. Even though there are many separate divisions to the sculpture, they seem to form a single unit. There are similar uses of angular and flat shapes in the painting and sculpture of cubist artists (Tour 10). Note the two faces on the right side of Picasso's *Les Demoiselles d'Avignon* and his obvious distortions of facial features to recall the tenets of African sculpture. In fact, the entire painting is composed of a similar system of contrasting diagonal arcs in opposition to one another.

2. We can appreciate the artist's use of surface refinements on the headdress by simply imagining the surfaces to be blank. The separation of body from legs, legs from neck, neck from head, and head from horns is ingeniously established. The artistry of the carver can be seen in the way different decorative shapes are placed side by side while maintaining the underlying units.

3. The Native American potter was concerned primarily with *form following function*. For instance, the use of pottery as containers for liquid, grain, or other materials, would determine to some extent the height and thickness of the sides, as well as the overall size of the pieces. Of course, if the vessel carried liquid, the opening at the neck would be smaller than the shoulder in the middle to avoid splashing over the top. Today's pottery often serves only decorative purposes and consequently is free of the restrictions of practical functions. Many have tiny openings at the top and their being hollow is only incidental to the artistic content.

4. Depending on which works are selected, you are likely to find angular surface decoration that is easily adapted to the carving of resistant material like wood. Or, you may find form following function. Another common thread could be the technique of employing different degrees of abstraction while retaining the natural integrity of the media.

SUGGESTED READINGS

Anton, Ferdinand. *Art of the Maya.* New York: Thames Hudson, 1979.

Anton, Ferdinand, and Dockstader, Frederick J. *PreColumbian Art and Later Indian Tribal Arts.* Panorama of World Art Series. New York: Harry Abrams, 1968.

Attenborough, David. *The Tribal Eye.* New York: W. W. Norton Co., 1976.

Benthall, Jonathon. *Science and Technology in Art Today.* New York: Praeger Publishers, 1972.

Berner, Jeff. *The Holography Book.* New York: Avon Books, 1980.

Davis, Phil. *Photography.* 4th ed. Dubuque, Iowa: Wm. C. Brown Publishers, 1982.

Deken, Joseph. *Computer Images: State of the Art.* New York: Stewart, Tabori, and Chang, 1983.

Griffiths, John. *Laser and Holograms.* Exploration and Discovery Series. Morristown, N.J.: Silver Burdett, 1983.

Highwater, Jamake. *Arts of the Indian Americas: North, Central, and South: Leaves from the Sacred Tree.* New York: Harper & Row, 1983.

Inverarity, R. B. *Art of the Northwest Coast Indians.* 2d ed. Berkeley: University of California Press, 1967.

Jencks, Charles. *Modern Movements in Architecture.* New York: Anchor Books, Doubleday, 1973.

National Geographic Society. *The Laser.* Washington, D.C., March, 1984.

Pericot-Garcia, L., et al. *Prehistoric and Primitive Art.* New York: Harry Abrams, Inc., 1967.

Peterson, Karen, and Wilson, J. J. *Women Artists.* New York: Harper & Row, 1976.

Roukes, Nicholas. *Art Synectics.* Worcester, Mass.: Davis Publications, 1984.

Schmitz, Carl A. *Oceanic Art, Myths, Man, and Image in the South Seas.* New York: Harry Abrams, n.d.

Scully, Vincent J. *Modern Architecture: The Architecture of Democracy.* New York: Braziller, 1982.

Segy, Ladislas. *African Sculpture Speaks.* 4th rev. ed. New York: Da Capo, 1975.

Willet, Frank. *African Art.* World of Art Series. London: Thames and Hudson, 1985.

Wilson, Stephen. *Using Computers to Create Art.* Englewood Cliffs, N.J.: Prentice-Hall, 1986.

Wingert, Paul S. *Primitive Art: Its Traditions and Styles.* New York: New American Library, 1965.

Woods, Gerald, et al. *Art Without Boundaries.* New York: Praeger Publishers, 1974.

The Information Desk

Just as the information desk in a museum or a gallery provides the visitor with information about admission, membership, current exhibits, lectures, films, and tours, this "Information Desk" is designed to assist you to better understand what goes on in a museum.

At most information desks, you will either sign a guest register or pay an admission fee or suggested donation. You most likely will receive a map or a floor plan identifying the galleries or the restaurant or the gift shop. Because many visitors ask the same questions, brochures prepared by members of the museum staff are often available to assist you in your visit.

This "Information Desk" will tell you how a museum functions as it prepares exhibits, educates its audiences, and preserves art objects. It will tell you who works there, how they are trained and what they do to make your visit an enjoyable and educational experience. It will explain the advantages of museum membership and will conclude with a section "More about Museums."

EXHIBITIONS

Lighting

Of all the requirements for displaying art effectively, perhaps the most improved by museums is the lighting. In the twentieth century, with artificial light available, it has become possible to carefully control the amount, the type, and the length of time an artwork is exposed to light.

While museum skylights were popular in the early 1920s, it was found that the excessive light they admitted was detrimental, particularly to old paintings that had been "cleaned" of their protective, but yellowed, coating of varnish. Artificial lights can be programmed to limit exposure; they can be used to light an object directly or indirectly and they can be filtered.

Display

The way in which a museum displays art today is a radical change from, say, the baroque era in the early 1700s when paintings covered walls and even ceilings, leaving no areas exposed and allowing no single picture to "hold the eye." In contrast, most of the artworks in today's museums hang in a single row along the wall, at a height that is comfortable for the average-sized viewer, and with enough space between each to allow the viewer to see a painting as an entity in itself.

In the late 1700s during the period of neoclassicism, it became popular to hang the paintings in chronological order as a means of instruction. This way of displaying art remains valid today and is common in museums.

Sometimes the best way to display art objects is to provide an historical context. For instance, when only fragments are available, it is necessary to provide the viewer with information that describes the artist, the country, the material, and the function of the work when it was created. All of these elements must be accessible and legible yet integrated in a way that does not detract from the units of the exhibit.

Special exhibits, which include the work of a single artist or that of certain periods or regions, may require greater use of skills on the part of the exhibition designer or preparator.

If the collection includes three-dimensional pieces, then special care will be given to the path that will allow the viewers to see all sides as they move through the exhibit. When the objects are from a region that may have unique environmental features, then these must be involved as part of the display. If the art objects will be better defined when placed on specific surface and background textures, these must be designed and created, often by craftspeople in the museum's workshop.

EDUCATION

For most museums, education of the public is an important part of their role as an institution and they divide it into two areas.

The first is their responsibility to visitors inside the museum, where regular tours of the collection, tours of specialized areas or shows, and electronically guided tours are all available. It is not unusual to find museums offering special programming for children and adults. Often the leaflets describing the artists and periods in different galleries of the museum can be put together to create a fine guide to the entire museum collection.

Secondly, museums may offer extension or outreach activities that include traveling exhibits, gallery films, and slide lecture sets, all designed to offer the collection to those outside the museum.

These educational activities require time and expertise. Educators, photographers, public relations personnel, research librarians, graphic designers, editors, and writers work together to make research accessible. This assists the public in its ability to better appreciate art through both print and nonprint media.

PRESERVATION

One of the main functions of each art museum is to preserve and protect objects in its particular collection. There are so many ways an art object can be harmed that it is essential for a museum to surround its collection with the proper environment and with knowledgeable staff. It is readily apparent to the visitors who observe the museum guards that security from theft or damage is important. When a well-known and often priceless masterpiece is stolen, it receives prominent space in the news media. (That notoriety in itself is a deterrent for resale.)

The guards, staff persons, and even the display cases that enclose some art objects, serve as protection against the unintentional damage that the viewing public can inflict by merely touching a piece of art. Even minute traces of oil residue on the fingertips can cause changes in art objects.

Atmospheric and environmental conditions constantly affect art. Temperature changes cause contraction and expansion of the artworks; fluctuations in humidity can cause warping and cracking; and impurities in the air surrounding us have a noticeable detrimental effect. Museums generally are equipped to maintain humidity in the range of 50 percent and a temperature of 65–70 degrees Fahrenheit. While special lighting, air filters, and humidity and temperature controls can protect the collection within the museum, the effects of both natural and man-made forces are readily apparent on many fine pieces of sculpture and architectural treasures that remain out of doors.

Sometimes the museum rules require visitors to check umbrellas, handbags, cameras, coats, and backpacks. They do not allow eating, drinking, or smoking. The inadvertent poke of an umbrella, bump from a backpack, or lingering residue from cigarette smoke are unacceptable given the preservation purpose of museums.

If a visitor is allowed to use a camera, it will most likely not have a flash attachment because repeated exposure to the high-intensity flash can damage the color in paintings and photographs. Even natural light with its ultraviolet rays can cause deterioration. Fortunately, the only existing light in many of the cathedrals and palaces where these art objects originally hung was that which entered through stained glass windows and door openings or that of dim candlelight.

Today's technology is creating new materials to help with the meticulous process of preservation. Pictures are now mounted on acid-free papers and with adhesives that will not produce harmful chemical effects. New techniques for cleaning art objects are available and chemists continue to create safer, more effective solvents and cleaning materials.

MUSEUM STAFF

Board of Directors

The governing board of a museum, often called the board of trustees, is made up of lay people who are interested in art. These men and women, who volunteer their services, determine the policies of the museum and well-being of the collection and the staff.

The Director

The crucial position of director requires an art history background and years of experience. The director will often strongly influence the formation of the collection in a certain area. As the executive and administrative officer of the museum, the director works with the governing board, enacting their policies, overseeing the employees and the program of the museum and also informing and involving its supporters and potential donors. The position of director can be likened to that of a diplomat because it demands sensitivity to many points of view.

The Registrar

The registrar has an extremely complex and exacting job, which includes assigning acquisition numbers, maintaining artist files, arranging transport of often priceless and/or delicate items, and literally documenting every object in the museum. This highly organizational position requires formal training in museology, including the history, philosophy, function, and management of museums. Further training may include various periods of time serving as an apprentice in a museum.

When an art object arrives at the museum, the registrar gives it a permanent identification number, called an acquisition number. Although there is no standard way of assigning the number, it is usually two or three numbers separated by a period or two periods. For example, the acquisition number 88.142 means that the item is the one hundred forty second object to be added to the collection in 1988. The visitor sees this number on the wall or case label. On this label may also be the notation that the object was a gift or bequest, or that it was a museum purchase. The label will probably also include title, artist, and life dates of the artist, medium, dimensions of the work in centimeters (art historians use the metric system), and whether or not the art is signed and dated. The words "school of" or "attributed to" may be given instead of the artist's name if attribution to an artist is not possible.

The Conservator

The training for a conservator, the person who is responsible for the condition of each art object, can be varied but might include an M.A. in art history; specialized training in physics, chemistry, and conservation; and further time spent learning the job as an apprentice. Conservators are often highly trained in very specialized areas; some work on only paper, canvas, wood, or metal. They must be current on many technological advances in treating art objects.

Conservation activities may include taking frescoes off walls and remounting them on panels, x-raying pictures to see how the layers of paint were applied and in what order, as well as how the composition changed while the artist painted it.

Conservators can repair works of art that have been damaged (sometimes by highly publicized acts of vandalism), and they can remove yellowed layers of varnish from old paintings thus revealing brighter, lighter colors. Sometimes they remove layers of paint only to discover that a totally different picture emerges. They also make certain that a support (the paper, canvas, or wood on which a picture is painted) is strong enough to hold the paint film and be exhibited. Conservators can also take a minute sample of all the layers of a painting, like taking a soil sample. Such a sample might also reveal, less happily, that the painting was painted over a print and is not an original composition.

Some conservators may also find it necessary to paint in a blank spot on a canvas where there is no longer any paint. To do this requires a great deal of knowledge of how the painter worked. This can be achieved by studying the works of the painter and documenting them so that they can be referred to as the conservator does in "in-painting." Some conservators are very concerned that the "in-painting" be removable.

The Curator

A museum's curator is considered the art history "expert" or "connoisseur." As the title suggests, this position requires a great deal of training, usually a doctorate in art history.

Curators often have training in foreign languages in order to translate documents and international literature. They also usually have good writing skills that are helpful in summarizing the information they gather, which is often published in exhibition catalogs and scholarly journals.

Curators can "fill in the gaps" in a collection. Their working knowledge of what is available as well as their continued research allows them to solve the puzzles in the history of art objects.

In a large museum in which many periods are represented, there may be several curators working on the art collection, each in specialized areas—a period or time in history, a single group of objects, or the work of only one artist. Whatever the specialty, the curator may study a particular area for a lifetime, doing research and documenting the museum's collection for its publications.

Volunteers and Docents

Often the most visible museum assistance is offered by volunteers. Some of these, called docents, are particularly interested in art and may even pay a moderate fee to attend a rigorous and excellent training program. The instruction is planned by the museum's curator or director of education, and often the docents attend monthly training lectures given by art historians who discuss their field of art expertise. The visitor who is guided through the museum by an enthusiastic, well-trained docent is certain to realize an enriched experience.

Most museums would find it difficult indeed to provide the services required by the viewing public without the enthusiastic efforts of volunteers. The tasks they perform can vary from cataloging, to guiding visitors through the museum, to staffing gift shops.

Whether the museum is large or small, whether the staff numbers 500 or only 5, the functions remain the same. Smaller museums require employees who are versatile and willing to perform the duties of more than one job description.

MUSEUM MEMBERSHIP

Nearly all museums print a brochure offering membership information, including several different membership levels that will allow most art lovers the opportunity to become members. By lending financial support to the institutions, the member may in turn receive many benefits, including free admission, newsletters, mailings about special events or exhibits, discounts in the museum gift shop, and use of the museum library. In addition, some museums have special programming available to members. Often a reduced membership rate is available for students who wish to become members.

MORE ABOUT MUSEUMS

American Association of Museums, 2233 Wisconsin Avenue, N.W., Washington, D.C. 20007 (for booklets, audio visuals, and other sources of information).

Burcaw, G. Ellis. *Introduction to Museum Work.* Nashville, Tenn.: The American Association for State and Local History, 1975.

Finn, David. *How To Visit A Museum.* New York: Harry N. Abrams, 1985.

Gealt, Adelheid M. *Looking At Art.* New York and London: R.R. Bowker Company, 1983.

Grinder, Alison L., and E. Sue McCoy. *The Good Guide: A Sourcebook for Interpreters, Docents, and Tour Guides.* Scottsdale, Ariz.: Ironwood Press, 1985.

Kleinbauer, W. Eugene. *Modern Perspectives in Western Art History.* New York: Holt, Reinhart, & Winston, 1971.

Lee, Sherman (Ed.). *On Understanding Art Museums.* Englewood Cliffs, N.J.: Prentice-Hall, 1975.

Museum Studies: A Curriculum Guide for Universities and Museums. Washington, D.C.: American Association of Museums, 1973.

Ripley, Dillon. *The Sacred Grove: Essays on Museums.* New York: Simon & Schuster, 1969.

Wittlin, Alma S. *Museums: In Search of a Usable Future.* Cambridge, Mass. and London: MIT Press, 1970.

Biographies of Artists

The name **JOSEF ALBERS** (1888–1976) and the word "color" have almost become synonymous in the visual arts. A German-born painter, designer, printmaker, and renowned teacher, he was a great influence on the op art movement of the 1960s.

He was a student of Germany's famous Bauhaus school of design in the 1920s and 1930s and later taught industrial design until the school closed in 1933. During the 1920s, his work was devoted to windows and collages of stained glass and eventually to paintings and prints. His most characteristic compositions are geometric, colored squares placed on top of one another. These carefully planned experiments in what he called "color interaction," proved that color can only be understood if seen in context with other influences. His most popular series entitled *Homage to the Square* were completed during the 1950s.

He left Nazi Germany in 1933 for the United States and became a citizen six years later. He taught courses at Harvard and completed a sixteen-year teaching assignment at North Carolina's Black Mountain College in 1949. In 1950, Albers moved to Yale where he eventually became the chair and professor emeritus of the department of architecture and design.

Like so many modern artists and composers, **GEORGES BRAQUE** (1882–1963) went through several stages of art style. Born in Argenteuil, France, he lived in Le Havre during the heyday of impressionism (Monet himself had lived in both towns), yet joined the ranks of the fauves. Many of his paintings in the first decade of the twentieth century, under the influence of Matisse and Derain, burned with the intensities of raw colors.

Later in that same decade, Picasso and Cézanne influenced a decisive change in Braque's style. His study of Cézanne's geometric treatment of forms, and close friendship with Picasso, resulted in the emergence of cubism. Together, Braque and Picasso perfected the fragmented, multidimensional approach to painting that finally led to Braque's inimitable collages, bits of paper and cardboard pasted on canvas and often enhanced by painted lines and shapes. Braque is usually remembered for this style.

After World War I, Braque's style became less definitive. His earlier cubist geometry seemed to dissolve into more plastic forms, and his subject matter seemed more symbolic, occasionally expressionistic. In 1920 he began sculpting and also worked in a medium called "incised plaster." Subsequent paintings reveal various directions that Braque was exploring simultaneously—some retained the cubist hard edges and others revealed a return to a softer, more humanistic quality.

The name **ALEXANDER CALDER** (1898–1976) is synonymous with kinetic art, or sculpture that moves. His innovative "mobiles" have become an American art expression and have led to many imitations ranging from works in the professional fine arts to the commercial objects hung over baby cribs.

The Philadelphia-born Calder was first an engineering major and then studied painting in 1923 at the renowned Art Students League in New York. He moved to Paris in 1926 where, "for the fun of it," he developed his famous animated wood and metal circus. His later work was influenced by the stark, geometric shapes associated with Mondrian. As a result, he turned his efforts to more abstract shapes in wood and wire while continuing to work with circus subjects in drawing, painting, and sculpture.

His motorized sculptures with stationary bases emerged in the 1930s, followed by his "mobiles," precisely balanced shapes set in motion in space by air currents only. It was at this time that he also developed what he called a "stabile" cut from sheets of steel. Later he added moving parts to these stationary forms. His repertoire included everything from large-scale sculpture to a three-inch mobile considered to be his smallest work, as well as household objects, toys, and jewelry. One of his last works, *Untitled,* is an enormous mobile that dominates the foyer of the National Gallery, Washington, D.C.

Considering the overwhelming obstacles of the time, it seems incredible that **MARY CASSATT** (1845–1926), a woman born to wealth and reared in Pittsburgh, was allowed to enter her paintings in the now-famous Paris Salon of 1874 and be considered among the leading French impressionists.

Cassatt had to overcome strong parental pressures in her early decision to become an artist. Although she studied for a time in Philadelphia, Cassatt soon moved to Paris where she was to live and study the works of her contemporaries Manet, Courbet, and Degas.

Her paintings stand out among the other impressionists' works because, instead of concentrating on lily ponds, haystacks, and ballerinas, she drew light and tender scenes of children with their mothers. While such a selection of subject matter could have resulted in maudlin sentimentality, Cassatt created her figures with a mastery of visible brushstrokes, a sensitive control of palette, and the serious quality of realism—resulting in true impressionistic brilliance of light and glimpses of real people in true-to-life situations.

Some critics thought the work of **PAUL CÉZANNE** (1839–1906) to be clumsy; others thought his "careless drawing and painting style" was surely the result of eye problems. His work was regularly rejected from such important exhibits as the École des Beaux Arts and went unnoticed in many other salons during the 1860s. Who would have guessed that this "outsider" would later become known as the Father of Modern Art? Cézanne's style eventually departed from accepted traditions by synthesizing the classical past with impressionist ideals.

Cézanne was born of a wealthy family in Aix-en-Provence. He visited for long periods of time in Paris where he worked with the impressionist Pissarro. He later inherited his father's wealth and house at Jas de Bouffan where he lived a secluded life, concentrating on his work. He died with the knowledge that his efforts had finally been rewarded.

A year after his death, an exhibition of his work had a pronounced effect on such masters as Matisse, Picasso, and Braque. They were only a few of the admirers of a painting style that sought to analyze form and color so as to express the solidity of objects in nature rather than only their surface appearance.

Looking at the art of **CHRISTO** (Christo Javacheff, b. 1935), one must wonder at the charismatic personality capable of mustering thousands of volunteers to help construct monumental works of sheer spectacle. One must also marvel at his organizational ability to muster the cooperation of local authorities, despite prohibitive ordinances, and to acquire the funding necessary to produce such awesome projects as surrounded islands, fenced landscapes, and wrapped bridges.

A study of Christo's origins is perhaps a clue to his curious style of art. Christo Javacheff was born in Bulgaria where, as a young man, he helped farmers cover unsightly piles of hay and farm machinery with tarpaulins, an activity that accounts, at least in part, for the style of his best-known works. He began his unusual style of "wrapped art" after moving to Paris in 1958. Christo came to New York in 1964 and began planning with his wife, Jeanne Claude (manager of his business affairs and fund raising efforts), the popular structures that have made him one of the world's leading artists. Among them are the *Wrapped Museum of Contemporary Art* in Chicago, *Wrapped Coast* in Australia, *Valley Curtain* in Colorado, *Running Fence* in California, and *Surrounded Islands* in Florida. Because of their temporary nature, few people have ever seen anything but photographs of these works of art.

SALVADOR DALI (b. 1904) was born in Figueras, Gerona, Spain, where he studied privately and formally at the École des Beaux Arts in Madrid. He was influenced by the painters de Chirico, Carra, Ernst, and Miró. He visited Paris in 1927, where he met Picasso and was associated with the surrealist movement between 1930 and 1934.

Dali was influential in popularizing surrealism in the United States where he worked on scenery for numerous ballets. During World War II, he resided in Pebble Beach, California, but returned to Spain in 1948 where he completed illustrations for Dante's *Divine Comedy.*

Regarded by many as a radical eccentric, Dali has said that his behavior can be traced back to childhood fits of violent hysteria. As an instructor at the Madrid Art School he was expelled after his extravagant behavior incited the students to riot. He also served a short prison term for subversive activities.

The popularity of Dali's paintings may be attributed to the recurring subject matter—human figures together with protruding desk drawers and limp watches melting in the sun; all depicted in exact detail against stark Catalonian landscapes.

HONORÉ DAUMIER (1808–79) was an artist of many talents—a political cartoonist, humanist, satirist, and journalist. As a satirist, he attacked politicians and other notables in Parisian society.

He was born in poverty in Marseilles and left for Paris with his mother at the age of eight. In his youth, he served as a bookstore clerk, becoming involved with lithographic prints to express his liberal views. One of his prints was considered an outrage against the king and resulted in a fine and a six-month prison term. Financial problems plagued Daumier for most of his career and his eyesight failed at the age of fifty-five.

His works, with themes drawn from everyday life, are still relevant today. Popular subjects are beggars, emigrants, the market, and scenes from railways and coaches, such as *The Third Class Carriage* at the Metropolitan Museum of Art. His abbreviated style has been called "sculptural," and his work illustrates a style of simplicity that eliminates all but the most important aspects of the subject and that usually has sharp contrasts of light and shade.

Hilaire Germain Edgar de Gas was popularly known by the way he signed his work—**EDGAR DEGAS** (1834–1917). Born in Paris of an emigrant Italian father and an American mother, he was one of the founders of the *Societe Anonyme des Artistes, Peintures, Sculpteurs, Graveurs,* a group better known as the impressionists. Most of his work was inspired by indoor subject matter, such as the ballet and compositions of figure groups, rather than the landscapes preferred by the impressionists.

Degas's traditional training at the Ecole des Beaux Arts included an exhaustive study of the old masters. He continually acknowledged this experience as the most valuable part of his training—in contrast to the study of nature, which had no significance for him. He liked to take his subjects from the ballet, bringing out the impression of space and solid forms from unexpected angles. He looked at the dancers with the same dispassionate objectivity that the impressionists looked at landscapes.

He was impressed by the Japanese master Hokusai, who often showed figures cut off by the margin of a print or an element within the picture. That influence shows in much of Degas's work in which only the dancers' legs or parts of their bodies are portrayed.

His failing eyesight in later years forced him to reject small work for larger-scale pastels in which he used colored powders compressed into sticks like chalk. He was an excellent draftsman who had the ability to capture on canvas what the viewer might glimpse in a fleeting moment.

"I feel against the grain of things," is one comment **JIM DINE** (b. 1935) has used to describe his art. As an art form, the Happening has been attributed to the Cincinnati-born Dine and collaborators including Claes Oldenburg, John Cage, Robert Rauschenberg, Roy Lichtenstein, and Allan Kaprow. Introduced in 1959, this art form required audience participation such as walking in, sitting down, and holding, turning, or pulling something. The happenings of the 1960s became more slices of life than representations of life, defying descriptions or labels as they moved outside the galleries and into the streets.

Dine has been placed in the category of a pop artist even though he personally denies belonging to this group. One series of his creations includes real objects such as lawn mowers, hammers, and saws placed on painted backgrounds. He has said, "I use objects as tubes of paint." His later work has returned to representational and traditional painted images.

The most famous of three artist brothers, **MARCEL DUCHAMP** (1887–1968), was born in Rouen, France. He began painting in 1902 as an impressionist but soon turned to fauvism. Duchamp's most important painting, *Nude Descending a Staircase,* 1912, reflects the influence of both cubism and futurism.

He inspired both the dada and surrealist trends of the post World War I years and perhaps even foreshadowed conceptual art and pop art, which were to develop decades later. Duchamp's experiments with a broad scope of media and materials lead us to believe that he was primarily interested in art ideas rather than in artistic products. It was as though he had anticipated every development in art since the war. Duchamp's style is difficult to pin down—perhaps the term "anti-art" fits best. It is, after all, his iconoclastic ideas that permeate virtually all art of the twentieth century.

He came to New York in 1915 and stopped painting in the 1920s to pursue his interest in chess.

HELEN FRANKENTHALER (b. 1928), the daughter of a New York State Supreme Court Justice, has enjoyed the benefits of fine training, travel abroad, and since 1950, a close association with virtually all of the giants of the art world—her colleagues include Jackson Pollock, Lee Krasner, Willem de Kooning, Franz Kline, David Smith, Hans Hofmann (with whom she studied briefly), Larry Rivers, Kenneth Nolan, and Morris Louis. She married another well-known artist, Robert Motherwell, in 1958.

The influence of such an array of important artists on the development of Frankenthaler's style may never be fully known. It was Pollock, perhaps, who inspired her to work with large canvases spread out on the studio floor, flooding them with richly colored paint. From this basic approach, along with the new freedom of abstract expressionism and Frankenthaler's own creative vision, a new technique emerged. Basically, in the mid-1950s, she began staining unprimed canvas, pushing thin paint down into the material so that the medium and the canvas surface became one entity. Viewers can see the threads of the canvas glowing with color. Often, shapes appear to have a halo where the oil base has spread out beyond the pigment. While no single technique characterizes Frankenthaler's work, her experimentation with many types of media and her different approaches to expression continue to evolve.

PAUL GAUGUIN (1848–1903) was a Parisian postimpressionist known for the romantic, adventurous life he lived while painting in Tahiti. He had served in the merchant marine and was a stockbroker and a prosperous financier until, at thirty-five, he left his job and his family to live in Britanny.

Gauguin was a free spirit who felt a kinship with native life. He yearned for an existence free of "suffocating" European influence. Until his health deteriorated and he died alone in poverty, Gauguin sought paradise in the South Seas. The Oceanic landscape and colorful natives renewed and inspired him. From his studio hut came many vibrant canvases filled with reds and oranges, blues and greens, and other intense, harmonious, color relationships.

Even though his work has been criticized as not possessing the same technical proficiency of a Degas or a Manet, he nevertheless gained the respect of many critics who now credit him with establishing a standard aesthetic level for all twentieth-century painting.

The teaching and paintings of **HANS HOFMANN** (1880–1966) became a major force in the development of the modern art movement in the United States. He was born in Weissenberg, Bavaria, painted in Munich and Paris, and had his first one-man show in Berlin in 1910.

His excellent teaching reputation led to the opening of a school of art in Munich. He taught in California and at New York's Art Students League, prior to the 1932 opening of The Hans Hofmann School of Fine Arts in New York, and the Provincetown Art School on Cape Cod. It was from these beginnings that The New York School of Artists developed in the 1940s. This group became classified into independent styles called *action painting, abstract expressionism,* and *abstract impressionism.* A subsequent decline in these movements followed in the late 1950s. Hofmann's avant-garde style was influenced by fauvism, as shown by his love of pure intense color and works often loosely painted with hard-edged geometric patterns and heavily textured surfaces.

JEAN-AUGUSTE DOMINIQUE INGRES (1780–1867) was born in southern France in the small town of Montauban. He learned to draw from his father, Joseph, a sculptor. In 1797, Ingres traveled to Paris to enroll in the studio of the great Jacques Louis David, France's leading painter during the Napoleonic era. Ingres learned much of his severe sculptural style of figure painting there; however, such influences can also be traced back to his father's work and his early training from sculptor Jean-Pierre Vigan at Toulouse, a town near his birthplace.

In 1806, Ingres left Paris to study and work in Rome and Florence. On his return to Paris some eighteen years later, his work was greatly praised by the Salon and his reputation as one of the greatest of neoclassic painters was firmly established. Subsequent works, such as *The Apotheosis of Homer, Odalisque With a Slave,* and *The Turkish Bath* made Ingres a national hero.

The relatively small number of paintings he left, in spite of a long life, attests to Ingres's constant quest for perfection. Many paintings were planned and executed over a period of years and various subjects reappeared several times in subsequent works.

He was thirty years old and a law professor at a Russian university before **VASILY KANDINSKY** (1866–1944) decided to become an artist. As was so often the case at that time, he had been urged by his parents to pursue an "honorable" profession rather than to study art. His life changed, however, when he saw Monet's serial paintings of haystacks.

He went to study in Munich, one of the most active centers of experimental art in Europe, and soon opened his own school of art. Although his beginnings were in a romantic expressionist style, he used color to create moods and emotions and eventually arrived at a truly abstract form of art. It was the articulate Kandinsky who said, "If destiny will grant me enough time I shall discover a new international language which shall endure forever and which will continually enrich itself." He was the impetus behind the formation of *Der Blaue Reiter* (The Blue Rider), a group of artists who believed in the nonrepresentational use of color. He produced many paintings before World War I, and after the war he devoted his energies to teaching in Russia, Germany, and France.

In 1912, he wrote a very influential book entitled *Concerning the Spiritual in Art.* He said the discoveries in the natural sciences at that time, such as the splitting of the atom and the theory of relativity, gave him the courage to overcome his feeling of obligation to reproduce the visible world.

ERNST KIRCHNER (1880–1938) was born in Aschaffenburg, Germany, and at his parents' insistence, studied architecture in Dresden. However, after a visit to Nuremberg and seeing prints by Albrecht Dürer, Kirchner decided to study art.

In 1905 he founded *Die Brücke* (The Bridge), a group of young architects who, like Kirchner, were dedicated to the "renewal of German Art." Led by Kirchner, who was influenced by medieval block prints, African and Oceanic art, and by artist Edvard Munch, *Die Brücke* produced expressionistic, angular works, some of which contain large blocks of bold color.

During the war years, Kirchner's health seriously deteriorated, and when he later recuperated he began to change from his severe expressionistic style to a more lyric mode of painting. His illnesses and depression ultimately returned, however, and at the age of fifty-eight, Kirchner committed suicide.

FRANZ KLINE (1910–62), a leader of the abstract expressionist movement, was born in Pennsylvania and studied at Girard College in Philadelphia and at Boston University. He later settled in London where he attended Heatherly School of Art.

He returned to New York in 1939 and made a rather uncertain living drawing caricatures, sketches, and portraits of patrons in a Greenwich Village tavern. The murals he painted for a Bleeker Street tavern foreshadowed the development of his later style. By 1950, Kline's well-known stark mannerism and broad sweeps of black on white began to develop when he noted the contrast between black and white on his studio wall as he projected images of his drawing of a rocking chair.

From the mid-1950s Kline began to paint with colors again and taught at Black Mountain College in North Carolina, Pratt Institute in Brooklyn, and the Philadelphia Museum School of Art.

The expressive power of black and white pervades the graphic art and sculpture of **KAETHE SCHMIDT KOLLWITZ** (1867–1945). Like Goya and Daumier, she found a unique beauty among poor and underprivileged people, who constituted a large measure of her subject matter. In her later works, Kollwitz began to use her artistic genius to address the ills of society; in particular, hunger, poverty, and war.

She was born in Prussia of an intellectual and socially enlightened family, who encouraged her to practice her artistic talent. After her marriage to Dr. Karl Kollwitz in 1891, she moved with her family to Berlin. Although her art reputation grew quickly, her life was filled with tragedy. Death profoundly affected Kollwitz, first with the crushing loss of a son during World War I and then again during World War II with the deaths of husband and grandson. Curiously, a great number of her works are self-portraits, which seem to catalog a life of caring, sorrow, and deep resentment of the war-torn society that surrounded her.

ROY LICHTENSTEIN (b. 1923) popularized comic strip paintings during the 1960s. These enlarged sections, sometimes several feet wide, imitate popular cartoon images and incorporate words of dialogue as part of the canvas. These subjects, meant only as nostalgic parodies on culture, have often been associated with the pop art movement of the 1950s.

The famous American painter Reginald Marsh was one of the teachers of New York-born Lichtenstein at the Art Students League. In 1949, after completing a Master of Fine Arts degree, Lichtenstein worked as a designer in Cleveland and held teaching assignments at The State College in Oswego, New York, and Rutgers in New Jersey and was elected to the prestigious American Academy of Arts and Sciences.

His paintings, sculpture, and ceramics are creations inspired by many sources including past style periods in art, as well as specific works such as Monet's *Rouen Cathedral.* Paintings and sculptures utilizing frozen brushstrokes dominated his work in the 1970s.

"Painting begins with Manet," was one of Gauguin's observations of the revolutionary French Painter **ÉDOUARD MANET** (1832–83). He was an artist whose affluent background, snappy clothes, and life-style never reflected the artist stereotype.

Manet and his two brothers were born in Paris and all were destined by family tradition to study law. However, Édouard's future was to have little to do with anything except art. Although Manet's father protested such trivial pursuits, his musically talented mother secretly supported his artistic desire. In 1850, he joined the classes of Thomas Couture, a painter of accepted academic subjects in the classic style; however, Manet rejected his work and teaching from the first day and after constant bickering, finally left the studio.

Manet's work was considered controversial and scandalous throughout his career because his compositions and subjects were provocative departures from accepted standards. Although scorned by the critics, a young group of painters, soon to become known as the impressionists, chose him as their philosophical leader.

HENRI MATISSE (1869–1954) was described by an early teacher as an artist "born to simplify painting." The prediction was realized in a man whose work would later influence all modern painting and result in a new language of art.

He was born in the town of Le Cateau located in the flat country of northern France. During childhood he was unimpressed with art. As an adult, he studied law for two years before taking up painting as a distraction during an illness. In 1895 he began studying with the famous teacher Gustave Moreau at the prestigious École des Beaux Arts. At the Louvre, Matisse copied such masters as Watteau, Fragonard, and Chardin, and was inordinately attracted to color. Fascinated by impressionist and postimpressionist paintings, and under the influence of Pissarro, in 1896 he began an in-depth study of impressionism.

In 1899 Matisse, the painter, turned to sculpting noticeably influenced by Rodin. His first one-man show in Paris in 1904 received mixed reviews. He became interested in experimenting with innovative uses for color and in 1905 his efforts at this new style appeared in an exhibition with such names as Rouault, Braque, and Vlaminck. This avant-garde group became known as the "wild beasts," or *fauves*. His break with the reality of impressionism was decisive, allowing him freedom to express his feelings rather than copy nature—"What I am after, above all, is expression . . ." This concept was to influence many generations of artists. Illness did not deter him from the practice of simplicity, freedom, and originality.

JOAN MIRÓ (1893–1983) was born in Barcelona, Spain. He, Picasso, and Gris are considered to be the three most important twentieth-century Spanish painters. All became deeply involved with the development of French art, but Miró maintained close ties with Spain throughout his life

Against the wishes of his father, a goldsmith, Miró began his studies in Barcelona and later attended the Académie Gali where he learned to draw objects discerned only by touch.

He moved to Paris during the 1920s where he became a friend of Picasso. He soon joined the Paris dadaists and subsequently became a surrealist, contributing to the first surrealist exhibition in 1926. Between 1954 and 1959, Miró devoted himself solely to pottery. One of his monumental projects was commissioned by Harvard University where he designed an entirely new style of ceramic wall.

Miró received many awards for his engravings and his paintings, which were filled with wit and fantasy. In 1975, he established a center for the study of contemporary art in Barcelona. From 1956 until his death, Miró lived in a large studio house on the island of Majorca.

CLAUDE MONET (1840–1926) was born in Paris and grew up in the seaport town of Le Havre, where he learned, as a teenager, the wonder of outdoor painting. Monet returned to Paris in 1862 to study at the Académie Suisse, and it was in Paris that he met his long-term friend and associate Pierre-Auguste Renoir (1841–1919). While still in their early twenties, Monet and Renoir joined the Barbizons in the forests of Fontainebleau and painted out-of-doors, a practice that was still rather rare because metal-tubed oil paint had just been developed. Monet's first great success occurred in 1866 with a portrait exhibited at the Salon.

Monet never adjusted to urban life, preferring the countryside or the seashore. After a series of financial problems and eye trouble, Monet moved in 1883 to Giverny, a small town south of Paris. It was here he produced the serial paintings of his lily pond. Beginning with compositions that included the sky and a footbridge, Monet gradually moved his artistic vision closer to the water itself until even the shoreline disappeared beyond the frame. The viewer is awed by the sensation of floating in a mist of vibrant color and light. It is because of the waterlilies paintings that Monet is considered by many to be the quintessential impressionist.

HENRY MOORE (1898–1986) is one of England's most eminent sculptors. Born in Yorkshire, he began his career early with an elementary school scholarship, which eventually led to a grant at the Leeds School of Art.

His early work was nearly always bold and carved directly in stone or wood. During World War II, he created a number of memorable drawings in London air-raid shelters. Since the war, most of his pieces have been cast in metal and portray abstract subjects of reclining female figures and family groups. His well-known sculpting style incorporates an exterior, or "supporting framework," and an interior that houses the "tender and defenseless." They are organically shaped sculptures, reminiscent of the natural forms from which they were often derived.

His commissioned works are located throughout the world, and some works are of large-scale proportions such as *Knife Edge Mirror Two Piece* in the plaza of the National Gallery of Art, East Building. He said of this work, "As you move around it, the two parts overlap or they open up and there's a space between. Sculpture is like a journey. You have a different view when you return."

LOUISE NEVELSON (b. 1900) came from Russia to America when she was six years old and settled in a small town in Maine. From that time on she knew she was going to be an artist; at the tender age of nine, Nevelson vowed to become a sculptor. With strong support from old-world Jewish parents, she studied at the Art Students League in New York and for a brief period in Europe. Her personal interests in the arts prompted her to remain in New York where she exhibited her first show in 1941.

A strong, independent woman, Louise Berliawsky, married Charles Nevelson, bore a son, and after a brief time regained her single status. In many ways, Nevelson's work is like the artist herself—bold, complex, handsome, and unique. Nevelson once stated that an artist's work is a reflection of the artist. One of Nevelson's most important life encounters was a brief period of study with Hans Hofmann in 1931 in Germany from whom she learned the importance of shadow on three-dimensional art. This was to evolve into the familiar monochromatic (usually black), stacked boxes containing found objects, all of which magically blend into eloquent statements of order and power.

The tenacious American painter, **GEORGIA O'KEEFFE** (1887–1986) was born in Sun Prairie, Wisconsin, and received her early training at the Art Institute of Chicago. O'Keeffe furthered her studies in New York City where she lived from 1916 until 1924. Her paintings were first exhibited at the Alfred Stieglitz Gallery during this time.

She then moved to Abiquiu, New Mexico, where her reverence for the barren deserts of the southwestern United States formed her unique attitude toward subject matter. It is likely that O'Keeffe's long association with, and subsequent marriage to, photographer Alfred Stieglitz (1864–1946) also influenced her stark linear treatment of skulls, rocks, flowers, and other objects typical of the area. Her approach was based on the idea that if small insignificant things were made large and significant, people would look at them more carefully. She used realistic subject matter only as points of departure; the concentration of close-up, hard-edged treatment of common objects leans more toward abstraction. Severe contrast between opposites such as bleached white bones and soft colorful flowers was also a favorite device, along with the monumental presentation of selected subjects isolated from their natural surroundings.

MERET OPPENHEIM (1913–85) was born in Berlin and studied in various German and Swiss schools from 1918 to 1930. She was a member of the surrealist school whose shocking, outrageous work was an outgrowth of the studies by Sigmund Freud. This group of artists agreed with Freud that dreams are only seemingly illogical—that they reveal meanings if certain principles of interpretation are known.

In Paris, Oppenheim met surrealists Giacometti and Arp. She was a disciple of the American artist Man Ray and worked as a model for him.

In 1938, she studied at the Kunstgewerbeschule at Basel, where she learned picture restoration, a vocation she pursued for several years. She then moved to Bern in 1948 and married. She was awarded the 1974 Kunstpreis of the City of Basel.

Oppenheim is probably best known for her fantastic fur-covered teacup, saucer, and spoon, which has become a trademark of surrealism.

PABLO PICASSO (1881–1973) was one of the most widely recognized art personalities of the first half of the twentieth century. Only a few artists have attained his reputation and influence. His prodigious output of fifty thousand works affected such well-known figures as Vasily Kandinsky, Piet Mondrian, and Jackson Pollock.

Picasso was born in Malaga, Spain, and in 1900 moved to Paris. His early artistic efforts at the age of fifteen were guided by his art teacher father. Some of the great artists who influenced the young Picasso were Goya, Gauguin, Van Gogh, and Velasquez.

Blue became a dominant color for Picasso's work when he developed his monochrome paintings of tragic figures in 1901. His subjects in the Blue Period were beggars, the sick, and the hungry. During his Rose Period, begun in 1905, he used cheerful colors and subjects from the circus world, including actors and clowns.

In 1906, African art became an important part in Picasso's development. His masterpiece *Les Demoiselles d'Avignon* was influenced by the expressive sculpture of tribal artists and became a key work in the development of cubism. These innovative forms in painting laid a foundation for most of today's nonobjective art.

The outbreak of the Spanish Civil War in 1936 was the catalyst that led to Picasso's depth of involvement (and eventual membership in 1944) in the Communist Party. The bombing in April 1937 of the Basque town of Guernica by German planes supporting General Franco inspired one of his most famous works. The *Guernica* painting made vivid the death and destruction, the grief and suffering of the people, and became an emblem of Spain's anguish in her fight against fascism.

The Musée Picasso, a renovated seventeenth-century hotel in Paris, is the new home for over four thousand works by Picasso. This extensive collection was given to the French government by his estate as payment for taxes.

For **JACKSON POLLOCK** (1912–56) the hard times of the Depression era plagued his slow rise to recognition as one of this country's leading artists.

Born and raised in the western states of America, he left his home in California in 1929 to study with Thomas Hart Benton in New York City. It was in the late 1940s that Pollock began to break away from realism and to develop his well-known style of free abstract expression. He achieved it by dripping, smearing, and flinging paint onto a canvas usually spread out on the floor or ground. Like Nevelson, Pollock came under the influence of Hans Hofmann whose freely painted, nonrepresentational works laid the groundwork for Pollock's spontaneous application of paint.

In 1945 he married New York artist **LEE KRASNER** (1908–84). Both continued to develop their abstract expressionist style in their New York studio as well as at their quiet country home in Long Island until Pollock's tragic death in an automobile accident in 1956. Pollock made an enormous impact on the art world of both America and Europe and is considered the definitive abstract expressionist.

Texas-born painter **ROBERT RAUSCHENBERG** (b. 1925) began developing his startling innovation and experimentation with collages and assemblages during the 1950s. His works are unpredictable and include unusual combinations of images and painted surfaces. They are often more reminiscent of sculpture than painting and defy categorization because he combines disparate media, objects, and unconventional techniques. For Rauschenberg, these works abolished the traditional "picture" and became known as "combine" paintings.

Rauschenberg is also considered one of the founders of the pop art movement. He created art with random images just as John Cage did with sound in music. Many of his oil canvases double as surfaces for provocative images employing photographs transferred to the canvas by the silkscreen process.

After attending the Académie Julian in Paris and training with the famous colorist Josef Albers at Black Mountain College, Rauschenberg worked at the Art Students League in New York. His abilities not only as a painter, but also as a dancer and a designer of stage sets and costumes have been recognized since the 1950s.

The work of French artist **PIERRE-AUGUSTE RENOIR** (1841–1919) typifies the objectives of nineteenth-century French impressionism.

He began his career as an apprentice to a porcelain decorator. Later he studied the works of his favorite painters Watteau, Boucher, and Fragonard and was greatly influenced by Courbet. He eventually became acquainted with other impressionist painters, the most important of whom were Monet and Sisley. Renoir was an out-of-doors painter and exhibited with his colleagues in many impressionist exhibitions. He traveled widely in such places as North Africa, Italy, England, Holland, and Spain and as a result his work became more structured than that of his impressionist friends, who preferred the spontaneous use of pure color. His work during this period was dominated by nudes instead of landscapes and flowers.

Arthritis struck in the early 1900s making it possible for Renoir to paint only if the brush was positioned awkwardly between his twisted finger joints or strapped to his wrist. Many of the nearly six thousand paintings that he completed can be seen in various galleries and museums in the United States.

A leader of the op art movement in the 1960s, **BRIDGET LOUISE RILEY** (b. 1931) was born and trained in England. She was influenced by the French op artist Vasarely and found her distinctive style after seeing a black and white marble plaza in Italy through a sheet of rain.

Riley's most successful works are those that deal with the effects of visual illusion. With curves and circles—working mainly in black, white, and gray—she uses interference and other optical effects to dazzle and confuse the viewer. Her creations, which tend to visually shift and vibrate, are a deliberate attempt to tease the eye.

She has also experimented with color using graduated tone variations to confound the eyes of the viewer with the effects of depth and motion.

Riley has taught at several art schools in England and is the recipient of many international prizes.

The most celebrated sculptor of the late nineteenth century was **AUGUSTE RODIN** (1840–1917). Born in Paris with the talent and commitment to become an accomplished sculptor by the age of twenty, Rodin was not deterred even when rejected many times by the important École des Beaux Arts Society. While sculpting, he also diligently pursued his studies in history and literature until the death of his sister changed his course of direction and he entered a religious order for a short time.

Eventually he returned to sculpting and to the study of the old masters such as Michelangelo. He considered himself to be "a bridge joining the two banks; the past and the present." His work was consistently nonconformist and he never failed to raise a stir in the press. His famous masterpiece, the *Age of Bronze,* was considered too "life-like," and was believed at the time to be a body cast.

Rodin believed that the artist should go beyond mere likeness and that a work of art should never be considered "finished." Rodin's abundant production of sculptures, drawings, and watercolors gained him universal acclaim and wealth.

The American sculptor **GEORGE SEGAL** (b. 1924) was educated at New York University and Rutgers. He is known for his characteristic and often unpainted white plaster figures combined with real objects such as chairs, tables, or coffee cups. During the 1960s his true-to-life creations included *The Gas Station, Laundromat, Cinema, The Subway,* and *The Restaurant Window,* all representing anonymous people in modern culture.

The career of this New York-born artist began with his interest in realistic painting. He then turned to his now popular life-like plaster casts of individuals and groups. During the late 1950s and 1960s he was associated with the art form known as the "Happening" in which spectators were expected to participate in the event.

HENRI DE TOULOUSE-LAUTREC (1864–1901), although born to the aristocracy in southern France, lived and painted in Paris in Montmarte, depicting life in the brothels, the theatre, and the circus.

Because of his dwarf-like stature resulting from broken legs in early adolescence, he exiled himself from the wealthy, upper class social life. He moved to Paris and soon found acceptance in its shadowy night spots. There he developed his powerful style of painting and lithography, combining realism with the idealism of such French masters as Ingres and David. A Parisian cabaret, the Moulin Rouge, became his favorite haunt and spawned his colorful energetic posters.

Crippled, self-conscious, yet tolerant, the prolific Toulouse-Lautrec worked among the entertainers of the night until bouts of alcoholism weakened him. His life ended at his family home when he was only thirty-six years old.

JOSEPH MALLORD WILLIAM TURNER (1775–1851) has been called the greatest of all English painters, with a total of nearly 20,000 watercolors and 282 oils to his credit. He willed many of these and other unsold works to Great Britain, and they are now in the collection of the Tate Gallery in London.

His initial work, until about 1796, was in watercolor. Later he turned to oil. In both media, he created characteristic use of color that was dramatic and full of powerful light and movement. This often obscured the content and brought negative comments from his colleagues. The artist Constable called his work "tinted steam."

Turner's earliest works were exhibited in his father's barbershop in London, but his genius was soon recognized and he was accepted into the important Royal Academy at the age of twenty-four. He remained there for thirty years as an instructor.

Turner's versatile talent allowed him to shift back and forth from the ethereal to the realistic with complete ease.

Some of the details in the short and tragic life of **VINCENT VAN GOGH** (1853–1890) may make him one of the best known of all artists. Born and raised in Holland, he didn't begin painting until he was nearly thirty years old. Until then, Van Gogh, the deeply religious son of a protestant minister, had worked in an art gallery, had an unhappy love affair, had a mental breakdown, and had served as an overzealous missionary to the poor and suffering.

He moved to Paris in 1886 and lived with his brother, Theo, who introduced him to the impressionist painters Toulouse-Lautrec, Pissarro, Degas, Seurat, and Gauguin. After painting typical impressionistic subjects, he moved to Arles in the Provence district.

Because of their close working relationship in Paris, Gauguin joined him in Southern France where both painters were working with brilliant color intensities and contrasts. However, their temperaments differed and after a raging quarrel, Gauguin left. In despair, Van Gogh cut off part of his ear, and sensing his own instability, committed himself to a mental institution and eventually killed himself.

Between his episodes of deep depression, Van Gogh saw things lucidly and clearly, presenting the world with a collection of paintings filled with the raw power of color. This zestful painter of sunlit Holland landscapes later created brooding scenes of night cafés and crows hovering over desolate wheatfields. His art, with roots in the impressionist tradition, signaled the beginning of twentieth-century expressionism.

ANDY WARHOL (b. 1928) is both an American painter and filmmaker. Born of immigrant Czech parents in Philadelphia, he studied at the Carnegie Institute of Technology in Pittsburgh, where he earned a B.F.A. in 1949. As an outgrowth of his work as a commercial artist for *Glamour* magazine, Warhol became identified with the pop art trend in the early 1960s. Because he attacked all conventions in art, his work was initially considered to be very controversial; however, as is the case with many avant-garde artists, his outlandish mannerisms have become vastly influential in both graphic arts and filmmaking. Two of his films stand out as classic examples of Warhol's obsession with the idea of similarity and literal repetition: *Sleep,* a film solely about a person sleeping; and *Empire,* a film consisting entirely of various views of the Empire State Building. Both films are six to eight hours in length and seem to be designed to test the ability of the audience to endure sheer boredom. Nevertheless, Warhol's now-fashionable style of casual acting, wandering camera movement, and passages of trivial dialogue are ideas that have influenced commercial filmmaking.

In June 1968, Warhol was shot and severely wounded by one of his movie superstars. He survived that attack, used it to illustrate his own unusual life-style, and continues today to make a unique impact on the American world of art.

FRANK LLOYD WRIGHT (1869–1959) is regarded as one of the giants of world architecture. During his career he designed over six hundred structures, including the Unity Church in Oak Park, Illinois (1906), the world famous Kaufmann House in Bear Run, Pennsylvania (1936), and his last major work, the Solomon R. Guggenheim Museum, New York City (1959). His innovations in architecture included the development of the reinforced-concrete cantilever that allowed more flexibility in design and construction techniques.

Wright was born in Richland Center, Wisconsin, and left college early to take a drafting position with the renowned architect Louis Sullivan in Chicago. After six years he started his own firm using ideas that were considered nonconformist in design and floor plan. His low, one-story houses in the 1930s, known as Prairie Houses, were meant to blend with the landscape. In a cubist style, he grouped blocks of space (rooms, balconies, gardens) around a central core. His intention was to create a complete environment, and this included designing even the furniture and fabrics for the interiors.

Glossary

abstraction The modification of forms in order to emphasize their intrinsic qualities.

abstract expressionism A style of painting developed in the 1940s characterized by an emphasis on methods of unconventional application of paint to the canvas. (See *action painting* and *color-field painting*.)

action painting Associated with abstract expressionism, action painting involves a free brushstroke or the application of paint by dripping, splattering, or any other action-oriented activity.

aerial perspective The manner in which artists achieve the illusion of depth in drawing and painting by making distant objects appear less distinct.

aesthetic The sense of beauty in all things.

alternation A theme that recurs with other elements in turns.

analogous colors *Hues* adjacent on the color wheel.

angular line A sharp-cornered, awkward, and frenzied line; opposite of *lyric line*.

aquatint A process of etching areas rather than lines. A metal surface is coated with rosin in fine drops and etched by acid to create many subtle tones unlike the sharp lines of an engraving tool. Values ranging from black to white are made possible by varying the time of acid treatment; named after its ability to imitate watercolor. (See *etching*.)

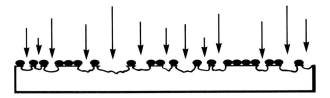

The arrows show the direction of acid as it "bites," or etches, into the metal surface between the drops of rosin. The rosin is then removed, and ink is wiped into the depressions left by the acid as in the *intaglio* printing process accomplished in *etching* and *engraving*. Different tones from white to black result from the grains of rosin being dispersed from close to farther apart. The wider the space between the drops, the darker the tone on the print.

arabesque An ornate design of floral and geometric figures.

armature A framework or core used by a sculptor to support added outer materials that are soft and unable to stand alone.

assemblage A type of sculpture resulting from the arrangement of unrelated pieces and scraps of various materials. Assemblage artists are limited only by the nature of discarded or regenerated objects found in the environment.

asymmetrical balance (See *balance*.)

background (See *pictorial space*.)

balance A compositional relationship of areas that may be achieved *symmetrically* or *asymmetrically*. A balanced composition possesses an equilibrium of opposing shapes, lines, and colors.

baldachino A canopy located over the altar in church architecture.

Barbizon School A group of mid-nineteenth-century painters who gathered at Barbizon, a small town near Paris, and worked out of doors in the nearby forest of Fontainebleau. Landscape painting became a favorite subject, and their work influenced the development of *impressionism*.

baroque A seventeenth-century style of art characterized by elaborate ornamentation, flamboyance, and strong emotional content.

basilica A church with an oblong floor plan and side aisles terminating in a semicircular recess at the altar.

bas-relief A technique of sculpting against a flat surface, as opposed to three-dimensionality. The subject is sculpted so that it is slightly raised from the background, the negative areas being lower than the positive.

biomorphic Shapes that resemble living forms or structures.

black figure A vase decoration technique in which the figures appear as black silhouettes against a light clay background.

burin (See *etching*.)

Byzantine A fifth-century style of art rich in religious iconography and known for elaborate stylization of figures. Byzantine architecture is characterized by intricate detail, rounded arches, and massive domes; painting is characterized by rich color and religious subject matter.

calligraphy The art of elegant handwriting with a brush or pen producing stylized line.

cantilever A projecting beam or other structural member supported at only one end or behind a vertical support known as a fulcrum.

capital The top section of a column. (See *Greek orders*.)

caricature A simplified likeness of an individual that usually exaggerates some prominent feature or features.

Carolingian An art style in northern Europe from the eighth to the tenth centuries.

cartoon A preliminary sketch used as a plan for the creation of a work of art.

champlevé An enameling process whereby the design is etched into the surface of a metal plate. The areas are filled with enamel and fired in order to bring the surface flush with the top of the base plate.

chance The random ordering of elements that results in a freely expressed artwork.

chasing A technique used by artists to decorate the surface of metal objects. A variety of steel chasing tools are used to pound lines, shapes, and textures into the surface. Chemicals are often applied into the depressions to create an interesting *patina* on the natural surface of metals.

chiaroscuro An Italian term for light and dark. Artists use the effects of light and shadow to create the illusion of three-dimensional form on a two-dimensional surface.

chroma (See *intensity*.)

classicism The style of ancient Greek art revived during the *Renaissance* and *neoclassical* periods and characterized by restraint, balance, and simplicity.

cloisonné A process in which glass, enamel, or gems are placed between dividing partitions forming a design on a metal surface.

closed form (See *sculpture in the round*.)

codices Books or manuscripts of ancient scriptures, laws, or classics. (Singular: codex.)

collage A work of art created by pasting bits and pieces of paper, cloth, or wood on cardboard or plywood.

color-field painting Associated with *abstract expressionism*, color-field painting involves the application of paint in broad areas of color, often on an unprimed canvas, allowing the fusion of paint and ground.

complementary colors *Hues* found directly across the color wheel from one another.

composition (See *design*.)

computer art Programmed images produced with the aid of high-speed mathematical calculations and realized by picture elements (*pixels*) on a video screen or printout.

conceptual art An endeavor since the 1960s to place emphasis on the idea or concept behind a work of art rather than the art object itself.

constructivism A form of sculpture influenced by the *cubists* in which objects appear to have been constructed or built up rather than carved and which involves an emphasis on the treatment of space.

content The meaning, intent, or *aesthetic* message of a work of art.

contour The outer edge of two- and three-dimensional forms.

contrapposto The disposition of the parts of a human figure that was employed by artists of the sixteenth century to give a more lifelike appearance to a subject. Artists caused the axes of the hips and shoulders to shift in opposite directions by placing the figure's weight on one foot.

contrast The juxtaposition of opposing elements of color, line, and shape to accentuate dissimilar qualities.

cool tone Colors and admixtures on the color wheel from the blue, green, and violet range. (See *warm tone*.)

corbeling An overlapping arrangement of *courses* that gradually extend outward and upward from the wall, like upside-down staircases.

Corinthian order The most elaborately ornate of the *Greek orders*; the *capital* resembles leaves.

courses Continuous layers of building materials such as bricks or stones.

crosshatching The use of repetitive crossed lines to depict shadow and three-dimensional shapes or value changes in a drawing or painting.

cubism A style of art developed by Picasso and Braque in which natural forms are reduced to geometric units and reordered to present several points of view simultaneously.

cult objects Objects used in ritual acts. The objects are thought to contain magical powers over natural forces and to ensure fertility.

dada A style of art characterized by whimsical subject matter; intended to mock serious art and the society that espoused it.

deep space (See *pictorial space*.)

design The pattern resulting from artists' arrangement of elements in a work of art.

developmental repetition Repeated elements that appear to be growing or evolving. (See *repetition*.)

divisionism The separation of colors into small facets to retain the vibrancy of unmixed hues. *Pointillism* refers to the application of colored dots of pigment to build forms, while divisionism is associated with the "divided" brushstrokes of *impressionism*.

Doric order The simplest and least ornate of the *Greek orders*.

Early Christian A style of art from the first through the fifth centuries, dominated by scriptural subject matter and Greco-Roman Traditions.

encaustic A painting medium made of wax mixed with pigment and applied while hot.

engraving An intaglio method of printing.

The *burin*, or *graver*, is used to cut lines in the surface of metal plates.

A, A cross section of an engraved plate showing burrs (ridges) produced by scratching a burin (cutting tool) into the surface of a metal plate; *B*, The burrs are removed and ink is wiped over the surface and forced into the scratches. The plate is then wiped clean leaving ink deposits in the scratches; the ink is forced from the plate onto paper under pressure in a special press. (See *etching*.)

environmental art Works conceived as integral parts of their intended surroundings.

etching An *intaglio* printing process. A metal plate is coated with resin, then images are scratched through the coating with a burin, or graver. Acid is applied, which "eats" or etches the metal exposed by the scratches. The resin is then removed and ink is rubbed into the etched lines on the metal plate. After the plate is wiped clean, it is pressed onto paper and the ink-filled lines are deposited on the paper surface. Other intaglio processes include *engraving* and *aquatint*.

A, Cross section showing all metal surfaces coated with an acid-resistant resin; *B*, The coating scratched with a steel burin to form the lines of the design; *C*, After immersion in acid, the scratched lines, unprotected by the resin, become etched into the metal surface—the longer the lines are exposed to the acid, the deeper and wider the lines become; *D*, The resin coating is removed and the plate is wiped with ink that fills the lines of the design. The ink-filled lines are forced from the plate onto paper under pressure in a printing press.

expressionism A style of art characterized by the depiction of the artist's feelings and subconscious world. Usually involves distortion and depicts the dark side of human experience.

fauvism An art movement in which bold color was used as the fundamental means of expression.

fetish An art object thought to possess magical powers strong enough to control nature. No religious function is associated with the object.

figure-ground The relationship of volume and space. *Interchange* can occur when the balance between the two elements is so tenuous that they seem to alternate. (See *positive* and *negative space*.)

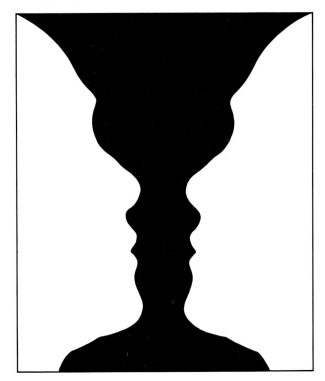

Interchange: The image flip-flops, or alternates with the image of a vase or of two profiles.

focal point Generally used to describe the center of interest in a work of art.

foil An element in art that serves to increase the quality of another element through contrast and interaction. (See colorplate 46.)

foreground (See *pictorial space*.)

foreshortening A system of drawing and painting in perspective by overlapping forms and making them smaller as they recede in space.

form The total visual organization in an artwork; also refers to the illusion of three-dimensional shapes.

format The size and shape of a work of art, either rectangular, round, square, etc. The artist selects a proportion that best suits the subject or idea being expressed.

fresco A painting executed on wet plastered surfaces that allows the paint to become part of the wall or ceiling upon drying.

frieze (See *pediment*.)

futurism Title describing the work of a group of artists who were dedicated to destroying past traditions and developing a new form of art characterized by violent motion and strong energy.

genre paintings Paintings that depict subject matter from everyday life.

geometric abstraction The reduction of natural forms to simple, angular images resembling rectangles, squares, circles, cubes, triangles, cylinders, or irregular shapes.

gesso A liquid, base-preparation made from a mixture of chalk and glue for canvas and wood surfaces.

gesture The use of spontaneous line to express the essence of a subject.

gilding The process of overlapping thin sheets of gold or metal leaf to cover wood or glass surfaces. The extremely thin sheets are shaped and applied as ornamentation, and these are sometimes covered with shellac to prevent their tarnishing.

glaze A coating used by the potter to create a glassy surface on ceramic ware. Different degrees of transparent and opaque color glazes may be applied in a variety of ways to create many decorative effects. (See *glazing*.)

glazing A method of superimposing thin, transparent layers of paint to create interesting illusions of volume or depth in a painting. (See *glaze*.)

golden rectangle (See *golden section*.)

golden section A method of achieving a pleasing proportional division of the painting surface. (See *proportion*.)

Gothic A style of church architecture in the late *medieval* period characterized by pointed arches and high-vaulted ceilings.

gouache A water-soluble paint that dries opaque.

Greek orders Types of columns in the classical Greek style. (See *capital; Corinthian, Doric,* and *Ionic orders*.)

hatching The use of repeated parallel lines to change value of shapes in drawing, painting, or printmaking. (See *cross-hatching*.)

holography The technique of producing projected, three-dimensional images with the use of *lasers*.

hue The designation or name of a color.

icons Symbolic images that often have religious meanings.

illusionism The use of painted images on architectural forms or canvas that create the illusion of three-dimensional space and mass.

impasto A thick application of paint, usually in layers, producing a roughly textured surface.

impressionism A style of art pioneered by Monet in the last half of the nineteenth century that is characterized by the play of light and divided brushstrokes. (See *divisionism*.)

incised line Line cut into the surface of an object creating patterns and textures.

Ionic order One of the *Greek orders* whose *capital* resembles a scroll.

intaglio Lines incised, or cut into, a hard surface. (See *etching*.)

intensity The relative purity and brightness of color; also known as *chroma* or *saturation*.

International Style A style of architecture, beginning in the 1920s, that moved the support walls from the outside shell to the inside of a structure for greater flexibility of design. Buildings in this style are usually without excessive ornamentation.

interchange (See *figure-ground*.)

Kachina dolls Gifts given to children during Indian tribal ceremonies in the southwestern United States. They were symbols used to educate children about the more than three hundred spirits the dolls represent.

kiln An oven or chamber in which ceramics are fired or baked; glassy surface glazes are produced by vitrifying the clay at high temperature.

kinetic sculpture (See *mobile*.)

kouros A Greek word for youth (plural: kouroi). In Greek sculpture a kouros was characteristically depicted as a standing male nude.

lasers Light Amplification by Stimulated Emission of Radiation. Light amplified and concentrated into coherent frequencies.

lettrisme An art form first used in the twentieth century by the cubists, who added bits of newspaper or sheet music to a *collage* or painting surface. Art forms of the 1960s, using typography and other symbols, evolved into sophisticated painting and sculpture.

light sculpture An art form utilizing electric lights as the medium of expression.

linear perspective A system used to depict the illusion of three-dimensional forms in deep space on a two-dimensional surface by causing lines to converge on one or more vanishing points. (See also *aerial perspective.*)

literal repetition Repeated elements that appear to be growing or evolving. (See *repetition.*)

lithography A method of making prints from a flat surface; also called *planography.*

An image is first drawn or painted with an oil-based lithographic crayon or pencil on a smooth limestone surface. The surface is wiped with water, which will not stick to the applied areas of greasy lithographic ink because oil and water do not mix. The greasy areas resist the water and are thus exposed.

The surface is then rolled with printing ink, which adheres only to the parts drawn in the oil-based medium. Dampened paper is placed over the stone, and a special flatbed press rubs the back of the paper transferring the work from the stone to the covering sheet.

local color The actual color of objects in their environment.

lost wax A process of casting an image carved from wax. The wax model is surrounded by a plasterlike investment, which, when heated, causes the wax to melt (to be lost) from the mold. Metal is then poured into the cavity left by wax model.

lyric line The effortless beauty of a line's graceful movement; the opposite of **angular line.**

mannerism A style of art that followed the High Renaissance; characterized by distortion and individual affectations.

mastaba A flat-roofed, rectangular, Egyptian tomb with sloped sides; said to be one of the forerunners of Great Pyramids of Giza.

medieval The term applied to the Middle Ages.

melody A series of tones that expresses a logical, musical thought; perceived as a complete unit. Tones in a melody express a thought to our aural perception as lines in a painting or sculpture affect our visual perception. *Melody* in music is similar to line in the visual arts.

metopes Decorative relief panels on a *frieze.* (See *pediment.*)

middleground (See *pictorial space.*)

minimalism Natural forms reduced to simple geometric units in both sculpture and painting. A reaction in the 1960s against *constructivism.*

mobile(s) Sculpture with moving parts set in motion by air currents or motors; also known as *kinetic sculpture.*

model The use of linear repetition on the surface of shapes to describe their three-dimensional quality. Modeling is also associated with the additive method of sculpture in which art media are built up or added to the work in the formative stages.

monochromatic The use of only one *hue;* usually seen in varying degrees of value and intensity.

montage A composition of pictures or photographs, often focused on a unifying theme.

mosaic The juxtaposition of small pieces or shapes to form larger patterns.

motif A repeated theme used in the development of an artwork; also, the actual subject of a work.

naturalism Refers to subject matter that closely resembles natural forms.

negative space The shape of open spaces around planes and volumes in two- or three-dimensional art forms; often referred to as *background.* (See *positive space.*)

neoclassicism A style of art around the turn of the nineteenth century; characterized by clarity of form and simplicity. Also involved the revival of classical antiquity, especially in sculpture and architecture.

neoplasticism A term coined by Piet Mondrian to describe his approach to painting in which neutral configurations comprise a universal language of artistic expression.

nonrepresentational art As distinct from *abstract art,* nonrepresentational art uses forms without any reference to reality.

open form (See *sculpture in the round*.)

one-point perspective An aspect of *linear perspective* in which lines converge on a single vanishing point.

op art A style of painting utilizing lines or colors in such a way that the eye senses motion; also called optical art.

palette knife A spatula-type knife used to apply smooth, flat, or thick layers of paint to the canvas; also used to mix color on the palette.
Painting and palette knives are available in a wide range of sizes and shapes.

patina Surface color, resulting from the use of chemicals on metal surfaces, used to enhance the quality of the work.

pediment A term used to describe the triangular area or gable formed by the sloping roof in classical architecture. The *frieze* is the horizontal surface located below the pediment area and often used for decorative relief sculpture.

perspective (See *aerial* and *linear perspective*.)

pictorial space Space created on a two-dimensional surface by dividing the area into roughly three sections: near objects in the foreground (shallow space), and objects progressively further away in the middleground and background (deep space).

picture plane A painting's surface, top-to-bottom and side-to-side.

piece mold A molding process in which two or more hollow pieces are joined together prior to casting.

pixels The vertical and horizontal picture elements dividing television screens. (See *computer art*.)

planography (See *lithography*.)

pointillism The technique of applying tiny dots of paint to the canvas to create form and optical mixtures of *hue*. (See *divisionism*.)

pop art A style of painting and sculpture in which subject matter was derived from (and often parodied) popular culture.

porcelain A fine-grained, translucent chinaware fired at high temperatures to achieve high luster and delicacy.

positive space The shapes of forms representing the subject matter; opposite of *negative space*.

post and lintel An architectural system using two vertical supports spanned by a crossbeam.

postimpressionism A style of art inspired by the impressionists' emphasis on light and color but characterized by bolder coloration, stronger formal elements, and expressive symbolism.

primary colors The pigmented hues red, yellow, and blue that cannot be produced by mixing other hues. (See *secondary, tertiary,* and *complementary colors*.)

primitive painting Usually refers to the works of self-taught artists. Images are often frank and bold but lack realistic proportions and traditional refinements; also called "native," "naive," or "folk art."

print A term used to describe an impression made by a printing process. Multiple prints are usually identified in pencil at the bottom with the print number, title, artist's name, and date.

The print number 10/20, for example, means the tenth impression from a total edition of twenty.

proportion A pleasant visual relationship between the parts in a work of art.

ready-mades Works of art constructed of preexisting objects that assume new functions and meaning.

realism Refers either to visual accuracy or to the selection of ordinary subject matter.

red figure A Greek vase-decorating technique in which the figures appear in the body of red clay against a black glazed background.

reducing glass An instrument that reduces an artwork to a dimension of one or two inches enabling the artist to analyze a composition from a new point of view.

reinforced concrete Concrete strengthened with embedded metal that allows greater flexibility in the design and use of precast forms in architecture. (See also *cantilever.*)

relief printing A basic printing process in which the designs of shapes and lines are raised above the plate or background, leaving the designs standing in relief. (See *woodcut.*)

reliquary African sculpture used as a grave figure and placed above a container holding the bones of an ancestor; it serves to deter evil spirits from entering the remains. Also a container to protect sacred relics related to saints or martyrs.

Renaissance A period of European history spanning the fourteenth through the sixteenth centuries; characterized by a humanistic revival of classical antiquity in art, literature, and music.

repetition The restatement of visual elements; used to create a sense of unity in painting and sculpture.

repoussé The technique of pounding or rubbing the back of metal in order to create a relief design on the front of the piece.

rhythm The pattern of recurring accents (strong and weak elements) in artworks.

rococo An eighteenth-century style of art that grew out of the *baroque;* characterized by elaborate, delicate ornamentation and frivolous subject matter.

Romanesque A medieval style of art influenced by the Romans and dating from roughly the ninth to the twelfth centuries.

Romanticism The prevalent style of the nineteenth century; characterized by strong emotional content, turbulent activity, and heroic subject matter.

Salon The official annual exhibition of paintings in nineteenth-century Paris; administered by a learned society of art critics.

Salon des Refusés The exhibit established as a result of public outcry for the exhibition of paintings refused by the nineteenth-century Salon Academy. (See *Salon.*)

saturation (See *intensity.*)

scale The actual or apparent size of an object in art.

scarification The tattooing of lines, shapes, and colors on human skin in tribal societies.

sculpture in the round The phrase used to designate three-dimensional work that can be viewed from any angle (often referred to as free-standing sculpture). *Open form* refers to sculpture with an extension of parts into open space. *Closed form* refers to work in which all parts touch and maintain most of the original size and shape of the media.

secondary colors *Hues* that result from the mixture of *primary colors.*

serial painting A sequence of paintings in which the artist paints the same subject at different times of the day or seasons of the year.

serigraphy (See *silkscreen.*)

sfumato A technique of softening contours by painting the hazy, smoky effects of real light in our atmosphere.

sgraffito A technique of decorating pottery by scratching covering glazes or slips, thereby exposing the clay beneath.

shade The degree to which a color has been mixed with black to neutralize the original color without obscuring its true quality.

shallow space (See *pictorial space.*)

shape An area in drawing, painting, and sculpture defined by line, color, and value. Shapes may be *actual* (real forms) or *implied* (shapes suggested by the positioning of real forms). (See the circles suggested by human forms in Bruegel's *The Wedding Dance,* fig. 2.8.)

silkscreen A printmaking technique employing the use of stencils; a stencil of the image is cut and attached to fine-mesh silk held by a frame. Printing ink is forced through the open areas of the stencil and deposited on the surface of paper, cloth, or other ground supports. Also called serigraphy.

1. A wooden frame is used to hold fine-mesh silk; a separate frame is used for each unit to be printed.
2. The image is cut from film before being attached to the silk. The open shapes in the stencil will become the printed areas.
3. A rubber-tipped squeegee is used to force printing ink through the stencil openings onto the printing surface.
4. The background film is dissolved from the silk following the printing process.

slip A thin, colored clay used for the decoration of pottery.

stabile A stationary sculpture with no moving parts; the opposite of *mobile*. Usually refers to the abstract work developed by Alexander Calder.

style A consistent use of basic elements that results in a recognizable method of presentation.

stylized The manner of execution in which artists express subject matter according to individual expression rather than nature; refers to *how* a work of art is done rather than *what* it represents.

subject matter The term used by artists to describe objects, places, shapes, or forms represented in art.

sunken relief A form of sculpture in which figures are cut to a shallow depth, allowing the negative space to stand out.

superrealism A style of art developed in the 1960s and 1970s that represented natural subject matter with highly detailed accuracy.

surrealism A style of art that grew out of the *dada* movement in the 1920s; characterized by subject matter derived from the subconscious and by mysterious *symbolism.*

symbolism The representation of ideas or meanings by using significant elements and objects.

symmetrical balance (See *balance.*)

synthesizer An electronic, tone generator that produces sounds resembling musical instruments.

tapestry Fabric created by a technique in which expressive or pictorial patterns are freely woven on a loom with weft (horizontal) threads dominating the warp (vertical) threads.

tempera A water-soluble paint with an egg yolk base; sometimes called egg tempera. Vegetable and animal glues are often used as binders.

terra cotta Clay that has been baked to maturity in a *kiln.*

tertiary *Hues* that result from a mixture of *primary* and *secondary* colors.

texture The patterns of lines and shapes on the surface of a work of art that impart either a visual or tactile quality.

totem pole A carved and painted pole with images venerated by American Indian tribes, most usually those of the northwest coast. They were sometimes erected outside the home and served as religious symbols or emblems of the social status of individuals, families, clans, or tribes. Totemic symbols include fish, birds, and plants.

triad A group of three colors spaced equally around the color wheel.

two-point perspective An aspect of *linear perspective* in which lines converge on two vanishing points.

Performers using a synthesizer in a studio recording session;
ARP Instruments Inc.

undercutting The carving around shapes on sculpture to create cast shadows in recesses.

underpainting A technique used by painters to prepare raw canvas for the final painting. Broad lines and shapes of color are often applied to parts or all of the canvas to establish a color tone that will alter, or show through, transparent layers of paint.

unity The consistent treatment of similar elements resulting in a work in which all the parts together form a harmonious whole.

value The amount of light or dark in a color.

venuses Prehistoric sculptured relics dating from ca. 15,000 B.C. in which fleshy female figures were carved as cult objects symbolizing fertility.

warm tones Colors and admixtures on the color wheel from the red, yellow, and orange range. (See *cool tones*.)

watercolor A water-soluble medium using a gum binder that allows for the option of using transparent as well as opaque color washes.

white ground A Greek vase-decorating technique using a thin layer of white *slip* as a supporting ground for the figures.

woodcut A relief printing process created by lines cut into the plank surface of wood. The raised portions of the block are inked and transferred by pressure to the paper by hand or with a printing press.

yin-yang Describes a dualistic principle of opposing but complementary forces in Chinese philosophy in which yin represents the negative and yang the positive.

ziggurat Assyrian or Babylonian pyramid-like temple or tower with ramp stairways leading to a sanctuary on the top level.

Index of Artists and Works Illustrated

Index

Nolde, Emil
 Christ among the Children,
 motion, colors, emotion, and
 composition in, 231–32, **231**
 *Portrait of the Artist and His
 Wife,* basic shapes in, 43,
 Plate 8
 Prophet, The, linear rhythm and
 power of emotion
 represented in, 32, **32,** 231
Nonrepresentational art, 43, 243, 343
North American Indian art, 322–25
North Frieze of the Parthenon, 110
Nov. 21–49 (Nicholson), lines,
 compositional design, and
 look of spontaneity in, 262,
 262
Nude (Modigliani), **Plate 16**
Nude Woman in a Tub (Kirchner),
 angular line in and rough
 visual texture in, 18, **18,** 30,
 231
Number 1, 1950 (Lavender Mist)
 (Pollock), rough texture in,
 and lack of recognizable
 image in title, 30, **30,** 256
#1 Rope (Winsor), tight density and
 evenly divided space in, 267,
 Plate 62
#12–1955–56 (Reinhardt), deep
 colors, and squares in, and
 hypnotic effects of, 261,
 Plate 64

Oath of the Horatii, The (David), **204**
Object (Meret Oppenheim), as symbol
 of surrealistic dream world,
 246, **246**
Oceanic art, 316–17
Odalisque in Grisaille (Ingres), use of
 long curved line in, 194,
 Plate 44
Ode to a Grecian Urn (Keats), 195
Oil paintings
 Abduction of Rebecca, The
 (Delacroix), 197–98, **Plate
 47**
 abstract expressionist, 255–60
 Adoration of the Kings, The
 (Bruegel, the Elder), 162,
 162
 Advice to a Young Artist
 (Daumier), 21, **21**
 Agony in the Garden, The
 (Bellini), 147–48, **147**
 Allegory of Love, I (Veronese),
 164, **165**
 An Allegory (Bronzino), 161, **161**
 Animals in a Landscape (Marc),
 49, **49,** 233
 *Annunciation with S. Emidius,
 The* (Crivelli), 148, **Plate 29**
 *Antoine Laurent Lavoisier and His
 Wife* (David), 193, **193**

Apollo Pursuing Daphne
 (Tiepolo), 12, **13,** 170
Arcadian Shepherds, The
 (Poussin), 180, **180**
Bacchus and Ariadne (Titian),
 158–59, **159**
*On the Banks of the Marne,
 Winter* (Pissarro), 215–16,
 215
Baroque Synchrony No. 11
 (Russell), 40–41, **40**
Basket of Apples (Cézanne), 238,
 Plate 55
Bath, The (Cassatt), 216, **Plate 48**
Bathers, The (Fragonard), 184,
 184
Bedroom at Arles, The (van
 Gogh), 219, **Plate 49**
Blue Mountain (Kandinsky), 66,
 233, **Plate 17**
Boating Party, The (Cassatt), 14,
 14
Broadway Boogie Woogie
 (Mondrian), **252**
Bullfight, The (Goya), 28, 29,
 Plate 6
Café (Kirchner), 48–49, **48, 49,
 Plate 12**
Cats (Goncharova), 81, **81**
Christ among the Children
 (Nolde), 231–32, **231**
*Christ Driving the Traders from
 the Temple* (El Greco), 163,
 163
Christ Mocked (Bosch), 152, **152**
Christ Mocked by Soldiers
 (Rousault), 232, **232**
*Christ with St. Joseph in the
 Carpenter's Shop* (La Tour),
 176, **Plate 35**
*In the Circus Fernando: The Ring-
 Master* (Toulouse-Lautrec),
 221–22, **221**
City from Greenwich Village
 (Sloan), 33
Cliff Walk, The (Etretat) (Monet),
 212, **212**
Close of the Silver Age (Cranach),
 165
Colossus (Goya), 198, **199**
Composition (Mondrian), 249–50,
 Plate 61
Composition 8 (Kandinsky), 76, **77**
Composition 1916 (Mondrian),
 71–72, **71,** 82
*Coronation of Napoleon I at Notre
 Dame* (David), 169
Cristoforo Colombo (Morley), 272
cubist, 235–40
Cupid Complaining to Venus
 (Cranach), 151–52, **151**
In the Current Six Thresholds
 (Klee), 81, **81**
Dance (first version) (Matisse),
 229, **229**

Dancers Preparing for the Ballet
 (Degas), 214–15, **214**
Dances (Davies), 43, **Plate 14**
Day of the God (Gauguin), 220,
 Plate 53
Death of Socrates, The (David),
 193, **Plate 41**
Death of the Virgin, The
 (Caravaggio), 176, **176**
Death Seizing a Woman
 (Kollwitz), 230, **230**
Delights of the Poet, The (De
 Chirico), 244, **244**
Descent from the Cross
 (Rembrandt), 21, **Plate 1**
Deuce (Davis), 262, **263,** 264
Diana Resting after Her Bath
 (Boucher), 183, **183**
*Disembarkation of Marie de
 Medici* (Rubens), 174, 175,
 Plate 40
Eiffel Tower (Delaunay), 66, **67**
*Embarkation for the Island of
 Cythera, The* (Watteau),
 183, **Plate 39**
Entombment, The (Michelangelo),
 155, **155**
Fair Rebecca, The (Indiana), 271,
 271
False Mirror, The (Magritte), 245,
 245
Family Group (Glackens), 28, **28**
Family of Saltimbanques
 (Picasso), 20, **20,** 21
fauvism and expressionism, 228–33
Football Players, The (Rousseau),
 76, **76**
In the Forest (Campendonk), **50,**
 51, **Plate 9**
Forge, The (Le Nain), 179–80,
 179
Funeral of the Anarchist Galli
 (Carra), 234, **234**
*Fur Traders Descending the
 Missouri* (Bingham), 200,
 200
futurist, 233–35
Garden in Vallauris (Picasso), 73,
 73
Garden of the Poets (van Gogh),
 223
Gelmeroda IV (Feininger), 83, **83**
geometric abstraction, 261–64
Girl and Laurel (Homer), 48, **48**
Girl Returning from the Market
 (Chardin), 184, **184**
Grainstacks, Snow, Sunset
 (Monet), 213, **Plate 54**
Green Coca-Cola Bottles (Warhol),
 79, **79,** 82
Green Violinist (Chagall), 75,
 Plate 21
Guardian of the Streets (Pollock),
 256, **257**
Guernica (Picasso), 236–37, **236**

INVITATION TO THE GALLERY

Text and Display Type: Times Roman/Wm. C. Brown Manufacturing Division

Cover Stock: Francote/Union-Camp Corporation

Interior Stock: 70# Sterling Dull Coated

Colorplate Stock: 80# Sterling Enamel

Printing/Binding: Wm. C. Brown Manufacturing Division